THE PELICAN HISTORY OF ART

EDITED BY NIKOLAUS PEVSNER

Z23

SCULPTURE IN BRITAIN: 1530–1830

MARGARET WHINNEY

MARGARET WHINNEY

SCULPTURE IN BRITAIN

1530 TO 1830

PENGUIN BOOKS

BALTIMORE · MARYLAND

First published 1964
Penguin Books Inc.
3300 Clipper Mill Road, Baltimore, Maryland

★

Copyright © Margaret Whinney, 1964

★

Made and printed in
Great Britain

TO THE STAFF AND
STUDENTS OF
THE COURTAULD INSTITUTE

★

CONTENTS

CONTENTS

Part Four

The Antique, the Baroque, and the Rococo
1714–1760

Part Five

The First Royal Academicians

Part Six

Neo-classicism

CONTENTS

Part Seven

The Early Nineteenth Century

The Plates

LIST OF PLATES

70 (A) Sir Henry Cheere: Monument to Admiral Sir Thomas Hardy, d. 1732. *Westminster Abbey* (Warburg Institute)

(B) Michael Rysbrack: Tomb of the 1st Duke of Marlborough, 1732. *Blenheim Palace, Oxfordshire* (A. F. Kersting)

71 (A) Peter Scheemakers and Laurent Delvaux: Monument to Lewis, Earl of Rockingham, 1725. *Rockingham, Northamptonshire* (Copyright *Country Life*)

(B) Peter Scheemakers and Laurent Delvaux: Monument to Dr Hugo Chamberlen, 1731. *Westminster Abbey* (Warburg Institute)

72 Sir Henry Cheere: Christopher Codrington, 1732. *Oxford, All Souls College* (National Buildings Record)

73 (A) Henry Scheemakers: Monument to Sir Francis and Lady Page, c. 1730. Detail. *Steeple Aston, Oxfordshire* (Dr M. D. Whinney)

(B) Sir Henry Cheere: Monument to Lord Justice Raymond, d. 1732. Detail. *Abbots Langley, Hertfordshire* (Dr M. D. Whinney)

74 Louis François Roubiliac: George Frederick Handel, 1738. *London, Messrs Novello* (V. and A.)

75 Peter Scheemakers: Monument to William Shakespeare, 1740. *Westminster Abbey* (Warburg Institute)

76 (A) Louis François Roubiliac: Jonathan Tyers, c. 1738. *Birmingham, City Museum and Art Gallery*

(B) Louis François Roubiliac: William Hogarth, c. 1740. *London, National Portrait Gallery*

77 (A) Louis François Roubiliac: Alexander Pope (marble), 1741. *Earl of Rosebery Collection* (National Portrait Gallery)

(B) Louis François Roubiliac: Alexander Pope (terracotta), c. 1738. *Mrs M. Copner* (A. Gill Ltd, Peterborough)

78 Louis François Roubiliac: Monument to John, Duke of Argyll, 1745-9. *Westminster Abbey* (Warburg Institute)

79 Louis François Roubiliac: Monument to John, Duke of Argyll, 1745-9. Detail. *Westminster Abbey* (Warburg Institute)

80 (A) Louis François Roubiliac: Monument to Bishop Hough, 1746. *Worcester Cathedral* (A. F. Kersting)

(B) Louis François Roubiliac: Monument to the 2nd Duchess of Montagu, 1753. *Warkton, Northamptonshire* (The late Mrs M. I. Webb)

81 Louis François Roubiliac: Monument to William and Elizabeth Harvey, 1753. *Hempstead, Essex* (Dr M. D. Whinney)

82 (A) Louis François Roubiliac: Monument to General William Hargrave, 1757. *Westminster Abbey* (Warburg Institute)

(B) Louis François Roubiliac: Monument to General William Hargrave, 1757. Detail. *Westminster Abbey* (Warburg Institute)

83 Louis François Roubiliac: Monument to General William Hargrave, 1757. Detail. *Westminster Abbey* (Warburg Institute)

84 Louis François Roubiliac: Monument to Lady Elizabeth Nightingale, 1761. *Westminster Abbey* (Warburg Institute)

85 Louis François Roubiliac: Monument to George Frederick Handel, 1761. *Westminster Abbey* (Warburg Institute)

86 (A) Louis François Roubiliac: Sir Andrew Fountaine, 1747. *Earl of Pembroke, Wilton House, Wiltshire* (Royal Academy of Arts)

(B) Michael Rysbrack: Sir Robert Walpole, 1738. *London, National Portrait Gallery*

87 (A) Louis François Roubiliac: David Garrick, c. 1758. *London, National Portrait Gallery*

(B) Louis François Roubiliac: Dr Martin Folkes, 1749. *Earl of Pembroke, Wilton House, Wiltshire* (Courtauld Institute of Art)

88 Louis François Roubiliac: The 9th Earl of Pembroke, 1750. *Birmingham, City Museum and Art Gallery*

89 Louis François Roubiliac: Dr John Belchier. *London, Royal College of Surgeons of England* (Courtauld Institute of Art)

90 (A) Louis François Roubiliac: Sir Robert Cotton (terracotta), 1757. *London, British Museum*

(B) Louis François Roubiliac: Joseph Wilton, c. 1761. *London, Royal Academy of Arts* (Courtauld Institute of Art)

91 (A) Louis François Roubiliac: Sir Robert Cotton (marble), 1757. *Cambridge, Trinity College* (R.C.H.M., Crown Copyright)

(B) Louis François Roubiliac: Francis Willoughby, 1751. *Cambridge, Trinity College* (R.C.H.M., Crown Copyright)

92 Louis François Roubiliac: Sir Isaac Newton, 1755. *Cambridge, Trinity College* (R.C.H.M., Crown Copyright)

93 Louis François Roubiliac: Self-Portrait. *London, National Portrait Gallery*

94 (A) Michael Rysbrack: Hercules, *c.* 1743. *The National Trust, Stourhead, Wiltshire* (Courtauld Institute of Art)

(B) Michael Rysbrack: Sir Peter Paul Rubens, 1743. *Earl of Harrowby, Sandon Hall, Staffordshire* (City Museum and Art Gallery, Birmingham)

95 (A) Michael Rysbrack: Monument to Sir John Dutton, 1749. *Sherborne, Gloucestershire* (National Buildings Record)

(B) Michael Rysbrack: 'Go, and do thou likewise', 1763. *Brussels, Musée Royal* (A.C.I., Brussels)

96 (A) Peter Scheemakers: Monument to Dorothy Snell, d. 1746. *Gloucester, St Mary-le-Crypt* (The late F. H. Crossley)

(B) Peter Scheemakers: Monument to the 1st Earl of Shelburne, 1754. *High Wycombe, Buckinghamshire* (A. F. Kersting)

97 (A) Sir Henry Cheere: Monument to Philip de Sausmarez, d. 1747. *Westminster Abbey* (Warburg Institute)

(B) Peter Scheemakers: Monument to General the Hon. Percy Kirk, after 1743. *Westminster Abbey* (Warburg Institute)

98 Peter Scheemakers: Monument to the 1st Earl of Shelburne, 1754. Detail. *High Wycombe, Buckinghamshire* (A. F. Kersting)

99 Peter Scheemakers: Captain Robert Sandes, 1746. *London, Trinity House* (Courtauld Institute of Art)

100 (A) Andries Carpentière: Monument to the Earl of Warrington, 1734. *Bowden, Cheshire* (W. Rhodes Marriott, Stockport)

(B) James Gibbs and Michael Rysbrack: Monument to Mrs Katherine Bovey, d. 1724, in Westminster Abbey, from James Gibbs, *Book of Architecture*, 1728 (Courtauld Institute of Art)

101 (A) Sir Robert Taylor: Monument to Sir Henry Penrice, d. 1752. *Offley, Hertfordshire* (Brian Delves)

(B) Thomas Adye: Monument to Charles Sergison, d. 1732. *Cuckfield, Sussex* (Brian Delves)

102 (A) James Annis: Monument to Sir George Fettiplace, d. 1743. *Swinbrook, Oxfordshire* (Dr M. D. Whinney)

(B) William Palmer: Monument to Lord Lexington, 1726. *Kelham, Nottinghamshire* (Bruce Bailey)

103 (A) Sir Robert Taylor: Monument to William Phipps, d. 1748. *Westbury, Wiltshire* (National Buildings Record)

(B) Thomas Carter I: Monument to Colonel Thomas Moore, after 1746. *Great Bookham, Surrey* (Dr M. D. Whinney)

104 William Woodman: Monument to Viscount Newhaven, *c.* 1728–32. *Drayton Beauchamp, Buckinghamshire* (Eric Meadows, Luton)

105 (A) Charles Stanley: Ceiling with portrait of Colen Campbell, *c.* 1728. *Compton Place, Eastbourne, Sussex* (Copyright *Country Life*)

(B) Anonymous Italian: Plaster chimneypiece, *c.* 1720–31. *Barnsley Park, Gloucestershire* (Courtauld Institute of Art)

106 Thomas Carter II: Chaloner Chute, 1775. *Basingstoke, Hampshire, The Vyne* (National Buildings Record)

107 (A) Filippo della Valle: Monument to Lady Walpole, 1743. *Westminster Abbey* (A. F. Kersting)

(B) John Cheere: Minerva. *Southill, Bedfordshire* (Courtauld Institute of Art)

(C) Michael Rysbrack: John Locke, 1755. *London, Victoria and Albert Museum* (Crown Copyright)

108 (A) Joseph Wilton: The Earl of Chesterfield, 1757. *London, British Museum* (Courtauld Institute of Art)

(B) Joseph Wilton: General Wolfe, *c.* 1760. *Earl of Rosebery, Collection* (The National Galleries of Scotland)

109 Joseph Wilton: Monument to General Wolfe, 1772. *Westminster Abbey* (Warburg Institute)

110 Joseph Wilton: Monument to Admiral Temple-West, d. 1757. *Westminster Abbey* (A. F. Kersting)

111 Joseph Wilton: Monument to Dr Stephen Hales, 1762. *Westminster Abbey* (Warburg Institute)

112 Joseph Wilton: Monument to the 2nd Duke of Bedford, 1769. *Chenies, Buckinghamshire* (Courtauld Institute of Art)

113 (A) and (B) Richard Hayward: Details of font, 1789. *Bulkington, Warwickshire* (Dr K. Downes)

114 (A) Joseph Wilton: Monument to Archbishop Tillotson, 1796. *Sowerby, Yorkshire* (Bruce Bailey)

FOREWORD

ENGLISH *sculpture between 1530 and 1830 has neither the interest nor the quality of English architecture and painting of the same period. Much of it is provincial in character, and even among leading sculptors there are few who will stand comparison with their European contemporaries. Many readers, and among them will inevitably be included some of my fellow-contributors to the* Pelican History of Art, *will grumble that so long a book, with so lavish a collection of plates, should be given to what may seem a poor subject.*

On the other hand, the series is primarily intended for English readers, and as much can be learnt about English taste from sculpture as from the other arts. Since no fully illustrated survey of the subject exists, this may therefore perhaps serve some useful purpose. The field is so large and the material so scattered that little beyond a survey has been possible, though an attempt has been made to consider the history of English sculpture both from the angle of English patronage and also in its relation to Continental style. I am well aware that the survey is incomplete. By far the greater part of the material with which it is concerned consists of tomb sculpture, for religious sculpture is almost non-existent in England and there are relatively few statues and busts before the eighteenth century. In a country where the main ambition of all classes was to hold land, men tended to be buried near their country estates, and so much English sculpture is scattered in village churches, sometimes hard to see and often impossible to photograph. Moreover, many tombs have been moved, and some have been and unfortunately still are being mutilated; and it is often hard to get precise information about the original design. Many monuments are signed or documented, but a surprising number of moderately distinguished works are still anonymous. So far as possible, I have drawn conclusions from documented works alone, and if I have risked attributions I have attempted to make this clear.

Since the quality of English sculpture over the period is extremely uneven, it seemed best to devote most space to the eighteenth century, when the level was fairly high. In some ways this gives a false picture; for the quantity of sculpture produced in the sixteenth and seventeenth centuries was enormous, and there is little reason to suppose that patrons were not satisfied with what they got. In the early nineteenth century there is much that is of interest; but since the century as a whole will be treated in another volume, I have dealt with this period somewhat arbitrarily, stressing its relation to the eighteenth century rather than looking at it from all angles.

Although no well-illustrated account of English post-medieval sculpture exists, the ground was broken more than thirty years ago by the pioneer work of the late Mrs K. A. Esdaile, who, at a time when the subject was totally neglected, was to devote a lifetime of enthusiasm to the investigation of many hundreds of monuments. More recently, an invaluable service has been performed by Mr Rupert Gunnis, whose Dictionary of British Sculptors, 1660–1851 (1953) *is packed with essential information, unobtainable elsewhere. The scholarly work of the late Mrs M. I. Webb is of lasting value in its clarification of many difficult problems.*

My debt to many of my friends and colleagues is very great. Indeed, without the generosity of Mr Rupert Gunnis, who has allowed me constant access to his library of photographs, answered endless questions, and given me much unpublished material, the book could never have been written. Professor Ellis Waterhouse, with his unfailing kindness, read a large part of the work in

draft and made many helpful suggestions, for which I am deeply grateful. Professor Sir Anthony Blunt read certain chapters and generously encouraged me to use his unpublished material on French influences in England, and Professor L. D. Ettlinger and Dr Peter Murray have also given me constant help and encouragement. Finally, I owe much to the advice of Professor Nikolaus Pevsner, without whose support I might well have despaired.

Many others have provided me with information or given me ideas which, I hope, have proved fruitful. Among them I must thank: Mr Geoffrey Beard, Dr T. S. R. Boase, Mr John Charlton, Mr Howard Colvin, Mr John Harris, Mr Terence Hodgkinson, Dr David Irwin, Mr Michael Kitson, Mr Oliver Millar, Mr John Pope-Hennessy, Mr Lawrence Stone, Sir John Summerson, Mr Lawrence Tanner, Mr Francis Watson, Professor Geoffrey Webb, Professor Rudolf Wittkower, and Mr John Woodward. This list only represents a fraction of the help I have received, and I would like to take this opportunity of thanking the staffs of many galleries, and above all of the National Portrait Gallery for their kindness in providing photographs and in disentangling problems. I also owe much to many former students of the Courtauld Institute, too numerous to mention individually, who over a long period have sent me information about examples of English sculpture. Their interest has been a constant source of encouragement.

The plates at the end of this book will be proof of my debt to a number of photographers, but my thanks must also be expressed. Professor George Zarnecki and Dr Kerry Downes have given time from their own work to take photographs specially for me; Mr A. F. Kersting's skill over the photography of difficult monuments will be clearly apparent. And my debt to the Conway Library and the Photographic Department of the Courtauld Institute is incalculable. Dr Peter Kidson and his staff have been endlessly patient in dealing with my constant requests; Miss Ursula Pariser, Miss Janet Balmforth, and Mr Raymond Hall have used their experience to provide me with fine photographs. All students of English sculpture must be grateful to the enterprise of the Warburg Institute in photographing the monuments in Westminster Abbey and St Paul's Cathedral in difficult but also surprisingly favourable conditions during the Second World War, and so providing an invaluable corpus of material for study.

I must also acknowledge the gracious permission of Her Majesty the Queen to reproduce works in the Royal Collection (Plates 58A, 124A, 128B, 167), and the kind permission of many owners, including the Duke of Beaufort (Plates 14, 39A), the Duke of Bedford (Plates 112, 190B), the Duke of Devonshire (Plate 37), the Duke of Marlborough (Plate 70B), the Duke of Norfolk (Plate 25B), the Marquis of Bath (Plate 62A), the Marquis of Exeter (Plate 53B), the Marquis of Salisbury (Plates 12B, 13, 15, 17), the Earl of Harrowby (Plate 94B), the Earl of Leicester (Plates 121, 136), the Earl of Munster (Plate 179), the Earl of Pembroke (Plates 86A, 87B), the Earl of Rosebery (Plates 77A, 108B), the Earl of Yarborough (Plate 122), the Earl Fitzwilliam (Plate 118B), the Lord Faringdon (Plate 105B), Mrs M. S. Copner (Plate 77B), Mr G. S. Finch (Plate 59A), Mrs T. Giffard (Plate 135B), Mrs Andrew Kerr (Plates 43A, 46, A and B), Mrs Maxwell-Scott (Plate 189), Mr H. Ricketts (Plate 187B), Mr S. C. Whitbread (Plates 107B, 135A), and Mr John Wyndham (Plates 155, A and B, 174). I hope that Directors of Museums and Galleries, and all others who, having the care of sculpture, have kindly given me permission to reproduce it, will accept the acknowledgement in the list of plates as an earnest of my gratitude.

Lastly, I must thank the Central Research Fund of the University of London for a grant towards the purchase of photographs necessary for the research required for this book.

March 1963

PART ONE

THE SIXTEENTH CENTURY

CHAPTER I

INTRODUCTION

THE history of English sculpture in the sixteenth century is a sorry tale. Though the quantity produced was great, its quality is at once mediocre and monotonous. The causes of this disappointing character of English sixteenth-century work lie in the limited opportunities offered to craftsmen, the narrowness of their training, and their restricted knowledge of Continental art. Conditions such as these are outside the sculptor's control, for they spring from the peculiar circumstances of English social and political history.

At the beginning of the period Gothic was a living art, and the cathedral workshops not only turned out a fair amount of architectural sculpture of respectable level, but also provided a training ground for craftsmen. The alabaster yards of the Midlands were still very active, and though the great demand for alabaster retables was dwindling, numbers of fine tombs were still being made.[1] The Dissolution of the Monasteries by Henry VIII in 1538 and the consequent break-up of the cathedral workshops was not the sole cause of the decline in English sculpture by the middle of the century, but it was a potent one, and the fact that no religious sculpture was required in England after about 1540 greatly restricted the field. Very little outside tomb sculpture was now commissioned. Indeed, for the next two hundred years the history of English sculpture is very largely a question of tombs and monuments. Inevitably the English interest in the family and in the individual strengthened the desire for handsome, permanent memorials, sometimes erected within a man's own lifetime, or under his will, or as a pious duty by his relatives after his death. Moreover, in the sixteenth century, since the new landed gentry, who had risen after the Wars of the Roses, or had been granted monastic estates by Henry VIII, were anxious to establish their standing, the great family tomb was to have an especial appeal. Many were still to be made by the Midland alabaster-men, whose industry was little affected by Henry VIII's policy regarding the Church; some yards were active till the last quarter of the century, but the quality of work steadily declined. Other tombs, made of freestone, were, until after the middle of the century, probably cut by men who had been trained in the cathedral workshops, or by carvers and masons who had themselves worked in them; in the last quarter of the century commissions were largely given to foreigners, which is a clear indication that English craftsmanship had deteriorated.

More significant, and probably even more damaging to the development of English

I

sculpture than the disappearance of religious subjects, was the lack of steady court patronage. Here the contrast between England and France is very great. The royal undertakings in France from the reign of Louis XII right down to the end of the century not only provided opportunities for sculptors to work in a number of different fields, but also established a training ground in which the standards were high, and where the ideas of distinguished artists would quickly become known to younger men. Nothing of the kind occurred in England. Early in the reign of Henry VIII and again in the late 1530s, there was considerable building activity at the court, and in consequence a demand for decorative sculpture. The king's interest in the arts, however, does not appear to have been very intelligent or deep-seated, but arose from his love of pageantry and his desire to outshine Francis I. As will be seen, his undertakings were too sporadic to lead to the establishment of a permanent body of trained artists. The reigns of his immediate successors were short and troubled, and Queen Elizabeth I found the exchequer empty on her accession. Such a situation was calculated neither to encourage English craftsmen nor to attract distinguished foreign artists. In the reign of Henry VIII two considerable artists, Pietro Torrigiano and Hans Holbein, worked for a number of years for the English crown; but between Holbein's death in 1543 and the first visit of van Dyck in 1621, the only foreign artists of any note to enter England were Antonio Moro and Federico Zuccaro. Neither stayed for long, and both were employed only as portrait painters. This isolation of England from Continental art worked in both directions; for no English sculptors, and indeed very few artists in any field, are known to have visited Italy or France.

Under such circumstances, it is not surprising that the standard of sculpture is low, nor that its style is confused. Though early in the century contacts with both Italy and France were strong enough to suggest that Renaissance ideas would quickly replace Gothic, these contacts progressively weakened, leaving little but some knowledge of Renaissance decoration. After Henry VIII's break with Rome, few patrons travelled to Italy, and those that did do not appear to have returned with any great appreciation of Italian art. More visited France, but though the influence of their journeys can be seen in architecture[2] and sometimes in decoration, they had little permanent effect on sculpture proper. In the last quarter of the century contacts with the Low Countries were to become closer than those with Italy or France; refugees from the Wars of Religion were to settle in England and were to exert considerable influence on both sculpture and decoration. They cannot, however, be said to have brought much new vitality or a truly distinguished standard of work.

Figure sculpture was, indeed, to develop on narrow and extremely conservative lines from the competent but stiff treatment of Late Gothic craftsmen to a greater naturalism which is seldom lively and is in general totally unambitious. Though a few classical figures are known to have been created in the reign of Henry VIII, none have survived, and they cannot have had much influence; later in the century the drawings for fountains in the *Lumley Inventory*[3] suggest a timid and clumsy adaptation of Flemish Mannerist art, and are likely to have been made by Netherlandish craftsmen; while the coarse and almost grotesque figures which adorn some English country houses, such as

those of the Nine Worthies at Montacute, Somerset (*c.* 1588–1601),[4] are an indication of the great void between English sculpture and that of the Continent. It is true that a fair amount of garden sculpture, some of it of classical subjects, but some only in the form of heraldic beasts, is known to have existed,[5] but nothing remains to suggest that it had any quality. Busts are extremely rare, though there are two groups of some interest, but it is improbable that either was the work of English craftsmen. Four marble busts of Tudor sovereigns, Henry VIII, Edward VI, Mary, and Elizabeth (Earl of Scarborough), first recorded in 1590,[6] have individuality, but it is not easy to suggest the nationality of the sculptor, and by Continental standards he was not an artist of great distinction. The three busts of the Bacon family (Gorhambury, Hertfordshire) of painted terracotta are closer to the best effigies on tombs made by sculptors from the Low Countries, but such objects are so rare that they cannot be regarded as typical of their age.[7]

Beyond this, the only field of employment outside tomb sculpture lay in decoration, and above all in chimneypieces. Few of these have figures until late in the century, when they are drawn almost entirely from Northern Mannerist pattern-books (Plate 14), and with very rare exceptions are too coarse in execution to warrant discussion.[8] Earlier in the century there is, however, one example of decorative work of high quality, the screen and stalls of King's College Chapel, Cambridge (1533–8; Plate 5).[9] Much of the ornament can be closely paralleled in France, and is comparable to work which will be discussed in the next chapter; but the figure carving with its twisted poses and wind-blown draperies, strongly Mannerist in feeling, seems closer to Flemish or even to German art. Though, however, both foreign and English craftsmen were employed on various forms of decoration through the century, little of their work can really be termed sculpture; and the tomb is the central interest of the period.

RENAISSANCE INFLUENCE FROM ITALY AND FRANCE

THE early years of the sixteenth century do not suggest that sculpture in England was to follow so isolated and dreary a path, for links with both Italy and France were strong.[1] Henry VII, usually regarded as a parsimonious man, was determined that, as founder of a new dynasty, he should be commemorated by a splendid tomb in a new manner. The commission was first given in 1506 to Guido Mazzoni of Modena,[2] whose design must have appeared very novel in England, for above *gisants* of Henry and his queen were to be kneeling figures of the king surrounded by four others, while at the sides were allegorical reliefs. The materials, too, were new, for they were to include black and white marble and bronze, with painting and gilding. The kneeling figures, which, like the whole design, are linked with Mazzoni's lost tomb of Charles VIII of France, do not seem to have found favour, for in the executed tomb of Henry VII and Elizabeth of York (Westminster Abbey, Henry VII's Chapel; Plates 1 and 2A), which was made by Pietro Torrigiano between 1512 and 1518, and therefore after Henry's death, they are replaced by recumbent figures. This fine tomb, by a Florentine trained with Michelangelo in Ghirlandaio's studio, though earlier than the limits of this book, must be considered in some detail, since it is the major Renaissance work created in England, and sets a standard against which later sixteenth-century sculpture must be judged. The materials are the same as those in Mazzoni's design – a black marble tomb-chest with a white marble top, the ornaments and figures being gilt-bronze. The pilasters at the corners and the moulded base are enriched with typical Quattrocento decoration; the royal arms have Florentine putti in the manner of Verrocchio as supporters, while the sides of the tomb-chest are adorned with bronze medallions each with two figures of saints within wreaths of oak and Tudor roses. On the four corners above are seated four grave child angels, dressed, not nude like the putti below, but still purely Italian in style. The effigies (Plate 2A), however, recumbent and with their hands joined in prayer, show that the vitality of the Gothic tradition in England could affect even a Florentine. The robes fall in almost unbroken lines from shoulders to feet, the forms of the body beneath being hardly perceptible; and though there can be no doubt that the head of the king is a fine posthumous portrait, based perhaps on the funeral effigy, it has none of the detailed realism of, for instance, Pollaiuolo's effigy of Sixtus IV. Torrigiano's other documented English tomb,[3] that of Henry VII's mother, Lady Margaret Beaufort (1511, Westminster Abbey), has also an Italian tomb-chest, but the beautiful effigy, itself extremely Gothic, is flanked by small Gothic buttresses and has a Gothic canopy over the head.

Torrigiano, who was in England from 1511 to 1520, was clearly the first artist to show the English something of true Renaissance style, brought direct from Italy, and also the first to introduce new materials. Neither innovation was to make a permanent

mark, though the second was to be taken up by other artists, not all of them, however, English. His own work certainly includes the monument to Sir Thomas Lovell (d. 1524, Westminster, Henry VII's Chapel), with its bronze profile medallion set in a wooden frame,[4] but this virile portrait seems to have had no followers. The same may be said of the terracotta busts of Henry VII and the so-called Bishop Fisher (V. and A. and New York, Metropolitan Museum), which are indeed so completely Florentine that they only belong by accident to the history of English sculpture.[5]

Torrigiano was followed by two other Tuscans, neither of such good standing, Benedetto da Rovezzano (in England c. 1524–c. 1535) and Giovanni da Maiano (arrived c. 1521). The former had worked in France in 1502 on the base of the tomb of the Dukes of Orleans, though he had been back in Italy till at least 1519; of the latter's earlier career nothing is known, though it is possible that he also had been in France. Little of Benedetto's work is now left in England,[6] but both artists seem to have been attracted by the patronage of Cardinal Wolsey rather than that of the crown. Up to Wolsey's fall in 1529, his palace at Hampton Court was the most splendid new undertaking in England, and there Giovanni da Maiano made for him the series of terracotta roundels with the heads of Roman Emperors which adorn the gatehouses of Base Court and Clock Court, and probably also the terracotta panel with the Cardinal's arms supported by two putti.[7] In spite, however, of the fact that the artist was Florentine, such decoration is North Italian, the best known example being the façade of the Certosa at Pavia; but by far the closest parallel is to be found in the work done for Cardinal d'Amboise at Gaillon.[8] Alliance with France was one of the keystones of Wolsey's foreign policy, and it is probable that his taste for the new Renaissance decoration was aroused by his political contacts with d'Amboise.

There seems, indeed, no doubt that such dissemination as can be found of Renaissance motives during the first sixty years of the century is inspired by French rather than by direct Italian sources. Torrigiano and Benedetto da Rovezzano founded no school, and were not followed by other Italian sculptors.[9] Some craftsmen, however, who could handle that un-English material, terracotta, were active in a number of places, though the character of their work suggests they were not Italian. The panels of putti holding rosaries over the door of Sutton Place, Surrey, are crude in design and execution, and the nearest counterpart to their unusual iconography appears on the coffering of the Hotel Lallemand at Bourges (probably before 1514).[10] The new French forms of Renaissance art must have been well known to the patron, Sir Richard Weston, who had been on several embassies to France, but unfortunately nothing is known of the craftsmen he employed. The other example of terracotta decoration of approximately the same date is at Layer Marney, Essex, though here there are no figures, but window frames and cresting with cherubs' heads, scrolls, and flattened shells.[11]

It is probable that the craftsmen who worked at Layer Marney Hall were also responsible for a group of East Anglian tombs which appear to date from the 1530s. They are notable for their use of terracotta and of Franco-Italian detail, some of which seems to have been taken from a single set of moulds. The group includes the tomb of Robert annys (1533–4, Norwich Cathedral), of Elisha Ferrers (Wymondham, Norfolk), those

of the 1st and 2nd Lord Marney (Layer Marney, Essex; Plate 4), and the Bedingfeld Chapel (Oxburgh, Norfolk).[12] The Marney tombs are the most impressive of the group, and have a special place in English sculpture, for they are among the earliest in which Gothic detail is entirely replaced by Renaissance decoration. Both have tomb-chests with coffered panels bearing shields of arms set in roundels, in one case framed by the Garter, and in the other by wreaths. Both have candelabra-like colonnettes between the panels. All this decoration is terracotta, but the slabs above and the recumbent effigies are of black marble. They are boldly cut, the 1st Lord's superior to that of the 2nd, and though they are, at first sight, less frankly foreign than the decoration, it is hard to believe they were designed and cut by an English craftsman. For these armoured figures do not rest their heads, in the traditional English manner, on their helms, but on cushions, a feature which hardly recurs until almost 1600. Moreover, the face of the 1st Lord Marney has not the smooth, somewhat empty modelling of English work, but in its sharp, deep hollows on either side of the mouth is reminiscent of the remarkable *gisant* on the tomb of Louis XII.[13] The tomb of the 1st Lord Marney is, like many medieval tombs, set between two piers of the chancel, and like them it has a canopy. Instead, however, of Gothic tracery, pinnacles, or pierced cresting, this is composed entirely of Italianate motives. On the other hand the cusps normal in Late Gothic work have not been forgotten, but are transformed into small semi-Corinthian capitals, supported by nothing, but hanging from the entablature above. The ornament is relatively high in quality, well-disposed, and very French in treatment; the putti on the Bedingfeld Chantry are, however, extremely crude in handling. The studio, wherever its headquarters may have been, appears to have been short-lived; but in view of the character of the material and the workmanship, it seems likely that the leading craftsman was either a Frenchman or an Englishman who had worked with Italians in France.

By the time these tombs were made, Renaissance ornament, though not in terracotta, had also appeared, often mixed with Gothic structural details, at many places in the South of England. The tombs of Bishops Toclyve and Poyntz at Winchester Cathedral, the chests made to contain the bones of Saxon kings, and the cresting of the presbytery screen were all the work of Bishop Fox about 1525, and all have details, notably roundels and an urn and flower motive, very close to those at Gaillon. From Winchester the style spread to Christchurch Priory in the same county (Draper Chantry, *c.* 1529; Countess of Salisbury Chantry, before 1538) and to Sussex (Boxgrove, Delaware Chantry, *c.* 1532; Plate 6B). Coarser and rather later examples may be found in the same county.[14] It is not easy to account precisely for the use and spread of these Franco-Italian decorative motives, which are generally, though not always, competently cut. Bishop Fox may have employed a foreign craftsman, who worked elsewhere himself and whose work was copied by others. On the other hand, Fox and other patrons may perhaps have possessed copies of the Books of Hours printed in Paris early in the sixteenth century, which have a number of not dissimilar motives in the framing of the pages.[15] It would surely not have been impossible for a cathedral-trained carver to copy them.

One fairly distinguished Sussex tomb, that of Sir Anthony Browne (1538–48, Battle), is characteristic of the group in its later phase.[16] The tomb-chest has panels with flattened shell-heads, divided by candelabra-balusters, and adorned with the usual shields and wreaths. The larger of the shields are supported by putti which are an inept imitation of the splendid figures on Henry VII's tomb. This motive was to catch the eye of English craftsmen. It is used on the otherwise traditional alabaster tomb of Sir Thomas Cave (d. 1558, Stanford-on-Avon, Northamptonshire), where the boys have curiously Gothic proportions, and their nakedness is carefully masked. On the tomb of Sir John Salusbury (d. 1578, Whitchurch, Denbigh; Plate 2B), obviously the work of a fairly good Midland alabaster shop, and competent in the cutting of clothed figures, the boys are grotesquely deformed, with enormous bloated bodies and tiny legs; those on the Humphrey Peyto (d. 1585, Chesterton, Warwickshire), probably from the same workshop, have been forced to kneel; and as late as 1590, on the tomb of Edward Burnett (Sibthorpe, Nottinghamshire) they still appear, squatting uncomfortably beside a shield, their wings now transformed into scarves.

The Winchester–Sussex group of tombs are rich in fairly low-relief surface detail; a different type of Renaissance decoration may be seen in the interesting tombs at Framlingham, Suffolk, though the date of these is obscure.[17] That of the Duke of Richmond, which has no effigy, has a tomb-chest articulated by fluted Doric pilasters, very respectable in design, and a frieze composed of panels with Old Testament reliefs, separated by small herms. The reliefs are still crude Late Gothic, and can hardly have been cut by the man who handled the pilasters. The tomb of the 4th Duke of Norfolk's wives uses the design more boldly, for Corinthian columns have replaced the pilasters, the sunk panels between them have an egg and tongue moulding, and instead of the Gothic frieze there are panels with griffins and acanthus. The tomb of the 3rd Duke of Norfolk (Plate 3A) is the finest of the three, and, indeed, one of the most distinguished of its time. Here the sarcophagus is surrounded by figures of apostles in shell-headed niches, separated from each other by candelabra-colonnettes. There can be little doubt that the duke had planned his tomb in the late 1530s on French models. He had been on several occasions to France, and no doubt had seen the tomb of the Dukes of Orleans (1502, Saint-Denis), or perhaps that of Francis II of Brittany at Nantes.[18] He may even have brought back a French craftsman with him who designed his tomb-chest and that of the Duke of Richmond. The figures of apostles, however, owe nothing of their style to France, but seem closer to Flemish or German models, and the effigies on both the Norfolk tombs are equally un-French and were, in all probability, supplied by Midland alabaster-men.[19]

Renaissance influence up to about 1540 was, therefore, except for the work of Torrigiano, almost entirely a question of new forms of ornament applied to monuments fundamentally Gothic in type, and often, as on the Countess of Salisbury's chantry, set in Gothic mouldings. A similar phase had existed in France, though there the new forms were more quickly and more completely accepted and transformed into a national style, and there, moreover, some French sculptors of talent, such as Michel Colombe, were active. French art underwent a further transformation owing to the royal work at Fontainebleau; but Henry VIII's sudden attempt, in the late 1530s, to rival Francis I brought

no parallel benefit to England. The fabulous palace of Nonsuch, begun in 1538 and completely destroyed in the seventeenth century, was lavishly decorated in a new manner; for the outer walls were adorned with figured reliefs of classical subjects in stucco, made in all probability by Nicholas Bellin of Modena, who had worked at Fontainebleau; stone statues of Roman Emperors were placed above the doors of the Inner Court and the King's Apartments were guarded by a statue of Scipio 'clothed in bronze garments', and the Queen's by Penthesilea. A likeness of Henry himself, enthroned and with his feet resting on a lion, appeared in the Inner Court, probably in relief, and there were fountains of Venus and of Diana and Actaeon. Indeed, the Rector of Cheam, describing the palace about 1590, and particularly the stuccos, stated 'everywhere there are Kings, Caesars, sciences, gods'.[20] Of all this, nothing except some small fragments of decoration have been recovered. If, however, the fine drawing (formerly Louvre) made for Henry VIII, probably by Nicholas Bellin, is any clue to the style of the figures, some at least were in the elegant and up-to-date Fontainebleau manner.[21]

Though, however, many foreign craftsmen, French, Italian, and German, are said to have worked at Nonsuch, there is astonishingly little direct influence of the new style.[22] Nor is it certain whether any of them except the Dutchman, William Cure, whose workshop will be discussed in the next chapter, remained long in England, or were employed by other patrons. Royal patronage came to an end with the death of Henry VIII in 1547, and the major mid-century building to show true Renaissance features, Old Somerset House, was destroyed in the eighteenth century, and no record remains of any sculptured decoration.[23]

There are, however, a few works which suggest that up to c. 1570 the major foreign influence was still French, coming either direct from France or via the Flemish versions of the Fontainebleau style, such as the engravings of Cornelis Floris and Cornelis Bos.[24] Moreover, it is possible that some French craftsmen may have been working in England. In Winchester Cathedral, the chantry of Bishop Gardiner (d. 1555), a major figure in the Catholic revival under Queen Mary and a frequent visitor to France, and the tomb of Thomas Mason (d. 1559), the first dean after the Suppression and probably an associate of the Lord Protector Somerset, both show strong French influence. In the Gardiner chantry this is largely a question of architectural detail, which reflects French mid-sixteenth-century classicism; but there are two puzzling and somewhat provincial figures on the inside of the screen which seem French rather than English.[25] The Mason tomb was dismembered in the seventeenth century, but fragments including figures of Adam and Eve now in the triforium (Plate 6A) have a certain air of Fontainebleau in their proportions, and are combined with large-scale strapwork which must be derived from that source.[26] A more puzzling problem arises at Lacock Abbey, Wiltshire, built by Sir William Sharington, a man who had visited France and had been closely associated with the friends of the Lord Protector Somerset. Some architectural details, including a great chimney now in the grounds, show ornament which is linked with the circle of Jean Goujon; but the two fine stone tables (1550–3) in the tower are purely Italian in form, though one has a base of crouching satyrs with baskets very close in

style to the engravings of Floris, and the other seems a clumsy adaptation of decorative motives on the base of Cellini's Perseus.[27] The only craftsman whose name is recorded at Lacock is William Chapman, but since his known work at Longleat House, Wiltshire, is a series of heraldic beasts, very conservative in style, it seems unlikely that he produced any of the more advanced work at Lacock.[28]

A few other examples of French influence can be quoted. The best-known is the tomb of Sir Robert Dormer (d. 1552, Wing, Buckinghamshire), which has no effigy, but on the front of the sarcophagus a remarkable frieze-like decoration of bull's skulls joined by swags. The fine straight canopy with its noble Corinthian order can be paralleled in both Italy and France; but the character of the swags, with large fruits and unusual frond-like leaves, is extremely close to the lost Louvre drawing attributed to Nicholas Bellin of Modena made for Henry VIII, and closer still to the engravings made at Fontainebleau by Antonio Fantuzzi.[29] It may therefore be that this tomb is one of the only works in England which could be connected with artists from Nonsuch. Perhaps more interesting, since it is a question of figure sculpture rather than decoration, is the joint monument of Sir Philip and Sir Thomas Hoby (Bisham, Berkshire; Plate 7). Both brothers had travelled in Italy and France, Thomas being so deeply aware of the Renaissance spirit that he had translated Castiglione's *Il Cortegiano*. He had died in 1566, while English ambassador in Paris, the tomb being erected by his widow. The sarcophagus has a tolerable Doric order, and the panels on it are surrounded by an egg and tongue moulding. It is, however, the effigies that are specially notable. Neither of the armoured knights lies rigidly on his back; both lean somewhat awkwardly on the left elbow, with a hand supporting the head. Sir Philip's right arm is across his body, the hand touching his sword; Sir Thomas's right arm is bent with hand on hip, and most unusually his feet are crossed. Such poses are unique in England at this date – for the recumbent effigy was universal – and the fine cutting of the heads, especially that of Sir Thomas, with its open eyes with incised irises, and its curling hair and beard, is far in advance of current English work. Indeed, it is so close in handling to the seated figure of Charles de Maigny (1557, Paris, Louvre) by Pierre Bontemps that the effigies may have been made by him in France at Lady Hoby's request, or possibly he himself or a talented member of his studio was called to England.[30]

It would therefore seem certain that between about 1540 and 1565 links with France of various kinds existed, and that the Winchester workshop at least contained either French or French-trained craftsmen capable of handling decoration, including small figures such as those on the Mason tomb, in a manner which presupposes a knowledge of the mid-century phase of French Renaissance art. Whether this atelier later split up and passed on its knowledge to English carvers is hard to say, but after 1560 pure French detail can be found in a number of tombs made by Englishmen, though in some cases it is combined with motives taken from Flemish engraved versions of the Fontainebleau style. A good example of the mixture can be found in the Harman tomb (1569, Burford, Oxfordshire), where the architecture is French; the large decoration surrounding the inscription, with figures struggling through strapwork, is Flemish and derived from the engravings of Cornelis Bos; and the groups of kneeling children, crowded into

panels framed with a clumsy guilloche pattern, are purely English. The monument to Alexander Denton (d. 1576, Hillesden, Buckinghamshire), signed by an unknown craftsman, Thomas Kirby, has something of the same mixture, though it is without figures, while his tomb of John, Lord Mordaunt (d. 1562, Turvey, Bedfordshire) is relatively pure and distinguished in its architecture and caryatids, but astonishingly tame in its treatment of the effigies.[31]

Though, however, English patrons and craftsmen had seen the work of the Italians employed by Wolsey and Henry VIII, and of the French craftsmen who were active in the middle years of the century, it is only in decoration, and not in figure sculpture, that the influence of the Renaissance can be traced. Even where Franco-Italian detail appears, it is, before about 1550, often mixed with Gothic tracery, and the figures retain their Gothic angularity. This is particularly notable in a group of Sussex tombs: Sir John Dawtry (1527, Petworth), Richard Sackville (c. 1540, Westhampnett), and two tombs of the Ernle family (c. 1545, West Wittering). The last three, which are certainly from the same workshop, are interesting, since they must be among the latest tombs in England to include religious sculpture. The Sackville tomb has a Pietà,[32] one of the Ernle tombs a Resurrection, and the other Christ as the Man of Sorrows, with an Annunciation on the tomb-chest below. The group is also distinctive in showing kneeling effigies in relief, flanking the sacred images. The quality is not very high, but the stylistic connexion with late-fifteenth-century English wall-painting, itself influenced by Flanders, is very clear. Another Sussex tomb, that of the 9th Lord Delaware (erected c. 1532, Boxgrove; Plate 6B), already mentioned for its use of French ornament, is of Caen stone and not local material, and, though mutilated, retains standing figures of the Virgin and Child and St George, which are somewhat less Gothic in feeling than the other Sussex works.[33]

Most of the work discussed so far is in the South of England, and was probably made there. By far the most important centre of tomb production lay, however, in the Midlands, where the fine alabaster quarried in Derbyshire and Nottinghamshire was made up and sent all over England. Little is known of the organization of the industry, the headquarters of which apparently moved in the sixteenth century from Nottingham to Burton-on-Trent; and though the names of a few craftsmen survive it seems that, as with the later Southwark workshops to be discussed in the next chapter, work was mass-produced and patterns largely interchangeable. Variants can be found, mainly in the arrangement of figures round the tomb-chest, and the earlier tombs are more vigorous than the later, but even so it was hardly a case of dominant artists, but rather of better trained craftsmen. The yards must have been extremely active, for great numbers of tombs were produced between the beginning of the century and about 1580.[34]

Midland-made tombs are generally altar tombs without canopies, with recumbent effigies whose hands are joined in prayer, and usually with children ranged in high relief round the tomb-chest. In the 1530s Gothic tradition is still strong. For instance, in the tomb of Sir Richard Knightley (d. 1534, Fawsley, Northamptonshire)[35] the children are set under cusped and crocketed canopies, the daughters wearing long, soft dresses which fall to their feet. The effigies themselves, especially that of the man, have some

force of character, and though neither features nor hands are subtle in cutting, they are well and roundly formed. The best Midland work of the next generation is represented by the tomb of the 1st Earl of Rutland (Bottesford, Leicestershire; Plate 3B), made by Richard Parker of Burton-on-Trent in 1543.[36] The children, in high relief, stand praying against a plain ground, monotony being avoided by varying the position of the hands, while the eldest son kneels at a fald-stool on the end panel. Here there is some indication that Renaissance decoration was already penetrating into the Midlands; for long wreaths of bay hang above the young man's head, and the corners of the sarcophagus are marked by broad, stumpy balusters on high, square bases. The effigies, however, have no Renaissance characteristics, but spring straight from the Gothic tradition. In both figures the robes fall in carefully arranged folds from shoulders to feet, revealing little of the forms of the body beneath them, and the heads, though clearly intended as portraits, are smooth and relatively empty in modelling.[37]

The most prolific Burton shop of the later phase seems to have been that of Richard and Gabriel Royley or Roiles.[38] Contracts with them have survived for two tombs, Thomas Fermor (1583, Somerton, Oxfordshire) and John Shirley (1585, Breedon, Leicestershire), but many others exist which are clearly by the same craftsmen, and it seems likely that the workshop first became active in the 1560s. The handling both of the tomb-chests and of the effigies is feeble and stereotyped; the faces are flattened and the features insignificant; if there are children ranged round the sarcophagus they have no individuality and their proportions are often grossly distorted; and though by now the Midlanders were aware, probably through engravings, of Renaissance ornament which could be applied to corner pilasters, the forms are misunderstood and degraded into clumsy and meaningless surface patterns.[39] Not all later Midland tombs are quite as weak in modelling as those known to have been produced by the Royleys, but few after 1560 have any force or distinction, and it is not surprising that in the last quarter of the century their trade was snatched by the Netherlanders working in Southwark.

C

CHAPTER 3

THE NETHERLANDISH REFUGEES

DURING the reign of Queen Elizabeth I the character of English sculpture was modified and the general level improved by the activities of craftsmen from the Low Countries. They were for the most part refugees from the Wars of Religion, and though they have often been referred to as 'Flemings', almost all of them seem in fact to have come from Holland.[1] Italian influence, direct or through France, now declines, though French influence by no means disappears, for J. A. du Cerceau's *Second Livre d'architecture* (1562), which contains a number of designs for both tombs and fireplaces, was much used as a source. It is, however, rare to find a case of precise copying of a whole design. Motives are borrowed and adapted, and in the later part of the century further ideas, chiefly for decoration, are taken from engraved designs by Vredeman de Vries.[2] English tradition was, however, clearly too strong for entirely novel tomb designs to find much favour. The altar tomb with the recumbent effigy, either free-standing or set against a wall with or without a canopy, was still the most popular type. On the other hand, there is a growing tendency to show figures in life and not in death. Kneeling figures had appeared in France before the end of the Middle Ages, and had increased in number in the early sixteenth century;[3] but they were very rare in England. After about 1570, and probably through the influence of the Netherlanders, they become increasingly common, sometimes on free-standing tombs, but far more frequently on wall-monuments, where they are shown praying on either side of a fald-stool. The other manifestation of this trend is the reclining figure propped on one elbow. Again the source may well be France.[4] The development of this type was slower; some grotesque examples of rigid figures in armour may be seen well after 1600,[5] and as late as *c.* 1614, Webster's well-known lines from the *Duchess of Malfi* show that the idea was still regarded as 'fantastical':

DUCHESS: Why do we grow fantastical in our death-bed? do we affect fashion in the grave?
BOSOLA: Most ambitiously. Princes' images on their tombs do not lie, as they were wont, seeming to pray to heaven; but with their hands under their cheeks, as if they died of the toothache: they are not carved with their eyes fix'd upon the stars; but as their minds were wholly bent upon the world, the self-same way they seem to turn their faces.[6]

The type was, however, to be increasingly used in the seventeenth century and was ultimately entirely to replace the recumbent effigy. After 1600 a few experimental types were introduced which can also be considered in this chapter, since they were mainly the work of Elizabethan sculptors.

No marked change takes place in the materials used in the second half of the sixteenth century. Alabaster remains standard for grander tombs, and the few contracts

which survive suggest that the effigy and the shields of arms which played so important a part in recording the pedigree of the deceased were coloured with oil paint, certain parts being also gilded.[7] Occasionally, however, a tomb may be seen in which the block of alabaster used for the effigy seems to have been carefully chosen for its beauty, and in such cases, failing other evidence, it is difficult to believe that it was covered with paint. Other materials, giving a contrast of colour, were often combined with alabaster, the chief being the black touch, presumably imported from the Low Countries, and raunce or rance, a red mottled marble from Brittany. These richly coloured tombs, in which the soft, warmly-tinted alabaster with its waxy surface was combined with other contrasting materials, and with bright colours and often much gilding, are typical of the somewhat garish splendour of the Elizabethan age, when richness and intricacy were more prized than elegance. It is obvious that subtleties of surface modelling were unnecessary, for they would have been lost beneath the paint; on the other hand, much care was lavished on details of dress, and here a high standard of competence is often reached. There are no bronze effigies within the period, but occasionally work is painted to imitate bronze.[8] Freestone, also often coloured, was much used, being presumably less expensive than alabaster, and there are many coarsely cut monuments scattered about the country made of local materials, and probably by local craftsmen.[9]

It is unfortunately hard to say precisely what designs the Netherlanders brought to England. Tombs of the later sixteenth century are now almost non-existent in the Low Countries themselves, and indeed, in view of the turmoil of the times it is uncertain how many were made. That the refugee sculptors owned patterns which they prized and passed on to their sons can be seen from their wills; but though some monumental drawings of the period have survived, these appear to have been made for individual clients, and few are earlier than *c.* 1590. It is therefore impossible to get any clear picture of what was imported, and what was evolved to suit the English market. Moreover, though the authorship of certain tombs is known, this is due to the accident of the survival of contracts, either still extant in family archives, or occasionally copied by eighteenth- and nineteenth-century antiquaries. Other tombs, which appear to be similar in handling or in use of specific details, have often been ascribed to known craftsmen, sometimes with considerable plausibility. It seems, however, possible that the same details were used by more than one workshop, possibly because of a common source, or because the foreign colony was closely knit (often by ties of marriage) and workmen trained by one master may well have worked as journeymen in another shop, and so interchanged patterns. Further, though the quality of their work is higher than that of the English alabaster-men of the mid century, it remains provincial, and before about 1610 no artist emerges with any real personality. It is, in fact, the work of a school rather than of individuals, and attributions to separate workshops can only be tentative, and are often unrewarding.

The best documented workshop, though not the earliest, is that of the Johnson family.[10] Garret Jansen, whose name soon became anglicized to Garret or Gerard Johnson, arrived in London from Amsterdam in 1567, and being forbidden, since he was an alien, to settle within the City boundaries, established a yard across the Thames

at Southwark, where other foreigners were already working. He married an English-woman, joined the English Church, and obtained rights of citizenship. Of his five sons, two, Nicholas and the younger Gerard, were to become sculptors. Nothing is known of the activities of the workshop for some fifteen years, but it must have been steadily building up a reputation, for by 1592 it was receiving important commissions. The 5th Earl of Rutland ordered two tombs for his uncle and his father, the 3rd and 4th Earls (d. 1587 and 1588; Plate 8B), to be erected with the others of the family at Bottesford, Leicestershire; the executors of the 2nd Earl of Southampton (d. 1582) carried out the instructions left in his will that a tomb was to be made at Titchfield, Hampshire (Plate 8A), with effigies of himself and his father and mother; and about the same time Johnson was working on two tombs for the Gage family at Firle, Sussex. All three com-missions have points of interest.

The Bottesford tombs, erected in 1591, are good examples of Southwark work. Both are wall tombs of alabaster, with recumbent effigies, their hands joined in prayer, lying under a straight canopy supported by Corinthian columns. The architectural details, though naturally much less refined than Italian or French work, are not uncouth either in proportions or in the profiles of their mouldings. The 3rd Earl has his only child, a daughter, kneeling in prayer at his head; in the tomb of the 4th Earl his larger family kneel, on a much smaller scale than the main effigies, round the plain sarcophagus, and at their parents' heads and feet. The male effigies are in armour, and lie on a plaited straw mattress rolled up under the head, a feature almost certainly brought in by the refugee sculptors: the ladies, however, have embroidered pillows under their heads. The figures are rather more solidly conceived than, for instance, Richard Parker's effigies on the tomb of the 1st Earl of 1543, and the long, almost Gothic lines of the earlier draperies have been replaced by an arrangement, which constantly appears in Southwark work, of the cloak of the female figures open to show the hands, and then folded over the body in broad dented folds, masking the line of the legs. Details of dress, armour, and the fur lining of the cloaks were recorded with care, but the features are more summary in modelling.

The papers[11] which have survived concerning the making of these tombs not only show that Gerard Johnson was paid £100 for each, but also give a lively picture of their delivery, a process which must have been the same for many other unrecorded commissions. The tombs were made in the Southwark yards (unfortunately there seems to be no record of the busy trade in materials into the port of London that must have existed to provide the stock from which commissions could be executed), sent by ship to Boston in Lincolnshire, and then by cart to Bottesford. The whole story can be reconstructed in detail from the payments: the unshipping, the loading by stages on to fifteen carts, the need for a man to watch one cart of which the axle had broken 'and for drinks for them that watched with him'. Gerard and his son, Nicholas, came up to superintend the setting up (there are charges for their board at the house of the local baker and for the grazing of their horses 'because he wolde not have them at Belvoire for feare of streinge awaye and beinge reddene with some hunters'); local carpenters and masons were needed for making trestles for the effigies and for alterations to the church

floor and walls, and in the next year payments were made to a Nottingham painter for 'inrichinge' to two tombs.[12]

The Johnson workshop evidently gave satisfaction to the Manners family, for when a tomb was needed for the 5th Earl in 1616 the commission was given to Nicholas, his father probably being dead.[13] The pattern has now slightly altered, for the effigies, though still recumbent, are set on different levels with above them a coffered arch under the straight canopy. Moreover, two additional columns appear at the sides, bearing clumsy little figures of nude boys, one with a spade and the other with an inverted torch, who represent Labour and Rest. Such timid allegories were to appear on other Southwark work by this date. Nicholas also uses a device extremely characteristic of early-seventeenth-century creations of the school, namely bunches of coloured ribbons set on either side of the inscription framed in strapwork behind the effigies; but so far as the figures are concerned, his work does not show any great change from that of his father.[14]

The three tombs made by Gerard Johnson for the Gage family (Sir John Gage, d. 1557, Sir Edward Gage, d. 1568, and John Gage, d. 1595) at Firle, Sussex, are more modest than the Rutland tombs; for they have no canopies, and are rather more conservative in style, for the dresses fall more stiffly from waist to feet.[15] Their special interest, however, lies in the fact that drawings, two of them signed 'Garat Johnson', are still in the possession of the family. They are craftsmen's rather than artists' drawings, simply set out with the pen, the perspective faulty where it is used, but giving an exact indication to the client of what was proposed.

The most elaborate of the known works of Gerard Johnson is the Southampton tomb (Titchfield, Hampshire; Plate 8A) in which he was again assisted by his son Nicholas. It is a large free-standing erection with three recumbent effigies, all with hands joined in prayer. That of the 1st Countess lies high in the centre, raised on an arcaded base above those of her husband and her son. The arrangement of the effigies at different levels is in itself unusual, but a further new feature is the use of four tall obelisks standing at the corners of the base. This must surely be a borrowing from Du Cerceau's *Second Livre d'architecture*, where a tomb with this device is shown, though in conjunction with a single reclining effigy on a curved sarcophagus. It seems probable that the Johnsons also made the tomb of Southampton's brother-in-law, Viscount Montague (Easebourne, Sussex) which originally also had corner obelisks.[16] Here there were also three effigies, the central one again raised above the others on an arcaded base. He is not, however, in the usual recumbent position, but is kneeling. If this is indeed a work of the Johnson yard (and many of the details correspond closely to the documented works of the same decade), it is the only example of their use of a kneeling figure, which, set thus on the top of the structure, must surely be derived from the French royal pattern.

After the father's death the sons carried on the business for a few years. Except for the Rutland tomb already discussed no independent work by Nicholas is known, and he disappears about 1618.[17] The best known work of the Johnsons, and also the worst, is the younger Gerard's wall-monument to Shakespeare (d. 1616, Stratford-on-Avon, Warwickshire). In type it differs from anything so far discussed; for it shows a half-

length figure, pen in hand, set between small columns, in fact a scholar-type, with grotesque seated allegories of Labour and Rest on the entablature above. Moreover, it is in stone and not in alabaster. It is, to the sorrow of many Shakespeare scholars, so feeble in modelling that the expression is almost vacant, but it was to be much revered in the eighteenth century.[18]

The Cure workshop was older than that of the Johnsons, and lasted longer: it was probably also of greater importance, since one of its members held office under the Crown. Though, however, some documents are known, there is nothing which can be compared with the vivid account in the Rutland papers of the transportation of the Bottesford tombs.

The founder of the workshop, William Cure (or Cuer) I, was probably Dutch, but not a refugee; for a Return of Aliens made in 1571 states that he was living in Southwark and had been in England for thirty years, 'sent for hither when the King did byulde Nonesutche'. He had married an Englishwoman, and had six children all born in England.[19] At his death in 1579 he left all his 'plots and models' to his sons, except those he had already given to his son-in-law.[20] Cornelius, William's eldest son, who being English born was eligible for admission to one of the City Companies, was apprenticed by his father to a marbler. In 1584 the Marblers' Company, having dwindled to some dozen members (Cornelius being among them), was absorbed by the larger and more flourishing Masons' Company, and in 1596 Cornelius Cure was appointed Master Mason to the Crown. It is of some interest that by that time he is known to have travelled, though where is uncertain and no direct foreign influence is visible in his work.[21] In 1605 the appointment was renewed, but Cornelius's son William II was associated with his father for their joint lives. This partnership did not last long, for Cornelius died in 1607.[22] William II remained in the service of the crown till his death in 1632, but he appears to have been a somewhat unsatisfactory official. Inigo Jones was to complain that when he should have been building the Banqueting House at White-hall Palace he had been absent for five months, so that another mason, Nicholas Stone, was employed in his place; even so, Cure continued 'careless and negligent' about royal works elsewhere.[23]

No monuments can be ascribed to William Cure I with certainty, but if the elaborate coloured drawing in the Bodleian Library for a tomb for Edward VI is his, and not his son's, it establishes the pattern of setting an effigy under richly coffered arches which reappears in other family work.[24] The rich decorative details seen in this drawing are also used for the tomb of Sir William Pickering (d. 1574, London, St Helen Bishops-gate) and for the wall-monuments to Sir Richard Alington (d. 1561, London, Rolls Chapel, Public Record Office) and Sir Richard Blount (d. 1574, St Peter-ad-Vincula, Tower of London).[25] This group of works, if the attribution is correct, suggests that the Cure workshop may, in the Pickering tomb, have been among the first to use the four- or six-poster type, which probably has its origins in French royal tombs, and also the wall-monument with kneeling figures.

The documented work of Cornelius Cure is only slightly more extensive than that of his father, but his position must certainly have brought him many commissions. One

of the most probable is the tomb of Lord Burghley (d. 1598, Stamford, Lincolnshire, St Martin), a six-poster with the effigy under a coffered arch.[26] It is competent work, though the pretty floral detail in the London tombs ascribed to Cornelius's father has disappeared in favour of a cresting of strapwork derived from Vredeman de Vries. His only certain tomb, that of Mary, Queen of Scots (1607–12, Westminster Abbey), is both more elaborate and more distinguished.[27] The general design, with columns carrying straight entablatures at each end, and a coffered arch rising above the effigy in the middle, carries on the pattern used by Maximilian Colt a couple of years earlier for the Queen Elizabeth I,[28] which itself appears to be an extension of existing Southwark types. Scarcity of documents and the disappearance and dismemberment of many tombs make it impossible to say with certainty in which workshop the use of the coffered arch originated, the more so as it evidently quickly became a common stock motive. The marble figure of Mary, Queen of Scots (Plate 12A), which rests on an elaborately moulded sarcophagus, is of very high quality: the details of the dress with the ermine-lined cloak folded over the legs are beautifully cut, and the head is an idealized portrait of great serenity. James may have been embarrassed by his mother during her lifetime, but he gave her a most memorable tomb. Cornelius Cure died soon after the work was begun, and it was completed by his son, William II. If, as seems possible, the effigy was the latter's work, he was no mean sculptor. One of his few other certain works, the monument of Sir Roger Aston (d. 1612, Cranford, Middlesex; Plate 10A) repeats the architectural pattern of the Mary, Queen of Scots, though it is set against a wall, and has seven kneeling figures instead of the single effigy. Again the cutting, both of heads and of costumes, is above the average.[29] The workshop was beyond question of considerable importance, and must have carried out much more work which cannot now be certainly identified; it was probably influential, though it would be dangerous to say categorically how far its patterns were copied by other men.

Not all the Southwark workshops were family affairs, though in one case at least a master–pupil relationship can be traced through at least three generations. Richard Stevens (1542–92), a Brabanter, who came to England in 1567, had as pupils Isaac James, whose real name was Harrer, and who was certainly a foreigner, and Epi-phanius Evesham, who was English-born. And James, in his turn, was to be the master and afterwards the partner of Nicholas Stone. Stevens is not himself a sculptor of great interest, for his documented tomb of three Earls of Sussex (1587/9, Boreham, Essex), which was taken from London in twelve carts, though now somewhat damaged, can never have been anything but stiff and uninspired.[30]

James is also a perplexing figure. He was for a time in partnership with Bartholomew Atye, living not in Southwark but in the parish of St Martin-in-the-Fields, and to-gether they made the tombs of Sir Edward Denny, now mutilated (d. 1599, Waltham Abbey, Essex) and Sir Richard Kingsmill (1600, Highclere, Hampshire). Both are well within the ordinary run of stock patterns, though the Highclere tomb has a greater naturalism in the treatment of hands and of Lady Kingsmill's softly falling dress than is common at the time. James was, however, capable of better work. The large tomb of Henry, Lord Norris (? after 1606, Westminster Abbey; Plate 10B) seems to be his,[31] and

is characteristic of the movement away from older types in the first decade of the seventeenth century; for though the effigies are still recumbent, there are large kneeling figures of the six soldier sons, cut with some liveliness, flanking the sarcophagus, and above, on the solid upper storey, are pictorial reliefs of a character unknown in the reign of Queen Elizabeth I. It is difficult to account entirely for such innovations, but it is perhaps worth noting that the distinguished Dutch sculptor, Hendrik de Keyser, was in London in 1606, and must have been in touch with James, for he took James's pupil, Nicholas Stone, back to Holland with him. No exact parallel in Dutch work can be cited, and the four-poster type on which James is elaborating does not seem to have been used in Holland; but, nonetheless, though the general upsurging of Dutch art is usually dated after the truce of 1609, some signs of it were already stirring, and the use of reliefs, rare in England, is fairly common in the later work of the de Keyser studio.[32]

Epiphanius Evesham (1570–after 1633) is the first English-born sculptor of any personality. Vertue's description of him as 'that most exquisite artist' has a ring of truth, for his works have a refinement, and what is more a depth of feeling, that is rare in his age.[33] Evesham, the fourteenth son of a Herefordshire squire, received his unusual Christian name because he was born on the feast of the Epiphany. It is possible that the family were recusants. Beyond the fact that he was in Richard Stevens's workshop at the time of the latter's death in 1592, nothing is known of his early life except that he engraved a sundial, now in the Hereford Museum, in 1587. He was to use similar techniques later in life. From 1601 to about 1614 he was living in Paris, where he is recorded as a master sculptor and a master painter. During this time several boys were apprenticed to him, one from Dordrecht; he designed a fountain of Neptune, six plaster chimneypieces for the house of M. Nau at Prèsles near Melun, and, among other things, the tomb of Jacques de Poyanne (d. 1609) in the church of the Grands Augustins in Paris. This had a life-sized kneeling effigy in front of a prayer desk, painted in natural colours. There are also records of partly finished pictures, one being of the *Baptism of Louis XIII*. Unfortunately he was afterwards involved in a brawl with the artist to whom he had sold his unfinished pictures.[34] Though there is no record of any contact with French artists he must, in the Paris of Henri IV, have become aware of certain characteristics of French Mannerist art, which were to find some echo in his own work, and he must have seen sculpture of a better standard than anything in England.[35] It is sad that nothing he made in France can now be traced.

The exact date of his return to England is unknown, but in 1618 he signed the tombs of Edmund West (Marsworth, Buckinghamshire) and Sir Thomas Hawkins (Boughton-under-Blean, Kent).[36] The Marsworth tomb is perhaps scarcely sculpture, for it is decorated with brasses, the largest showing the deathbed scene, the other plaques having single figures, the iconography of which is not easy to decipher, beyond those of Christ as Redeemer and Death with his scythe. The forms are elongated and the poses twisted, but as in much French Mannerist art there is considerable intensity of feeling. The Hawkins tomb also has unusual features (Plate 11B). The recumbent effigies, it is true, show little that is new, but the figures of children on the front of the sarcophagus are no longer arranged in straight and placid rows, but are grouped in an almost pictorial

manner, some kneeling and some standing. The sons have little expression, but the daughters, tall and slender, are twisted with grief. Evesham was later to use the same device with greater assurance in what is perhaps his most attractive monument, that to Lord Teynham (1632, Lynsted, Kent; Plate 9B), which is also signed. Here, instead of the two stereotyped recumbent effigies, Lord Teynham alone lies on the sarcophagus, while his widow, a figure of great dignity, kneels in the centre behind him. Again the children are arranged in groups, and again the grief of the daughters is violent. These reliefs are deeper than those on the earlier Hawkins tomb, and the small figures are less elongated. They have indeed great humanity and charm; the daughters mourn, but have their pets with them, the sons have left their sports to pray, but will return to their hawk and hounds. The Christian spirit of the mourning groups is shown by the band of clouds and cherubim above them, on which one daughter fixes her eyes.[37]

A number of other works can, with some degree of probability, be attributed to Evesham, the most interesting being the tomb of Lord Rich (d. 1567, Felsted, Essex). It was probably erected shortly after the death of Lord Rich's grandson in 1619,[38] and has several unusual features. The effigy, in Lord Chancellor's robes, reclines, but turns his head over his shoulder to look towards his son (d. 1581), kneeling beyond the canopy. On the front of the sarcophagus are incised slate slabs, one showing Rich lying in state, and the other his arrival as Lord Chancellor in Westminster Hall. Behind and at the feet of the effigy are reliefs, representing different moments in his distinguished career, his figure in each case being accompanied by appropriate female allegories. These are lively in both design and cutting, and have above a band of clouds and cherubim identical with those on the Teynham tomb. The memorial to his grandson, Robert Rich, Earl of Warwick (d. 1619, Snarford, Lincolnshire) with its fine medallion portrait (Plate 11A), is almost certainly also by Evesham.

Evesham's tombs have therefore a personal character which renders them attractive among so much that was clearly mass-produced. He was a lively and inventive artist, though his Southwark training no doubt gave him a foundation knowledge of the current type of tomb with a straight canopy, and perhaps prevented him from the introduction of extravagant types which might not have been acceptable to his patrons. His cutting at its best, for instance in the Teynham tomb or the Lord Rich, has distinction, though it hardly reached the level to be attained between 1615 and 1630 by Nicholas Stone.

The most puzzling of the last generation of refugee sculptors was Maximilian Colt, whose career began with great promise, and then dwindled, apparently, almost to nothing. He came from Arras, perhaps via Utrecht, in the mid 1590s, to join his elder brother John, their surname being anglicized from Poultrain. John, about whom little is known, was still alive in 1635 and Maximilian apparently for at least ten years longer.[39] The brothers settled, not in Southwark, but on the other side of London in the parish of St Bartholomew the Great, but they were in touch with the Anglo-Netherlandish colony, and it is possible that Maximilian may have had some hand in the finishing of Richard Stevens's tomb of Sir Christopher Hatton in St Paul's. In some way he attracted the notice of the Earl of Salisbury, worked for him at Hatfield, where he made chimney-

pieces (Plate 15), and seems through him to have been chosen to make the important tomb of Queen Elizabeth I at Westminster.[40] This, with its ten columns and its effigy under a coffered arch, is an elaboration of Southwark types, though the frank realism of the head, very different from the idealized portrait which the Cures were soon to make of Mary, Queen of Scots, suggests that it is almost certainly based on a death mask.[41] It was a popular image, since a number of casts of it are known.

Although the tomb of Queen Elizabeth I was imposing, it was not especially original. Within a few years, however, Colt was to produce a monument, that of the 1st Earl of Salisbury (1612, Hatfield, Hertfordshire; Plates 12B and 13), which was a novelty in design, and very different from Southwark work in its cutting.[42] Here, the gaudy colouring of Elizabethan and early Jacobean tombs is replaced by a simple contrast of black and white marble, and their elaborate architectural settings have gone. Instead the white effigy, a fine, calm figure, lies on a plain black bier, which is supported on the shoulders of four kneeling Virtues. Below, on a mat, is the skeleton. The Virtues are solidly built figures in thick draperies, remotely classical in type, though quite unclassical in treatment. Parallels for them are not easy to find. The design of the whole is, perhaps, a combination of various patterns. It is usually associated with that of Englebert II of Nassau (c. 1535, Breda), once ascribed to Tommaso Vincidor, but now to Jean Mone; but there the bier is carried by four warriors. On it is only the armour of the deceased, and the effigies lie below it. Du Cerceau, however, illustrates a tomb with an effigy and four warriors, and it would almost seem as if Colt's design has its roots in France, for the *gisant* could well be imitated from the tomb of Henri II at Saint-Denis, and the warriors transposed into Virtues related in type and conception to those seated at the corners of the sarcophagus of Louis XII, or to the standing Virtues placed by Michel Colombe round the tomb of Francis of Brittany at Nantes.[43] It is an interesting, and in its way a distinguished work, but it does not seem to have found much favour. The nearest imitation is the monument to Sir Robert Hitcham (1638, Framlingham, Suffolk), by an otherwise unknown sculptor, Francis Grigs, which has a plain bier supported on the shoulders of four kneeling angels, not very accomplished in cutting; but neither effigy, armour, or *gisant*. A far finer work is the Sir Francis Vere (d. 1609, Westminster Abbey), which may perhaps be by Colt; but this, with warriors supporting the armour-laden bier, is, in fact, closer to both the Breda tomb and to the Du Cerceau engraving than to the tomb of the Earl of Salisbury.[44]

Colt's work on the tomb of Queen Elizabeth I and his association with King James's Secretary of State gave him a position which should have assured a distinguished career. In 1608 he was made Master Sculptor to the Crown, and in the next year the gift of broad cloth and a gown was confirmed yearly for his life.[45] But, except for the tomb of James's infant daughter, the Princess Sophia (d. 1606), in her cradle at Westminster,[46] he carried out singularly little work of any importance for the Crown. His name appears fairly frequently in the royal accounts down to the mid 1620s, but only in connexion with small decorative commissions – capitals and a chimneypiece at Somerset House, a lion and a unicorn for Whitehall, and a 'great newe wyndowe' for the chapel at Greenwich 'with the King's armes overhead borne by 2 boyes with two Victories on

each side of them'.[47] His duties in connexion with the funeral of James I brought him into distinguished company, for he was sent to Theobalds to take the death-mask to be used as the basis for the effigy set on the catafalque designed by Inigo Jones;[48] but it is significant that not Colt, but Hubert Le Sueur, executed the allegorical figures.[49] Here, perhaps, lies the secret of Colt's failure to make any real impression on seventeenth-century sculpture; for except in the Salisbury tomb, which is a curiously isolated work, he seems to have been inherently conservative. As late as 1627 his tomb of Sir George Savile (Thornhill, Yorkshire) is still in the Southwark manner of the turn of the century, with its recumbent effigy on a straw mat, its straight canopy, its use of strapwork, and of alabaster, touch, and raunce.[50] By now, Nicholas Stone was able to please the more sophisticated taste of the court of Charles I, and new foreign artists were developing new ideas. Colt could not compete with them; in 1641 he was imprisoned for debt, and nothing is known with certainty of his later work.[51]

The careers of Evesham and of Colt have carried the discussion well into the early seventeenth century. Before this can be considered, however, there are a few other aspects of Elizabethan sculpture to be noted. Although most of the refugee sculptors settled in London, their influence was naturally widespread, and one at least, Jasper Hollemans, chose to make his home at Burton-on-Trent, in the heart of the alabaster district.[52] His documented tombs of Sir John Spencer I (d. 1586), Sir John Spencer II (d. 1599), and the first Lord Spencer (all erected 1599, Great Brington, Northampton-shire) are coarser in their architectural detail than contemporary London work, and borrow their motives, notably the pendants on Lord Spencer's tomb, direct from Vrede-man de Vries. The effigies, however, have a certain originality. The heads are summary in modelling but the details of the clothes, such as the honeycombed sleeves, the ruffs, and the great peaked headdresses of the ladies are reduced to simple, almost geometrical forms, which are very telling. A similar treatment can be seen in the tomb of Sir William Spencer (d. 1609, Yarnton, Oxfordshire), though here the curling ribbons used by the Southwark School appear mixed with the strapwork detail. If, as seems likely on the similarity of the effigies, Hollemans also made the tomb of Sir George (d. 1612) and Lady (d. 1628) Fermor (Easton Neston, Northamptonshire; Plate 9A), his sense of pat-tern enabled him to create one of the prettiest tombs of its class in England, for behind the effigies is an array of pennons springing from a peacock's tail.

Very many tombs exist for which no sculptor can be found, some showing variations, skilful or crude, of common types, while others, though not necessarily successful, are more original. The monument to Sir Roger Manwood (d. 1592, Hackington, Kent) must be from a Southwark shop, but it shows, unusually, a long bust with hands, cut straight at the waist, and flanked by small kneeling figures of children, while on the sarcophagus, instead of an effigy, is a skeleton on a straw mattress. The splendid tomb of Lady Russell (erected c. 1607, Bisham, Berkshire), with its eight life-sized kneeling figures, must also be Southwark work, and innumerable smaller wall-monuments have kneeling figures only. Seated figures also sometimes appear in the work of Southwark craftsmen, a simple but attractive example being the monument to Margaret Legh (d. 1605, Fulham, London), with her two infants,[53] while more unusually the tomb of

John Wolly (d. 1595, London, Old St Paul's) had three figures seated on the sarcophagus, one leaning his head on his hand.[54] Monuments were, indeed, becoming more varied and less stereotyped than in the middle years of the sixteenth century, but except in rare cases, such as the works of Epiphanius Evesham, there is little real attempt to convey emotion, and the general level is competent, but no more. Some work in the provinces is, indeed, very crude, though 'Tomas Greenway of Darby', who signs the monument to Francis Williamson (1612, Barnack, Northamptonshire), was no doubt proud of his many small figures and lavish ornament of many different kinds.[55] Local craftsmen were to draw freely from a strange repertory of motives, sometimes perhaps inspired by the grotesque chimneypieces favoured by the Elizabethans: one of the most extreme examples is the tomb of Richard Bertie (d. 1582) and his wife Katherine, formerly Duchess of Suffolk (d. 1600, Spilsby, Lincolnshire). Two small half-length busts are set in arcades completely covered with a lozenge pattern, and instead of columns carrying the monstrous entablature, there are caryatids in the shape of two 'wild men' and a hermit.[56]

The amount of sculpture commissioned for tombs in sixteenth-century England is formidable, and is a striking testimony of the increased sense of family, and indeed of national, security. Its quantity has therefore demanded a longer consideration than its quality deserves.

PART TWO

THE EARLIER SEVENTEENTH CENTURY

CHAPTER 4

NICHOLAS STONE AND HIS CONTEMPORARIES

Introduction

IN the first quarter of the seventeenth century English architecture was to undergo a transformation, perhaps the most striking in its whole history, when owing to the genius of Inigo Jones, the interesting but hybrid style of the turn of the century was changed to a mature, Italianate method of design, filled with a new understanding of Antique and Renaissance architecture. In painting, too, the course of English art was to be materially altered by the sojourn of van Dyck from 1632 to 1641, and by the presence of other competent, though less brilliant, foreign painters. Unfortunately, no parallel occurs in sculpture. No English sculptor emerged of the calibre of Inigo Jones; and though Charles I employed foreign sculptors at his court, they none of them had the stature of a van Dyck, or even of a Mytens. And though they were not entirely un-influential, the mark they left on English sculpture was comparatively slight. The in-fluence of the Low Countries, so strong in the last years of the sixteenth century, was to become even stronger, though slight traces of Italian influence (but of the High Renaissance, rather than of the rising Baroque) can occasionally be seen, and the presence in England of two of the earliest major collections of antique sculpture outside Italy, those of Charles I and of the Earl of Arundel, were not without their effect.

The workshop tradition established by the Netherlandish sculptors settled in South-wark persisted, and was enlarged by men who were masons in fact as well as in name, and who undertook building contracts in addition to sculpture. Except in the work of Charles I's foreign sculptors, the tomb is still by far the most important field. A few statues, mainly royal, were made for public buildings, and again records exist of garden sculpture, especially fountains, though little has survived. Tomb types, however, be-come more varied, and though the recumbent effigy with hands joined in prayer was still widely used, its popularity was increasingly challenged by the livelier patterns al-ready discussed, with reclining figures propped on one elbow, or by monuments, large or small, with figures kneeling on either side of a fald-stool. Bust monuments, with the figure cut by a round or oval frame, which had appeared before the end of the sixteenth century, were much used, especially by middle-class patrons who did not wish for the expense of a more elaborate tomb, and single standing figures sometimes occur.[1]

Alabaster was still much in favour at the beginning of the century, and freestone monu-
ments, often painted, continue; but some of the most distinguished tombs of the period
employ the simple contrast of black touch and white marble which had been used by
Colt so impressively in the Salisbury tomb.

Nicholas Stone

No single craftsman can be indicated as the certain originator of all the variants on old
and new types, for there was probably still some interchange of patterns and also of
journeymen, between the main London workshops. Nicholas Stone (c. 1587–1647) was,
however, to emerge as the leading mason-sculptor by about 1625. His large and varied
output is on occasions of finer quality than that of his contemporaries, though at other
times it is characteristic of the general level of London work. Almost all the common
types, as well as some unique designs, were produced in his workshop, about which we
are exceptionally well-informed, since a notebook, probably compiled late in his life,
giving a summary of his main commissions, and a detailed account book covering the
years 1631–42 have survived. These record about eighty monuments and almost as
many other jobs, large or small, executed in his capacity as a mason.[2]

Nicholas Stone, the son of a Devon quarry-man, was born probably in 1587. His first
master is unknown, though he may have been a local craftsman, but the last two years
of his apprenticeship were served in London, in the Southwark workshop of Isaac
James, where he would have absorbed the best traditions of the Netherlandish studios.
In 1606 Hendrik de Keyser, architect to the City of Amsterdam and also a distinguished
sculptor, visited London to study the Royal Exchange as a pattern for the new exchange
to be built at Amsterdam. He would naturally have got into touch with his compatriots
in London, including Isaac James, and it was possibly on the latter's recommendation
that he took Nicholas Stone back to Holland as a journeyman. Stone was to remain with
de Keyser until 1613, when he married his daughter and returned to England.

In Hendrik de Keyser's busy studio Stone would have seen, and perhaps had some
part in, a wider and more ambitious range of works than any undertaken in England.[3]
Parts, at least, of the black and white marble screen with standing figures and reliefs set
up in the church at s'Hertogenbosch in 1613 (V. and A.) were cut in the Amsterdam
studio. Several different hands can be detected, the elegant and finely modelled St John
being by de Keyser himself, and it has been suggested with some plausibility that the
figure of Justice, much inferior in handling, may have been cut by Stone.[4] In its treat-
ment of dented folds it is not unlike the work executed on his return to England. Stone
must also have had some knowledge of the most important of all de Keyser's works as a
sculptor, the elaborate tomb of William the Silent at Delft, though this was largely
executed after he left. It is a somewhat overloaded variant of the mid-sixteenth-century
type of French royal tomb, the clear-cut lines of French architectural settings being con-
fused by broken pediments, and the usual kneeling figures replaced by two effigies, one
recumbent and one seated, within the architecture; but the bronze Virtues at the corners,
though not so distinguished as those by Germain Pilon on the tomb of Henri II, are

nevertheless descended from them. This French Mannerist influence in the de Keyser workshop was to be of some importance to Stone, for it is responsible for the small, elongated allegorical figures which appear constantly on his tombs.

His career on his return to England is not at first easy to follow, largely because his notebook, compiled late in life, is not very explicit. He apparently at once set up his own studio, for by the end of 1613 he was paying rates for the premises in Long Acre he was to occupy till his death.[5] During the next two years he was to receive important commissions, but for two at least of them he collaborated with older sculptors. The tomb of Henry Howard, Earl of Northampton (1615), for which he states he took his old master, Isaac James, as a partner 'in cortisy', has a special interest; for it was set up by Northampton's great-nephew, Thomas Howard, Earl of Arundel, at that time the greatest collector in England of both pictures and antique sculpture. Although the work now stands dismembered in the chapel of Trinity Hospital, Greenwich, it can be reconstructed from drawings,[6] which reveal that the type was by no means new, for it is of the French royal pattern with a kneeling effigy above an arched canopy. Since this had already been used in England, perhaps by James's master, Richard Stevens, for the Montague tomb at Easebourne, Sussex (1592),[7] it is impossible to be sure whether James or Stone was responsible for the design. The small, rather clumsy Virtues which stood at the corners of the canopy have a greater interest, for they seem to be the earliest remaining figures in England which consciously imitate the antique, and must have been influenced by Arundel's marbles.[8]

The other large early tomb, that of Thomas Sutton (London, Charterhouse Chapel; Plate 18A), was made in collaboration with Nicholas Johnson and Edmund Kinsman, and was finished in November 1615.[9] Although it is again impossible to be certain which artist was the designer, it is an interesting elaboration of the standard Southwark type with a recumbent effigy beneath a straight canopy supported on colonnettes. The sculpture has, however, been extended to include two standing warriors behind the effigy, perhaps a reference to Sutton's early military career, and a relief above the entablature showing the Master of the Charterhouse addressing the Scholars and Brethren of Sutton's famous foundation. In addition, there is a lavish use of small allegorical figures, elegantly posed, which are almost beyond question the work of Stone.[10]

These two large tombs made in collaboration with older artists are not, however, entirely characteristic of Stone's early work. The small bust monuments, both of 1615, to John Law (London, Charterhouse Chapel; Plate 24A) and Anne Bennet (York), variants of the same design, have a charming decorative quality in the harpy-like winged figures enclosing the frame within which the bust is set, though the busts themselves are not very lively. An equal novelty in the use of small allegorical figures appears in the monument to Thomas Bodley (Merton College, Oxford) of the same year.[11] Here they are profusely employed, both in relief and in the round, to represent Arts and Sciences, their slender proportions and classical draperies suggesting the influence of engravings in the Fontainebleau style; though a very different and more childish use of allegory is mingled with them in the pilasters made of books, a clear though clumsy reference to Bodley's great library.

During the next few years Stone was to build up a large practice. Sometimes he was content to follow familiar patterns and to introduce nothing new, as in the monument with kneeling figures to Sir Henry and Lady Belasyse (1615/16, York) or that with recumbent effigies with hands joined in prayer to Sir Thomas Hewar (1617/18, Emneth, Norfolk).[12] Both types were to remain in Stone's repertory throughout his life: two of his major tombs of 1638, those of Lord Spencer at Great Brington, Northamptonshire, and of Lord Chief Justice Coke at Tittleshall, Norfolk, retain recumbent effigies in prayer, while Viscount Fauconberg (1632, Coxwold, Yorkshire) no doubt favoured the kneeling pattern used for his father, Sir Henry Belasyse. Some patrons were probably precise in their instructions that traditional types were to be used. In other cases, Stone was able to give a new twist to old patterns. The beautiful tomb of Lady Carey (1617/18, Stowe-Nine-Churches, Northamptonshire; Plate 16), made in her lifetime, shows the white marble figure on its black slab lying asleep, the head slightly turned on the embroidered pillow, and one hand resting on the breast. The fine and vigorous cutting of both the head and the rich dress, the latter naturalistically treated with the big dented folds so characteristic of Stone's early work, make a striking contrast with the far more mechanical handling of the effigies on the Spencer tomb, only a few miles away, where it is known that the work was executed by journeymen.[13] More unusual still is the moving grey marble figure, partly covered by a shroud, and twisted as though suddenly overcome by death, of Sir William Curle at Hatfield, Hertfordshire (d. 1617; Plate 17), where Stone reveals not only an original feeling for design unusual in his day, but also remarkable sensitivity in modelling. Neither this, nor any other work of about this time, has any of the reference to antiquity noted in the Virtues from the early Northampton tomb, and Stone's contact with Inigo Jones, with whom he was working from 1619 to 1622 as Master Mason at the Banqueting House, Whitehall, does not appear to have left any strong mark on his style as a sculptor, though in some, but by no means in all cases, the architectural detail of his monuments becomes more refined in the next decade. This is notably the case in the tomb of Lord Knyvett (1623, Stanwell, Middlesex), where the two white marble figures kneel on an alabaster sarcophagus with cleanly cut, fine mouldings and heavy festoons of fruit in the new Italian manner of Jones. This tomb is interesting, too, in being among the first examples of a device that was to appear fairly frequently in the work of Stone and other artists during the next two decades, namely the use of coloured marble curtains drawn back and here tied to the columns as to bed-posts, revealing the kneeling figures within. Since the architrave above is finished with a fringe, it may be that the device is indeed taken over from four-poster beds with hangings.[14]

The 1620s were clearly an interesting and inventive period of Stone's career, but the sequence of his work is not easy to follow, since in the notebook several commissions, notably those at Westminster, are grouped without dates. Two of these Westminster monuments, those of Francis Holles (d. 1622; Plate 20) and Sir George Holles (d. 1626), sons of the Earl of Clare, are unique in the England of their day, for they appear to borrow direct from Michelangelo. Francis Holles is seated in Roman armour, his head turned and raised, while Sir George, in the same type of dress, stands between relatively

massive mourning female figures on the back of a broken pediment. Some direct refer-
ence to the Medici tombs must surely be admitted, though the fine contrapposto of
Giuliano's pose is completely lacking in Stone's somewhat flabby figure, and the whole
design of Sir George's monument, which includes a battle relief of his exploits in the
Flemish wars, is remote from Michelangelo. Stone had never visited Florence, and can
presumably only have known of the tombs through some other man's drawing.[15]
Nevertheless, the mere existence of these monuments is indicative of the growing
awareness of Italy about the time of the accession of Charles I. Further, the use of a
standing figure, or indeed a seated figure, on an isolated pedestal is new in English
monumental art, though standing figures in niches had adorned some Elizabethan
country houses and were at this time being set up on the Royal Exchange. Stone may
have transferred the idea from these, or from public monuments in Italy, of which he
had heard but never seen. Standing figures in armour were gradually to become
acclimatized in England, though the type is not very common until the second half of
the century.[16]

One other monument of this decade, that to Sir Edward Pinchon (d. 1625, Writtle,
Essex; Plate 19A), deserves attention for the novelty both of invention and theme.
Biblical themes are almost non-existent in Protestant England, and this is well outside
the charge of Popish imagery, for it shows the parable of the Sower and is, in fact, a
Resurrection monument, for the Angel of Judgement stands above the Living Rock of
Christ, in front of which are garnered sheaves. Beyond the pilastered frame, which is
decorated with agricultural implements, are two seated angels in large harvesters' hats,
and below is a winnowing frame and a corn shovel.[17] Stone has here been able to give
his invention full play, and the resting angels, tired after their labours, have a freshness
and charm which is all too rare in English sculpture of the time.

Stone's inventions were not, however, always well received. About 1622 he was com-
missioned to make four royal figures, Edward V, Richard III, Henry VII, and Queen
Elizabeth I, for the Royal Exchange. The first three were accepted and set up, and pre-
sumably perished in the Great Fire of 1666. The Queen Elizabeth was rejected; it was
taken down and moved in Stone's lifetime to the entrance porch of the Guildhall
Chapel, and is now in the Guildhall Museum.[18] It is not, perhaps, surprising that con-
servative City patrons did not like Stone's figure, for the queen was not shown in con-
temporary dress, as many of them might have known her, but in semi-classical draperies,
with long hair falling on her shoulders and standing on a phoenix. She is a sturdily built
figure, solidly conceived but static in pose, her draperies arranged in the deeply cut and
dented folds of Stone's work up to about 1630, and although there is beyond question a
desire to create an allegorical figure in what the sculptor regarded as a classical style, the
treatment is very far removed from the antique.

By 1630, however, Stone had new opportunities of studying antique sculpture, for
Charles I acquired a very large number of pieces from the collection of the Duke of
Mantua.[19] Henry Peacham, in the second edition of his *Compleat Gentleman* (1634), a
revealing English descendant of Castiglione's *Il Cortegiano*, comments admiringly on
the wealth of antique sculpture to be seen in England:

'And here I cannot but with much reverence mention the every way Right Honourable Thomas Howard, Lord High Marshall of England,[20] as great for his noble Patronage of Arts and ancient learning, as for his birth and place. To whose liberall charges and magnificence this angle of the world oweth the first sight of Greeke and Roman statues, with whose admirable presence he began to honour the Gardens and Galleries of Arundel House about twentie yeeres agoe, and hath ever since continued to transplant old Greece into England. King Charles also ever since his coming to the Crowne, hath amply testified a Royall liking of ancient statues, by causing a whole army of old forraine Emperors, Captaines and Senators all at once to land on his coasts, to come to do him homage, and attend him in his palaces of Saint James and Sommerset House. A great part of these belonged to the late Duke of Mantua. . . .'[21]

Peacham goes on to note that the king's French sculptor, Hubert Le Sueur, whose work will be discussed later, had added to the collection a series of bronzes from antique models, including the Borghese Gladiator, the Farnese Hercules, the Belvedere Antinous, and the Diana of Versailles, which are now in the East Terrace Garden at Windsor Castle.[22] His list of available antiques also includes 'those Romane Heads and Statues' acquired by the Duke of Buckingham from Rubens's collection,[23] and he refers with equal admiration to Giovanni Bologna's Samson and a Philistine (then known as 'Cain and Abel') which stood in Buckingham's garden at York House.[24] Peacham's approach to these works foreshadows that of eighteenth-century connoisseurs, for in addition to 'the pleasure of seeing and conversing with these old Heroes (whose meere presence . . . cannot but take any eye that can see:) the profit of knowing them redounds to all Poets, Painters, Architects, and generally to such as may have occasion to employ any of these, and by consequence to all Gentlemen'. A knowledge of antique art as part of the equipment of a gentleman is a relatively new idea in England at this date; during the remainder of the seventeenth century its effects are more apparent in architecture than in sculpture, though even there some echoes of it are to be found. It is, moreover, revealing that while 'Poets, Painters and Architects' were artists worthy of mention, sculptors, who were still regarded as mere craftsmen, are ignored.

There can, however, be little doubt that Charles I's purchase of the Mantuan collection, which included a number of seated and standing figures, had a considerable impact on the style of Nicholas Stone. Its first repercussion can perhaps be detected in the untraditional monument of Sir Dudley Digges (1631, Chilham, Kent) which has four Virtues seated round a fine Roman Ionic column bearing an urn.[25] The Fontainebleau elegance of Stone's earlier female figures has almost completely disappeared; proportions are heavier, and in the Fortitude at least, with one bared breast, there are signs of an interest in the nude and also of the study of an antique head. The draperies for the most part are still arranged in big and somewhat clumsy folds, though there are some signs of a change here also.

The outstanding example of Stone's new style is the wall-monument to John and Thomas Lyttelton (1634, Oxford, Magdalen College; Plate 21). It commemorates two youths who were drowned, and who are shown as life-sized, semi-nude figures standing cross-legged on either side of a large tablet. The draperies covering the lower parts of their bodies are cut in fine small folds which follow each other round the forms, and

are thus a much closer imitation of the antique than Stone's earlier work. The heavy rounded heads, arms, and torsos are equal evidence of a new attention to classical models.

Even in his treatment of contemporary dress there is a change in Stone's style. In St Mary's church at Watford, Hertfordshire, are two large tombs, similar in pattern but very different in treatment, made for the Morison family[26] (Plates 18B and 19B). The earlier Sir Charles Morison (1619) is in richly coloured alabaster, with the son and the daughter kneeling life-sized at either end of their father's sarcophagus. The later tomb of Sir Charles Morison, Bt (1630), follows the same pattern, though instead of the varied colour it is of sober black and white, the architectural detail being much more refined. It is, however, in the figures of the kneeling daughters that the change is most apparent. Both have cloaks falling to the ground, the earlier broken into broad, dented folds, the later with the fine small repeated curves which Stone would have seen in the king's antique sculpture. A similar use of small, fine folds applied to contemporary dress can be seen in the tomb of Arthur and Elizabeth Coke (1634, Bramfield, Suffolk) and in the Spencer tomb (1638) at Great Brington, Northamptonshire.[27]

One further novelty appears in Stone's work of this decade. Although in some bust monuments (Sir Thomas and Lady Merry, 1633, Walthamstow, Essex) he still cuts the figure by the oval of the frame, in others (Lady Katherine Paston, d. 1636, Oxnead, Norfolk, and Sir William and Lady Peyto, 1639, Chesterton, Warwickshire)[28] he adopts the newer pattern of a bust on a pedestal. Here there may almost certainly be seen the influence of Charles I's foreign sculptors, who, as will be shown, were responsible for a fresh interest in the portrait bust.

During the 1630s Stone was a very busy man. In 1632 he succeeded William Cure as Master Mason to the Crown, and in two successive years, 1633 and 1634, he was Master of the Masons' Company. Much of his time was indeed given to masons' work, including marble paving for the Queen's House, Greenwich, and other royal palaces, which suggests that he had a big business as an importer and worker of marble, especially of black marble which he obtained from Holland.[29] He had kept in close touch with his de Keyser relatives, and two of Hendrik's sons, Willem and the younger Hendrik, worked for a time in Stone's studio.[30] His account book gives an interesting picture of a big, active studio, showing that special craftsmen were employed for polishing, and journeymen used for tasks such as the carving of the white marble corner pieces with cartouches and festoons on the tomb of Sir George Villiers (1631, Westminster),[31] or the cutting of the elaborate achievements-of-arms on that tomb and the Spencer tomb at Great Brington, Northamptonshire. In a very few instances only was an assistant paid for carving the effigy, which was presumably generally undertaken by the master himself. John Hargrave carved that of Lord Spencer for £14 and Richard White that of Lady Spencer for £15, sums which seem surprisingly small compared with the £600 Stone had for the tomb, though that, of course, included the provision of the black and white marble.[32]

Though most of Stone's practice as a sculptor was for tomb-making, he was also, in this last active decade of his life, to make a number of classical statues, including one, now lost, for Charles I, a 'Diana or chast love taking her repose having bereaved Cupid

of his bow and arrow and turned him to flight', made for a gate at Windsor in 1636. During this decade also the taste for the antique was spreading beyond the court. A number of classical busts are recorded in the account book, including the head of Apollo 'almost twise as big as the life', still in place on the north side of the courtyard at Kirby Hall, Northamptonshire. Even more interesting was the considerable series of classical statues and busts made from 1632 onwards for the Pastons at Oxnead, Norfolk, apparently as ornaments for the house rather than the garden. Only a battered Hercules, now at Blickling Hall, Norfolk, survives, which in its present state does not suggest that the quality can ever have been very high; but the mere fact that such a collection was ordered by a country gentleman is revealing.[33] Stone had clearly adjusted himself better to new ideas than Maximilian Colt, who still retained the office of Master Sculptor to the Crown, but was only used for decorative work.

One of his last monuments was indeed to a man who had done much to further the development of the new taste. Sir Dudley Carleton, Viscount Dorchester, is well known for his embassies to Venice and Holland, and his friendship with Rubens and Arundel. He died in 1632, and in 1640 his widow ordered his tomb at Westminster from Stone. It is one of the most noble in design of all Stone's works, and was to set the pattern for Westminster tombs for another sixty years. The effigy, more suave in its lines than most of the sculptor's figures and in a new manner, for broad flat unbroken folds in large looping curves replace the small rhythms of the antique, reclines on one elbow between two great Ionic columns carrying a broken pediment. There are no subsidiary figures, and the simple if somewhat heavy architectural frame does not conflict with the elegance of the figure. The cutting, however, seems less accomplished than in much of Stone's earlier work.[34]

Stone is an important sculptor in his own right, since much of his work is both vigorous and original, and his influence was considerable, for many tombs remain which show the impact of his inventions. Some, but by no means all, are likely to be by men who had worked for him; a few are recorded at the end of his notebook as the work of his youngest son, John (1620–67), who alone of his family long outlived him. These include a few monuments with busts (Lady Clarke, 1654, Sonning, Berkshire; John and Elizabeth Cresswell, 1655, Newbottle, Northamptonshire) which are a little more ambitious in their drapery patterns than his father's busts; but for the most part he appears to have been an uninventive sculptor with a curious lack of taste, as in the ludicrous monument to Sir Edmund Spencer (1656, Great Brington, Northamptonshire) who emerges in armour from a large urn.[35]

Stone's second son, the younger Nicholas (1618–47), might well, had he lived longer, have proved a more interesting figure. He was brought up to the business and was in 1638 sent to join his eldest brother Henry, a painter, for a four years' tour abroad. This in itself was unusual for a man of his day and class, and is a clear proof that the elder Stone's association with the court had suggested to him that England and even Holland could not provide all that an artist required. The young men went to France and Italy, and fortunately Nicholas kept a detailed diary, the earliest by an English artist, recording much of what he saw and did.[36] One passage at least has an interest beyond the field of

English art; for he visited Bernini, who inquired about the impression which his bust of Charles I, delivered in 1637, had made in England, and told him of a conversation he had had with Urban VIII about the relative value of painted and sculptured portraits.[37] In the history of English sculpture, however, the interest of the diary lies in the readiness with which the young man was willing to admire works by Donatello, Michelangelo, Giovanni Bologna, and Bernini; and above all in the amount of time which, as early as 1640, he spent drawing from the antique both in Florence and Rome. From the accounts which survive with the diary it can be seen that he bought and shipped back to England a small number of casts from the antique; and figures of children (no price is given, so it is impossible to tell if they were casts or marbles) by Francesco Duquesnoy, and an Apollo in wax by the same artist. Unfortunately the young man arrived back in England just at the outbreak of the Civil War and was to die five years later, shortly after his father; so he had little opportunity of profiting by his studies, and the possible effect of this immediate impact of Italy and Antiquity on an English sculptor was lost.[38]

The Contemporaries of Nicholas Stone

Though Nicholas Stone was certainly the leading mason–sculptor in the first half of the seventeenth century, he was by no means the only one to build up a good practice. Edward Marshall (1598–1675) was not without talent, but his work was uneven and his scope limited. Unlike Stone, he appears to have had no training under the Southwark sculptors of the previous generation, for he was apprenticed to a mason, John Clarke,[39] became free of the Masons' Company in 1626, and was to rise to the offices of Warden in 1643 and 1647, and Master in 1650. After the Restoration he became Master Mason to the Crown till his death, the post then passing to his son, Joshua.[40] One of his earliest known works, the tomb of George Carew, Earl of Totnes (d. 1629, Stratford-on-Avon), does, however, suggest a strong influence from the Southwark School. The two recumbent effigies, with hands joined in prayer, lie under the familiar arched canopy on colonnettes, the coffered ornament under the arch being so grossly misunderstood that the rosettes in the panels are almost Gothic pendants. Small allegorical figures, clumsy cousins of Stone's allegories on the Bodley monument, appear both in relief and in the round, and perhaps the most individual feature of the tomb is the relief of cannons and other weapons on the front of the sarcophagus. The whole is indeed an ambitious conglomeration of motives, in which heraldry also plays a considerable part, the blazoning of the shields and the colouring of the effigies giving it the gay but coarse effect typical of Jacobean tombs.

In the next decade, however, Marshall's work became more refined, and his sense of form more developed. The altar tomb with the effigy of Elizabeth, Lady Culpeper (1638, Hollingbourne, Kent) has a fine simple design in black and white marble. One hand rests on the breast, the other holds a fold of the cloak; and the dress falls in heavy, almost unbroken masses to the feet. It is less intimate than Stone's Lady Carey, and the head seems less individual, but it is, nevertheless, a work of great dignity. The monument to Henry Curwen (1638, Amersham, Buckinghamshire) is more original in de-

sign.[41] The doors of a tabernacle are opened by two angels to reveal a standing shrouded figure, which is surprisingly ambitious, though not entirely successful in pose, for one foot is raised and rests on a skull, the head is turned over the weight-bearing leg, and the arms cross the body in the opposite direction. So elaborate an attempt at contrapposto is rare in its generation, and though the flanking angels have affinities with the work of Stone, the central figure has none.

Shrouded monuments were enjoying a considerable popularity about this time, owing perhaps to the sharpening of religious controversy, but the Curwen is unusual. Stone himself had made perhaps the most famous example, that of Dr Donne (1631; Plate 22A), which was saved from old St Paul's after the Great Fire of 1666, and re-erected on one of the piers of the south ambulatory in Wren's cathedral, with the figure standing motionless and erect, swathed in grave-clothes above a small urn.[42] Other shrouded figures, like the lovely Lady Kinloss (d. 1627, Exton, Rutland), the sculptor of which is unknown, lie peacefully asleep. Henry Curwen is, however, clearly living, and therefore his is to some extent a Resurrection monument, though neither the angels at the sides nor the far more clumsy figures in relief above are sounding trumpets. Joshua Marshall (1629–78) was to use his father's device of an open sepulchre revealing shrouded upright figures on his signed Noel monument (1664, Chipping Campden, Gloucestershire);[43] that to Sir Geoffrey (d. 1670) and Lady Palmer (d. 1655, East Carlton, Northamptonshire) uses a similar pattern, and since it is of better quality may well be Edward Marshall's work. Another fine and unusual shrouded monument, that of Duchess Dudley (d. 1668/9) and her daughter, Alicia (Stoneleigh, Warwickshire; Plate 22B), is almost certainly from the Marshalls' yard.[44] Erected during the duchess's lifetime, it combines the traditional motive of two recumbent effigies, one above the other, though here both shrouded, with the device of two nude winged boys, pulling aside curtains and sounding trumpets. The curtains, which hang from a great tester supported by black Ionic columns, open on to another heavily fringed curtain like a backdrop, and the glories of Heaven are not yet revealed. Both the boys and the shrouded figures of the duchess and her daughter have some quality in their modelling, the soft undulating forms of the women's bodies being understood and tenderly combined with the fine soft curves of the thin shrouds. The style seems a possible development from Edward Marshall's Curwen monument, but less easy to relate to Joshua's clumsy figures at Chipping Campden. The Marshalls had, however, no monopoly for tombs in this vein. The Christmas brothers, whose work will shortly be discussed,[45] frequently used half-length shrouded figures, and when Sir Ralph Verney in exile in 1651 wrote home about a shrouded tomb he wished to erect at Middle Claydon, Buckinghamshire, to his parents, his wife, and himself, he suggested that it should be made by William Wright of Charing Cross.[46] No shrouded tomb certainly by this undistinguished sculptor is known, but he clearly had some reputation for such work.[47]

After many changes of plan, the Verney tomb was eventually executed in 1653 by Edward Marshall, and is characteristic of another side of his practice, for it has four portrait busts. None can have been made from life and all are somewhat wooden. They are, however, a clearly distinguishable type, probably characteristic of the studio: frontal,

rather long, but with the shoulders and armpits completely masked by rounded draperies, which in the case of the female busts are knotted on the breast.[48] Edward Marshall was to make a similar rounded bust for the monument of Dr William Harvey (d. 1657, Hempstead, Essex; Plate 25A), a work which suggests that, given better opportunities, he might have become something of a portraitist. The monument of Sir Robert and Lady Barkham (d. 1644, Tottenham, Middlesex; Plate 23B), with two half-length figures above and kneeling children beneath, again suggests that Marshall had some sense of character, for the domineering woman and her timid husband are far from being stock effigies.[49] Half-length figures and busts on the Marshall pattern are fairly common in the middle years of the century. Some may well have come from the Marshall workshop, but unless they are signed, it is dangerous to make attributions. On two occasions, at least, Marshall created busts which prove that he, like Nicholas Stone, had looked at Charles I's classical sculpture. One is the laurel-crowned bust of the poet Michael Drayton (1631, Westminster),[50] with its cloak all'antica draped over contemporary dress and knotted on the left shoulder. The other, which is of greater interest, is the head of Apollo, formerly above Ben Jonson's seat in the Devil's Tavern, and now at Child's Bank. It is undated, but may be before 1637, the year in which Jonson died. Here the head is sharply turned, and is probably inspired by some Late Imperial pattern in the royal collection. The design of the work is, however, naïve, for the large brooch is placed on the shoulder under the turned chin, proving that its function of providing a contrapposto element in the design has been misunderstood.[51]

Edward Marshall has been discussed in some detail, partly because his best work has character, but chiefly because he is a good example of a competent craftsman, using the manner and designs current in his day. His contemporaries can be dismissed more briefly. Thomas Stanton (1610–74) established a workshop which was to be carried on by his nephew William and his great-nephew Edward for almost a century.[52] He himself was apprenticed to a mason, Christopher Kingsfield. He became free of the Masons' Company in 1631, Warden in 1638, and Master in 1660. Though no building contracts appear to be known, he must have been much employed on such work; for the amount of sculpture which is certainly his is small. The earliest is the conservative monument to Judith Combe (1649, Stratford-on-Avon, Warwickshire) with two half-length figures holding hands;[53] the most important is that to Dame Jane Bacon (1655–8, Culford, Suffolk).[54] This large black and white tomb is dominated by the seated figure of Dame Jane with one child on her lap, while a row of little girls stand frontally on either side. Below is a stiff male effigy, probably that of her first husband, Sir William Cornwallis, since Sir Nicholas has a separate monument in the same church. The whole is a heavy and clumsy affair, but some of the little girls have charm and look forward to the agreeable child portraits produced later by the Stanton workshop; and the design is a welcome change from the much more widespread type with kneeling figures.

Another workshop which lasted for two generations was that of the Christmas family, though they were not masons, but carvers to the Navy and pageant masters to the City of London. Gerard (or Garret) Christmas worked near Cripplegate and died in 1633; his two sons, John and Matthias, appear to have worked with him. Matthias

eventually became Master Carver of His Majesty's shipyard at Chatham, where he died in 1654 aged about forty-nine.[55] The father was active as a sculptor in the reign of James I, for he made an equestrian figure of the king in relief (known only from poor engravings) on the city gate at Aldersgate. All the remaining works of any member of the family date from between 1635 and 1640. Of these, considerably the largest is the tomb of Archbishop Abbot (d. 1633, Guildford, Surrey, Holy Trinity) which is signed by John and Matthias, but for which the contract is said to have been given to Gerard before his death.[56] The effigy lies under a straight canopy supported by six black marble columns and is thus a continuation of the familiar type used for Queen Elizabeth I. There is, however, a wealth of symbolism absent in the royal tomb. The pedestals of the columns are supported by piles of books (echoing Stone's Bodley monument); the tomb-chest is a charnel-house filled with bones, and there are nine allegorical figures on the canopy and two larger ones at the foot of the tomb.[57] Stylistically, the figures are completely characteristic of the England of their day. An indeterminate classical dress is used, but there is less knowledge of classical sculpture than in the work of Nicholas Stone of this decade. The structure of the figure is not fully understood, and the draperies are more broken and confused than in, for instance, Edward Marshall's Curwen monument of 1636. The long necks and swaying poses place them clearly in the stream of late and very provincial Mannerist art.

Similar figures flank the half-length shrouded effigy of Mary Calthorpe (Plate 23A), signed by John and Matthias (1640, East Barsham, Norfolk), who is shown rising from her tomb, while above an angel resting on clouds looking like large boulders, is sounding the Last Trump.[58] Other signed monuments show familiar patterns such as busts in roundels (Ralph Hawtrey, 1638, Ruislip, Middlesex), two half-length figures holding hands (Sir Henry Calthorpe, 1638, Ampton, Suffolk), or kneeling figures with a prayer-desk (Robert Leman, 1639, Ipswich, Suffolk, St Stephen). There are also two tombs with full-length effigies. That of Sir Edward Lewknor (1638, Denham, Suffolk) is old-fashioned, for the armoured figure lies on his back on the straw mattress of the Eliza-bethan sculptors, but it has a simple dignity which is absent from the William Pitt (1640, Stratfieldsaye, Hampshire) with its two figures awkwardly propped on their elbows, the lady much impeded by her clothes. Were it not for the fact that they signed their monuments the Christmases would hardly emerge as individual sculptors; for they were clearly willing to produce any type that was ordered, and though tolerably competent as craftsmen, they are nothing more.[59] A great number of monuments, similar in type and quality, may be found all over England, and there must have been many masons' yards, possibly in London and certainly in the provinces, of which nothing is known.

SCULPTURE AT THE COURT OF CHARLES I

BEFORE his accession to the throne, Charles I, during his journey to Paris and Madrid in 1623 to woo the Spanish Infanta, had his eyes opened to the backward nature of English painting and sculpture. Thereafter he was continuously to attempt to attract distinguished foreign artists to his kingdom. With painters he was successful, with sculptors he failed; for of the three foreign sculptors who worked at his court, Hubert Le Sueur, Francesco Fanelli, and François Dieussart, none has much claim to distinction. The first two were, however, competent craftsmen in bronze, a material almost entirely neglected in England since the Middle Ages; and though, perhaps because of the Civil War, they left few followers, their use of bronze makes a sharp distinction between court art and that of the mason–sculptors.[1]

Hubert Le Sueur (worked c. 1610–51), a Frenchman, was probably the first of the foreign arrivals. His birth date is unknown and his training uncertain, for it is unlikely that he was, as Henry Peacham states, a pupil of Giovanni Bologna, though he may have had some contact with the Italians who, in 1614, set up the equestrian statue of Henri IV on the Pont Neuf in Paris, begun by Giovanni Bologna and finished by Pietro Tacca.[2] It seems more probable that he was trained in France, under an artist such as Barthélemy Tremblay or Pierre Biard, with whom his style has strong affinities, for by 1610, before the Italians came to France, he is recorded as 'Sculpteur du Roi'.[3] He is further mentioned in the French royal service in 1618 and 1619 as 'Officier' or 'Sculpteur du Roi', and in 1624 as an artist with special skill in bronze casting.

He is first recorded in England in 1626, when he made twelve figures for the catafalque of James I, designed by Inigo Jones.[4] His fee was small, only £20, and the figures were in some impermanent material.[5] His skill as a bronze-caster was, however, soon to be employed on two important tombs, those of the Duke of Lennox and Richmond, and of the Duke of Buckingham, both in Henry VII's Chapel at Westminster.[6] Both have recumbent effigies, but both have also much more elaborate allegorical and decorative figures than were usual in contemporary mason–sculptors' work. Lennox lies under a great hearse-like canopy of pierced bronze, supported by four female figures, the whole being surmounted by a winged Fame with a trumpet.[7] Buckingham has a similar but smaller Fame at the foot of the sarcophagus, and four seated mourning figures, nude or in classical dress. The last are ambitious works, but strangely insensitive in design and modelling, lacking completely the nervous energy of the surviving figures (Louvre) from the base of the Henri IV statue. Like all Le Sueur's work, they have a curious, inflated appearance, as if they were not modelled, but blown up from within. Such bronze figures were, however, a novelty to patrons who had hitherto been dependent on the mason–sculptors, and no doubt they furthered Le Sueur's reputation.

He was, indeed, to make a number of bronze statues, all of which are accomplished in

their casting, though not in their design. The William, Earl of Pembroke (*c.* 1629, Oxford, Schools Quadrangle), is a stiffly posed figure in which the richly fashioned armour is the chief interest,[8] and the Admiral Sir George Leveson (1633, Wolverhampton, St Peter) is much the same, though of poorer quality.[9] There are also two pairs of royal figures, Charles I and Henrietta Maria (1634, Oxford, St John's College; Plate 26A) and James I and Charles I (1638, Winchester Cathedral),[10] which reveal that his ideas of design were meagre and static and that his style had hardly changed in ten fairly active years. His most famous work is the bronze equestrian statue of Charles I at Charing Cross (1633; Plate 27),[11] which from a distance has some air of majesty, though detailed inspection reveals the deplorable emptiness of modelling in the head. For this work the artist was instructed 'to take the advice of the King's riders of great horses for the shape and action of the horse and of his Majesty's figure on the same'; but it seems improbable that Le Sueur, who was enormously conceited, would have taken any advice, and the statue follows very closely the pattern of the Henri IV.

Le Sueur was certainly in the royal service by 1631, for in that year he was paid for bringing from Italy 'moulds and patterns of certain antiques there'.[12] These were no doubt the figures subsequently cast in bronze and referred to by Henry Peacham as being at St James's Palace.[13] He had also made his first bust of the king, and it is perhaps in this field that his chief importance lies. Portrait busts in their own right, and not as part of a tomb, had been very rare in sixteenth-century England, though they were much in favour on the Continent. Le Sueur's work brings England into the European stream, and introduced to English patrons and mason–sculptors the Continental form of bust set on a pedestal, which was gradually to replace the current English type of monumental bust set in a roundel and cut by the frame.

Le Sueur's busts of Charles I present a confusing problem, for a considerable number, with slight variations, exist, some of which may well be later copies of a well-known type. The earliest dated version is a somewhat damaged marble of 1631 (V. and A.); with it can be linked a number of bronzes, that with the best pedigree being the one presented to the Bodleian Library at Oxford in 1636 by Archbishop Laud (Plate 24B). All are strictly frontal and show the king in contemporary armour, though the marble has an acanthus pattern on the breastplate and the bronzes have plain studded armour. It looks as if a pattern was created and approved, and several repeats were made.[14] The type, both in the treatment of the armour and the scarf, seems to be derived from Barthélemy Tremblay's bust of Henri IV (Paris, Jacquemart André Collection), though Le Sueur's work is less lively. A more striking bust is that of the king in Roman dress and with a dragon helmet (National Trust, Stourhead, Wiltshire), which was recorded as being in the Chair Room at Whitehall Palace before 1638.[15] It has, especially in the treatment of the helmet and the hair, a fine decorative quality, but the face has the same smoothness and lack of interest in structure that mars all the artist's work.

By the end of the decade it seems likely that the king realized that Le Sueur was a little tedious. In 1637 the marble bust made by Bernini from the triple portrait by van Dyck had been delivered, and its quality, both in design and cutting, must have revealed that Le Sueur was an old-fashioned and second-rate artist.[16] Moreover, he was becoming

pretentious. His bills for work for the queen at Somerset House, which included a Mercury for a fountain, a Diana, a 'Spinario', and a number of classical busts, are signed 'Praxiteles Le Sueur'; but in most cases the price has been reduced by the king, and one item is marked: 'This I will not have.'[17]

Le Sueur must have left England soon after the outbreak of the Civil War, for he was in Paris by 1643, and was still living there and calling himself 'Sculpteur du Roi' in 1651. Before he went, however, he made his one real contribution to English tomb design, for his Westminster monuments of Sir Thomas Richardson (1635) and Lady Cottington (c. 1634)[18] have bronze busts on pedestals, a type which, as has been shown, was quickly to be copied by the mason–sculptors in marble or stone, though it was to be many years before the older type of long bust, cut by the frame, was finally to disappear.

Both the other foreign sculptors, Francesco Fanelli (worked 1608–65) and François Dieussart (worked 1622–d. 1661), who are recorded at the court in the 1630s, seem to have been slightly more talented than Le Sueur, but even so, their work is not of the first order. The date of Fanelli's arrival is unknown, but he had clearly been trained in a good Italian tradition, though possibly not in his native Florence, and seems at first to have specialized in the making of small bronzes, notably of Cupids with a horse, of which several still exist.[19] Some were made for the king and others for the Duke of Newcastle, Governor to the Prince of Wales, for whom Fanelli also made a bronze bust of the prince at the age of ten (1640, Duke of Portland Collection).[20] This is much less shallow in modelling than Le Sueur's busts, the smooth inflated surface being replaced by a livelier sense of form, and a greater ability to contrast the different textures of flesh, crumpled collar, and splendidly chased armour. The same more lively and more Italianate treatment may be seen in the bust of Sir William Ayton (d. 1637, Westminster), sometimes attributed to Le Sueur.[21] The superiority of Fanelli's work was recognized by one of the most discriminating of patrons, the Earl of Arundel, who ordered in his will that his tomb should have a figure '... (of white marble or brasse designed by Sign^r Francesco Fanelli) sitting and looking upwards ...'.[22] The tomb was never executed, as Arundel died abroad, and so English sculptors were deprived of the example of a seated figure, as in life, designed by an Italian. No tomb certainly by Fanelli remains, though it seems probable that the Lord Treasurer Weston (d. 1636, Winchester Cathedral) is his.[23] The effigy, with its finely modelled head and superb armour with trophies and fettered figures on the breastplate, is closer to Fanelli's Charles, Prince of Wales, of 1640 than to any work by Le Sueur, and the use of pink marble with bronze mounts for the sarcophagus suggests an Italian rather than a French designer.

Fanelli's chief remaining work in England, the Diana Fountain in Bushey Park, Middlesex (Plate 26B), is all that now remains (beyond Le Sueur's casts at Windsor) of the wealth of garden sculpture made for Charles I. The fountain was moved in the early eighteenth century from the Privy Garden at Hampton Court, and reset in the middle of too large a pond, on a much higher base, some of the figures being recast. The crowning figure of Diana therefore seems too small, and the charming design of the sirens spouting water from their breasts and the boys struggling with fish cannot be

appreciated.[24] Fanelli, who left England in the early 1640s, had evidently inherited the Florentine taste for fountain design, for he published in Paris a book of fountains and architecture, in which he describes himself as 'Scultore del Re della Gran Bretagna'.

The remaining foreigner whose work can still be traced was the Fleming François Dieussart.[25] His approach was less conservative than that of Le Sueur or Fanelli, for he had been trained in Rome, perhaps in the studio of his countryman, Duquesnoy, and must also have seen works by Bernini. His bust of Charles I (signed and dated 1636, Duke of Norfolk Collection) is both wider and shorter than the Le Sueur pattern; the head is slightly turned, and considerable play is made with the crumpled collar and deeply undercut hair with long locks falling over one shoulder. In spite of this, the work is in the main static, and the modelling, though superior to that of Le Sueur, a trifle dull. The somewhat heavy style may also be seen in the unsigned bust of Charles Louis, Elector Palatine (1637), in the same collection[26] (Plate 25B). Dieussart's major work in England was 'a machine . . . to exhibit the Holy Sacrament and give it a more majestic appearance' which he devised for the Queen's Chapel at Somerset House in 1636. A description reveals that it combined a full Baroque panoply of architecture, sculpture, and painting, the last with an illusionist effect.[27] Its existence was, however, short, for it was destroyed during the Commonwealth and it seems improbable that it had any influence on the course of English sculpture.[28]

RESTORATION SCULPTURE
AND THE BAROQUE
1660—1714

CHAPTER 6

INTRODUCTION – THE BERNINESQUE ECHO IN THE
WORK OF JOHN BUSHNELL – EDWARD PIERCE

Introduction

DURING the period between the outbreak of the Civil War in 1642 and the Restoration in 1660, no marked developments occur in English sculpture. This is not surprising, for court patronage was at a standstill, and though many tombs were made, these were for the most part for middle-class patrons, and therefore conservative in character. Aristocratic tombs are relatively rare, and it is not unusual to find that a member of a great family had no memorial erected to him for many years. For instance, the monument of the 7th Earl of Rutland, who died in 1640, was set up with that of his successor in 1686. Most of the foreign sculptors who had worked for Charles I left the country at the beginning of the troubles; the mason–sculptors continued their traditional types of the early part of the century, though it would seem that by the Restoration some of them had followed the example of Nicholas Stone and adopted the foreign pattern of the free-standing bust, of which an example is on the monument to Captain Thomas Sondes (d. 1668), signed 'W.S.' (presumably William Stanton), at Throwley, Kent.

One foreign sculptor, Peter Besnier (or Bennier), remained, and was re-installed in the post of Sculptor-in-Ordinary to the Crown in 1660. He had probably worked with Hubert Le Sueur,[1] from whom his style is derived, as may be seen in his only signed work, the monument to Sir Richard Shuckburgh (d. 1656) at Shuckburgh, Warwickshire, which has a bust in armour of moderate accomplishment. It is not unlikely that he also worked for the Fermors of Easton Neston, since the two families were related by marriage. The large family tomb to Sir Hatton and Lady Fermor (1662) is an ambitious but somewhat incoherent design with two standing figures, a bust on a pedestal between them, and three half-length figures above. The last are stylistically very close to the weaker of the two monuments to daughters of the Noel family at Chipping Campden, Gloucestershire, which link well enough with Le Sueur, and form, with the Shuckburgh, a fairly convincing group.[2] Together they are at least enough to show that the tradition of Le Sueur persisted into the second half of the century, but it is strange and

somewhat disquieting that, though Peter Besnier enjoyed his office till his death in 1693, no later works by him are known.[3]

After the Restoration considerable changes may be seen. Charles II was not so eager a patron as his father (though he spent more on building than is often recognized), and was less lavish in his invitations to foreign artists.[4] There is no longer, therefore, the fairly sharp distinction between patronage within and without the court. On the other hand, some at least of the new trends in sculpture reflected tastes created by the compulsory exile. Charles and his immediate circle had spent more than ten years abroad, partly in France, but mainly in the Low Countries. Other English gentlemen had gone farther afield, and found themselves in Italy. And, apart from the political exiles, travellers were going in increasing numbers to the Continent, and the Grand Tour was beginning to take a recognized shape.[5] These men must have returned with an awareness of the far greater variety and competence of sculpture in France, Italy, and the Netherlands. They may not have felt any instant sympathy with the more extreme forms of Baroque art, either as displayed by Bernini or Fayd'herbe, for they were inevitably linked with Popery; but less dramatic though highly accomplished artists such as Algardi, Sarrazin, and, rather later, Girardon must have had a greater appeal. Moreover, though the reputation of Francesco Duquesnoy may not have been as high in England in the seventeenth century as it was to become in the eighteenth, casts of his small figures were admired;[6] and it is fairly clear that it was his modified classical-baroque style, continued in the Netherlands by Jerome Duquesnoy and the elder Quellin, that was most agreeable to English taste. The admiration for Antiquity already voiced in the first half of the century by Henry Peacham was fostered by travellers to Rome, who not only saw (and no doubt discussed on their return) the monuments of Antiquity, but who also were eagerly buying engravings of them. Vitruvius and Italian architectural treatises had long been popular in England; now books such as Santo Bartoli's *Admiranda Antiquitatum Romanorum* with its wide range of plates of ancient sculpture also found their place in the libraries of English gentlemen.[7] And contemporary sculpture of a type much to English taste could have been studied in Hubertus Quellin's publication, *Voornamste Statuen ... van het konstrjck Stadthuys van Amsterdam* (1655 and 1663), showing his brother's work at the Royal Palace at Amsterdam.

It was, however, not only potential patrons who travelled. Most of the leading sculptors in the second half of the seventeenth century had also spent some time on the Continent, and had there acquired some knowledge of contemporary style, and an increased opinion of their own status. For they refer to themselves as 'statuaries', and though they were generally willing to become Freemen of one or other of the City Companies, and so to enjoy the privilege of working within the City Liberties, they did not conform to the older mason-sculptor type. Some of them, indeed, had been born abroad, but had settled in England and worked for a wide variety of patrons, and so do not fall into the same class as the foreign visitors at the court of Charles I. It is, in the main, from these men, Bushnell, Cibber, Gibbons and his partner Arnold Quellin, Nost, and Bird that new ideas and new designs emanate. But such novelties as they introduced were often quickly copied by sculptors who had not travelled, and it is mis-

leading to attempt too sharp a separation between the two groups. Nor must it be supposed that the work of the more experienced artists is necessarily of better quality. Edward Pierce is at least as good a sculptor as any of his more travelled contemporaries, but even so it is a regrettable fact that the general level of English sculpture of the second half of the century is far below the Continental average. Patronage was, admittedly, on a less lavish scale, with religious sculpture non-existent, and no great royal focus as in France and in consequence no established tradition of academic training.[8] Nonetheless, there were ample opportunities for sculptors. Wren's architecture, especially in its later phases, required more from the sculptor than that of Inigo Jones; a considerable amount of figure sculpture was commissioned after the Great Fire of 1666 (for instance, all the City Companies gave statues for the courtyard of the new Royal Exchange); busts became more common, and the demand for tombs was unending. That little of real distinction was produced was evident to visitors from abroad; and Conrad von Uffenbach's comment on what he saw in Westminster Abbey in 1710 is not entirely unjust: 'After we had seen everything in the chapels, we walked about the church and looked at the vast number of monuments which are to be seen both on the walls of the church and on all sides of the chancel. The English can never have been great connoisseurs of sculpture, or else they have lacked skilful artists. For there is not a single monument of any magnificence or fine workmanship . . .'[9] The interest of the period in fact lies chiefly in its acceptance, in a somewhat hesitant way, of certain aspects of Baroque art, and in the insular and basically provincial use that was made of them.

Documentary evidence concerning sculpture is richer from now onwards. While nothing comparable to the notebook of Nicholas Stone remains and few seventeenth-century works are signed, more contracts have survived and information about leading sculptors is to be found in the notebooks of the eighteenth-century engraver and antiquary, George Vertue.[10] Though his statements are sometimes confused, the notes were often made during the lifetime of the sculptors concerned, or from information given by men who had known them, and are therefore of great value.

The Berninesque Echo in the Work of John Bushnell

The first of the sculptors of the reign of Charles II who had something new to say was John Bushnell (c. 1630–1701).[11] His contribution was indeed considerable, and might have been much greater but for a mental instability which early affected his work, and ended in complete insanity. He was the first English artist to show any knowledge of Baroque sculpture; his work therefore must have been a revelation to many of his English contemporaries. Unfortunately, it was often crude and pretentious, and will not stand comparison with that of even second-class sculptors in Italy or France.

He was born probably in the 1630s, the son of a plumber, Richard Bushnell, and was apprenticed to Thomas Burman (1619–74), who was well within the mason–sculptor tradition, since he himself had served his apprenticeship under Edward Marshall. No works by Burman before the Restoration are known, so nothing can be deduced about his possible influence on the younger man. His signed and dated monument of 1661 to

John Dutton at Sherborne, Gloucestershire, with its rather insipid treatment of the standing shrouded figure, does not, however, suggest an artist of much talent.[12] He can hardly have taught Bushnell more than the rudiments of his craft, for before the apprenticeship was ended he forced the younger man to marry a servant he himself had seduced, and Bushnell fled to the Continent. According to his sons he remained there for at least ten years, returning, it seems, at the end of the 1660s. Little is known in detail of his years abroad; he is said to have spent two years in France, then to have continued his studies in Italy, to have come back via Vienna and Hamburg, and also to have visited Flanders.[13] He is said to have worked as a labourer under masters in several towns, but the only place in which he can be traced is Venice, where in the winter of 1663/4 he was seen by an English traveller, Philip Skippon, working on the tomb of Alvise Mocenigo in S. Lazzaro dei Mendicanti[14] (Plate 30). That he recollected the work with pride is shown by the careful description of it he gave to his sons, which they in turn passed on to George Vertue. The tomb, designed by Giuseppe Sardi, follows the usual Venetian pattern of a two-storey erection, with very competent statues in the lower storey signed by the Fleming, Giusto de Corte, for whom Bushnell was perhaps working as a journeyman. Above is a columned niche framing the main figure, flanked by two large, highly ambitious and somewhat confused reliefs showing Mocenigo's victories over the Turks in 1650.[15] The central figure is clumsily proportioned, muffled in a heavy cloak, and stands stiffly with a baton in his hand. It would seem almost certain that Bushnell went to Rome after he had worked in Venice, for his style when he returned to England shows a knowledge of the Berninesque and an admiration for the deeply undercut, tossing draperies of a figure such as the S. Longinus in St Peter's, that could hardly have been gained in Venice in the 1660s. Unfortunately, his Continental experience led to an extreme arrogance which, combined with his dilatoriness and his growing eccentricity, soon lost for him the leading position he might have held.

When he first came back, however, he received some important public commissions. In 1670 he made four statues of the three Stuart kings and a queen for the newly erected Temple Bar, and in the next year the figures of Charles I (Plate 28), Charles II, and Sir Thomas Gresham for the new Royal Exchange, now nearing completion after the destruction of the Great Fire. All these still exist: the Temple Bar figures, much weathered, are *in situ*;[16] the others, in better condition, are in the Old Bailey. In them Bushnell attempts, and almost achieves, a full Baroque drama. The figures turn and gesticulate, wrapped in loose cloaks with fluttering ends which add to the agitation. The Exchange Charles I has his hand on his breast, drawing attention to his sufferings; Charles II, in Roman armour beneath his cloak and holding a scroll, is more heroic and less pathetic. The curls are deeply undercut (Bushnell had clearly learnt the use of the drill in Italy) and their liveliness of treatment is repeated in the fine portrait-like quality of the faces. A greater contrast to Le Sueur's stiff royal images can hardly be imagined. But the legs of Bushnell's statues are lamentably weak and, revolutionary though the figures must have seemed, their design suggests that the artist had never completely achieved that disciplined knowledge of anatomy which was an integral part of Italian training. And in the Exchange figures in particular, there is a basic neglect of the laws of contrapposto, or

of the Baroque convention of counterbalancing a twist of the body or an extended arm by a mass of drapery, and in consequence the dramatic impact is weakened by a sense of unsteadiness of pose. However, these figures, set up in the heart of London, must have provided many English craftsmen with their first sight of full-length Baroque statues, and must have established the sculptor's reputation. At least six more royal figures for the courtyard of the Exchange were commissioned, but these, though begun, were never finished, and Vertue, who saw them, noted: 'his air and planting of these statues are very indifferent. especially the leggs are intolerable'.[17]

Bushnell did, however, on one occasion, overcome his natural weakness of design. The monument to Lord Mordaunt (d. 1675) in Fulham parish church (Plate 29) is his most satisfying work, and is probably the finest tomb of the period. In design it is entirely new and very arresting. There is no architectural frame; the white marble figure stands erect and vigorous on a black marble slab supported on a white pedestal with a fine gadrooned base. At the angles are four smaller pedestals, those in front bearing the viscount's coronet and gloves, while behind is a tall black panel with a curving trefoiled top. The figure, wearing his own hair in short curls, turns sharply to his right, over an extended leg. The balance is, however, restored by the line of the baton in his right hand, and by the mass of drapery caught up by the left arm resting on the hip. Moreover, the weakness of the legs, encased apparently in tights and Roman boots (and therefore rather incongruous with the buttoned doublet), is rectified by the falling mass of the cloak behind them. The cutting, though a little coarse, especially in the hands, is very competent, and the head, with its deeply incised eyeballs, has the air of a lively portrait.

Bushnell's other important tomb of this decade, that which William Ashburnham erected in 1675 for his wife Jane and himself at Ashburnham, Sussex (Plate 31B), is even more ambitious in design. William Ashburnham kneels, his hands thrown out in a gesture of grief, at the feet of his wife, who is shown in a reclining posture, being crowned by a flying putto. Behind are curtains, held back by two more putti, while at the sides, on pedestals similar to those on the Mordaunt tomb, are a coronet and plumed helmet, a shield, and a burnt-out lamp. This dramatic tomb, with its intense expression of grief, and its direct appeal to the spectator, was certainly a novelty in England; so, too, is the fact that both the figures wear loose classical draperies. But unfortunately the distinction of the conception is matched rather by the beauty of the epitaph which records how William, 'coming from beyond sea, where he was bred a soldier, married her and after lived almost five and forty yeares most happily with her' for 'she was a very great lover', than by the quality of the sculpture. William's head, with its expression of yearning, has pathos, but the pose is weak, and the draperies are dragged across the figure in small meaningless folds. In the Mordaunt Bushnell shows some mastery of the Baroque approach to drapery which gives it an importance of its own, beyond the simple function of clothing a figure, and makes it play a major part in the design. This is completely lacking here, nor does the drapery add to our knowledge of the forms beneath it in the manner adopted by the more classical group of Baroque sculptors from Duquesnoy onwards. The proportion and disposition of the lady's limbs is very clumsy, and though her neck has been broken and re-set, the simpering silliness of her expression

belies the dignity of her epitaph. Presumably, however, the figure was not without its admirers, since it seems to have been repeated almost exactly in the monument Lady May erected for herself at Mid-Lavant, Sussex.[18]

The arrogance and suspicion which Vertue records, and possibly a growing recognition that his work was unreliable, prevented Bushnell from obtaining further important commissions.[19] These were to go to Cibber or Gibbons. He did, however, make a small number of monuments, those to Sir Thomas and Lady Myddelton and Elizabeth, Lady Myddelton, which were set up in 1676 at Chirk, Denbighshire, being among the most interesting. The former has two half-length busts on pedestals, the latter a reclining figure of the young mother suckling her baby. The main interest of this monument lies, however, in the fact that a painted portrait of the lady was sent up to London 'for Bushnell the stone-cutter to draw a pattern to make her monument at Chirke . . .'.[20] The busts on the other show the sculptor's frequent weakness in setting the head on the shoulders, but the lady has a certain languid charm, and the arrangement of her arms and draperies is less awkwardly conceived than in the male figure, where the left arm protrudes with a baton in the hand, but the right does not seem to exist. Another bust monument recorded by Vertue was the Mrs Grew (d. 1685) at Christ Church, Newgate Street (destroyed in the Second World War), but there can be little doubt that the Katherine Stewkley (d. 1679) at Hinton Ampner, Hampshire (transferred from Laverstock, Somerset), and the Mrs Pepys (d. 1669) still in St Olave's, Hart Street, are his. Both have many decorative features in common with his documented works, and the Mrs Pepys, with her turned head, and slightly open mouth, as if admonishing her wayward husband, is the liveliest of his female busts. His only certain late work is the strange tomb of the 7th Earl of Thomond at Great Billing, Northamptonshire, erected by his widow in 1700. Here, on a black and white architectural base of distinction (which seems more closely related to Florentine Mannerist art than any of his other work), Bushnell has erected a group of kneeling figures in front of his favourite looped-back curtains. In their disposition, the parents in the centre, the elder children at the sides, and the younger in a row in front, they recall traditional late-sixteenth-century types. But these grotesque figures with enormous heads and puppet-like bodies can only indicate the growing disorder of the sculptor's mind. Vertue's account of the unfinished works in the house (still in the 1720s without floors or staircase) which Bushnell built for himself in Park Lane is very revealing: 'the statue of K. Charles 2nd on horseback a model in plaster, designd for to be cast in Brass almost ruin'd, but by what remains I coud observe his manner of design great and spirituous, not elegant or gracefull, consisting chiefly of a manner neither easy nor agreable. A statue of Alexander when young (I think) being a naked, to show his skill in Anatomy, as I have heard, because he was by other statuarys not allowd to be so good at that, as at drapery.'[21] And there was a bust of the architect William Talman, with a long neck like a woman, and the ruins of a Horse of Troy, which would have held twelve men.[22] It is small wonder that these, and the law-suits in which he constantly engaged towards the end of his life, deprived him of his senses.

It has already been suggested that Bushnell's chief importance lies not so much in the

quality of his own work as in the fact that through it other men were shown a new and more up-to-date approach to sculpture. He may also have popularized a wider range of materials. One of his first commissions after his return from Italy was the modelling of the effigy of General Monck for his state funeral at Westminster Abbey in 1670. The figure was made of 'stucke' (i.e. plaster) and the face and hands of wax.[23] This technique was not entirely new in England, but Bushnell also probably made models in baked clay or terracotta, a method which was to become widespread in England in the early eighteenth century, but which had hardly been used since the reign of Henry VIII. One of the finest busts of Charles II exists in two versions, a marble, weathered and badly repaired, at Melton Constable, Norfolk (where family tradition states that it was a work of Bushnell given by the king to Sir Jacob Astley), and a terracotta at the Fitzwilliam Museum (Plate 31A). In addition to the interesting light it throws on Bushnell's method, it has an importance in the history of the English bust; for it combines the older type, cut just above the waist, with a new Baroque liveliness in the turn of the head, the rich treatment of the wig and cravat, and the drapery over one shoulder. If it is by Bushnell, it shows the artist in his sanest mood, and it makes it all the more regrettable that he was unable to produce more of the standard of this or of the Lord Mordaunt.

Edward Pierce

That so difficult a man as Bushnell left no followers is not surprising: the example of his works, however, would seem to have been a main formative influence on the style of Edward Pierce (c. 1635–95) who apparently never went abroad.[24] He was the son of a decorative painter[25] and became a Freeman of the Painter Stainers' Company by patrimony in 1656. He may have had some training as a painter, but his recorded work is as a mason, a carver, an architect, and a sculptor. Only the last is of importance here, but his practice as a mason–contractor was large, much of his work being done for Sir Christopher Wren.[26]

It is not known when he first turned his hand to sculpture, or by whom he was taught. But Vertue's statement that he 'cut the statue of Sr Tho. Gresham at the Royal Exchange' has perhaps been too lightly rejected. For the entry has been carefully corrected from 'made' to 'cut', which suggests Vertue had reason to believe that Pierce executed another man's design.[27] It is therefore possible that Bushnell employed Pierce to assist him in one of his three Royal Exchange figures (now in the Old Bailey), all of which were finished in 1671. The three would have been a large undertaking for one man, especially as the four Temple Bar statues must have been in hand at the same time; and Pierce, who was about this time carrying out carving on the exterior of the Guildhall, may well have seemed a suitable assistant. The Gresham (for which Bushnell had the fragments of an older statue sent to him as a model) is shown in Elizabethan dress, with a cloak wrapped round him. The cutting of the head, and particularly of the beard, is much less accomplished than are the heads of the two kings, and suggests another hand unaccustomed to the use of the drill. Moreover, the only remaining full-length figure by Pierce himself, the wooden statue of Sir William Walworth (1684; Plates 33B and 35)

on the staircase of Fishmongers' Hall, certainly owes much to the Gresham. Tudor costume is used for this fourteenth-century Lord Mayor, but it is managed far better than in Bushnell's figure; the long fur-lined cloak falls solidly behind the legs, and in front is drawn in dramatic, diagonal folds from the right foot to the left hip, thus hiding the abrupt, uneasy change from breeches to hose. The movement, which runs through the whole figure, counterbalancing the sharp turn of the head, is much more convincing, and the ambitious attempt to suggest arrested action is by no means unsuccessful; and the artist's technical accomplishment as a wood-carver is well displayed in the lively and vigorous cutting of the head. Pierce also executed at least three of the series given by the City Companies for the niches in the courtyard of the Royal Exchange:[28] Henry V for the Goldsmiths' Company, Elizabeth I for the Fishmongers', and Edward III for the Skinners'. Nothing is known of the first, but a drawing of the Elizabeth made in the late eighteenth century reveals that it was a frontal figure based on the effigy on her tomb in Westminster Abbey.[29] The Edward III appears to have been more interesting, for a small model of it belonging to the Skinners' Company shows an armoured figure turning towards the right, and steadied by a long falling cloak. Had it survived, it would have offered an interesting contrast to Le Sueur's royal figures in armour, for it suggests that Pierce had, in spite of the confining forms of plate armour, achieved a Baroque design.

It is not, however, for his standing figures that Pierce is chiefly remarkable, but for his few extremely interesting busts. The earliest is perhaps the small clay head (which belonged to Vertue) of Milton at Christ's College, Cambridge, which is conceivably *ad vivum*. The two signed busts of Oliver Cromwell (marble, Ashmolean Museum, Oxford; bronze, dated 1672, London Museum) are more interesting and more puzzling. The latter cannot, from its date, be from the life: it is related to the so-called life mask at Chequers, but both may be derived from the funeral effigy, modelled in wax by Thomas or Abraham Simon, of which a plaster version is in the Bargello.[30] The Oxford bust, on the other hand, does not conform to any of the known types of Cromwell portraits, and may be an idealized head. Both are rather long busts, and almost frontal, though in the bronze the head is very slightly turned. Neither reveals any knowledge of the Baroque bust. The Sir Christopher Wren at the Ashmolean (Plate 32A) is, however, very different. This, according to Wren's son, who gave it to the university, was made in 1673 and may therefore have been a present to him at the time of his knighthood. It is a shorter, wider bust than either of the Cromwells, with the sitter wearing a loose-necked shirt, covered by broadly-handled drapery which falls forward in big, deeply-cut folds. The head is slightly raised and turned, and the animation is increased by the design and handling of the long curling hair, which shows complete mastery of the use of the drill. The features are modelled with great sympathy; the sensitive mouth and the lifted eyes (with the eyeballs deeply incised) are lively and intimate and make this the most memorable of all the portraits of Wren. It is difficult to account for the great advance between this and the bronze Cromwell, made only one year earlier, for it is a truly Baroque creation, and cannot be paralleled by anything produced in England before its time. Nothing seems to have been made by Bushnell which could have served as a pattern, and it is tempting to think that perhaps the sitter himself had some say in its design. He had been in

France in 1665, when he saw Bernini's bust of Louis XIV at a fairly early stage,[31] and must certainly have realized that livelier patterns had superseded the old long, frontal busts. That his own portrait is more reserved and less flamboyant than Bernini's of the king is not surprising, for it is not a propaganda portrait of an absolute monarch, but an astonishingly intimate study of an English scholar. The tossing hair and draperies which give an air of immense and dominating energy to the portrait of Louis XIV are transmuted; pose and expression alike have a serene and contemplative air, and the whole has a distinction beyond any English work of its time. It is, indeed, nearer in feeling to the busts of Coysevox (for instance the Charles Le Brun), but none of these appears to be earlier than the mid 1670s.

Pierce's two later busts, though not of the same quality, are nevertheless among the outstanding examples of English sculpture of the later part of the century. The large bust of Dr Hamey (1675; Plate 32B) at the Royal College of Physicians is more pronouncedly asymmetrical in planning than the Wren and even wider in form.[32] The Thomas Evans (1688, London, Painters' Company; Plate 34) is much more assured in design, though somewhat coarse in cutting. Here Pierce shows true ability in the use of contrasting textures, the furred robe, the patterned cravat, and the rich curls of the wig, all of which add to the liveliness and vigour of the bust. These busts prove beyond question that Pierce was the best portrait sculptor of the century in England; it is sad that either his other activities or lack of commissions prevented him from doing more in this field.

So competent an artist must surely have received commissions for tombs, though none executed by him can be identified. A drawing (B.M.), almost certainly by him, for an elaborate tomb for the 2nd Duke of Buckingham (d. 1687), with both recumbent and standing effigies in contemporary dress, was never carried out, and other designs apparently by his hand seem to have been executed after his death by John Nost.[33] Some idea of Pierce's approach to tomb design, and also of the taste of the City patrons for whom he had constantly worked, can, however, be gained from the single tomb signed by his only known pupil, Richard Crutcher (c. 1660–1725), erected in 1705 at Bletchingley, Surrey, by the wealthy and distinguished Lord Mayor of London, Sir Robert Clayton (Plate 50A). It is of good quality, with two standing figures in contemporary dress, recalling the Buckingham drawing, and as might be expected of a pupil of Pierce, the cutting is lively and the sense of portraiture strong. Clayton would hardly have employed a man whose work he did not know, but what little else is recorded of Crutcher is masons' work and not sculpture.[34]

Pierce himself was occupied with decorative carving up to the end of his life; for the fine marble urn with a relief of Amphitrite made for Hampton Court and now on the East Terrace at Windsor is further proof of his ability. His reputation among his fellow-artists was evidently high; for a letter written to the architect William Talman by his son John in 1711, describes a lavish entertainment the young man had given in Rome, when his rooms were decorated with painted heads of poets and artists.[35] Italy was represented by Palladio, Raphael, and 'Bonarota'; England by Inigo Jones, Fuller, and Pierce. The comparison is ludicrous; but John Talman at least showed some judgement in choosing Pierce as his representative of English sculpture.

THE INFLUENCE OF THE NETHERLANDS

THE work of Bushnell and to a lesser degree of Pierce is the somewhat pale reflection in seventeenth-century England of the Berninesque trend in Baroque sculpture. Other sculptors, as will be seen, show an occasional awareness of Roman Baroque drama, but for the most part they are connected with the more classical stream, and particularly with that current of it appearing in the workshop of the eldest Quellin in Holland. In spite of the fact that England and Holland were constantly at war during the third quarter of the century, artistic ties were close, and the economic (and to a large extent the political) interests of the two peoples were very similar. Charles II himself might retain close ties with his cousin, Louis XIV, but he and his court had spent part of their exile in Holland, and to many Englishmen the Protestant States and the House of Orange were more agreeable than Catholic France. There is, indeed, far more Dutch influence in English art as a whole in the reign of Charles II than there is in the reign of William III, paradoxical as this may seem.[1] Dutch sculpture of the middle years of the century is completely un-Berninesque. A restrained classicism may be seen in Artus Quellin's reliefs of Justice scenes in the Vierschaar of the Royal Palace at Amsterdam, though this is combined with a certain opulence in the build of his female figures (such as for instance the Prudence) which recalls the fact that, although Artus had worked in Duquesnoy's studio in Rome, he was a native of Antwerp, and no man of that city could escape the overwhelming impact of Rubens.[2] There is, too, an increasing interest in naturalism in Dutch sculpture which is easily paralleled by the general character of Dutch painting. Echoes of this art, so different in its style and intention from the ecstatic art of Bernini, were soon to travel to England.

Caius Gabriel Cibber

Links with the Low Countries in the first half of the century had in many cases been strengthened by personal ties; Nicholas Stone had a Dutch wife, and it seems that his son, John, who had carried on the workshop after his father's death,[3] had kept in touch with his de Keyser cousins. He was in Holland about the time of the Restoration, when he was taken ill, and his foreman, Caius Gabriel Cibber (1630–1700), went to fetch him home. It is possible that Cibber, some of whose works suggest a knowledge of Dutch sculpture, had in the first place been recommended by Stone's Dutch relations.

Cibber was not, however, a Dutchman.[4] He was born at Flensburg and was the son of a cabinet-maker to the King of Denmark. According to Vertue[5] he was sent at the king's expense to study in Rome, and although nothing is known in detail of his journey, his works reveal Italian influence, though this cannot be described as specifically Roman. He apparently came to England before the Restoration, and seems to have continued in

charge of John Stone's workshop from the time of the latter's illness until his death in 1667. During this time he is not known to have carried out any independent work. He must, however, have been building up a reputation, for in the year of Stone's death he was recommended by the Earl of Manchester (who was then Lord Chamberlain) to the Gresham Committee[6] as a suitable man to make the statues to adorn the new Royal Exchange. It appears, indeed, that he had already made models for them which had pleased the king. His application was obviously premature, since the building was not yet begun, and he then applied for the post of surveyor to it, though there is no evidence that he was qualified for such a task. He probably needed money (he generally seems to have been short of it), and also hoped to increase his reputation by obtaining work in the City. He succeeded in becoming a Liveryman of the Leathersellers' Company in 1668 (which gave him the coveted right to work within the City Liberties), but was to have great difficulty in finding his fee of £25. He was eventually to discharge this debt in 1679 by making 'a stone mirmayd over the pumpe' in the courtyard of the Leather-sellers' Hall, a minor work (now lost) of some interest, since an engraving[7] shows that the two-tailed figure with water spouting from her breasts is imitated from the Naiads surrounding Giovanni Bologna's Neptune fountain at Bologna. This is not the only place which reveals that Cibber had been attracted as much by Mannerist sculpture in Italy as by the full Baroque.

Though he was not granted either the post of surveyor to the Royal Exchange or the commission for the series of royal statues, Cibber carried out one important piece of work in the City, which must surely have greatly increased his prestige. In 1674 he was paid for the large relief on the Monument (Plate 36A), the memorial column set up close to the place where the Great Fire had broken out. This is a grand, allegorical piece, showing Charles II, in Roman armour, directing Architecture and Science to succour the mourning figure of the City of London who, upheld by Time, sits disconsolate on the ruins. Behind her, London burns, while behind the king it rises anew. Above, in billowing clouds, are Peace and Plenty. It is perhaps the most elaborate piece of sculpture which had been produced in England since the Middle Ages. In its richness of allegory and its strongly pictorial character it betrays its links with Italy, and must be regarded (like the work of Bushnell) as a provincial variant of Italian Baroque; for, though it is competent, it is not distinguished. The figures are strung out across the foreground, and the gestures linking them together are rather too carefully planned to be convincing. Moreover, though great play is made with the perspective of the buildings running diagonally inwards, the relief is not, in fact, conceived in depth, for all the movement is parallel to the surface plane. At the sides, the artist has attempted a somewhat timid illusionism, for two figures break the line of the frame, but though the intention of the whole is clearly dramatic, Cibber lacks the force necessary fully to achieve his purpose.

On a more limited scale, however, and perhaps on one occasion only, he was to show considerable dramatic power. The two figures of Raving and Melancholy Madness (Plate 36B), originally made for the gate of Bedlam Hospital and now in the Guildhall Museum, stand apart from all his other work.[8] These two powerful nudes, horrifying in their realism, must surely have been studied from the life, and though they may owe

something to Michelangelo's Medici tombs, and more to Pietro Tacca's slaves round the base of the statue of the Grand Duke Ferdinand at Leghorn,[9] they show, as the Monument does not, a truly inventive quality and an impressive though coarse strength of modelling. Inventiveness, though of a different order, also appears in Cibber's only certain tomb, that of Thomas Sackville at Withyham, Sussex, the contract for which is dated 1677 (Plate 38).[10] The document itself is not without interest, for it states that final payment will be made when the monument is set up in its appointed place 'to ye well liking of Mr. Peter Lilly his Matys painter, or any other Artist who shall be desired to give their Judgement thereof'. It would seem that a sculptor was still regarded as more of an artisan than a painter, and that the judgement of the latter (especially presumably in connexion with the soundness of the portraiture) was thought to be superior. In this tomb, which stands in the centre of the family chapel, Cibber has taken a traditional theme but has changed it into something new; for the dead boy reclines on the black and white altar tomb, his hand on a skull, and his mourning parents kneel, gazing at him, on either side. Earlier free-standing tombs, for instance that of Bridget, Countess of Bedford (d. 1601) at Chenies, Buckinghamshire, had used large kneeling figures to flank the effigy. But they are not turned inwards, and so the intimate feeling of grief, which is so strong at Withyham, is absent. Here indeed, without the dramatic over-emphasis of Bushnell in the Ashburnham tomb, Cibber has created a monument which, in its impact on the spectator, is basically Baroque, but which in its reserve and dignity is markedly un-Berninesque. The modelling is smooth, and though not very sensitive has a simplicity which is most happily in keeping with the general tenor of the work. And it is surely not only the costume of the mourning mother that irresistibly recalls Holland. The whole work, in its unaffected naturalism, its solid and simple figures, is far nearer to Dutch than to Italian art.[11] It is surprising, in view of the quality of this monument, that Cibber did not, apparently, receive further commissions for tombs; but in the 1680s the studio of Grinling Gibbons was beginning to capture important orders, and for part at least of this decade Cibber was occupied with architectural sculpture outside London. Before he left, however, he executed one other interesting work, a fountain in Soho Square in which Charles II in armour stood on a pedestal surrounded by the four chief rivers of England, Thames, Humber, Tyne, and Severn, a work which must surely have been inspired by Bernini's fountain in the Piazza Navona, Rome. The figure of the king, much restored, has recently been returned to Soho Square; the river gods, described by Aubrey as 'old fathers with long wett beards', were until lately in the garden of Grimsdyke, Harrow Weald.[12]

This is perhaps the last of Cibber's works in which the influence of Italy is paramount. The Dutch influence, already noticed in the Sackville tomb, now becomes stronger, and the four figures of Divinity, Law, Physics, and Mathematics which he finished in 1681 for the parapet of Trinity College Library, Cambridge, are much closer to the style of followers of Artus Quellin.[13] They are heavily built, with heads which are markedly classical in type, but the draperies are awkwardly drawn across the bodies, confusing the pose, retarding the movement, and adding nothing to the interest of the design. The same characteristics appear in the garden figures, the four Seasons, two Senses, and a

Juno, which were being made at the same time for the 9th Earl of Rutland for Belvoir Castle.[14] Dutch influence is also to be seen in his garden figure of a very different kind, the Boy playing Bagpipes (V. and A.), which is very close to genre sculpture produced in Holland by P. R. Xaveri. More garden sculpture, busts of Caesars, and pediment figures, of which a sphinx survives, were made for the Earl of Kingston at Thoresby, Nottinghamshire by 1686, and then Cibber and the architect, William Talman, both went on to Chatsworth. Cibber was to work there from 1688 to 1691, both in the garden and in the house itself.[15] Most of the garden figures, now much weathered, have been moved from their original positions, but the rather flabby Apollo and Pallas remain on the staircase. More important are the Faith and Justice (Plate 37) above the altar in the chapel; for, with the wall and ceiling paintings by Laguerre and the altar-piece by Verrio, they combine to make this perhaps the most complete remaining Baroque interior in England. But whereas any Continental altar would have shown saints in ecstasy or angels alighting from rapid flight, Cibber's figures are completely static and have the same clumsily designed draperies, dragged across the bodies, as the Trinity College figures.

Sir Christopher Wren seems always to have had a good opinion of Cibber (in 1682 he had recommended him to the Bishop of Oxford for a commission which does not seem to have matured),[16] and during the 1690s he was to employ him both at Hampton Court and at St Paul's. At the former the garden statues he made have disappeared,[17] but his finely designed urn is now on the East Terrace at Windsor (with that by Edward Pierce); his chief work was, however, the pediment on the garden front showing the Triumph of Hercules over Envy (a reference to the victories of William III over Louis XIV).[18] This is an extremely ambitious but not wholly successful work. It is less pictorial than the relief on the Monument, since there is no scenic setting; the figures are in even stronger relief and the draperies are more boldly cut. Moreover the figures themselves are rather more elegant in their proportions and have a faint air of French classicism about them. But the general design is confused, and is far less effective seen, as it must be, from a distance, than that which Francis Bird was shortly to produce for the west pediment of St Paul's. Cibber was working at the cathedral at the time of his death in 1700. He carved the keystones of the eight great arches supporting the dome, the pediment of the south transept front with the phoenix rising above the flames, and was beginning to work on the finials on the same front when he died.[19] He appears to have been a reliable and reasonably competent sculptor, and if his work is not very exciting it has some interest in its reflection of both Italy and Holland.[20]

Grinling Gibbons and Arnold Quellin

The name of Gibbons is probably better known than that of any other English seventeenth-century sculptor. His extreme virtuosity as a wood-carver has delighted many connoisseurs from Horace Walpole onwards, and even today there is still a tendency to assume that any fine seventeenth-century wood-carving must be his.[21] In that field, which lies largely outside the scope of this book, he is unsurpassed, but his immensely

elaborate trails of fruit and flowers, cut in the round and applied to the ground, give an air of rich domesticity and good living to many an English Baroque interior. Here at least there can be no doubt that he was a superb craftsman. He also had a large practice as a sculptor, and one at least of his commissions, the bronze statue of James II now outside the National Gallery, equals, and indeed surpasses, Bushnell's Lord Mordaunt. But other works show, beside it, such an astonishing incompetence that it seems hardly possible that they are by the same hand. Indeed, in all probability they are not, for Vertue, who began to compile his notebooks in Gibbons's lifetime, and must have known many artists who had been intimate with him, records: 'he was a most excellent Carver in wood he was neither well skilld or practized in Marble or in Brass for which works he imployd the best Artists he coud procure'.[22] And on occasions it would seem that not only the execution but also the designing was perhaps left to other men. Except however in the mid 1680s, when Arnold Quellin was working with him, little is known of his studio, and its output must therefore be discussed as a whole even though it is evident that various hands were concerned. It is reasonable to assume that Gibbons, as head of a studio of some standing, retained control of the designs carried out, and that therefore the swing, apparent after Quellin's death in 1686, from a modified Baroque to a somewhat clumsy classicism in the pose and handling of figures, was due to his own inclination.

Grinling Gibbons (1648–1721) was born at Rotterdam. His father, James Gibbons, was a Freeman of the Drapers' Company (to which his son was to be admitted by patrimony in 1672); his mother was possibly Dutch (her name was Gorlings or Gurlings) and, even making allowances for the general looseness of seventeenth-century spelling, it would seem that Grinling never really mastered the writing of English. It is not quite certain when he came to England, but probably when he was about nineteen after some training in Holland. The character of his wood-carving has close links with Dutch flower painting, and though it is difficult to find woodwork in Holland dating from the 1660s which offers any exact parallel, some of the marble decoration carried out by the Quellin workshop in the Royal Palace at Amsterdam (especially in the two halls flanking the Burgersaal on the first floor) has flowers, fruit, and shells of an almost equal naturalism. It is with this studio that Gibbons's style, both as a sculptor and as a carver, is most clearly connected, and the fact that a member of it came later to work with him in England strengthens the possibility that he may have spent some time in it himself. On his arrival in England he is said to have worked for a time at York, but by 1671 he was in London. John Evelyn gives a picturesque account of how he discovered the modest young man, in a solitary thatched house near Deptford, carving that 'large Cartoone or Crucifix of Tintorets, a copy of which I myself had brought from Venice, where the original remains'.[23] Evelyn was enchanted with the work, brought the young man to the notice of the king, and hoped in vain that the queen (the Catholic Catherine of Braganza) would buy the Crucifixion. It was later bought for £80 by a City merchant, Sir George Vyner, and may be the relief, after Tintoretto's Crucifixion in the Scuola di S. Rocco, at Dunham Massey Hall, Cheshire, though the carved frame is coarse, and does not conform to Evelyn's description of 'flowers and festoons'.[24] The

transformation of the Venetian painter's crowded and complex design into a relief is not unskilful, and the whole conception is clear proof of the ambition of the carver. That he was capable of extremely elaborate sculpture in this medium is shown by the large relief, in which the foreground figures are cut in the round, of the Stoning of Stephen in the Victoria and Albert Museum (Plate 40).[25] This, too, must surely be based on a painted or engraved original, though the source has not so far been traced. It is a *tour de force* rather than a great work of art, with little, posturing, semi-classical figures which reappear in other works by Gibbons.

Evelyn implies that it was through his introduction to Sir Christopher Wren and to Hugh May, the Comptroller of the Royal Works, that Gibbons first gained advancement, but the young man had probably already been recommended to May by the painter Sir Peter Lely.[26] It was certainly May rather than Wren who was to give Gibbons his first opportunity as a decorator (at Cassiobury and in the great suite of new Royal Apartments at Windsor, where he worked from 1677 to about 1682, being referred to as a 'Forreiner'); and Gibbons, Lely, and May were to be linked by ties of business and friendship which are recorded in Lely's double portrait at Audley End of himself and May with behind them a bust of Gibbons and a view of Windsor Castle, and by the monument Gibbons was to make to Lely in St Paul's, Covent Garden, after the painter's death in 1680.

While Gibbons was working for Hugh May at Windsor, he was almost certainly associated with another project there. In 1678 money was voted by Parliament for a mausoleum for Charles I, and designs for a circular building (never to be carried out) were prepared by Wren.[27] It was to contain an ambitious sculptured group and, according to Stephen Wren's *Parentalia* (1750), the two alternative draughts were supplied by 'that eminent artificer Mr. Gibbons'. The surviving drawings at All Souls College, Oxford, are basically Flemish in character and accord well enough with later drawings by Gibbons. The two designs (one for bronze and the other for marble) show the royal martyr in contemporary armour standing on a shield supported by a group of four Virtues, while pressed down beneath them are Rebellion, Heresy, Hypocrisy, and Envy. Above the king's head (and indeed the most attractive part of the designs) are groups of flying cherubs, bearing the martyr's crown and palms. In the bronze the main figure is stiffly frontal, the Virtues timidly posed, and only the Vices, crushed beneath a heavy block, have any animation. The other is more lively but the gestures seem a little foolish and the jagged lines of the composition and lack of support for the royal figure would hardly have been satisfactory in execution. Both conceptions, indeed, make it clear that the designer had little experience of large-scale work in either marble or bronze.

It must, however, have been his association with court artists that gave Gibbons a rising reputation. He seems to have designed little in the way of monuments before 1680, though a modest and clumsily designed tablet with two putti at Sutton, Bedfordshire, was ordered in 1677 by Sir Ralph Verney to commemorate Sir Roger Burgoyne. The price was to be fixed by Lely and May when the work was done.[28] In the next decade, however, he was to get many orders for sculpture. The group of royal figures, the Charles II at Chelsea Hospital, the James II in Trafalgar Square, the Charles II that

stood in the centre of the courtyard of the Royal Exchange; the statues for the altar of James II's chapel at Whitehall; the tombs of the 7th and 8th Earls of Rutland at Bottesford, Leicestershire, and of Viscount Campden at Exton, Rutland, were all completed by 1686. They form a coherent stylistic group, and are very different from the works to be produced by the studio in the 1690s. Since Arnold Quellin was working with him in the mid 1680s it seems almost certain that these works (on which Gibbons's reputation as a sculptor chiefly rests) should be regarded as, at least, joint productions.

Arnold Quellin (1653–86) was the eldest son of the distinguished sculptor whose workshop had decorated the Royal Palace at Amsterdam, and the cousin of Artus Quellin II, who had worked mainly in the family's native town of Antwerp, his chief extant works there being the high altar in Saint-Jacques and the elaborate confessionals in Saint-Paul.[29] These, created for a Catholic community, are far more emotional in content and far more Berninesque in style than the eldest Quellin's classicizing work at Amsterdam. It is not clear why the younger Arnold, a sculptor of twenty-five, with good workshop connexions in both Amsterdam and Antwerp, chose to come to England unless he already had English friends; for, though the great period of artistic activity in Holland was over, and Flanders was beginning to suffer from the wars of Louis XIV, many tombs were still being made for Flemish churches. On the other hand it is true that, though Arnold Quellin appears a relatively good sculptor by English standards, his work is below the average then being produced in Flanders, and he may have felt that competition would be less damaging in England. He is first recorded among the foreigners working under Hugh May at Windsor in the late 1670s,[30] but his earliest independent commissions appear to have been for City patrons: the standing figure of Sir John Cutler at Grocers' Hall was paid for in 1681/2 and one (and perhaps both) of the statues of Charles II and Cutler from the College of Physicians now in the Guildhall Museum were made in 1683.[31] The Grocers' figure, which is much better preserved than the other two, shows Cutler with his long furred robe looped up across his body, and his left hand extended. It betrays a good training in the actual cutting, and the pose, though a little dull, is at least convincing, for the man stands firmly on his feet. His only certain tomb, that of Thomas Thynne[32] in the south nave aisle of Westminster Abbey, is far finer in design. Thynne was murdered in his coach in Pall Mall in 1682, the scene of the attack by three horsemen[33] being shown with clarity and economy of means in the relief on the base. Above lies Thynne's half-draped figure with a splendidly modelled putto at his feet pointing to the inscription which records the manner of his death, while over the curved top of the tablet is a very large looped and fringed drapery, the folds of which are deeply cut and planned with skill and variety. The figure, though somewhat insensitive in modelling, is well designed, for the drapery follows the main lines of the body, strengthening the rhythm and not confusing the eye, which is so often the case in English work. But it is perhaps in the brilliant vitality of the putto that Quellin's training can best be seen, for it descends from the 'boys' for which Duquesnoy had been famous and which were so much admired and so much copied in the Netherlands. One has only to turn and compare this little figure with the two boys on Gibbons's later monument to Admiral Churchill in the same aisle, or the

drapery with the dull and formalized curtains hanging above Sir Cloudesley Shovell, to realize the superiority of Quellin as a craftsman.

At the same time Quellin was also collaborating with Gibbons. In 1684 a statue of Charles II was erected in the middle of the Royal Exchange by the Merchant Adventurers of England, of which Vertue records that, though a special copyright forbidding its reproduction in engraving without permission was granted to Gibbons, the statue 'was actually the work of Quelline'.[34] This figure, 'done with great Beauty and Spirit, in the ancient Roman Habit of their Caesars, with a wreath of laurel on the head',[35] was lost in the fire of 1838, but it sounds curiously similar to the Charles II at Chelsea Hospital and the James II in Trafalgar Square (Plate 42A). Both are laurel-crowned and in Roman armour, with a cloak over the left shoulder and a baton in the right hand. This Roman victor type, a novelty for royal statues in England, was probably a direct importation from France; it therefore affords a close parallel to the markedly French character of Charles II's 'King's Stair' at Windsor and the palace he was building at Winchester, both of which date from the early 1680s. For a colossal statue of Louis XIV, in Roman armour, laurel-crowned and carrying a baton, now in the Orangerie at Versailles, had been made between 1679 and 1683 by a Dutchman trained in Antwerp, Martin van den Bogaert, known as Desjardins, for the newly-projected Place des Victoires.[36] It is so close in type to the Stuart figures that the resemblance can hardly be accidental, though whether the knowledge of the French statue came through Charles II or through the sculptors themselves cannot be decided. The Chelsea Charles II moves sharply forward with his head turned; the James is beautifully poised, looking down towards his baton, the line of which plays a great part in the design, and would compare most favourably with any Continental work. And indeed it is Continental and not English work; for though it was ordered from Gibbons for £300 by Tobias Rustat, Yeoman of the Robes, and set up in the Palace of Whitehall at the end of 1686, two Flemings, Laurens of Malines and Dievot of Brussels, were employed to 'model and make' it.[37] No other work by either is known, and it is impossible to say if one of them also designed it, or whether, as in the case of the Charles II in the centre of the Royal Exchange, the credit should really be given to Quellin. That he was, before the end of his short life, capable of designing a figure of great ease of pose is shown by the model in the Soane Museum for yet another Charles II which was set up by the Grocers' Company in the Royal Exchange[38] (Plate 42B). This is in contemporary dress, and the cloak falls in much heavier curling folds than that of the bronze James II, but compared with the same artist's Cutler of only a few years before, it shows a great advance, and suggests that Quellin's early death deprived English sculpture of a notable figure.

Gibbons's major commission of the 1680s, the altar for James II's Catholic chapel at Whitehall Palace, was also shared by Quellin, though the part each played is not specified in the accounts. The existence of this chapel greatly shocked John Evelyn, but he was forced to admire its decoration: 'Nothing can be finer than the magnificent marble-work and architecture at the end, where are four statues representing St John, St Peter, St Paul and the Church, in white marble, the work of Mr Gibbons, with all the carving and pillars of exquisite art and great cost.'[39] Evelyn's iconography must be wrong, for

the four statues survive in a much weathered condition in the Canons' Garden at West-minster Abbey, and two of them are female. Two angels (Plate 41A) and four reliefs of cherubs have found their way to Burnham Church, Somerset.[40] All of them must once have been of some quality. The standing figures turn and gesticulate in a manner that recalls Antwerp work, and the St Paul in particular may well once have been of real beauty. The angels at Burnham are much better preserved; their deeply undercut draperies have a fine swinging line unlike any known figures by Gibbons, and it may well be that he only carved the elaborate decorative work and left the figures to his fellow-sculptor.

Quellin's name does not appear in connexion with the tombs Gibbons executed for Viscount Campden at Exton, Rutland (Plates 39B and 41B), and those of the 7th and 8th Earls of Rutland at Bottesford, Leicestershire,[41] but it is certainly impossible that Gibbons could have carried out so much work himself. The simpler of the two Rutland monuments (to George, the 7th Earl, who had died in 1640) has a single standing figure in classical armour in a twisted pose with some animation in the gestures and in the rich folds of the cloak. It does not seem to be designed or cut by the same hand as the male figures on the other two tombs. These are closely allied in design, though the Exton tomb is on a far grander scale. The type is new, for it has two standing figures, both in classical dress, with an urn between them. At Exton the whole is backed by a niche, with a broken pediment above; but the lines of the architecture are masked by obelisks and draperies, and the main emphasis is on the figures and the rich reliefs. Campden, who died in 1671, had married four times, and the tomb, which was completed in 1686 by the third son of his last wife under his mother's will, is a family piece on the most lavish scale, for all his wives and their nineteen children are shown. The reliefs (Plate 41B) of the successive families have much greater charm than the rather pretentious life-size figures of Campden and his last wife: all the figures appear in classical dress, and the smaller ones are in type very close to paintings in the same convention by Sir Peter Lely.[42] The poses are not very vigorous, the boys being poised on tiptoe like many of the figures in the relief of the Stoning of Stephen, and the draperies are looped in some-what meaningless folds, but the cutting, especially in the bottom relief, which is by far the best and simplest, with no apparatus or looped curtains, is not without accomplish-ment. The tomb of the 8th Earl of Rutland is a simpler edition of the Campden, without its reliefs, and was probably inspired by it, for the 9th Earl who set up both the Bottes-ford tombs had married one of Campden's daughters. The main figures on both tombs are very similar, the men in a short Roman tunic under a closely fitting cuirass, with bare legs and Roman boots, and a cloak looped in heavily undercut folds across the body and falling behind the legs. Both wear their own long hair, and make timid gestures with their hands. The wives are Junoesque in build, with loose classical dresses which slip down over the breasts, though the gestures seem to be modestly restraining them. And, like their husbands, they both wear heavy cloaks wrapped round them in thick diagonal folds. These ladies are not far from Cibber's Trinity College figures, or his garden statues at Belvoir, though the draperies are more deeply cut and the patterns rather more animated, with a fuller understanding of the rules of contrapposto: in both

cases, they derive mainly from Holland. But the new tomb type is not Dutch, and indeed, it is hard to find a parallel anywhere on the Continent: it seems to be an invention of the Gibbons studio, and is perhaps a transposition of the traditional English form with two figures kneeling on either side of a prayer-desk into something which was felt to be both classical and up-to-date.

One other work perhaps made before the death of Arnold Quellin in 1686 (and therefore possibly a partnership affair) is of interest for the very strong connexions it reveals with Flanders. This is the marble font in St James's, Piccadilly, erected in 1686.[43] The bowl is supported on a realistic tree, from which Eve picks an apple and the serpent emerges, the whole group being, in its rich use of plant life, closely related to the elaborate wooden pulpits which still exist in many Flemish churches.

After the death of Quellin in 1686 the style of figure sculpture produced by Gibbons changes and becomes more frankly classicizing. The undercut draperies disappear, there is less attempt at movement, and often extreme clumsiness in design. The last is very apparent in the awkward Duke of Somerset in the library of Trinity College, Cambridge, dating from 1691.[44] The figure is again in Roman armour, holding a baton and with the left hand resting on the hip, close indeed in idea to the James II in Trafalgar Square, but totally different in execution. The beautifully controlled balance of the earlier figure has given place to a clumsy stiffness, in which the action of the legs is reversed and the contrapposto ruined, and the line of the baton plays no part in the general design. The proud character of Somerset was notorious, but his statue is only silly and supercilious. A parallel change occurs in the handling of female figures. The tomb of John, Lord Coventry (1690, Croome d'Abitot, Worcestershire), has been re-set and mutilated, so that the coronet which should be 'tumbled at his feet' is now perched on his head like a bowler hat which is much too small, but the standing figure of Faith appears undamaged. Though she wears similar classical robes to those of the Countess of Rutland and Viscountess Campden, the heavy Baroque treatment has gone, the folds are flatter and more meagre, and the forms beneath are fully revealed.[45]

In 1684 Gibbons was made Master Sculptor to the Crown. Among his first tasks may have been the design for a monument to Queen Mary II,[46] who died at the end of that year. Either at the same time or after the king's death in 1702, he produced a further design for both monarchs.[47] These, intended for Westminster Abbey but never carried out, are of considerable interest. They are the most elaborate projects of the age, with groups of figures between coupled columns and much Baroque display of clouds and rays and flying angels. The figures, however, are curiously elongated in their proportions, with an unstable, swaying elegance.[48] That they would not have been so in execution is proved by the tomb of the 1st Duke of Beaufort (d. 1700, Badminton, Gloucestershire; Plate 39A),[49] which, though undocumented, is certainly by Gibbons, since it repeats exactly the figures of Justice and Truth from the William and Mary design, and uses coupled columns covered with foliage like the smaller wooden ones on the bishop's throne in St Paul's Cathedral. These solidly built, clumsy figures have the same drapery treatment as the Faith on Lord Coventry's tomb; and though it must be assumed that Gibbons was aiming at something he thought to be classical, he had no

understanding of classical contrapposto, or of planning a figure so that the weight and balance are clear. The mixture of a cold, but misunderstood, classicism in the supporting figures and the Baroque elements in the decoration is disagreeable, but characteristic of the artist's work about this time, and a comparison between the treatment of these figures and those on the Exton tomb clearly reveals the change of style after Quellin's death. Gibbons's most ambitious official style is even less attractive, as can be seen in what is perhaps at once the largest and least successful of his tombs, that erected by the queen for Sir Cloudesley Shovell (d. 1707, Westminster Abbey), with its clumsy figure in classical armour, dumped on a sarcophagus too small for it. Gibbons has failed singularly to suggest the dramatic character of the admiral's career,[50] and his failure was as apparent to Joseph Addison as it is today:

'As a foreigner is very apt to conceive an idea of the ignorance or politeness of a nation from the turn of their public monuments and inscriptions, they should be submitted to the perusal of men of learning and genius before they are put in execution. Sir Cloudesley Shovel's monument has often given me great offence. Instead of the brave rough English admiral, which was the distinguishing character of that plain gallant man, he is represented on his tomb by the figure of a beau, dressed in a long periwig, and reposing himself upon velvet cushions under a canopy of state. The inscription is answerable to the monument; for, instead of celebrating the many remarkable actions he had performed in the service of his country, it acquaints us only with the manner of his death, in which it was impossible for him to reap any honour. The Dutch, whom we are apt to despise for want of genius, show an infinitely greater taste of antiquity and politeness in their buildings and works of this nature, than we meet with in those of our own country. The monuments of their admirals, which have been erected at the public expense, represent them like themselves, and are adorned with rostral crowns and naval ornaments, with beautiful festoons of seaweed, shells, and coral.'[51]

Many influential Englishmen as well as Addison, and perhaps also Gibbons himself, must have known of the moving simplicity of the tombs of the Dutch admirals van Tromp and de Ruyter, but it would seem that in the first decade of the eighteenth century, the growing interest in Antiquity, already foretold in the standing figures in Roman armour, and strengthened by Gibbons's own inclination after Quellin's death, was becoming unmanageable in the hands of this elderly artist. An infusion of fresh blood from abroad was needed before sculpture in England developed the strength and discipline required to control the antique theme, and a generation was to pass before this was triumphantly accomplished by Rysbrack in the Newton monument.

It is good to turn from these large pretentious works to something more within the sculptor's range. The monument to Robert Cotton (d. 1697) at Conington, Cambridgeshire (Plate 45),[52] is, unusually for Gibbons, signed, and he may well have carved it himself. The bust of the boy in high relief is not very lively and is shown in three-quarter view (and so is more closely related to contemporary portraiture than to antiquity), but the medallion enclosing it is surrounded by superbly cut fruit, flowers, and palms in the manner of Gibbons's finest wood-carving. He made a few other monuments with similar medallion portraits, including that to Sir Richard Head (d. 1689, Rochester Cathedral), and the Sir Peter Lely, unfortunately lost in the eighteenth-century fire at St Paul's, Covent Garden.[53] Perhaps the finest example of this type is that to Gibbons's

patron, Tobias Rustat, at Jesus College, Cambridge (Plate 44). Rustat died in 1693, but the monument was apparently made some years before his death,[54] and its lively medallion portrait, together with the character of the drapery and also of the two supporting boys, suggests the hand of Quellin. The fruit and flowers, moreover, are noticeably poorer in design and cutting than those probably from Gibbons's own hand on the Cotton monument.

Gibbons was also willing to provide more modest monuments, with little or no figure sculpture. In 1683 the executors of German Pole of Radbourne, Derbyshire, ordered a monument with urns and 'cherabims [sic] heads and drapery' for the not inconsiderable sum of £300; but ten years later the sculptor made a very simple tablet for only £10 to Henry Newdigate at Ashtead, Surrey (admittedly he had received other contracts of more importance from the same family).[55] Sometimes it would seem that an existing monument was repeated, for that to Francis, Lord Bradford (d. 1708, Wroxeter, Shropshire), is almost identical (except that it has no flanking obelisks) with the one set up to Admiral Churchill in 1710 in Westminster Abbey.[56] Most of these works, and there are probably many more of them, are agreeably designed; the flaming urns which are so constant a feature are well proportioned, and they are usually set on a gadrooned base.

The workshop was prolific and must have been large, for in addition to sculpture many orders for decoration were executed, including much at Hampton Court Palace, panelling and fireplaces in many country houses, the choir stalls and some of the stone carving at St Paul's, and, in the last decade of Gibbons's life, a great deal of architectural ornament and some figure sculpture for Blenheim.[57] Wren used Gibbons mainly as a decorator and not as a sculptor, for after the death of Cibber he turned to Francis Bird for the figure sculpture at St Paul's, and the fine quality of the capitals and doorways at Blenheim cut in Gibbons's shop suggests that the learning and taste of Nicholas Hawksmoor was responsible for their design. Gibbons's work as a sculptor bridges the gap between the Berninesque art of Bushnell and the mature classical-baroque of Michael Rysbrack, who began his work in England at about the time of Gibbons's death in 1721. He was lucky in having few rivals of any distinction: his large practice proves he had a success beyond his deserts.

John Nost

Though a considerable part of the work of John Nost, who was in England from about 1678 until his death in 1729, falls within the eighteenth century, his style until the very last years of his life remains, broadly speaking, linked with that of the Gibbons studio. Born in Malines, he is first recorded among the foreigners working under Hugh May at Windsor, and by 1686 was foreman to Arnold Quellin, whose widow he subsequently married.[58] Nothing is known of his training, or indeed of the date of his birth. He was to build up a good practice for himself both as a sculptor in marble and as a maker of lead garden figures. His earliest style has some reflections of the classicizing tendencies of Gibbons's later work; but he then develops a peculiar and easily recognizable form of looped, swirling drapery which is inherently Baroque. Parallels, though

not very close ones, for this manner can be found occasionally in Flemish woodwork, for instance in figures in the style of Nicolas van den Eynden on the stalls from the Abbey of Liliendal, now in the church at Vilvorde, and in some of the sculpture carried out by Arnold Quellin's brother Thomas in Denmark.[59] It is probable therefore that he had had some training in Flanders before he came to England, though since he was a native of Malines it is curious to find no echo in his work of the full Baroque tradition established there by Luc Fayd'herbe.

His earliest dateable work seems to be the monument to Sir Hugh Windham (1692, Silton, Dorset), which he was setting up at the same time as he was providing marble tables and garden figures for Lady Mary Bridgeman at Castle Bromwich Hall and for the Earl of Devonshire at Chatsworth.[60] Windham is a quiet, dignified figure in judge's robes, standing on a gadrooned base and flanked by two seated mourning ladies in smoothly treated classical dress. The figures are more restrained than their setting; for they are framed by twisted columns carrying a curved entablature from which hang loops of drapery, while above are shields, cherubs' heads, and trails of naturalistic flowers. Though the cutting is at least as competent as that of work coming from Gibbons's studio in the 1690s, the design as a whole is not entirely well integrated; and this inability to weld figures and architecture together, which gives a queer jerkiness to Nost's style, is a fairly constant factor and is matched by the abrupt angularity of some of his garden figures and of the statue of William III in Garter Robes which he made for the Royal Exchange in 1695.[61]

It seems possible that after Edward Pierce's death in 1695 Nost took over some of his commissions, including the Withers monument (d. 1692, Arkesden, Essex) and the tomb of the 2nd Viscount Irwin (d. 1688, Whitkirk, Yorkshire). A group of drawings,[62] which includes one certainly for the former, and another possibly for the latter, appear to be by Pierce; but the Irwin tomb was erected by Nost in 1697.[63] Its three figures, the viscount reclining on one elbow with his widow seated at his head and a child with a skull at his feet, do not follow the Pierce drawing exactly, and are no better integrated than those on the Windham monument. The fine relief of skulls and laurels formerly on the sarcophagus is very nearly related to that on the Arkesden monument.[64] The latter monument has also two forceful, though somewhat coarsely cut busts, a feature which, so far as is known, does not appear elsewhere in Nost's work.[65] Nost is known to have finished one of Pierce's vases for Hampton Court, and the most likely explanation of this group of works is that he took them over also, though since no monuments by Pierce are known, nor are any commissions recorded, the problem is a difficult one.

Nost's disjointed methods of composition are very clearly seen in his only signed monument, that of the 3rd Earl of Bristol (d. 1699, Sherborne, Dorset) and his two wives.[66] Here the architecture is simpler than in the earlier Windham monument, but the figures and the finely cut reliefs of laurel and palm are much more elaborate.[67] Its pattern of standing figures continues the type of Gibbons's Exton and Bottesford designs, but the central figure (Plate 43B) is in contemporary and not in classical dress. All three figures are tall and stiff; the ladies have long, narrow heads awkwardly set on their necks, the slightly grotesque effect being increased by curls piled high above the fore-

head; and their thin draperies cling very closely to the upper parts of their bodies, revealing the details of the nude forms beneath, while cloaks swirl over the hips and are bunched up in great loops at the sides, giving a strange animation to the otherwise static poses. These lively, swirling draperies are totally unlike the clinging, classicizing garments of Gibbons's figures at this time, though they could perhaps be regarded as a development of the earlier Gibbons–Quellin style, towards something more elegant, if more mannered. The two boys at the sides with inverted torches are also superior to comparable late works by Gibbons, and reflect Nost's undoubted knowledge of Duquesnoy models. The style of this signed tomb suggests that two undocumented works are certainly by Nost's hand, and probably close in date. The Sir Josiah Child (d. 1699, Wanstead, Essex) has an elaborate array of standing and seated figures; and the handling of the draperies here and on the family tomb of Sir Henry Spencer (d. 1685, Yarnton, Oxfordshire) is almost identical with that of the Sherborne tomb. Indeed, it looks as if Nost had a large practice as a tomb maker: his prices were lower than those of Gibbons, and his more animated figures may, by some patrons, have been found more agreeable.[68]

Nost's remaining documented tomb, that of the Duke of Queensberry (Durisdeer, Dumfriesshire), for which he was paid in 1711, is more puzzling, for its style is closer to his early work.[69] The whole design, possibly owing to the wishes of the patron, is conservative, for the duchess lies quietly on her back on a rolled-up mattress; and the duke, propped on one elbow, is more awkwardly designed than the similar figure at Whitkirk, made fifteen years earlier. The group of flying boys holding a scroll is, however, a new and pretty piece of decoration, and details of dress and of hair add to the richness of the whole, but there is no real fluency of design or originality of conception.

Nost was, however, much more successful on a more limited scale. The chimney-pieces in the King's and Queen's Galleries at Hampton Court Palace, one with the Car of Venus (Plate 47) and the other with an attractive bust and a charming arrangement of doves, are of high quality. The Venus relief, with its long-limbed figures, has a greater elegance than any of his other work, and suggests that he was not untouched by the revival of interest in Italian Mannerist sculpture which had occurred at Versailles.[70]

Nost's garden sculpture is more important than his tombs, and had far greater influence; for many of his moulds were still in use till at least the mid eighteenth century. For his models he turned to both Italy and Flanders, though some pieces were clearly his own inventions. At Melbourne Hall, Derbyshire, for which he was producing garden ornaments between 1699 and 1705, there is a Mercury based on the well-known figure by Giovanni Bologna, and the kneeling negro and Indian slaves supporting trays above their heads are, in their smooth slimness, an imitation of his style. The Andromeda, on the other hand, in type though not in pose seems to recall French classicism as seen, for instance, in the work of Girardon; while the Perseus (Plate 43A) has the curious angular elegance characteristic of much of the artist's work. There are also a number of little lead boys, either single figures or in pairs (Plate 46, A and B). Of the former, two at least, Cupid shaping his Bow and Cupid with a curling Horn, are directly imitated from works by Duquesnoy.[71] The pairs have a more unexpected derivation; for these little groups showing the stages of a quarrel and a reconciliation repeat the design of Annibale

Carracci's painted amorini in the corners of the ceiling of the Farnese Gallery. There is no reason to suppose that Nost had seen the original, but all the figures on the ceiling were well known in the North in engravings. Indeed, it is clear that he must have used the engravings, since the designs are reversed.[72] Other garden figures, however, have the same stiffness of pose as his tomb figures. The series which still remains at Rousham, Oxfordshire, dating from about 1701, must be from his own design, for they have the same jerky movement, the same swirling drapery, and indeed the same silliness of expression as the figures on the Digby monument. But in the same garden there is a boy on the back of a swan that must surely be derived from some antique source.[73]

Nost's last works suggest that he was not untouched by the new infiltration of classical ideas after about 1715, which will be discussed in a later chapter. His bronze equestrian statue of George I, made in 1717 for Essex Bridge, Dublin, and now at the Barber Institute, Birmingham, is largely based on the Marcus Aurelius; though the laurel-crowned king, in modern, not in Roman armour, stands almost upright in his stirrups. It is, however, in the proportions of the figure, which is much more heavily built than in the sculptor's earlier work, and also in the diminishing interest in lively decorative detail, that the change can most clearly be seen. It is even more apparent in the standing figure of George II, made for Canons, now in Golden Square. This king in Roman armour with his cloak falling behind him repeats almost exactly the type of the Charles II and the James II made some forty years earlier in Gibbons's studio in the lifetime of Nost's master, Quellin. The treatment, however, is very different, and even more different from that of Nost's own earlier tomb-figures. George II is shown as a short, thick-set man, heavily built and fully and roundly modelled. The pose is almost frontal; but though the Baroque twist of the body of the earlier royal statues has gone, the treatment of the cloak and armour is close to the heavier Baroque handling of classical models which Nost would by now have seen in the early works of Rysbrack and Scheemakers.[74]

CHAPTER 8

THE MASON–SCULPTORS

In spite of the fact that the leading Restoration sculptors liked to be thought of as 'statuaries', it is not possible (except perhaps in the case of John Bushnell) to make so sharp a distinction between their work and that of the mason–sculptors as can be made between the latter and the court artists in the reign of Charles I. Edward Pierce had a big mason's yard; and though Gibbons and Quellin did not work as masons (and were never members of the Masons' Company), the former, as has already been stated, was prepared to carry out fireplaces and architectural decoration. Moreover, though it would seem that in most cases the new types of monument (Bushnell's Mordaunt and Ashburnham tombs, or the figures in Roman dress standing by an urn which Gibbons used at Exton and Bottesford) were introduced by men who had not been trained under the English apprenticeship system, the mason–sculptors were by no means uninventive. Their contribution, however, lay mainly in giving a new twist to older patterns; and while many were prepared to follow the growing taste for marble as the most suitable material, some of them still used alabaster right up to the end of the century.

A very great body of work was indeed produced between 1660 and 1700 by men who had received their first training in masons' yards, by no means always in London, and the quality naturally varies considerably. Many of these works are dull and extremely conservative in design and may repeat the manner of Nicholas Stone well into the second half of the century. Most of them remain, and probably always will remain, anonymous. On the other hand, the leading London craftsmen were in considerable demand and their works are to be found all over the country. Their prices were no doubt lower than those of Gibbons; they were probably more businesslike than Bushnell; and their best work is competent and often very pleasing.

Nicholas Stone's workshop came to an end with the death of his son John in 1667, but the other two major yards of the first half of the century, those of the Marshalls and of the Stantons, were still active, and the latter, indeed, was to remain alive until almost the middle of the eighteenth century. Edward Marshall's eldest son, Joshua (1629–78), was, with his father who lived till 1675, much engaged on building work in the City after the Great Fire. He carried on and developed some of his father's patterns, but seems to have had less talent as a sculptor and little power of invention. The shrouded figures in his Noel monument (1664, Chipping Campden, Gloucestershire) are clumsy, with very large heads, and though the sculptor has clearly tried hard to make the drapery interesting, the task is beyond his powers. He continues his father's type of bust monument with greater success, though none of his portraits have the distinction of Edward Marshall's William Harvey. The Whatton monument (1656, Leicester Cathedral) has three busts, all frontal, set in ovals; other examples, the Crispe family tomb at Birchington, Kent, with six busts, and that with a single bust to Lady Cotton (d. 1657,

63

Conington, Cambridgeshire), though not signed, are so close in type that they are almost certainly his, and this list could easily be enlarged.

William Stanton (1639-1705), the nephew of Thomas Stanton, was a much finer sculptor.[1] He carried on the family yard in Holborn, was Master of the Masons' Company in 1688 and 1689, and acted as building contractor at Belton House, Lincolnshire, in the 1680s. The large number of his signed or documented monuments, ranging from simple wall-tablets to elaborate tombs with several figures, suggests that he must have had a thriving practice. And he was prepared to adjust his designs to the taste of his patrons. Among his most beautiful works are two altar tombs with recumbent effigies (among the last to conform to that medieval pattern), made for the Shireburns at Mitton, Yorkshire (Plate 48).[2] They were a Catholic family, no doubt retaining a strong sense of tradition; but the designs are by no means stereotyped. The draperies are handled with easy assurance, but are so designed that in spite of their naturalism, they do not detract from the peace of the figures; and the heads are sensitively cut. The last of the family monuments, which is as late as 1703, shows more freedom of invention, for the child who is commemorated starts back in horror from the skull at his feet. William Stanton's work is as a rule, however, more conservative in design, a typical instance being the tomb of the 1st Earl of Coventry (d. 1699) erected by his widow at Elmley Castle, Worcestershire (Plate 49B). The architectural frame, carried on four columns with small Virtues seated on the broken pediment, is a simple development of the mason-sculptor types of the earlier part of the century; but the bewigged figure of the earl reclining on one elbow, though not new in type, shows considerable ability in the management of contemporary dress and also in portraiture; while the large angels standing at the sides suggest that Stanton was not unaware of Gibbons's late classicizing style. They reveal, however, that while he could manage drapery with real competence, he was less assured in his handling of the nude.[3] Occasionally he attempts a more Baroque manner, as in the ecstatic praying children in twisted poses on the Saunders monument (c. 1690, Flamstead, Hertfordshire). Towards the end of his life, he was no doubt assisted by his son Edward, whose work will shortly be discussed; but his last work, the monument set up in 1704 to the 4th Earl of Leicester at Penshurst, Kent, with its two charming but slightly rustic running angels, was completed by William Woodman the Elder.[4]

Several of Wren's masons also worked as sculptors. Thomas Cartwright (c. 1617-1702) provided a timidly posed statue of Edward VI for St Thomas's Hospital, and is also known as a tomb-maker.[5] Jasper Latham (d. 1693) probably had more ability, for his much-damaged tomb of Archbishop Sheldon (1683, Croydon, Surrey) has some fluency in the design of the reclining effigy, and his lead statue of Captain Richard Maples (1683, London, Trinity House; Plate 33A) is more alive than Cartwright's Edward VI. Though it is interesting as an example of purely English work outside the field of tomb design, it does not suggest that the standard of competence was very high.[6]

The influence of Gibbons appears more strongly in decoration than in sculpture, and before the end of the century great numbers of well-designed wall-tablets, often

with elaborately scrolled cartouches backed by drapery, include the heads of winged *amorini* in his style. Nothing is known of the methods of production, few of them are signed or documented, and no pattern-books have survived. Many of them are far more agreeable than more pretentious works and they reveal that, on a limited scale, English craftsmen were able to put to good use ideas they had absorbed from foreign sources. Larger examples of the influence of Gibbons are less happy. The monument at Christ's College, Cambridge, to John Finch and Thomas Baines, erected in 1684 and signed by Joseph Catterns, of whom no other work is known, has two portrait medallions in high relief and three-quarter view, in the Gibbons manner, joined by trails of fruit and flowers; but the design lacks unity and the seated boys at the sides are notably inferior to those of artists trained in the Duquesnoy tradition.[7] Sir Christopher Wren, writing in 1694 to the Treasurer of Christ's Hospital,[8] put his finger on the fundamental weakness in English training: '. . . our English artists are dull enough at Inventions but when once a foreigne patterne is sett, they imitate soe well that commonly they exceed the originall . . . this shows that our Natives want not a Genius but education in that which is the ffoundation of all Mechanick Arts, a practice in designing or drawing, to which everybody in Italy, France and the Low Countries pretends to more or less'. Although Wren's words were heeded and a drawing master, Bernard Lens, was invited to visit the school, a long time was still to elapse before the average English-trained sculptor was sufficiently disciplined in drawing to achieve complete mastery of the human figure.

The men of the next generation, indeed, carried on the types and style of the seventeenth-century yards until almost 1730, in spite of the fact that by then new models imported from abroad were available. There is, perhaps, a greater restraint in architectural details, the twisted columns and gadrooned bases being gradually replaced by a less florid style imitated from Francis Bird,[9] but the figure sculpture coming from the masons' yards shows no marked change. Edward Stanton (1681–1734) carried on his father's business both as a building contractor and as a maker of monuments, and possibly increased the practice; for when the antiquary John Le Neve asked a number of sculptors to supply him with lists of their works for his *Monumenta Anglicana*, a survey in five volumes published between 1717 and 1719, Edward produced about one hundred and fifty items.[10] Some were his father's work, and many of his own were very modest – plain ledgers or cartouches – but there were some designs with busts and a few more elaborate tombs with life-sized figures. His signed monument to Sir William Lytton (d. 1704/5, Knebworth, Hertfordshire)[11] follows the pattern used by his father at Elmley Castle; but the cutting, though more ambitiously Baroque, is a trifle coarse. The type persisted into the next decade, for the tomb of Thomas Vernon (d. 1721, Hanbury, Worcestershire), in which Edward's partner, Christopher Horsnaile, collaborated, has a similar reclining effigy, but the flanking Virtues are cramped and feeble in design and handling.[12] Perhaps the most successful of the partnership works are unpretentious tablets, such as that to Jacob Wishart (d. 1723, Leatherhead, Surrey) surrounded by a pleasing array of naval trophies, indicating the career of the deceased. Edward Stanton was a less sensitive sculptor than his father (he never achieved the tenderness of the recumbent effigies of Richard and Isabella Shireburn); but though on the whole

conservative, he was not unwilling to attempt new designs. His bust monument of Dr Edward Tyson (d. 1708, formerly All Hallows, Lombard Street and now All Hallows, Twickenham; Plate 51A) adopts the long pattern with hands introduced by Francis Bird in his Sir Orlando Gee of 1705[13] (Plate 51B); but though the incised eye-balls and gesticulating boys give it a certain Baroque liveliness, Stanton is unable to invent a fully Baroque pose, and the work remains typically that of a craftsman rather than of an artist.

A similar awareness of Baroque handling with little understanding of Baroque design can be seen in the work of other men of the same class. Thomas Stayner (c. 1668–1731) is known as the maker of some half a dozen monuments, but may well have produced more.[14] The Dr Thomas Turner (1714, Stowe-Nine-Churches, Northamptonshire; Plate 50B) has some originality in its design of a standing portrait balanced, on the oppo-site side of the inscription, by a figure of Faith bearing a model of a circular church. Here the cutting is competent and, in the Faith, ambitiously Baroque, but the design as a whole is curiously static. Equally Baroque handling can be seen in the Sir Henry Bendyshe (1717, Steeple Bumpstead, Essex) where the limbs of the reclining effigy are lost in the broken and undercut folds of the cloak. Thomas Green of Camberwell (c. 1659–c. 1730), who had worked with Thomas Cartwright, is another ambitious but uneven craftsman. His signed monuments date from between about 1710 and 1720 and vary considerably in size and design. The Lord Justice Holt (d. 1709, Redgrave, Suffolk; Plate 49A) has a dignified seated figure, itself an unusual motive at this date, planned with some notion of contrapposto, since the turned head balances the outstretched hand. The flanking figures of Justice and Truth, however, reveal all too clearly Green's lack of academic training; for had he ever drawn a nude he would have known that women seldom stand erect with both knees bent. Comparable weaknesses in the management of limbs can be seen in the ambitious monument to the Furnese family (Waldershare, Kent), though, since here the mourning ladies are seated at the corners of the tiered centrepiece, the effect is less distressing.[15] His most successful works follow less elaborate patterns. The Richard Welby (erected 1714, Denton, Lincolnshire) and the Dr John Powell (d. 1713, Gloucester Cathedral) have standing figures in contemporary dress in architectural frames; and the Sir Peter Seaman (d. 1715, Norwich, St Gregory) a coarsely-cut half-length bust, probably borrowed like Stanton's Edward Tyson from the type introduced by Francis Bird. Nothing of Green's is the equal of Richard Crutcher's contemporary Clayton monument[16] (Plate 50A); but his work is fair proof that a man with a purely English training could produce competent monuments when he was not too ambitious. It seems improbable, however, that English sculpture would have produced much of true interest without a further stimulus from abroad.

PART FOUR

THE ANTIQUE, THE BAROQUE, AND THE ROCOCO
1714—1760

CHAPTER 9

INTRODUCTION

THE provincialism which had marred English sculpture for at least two centuries was, by about 1725, to give place to a style of far greater accomplishment. The change did not result from the example of a single artist but was due rather to a variety of causes which did not all come into operation at any precise date. These finally combined to bring about entirely new standards of both quality and taste.

English artists themselves were not unaware that facilities for training fell far below those of the Continent. The confusion of style and weakness of handling caused partly by lack of academic training have been indicated in the previous chapter, and Sir Christopher Wren's complaint that English craftsmen lacked a basic knowledge of drawing has already been mentioned. This was to be echoed by Jonathan Richardson in 1719;[1] but by then some steps at least had been taken towards the provision of better facilities by the establishment in 1711 of an Academy under the Directorship of Sir Godfrey Kneller and later of Sir James Thornhill, assisted by a Board of Directors.[2] Sculpture had a recognized place in this movement, for Francis Bird, the leading sculptor of the transition, was one of the Directors; but judging from the scheme drawn up by George Vertue for an art school in the 1720s,[3] the main function of the 'statuary' was to provide casts from which the students could draw. This, however, introduces new issues of some importance, for Vertue lists the casts which he thought desirable: 'the Gladiator. Venus. Laocoon. Hercules. Appollo [sic]. Faunus. Boys of Fiamingo or others . . .'. And he notes later in the same passage: 'There is lately brought from Italy several brass Statues finely done from Antient and Modern statues about 2 foot high or thereabouts such as would be of perpetual use in these schools . . .'. Here is clear evidence of a strengthening interest both in the antique and in the works of some 'modern' sculptors. The casts made by Le Sueur of the Gladiator (the Borghese Warrior), the Farnese Hercules, the Belvedere Antinous, and the Diana of Versailles[4] had been known and admired throughout the previous century, and other antique patterns could have been seen by a few artists in either the royal or a few private collections. But there is

little evidence that in seventeenth-century England they were freely available for study as part of a sculptor's training (though the Charles Beale sketch-books suggest that some were available to painters); or that antiques were at all widely collected. And though the group of royal figures as well as the Bottesford and Exton tombs made in the studio of Gibbons had used Roman dress, these were the exception rather than the rule. After about 1720, however, almost the only monuments showing men in their own dress are those of lawyers and divines, for gowns are ceremonial dress in their own right and outside changes of fashion. All members of the aristocracy and many professional men now appear on their tombs in Roman dress, and often, whether it is appropriate or not, in Roman armour. And further, their houses were adorned with busts in the antique manner and with reliefs copied from engravings of those on the Arch of Constantine or other famous monuments of ancient Rome; and their gardens were peopled, to a far greater degree than in the previous century, with the gods of Antiquity, copied often from Antiquity itself, or occasionally from the works of Giambologna.

This fresh turning both to sixteenth-century Italy and to Antiquity is not seen in sculpture alone, but can be very closely paralleled in the new Palladian taste in architecture. Both are, to some extent, the outcome of the increased popularity of the Grand Tour which, after the end of the long wars with France, took its place as an integral part of the education of an English gentleman. Even before 1715, however, there is some evidence that Englishmen, especially if they were of the Whig party, were showing a new concern with ancient Rome; though admittedly with its history and literature rather than with its art. Joseph Addison's *Letter from Italy to ... Lord Halifax in the Year 1701* had drawn an analogy between 'the deathless acts' of the 'old Romans' and the heroic role of England in defending the liberties of Europe; and in 1713, in his classical drama, *Cato*, he uses a Roman Republican theme as Whig propaganda against the proposed military dictatorship of Marlborough. His own comments on antique art, made very soon after the turn of the century, reveal that he was chiefly moved by the illustrations it provides to antique literature;[5] but that an interest in literature and in politics should precede an aesthetic interest is not out of keeping with the general character of English thought.

By 1720, however, an Englishman going to Italy would have looked at what he saw in a very different spirit; for he would have gained from the writings of the 3rd Earl of Shaftesbury, himself a zealous Whig, a new view of the moral value of an appreciation of works of art.[6] Shaftesbury's writings, filled with Platonic idealism, and consequently holding up the art of Raphael and Antiquity as the two patterns of perfection, are precise in their passages connecting good taste and good morals: 'Thus are the Arts and Virtues mutually friends; and thus the science of virtuosi and that of virtue itself, become, in a manner, one and the same.'[7] And he had gone further than that. He had voiced a hope, even before the end of the war with France, that England would achieve a higher position among the nations of Europe, which if it were enhanced by the virtues derived from knowledge and taste, would render Britain 'the principal seat of the arts'. Shaftesbury's works were widely read, and certainly in university circles from which the tutors of young travellers were largely drawn; and they were to be the chief source

for the writings of Jonathan Richardson the painter, which, though mainly concerned with propaganda for the establishment of a better school of painting in England, are not without interest in the history of sculpture. For Richardson, writing in 1715, just after the end of the French wars, strikes a note which must have echoed in the hearts of many Englishmen seeing the Continent for the first time:

'Whatever degeneracy may have crept in from causes which it is not my present business to enquire into, no nation under Heaven so nearly resembles the ancient Greeks and Romans than we. There is a haughty courage, an elevation of thought, a greatness of taste, a love of liberty, a simplicity, and honesty amongst us, which we inherit from our ancestors, and which belongs to us as Englishmen; and it is in these this resemblance consists. I could exhibit a long catalogue of soldiers, statesmen, orators, mathematicians, philosophers etc., and all living in, or near our own time, which are proofs of what I advance, and consequently do honour to our own country, and to human nature. . . . Greece and Rome had not Painting and Sculpture in their perfection till after they had exerted their natural vigour in lesser instances . . .'.[8]

The time, he hoped, was ripe for a better school of painters, but it was ripe also for a more informed body of patrons: 'If our nobility and gentry were lovers of Painting, and connoisseurs, a much greater treasure of pictures, drawings, and antiques would be brought in, which would contribute abundantly to the raising, and meliorating our taste, as well as to the improvement of our artists'; and: 'To be a connoisseur is to have an accomplishment which though it is not yet reckoned amongst those absolutely necessary to a gentleman, he that possesses it is always respected and esteemed on that account.'[9] Nationalism and vanity are coarser bait than virtue, but they probably caught more fish; and Richardson's new man, 'the connoisseur', was henceforth to become a familiar figure, frequently ridiculed by William Hogarth.

That there was indeed a public who wished to be informed seems clear from the immediate popularity of that vast compendium of information, the Abbé Montfaucon's *Antiquité expliquée*, which, though only published in 1719, was available in English translation in 1721, and by the appearance in the next year of Richardson's own guide book, *An Account of the Statues, Bas-reliefs, Drawings and Pictures in Italy, France, etc.* Englishmen, now well primed as to what they should admire, became avid souvenir hunters, and brought back from Italy numberless works of art, originals or copies, bought with enthusiasm if often with little discrimination as to quality. And on their return they were further willing, as will be seen, to purchase statuettes or garden figures made from models imported by enterprising artists. By 1734 the combination of con-noisseurship and the Grand Tour was to receive social recognition by the foundation of the Society of Dilettanti,[10] an exclusive club (which still exists) consisting of a small group of wealthy men, the moving spirit being Sir Francis Dashwood. Only those who had been to Italy were admitted to membership. Later in the century the Society was to play an important part in the history of English art by its active patronage of the publication of antiquities. Nor was it the only body which furthered publication. The Society of Antiquaries, after several false starts in the late sixteenth and seventeenth centuries, finally established itself in 1717 (though it did not receive its Royal Charter until 1751).[11] It was chiefly concerned with the antiquities of Britain, and its interests in the

first few years were remarkably wide, ranging from Stonehenge to an engraving made for the Society by George Vertue of the font in St James's, Piccadilly; but by the 1730s there was a marked increase in the attention given to Roman Britain. Moreover its acceptance of the supreme place of Antiquity in the world of learning is shown by its choice of a Roman lamp for the Society's device, designed by John Talman in 1718 and still in use as its seal. The Fellows themselves were, for the most part, drawn from the learned professions and could seldom afford a Grand Tour; but many of them were passionate collectors on a smaller scale, and their coins and their engravings must have provided many happy evenings for their owners and their friends and may well have given ideas to their aristocratic patrons for their tombs.

Inevitably the new enthusiasm for Antiquity and Raphael was avowedly anti-Baroque, as was Lord Burlington's reverence for Palladio and Inigo Jones. It is, however, one of the anomalies of English art that the houses created by Lord Burlington and his circle, though austere in their exterior design, have the most lavish stuccoed and painted interiors.[12] A similar ambivalence may be seen in English sculpture, though it arises from different causes. In the early years of the eighteenth century, new ideas were brought back from Rome by Francis Bird, who made at least two journeys to Italy, and after about 1709 by the architect James Gibbs, who had spent four years in the studio of Carlo Fontana. Both had felt the impact of contemporary Roman art, which was calmer and less exuberant than that of Bernini. But the change there was only relative, and as a study of the statues which between 1710 and 1718 were placed in front of the piers in the nave of St John Lateran will show, a wide variety of styles, ranging from figures with deeply undercut, broken, and tossing draperies to a smoother, more directly classical manner, was tolerated in Rome itself.[13] One clear example of the mixture of influence can be seen in England. The 5th Earl of Exeter died in France in 1700, having already ordered his tomb from Pierre Monnot in Rome. It was sent over and erected in 1704 in the church of St Martin, Stamford (Plate 53B). The earl and countess recline on their elbows in the Etruscan manner, on a severe sarcophagus, with a plain dark pyramid behind them.[14] Their heads owe much to Roman portrait busts, and their costume is also Roman. But the draperies are treated in great curling folds, and though the two fine allegorical figures standing at the sides have the severe, clear-cut features of Antiquity, their garments and indeed their poses are not treated with equal restraint.[15]

Bird, Kent, and Gibbs were all to reveal in their work this mixture of styles prevalent in Rome. The two last were, of course, architects (and Kent was a painter as well), but they are of importance in the history of sculpture as designers of monuments. Their appearance, indeed, indicates a new phase in English sculpture, for it suggests a growing awareness on the part of patrons of the necessity of good design. In the seventeenth century it was very rare for an architect to play any part: Inigo Jones's monument in the form of a Roman tombstone to his friend George Chapman in St Giles-in-the-Fields, London,[16] is an almost unique example, and Wren and his associates do not seem to have been engaged on such work. Tombs were designed in the yards of the mason-sculptors who made them, or by men such as Gibbons, whose ability, except on a small scale, was limited. The change may be largely due to James Gibbs, who had seen in

Rome that his master, the architect Carlo Fontana, himself the pupil of Bernini, had been willing to design monuments,[17] and both Gibbs and Kent may well have known that the painter Carlo Maratti had designed sculpture, including the twelve Apostles on the piers of St John Lateran (1708–18).[18] Although there is still some uncertainty about Gibbs's first patrons when he came back from Rome in 1709, he was probably fairly soon designing monuments, and between 1720 and 1740 both he and Kent were to work in collaboration with the best sculptors of the new generation, creating works which, if they seldom completely achieve the disciplined integration of concept and design which characterizes the best work of the Roman Baroque, show at least that sense of proportion and mastery of architectural detail which is often absent in English work of the seventeenth century.

The modified Baroque of Fontana's generation in Rome was not, however, the only formative foreign influence, for between 1715 and 1720 a new and more distinguished group of Flemish sculptors arrived in England. Patronage in Flanders was at its lowest ebb in the years following the Peace of Utrecht, and many Flemish artists can be traced in other countries in the early eighteenth century. Plumier, Delvaux, Scheemakers, and Rysbrack were all here by 1720, and the two last were to make major contributions to English sculpture. All had been trained in Flanders (Scheemakers had also been to Italy), and though in Flanders itself, notably in the work of Rysbrack's master Michael Vervoort, there is something of the same stilling of Baroque exuberance that has already been indicated in Rome, the whole tradition in which they had been trained was founded on the Flemish developments of the Duquesnoy school. They were to be profoundly touched by the rising enthusiasm for the antique; but they found it hard to forget either the sentiment of the founder of their school, who in Italy had been known as 'Fiammingo', or the swinging Baroque patterns of seventeenth-century Antwerp.

It is perhaps in tomb design that the combination of antique and Baroque can most clearly be seen. Elaborate architectural settings still appear, though they become less frequent as the century progresses, but the architecture itself, in conformity with the new Palladian fashion, is far more restrained. Twisted columns disappear, pediments are straight rather than curved, and though swags and trails of naturalistic flowers may often be seen in the 1720s (and in the work of Sir Henry Cheere later still), they too eventually vanish. Though, however, the architecture is more severe, the materials of which the tombs are made are often richer. White marble becomes the almost invariable rule for figures, but it is combined with coloured marbles to a degree unknown in England in the seventeenth century. Admittedly, compared with the rich colour of Italian Baroque tombs, English eighteenth-century examples are low in tone; but a variety of grey veined marbles is frequently used, and more occasionally yellow, while the pyramid, which becomes the universal background to the figures, is always black or dark grey. This form, which was to be an important controlling factor in design, seems to have been brought from Rome by Bird and Gibbs, and was much exploited by the latter. It is in itself characteristic of the confusion of sources, for while as a free-standing monument it had the authority of Antiquity (beyond the Pyramids of Egypt the Pyramid of Cestius was probably its best-known use as an antique tomb-type), it had been revived

71

as a decorative form by Raphael in his Chigi tomb in S. Maria del Popolo in Rome. The decoration of the Chigi Chapel had been completed by Bernini and his pupils between 1655 and 1661,[19] and by the end of the century the combination of figures and pyramid was a fairly frequent theme in Rome and had spread to France. Another antique motive probably introduced by Francis Bird, which was to become one of those most constantly used in the tomb designers' repertoire, was the head in profile set on a medallion, cut at the neck and clearly derived from cameos or coins, both objects dear to the collector.[20] Though, however, motives and dress echo Antiquity, tomb types do not. Many antique stelae with half-length figures cut in the round and set in a recess are illustrated in Montfaucon, but the type never appears in England. It may have been regarded as too pagan, though few eighteenth-century monuments before those of Flaxman have any marked Christian sentiment. On the other hand, the increased popularity in the 1720s of the figure reclining on a sarcophagus (a type which had, of course, been in use in the seventeenth century) may have resulted from a feeling that it had the sanction of Antiquity, since Montfaucon includes several plates of Etruscan tombs with single reclining figures.[21] In England, however, though the reclining figure is sometimes alone, it is often accompanied by a seated figure, or by standing figures at either end of the sarcophagus, for which there is no precedent in Antiquity, though some, in slightly different contexts, in seventeenth-century France and Flanders.[22] And lastly the boys of Duquesnoy are never forgotten; they hold medallion portraits, offer coronets or wreaths, or mourn the dead, but their soft, chubby bodies, and indeed the drapery patterns of the larger figures, are far removed from the smoothness and calm of the classical ideal.

The other great contribution of the first half of the eighteenth century lies in the field of the portrait bust. Portrait painting has always played a great part in the history of art in England; in the seventeenth century little else of note was produced, and in the age of Reynolds and Gainsborough English portrait painters were to equal any in Europe. But from the death of Kneller in 1723 until the return of Reynolds from Italy in 1753 the most serious and most original portraiture in England was the work of sculptors. The sudden rise to favour of the portrait bust is a remarkable phenomenon. Busts, as objects to adorn a house, had never become really popular in seventeenth-century England; and between the death of Edward Pierce in 1695 and the early 1720s no example made in England is known, though monumental busts were common enough. By 1732 Vertue records that Rysbrack alone had had some sixty sitters. It is unlikely that the immigrant sculptors created the new demand; for they were for the most part Flemings, without the strong tradition of bust sculpture common to seventeenth-century Italy and France. Their ability, on the other hand, enabled them to provide the supply. The bust, however, in whatever style, derives its ultimate authority from Antiquity, and the tendency, already discussed, of the English to regard themselves as the re-incarnation of the Romans seems sufficient to explain the sudden desire for busts.[23] This is, indeed, borne out on occasions by the way in which they were used. In the Stone Hall at Houghton the bust of Sir Robert Walpole, made in the antique manner by Rysbrack, is set over the fireplace, while other classical busts and reliefs decorate the room. It, rather

than a painted portrait, is the image of the founder of the house to be handed down to posterity, and therefore is the re-creation of the Roman ancestral bust.

Soon busts were to be the normal decoration of a gentleman's library. Sometimes they are of famous men of the day (so that many notable busts are known in several copies), or of the scholars and poets of Antiquity, based on real or faked antique portraits; but sets of British 'Worthies' – Milton, Shakespeare, Cromwell, Locke, or Bacon – were also made. Naturally the antique copies, and the busts of moderns based on antique patterns, vary considerably in type; but interest would seem to have been directed chiefly towards busts of the Late Republican period so dear to the Whigs; and the historical glamour of Marcus Brutus, Julius Caesar, and Cicero is proved by the quantity of busts in English eighteenth-century collections which, often quite unwarrantably, bear their names. Such busts were impressive owing to their strongly characterized features; they had a static, timeless air, since the eyeballs were not incised as in Late Imperial busts; but it must also be remembered that many of those that were bought, for instance by the Earl of Pembroke about 1720, did not preserve the small, severe pattern of the undraped Republican bust, but had had shoulders and drapery, usually in the form of a cloak looped across the chest and brooched on one shoulder, added by Italian restorers.[24] This form seems to have been generally regarded up to the late eighteenth century in England as the authentic standard antique pattern.

By no means all the busts made in England in the first half of the eighteenth century follow antique models, though these were chiefly favoured by Whig patrons. Many distinguished busts showing the sitter in contemporary dress were also produced, and these are Baroque or Rococo in style. Moreover, even in classicizing busts, the same ambivalence that has been noted in tomb design may be seen; for the shape and the cutting, and especially the handling of the drapery, is often nearer to the Baroque than to the antique.

All these varying factors combine to make the period from 1720 to 1760 one of the most distinguished in the history of English sculpture. The two leading artists, Rysbrack, who was here by about 1720, and Roubiliac, who does not appear to have arrived until after 1730, were men of real talent. Scheemakers was a less interesting figure, though he was competent enough, and one of his works, the Shakespeare monument of 1740, was to have a resounding success, and was, with the rising popularity of Roubiliac, to cause a marked change in Rysbrack's style. And, in addition to these leading sculptors, a number of other artists produced work of good quality. Sir Henry Cheere at his best is a finer artist than Scheemakers, and many others, Thomas Carter, William Palmer, and Thomas Adye among them, show that the general level of sculpture was high, and prove that Vertue was justified in thinking in 1730 that the reputation of sculpture was higher 'than it hath been heretofore', and that by 1738 it had made 'greater advances' than the art of painting.[25]

FRANCIS BIRD

THE leading sculptor whose career bridges the gap between the age of Gibbons and the age of Rysbrack is Francis Bird (1667–1731); indeed, in 1730 Vertue groups him with Rysbrack and Scheemakers as the sculptors whose work 'Will better support the reputation of that art than heretofore'.[1] This is perhaps rating Bird rather high; he was never so good an artist as Rysbrack, and though his best work is superior to the average of Scheemakers, his worst seems not much better than that of a mason–sculptor. This varying level is puzzling and is rendered more so by the fact that few of his works are precisely dated;[2] but it is clear that he had a large practice and must have made free use of assistants in execution. He appears to have had a good continental training, though its details are somewhat obscure. He was born in London, but was sent at the age of eleven to Flanders, where, according to Vertue, he worked under 'Cozins a statuary (who had before been in England)'. From Flanders he went on to Rome, where he is said to have worked under Le Gros (though this is impossible on grounds of date), and on his return to England, when he was either nineteen or twenty-two, he could hardly speak English.[3] He did not at first set up independently, but worked for Gibbons and then for Cibber. Nothing is really known of his work at this time. Vertue then mentions a second and shorter journey to Rome, during which Bird worked with Le Gros for nine months, but the date of this cannot be fixed, though its start may be recorded in the issue of a pass to go to Holland in October 1695.[4] If this is so, the journey as a whole may have been longer than Vertue suggests, since he himself makes it clear that Bird's reputation as an independent sculptor dates from after 1700. It would seem that Bird was again in Rome in 1711, but of this journey nothing is known.[5]

In any case it is certain that he had had better opportunities than any English sculptor before him of absorbing the art of both Italy and Flanders, and one of his earliest works (which is also one of his best) suggests that he had acquired a disciplined sense of design. The tomb of Dr Busby, the famous headmaster of Westminster School, is beyond question the finest monument of the period in Westminster Abbey. Busby had died in 1695, but Vertue dates the tomb 1703,[6] and since no documents remain there seem no grounds for challenging his statement. The doctor reclines easily on one elbow, with an open book in his other hand, while on the sarcophagus below is a relief of more books. A comparison of this tomb with that of Gibbons's Sir Cloudesley Shovell immediately reveals the superiority of Bird. The design is far less pretentious and the figure far better integrated into the whole, for it is admirably proportioned with the architectural background (instead of being dwarfed by it); the draperies fall over the mattress on which the figure rests, and so the sense of the figure conceived separately and then dumped on the sarcophagus is avoided; and the head (which was made from a death mask)[7] is finely cut. If it is seen in a good morning light, it is one of the most beautiful things in the

abbey. Another competent and probably fairly early monument is that to Thomas Shadwell, in the south transept of the abbey. Though Shadwell had died in 1692, his monument cannot have been erected until after 1700, the year in which his son, who is mentioned in the inscription, received his doctor's degree. The work, though on a much smaller scale, is more florid than the Busby, and has a bust backed by a pyramid (perhaps the first to appear in England) and framed by draperies which are gathered below to receive the inscription. The bust, broad at the shoulders and with the head turned sharply to the left, is fully Baroque. The sculptor has seized the rather gross character of the face with its thick lips, fat cheeks, and double chin and has emphasized the heavy, curving forms. The Laureate's wreath is used as a rich decorative motive; the loose shirt open at the neck and the drapery over the left shoulder echo the curving forms of the features. The cutting is much less sensitive than the Busby, but it is bold and very assured.

It was perhaps while Bird was working for Cibber that he first became known to Sir Christopher Wren. In any case, after Cibber's death Bird and not Gibbons (who as Master Sculptor to the Crown might have expected the commission) was engaged to complete the sculpture on St Paul's. His major work there was the representation of the Conversion of St Paul (Plate 53A), which fills the west pediment, and for which he was paid £620 in 1706.[8] This spirited work has not received the credit it deserves, mainly because its height makes it difficult to see or to photograph adequately, and also because it is a good deal weathered. If it is compared with Cibber's Hampton Court pediment, the value of Bird's Roman experience is at once apparent; for instead of a somewhat incoherently grouped mass of figures which are difficult to read from the ground, here the dramatic action is concentrated on the figure of St Paul, falling from his horse but throwing his head and his arms up in a strong diagonal movement leading to the vision and the rays above him, while the confusion into which the cavalcade has been thrown is clearly indicated by the rearing horses on either side. The central incident is in very strong relief – indeed the foremost figures are almost in the round – while at the corners of the pediment the landscape setting is kept relatively low and so does not distract the eye. Bird had clearly studied Roman Baroque pictorial sculpture to good effect, and also probably Bernini's Constantine statue and perhaps even his sketch, which had remained in Rome, for the equestrian statue of Louis XIV, for his rearing horses, especially those on the left, seem to owe much to these models. No other sculptor working in England at the time could have conceived so daring and so dramatic a design, or could have carried it out with the necessary boldness. But it, like St Paul's itself, soon fell out of fashion, and Horace Walpole was only voicing general opinion when he slightingly re-marked: 'Any statuary was good enough for an ornament at that height, and a great statuary had been too good.'[9] The reliefs round the west door, which illustrate scenes from the life of St Paul, and which were not cut until 1712/13, are less successful; their designs are weaker and the drapery patterns confused; and though the figures on the parapet of 1720–3 seem to have had some variety of pose, they are now much weathered, or are later replacements. The worst of Bird's works at St Paul's is the monument to Jane Wren (d. 1702) in the crypt. It is a relief of St Cecilia (referring to the girl's love of music), but though it is in the full Roman manner, it is grotesquely immature. It is

G

indeed hard to explain how a man who could create the Busby and who had the ability to understand the requirements of pediment sculpture, could have produced so childish a work. The statue of Queen Anne, surrounded by figures of England, Scotland, Ireland, and France, which stood in front of the cathedral must, however, have been a much more successful affair, and probably brought the sculptor considerable prestige. It is now unfortunately represented by a poor nineteenth-century copy;[10] but engravings of the original suggest that Bird had succeeded in giving some imperiousness to the dumpy figure of the queen, while the supporting figures appear competent if not very striking in design. Variants of the queen's figure were evidently ordered: one, much clogged with paint, is in the market-place of Kingston-on-Thames, Surrey, and another was given to the town of Minehead, Somerset, by its Member of Parliament, Sir Joseph Banks, in 1715. In the latter case neither the dress nor the pose exactly repeat that of the St Paul's figure.

By the time he had finished the Queen Anne Bird had, with the painters Thornhill, Laguerre, and Richardson and other artists, been chosen as one of the Directors of Sir Godfrey Kneller's Academy; and he had probably also received a number of commissions for monuments, though the date of their erection is admittedly uncertain. The Mrs Fitzherbert (d. 1699) at Tissington, Derbyshire, has a somewhat mechanical bust, and the Sir Orlando Gee (d. 1705; Plate 51B) at Isleworth, Middlesex, a half-length figure holding a scroll, the latter being a type new to England, but doubtless an adaptation by Bird of the Roman Baroque monument showing a figure with hands exploited by both Bernini and Algardi.[11] Here great play is made with the rich curling wig and the enveloping cloak, while the modelling of the features is close in style to the Shadwell. The tomb of the first Duke of Bedford at Chenies, Buckinghamshire, though apparently undocumented[12] and much less influential, must have been one of the largest tombs yet made in England. Amid a great display of coloured marble architecture, the duke and duchess are seated, he in Garter robes, but she mourning their son Lord William Russell, who had been executed for supposed complicity in the Rye House Plot in 1683. His portrait, in the three-quarter view common in the late seventeenth century, is set in a large medallion above, beneath draped curtains, while at the sides are eight smaller medallions with portraits of the other children. These, however, depart from the seventeenth-century pattern, for they are shown in profile, cut just below the neck in the manner of antique coins; though their freely treated hair and the loose draperies at the base of the necks are not antique. The whole is, inevitably, a little pompous, and the figure of the duke, leaning stiffly back in an immensely supercilious attitude, begins to show the weaknesses which were to appear in Bird's later work. Not only is the pose itself unconvincing, but the drapery treatment, for all its richness, has become rather mechanical. The folds lack variety; they are flattened and follow each other in parallel lines or loops, and though the rhythms on which they are planned are Baroque, they have none of the liveliness derived from an unexpected pattern of light and shadow which is one of the basic characteristics of good Baroque sculpture. The same mannerisms appear in two tombs with reclining figures, the Archbishop Sharp (d. 1714) at York and the Dr Robert South (d. 1716) in Westminster Abbey.

Two other monuments made by Bird for the abbey in the second decade of the eighteenth century are of greater interest, for both herald new types.[13] The Admiral Henry Priestman (d. 1712) has a tall pyramid background, with a medallion, showing the profile head strictly *all'antica* (cut short at the neck with no drapery), hanging on a ribbon tied to a nail. This motive was to be freely and much more elegantly used later in the century. Bird's design is clumsy; for the base of the pyramid is confused by piles of naval trophies, recalling Dutch rather than Italian monuments and cut with a coarse realism which seems out of keeping with the classical style of the head. The Dr John Ernest Grabe (d. 1711; Plate 52) in the south transept is much more impressive. The doctor, in Geneva robes, sits reading on a fine curved marble sarcophagus; on one side is a pile of books and on the other a lamp. The whole is set on a shelf supported by consoles, and since no record can be discovered to suggest that it has been moved, it was presumably always, as now, without any form of background. Although the draperies have many of the repeated flattened folds that have already been indicated as characteristic of Bird's later work, there is also a bigger mass of crumpled drapery over the lap, giving variety and materially assisting the design, and the figure as a whole is finely conceived. The question must be asked, though it cannot unfortunately be answered, how far in these two works Bird was influenced by James Gibbs. Profile medallions tied to pyramids by ribbons and figures seated on a sarcophagus appear among his published designs for monuments; and though these did not appear in book form until 1728,[14] several of them are identified, and at least one of them (that for John Sheffield, Duke of Buckingham) must have been made before 1720. Gibbs must have known Bird as early as 1711, for he was one of the electors who chose the Directors of Kneller's Academy and it is likely, since both men knew Rome, that they had made friendly contact. It is perhaps also revealing that while the Busby, which was certainly made before Gibbs's return from Rome about 1709, is set on a square base with a gadrooned top (continuing the Gibbons tradition), Bird's tombs of the second decade, the Archbishop Sharp, the Priestman, and the Grabe, all have sarcophagi, either curved or straight-sided and set on feet, types which were to reappear frequently in the designs in Gibbs's *Book of Architecture*.[15] On the other hand, the possibility of a common source, namely Rome, cannot be excluded, and Bird might well have gathered new ideas during his visit of 1711. His commitments at St Paul's, however, cannot have allowed him to be away for very long, and it would be a little odd if this journey had made a deeper impression than his earlier and longer visits. The number of precise links with Gibbs, indeed, seem to point to some fairly close association between the two artists.

By about 1720 they were certainly working together on the best known and most controversial of Bird's works, the monument to John Holles, Duke of Newcastle, commissioned by his son-in-law, that great patron Edward Harley, Earl of Oxford, and erected in 1723. Harley had, indeed, also been the patron for the monument of Dr Grabe.[16] The large Newcastle tomb, which stands just inside the north door of Westminster Abbey, was designed by Gibbs and executed by Bird.[17] The great architectural frame, supported by Corinthian columns, is rich with coloured marbles and is designed on a curve. On a dark sarcophagus and against a dark pyramid the duke, in modern

armour with a cloak wrapped round him, reclines with a baton in one hand and his coronet in the other. His head is silhouetted in sharp profile against the dark background as he looks up to one of the two angels seated on the pediment. Beyond the columns stand figures of Wisdom and Sincerity. The design is a good deal finer than later critics would allow, though it is now so much cramped by more recent monuments that it is difficult to appreciate its grandeur: the sculpture, however, is more timid than the architecture. The main figure is carefully designed as a big triangular mass, with the baton, the folds of the cloak, and the coronet forming a diagonal to counteract the main axis. But the cutting is coarse, and the appearance of the head with its double chin rising above the stiff gorget is almost grotesque. Newcastle's features would perhaps have looked more ducal if not seen in profile. The two Virtues are more static in pose and in the treatment of their draperies; they have fine antique features and make a somewhat uncomfortable contrast with the over-animated ducal figure. But if they are compared, as inevitably they must be, with the very similar figures that Scheemakers and Delvaux were to execute within ten years for the monument to Dr Hugo Chamberlen in the north choir aisle, it becomes clear that Bird was only able to pay lip-service to Antiquity and that he had not given the same careful attention to the fine variations of antique drapery treatment, nor had he an equal control of the forms beneath it. Scheemakers (who seems to have been a disagreeable man) had worked for Bird soon after he first came to England, and was to be very scathing about the Newcastle monument, for he 'told his Lordship to his face that in that magnificent monument there was indeed a great deal of fine marble which was well, but there was such figures that disgracd it, that to do right, his Lordship should take them away'.[18] No doubt he would have liked the chance of replacing them.

During the last decade of his life Bird seems to have carried out relatively little work. The new immigrants were much to the fore (Bird lost the commission for the Kneller monument to Rysbrack),[19] and though he had undertaken a fair amount of work, partly under the patronage of Harley, in the way of standing figures at Oxford,[20] these also came to an end. He inherited money from his father-in-law and seems to have had a considerable business as an importer of Italian marbles.[21] There is, however, one attractive late work in Westminster Abbey, the monument in the nave to the dramatist William Congreve (d. 1729) set up by Henrietta, Duchess of Marlborough. Above a finely designed sarcophagus in the manner of Gibbs, on which are piled emblems of the theatre, is a large oval medallion with a half-length figure of the dramatist. Bird has here abandoned any attempt to cater for the new taste for Antiquity, and has based his figure on Kneller's portrait in the Kit-Kat series (N.P.G.). It is not, perhaps, very sensitively cut, but the design as a whole is extremely successful, and with the Busby, the Shadwell, and the Grabe (rather than the more pretentious Bedford and Newcastle monuments) makes it possible to understand Vertue's high opinion of the artist.

THE FIRST FOREIGN IMMIGRANTS

THE foreign artists who were to do so much to transform the character of English sculpture between 1715 and 1730 came for a number of different reasons, some of them still obscure. It is, however, certain that the two who seem to have arrived first, Denis Plumier and Giovanni Battista Guelfi, were invited by English patrons. The former in all probability brought assistants with him, and therefore played an important part in the creation of the new style. Guelfi, on the other hand, worked alone, and though one of his monuments was to prove extremely influential, he was neither to establish a school, nor to be followed by other Italian sculptors.

Denis Plumier or Plumière (1688–1721), an Antwerp sculptor,[1] arrived about 1717 at the suggestion of Lord Cadogan, who had played a considerable part in Marlborough's wars and had shared his exile in 1712. Plumier evidently had some success, for before his early death in 1721 he had snatched from Gibbs the important commission for the tomb of John Sheffield, Duke of Buckingham, in Henry VII's Chapel. Gibbs's design[2] shows the duke reclining (or rather uncomfortably slipping forward) on the top of his sarcophagus, while the duchess, seated behind him, points to a tablet held by a boy. Two standing Virtues, very similar to those on the Newcastle monument, are at the sides, and the whole is backed by a pyramid with flaming urns. It may be that this design, with its four large figures, proved too expensive, or perhaps the complex base and pyramid were thought too elaborate. Plumier's design with three main figures is less coherent (Plates 54B and 55). The duke, bare-headed and in Roman armour, reclines propped on one elbow; the duchess, her hand to her head, sits at his feet and looks at him in yearning; above them, on a shelf supported on a console, is a fine figure of Time, who carries medallions with profile portraits of the children, helped by one boy, while another mourns. Although the reclining figure had been common enough in England before this date, the treatment here is entirely new. A close parallel can, however, be found in Coysevox's tomb of the Marquis de Vaubrun (Château de Serrant, Maine-et-Loire), probably made about 1680.[3] Here, too, Roman armour is used (though the marquis wears his curled wig) and his widow sits mourning at his feet. No similar tomb with two figures appears to have been made in England before the Buckingham, and the resemblance, which is strengthened by the use of a disconnected figure above (in the Vaubrun it is not Time, but a flying Fame), seems too close to be accidental. Either some Flemish artist working in France had brought a drawing back to Antwerp, or else Buckingham's widow, who was an illegitimate daughter of James II, had obtained a description of the French tomb. Unfortunately Plumier was only able to make the model before his death, and the Time was cut by Laurent Delvaux and the rest by Peter Scheemakers (who may possibly have been among 'the workmen' said by Vertue to have come over with Plumier and his family). The style of the figures may therefore be

partly due to them, but the design of the Time, a figure new to English sculpture, and one who does not appear again until the mature works of Roubiliac, when he is handled very differently, is very closely linked with Plumier's signed works in Flanders, and especially with his tomb of Philippe Spinola (d. 1712) in Notre Dame de la Chapelle at Brussels.[4] This tomb and his fountains with river gods and boys (signed and dated: 1715) splendidly modelled in the Duquesnoy tradition, in the courtyard of the Hôtel de Ville at Brussels, suggest that his early death deprived England of an able sculptor.[5] As it is, his importance chiefly lies in his establishment of a workshop which attracted other Flemish artists who were themselves to become leading exponents of the new manner.

The other artist who was definitely invited to England was a man of very different character, of whom, no doubt, high hopes were entertained. Giovanni Battista Guelfi (fl. 1714-34) was brought from Rome by no less a patron than the Earl of Burlington.[6] He had been trained by Camillo Rusconi, the friend of Carlo Maratti and the pupil of Ercole Ferrata, in whose work Algardesque and Berninesque trends are combined. Rusconi's style might well have attracted the young Burlington on his first visit to Rome, before he had become so passionate a Palladian, and it would almost certainly have been admired by William Kent, who had spent some time in the studio of the Marattesque painter Luti, but who was at heart a Baroque artist. Rusconi's pupil lacked, however, the accomplishment of his master, and was in the end to prove a tiresome encumbrance to his patron. Burlington brought Guelfi to London about 1715 and was to instal him as one of the circle living at Burlington House. Quite soon, however, perhaps because of Burlington's second journey to Italy, his sculptor was being employed by the Earl of Pomfret to restore the Arundel Marbles (part of the collection of antiques made by the 1st Earl of Arundel and subsequently given by the Countess of Pomfret to the Ashmolean Museum, Oxford). He possibly also made the busts of the earl and countess which went to Oxford with the marbles.

Guelfi's most important work is the monument erected in 1727 to James Craggs, one of the Secretaries of State (d. 1721), in the nave of Westminster Abbey (Plate 54A). Craggs had been a friend of Pope, who wrote his epitaph, and it was doubtless because of Pope's connexion with Lord Burlington that Guelfi was chosen as the sculptor. The design, however, was made by James Gibbs (two drawings are in the V. and A.), a clear proof of the prestige of Gibbs as the leading designer of monuments in the first half of the 1720s. Since Guelfi had never seen Craggs, he worked from 'two paintings and a print' which are referred to in a letter from Pope written, probably in July 1724, to one of Craggs's sisters, but there seems some doubt as to whether he achieved a good likeness.[7] He and Gibbs did however achieve a monument which was both new and striking and which was to promote a lasting fashion. Craggs is standing cross-legged, leaning on a large urn; his head, with long hair to his shoulders, is slightly raised and turned and, to balance the pose, the right arm is bent, resting on the hip. The figure was set against a pedimented background, but it has now been moved; it is set too high and the background has gone. The dress is indeterminate; it can be rightly described neither as antique nor as contemporary, though the former was undoubtedly in the sculptor's

mind. But the muffling cloak is planned on a series of diagonals that echo or counter-balance the diagonals of the crossed legs, and though the folds are flat, they are larger, heavier, and more varied than in antique prototypes. Indeed, in the free use of diagonals, as well as in the drapery treatment, the work reflects the Late Roman Baroque background of both artists. The pose itself, which was to be used frequently by other sculptors later in the eighteenth century,[8] is probably an adaptation from one of the cross-legged statues of Antiquity, several of which are illustrated by Montfaucon, and would probably have been known to both Gibbs and Guelfi in the original.[9] The monument is something of a landmark in English art, for the pose was to be taken up by painters as well as sculptors; but though it is distinguished in design, it is, like all Guelfi's work, more than a little dull in cutting.[10]

It probably brought him two further commissions, for the monument designed by Kent to the Hon. Thomas Watson Wentworth (d. 1723) in York Minster and for that to Addison's stepson, Edward, 7th Earl of Warwick and 4th Earl of Holland, in St Mary Abbots, Kensington.[11] Guelfi was paid £100 for the latter in 1730. The York monument had a pyramid background which has now disappeared, and again uses the motive of a figure leaning on an urn, though in this case there is a seated female figure as well. Both are somewhat wooden in pose, and both show the awkwardness in setting the head and neck into the shoulders which was to be so marked a characteristic of Guelfi's busts. The drapery of the standing figure is, however, more vigorous and more Baroque in its broken folds than that of Craggs. The Kensington monument also uses an urn, but here the figure is seated, and, though competent, is not very lively.

A small number of monuments with busts are also from Guelfi's hand. Of these, the most interesting is that to Anne, Duchess of Richmond, of 1734 at Deene, Northants; for the frame, which was cut by John Boson or Bossom, is almost identical with the frontispiece of Lord Burlington's publication *Fabbriche Antiche disegnate da Andrea Palladio* (1730), the design of which by William Kent is said to have been based on a drawing by Palladio himself. The bust, the terracotta model for which is in the Victoria and Albert Museum, is smoothly and roundly modelled, the forms being much generalized; the same characteristics appear in a group of monuments, all with busts, made under the will of Katherine, wife of the 6th Earl of Westmorland, to her parents, Thomas and Katherine Stringer, at Kirkthorpe, Yorkshire; to her first husband, Richard Beaumont, at Kirkheaton, Yorkshire; and to Thomas Stringer, a distant relative, at Enfield, Middlesex. The first was designed by Kent, though Rysbrack, who was also consulted, did not care for the design. All Guelfi's portraits have the same long faces, large-featured, haughty, and slightly horse-like – in fact, to an Italian, the typical English face. He was, indeed, much inferior as a sculptor to Rysbrack, and though he began a series of busts for Queen Caroline's Grotto at Richmond, and apparently executed those of Locke, Newton, Wollaston, and Clarke, only the last was in fact set up, and the others were replaced by busts on the same pattern executed by Rysbrack.[12]

In spite of the fact that Guelfi was brought to England by Lord Burlington, presumably to work for him, little such work has been identified, though he may well have been concerned with the statuary for the gardens of Chiswick House. It is clear, how-

ever, that by the time he returned to Italy in 1734, he had outstayed his welcome, for Vertue records him as: 'a man slow of speech. much opiniated. and as an Italian thought no body coud be equal to himself. in skill in this Country. Yet all his works seem to the judicious very often defective. wanting spirit and grace. its thought that Ld. Burlington parted with him very willingly'.[13]

MICHAEL RYSBRACK

A FAR more interesting and distinguished figure is Michael Rysbrack (1694–1770), who was to spend about fifty years in England.[1] He was beyond question the leading sculptor between 1720 and 1740, setting a standard which his rivals failed to reach during these years. He was inherently a more talented artist than any sculptor who had worked in England since the visit of Torrigiano in the early sixteenth century; and he evolved a style which combines many of the best features of Late Baroque sculpture with the classical elements so attractive to his English patrons. He was also an extremely fine portraitist, with a strong sense of character and a ready invention, his contribution in this field being of especial importance. His work presents a singularly coherent and impressive picture; and it will therefore be well to consider it first, and then return to that of Delvaux and Scheemakers, even though they arrived in England slightly earlier.

Michael Rysbrack was born in Antwerp in 1694 (he was baptized John Michael, but seems never to have used his full name), and was one of the younger sons of a landscape painter, Peter Rysbrack, who had worked in England in the reign of Charles II, but owing to the outcry against Papists at the time of the Rye House Plot in 1683, had gone to Paris with the French painter, Nicolas Largillierre. Having married in Paris, he returned to Antwerp after about four years, and lived in Flanders until his death in 1729. All his sons were to become artists, and one of his nephews, Jacques Verbrecht or Verbecht, was to decorate rooms for Madame de Pompadour.[2] Michael therefore grew up in a circle immediately concerned with the arts, linked with countries beyond Flanders. He was, moreover, almost certainly apprenticed from 1706 to 1712 to a man who had travelled, the distinguished Antwerp sculptor, Michael Vervoort or Van der Voort,[3] who is said to have spent some ten years in Rome. Vervoort's style, which in its maturity can best be studied in the two tombs of the Precipiano family in the cathedral at Malines, is notable for its frank return to the manner of Duquesnoy. The Baroque art of Flanders, which can be seen at its most distinguished in Fayd'herbe's tomb of Bishop Andreas Creusen (c. 1660) in the same church immediately opposite that of Bishop Humbert Guillaume de Precipiano (1709),[4] has in the latter been completely rejected in favour of a calmer style which suggests that Vervoort had studied the antique as well as the works of Fiammingo. On the other hand, his portraits have a detailed realism, and his bust of van Caverson in the Musée Royal at Brussels, though un-Baroque in form, since it is very long (almost in fact, to the waist) and rather narrow, shows in the thickly folded drapery falling forward from the torso, the emphasis on the curling patterns of the long heavy wig, and in the general design with the turned head balanced by the loop of the drapery, an understanding of and sympathy with some at least of the principles of Baroque design. Rysbrack's work was also to show a duality of influence; much of it,

indeed, is more Baroque than that of Vervoort, whereas on other occasions it seems even more immediately dependent on the antique.

By 1714 Rysbrack's name appears as a Master of the Guild of St Luke at Antwerp, but no work by him is known before he came to England, where he apparently arrived about 1720. According to Vertue he had an introduction to James Gibbs, and certainly was to be associated with him for some years; but he may also have had other recommendations. It is likely that the large bust of the Duke of Marlborough, now high up in the hall at Blenheim, had been made by Vervoort,[5] and since one of Rysbrack's earliest dated works in England is a bust of Marlborough's son-in-law, the Earl of Sunderland (1722), also at Blenheim, it is possible that he brought an introduction to the family. He was certainly to execute much work for them.

He seems almost immediately to have received important commissions. By 1723 he had executed a large relief over a fireplace at Kensington Palace, in one of the rooms then being redecorated by William Kent; the monument of Matthew Prior in Westminster Abbey from the designs of James Gibbs; a distinguished bust of Daniel Finch, Earl of Nottingham (G. S. Finch Collection); and, in addition, he had snatched the commission for the monument to Sir Godfrey Kneller from Francis Bird. It was a formidable achievement for a young foreigner, for it meant that, though he was associated with Gibbs and Harley, and consequently with the Tory party, he was also, in his work at Kensington, accepted by the Whig Lord Burlington, who was by now assuming his position as an arbiter of taste. And his success with Kneller, who approved the design of his monument before his death, shows that he was able to please the foremost painter in England. He was, indeed, always to get on well with his fellow-artists; he was the only sculptor in the 1730s to be a member of St Luke's Club (a dining club whose history goes back to van Dyck), and Vertue seems to have liked him better than any of the other foreigners.

The relief at Kensington Palace[6] is of a Roman Marriage (Plate 58A), and is based on an engraving by Santi Bartoli in Bellori's *Admiranda Romanorum Antiquitatum* (Plate 58B) of a relief in the Palazzo Sacchetti, Rome. Rysbrack, of course, had not been to Rome and therefore could not have known the original. Though, however, he is drawing directly upon an antique source, the modifications, perhaps unconscious, which he makes are very revealing. Compared with the engraving his figures are fuller and broader, the heads of the bride and bridegroom incline towards each other, charging the group with a stronger emotion, and the lines of the linking arms are slightly changed. The curves of draperies are much more pronounced, especially in the female figure, and the edges more broken; the whole mood is, in fact, far more Baroque. The Prior monument in the south transept of Westminster Abbey (Plate 56) also has antique and Baroque elements, and shows, even more fully than the Kensington relief, Rysbrack's Flemish training. The architect, James Gibbs, was designing a setting for the brilliant bust of Prior made about 1700 by the great French sculptor Coysevox (Plate 57), which shows the poet *en negligé*, turned sharply to the right, with his shirt open at the neck and a folded cap on his head.[7] This was set on a dark sarcophagus against a blue-grey marble background surmounted by a pediment on which recline two boys,

richly modelled in the best Flemish tradition, one holding an hourglass and the other an extinguished torch. Below stand two Muses, one with a recorder and one with a book. These two slenderly built female figures have finely cut classical heads with rather small features, slightly open mouths, and richly dressed hair. These heads are extremely close in type and handling to those of the Four Continents which support the pulpit made by Vervoort about 1713 (just after Rysbrack had left his studio) for the cathedral at Antwerp. But whereas the garments of Vervoort's figures fall in almost entirely vertical folds and the figures themselves are relatively static in pose, Rysbrack's Muses are planned with a strong contrapposto, their bodies turning outwards and their heads inwards, looking towards the bust, and the cloak of the figure on the right, swinging round her hips, stands away from her body in deep folds which double back into little curling edges. The sculptor is not here following exactly the architect's design,[8] but is indeed improving it, for his figures have far more animation, an animation which is achieved by the use of more ample and more sensitive curves (this is very marked in the poses of the two boys) and by allowing the drapery a freer play in the pattern of the figures. There can be no doubt that the monument owes much to the execution, but the sculptor's reward was meagre, for he complained to Vertue that though Gibbs had from Lord Harley, who erected the monument, a hundred pounds for each figure, he only gave Rysbrack thirty-five pounds apiece.[9]

The impression made by Coysevox's bust of Prior on Rysbrack can be seen in his Kneller monument. The painter, who took a deep interest in his own monument, and who rejected Francis Bird's design in favour of one of his own,[10] had wished it to be set up in Whitton church, near Twickenham, Middlesex, where he is in fact buried. The conspicuous place he wished it to occupy (he was a very vain man) was however already taken for a monument to Pope's father, and Rysbrack's work was therefore in 1730 erected in the nave of Westminster Abbey. On a curved base above a tablet, which bears an epitaph written by Pope, a bust of Kneller is placed between two boys, one of whom holds a medallion portrait of Lady Kneller. The bust shows a handsome, vigorous man in middle age (Kneller was over seventy when he died), with the head thrown up and back in a commanding gesture. The pattern is that of the Prior, *en negligé* with a loose cap. It is, however, much wider and less compact, with drapery falling over the chest in looser folds, and curling round over the cut arms. Its bold Baroque character might well have appealed to Kneller; but it forms a striking contrast with the other important bust made by Rysbrack during these years, that of Daniel Finch, Earl of Nottingham (Plate 59A).

The Nottingham is perhaps the most important of these early works of Rysbrack; and since it is a landmark in English sculpture (and indeed probably unique in the Europe of its day) it is worth examining it in some detail. There can be no doubt that it is a novel and deliberate attempt at portraiture in the Roman manner, and that it is at first sight both convincing and successful. The noble but individual features, the close-cropped hair arranged in small waves which do not break the outline of the skull, the loose undergarment, and the cloak brooched on the right shoulder are all derived from Roman models. The head, which is almost frontal and in which the eyes are not incised,

must be inspired by a Late Republican bust (possibly a Julius Caesar),[11] while the general pattern of the drapery is closer to that more normally used in Late Imperial busts. A closer inspection, however, reveals many departures from the antique in Rysbrack's work. The form of the bust, with its long concave curves below the arms, is not derived from Antiquity, and may be an echo of the long form still being used for busts in Rysbrack's youth by his master, Vervoort.[12] Nor is the drapery treatment, with its deeply undercut folds standing away from the body, a close imitation of Antiquity, but is still Baroque in feeling. Most interesting of all, perhaps, is the treatment of the features. A few years before this bust was made, Kneller had painted the sitter in three positions, possibly for the use of a sculptor.[13] This portrait (N.P.G.) shows that Nottingham had a domical head, that the line of his jaw ran sharply down from his unusually large ear to his chin, and that though he had a fine aquiline profile, his features were less nobly proportioned than in the bust. Rysbrack has improved the shape of the head, the angle of the jaw, and the shape and position of the ear, and given a greater dignity to the face. Moreover, if his portrait is compared with any antique bust, it is quickly apparent that instead of the generalized, reticent, and often flattened surfaces, his forms are full and rounded and within the area of the cheek a play of curve against curve is stressed. In it there is therefore a combination of the lofty idealism and the veneration of Antiquity advocated by Shaftesbury with a richness of pattern and a fullness of form derived from the sculptor's Baroque background.

It is not surprising that the maker of this bust was to build up so large a practice for portrait busts (Vertue lists more than sixty which had been made by 1732);[14] for his ability to seize a likeness and to give it distinction and vitality was far beyond anything that had yet been seen in England in his own art, and noticeably greater than that of the portrait painters who succeeded Kneller. Many of the busts exist in two versions; for it was Rysbrack's practice to make a terracotta model, if possible from the life, and to cut the marble from it.[15] Some of the busts on Vertue's list seem, when he saw them, to have got no further than the model; in other cases he specifies: 'a marble'. Sometimes, too, more than one marble was made from a single model, generally with slight variations; for instance the bust of the Duke of Marlborough, laurel-crowned and in Roman armour, which was presented to Oxford by the duchess in 1730 and is now in the Ashmolean Museum, is repeated with variations in the armour, at the National Portrait Gallery, at St Giles's House, Dorset, and in the Duke of Northumberland's Collection. The repetitions are perhaps workshop pieces; for good though they are, the modelling is slightly more mechanical; small changes have been made in the proportions of the features, in the lively design of the laurel crown, and above all in the eyeballs, which are incised in the Oxford bust, but blank in the others, all of which make the repetitions more of an ideal portrait.

Vertue's list makes it clear that Rysbrack's patrons were very varied. There are royal portraits: George II from the life (terracotta, signed and dated 1738, and marble, signed, both at Windsor); George I, not from the life, and an obviously idealized head with the White Horse of Hanover on his breast-plate (Christ Church, Oxford); and Queen Caroline (terracotta, signed and dated 1738, and marble, signed, both at Windsor, and a

further signed marble in the Wallace Collection) which, though not done from a formal sitting,[16] must have been created from frequent memories of the queen's face. It is, indeed, one of Rysbrack's most tender and penetrating portraits and though, as in much of his work, the features may well be a little improved, it is nevertheless an unforgettable image of a distinguished woman. There is the bust of the Prime Minister, Sir Robert Walpole: 'a large head, broad face', the marble version of which stands over the fireplace of Sir Robert's great house at Houghton, Norfolk, while the terracotta is in the National Portrait Gallery (Plate 86B). This follows the same pattern as the Nottingham, with the same ambivalence between the treatment of the drapery and that of the head, though there is a further concession to actuality in the appearance of the Garter Star carved on the cloak. There are many other aristocratic portraits, the Marlboroughs, the Argylls, the Duke of Kent and Lord Orkney,[17] and the enchanting little Lady Margaret Harley. But there are also many of professional men: the Rev. Dr Harbin at Longleat (Plate 62A), bland in his short curled wig, and the splendid terracotta (signed and dated 1728) of an unknown clergyman in surplice and bands, but with a soft cap (V. and A.). More interesting still are the writers and artists, though many of these including the William Kent and the Thomas Ripley (both members of Lord Burlington's circle) cannot now be traced. The James Gibbs (signed and dated 1726; Plate 59B) at the church of St Martin-in-the-Fields[18] is of special interest since it is an early work, only some three years later than the Nottingham. It is a shorter, wider bust, far less antique in inspiration, and though the dress is informal, the full curling wig is a splendid setting for the arrogant face. This must have been a highly satisfactory portrait to the sitter, for it shows him as handsome and assured, with a far greater firmness in the mouth than is to be seen in the painting by J. M. Williams (N.P.G.). Even more memorable is the marble bust of Alexander Pope (dated 1730; Plate 60) belonging to the Athenaeum Club, London. Again the conventions used are a combination of the Baroque and the classical, but they are here welded into a whole of great beauty. The high intellectual character of the sitter is conveyed with compelling force: this is Pope at his most noble and least frail. There is no sense of the crippled body, but only of the fine mind. Far more frankly Baroque is the superb terracotta of Sir Hans Sloane (B.M.; Plate 62B). This is a trifle later than the busts so far discussed, since it was almost certainly a life-study for the statue of Sloane erected about 1737 in the Physic Garden at Chelsea. The sharp turn of the head, the long curling wig (sketched with the utmost brilliance), the elaborate lace cravat, and the tassels on the shoulders of the gown give it a richness of surface and a liveliness of movement rare in Rysbrack's work. Moreover, the face is handled with detailed realism; the lifted eyes are incised, the wrinkles at their corners carefully studied, and the sensitive mouth is full of expression. Here Rysbrack almost seems to anticipate the greater naturalism of Roubiliac. In the full-length statue at Chelsea the Baroque elements are muted, for though the turn of the head is exactly repeated, the pose as a whole is static and frontal.[19]

So far, only the busts of Rysbrack's contemporaries have been considered, but Vertue's list also includes many of men he could never have seen: the Black Prince and Oliver Cromwell; Milton, Spenser, and Ben Jonson; Michelangelo, Palladio, and Inigo

Jones. Such busts, and others of 'British Worthies', were greatly in demand for the adornment of grottoes or garden buildings, or for the decoration of libraries, and reflect the growing sense of the glory of England's past of which William Kent's painting of the Battle of Crécy (Windsor) is an early expression. The many engravings of English antiquities, published by the Society of Antiquaries, and the extremely popular prints from designs by Francis Hayman, published in 1751, illustrating Rapin's *History of England*, are further examples of the same trend. By the middle of the century, this nostalgic interest in the past was to find its greatest exponent in Horace Walpole, with his passion for 'the true rust of the Barons' Wars'; but the Temple of British Worthies at Stowe, for which by 1732 Rysbrack had made busts of Queen Elizabeth I, Bacon, Shakespeare, King William III, Locke, Newton, and Milton,[20] represents an early phase of the same movement.

The Palladio and the Inigo Jones are, on the other hand, linked with a different aspect of English art; for they represent the two great heroes of Lord Burlington's circle. The busts were almost certainly created for him, probably before 1727. The marbles now at Chatsworth came from his collection, but several other versions of the Jones are known. Here it is possible to be sure of the sources used by the sculptor, for the Palladio is based on an engraving used by Lord Burlington as the frontispiece of his publication *Fabbriche antiche disegnate da Andrea Palladio* (1730), while the authority for the Inigo Jones was the portrait by van Dyck.[21] In both cases Rysbrack has transformed a two-dimensional portrait into his three-dimensional art with great skill, and thereby proves that, given some visual authority for a likeness, he could imbue it with new life. This is not the case in such ideal portraits as his King Alfred (Stowe, *c*. 1735, and Stourhead, 1764) for which there was no prototype. The Jones and the Palladio appear again in statue form outside Lord Burlington's villa at Chiswick, where they were probably erected about 1730. These two figures, which are some years earlier than the Sir Hans Sloane already discussed, are very different in conception. Both have a turning movement which runs through the whole body, both are shown in action, with the weight about to fall on the foremost foot, both are enveloped in deeply-undercut cloaks, and neither is a completely closed composition. It would seem, therefore, that in the design of standing figures, Rysbrack moved in the 1730s from a markedly Baroque to a more static style: the further changes after 1740 must be discussed later.

During the time that Rysbrack was transforming the position of the portrait bust, he was also much in demand as a tomb sculptor. Here again his best work is very distinguished. His association with Gibbs was continued for a time, and both were concerned with two monuments in the nave of Westminster Abbey, to John Smith (d. 1718)[22] and to Katherine Bovey (d. 1724; Plate 100B). Both have medallion portraits (the Smith shows the old-fashioned type with the three-quarter view), and both have allegorical figures seated on the sarcophagus, a motive new in England, and almost certainly derived from the tomb of Gregory XV (1697, Rome, S. Ignazio).[23] That on the Smith is a more emotional figure than is often found in Rysbrack's work, for she clasps her head in grief and her dishevelled draperies planned on bold diagonals carry the sentiment through the whole figure. Neither, perhaps, shows Rysbrack at his best, but the cutting

of the drapery in fairly big folds makes an instructive comparison with the much smaller rhythms used by Scheemakers and Delvaux.[24]

It was, however, at the beginning of the 1730s that Rysbrack was to rise to his greatest heights as a tomb sculptor. Early in 1731 the scaffolding was taken down from his monument to Sir Isaac Newton in Westminster Abbey (Plates 64 and 65), and two years later the companion monument to the 1st Earl Stanhope was also finished. They are set facing down the nave at the entrance to the choir and cannot now be seen to full advantage, since the tracery of the nineteenth-century Gothic screen masks the upper parts, which originally stood clear above a low, straight-topped screen. Even so, they are extremely impressive. Here Rysbrack was associated not with Gibbs, but with William Kent, which may partly account for the fact that these monuments are basically un-architectural in conception; the figures move freely in front of the pyramid back-ground, and in both at one point or another, they are allowed to break its enveloping line. The Newton is perhaps the finest of all the post-medieval tombs in the abbey, and though both artists are concerned with its evolution (there is a drawing by Kent in the Victoria and Albert Museum and one by Rysbrack in the British Museum, the executed work being superior to either), it is probable that the credit for the idea must be given to Kent. Newton, in loose classical robes, reclines on a black, straight-sided sarcophagus which rests on beautifully designed white scroll feet. His right arm leans on a pile of books: his other hand, the fingers, alas, now broken, points to a scroll held by two boys on which is drawn a diagram relating to the solar system. Above him is a large globe with constellations showing the path of the comet of 1681, which Newton had deter-mined. On the globe is seated Astronomy, weeping, with a star above her head. Below on the sarcophagus is a charming relief of boys with instruments in their hands, all relating to Newton's discoveries as a scientist, or to his activities as Master of the Mint. The design is based on a series of balanced diagonals, Newton's glance and the main lines of the figure of Astronomy leading the eye in one direction; his hands, the drapery across his knees, and the pointing finger of the boy making a cross movement in the other. The execution throughout is masterly. The boys, both the standing pair and those in the relief, are fully modelled in the best Duquesnoy tradition, the draperies are rich and varied in their folds, but do not confuse the eye, and the noble head (Plate 65), 'a just resemblance, but a handsomer one', is a splendid conception of genius, a fitting portrait to adorn the monument of one of England's greatest sons.[25] Compared with the Newton, the Stanhope, with its pictorial background in the form of the general's tent, is a little confused, and the virile figure in Roman armour is less finely posed, but here, too, the execution is of the highest quality.

At the same time as Rysbrack and Kent were concerned with these two tombs they were also engaged on an even grander commission, the great monument which Sarah, Duchess of Marlborough, was erecting to the Duke in the chapel of Blenheim Palace (Plate 70B). This was being set up in May 1732.[26] As a whole it is far less successful than the Newton, though parts of it are beautifully done. The design is very rich, using pink, grey, and brown marbles for the two-tiered base, and grey veined with pink for the sarcophagus, on which rest the white figures of History and Fame. Above them is a

somewhat unhappily posed family group in Roman dress (though the duchess retains her coronet). The duke, in armour and crowned with laurels, rests one foot on his helmet and twists stiffly round to look at the adoring duchess, who, seated with her youngest son, nude, between her knees pointing up at his father, is a surprisingly moving figure; but the elder son, standing behind his father, looks away and is not well integrated into the group. On the lower part of the base is a pictorial relief of the surrender of Marshal Tallard at the Battle of Blenheim, perhaps the greatest moment of Marlborough's career, the terracotta model for which is in the Soane Museum. There can be little doubt that the design is based on a papal pattern; for in the early eighteenth century the figures standing at the ends of the sarcophagus, so much used by Bernini's generation, had given place to the seated figures seen in Le Gros's tomb of Gregory XV and also in Rusconi's Gregory XIII (1720-3) in St Peter's.[27] But in the latter the figures lean outwards but look inwards, and the figure of the pope above is isolated as the clear focal point of the whole. Rysbrack's seated figures leaning inwards are closer to those in the Gregory XV, but there the pope is raised much higher, and the design is unified by a great falling drapery behind, which is supported by two figures of Fame, flying rapidly inward on either side, so that the white figures are planned on diagonals leading the eye to the centre. The Marlborough design is at once more complicated and more timid. The six white figures are crowded into too small a space, and no real attempt is made to connect History and Fame with the group above their heads. Moreover, the family group is, inevitably, a less impressive climax than a single papal figure, and even within the group the duke's figure is not sufficiently dominant. The ubiquitous dark pyramid which forms the background should help to tie the whole together, but its lines are too light to control the busy movement within. The same faults appear in the large tomb of the 1st Lord Foley at Great Witley, Worcestershire, made probably between 1735 and 1743, where the figures themselves are individually more static.

Rysbrack was, however, outstandingly successful in some of his smaller monuments of the 1730s. That of the 1st Lord Harborough (d. 1732) at Stapleford, Leicestershire (Plate 66), shows the male figure reclining in Roman dress at the foot of a pyramid, while at his feet sits his wife with their child on her lap. The group of mother and child is most tenderly conceived, and beautifully modelled with rounded forms matching the richly curving lines of the draperies. It is inherently Flemish rather than Italian, and suggests that Rysbrack, perhaps unconsciously, had Rubens's treatment of the theme of the Madonna and Child firmly imprinted on his mind. A complete contrast is presented by the Lord Chancellor King (d. 1734) at Ockham, Surrey, which has two seated figures, the male in contemporary dress, flanking an urn.[28] And, on a smaller scale still, it would be hard to find a more attractive little work than the monument to John Gay, erected in 1736 and now in the triforium of Westminster Abbey (Plate 67B).[29] A small winged boy, standing on a curved base in front of a black pyramid, leans on a medallion bearing the portrait of the poet en negligé. A drapery softens the edge of the medallion, and its curving line is carried round the body of the boy and up to his wing. The boy himself is one of Rysbrack's most splendidly modelled children; the design, however, is not original, for it is borrowed from Girardon's tomb of Bonneau de Tracy (1683) in

Tournai Cathedral. Rysbrack may conceivably have known the original, but it is far more likely that he used the engraving by Sébastien Leclerc.[30]

Monuments and busts, only a few of which have been discussed, were not the sole fields in which Rysbrack worked in this decade. There are marble reliefs over the fire-places at Houghton, Norfolk, with subjects drawn directly from Antiquity, that in the Stone Hall being a Sacrifice to Diana taken from one of Montfaucon's plates of the Arch of Constantine. The same subjects were to be used again in 1755 at Woburn Abbey, though these later reliefs, which are in stone, are inferior in quality. Similar chimneypieces in the classical manner were made by Rysbrack, probably by 1730, for Clandon Park, Surrey (Plate 63).[31] The relief for the East India Company, recorded by Vertue in 1729,[32] showing Britannia receiving the riches of the East, is however very different in style, for in its soft modelling, its variations from high to very low relief, its pictorial background, and above all in the way in which the light playing over it is broken up into small and gently modulated patches, it is far more Baroque.

Baroque, too, in conception is Rysbrack's most important statue of the period, the bronze equestrian figure of William III at Bristol finished in 1735 (Plate 68B), which has, until recently, been far too much neglected.[33] Here Rysbrack was in competition with Peter Scheemakers, whose figure, carried out in lead and pewter and then gilded, is now at Hull (Plate 68A). A comparison of the two is revealing and gives strong support to Vertue's insistence that Rysbrack was the superior artist. Both are basically derived from the famous statue of Marcus Aurelius on the Capitol at Rome, though Rysbrack must also have studied Girardon's model for the statue of Louis XIV.[34] Both show the king as a Roman general, but whereas in Scheemakers's work he sits stiffly upright, with a slightly anxious expression on his face, in the Rysbrack the pose is far easier and far more convincing. The expression is also much finer, for the head is slightly raised and the features strongly modelled with the eyes deeply set under the firm brow, giving the face an air of command. The cloak and the tassets of the skirt flutter back as if in a wind, while at Hull they fall in straight, dull folds; Rysbrack's horse too is far more vigorous. But Scheemakers was to learn from his defeat. By 1740 the town was to ring with the praises of his Shakespeare monument, and the success of this and the rising popularity of Roubiliac's more informal art were to have a marked effect on Rysbrack. The modifications he made in his style to meet the new challenge must be discussed in a later chapter; his work of the thirties has been treated in some detail, since it is among the most distinguished sculpture ever produced in England and was indeed the main factor in lifting the art from its provincial backwater and giving it a not unworthy place in the European stream.

CHAPTER 13

PETER SCHEEMAKERS AND LAURENT DELVAUX

NOTHING is certainly known of either Peter Scheemakers (1691–1781) or Laurent Delvaux (1696–1778) until they are recorded in the employment of Denis Plumier in England shortly before his death in 1721.[1] Both were Flemings, the former being the son of a well-known Antwerp master of the extreme Baroque group, whose Keurlinckx monument of 1688 in the cathedral and that to the Marquis del Pico in Saint-Jacques show a strong taste for the macabre. There are no contemporary records concerning the training of either of the young men, though it is likely enough that Scheemakers learnt something in his father's studio. J. T. Smith, however, asserts[2] that before coming to England (when he would have been between twenty-five and thirty) he had been to Copenhagen and then, wishing to study in Rome, had walked to Italy. Smith's statements about early-eighteenth-century sculptors are not always reliable, but he had presumably obtained these facts from Nollekens, who was Scheemakers's pupil. Scheemakers's earliest works unquestionably betray a greater knowledge of the antique than could have been obtained without a visit to Italy, and since his father's art is stylistically not far distant from that of Thomas Quellin, who was working in Denmark, it is possible that the younger Peter was also sent for a time to his workshop.[3]

The part played by Delvaux and Scheemakers in the execution of Plumier's monument to John Sheffield, Duke of Buckingham (Plate 54B), has already been discussed; both apparently also worked for a short time for Francis Bird, possibly on the Newcastle monument.[4] By about 1725 they were in partnership, and both signed the large monument to Lewis, Earl of Rockingham, at Rockingham, Northamptonshire (Plate 71A), erected in that year by his daughter.[5] Although it is signed *invt et fecit*, the invention is not very great, for the pattern is still that of Gibbons's Exton and Bottesford tombs (Plate 39B), neither of them very far away, though it is adjusted to conform with newer taste. The earl and his wife stand on either side of a large casket with claw feet, instead of beside an urn, in front of a relatively severe rectangular setting, while between them flies a rather sulky-looking boy with a wreath and a trumpet. Rockingham, bare-headed, in Roman armour and carrying his plumed helmet, appears to be a fine portrait; his wife is in contemporary dress which falls in thick, straight folds, and though a fur-lined cloak is wrapped about her, its heaviness is stressed and the folds are broad and smooth. There is none of the variety of form, the broken edges, or the deep undercutting which characterizes Rysbrack's work of this decade; the smooth modelling of the drapery is well attuned to the placid pose and the soft handling of the lady's plump face and arms, and only in the flying boy, with a scarf looped round him, is there any echo of Antwerp style.

An even stronger dependence on Antiquity may be seen in the standing figure of Sir Samuel Ongley (1726, Old Warden, Bedfordshire), whose monument is again signed

by both artists; for instead of armour he is wearing a short chiton, with a toga brooched on the shoulder and falling behind him to his feet. These antique garments are treated in a markedly antique manner, in small, soft, parallel folds: but again the seated boys at the sides, though less vigorous in design and cutting than Rysbrack's children, betray the sculptors' Baroque background. There is, however, little doubt that they wished to benefit from the increasing taste for Antiquity and, probably with this in view, they seem already to have been planning a journey to Rome to improve their own knowledge. They did not, in fact, leave until the summer of 1728, but two years before that they sold off their sculpture and models in Covent Garden.[6] Scheemakers was to stay in Rome for about two years, whereas Delvaux was away until 1733, when he returned to England for a short time and then left for Flanders. It seems therefore that some at least of the work on the finest of their joint productions, the monument to Dr Hugo Chamberlen in Westminster Abbey (Plate 71B), must have been done before they left, though it was not erected until 1731 after Scheemakers's return, since Vertue specifically states that one of the figures was made by Delvaux.[7] In this tomb the artists adopt the pattern of a figure reclining on a sarcophagus, with standing allegorical figures at each end, one of them being, according to Vertue, the Goddess of Health. It is possible that the design was their own; for, rather unusually for a monument of this date, the upper part of the background is rounded with a drapery thrown over it and tied in knots at the side, a motive which is reminiscent of Quellin's Tom Thynne and has no counterpart in the monuments designed by Gibbs or Kent. The two standing figures, not unlike those on Bird's Newcastle monument, though they are finer both in design and cutting, form an interesting contrast. The Goddess of Health (with her serpent) is a direct imitation of the antique. She is a carefully balanced, static figure, with soft, thin draperies falling in small parallel folds; and though the snake runs diagonally across her body, the angle is not very sharp, and the main composition lines are almost verticals and horizontals. The other figure, Longevity, has a far more definite movement and her cloak falls in a big, oblique fold. Again the material of her robes is thin and soft, but here the small folds have more variety and the treatment is outspokenly antique. Vertue does not state which of these two figures is by Delvaux, but his later work (for instance the pulpit in the cathedral of Ghent of 1745) suggests that he was basically the more talented sculptor, and it therefore seems likely that the beautiful left-hand figure is his, a supposition which is strengthened by the resemblance of the other to known works by Scheemakers. There is, however, no doubt that the effigy of Chamberlen is by the latter and he was seldom if ever to create anything of equal distinction. The figure is well designed and the head has the air of a fine portrait. Chamberlen's broad face with its firm, regular features suited the artist's style, for it lent itself to generalization. A comparison of the finished work with the terracotta model in the Victoria and Albert Museum throws interesting light on the sculptor's outlook, for the head of the model is far more particularized. The brow is furrowed, and there is a deep depression on the bridge of the nose and sagging wrinkles under the eyes. In the marble all these have disappeared, and the head is ennobled and given an ideal beauty. This figure is almost contemporary with the similarly posed Newton by Rysbrack (Plate 64); the difference in the styles of the

93

two artists, both almost at their best in these two works, can quickly be perceived. Rysbrack's figure has far greater energy; the structure of the body is much more strongly felt and plays a far greater part in the design. Moreover, Newton's pose, though apparently so easy, is based on a most carefully planned system of diagonals, which give it a nervous tension which is absent in Scheemakers's work. The drapery treatment, too, is very different. Rysbrack uses a wide variety of types of fold, mingling large with small, and making great use of flattened or triangular folds, often with sharp edges. Scheemakers's fold patterns, like his pose, are more languid. There is, admittedly, more variety here than in most of his works, but he prefers drapery lines which repeat each other in flowing curves and rise up to a tubular edge. In his less lively works they become stereotyped and his dullest works are very dull indeed. It is, however, probable that he did not cut them himself, for he was eventually to have a large workshop.

The examination of the Chamberlen has taken us beyond the Roman journey of 1728. Scheemakers appears to have worked hard: indeed, his diligent study is said to have surprised both the Italians and also other artists from England, who were not accustomed to such application.[8] The fruits of his journey were a number of models in clay after the antique, which he brought back to England. In 1730 Vertue saw eighteen or twenty statues thus modelled and also some busts. Some of the statues repeat models he himself had quoted earlier in his list of desiderata for his art school,[9] but there are many new items: Young Bacchus; the Centaur with Cupid on his Back; the Venus crouching and the Venus and Cockle Shell; the Flora; the Ceres; the Hermaphrodite and a Woman; the Laocoon and his Sons; the Sphinx and Lyons; an 'Egyptian statue' and 'one of the Fiammingo – as fine as the Antique'.[10] Vertue examined them carefully and found: 'some so soft and fleshy. others a fine spirit and true antique tast[e] – I am persuaded no one master heretofore hath brought so many compleat works in that perfection of their own studies to England', and he felt 'they well deserve to be made of a more durable material than clay'.[11] Many of them were in course of time to be repeated in stone; for instance the Gladiator (of which Scheemakers also brought a new model) and the Ceres are still in the gardens at Rousham, Oxfordshire, and by 1747 he was selling sets of plaster models of five of his antiques – the Hercules, Flora, Venus, Faunus, Zingara (or Egyptian woman) – at five guineas the set. This must have been a cheap way for the gentry to establish a reputation as connoisseurs.

The reference to the 'soft and fleshy' character of some of the statues is interesting, especially as the list of models also includes a Hermaphrodite and a Woman (presumably Salmacis); for it suggests that some of Scheemakers's models had been made by Delvaux. The latter is known to have carried out commissions for English patrons (among them the Duke of Bedford) when he remained in Rome after Scheemakers had returned. At Woburn there are still a Salmacis and Hermaphrodite (based on the Cupid and Psyche now in the Capitoline Museum) and a Crouching Venus by Delvaux which are notably soft in modelling. Even before he left for Rome, Delvaux seems to have obtained some orders for groups of this type; for the Vertumnus and Pomona (Plate 69) now in the Victoria and Albert Museum, the model for which was sold in 1726, was probably made for Canons.[12] It, also, has a marked fleshiness in the treatment of the

nude, but the somewhat loose movement within the group and the fluttering ends of the drapery reveal it as the work of a Baroque sculptor. Delvaux's work after 1733 in Flanders is outside the scope of this book, but he evidently occasionally still worked for English patrons.[13]

Scheemakers was, however, to spend the rest of his working life in England. He was to gain much fame, especially after 1740; but in the thirties he could not compete on an equality with Rysbrack, and even at the height of his success he tried to gain work by cutting his prices, for as Vertue relates, when Rysbrack's normal charge for a model and a marble bust was thirty-five guineas, Scheemakers would do it for ten.[14] The rivalry between the two sculptors in the decade after Scheemakers's return from Rome must have been great. The Chamberlen and the Newton were erected in Westminster Abbey within a few months of each other, and by 1732 both men were making models for the equestrian statue of William III for Bristol.[15] Both were also working about 1733 for Lord Cobham for the gardens at Stowe, though it is hard to disentangle their work,[16] all of which is now so much weathered that attributions are dangerous. Scheemakers may have supplied some of the busts for the Temple of British Worthies, and according to some early accounts the pediment relief of the Temple of Concord, showing Britannia receiving gifts from the Four Quarters of the World, is his, though others give it to Rysbrack. It is, however, clear that during these years Scheemakers received no commission comparable to the Marlborough tomb, or indeed to the Newton and Stanhope. His Westminster Abbey monument of Dr John Woodward, with its seated Ceres-like figure holding a portrait medallion, is competent enough, but it is not a major work; and the majority of his monuments in this decade are more modest, some indeed being only ledgers with no figures, while others, such as the Sir Justinian Isham of 1737 at Lamport, Northamptonshire, or the Sir Thomas Hodgson (d. 1732) at Barnby-on-Don, Yorkshire, have busts. Sometimes his designs seem to echo those of Rysbrack, though they are seldom so skilful. For instance, the monument to Sir Richard Brodrepp and his family of 1739 at Mapperton, Dorset (Plate 67A), with its medallion portrait framed by a drapery held by boys, is an elaboration of the theme used by Rysbrack in the Gay monument. A comparison of the two immediately shows the superiority of the latter. Scheemakers's design lacks entirely the wonderful fluid curves which bind Rysbrack's work together and which echo and re-echo in the rounded modelling of the child's body. Scheemakers's boys are far more superficial in handling; the articulation of their limbs is feeble, the movement from one rounded plane to another less carefully studied, and in consequence the figures lack life.

The same superficiality, compared with Rysbrack, appears in his busts, though the best of them is by no means negligible. The Viscount Cobham (V. and A.; Plate 61) is likely to have been made when Scheemakers was working for Stowe, when the sitter, born in 1675, would have been about sixty. It is a distinguished and virile portrait, but the forms are all a little flatter than they would have been in a comparable head by Rysbrack, and the hair is disposed in tidy, close, parallel waves; whereas Rysbrack, even in the Nottingham, breaks up the pattern with looser locks curling in different directions. The drapery of the Cobham, too, is typical of Scheemakers. The neck-line of the

Roman cuirass is square and hardly softened (in his Marlborough and also in his Godolphin in Earl Spencer's collection Rysbrack had used the same square, but had softened it by a rounded under-garment). And the fringed cloak, brooched at one side, which falls over the cuirass is treated in heavy, flat folds with, perhaps most revealing of all, a strong vertical on each side. This stress on the vertical and the horizontal of the neck-line gives to the bust a static character which is without parallel in the work of Rysbrack, for though he was on occasion compelled to use a vertical, especially in his busts of divines (for instance the Dr Harbin (Plate 62A) or the Unknown Man in the V. and A.), he breaks the edges and introduces a variety of slanting folds to give a more lively pattern. It would not, however, be true to imply that Scheemakers never showed interest in a more Baroque pattern; for the fine bust of Sir Justinian Isham *en negligé* at Lamport Hall, Northamptonshire,[17] makes free use of diagonals, both in the soft cap and in the drapery round the shoulders, and the folds are more deeply cut than is usual in the artist's work. In the shirt, however, with its many small folds gathered into the collar, he resorts to his characteristic repetition of parallels, and the large-featured face, though of considerable dignity, is a little mask-like in its over-simplification.

Towards the end of the decade Scheemakers began to change his manner and to move away from his close dependence on the antique for his drapery style. It may be that he was beginning to appreciate the reasons for Rysbrack's success, especially in the statue of William III, and that he felt that something a little more lively would pay. His monument to Marwood William Turner, finished in 1739, at Kirkleatham, Yorkshire, is to some extent a tamer version of Guelfi's Craggs; for the figure leans against a pedestal, and though the legs are not crossed, one knee is bent, giving a diagonal movement which is stressed by the lines of the falling cloak. The dress is contemporary and not classical, and though the figure is stiff, there is a clear attempt to treat it in a new manner. This new, more Baroque manner is used with much greater success in the small statue of Edward VI erected in 1737 in the quadrangle of St Thomas's Hospital.[18] Here, as Vertue rightly notes, 'the attitude of the Statue and graceful disposition of the limbs is judiciously done and meritts great applause'. He also tells us that the figure was modelled on a portrait of the king ascribed to Holbein and then at Kensington Palace;[19] and so far as the head and the costume are concerned the sculptor has followed his model faithfully. But the rather timid frontal pose has been much modified; the head is turned over an outstretched arm, the gesture being balanced by the other arm, bent, gathering up the cloak and resting on the hip. The cloak falls in broad swinging folds behind the figure, proving that the artist, when once he could free himself from that close dependence on a classical prototype which weakened his William III, was able to create a work of real originality. It was, no doubt, the right preparation for his most famous work, the Shakespeare monument (Plate 75).

The cult of Shakespeare had been growing in the third and fourth decades of the eighteenth century,[20] and though the poet's grave at Stratford-on-Avon was much venerated, it was now thought fitting that he should be further commemorated by a monument in Westminster Abbey. Funds were raised by public subscription and by benefit performances at Drury Lane and Covent Garden, and placed in the hands of

Lord Burlington, Pope, and Dr Mead.[21] Scheemakers manoeuvred so that the commission was offered to him outright, without competition, though Vertue, who disliked him intensely, is fair enough to admit that he produced 'an excellent well dispos'd and wrought statue' which was generally commended by the 'crowds of spectators [who] daily resort to see it'. The design of the monument was entrusted to William Kent, whose name, with that of the sculptor and the date 1740, appears on it. Within a simple but finely cut pedimented frame, Shakespeare leans cross-legged on a pedestal bearing a pile of books, his left hand pointing to a scroll which bears some of his most famous lines, chosen perhaps for their suitability to a monument which otherwise has no emblems of mortality:

> The Cloud cupt [sic] Tow'rs
> The Gorgeous Palaces
> The Solemn Temples,
> The Great Globe itself
> Yea all which it Inherit
> Shall Dissolve
> And like the baseless Fabrick of a Vision
> Leave not a wreck behind.[22]

The pedestal is adorned with a device of a laurel wreath, a dagger, and an actor's mask; and somewhat curiously placed at its corners are busts of Queen Elizabeth I (presumably as Shakespeare's patron) and two of his most famous historical characters, Henry V and Richard III. Shakespeare himself is shown in costume which is a compromise between the Elizabethan and the 'van Dyck', for with his doublet and falling collar he wears tight breeches which were not in use by the time of his death, though they accord well enough with the Baroque treatment of the pose, in which the large broken fold of the cloak, bending almost in a right angle above the left hip, is vital to the composition. The Baroque design is probably due to William Kent, but Scheemakers has exploited it to a degree unknown in his earlier work; and though the cutting is neither so varied nor so interesting as would have been the case had Rysbrack executed Kent's design, it is nevertheless a striking figure. The head is less impressive. Scheemakers used as his model the 'Chandos' portrait of Shakespeare (N.P.G.),[23] which was much prized in the eighteenth century, since it was held to have been painted from the life by Shakespeare's fellow-actor, Richard Burbage. His copy is faithful enough, but he had not the imagination to infuse it with life. Both Rysbrack and Roubiliac were later to create images of Shakespeare; both were to realize that the traditional portraits were not adequate representations of genius, and both in their different ways were to alter, to improve, and to give new life.[24] With the Shakespeare Scheemakers reached the peak of his career: for a short time after its creation he was to surpass Rysbrack in popular esteem, but by the end of the 1740s, as will be discussed in a later chapter, both were to be overshadowed by the new art of Roubiliac.

CHAPTER 14

HENRY SCHEEMAKERS AND HENRY CHEERE

THE only other sculptor who produced work of real distinction before 1740 was Henry (later Sir Henry) Cheere (1703–81).[1] His earliest works have something of the same mixture of the Baroque and the classical that has been seen in those of the Flemings, but he was in the 1730s to develop a more personal manner, lighter and far more Rococo in style. This may well be due to his different origin, for though he was born in Clapham and members of his family belonged to the Haberdashers' Company, they were probably of Huguenot extraction; moreover, Vertue speaks of him as a foreigner and writes his name incorrectly as Shears or Sheers.[2] If he was, therefore, of French descent he might well have maintained contacts with France, and so have become aware of the change from Baroque to Rococo art.

He was apprenticed, however, to an English mason–sculptor, Robert Hartshorne,[3] but about three years after he had finished his articles he was working in partnership with one of the Flemings, namely Peter Scheemakers's brother Henry. Henry Scheemakers was probably younger than his brother Peter, though his birth date is unknown. He was in England by 1726, and may well have been here sooner, for by that year he was sufficiently established and sufficiently well regarded for John Nost to apprentice his son John to him for seven years.[4] Whether Henry Scheemakers was already working with Cheere is uncertain; they had adjacent premises in St Margaret's Lane, Westminster, from 1729 to 1733 and during these years jointly signed a small number of monuments. In 1733 Henry Scheemakers disappears; he is said to have gone to Paris and then returned to Antwerp, where he died in 1748.[5] No work of his outside England is known, and it is therefore difficult to assess the shares of the two men in the partnership works.

The most important of these is the tomb of the 1st Duke of Ancaster at Edenham, Lincolnshire, erected by his trustees in 1728. The duke is shown alone, standing in front of a dark marble niche flanked by Corinthian columns, with a winged head and swags of flowers above. He wears the armour of a Roman general, and is somewhat over-posed, with his left hand on his hip, his right holding a baton and resting on a draped pedestal, his body having a marked twist. Indeed, the artists, in their anxiety to give a lively movement to the figure, and at the same time to keep the laws of contrapposto, have raised the left hip too high, and made it project too much. The duke is a heavily-built, fleshy man, and the bold, rounded forms are echoed in the thick, heavy folds of the cloak, and in the curling edges of his skirts, which turn back over his extended right leg. There can, indeed, be little doubt that the sculptors see the antique theme with Baroque eyes. The only other work to be jointly signed is a tablet to Hammond and Anthony Twyman at Westbere, Kent, set up some time after the death of the former in 1727. This is a good Baroque cartouche, placed against a background of looped drapery,

98

with a winged head below, which is not in the usual frontal pose, but is tilted sharply to the right, balancing the direction of the crest at the top. Henry Scheemakers, however, signs two other notable monuments, the first being easily the equal, if not indeed the superior, of any of his more famous brother's work. This is the tomb at Steeple Aston, Oxfordshire, to Sir Francis and Lady Page (Plate 73A), erected probably soon after the lady's death in 1730 (her husband lived until 1741). The two figures recline, the judge being behind and above his wife, in front of a dark pyramid and under a pedimented frame. The design is admirable and the cutting fine though not brilliant. He, wearing his judge's robes and heavy wig, is a splendid, dignified figure; the lady with a book is more tenderly conceived. The draperies are handled with skill and in a strongly individual manner which, though it can in some ways be paralleled in the early work of Henry Cheere, is in reality more accomplished. The lady's dress and the cloak which is wrapped over the lower part of her body have many small folds, not following each other as in Peter Scheemakers's figures on the Chamberlen or Woodward monuments, but broken into lively and rippling patterns and in the cloak deeply undercut, so that they stand away from the body. The forms are all much smaller than they would be in the work of Rysbrack and have much more vitality than those of the sculptor's brother. Henry's other monument, that to the boy John Bradbury who died in 1731 at the age of ten, at Wicken Bonhunt, Essex, takes the unusual form of a large tablet with scrolled sides and looped drapery over the top bearing a relief showing the boy rising above clouds, surrounded by putti and rays. The proportions of the boy are not very happy, the upper part of his body being too big, and the cutting is not nearly so fine as that of the Page monument; but the form of the memorial and its strongly pictorial character are more nearly paralleled by seventeenth-century Flemish works (for instance, the monument to Rombaut Huens of 1651 in the church of Saint-Jean, Malines, by Fayd'herbe) than by anything to be seen in England.[6]

It seems likely that Henry Cheere learnt a good deal from his partner, for it is hard to believe that the training he had had from Robert Hartshorne would have helped him to develop his own lively style without the experience of working with an Antwerp-trained artist. The exact sequence of his independent works is obscure, but it seems likely that the signed monument to Robert Davies (d. 1728, Mold, Flintshire) is among the earliest. The pose is modelled almost exactly on that of Guelfi's Craggs and is therefore perhaps one of the first examples of its influence, but there the resemblance ends. Davies is shown en negligé with a loose cap on his head and his shirt open at the neck; but a cloak is wrapped round his body and he wears Roman boots. The fold patterns are not unlike those on Henry Scheemakers's Page monument, though they are a little more mechanical; for there is a greater tendency to repeat the same fold, while the actual fall of the cloak is far more improbable and its thin, turned-back edges are slightly reminiscent of the work of Nost.

By the early 1730s, however, Cheere was developing his own personal manner, quite distinct from that of either of the Scheemakers or of Rysbrack, and he was to obtain many commissions before the end of the decade. At the end of 1732 he signed a contract with the Fellows of All Souls, Oxford, for a statue of their benefactor, Christopher

Codrington (Plate 72), which was to be completed two years later and placed in the new library which bears his name. The figure is a variant of that of the Duke of Ancaster, but it is more taut in pose and the modelling is a little lighter. The balance is much improved, for the hip does not stick out so awkwardly and the right hand has been dropped close to the side and holds a baton, the line of which makes a pleasing parallel to that of the upper left arm, and to the folds of the cloak gathered in the left hand. The movement of the skirts is less fussy, that of the cloak less heavy. Cheere is beginning to use the smaller forms, the sharper linear rhythms which lead him away from Baroque, and eventually give to his work a fundamentally Rococo character. The difference between his style and that of Rysbrack can very easily be studied in Westminster Abbey, for his monument to Admiral Sir Thomas Hardy (d. 1732; Plate 70A) at the west end of the nave makes an interesting comparison with Rysbrack's Stanhope of 1733, with which it must be almost contemporary. Both show figures in Roman armour reclining on a sarcophagus with an attendant winged boy. Rysbrack's figure is seen from the front with the legs slanting forward, and consequently its design in depth, with the foreshortened passage from knee running back to hip, has been carefully planned. Cheere's admiral is arranged almost in profile, both the head and the legs being sharply so, though the shoulders are twisted to a frontal view and the left hand rests, in a rhetorical gesture, on the breast. But it is the long, clean linear rhythms which give this figure its character, swinging right down the body from the shoulders to the feet, up and across the arms and running on in the flattened drapery falling over the edge of the sarcophagus. Compared with the Rysbrack, all the folds are flat and relatively small; there is none of the deep undercutting which helps to give bulk to the figure; instead there are a series of surface rhythms; and the sharply defined profile, the bent arm, and the pointed feet give a brittle elegance which is far away from the rich rounded forms of the Stanhope. The tomb of Bishop Willis (1734) at Winchester Cathedral is fairly close in type, but by no means all of Cheere's early work is as crisp as this, though it is all of fine quality. The monument to the Chief Justice Lord Raymond (d. 1732, Abbots Langley, Herts.; Plate 73B) is an aristocratic 'conversation piece' which, though it pays lip-service to Antiquity, is less formal in its approach than any contemporary work by Rysbrack or Peter Scheemakers.[7] The judge in his robes reclines, leaning on a pile of books, and turns his head towards his wife, who sits behind him, and draws her attention by a gesture of his left hand to the boy at his feet who is offering him a coronet. Lady Raymond is in classical dress and holds a medallion portrait on her knee, but her head with its small features, slightly amused expression, and naturalistic hair-style is not in strict conformity with classical convention. His head is a splendid, naturalistic portrait, taken perhaps from the painting by Jonathan Richardson (R. Gunnis Collection), but like so much of the sculpture of this period, far more lively and convincing. It, and indeed the whole treatment of the robes, reveals very clearly Cheere's detailed interest in small forms. In the face there is a much quicker movement from plane to plane, from bulge to hollow, in fact from light to dark, than would have been acceptable to Rysbrack; the rich, small curls of the wig have fascinated the artist (and their treatment is immeasurably more lively than that of Henry Scheemakers's Sir Francis Page), and he makes great play with

small curling edges in the drapery. Indeed, the drapery rhythms are far closer to Hogarth's Captain Coram (1740), with their toning down of Baroque *bravura*,[8] than to any other works of the time produced in England. And further, a comparison of Lady Raymond with Rysbrack's contemporary Lady Harborough (Plate 66) at Stapleford, Leicestershire, stresses once more the strength of the latter's Baroque inheritance. Not only are his forms always larger and fuller, but the play of curves throughout the figure, as well as such details as the width of the brow and the treatment of the hair, provide a revealing contrast to the slighter, more upright figure with the sharply bent arms of Lady Raymond. It is true that in this work Cheere undercuts his draperies to a greater extent than in, for instance, the Admiral Sir Thomas Hardy; but a few moments' study of his treatment of edges (so often a crucial matter in a sculptor's style) shows that they have the small broken lines which are alien to Rysbrack's art.

Cheere was evidently favoured by the University of Oxford in the 1730s, and much of his work may be seen there; though some of it unfortunately is high up and not easily visible. There are the statues of Law, Physic, and Poetry which crown the pediments of The Queen's College, and that of Queen Caroline for the same college, which stands over Nicholas Hawksmoor's entrance gate. In 1737 he made two statues, an Archbishop Sheldon and a Duke of Ormonde, for the Sheldonian Theatre. The last, though now both damaged and weathered, is yet another variant of the formula already employed for the figures of the 1st Duke of Ancaster and Christopher Codrington, though, per-haps because here the artist was creating an ideal portrait of a man long since dead, the proportions are much more slender, and the whole build of the figure lighter. Cheere's association with Oxford, and particularly with the Codrington Library at All Souls, supports the stylistic attribution to him of the fine bust in the possession of the college, which is traditionally (and most probably) a portrait of Nicholas Hawksmoor.[9] He is shown bare-headed, with an open shirt and drapery thrown round his shoulders, so that the artist combines the Roman portrait type (first used by Rysbrack for the Nottingham) with the bust *en negligé* (deriving from Coysevox's bust of Prior), in which, however, the sitter is more usually shown wearing a cap. The handling of the drapery, with its edges curling back, corresponds very closely to the Raymond monument; while the quality of the head, in which the artist has captured the mood of an elderly, fat, and saddened man, is masterly. Peter Scheemakers never achieved a bust with so much character; Rysbrack would have found it hard to avoid ennobling the coarsened fea-tures; in many ways, therefore, this bust looks forward to the naturalistic works of Roubiliac, though it has not quite the same brilliance and power as his mature portraits of ugly men.[10] Cheere had by this time begun to make monuments with busts,[11] but he had not yet developed the charming Rococo type of monument which is, perhaps, most characteristic of him, and which must therefore be left for later discussion. By 1740 he was also beginning to carve chimneypieces, though these were not necessarily of his own design. Those at Ditchley, Oxfordshire (some of them from the designs of Henry Flit-croft), are fine in workmanship, one having a head of Bacchus and another naturalistic flowers in very high relief, but they fall rather into the category of interior decoration than into that of sculpture.

CHAPTER 15
LOUIS FRANÇOIS ROUBILIAC

LOUIS FRANÇOIS ROUBILIAC (1702/5–62) was probably the most accomplished sculptor ever to work in England. His range was greater than that of Rysbrack and his handling more brilliant; though it must be acknowledged that he seldom displays the nobility of conception which is so impressive a feature of Rysbrack's best work. This is due not only to a difference of temperament, but also to a difference of training and of intention. Roubiliac was not Flemish but French; he grew up at the moment when the solemn, formal art of the later part of the reign of Louis XIV was giving way to the new informal mood of the Rococo in which the broad, swinging lines of Baroque were replaced in painting and sculpture alike by smaller rhythms and quicker movement. In sculpture these produce, in their concentration on smaller forms, a more rapid variation of light and shadow, a ripple of light on the surface, a concern with the accidents of a face rather than with its ideal structure, and a new approach to drapery, using it to suggest the movement beneath instead of allowing it to have an independent movement of its own.

Roubiliac was born in Lyons in 1702 or 1705.[1] The city had already produced distinguished sculptors, Coysevox and his nephew Nicolas Coustou; but according to J. T. Smith,[2] who had some reason to know, since his father Nathaniel Smith had been apprenticed to Roubiliac, the boy's parents, who were almost certainly Huguenots, did not at first choose one of their famous fellow-citizens as his master. Instead he became a pupil of the great German Baroque sculptor, Balthasar Permoser, presumably at the time when he was working for the Protestant Elector of Saxony on the Zwinger Pavilions at Dresden. Neither the dates nor the length of Roubiliac's time in Permoser's studio are known, and no strong effect can be detected in the younger man's style, but from his first master, himself a pupil of Bernini, he would have learnt the Late Baroque style, elegant and full of complex movement, which was sweeping Central Europe and laying the foundations for the development of one of the most exciting manifestations of the Rococo. Roubiliac is next said to have worked in the studio of his fellow-citizen, Nicolas Coustou, by now one of the leading sculptors in Paris, but there is no certainty as to how or when he went there. The only contemporary record of his early years is the award in 1730 of the second Grand Prix for sculpture at the French Academy for a relief of an Old Testament subject.[3] The medal for this was presented to him in August of the next year and he may have come to England soon after, though the first record is his marriage in London in 1735 to a Huguenot, Catherine Hélot.[4] Early-nineteenth-century tradition, however, asserts that he first worked for 'Mr Carter' (probably Thomas, but possibly Benjamin)[5] and that he was then lucky enough to find and honest enough to return a pocket book full of bank notes which belonged to Sir Edward Walpole, the illegitimate son of the Prime Minister.[6] Walpole introduced him to Henry

102

Cheere, who gave him employment,[7] and apparently obtained for him his first commission, that for the marble statue of Handel erected by Jonathan Tyers in Vauxhall Gardens in 1738[8] (Plate 74). This work, now in the possession of Messrs Novello, London, the terracotta model being in the Fitzwilliam Museum, caught the fancy of the town. It was indeed something entirely new: for instead of an Apollo or an Orpheus to represent Music, here in the fashionable pleasure-gardens was Music in the form of the great composer whose works were often played there and whose operas and the quarrels they had caused were in everyone's mind. The work was at once novel, informal, and topical. Handel is seated *en negligé*, touching a lyre: he leans on bound volumes of his own scores, while a naked boy at his feet transcribes the notes as he plays them. The lyre was an instrument Handel can never have played, but it was nonetheless immediately associated with his work, for in 1736 he had composed *Alexander's Feast*, a setting for Dryden's *Ode to St Cecilia's Day*, and earlier in 1738 the title-page of the published score appeared with an engraving designed by Hubert Gravelot of 'Timotheos plac'd on high. . . . With flying Fingers touch'd the Lyre'. This score is the only one with a precise title among the books beneath Handel's elbow in Roubiliac's work, and since the two Frenchmen must certainly have known each other, there can be little doubt that the conceptions, and perhaps even the designs, were connected. Both artists play an important part in the development of Rococo art in England.[9] Roubiliac's statue, both in composition and in mood, is indeed a major contribution to it. The rhythms are quick, the pose informal and realistic, and above all the expression of the face, with the composer listening intently to the notes he is playing, is an example of that interest in a transitory mood, in change rather than in a permanent ideal, which is a fundamental characteristic of the Rococo.

Although Tyers possibly gave Roubiliac further work for the Gardens, for a lead figure of Milton 'as drawn by himself in his *Il Penseroso* seated on a rock; and in an attitude of listening to soft music' was in 1822 recorded as his,[10] the sculptor does not, in spite of the undoubted success of the Handel, seem to have received any other important commissions for some time; but these were the years when Rysbrack, Scheemakers, and Cheere were high in public favour and a new man would therefore have found himself faced with formidable rivals. During the next few years he began to build up a reputation as a maker of busts, his first patrons evidently being found for him by Tyers. By 1740 he was sufficiently prosperous to take a house in St Martin's Lane, where his ability was soon recognized by his fellow artists, for by 1745 he was to be concerned with the teaching of sculpture at the St Martin's Lane Academy, the art school of which Hogarth was the chief promoter.

The group of early busts includes the Jonathan Tyers (marble, Birmingham Art Gallery; terracotta, V. and A); the marble Handel of 1739 at Windsor and its terracotta at the Foundling Hospital; a terracotta of Hogarth at the National Portrait Gallery of which no marble is known; and at least three different busts of Pope.[11] The Tyers, the Handel, and the Hogarth all show the sitters wearing soft caps, but they reveal that from the very first Roubiliac was averse to creating a formula for the treatment of the shoulders and drapery, and evolved a new pattern for each individual bust. The Tyers

(Plate 76A) is the least original, for he has a shirt open at the neck with details of the falling frill and the buttonholes treated realistically, under a collarless coat over which a loose drapery is thrown to round off the lower edge of the bust. Although the features are also handled with realism and the eyes fairly deeply incised, the fact that Tyers had a plump, rounded face gives this bust, with its big fold round the shoulders, a largeness of form which is not entirely characteristic of the sculptor. The Handel, being also the portrait of a heavily built man, is fairly broad in its treatment of the head; but the planes of the cheek are broken into smaller forms than in the Tyers, and the drapery is much less stereotyped; for the left side of the frogged cloak turns over in a triangular lapel, counterbalancing the twist of the head, but keeping the movement within the outline of the bust, and so rendering it quicker and sharper. The Hogarth (Plate 76B) is the liveliest of the three; for the head is turned sharply, indeed pugnaciously, to the left, the action being balanced less by the drapery than by the arrangement of the cap, jutting out behind the head. The shape of the bust, too, has changed; it is no longer rounded off, but slopes sharply downwards from the shoulders, and is cut horizontally above the base which bears the painter's brushes and palette. The two artists were friends, so that this portrait presumably does not depend on one or two sittings, but was the result of constant close observation of Hogarth's attitude and expression. Here is the dogged, fiery little man, with his quick eye for the world around him, shown with an intimacy but with a remorseless realism that far surpasses any bust made by Roubiliac's rivals.

In the three busts so far discussed, Roubiliac was using a formula which must have been familiar to him before he came to England, for the bust *en negligé* was first created in France, and the fine terracotta by Guillaume Coustou in the Louvre of his brother Nicolas (Roubiliac's master), which develops the pattern evolved by Coysevox and seen in his bust on the monument of Matthew Prior, might well have served as his model. For his portraits of Pope, however, he adopts a pattern which must have been new to him, namely that first used by Rysbrack for his bust of Nottingham, with its close-cropped hair and loose, classical drapery. Roubiliac made at least four marble busts of Pope before 1741, all of them inscribed: *ad vivum*. Vertue speaks of 'several' from the life which he saw in that year and notes: 'more like than any other sculptor has done I think'.[12] The terracotta model (Plate 77B) on which all four appear to be based (Elton Hall, Peterborough, Mrs M. Copner Collection) is not signed or dated; the signed marbles are spread over three years (Temple Newsam House, Leeds, 1738; Earl Fitzwilliam Collection, 1740; Gateshead, Shipley Art Gallery; and Earl of Rosebery Collection, 1741; Plate 77A) and vary somewhat in the treatment of the shoulders.[13] Pope was fifty when the first of these busts was made, with years of ill-health behind him; the Rysbrack of 1730 (possibly begun five years before; Plate 60) is not therefore a completely just comparison. The poet was, however, always frail and a cripple, which could hardly be guessed from the noble serenity of Rysbrack's portrait. Roubiliac is more uncompromising; the furrows of pain and the sunken cheeks are clear enough, though they do not mar the superb intellectual dignity of the head with its lofty brow and mobile, over-sensitive mouth. This portrait, in its realism, has a pathos that was outside

Rysbrack's range; though as an ideal and most beautiful representation of a poet, his is unsurpassed.

During the 1740s Roubiliac began to obtain a small number of commissions for tombs outside London, the most important being that to Bishop Hough, erected in 1746 in Worcester Cathedral (Plate 80A), which was to be admired by Horace Walpole in 1753 as 'a fine tomb, in the Westminster Abbey style'. It was, indeed, to be the prelude to Roubiliac's more important London work. Its major innovations lie in the drama and asymmetry of the design. Hough is seated on a high sarcophagus, with his hands clasped; he makes a sudden turning movement, his head thrown up as if he saw a vision or heard the Last Trump. Below on the right a fine figure of Religion unveils a relief showing the only notable incident in the bishop's career, his expulsion from the Presidency of Magdalen College by order of James II; while at the other end of the sarcophagus, in-stead of a full-sized figure, there is a small seated boy, holding a medallion portrait of the bishop's wife. The design is extremely successful, though it seems possible that the sculptor did not know precisely how the monument would be placed, for the intention of the dramatic gesture of the bishop is lost because he is gazing upwards at an arch, instead of into the heights of the crossing. Nevertheless, he is an impressive figure and his draperies, broken into many small folds, none of them making very deep shadows, compel the spectator to consider the pose as a whole. The Religion is a quieter figure, and her vertical lines play a great part in steadying the design. Roubiliac is here content to set his figures against a truncated pyramid background, light with a dark edge, though he allows the Religion to break beyond its lines. The theme, though simple compared with the sculptor's later work, nevertheless opens a new phase of English sculpture, for it has a dramatic unity of action unknown in the works of Rysbrack, Scheemakers, or Cheere. Their reclining effigies flanked by Virtues and Muses are essentially a generalized use of allegory; and though in, for instance, the Newton (Plate 64) the allegory has reference to the life of the man commemorated, he himself plays no part in the story told. The Hough tomb, on the other hand, derives from the French tradition, originating in the late-seventeenth-century monuments designed by Charles Le Brun, in which the deceased is a leading actor in the drama.[14] Roubiliac must have been fully familiar with this dramatic tradition, though the relatively uneventful life of the Anglican bishop did not offer him a very effective subject. The asymmetry of the design, new in England, probably also comes from France, though it is, broadly speaking, a common characteristic of Rococo art.[15] In the same year as Roubiliac com-pleted the Hough he also finished the tomb of Roger Owen at Condover, Shropshire. This follows the common pattern of a reclining figure with a mourning wife seated at his feet, though the pathos of expression and the complex draperies, using the characteristic small folds, make it notably more dramatic than the many similar tombs by other sculptors.

By now, however, Roubiliac was working on his first major London commission, for the terracotta model in the Victoria and Albert Museum for the monument to John, Duke of Argyll, is signed 'L. F. Roubiliac invt sct 1745', though the monument itself in Westminster Abbey (Plates 78 and 79) was not completed until 1749.[16] The form of

the signature, which is constant on this master's works, is revealing, for it proves that unlike Rysbrack he was, for better or for worse, almost invariably his own designer.[17] Kent was dead and Gibbs no longer active, and few of the architects of the middle years of the century had the reputation or indeed the talent to be employed as designers of monuments, though later both James Stuart and Robert Adam were to play some part in this field. In the Argyll Roubiliac develops a French seventeenth-century theme, that of the expiring hero, exploited by Le Brun in his design for the tomb of Turenne executed by Tuby in the Invalides, with the effigy raised high above the attendant Virtues. Basic changes are, however, made in the pattern, all of them heightening the drama and breaking up the controlled balance of the seventeenth-century tradition. Argyll sits with his legs hanging over the edge of his sarcophagus, his body twisted and resting against a winged figure of Fame who, leaning forward, inscribes his name on the pyramid of Eternity. This device of a writing Fame is derived not from French sources, but from Fischer von Erlach's Mitrovitz monument at Prague, illustrated in his *Historische Architektur*, an English edition of which had appeared in 1730.[18] The main group is planned on two crossing diagonals, and it is perhaps characteristic of the artist that the one which is longer in line (made by the languid figure of the dying duke) should be weaker in force, for the shorter diagonal is strengthened by the rapid movement forward of the female figure. The seated figures below show the same loosening of design. On the right Pallas, denoting Valour, sits with her shield and lance, looking obliquely up to the central group above her;[19] while on the other side, instead of a seated figure, there is the standing Eloquence, leaning forward, her hand outstretched to dominate her audience. Her draperies seem to quiver in sympathy with her nervous effort; as Vertue observed, they are 'really more like silk than marble',[20] and indeed no other material but a slightly stiffened silk such as taffeta could have given the sculptor the rich, shimmering, but at the same time lively patterns that he needed. Between these two is a low and extremely pictorial relief of Britannia holding the Cap of Liberty with attendant boys, one carrying Magna Charta and another a fire-arm, presumably in reference to Argyll's defence of Britain against the Jacobite invasion of 1715. Though, however, the design is charming and the female figure beautifully cut, the boys are noticeably weaker in handling than those of the Flemish artists who had inherited the Duquesnoy tradition.

It is not surprising that the Argyll had an enormous success. Vertue, writing just after it was erected, recorded Roubiliac's struggle for reputation in the face of established masters but felt that 'this monument now outshines for nobleness and skill all those done by the best sculptors this fifty years past';[21] later sculptors were to borrow motives from it, and Canova, an artist in a very different tradition, was to regard the Eloquence with admiration, holding it to be one of the finest statues he had seen in England.[22] In spite, however, of the admiration it has justly received, the monument, like almost all Roubiliac's larger works, betrays a certain hesitancy in intention. The design is loose not only in its asymmetry but also in the absence of unity in concept and design of the various figures. The artist never fully faces and resolves (as Kent and Rysbrack had done in the Newton monument) the conflict between two-dimensional and three-dimen-

sional movement. The central group, dominated by the writing Fame, is in strict classical relief; the turning figure of Valour, linked with the group above by the device of the up-turned gaze, is a straight derivation, in idea as well as in type, from the Baroque, and the strong twist of her body might lead one to expect a three-dimensional rather than the two-dimensional climax to the whole composition. The rapid movement forward of Eloquence, breaking completely through the front plane, is even more at variance with the classicizing Fame, and has no compositional link with the Valour. Roubiliac's uncertainty in design on a large scale, which is his greatest weakness as an artist, may be due simply to the limitations of his talent, or it may be the result of the lack of assimilation of both his early experience in the Baroque studio of Permoser, and his later work in the more classical tradition of Paris. The superimposition of the Rococo on the mind of a man who was not entirely certain of the tradition in which he was working might well have led to confusion. He had neither the solid Baroque foundation of Rysbrack nor the first-hand knowledge of Antiquity of Scheemakers; and though he is an immeasurably finer artist than the latter, some discipline seems lacking that he might have obtained by a more orthodox training.

In the next year (1746) Roubiliac was to complete an even more novel monument for the abbey, that of General Wade, which, like his later monuments to General Fleming and General Hargrave, is set high against the south windows of the nave, and so is very hard to see. Here there is neither sarcophagus nor pyramid, but above a tablet with a medallion portrait of the general, Fame repulses Time in his predatory advance on the column which bears the trophies of the general's victories. Such a theme as this was unknown in England; but in France the eternal drama of Time, Fame, and Death constantly formed part of the elaborate catafalques set up at funeral ceremonies.[23] The tradition goes back to the late seventeenth century, and so would have been known to Roubiliac before he left France, but a few of the later and more elaborate designs were engraved, and all were described in detail in the *Mercure de France*. Roubiliac was by no means the only French artist working in England,[24] and it is reasonable to suppose that knowledge of happenings in France was easily available. The idea in the Wade is both more dramatic and more condensed than that of the Argyll, but the design is much more confused. It is, however, probable that the sculptor did not know that it was to be placed so high.[25]

In these first two Westminster Abbey monuments Roubiliac displays to the full his natural bent for drama, his mastery of figures in movement, his extreme naturalism, and his predilection for small forms. A comparison of the head of the Argyll (Plate 79) with Rysbrack's Newton (Plate 65) or Scheemakers's Chamberlen shows the same rapid movement from plane to plane, the same breaking up of the large surfaces of cheek or brow, compared with the Flemings' larger, more generalized vision, that has been noted in his early busts. His two most important tombs outside London of about this time, those of the Duke and Duchess of Montagu at Warkton, Northamptonshire, show the same stylistic characteristics but are far gentler in theme.[26] The duke's was at the model stage by 1751; the duchess died in that year, and her tomb was erected by 1753, but it is uncertain whether it was begun before the artist's short visit to Italy in the late

summer of 1752. In both monuments Roubiliac completely abandons the pyramid background; and both are markedly asymmetrical in design. In one the mourning duchess stands below, while diagonally above her a Charity with three children is hanging up a medallion portrait of the duke. This work has more charm than anything the artist had as yet created: its counterpart on the other side of the little church, though grimmer in theme, is nevertheless one of the prettiest monuments in England (Plate 80B). It shows the Three Fates: Clotho seated with her distaff on the left, Lachesis with hand outstretched on the right, and below them Atropos standing with the shears. If, as seems possible, this tomb was not made until after Roubiliac's visit to Rome, it is conceivable that the seated female figures were inspired by those on papal tombs of the early eighteenth century, and that the setting beneath a deeply coffered arch is derived from some model such as Bernini's Countess Matilda. But there is little Baroque feeling here. The mood is light, for the Fates are elegant Rococo ladies *en negligé*, and though the urn above them suggests mortality, it is wreathed with flowers and has children playing round it.

By the time Roubiliac took his short journey abroad in 1752 his practice had become considerable, for in addition to the important monuments so far discussed he had made several smaller ones, including the fine high relief to Lord Justice Spencer Cowper at Hertingfordbury, Hertfordshire, and he was already famous for the realism of his busts.[27] His energy must have been prodigious; he had few assistants, and like Rysbrack, but unlike Scheemakers, did most of his work himself. The Roman journey, taken in the company of Thomas Hudson, the portrait painter, only lasted four months,[28] a fact which Flaxman was later to notice with scorn, but it seems possible that he exaggerated when he said that Roubiliac was only three days in Rome; for as James Northcote, the biographer of Reynolds, records, the sculptor 'expressed himself in raptures on what he had seen on the Continent – on the exquisite beauty of the works of antiquity and the captivating and luxuriant splendour of Bernini', and with great modesty admitted that his own work looked 'meagre and starved, as if made of nothing but tobacco pipes'.[29]

The monument of Admiral Sir Peter Warren, now much mutilated, in the north transept of Westminster Abbey must have been one of his first works finished after his return, and in its original state, backed by a great falling flag which has now disappeared, was both more compact and more robust than his earlier work. The massive figure of Hercules supporting the bust is evidence of his studies of antique models (though the pose is a free invention), and the curved pedestal and the seated figure of Navigation are reminiscent of earlier eighteenth-century Italian models.[30] Not all the monuments of the later 1750s, however, can be linked with the Italian journey. The General Fleming in the nave of the abbey, which follows, to a great extent, the pattern of the General Wade, may have been designed before he left (the general died in 1751), though the Athena and Hercules who tie together emblems of wisdom, prudence, and valour may, in their types, echo the antique sculpture he had seen abroad. The work is, however, set so high that it is hard to assess its quality. The Viscount Shannon, however, at Walton-on-Thames, Surrey, cannot have been made before 1755, since it was erected by a daughter under her mother's will. It is among the least known of the sculptor's

larger works, but it is notable not only for the use of contemporary dress for the field marshal, but also for the splendid illusionism of the great pavilion behind him, which appears to project in high relief. In fact, the relief is only perhaps two inches, but marbles of different colours are used for the two sides, and so a false but completely convincing effect of perspective is achieved.[31]

Even more striking, and far more famous, are Roubiliac's last tombs in Westminster Abbey: the General Hargrave erected in 1757, and the Lady Elizabeth Nightingale and the George Frederick Handel, both of 1761. The Hargrave (Plates 82, A and B, and 83) is indeed one of the most remarkable tombs ever made in England. Although no Christian symbols appear, the Christian theme of Resurrection is now combined, with the maximum pictorial effect, with the pagan allegory of Time and Eternity. The general, casting off his shroud, rises from the tomb, called by the Last Trump sounded by a boy angel above him. At its sound the pyramid of Time crumbles, and Time himself, the feathers of his wings draggled and drooping, breaks his scythe across his knee, while below him Death, his crown rolling from his head, falls headlong into the abyss. The same theme, on a more limited scale, had been used by Roubiliac about 1750 for the tomb of Miss Mary Myddelton at Wrexham, Denbighshire, where the dead woman, who had lived to old age, rises in youth from her sarcophagus. Again a child blows the Last Trump and a pyramid crumbles: but the visible overthrow of Time and Death, which adds so greatly to the drama of the Hargrave, is not included. It is probable that in both monuments Roubiliac was developing a theme known to him in the tomb designed by Charles Le Brun for his mother in Saint-Nicolas du Chardonneret, Paris, where an aged woman, her hands joined in prayer, emerges from her sarcophagus at the sound of the Last Trump blown by an angel flying above her (though this second figure has now disappeared).[32] But by the time he executed the Hargrave, Roubiliac had so much enriched Le Brun's relatively simple statement that it is almost a fresh invention. Moreover, by now his skill as a designer is far more assured than, for instance, in the Argyll, where the linking of the figures is somewhat loose. Now the design grows out of the drama but adds to it; for though as always much use is made of diagonals, these are arrested and controlled by the strong horizontal of the shroud stretched on the extended arm. Unfortunately the position of the monument, again high up against a window in the nave, makes both the composition and the handling hard to appreciate; and it is, indeed, only since it was photographed when the windows were boarded during the Second World War that it has been possible to judge it fairly. The forms are, admittedly, too small for their distance from the eye, though they probably looked well in the model; but since it is likely that Roubiliac must have guessed the fate of his work, he should perhaps have broadened his handling.

The famous monument in the north transept to Lady Elizabeth Nightingale (Plate 84), made four years later, is much easier to study, since it is placed on the ground. The lady had died thirty years before following a miscarriage caused by the shock of a violent flash of lightning; the monument was erected under her son's will. Here there is no Christian resurrection but the triumph of Death; for Death emerges from his prison and strikes with his spear at Lady Elizabeth, while her husband in horror tries to ward off his

stroke. The design has a greater clarity than any of the sculptor's other major monuments. It is welded together by the framing arch of black marble beneath which the white figures form a compact triangle, while below them black and white are again used to suggest the pitiless strength of Death's prison. The device of Death emerging from a door below the deceased must surely be taken from Bernini's tomb of Alexander VII in St Peter's, but there the upper and lower halves of the design have less visible unity, for the pope kneels undismayed in prayer, seemingly unaware of the nearness of Death, who does not strike with an arrow, but brandishes an hourglass. Bernini's tomb is rich in colour, Roubiliac's sober in black and white, but its over-charged drama is far more violent and less Christian. To many Englishmen it has seemed theatrical, but its departure from the conventional attracted one great figure who also challenged the complacency of the age, for John Wesley regarded this and the Hargrave as incomparably the finest and most Christian works in the abbey.[33] It is not only in compactness of design and directness of content that the Nightingale differs from Roubiliac's other works: there is also a marked change in the handling of the figures. Both Lady Elizabeth and her husband are in loose classical dress, there is no interest in variety or richness of material, the thin robes cling more closely to the bodies, and the drapery patterns are simpler. In the male figure in particular, with the contours of the leg seen through the drapery and the small parallel folds at shoulder and neck, there is a stronger echo of the antique than in any earlier work. Roubiliac could hardly have felt the full impetus towards the antique which in the 1760s was to mark the true beginnings of neo-classicism, but he may well have been aware of the new impact of Rome on his younger contemporaries. Joseph Wilton had returned from Italy in 1755, and by 1761 had erected his monument in Westminster Abbey to Admiral Holmes, in which he used a modified form of antique drapery. And the Duke of Richmond's gallery of casts had been opened to sculptors in 1758.[34] Roubiliac's remarks to Reynolds, already quoted, suggest that he was a modest man, deeply conscious of his own limitations, and it is likely therefore that right up to the end of his brilliant career he would have been anxious to seize opportunities to enlarge his knowledge.

His last monument, the Handel (Plate 85), erected in the same year as the Nightingale, is more modest in size and more intimate and more pictorial in treatment. Handel in his richest clothes stands pen in hand, with his most famous aria from *Messiah*, 'I know that my Redeemer liveth', half written on a manuscript. Behind him, filling the space between the Gothic shafts, is a false perspective niche closed at the back with an organ, while a winged figure with a harp, said in contemporary descriptions to be King David, floats above on clouds. Handel indeed seems to be almost conducting the heavenly music, and the combination of extreme realism in his figure with the allegorical setting is not entirely happy.[35]

Roubiliac's monuments, though not all equally successful, are among the most remarkable and individual works of sculpture ever produced in England. Not all are on the ambitious scale of the Westminster designs, and indeed some of the smaller works have a greater dignity. The simple monument to William (d. 1742) and Elizabeth (d. 1761) Harvey at Hempstead, Essex (Plate 81), erected in 1753, has two medallion

portraits set on a white cloth against a grey pyramid. It is completely unpretentious, but the portraits, especially that of the old lady, have the same distinction as the busts made in his maturity. His greatest strength, beyond all doubt, lies in the realism of his portraiture, and in his ability to create character by design. In this, he far outshines Rysbrack, though in tomb sculpture the Fleming is often superior. A fairly large number of busts are known, and in many cases both the preliminary model and the final marble have survived; for most fortunately Dr Matthew Maty, a sub-librarian at the newly founded British Museum, bought a number of terracottas and plaster casts from models at the sale of Roubiliac's effects in 1762.[36] The plaster casts have a special importance in Roubiliac's work, for it seems probable that he made his original study in modelling clay, then making a mould from which a plaster cast or a terracotta squeeze could be taken.[37] Even though he cut the marble himself, the brilliance of the first sketch often seems to modern eyes to have become a little dulled in execution, though the changes which he himself thought necessary for a permanent and final work are often revealing.

By the end of the 1740s his practice as a portrait sculptor had greatly increased; the circle of his patrons was much enlarged, and though his earliest busts, such as the Handel or the Hogarth already discussed, had continued the Coysevox tradition, it would seem that his success with the various versions of the Pope encouraged him to challenge Rysbrack and Scheemakers in the field of classicizing busts. Two of his finest essays in this manner, made for the 9th Earl of Pembroke, who had inherited the great collection of antiques bought by his father, and was himself an enthusiastic amateur architect, are the Sir Andrew Fountaine of 1747 (Plate 86A) and the earl's own bust of 1750 (replica, Plate 88), both still at Wilton House.[38] Fountaine appears with his great bald head set on shoulders over which a cloth (it cannot be called a garment) is draped with one end hanging in a point. Such drapery has almost no reference to Antiquity; but the head, of senatorial dignity, must in its treatment surely have pleased the sitter, himself a great collector of antiques. Again, as in the case of Rysbrack's Nottingham, the inspiration must have come from a Republican rather than an Imperial bust; but it is less noble and more realistic than a Rysbrack, and the pouches under the eyes and the folds of sagging skin at the neck are emphasized rather than softened. The Pembroke is very different in pattern. It is wider at the shoulders (the Fountaine is narrow and slopes down sharply to the pedestal), with the drapery swinging across and tied in a knot at the right. The head turns sharply over the left shoulder and the hair is freely and loosely treated, breaking the outline of the skull. There seems little doubt that there is here an echo of that interest in movement, in the turn of a head to give an expression of greater life, which appears for a short period in Late Imperial busts; and it is probably relevant that among the antique casts in the sculptor's posthumous sale there was a bust of the Emperor Caracalla, which is perhaps the most famous example of the type. It is completely in character that this pattern should have caught the attention of a sculptor so deeply interested in movement, whereas Rysbrack, with his innate feeling for the noble and the permanent, should have preferred the more static Republican or Augustan types.

Classicizing busts are, however, relatively rare in Roubiliac's work. His greatest successes are less formal in approach and show the sitter in contemporary dress, usually in

the loose cap which the sculptor used to great advantage in the design. And, since he was supremely interested in the real rather than in the ideal, he achieves his greatest triumphs in his busts of ugly men. It would indeed be hard to find a less prepossessing sitter than Dr Martin Folkes, President of the Royal Society, whose bust was made to order of the 9th Earl of Pembroke in 1749 (Plate 87B). The marble at Wilton House shows Folkes in an open shirt covered by a furred gown, with a loose folded cap edged with fur on his head. The heavy features, the obstinate mouth, firmly closed with protruding under-lip, present a most impressive character study. The plaster at the British Museum tells even more about the man; in it the eyeballs are incised and the face has an alert intelligence which is lacking in the marble, where the sculptor bowed to the convention of the blind eyeball. To us today the plaster is the more interesting portrait (other features as well as the eyes are slightly hardened in the marble), but Vertue found the marble 'a most exact likeness of him – his features strong and musculous, with a Natural and Just air of likeness – as much as any work of that kind ever seen – equal to any present or former ages –'.[39] The Folkes was almost certainly made from the life; for the Swift of 1749 (Dublin, Trinity College), which is very similar in pattern, Roubiliac must have relied on portraits and descriptions, but by giving the head a sharp turn and the cap a jagged outline jutting aggressively forward, a more volatile and indeed a more venomous spirit is suggested than in the cautious, watchful Folkes. Later busts in informal dress – the Daniel Lock (d. 1754) on his monument in the ante-chapel at Trinity College, Cambridge, the Dr John Belchier at the Royal College of Surgeons (Plate 89), and the Dr Frewen of 1757 at Christ Church, Oxford – show an ever-increasing assurance and ability to impart depth and dignity of character to the ungainly sitters. With them must be grouped the magnificent Self-Portrait (N.P.G., terracotta; Plate 93), clearly made late in life, in which he offers his serious, searching face with compelling and relentless realism. These are perhaps the finest and most original of all the sculptor's busts and are among the most memorable portraits of their age.

Roubiliac also made a number of more formal busts which, though a trifle less impressive, are none the less full of invention. In the Lord Ligonier (Windsor Castle, marble; N.P.G., terracotta, half-size) the martial energy of the sitter is conveyed by the head slightly thrown back in the final version (though not in the model) and by the raking diagonal of the fur-lined cloak on which is displayed the Order of the Bath. George II (Windsor Castle) is given a panache he probably did not possess, though it may well have pleased him, since he was proud to have led his troops into battle,[40] for he is shown in armour with a falling lace cravat and a great scarf tied in an elaborate knot at one side. For his Garrick (N.P.G., plaster; Plate 87A), probably of 1758, Roubiliac has chosen a quieter pattern; for the figure is enveloped in a cloak, but its crumpled collar, taken with the wide, mobile mouth, the broad forehead, and the expressive eyes, suggest well enough the energy and versatility for which the great actor was famous. Most original of all, from the point of view of design, is the Joseph Wilton (London, Royal Academy; Plate 90B) of c. 1761, for the bust is so long that it includes the whole right arm bent across the chest. The head turns to the right, but it is counterbalanced by the long diagonal of Roubiliac's favourite turned-back edge of the coat, running down

to the mallet held in his fellow-sculptor's right hand. In this late work the forms are seen more broadly, especially in the head; and though the coat is still broken up into small areas of light and shadow, the folds are neither so deeply cut nor so restless as in earlier examples.

As might be expected, the sculptor was more successful with elderly or middle-aged women than with the young. His Princess Amelia (Cambridge, Fitzwilliam Museum), a tall, narrow bust with soft drapery caught up and falling in a cascade of folds at the breast, has charm but is a little insipid, and notably lacking in vitality compared with the Mrs Aufrere (Earl of Yarborough) of 1748. Here Roubiliac had a sitter who, like himself, was of Huguenot descent. He does not idealize her large nose, slightly slanting eyes, and shrewd mouth, but makes a most convincing portrait of a woman of character whose lively irregular features are well matched by the asymmetrical treatment of the drapery lying loosely over her shoulders and tied in a knot in front. It is one of the most Rococo of his busts, and markedly French in feeling. Equally French are the two busts of Lady Grisel Baillie (1746), and her daughter Grisel Baillie, Lady Murray (1747), both belonging to the Earl of Haddington, for their pattern with a shawl over the head is derived from a Coysevox type seen in the Marie Serre in the Louvre.[41] The Lady Murray, a woman of fifty-five, is so sympathetic a portrait that it is sad that the sculptor did not obtain more commissions of this type.

It has already been shown that, in the case of the Swift, Roubiliac could produce a successful bust of a man he had never seen. The most remarkable examples of his imaginative ability to re-create a head are to be found among the series of portraits made between 1751 and 1757 of distinguished members of Trinity College, Cambridge.[42] None is from the life, but it is at first sight hard to believe that this astonishing series of character studies, so varied in design and so brilliant in handling, were based on painted portraits. Roubiliac has studied and exploited the possibilities of the costume of different periods, and only in the Sir Francis Bacon (1751), whose big, stiffened ruff was too intractable to fall in with his love of easy, flowing patterns, does he fail to use the dress to add to the interest and character of the work. The two other busts, both dated 1757, of Jacobean scholars are masterly: the Sir Edward Coke with his cold, judicial head set arrogantly above wide shoulders, the Sir Robert Cotton (Plate 91A), less formal, with a soft, pleated ruff which is treated with great virtuosity and love of texture. In the latter there is a considerable difference between the intimate charm of the terracotta (B.M.; Plate 90A), with the head looking down and slightly turned, and the more aloof marble with the head erect. The Francis Willoughby (1751; Plate 91B) stands a little apart, for it is a portrait of a comparatively young man (the naturalist died at the age of thirty-seven) with strong, regular features, and long hair falling to his shoulders over a deep tasselled collar, one edge of which curls back; it provides a perfect contrast to the weather-beaten face of his friend John Ray, a bust made in the same year. Each bust in the series differs from the others in form; the Willoughby and the Bentley are long, though the collar of the former gives a horizontal emphasis and the robes of the other a vertical; the Ray and the Barrow are short and wide, but the latter exploits the contrast of smooth drapery and richly curled hair, while in the former there is a richer all-over

texture embracing both head and cloak. Three of the eighteenth-century sitters are shown in classical dress: the Newton (1751), which is based on Thornhill's painting belonging to the college, the Lord Trevor (1757), and the Lord Whitworth (1757), but in all the drapery patterns are individual, and in the last, with its strong, folded diagonals, fundamentally un-antique.

A number of other busts of men long dead were also made by Roubiliac: a perceptive Milton (terracotta, N.P.G. of Scotland); an alert and virile Cromwell (terracotta, B.M.) with his head sharply turned and a scarf knotted over his armour; a Shakespeare (terracotta, B.M.) of van-Dyckian elegance, in which it is clear that none of the traditional portraits of the dramatist satisfied Roubiliac as a true account of genius, for he has greatly ennobled the head; and a Charles I (marble, London, Wallace Collection; terracotta, B.M.). The last, with the head raised, the hair longer on one shoulder than the other, and the wide scarf gathered into a knot on the left, has possibly a special interest; for it is one of the most Baroque of the sculptor's busts, and it is probable that part of its inspiration, at least, came from Bernini's lost bust of the king of which George Vertue's cast must have been known to Roubiliac. Though it is not a precise copy of the Bernini, it is a livelier and more convincing recollection of it than the tedious, but closer copy (possibly by Francis Bird) at Windsor Castle.[43] Roubiliac is also known to have made small medallion portraits, the identifiable examples being more like miniature busts in high relief than portrait medals. Only the gilt bronze of Garrick (1758, London, Garrick Club) is signed and dated, but the few others known in either bronze or terracotta would seem to have been modelled in the last years of the sculptor's life.[44]

In addition to monuments and busts, Roubiliac made a small number of statues, though he did not obtain such important commissions in this field as Rysbrack or even Scheemakers, nor was he always successful. His gifts as a designer seem more suited to the problems of the individual bust, and his rhythms tend to be too small for an isolated, life-sized figure. The seated Lord President Forbes (1752) in the Sessions House at Edinburgh, with his hand outstretched as if silencing a mob, is a lively and original invention, but the complicated light and shade of the long curled wig and the many small broken folds of the robes, distract the eye and slightly weaken the force of its impact. The Sir Thomas Molyneux of the same year, now in Armagh Cathedral, in classical dress with an open book seems unconvincing in stance, and again restless and uneasy in the design of the drapery.[45] Two of his standing figures, the Shakespeare (marble, B.M.; terracotta, V. and A.) and the Religion (Leicester Art Gallery), were designed for special settings, and it is probably unfair to judge them now that they are isolated in museums. The first was made in 1756 for Garrick's Shakespeare Temple in his garden at Hampton; the latter, probably also a late work, stood on an elaborate cenotaph in an Ionic temple in the grounds of Gopsall, Leicestershire. Both, in their different ways, express the theme of inspiration, the Shakespeare a little blatantly, for he stands in a twisted pose, hand to chin and pen in hand, as if listening to his Muse. Roubiliac only handles allegory with success in his tomb designs, where he can show a group in action, but the great psychological insight which he displayed in his busts reappears in the finest of all his standing figures, the Newton (1755) in academic robes in the ante-chapel of Trinity College,

Cambridge (Plate 92). Newton may in life have had a more insignificant physique; his painted portraits do not suggest a man of great serenity: Roubiliac gives him physical beauty, serenity of mind, and a compelling greatness. If one knew nothing of the man, Roubiliac's statue, derived from painted portraits and the death-mask, and transformed by his imagination, would enforce instant recognition of his genius.[46] Here, and to a high degree, Roubiliac appears as a true creative artist.

THE LATER WORKS OF RYSBRACK, SCHEEMAKERS, AND CHEERE

IT is not easy to assess how far the novelty and brilliance of Roubiliac's work affected the practices of his fellow-sculptors. About the middle of the century there seems to have been some falling off in the commissions for portrait busts given to Rysbrack, Scheemakers, and Cheere; and there is no parallel in the later work of Rysbrack to the long list of his busts quoted by Vertue in 1732.[1] All three, however, continued to use busts on monuments, and that the interest of patrons was still keen is shown by a note in *The London Tradesman* of 1747: 'The taste for busts and figures in these materials [i.e. clay, wax, and plaster of Paris] prevails much of late years, and in some measure interferes with portrait painting. The Nobility now affect to have their busts done that way, rather than sit for their pictures, and the fashion is to have their apartments adorned with bronzes and figures in plaster and wax.'[2] It is perhaps again worth stressing the fact that until about 1755 'the Nobility' were justified in feeling that a sculptor, rather than any contemporary painter, would provide a portrait of character and dignity.

Not all English patrons, however, seem to have cared for the dramatic character of Roubiliac's tombs; there was still a big demand for the designs and types created by the older men. Scheemakers, indeed, appears to have been quite untouched by Roubiliac's style; Rysbrack, on the other hand, was certainly influenced by it in his last years, though before that his own style had undergone certain modifications.

In 1743 Vertue recorded that business was not so brisk with Rysbrack as it had been for some years, and that he found himself 'somewhat at leisure', owing to the 'great and unproportioned exultation of that statue of Shakespeare erected in Westminster Abbey – done by Scheemakers'.[3] Rysbrack was therefore spending his time on two projects, neither apparently a commission, the first being three statuettes of Rubens (Plate 94B), van Dyck, and Duquesnoy (terracotta of Rubens dated 1743, Earl of Harrowby Collection, of van Dyck and Duquesnoy probably those sold at Sotheby's, 4 December 1956, bt. H. Blairman and Sons)[4] and the second the statuette of Hercules at Stourhead (Plate 94A).[5] In these works, which Vertue states were made with much study, Rysbrack is clearly attempting to rival the Shakespeare and to recapture his position as the leading sculptor of his day. The statuettes of his three famous countrymen are lively and elegant, with quick gestures and richly modelled draperies. Like the Shakespeare, they exploit the possibilities of early-seventeenth-century costume; but they are far lighter (and also far more convincing as portraits) and are, perhaps, the nearest approach to Rococo to be found in the work of Rysbrack. The Hercules, on the other hand, is an exercise in the Antique, not only in intention, but in method. For in order to find 'the most beautiful or the most perfect parts', Rysbrack had seven or eight different models, the chief among them, who stood for the pose and also for the head,

being a famous boxer.[6] It would be obvious, without Vertue's confirmation, that Rysbrack had the Farnese Hercules in mind, though he deliberately posed his figure in a different attitude. The fact that the legs are crossed is revealing. The pose was used (though not exactly) in Antiquity and could have been known to Rysbrack in engraving; but it is surely significant that this revival of it should immediately follow Scheemakers's success with his cross-legged Shakespeare. Rysbrack's Hercules seems, indeed, a strange mixture; for though it is an academic exercise of some nobility, the artist has been so deeply preoccupied with the twisted head and the diagonal movement that the balance of the figure has become confused, and the weight of the massive torso seems ill-supported by the tapering legs, which give to the whole a slightly Rococo flavour.

During the remainder of his life Rysbrack was occasionally again to attempt the elegant manner to which he was driven after 1740, but which was, perhaps, alien to his temperament. The most notable example of it is the statue of the 6th Duke of Somerset, signed and dated 1756, in the Senate House at Cambridge, which is not entirely happy in its use of van Dyck dress and its uneasy, arrested movement. The sculptor is far more impressive when he retains the classical costume and rich fold patterns of his earlier style. The monument of Sir John Dutton (1749) at Sherborne, Gloucestershire (Plate 95A), with its cross-legged figure leaning on an urn, owes its inspiration, no doubt, to Guelfi's Craggs (Plate 54A), but it is far more virile; and the handling of the heavy draperies behind the figure is masterly, giving a strength to the legs which the Somerset lacks. The most distinguished of his later works is, perhaps, the statue of Locke of 1755 (marble at Christ Church, Oxford; terracotta, V. and A.; Plate 107C). This splendidly designed figure, set too high to photograph adequately, supporting a great book in one hand on a slightly bent knee, with the other hand resting on the breast, has, apart from the portrait quality in the head, something of the air of an evangelist figure such as those in the nave of the Lateran; and suggests that, had England required monumental religious sculpture, Rysbrack would have been well equipped to provide it.

Some of Rysbrack's later monuments repeat almost exactly his earlier patterns – a sure sign that they were still in line with public taste. For instance, the Thomas, Lord Wyndham (1745), in Salisbury Cathedral has the same seated mourning female figure (though with different attributes) which had appeared on the Nicholas Rowe at Westminster of 1739. Sometimes two earlier themes are combined, for in the Sir Watkin Williams Wynn (erected 1754) at Ruabon, Denbighshire, the reclining figure is based on the Newton at Westminster, while the boy supporting the medallion is very close to the Gay monument, though reversed. In neither case, however, is the repetition exact: Rysbrack was not one of those artists who sets up a big workshop and is content to allow his assistants to turn out endless versions of a design. Each is, in fact, a fresh composition, with new drapery patterns adjusted to slightly altered circumstances. And there are also entirely new compositions, though not all are as successful as the works of the 1730s. Perhaps the most striking is the monument to the 2nd and 3rd Dukes of Beaufort (1754) at Badminton, Gloucestershire. Here the problem of representing two male figures has been solved by setting one upright, and the other reclining on a great fringed drapery which falls in a heavy mass down over the dark marble sarcophagus to

the white base below. The design as a whole is successful, in spite of the somewhat rhetorical pose of the standing figure; it differs from the sculptor's earlier work in its marked asymmetry; and though this is to some extent dictated by the poses of the two figures, it is deliberately stressed by the fall of the drapery. Rysbrack may by now have paid attention to Roubiliac's exploitation of asymmetrical designs, and here be trying his hand at the new fashion. The handling of this Badminton monument, with its rounded forms and deeply undercut, varied folds, is, like that of the Sir John Dutton, still in the virile Baroque manner of the thirties. In other late works, however, Rysbrack uses a slightly different system, in which the folds are smaller, more repetitive, and less rounded in form. The change is very marked in the second monument at Badminton, that of the 4th Duke of Beaufort (d. 1756), which has a single standing figure, moving forward with hand outstretched, and on the left a boy holding a coronet. It is noticeably weaker in design and execution than the monument made a few years before.

Rysbrack's late style is perhaps most clearly displayed in a signed statue of 1763 in the Musée Royal at Brussels (Plate 95B), which bears, on the base of the column on which the figure leans, the words: 'Go, and do thou likewise.' It is yet one more of the cross-legged figures in classical dress which derive from the Craggs, though in this case the urn is replaced by the column, and the figure holds an open book. In it Rysbrack has completely abandoned the flowing Baroque curves and rounded folds, deeply cut but running round or across the figure, giving it volume and adding to the dignity and balance of the design, for a style which suggests that the garments are made of thinner but stiffened material (almost, indeed, of the stiff silk of the robes of the Eloquence on Roubiliac's Argyll monument), gathered into masses which do not grow from the pose of the figure, but break in angular lines across it and confuse the eye. There can surely be little doubt that here Rysbrack had looked with care at the great series of Roubiliac monuments at Westminster, and under their impact had attempted to modify his style. This is further borne out by his own last Westminster monument (the only one of any importance he had made for the Abbey since 1740), that of Admiral Vernon (erected 1763) just inside the north door. For here, for the first time in his long career, he attempts a swiftly moving figure in the Victory running forward to crown the portrait bust. Once more, as in the Brussels statue, the effect is unhappy, for the broken, agitated draperies do not accord well with the solidly built figure, strongly reminiscent of Nicolas Poussin.

Rysbrack's best and most characteristic work is, indeed, in a direct line of descent from Poussin and Duquesnoy. He owned engravings after the former, and translated one, the Testament of Eudamidas, into a relief at Stourhead. Terracottas of Duquesnoy were included in one of the sales of his collection held before his death.[7] No doubt his interest in them, as well as his interest in the antique, was first aroused in his youth in Vervoort's studio. Combined with this instinctive admiration for the classical, and for the most classical of Baroque sculptors, he inherited also something of the tradition of Antwerp. Figures of Rubens and van Dyck were among the relaxations to which he turned when he had time to do what he liked, and their works also were represented in his sales. He cannot be regarded as a purely classical, nor as a purely Baroque artist. Those two art

historians' labels, now held to be antipathetic, meant nothing to him; but he used both Baroque and classical art as means of expression and combined them in a style at once idealistic and assured, and which perhaps more than the work of any other artist reflects the taste of Augustan England. His career throughout the fifty years he spent in this country is impressive, both for the quantity and the quality of the work he produced, and though he had few direct pupils, since he preferred to execute his work himself, his influence was great and his importance in the history of English sculpture can hardly be sufficiently stressed.[8]

It is not easy to write of the later career of Peter Scheemakers with the same respect and enthusiasm which must be accorded to Rysbrack. A vast quantity of work emerged from his studio, but though some of it is fair in quality, far too much is dull and repetitive, the work of assistants whose master had not the same personal interest in his work, nor the same integrity as an artist as Rysbrack. Neither in style nor in design (except when he was working with an architect of a younger generation such as James Stuart) can any marked development be traced; and the promise of a livelier manner seen in the Edward VI and the Shakespeare is only rarely fulfilled in informal works such as the lead statue of Captain Robert Sandes (1746, London, Trinity House; Plate 99).

Scheemakers was, presumably as a result of the success of the Shakespeare, to receive far more commissions for monuments in Westminster Abbey in the forties and fifties than Rysbrack, but the results are remarkably dull. Some of them, the Lord Aubrey Beauclerk (d. 1740), the Hon. Percy Kirk (erected after 1743; Plate 97B), and the Dr Richard Mead (d. 1754), are variants of the bust monument; but only the last (of a man Scheemakers certainly knew, since he had been one of the trustees concerned with the Shakespeare monument) has any character in the head.[9] Bust monuments, set against a pyramid or a pedimented background, and usually with rather flabby mourning boys with hourglasses or torches reversed, were sent from the workshop to many parts of the country, those to Thomas Lewis (d. 1747, Soberton, Hampshire) or to Mr and Mrs Tothill (after 1753, Urchfont, Wiltshire) being typical examples. Such monuments were probably moderate in cost, but the fact that they bore a classical bust and the signature of a famous London sculptor made them highly acceptable to the gentry who wished for a memorial in good taste. The busts themselves are usually pedestrian in quality, static and almost frontal in pose, with coarse, insensitive modelling. Scheemakers was, however, still capable of producing busts of some distinction. Though his Sir Paul Methuen (d. 1757, Corsham Court, Wiltshire) is a posthumous portrait, it is convincing; and the modelling, especially the passages round the unusually deep-set eyes, is greatly superior to that of the average bust provided for a monument. It is perhaps his tendency to allow the eyeball to protrude that gives to so many of his busts an air of stupidity; his patrons, however, must have been contented with his work, or he would not have received so many commissions.

Another type which was clearly popular was the monument with a seated female figure, sometimes allegorical but occasionally a widow, holding a medallion, often with the assistance of a boy, before the ubiquitous dark pyramid background. The most ambitious is the Admiral Sir Charles Wager (1747) in Westminster Abbey; but the

grouping is clumsy (Scheemakers was here presumably his own designer, and he lacked Rysbrack's sense of flowing curves) and the drapery of the seated Victory is arranged in awkward, flattened folds. More pleasing, because more varied in its cutting, is the monument to Dorothy Snell (d. 1746) at St Mary-le-Crypt, Gloucester, with a good profile portrait on the medallion (Plate 96A).[10]

Scheemakers's most ambitious late work is the large family piece of 1754 to Lord Shelburne at High Wycombe, Buckinghamshire (Plates 96B and 98). A great deal of care, and presumably a great deal of money must have been lavished on it, and the result is one of the grandest monuments in the classical taste of the mid eighteenth century, very different from the dramatic allegories with their flickering movement produced by Roubiliac in the same decade. The basic pattern, with the Lord Chancellor and his wife, both in Roman dress, in a semi-reclining position, is derived from Pierre Monnot's Exeter tomb at Stamford[11] (Plate 53B). Instead, however, of the single standing Virtues at the ends of the sarcophagus, Scheemakers has placed two groups of the descendants, the son with his wife and infant on the left, and two daughters and a young boy on the right. Little attempt is made to integrate the various groups into a unified whole, but they are well designed in themselves and achieve a fine Roman dignity.

The pattern with the single reclining figure, used with such distinction by Scheemakers and Delvaux for the Dr Chamberlen at Westminster about 1730, remained a popular theme in the artist's repertoire through the middle years of the century. Sometimes the male figure appears alone, against a pedimented frame, as in the John Piggott (d. 1751) at Grendon Underwood, Buckinghamshire; sometimes he is accompanied by a mourning widow (carrying on the theme of the John Sheffield, Duke of Buckingham), as in the monument erected to Charles Savile (d. 1741) by Aletheia his wife at Methley, Yorkshire. At Ledsham, in the same county, the sarcophagus on which Lady Elizabeth Hastings (d. 1739) reclines is flanked by two standing Virtues who are the less distinguished sisters of those on the Chamberlen monument; while the same two ladies, though with different attributes, are seated beside the small sarcophagus (without an effigy) of Robert, Lord Raymond (d. 1756, Abbots Langley, Hertfordshire). The figures are competently, though sometimes stiffly, posed; the drapery patterns, with their small folds running round the bodies in repeated curves, are not unpleasing; but the general effect is almost always a little pompous, and the cutting lacks life. The theme of the boys with a medallion goes on even longer, and may be seen, combined with the architectural detail of a later generation, in the monument to Charles Yorke (d. 1770, Wimpole, Cambridgeshire). The impression given by Scheemakers's later œuvre is that of a big and very active business, content to exploit its stock-in-trade, and only very rarely, as in the Shelburne tomb, ready to produce a distinguished new design.

Scheemakers was, towards the end of his life, occasionally called upon to work with an architect of a younger generation; but for all his inherent classicism his collaboration with 'Athenian' Stuart is less happy than that with William Kent. Two monuments, both almost as late as 1760, and both interesting for their content, since they exploit the colonial theme, signed by both artists, are in Westminster Abbey. That to Lord Howe, who was killed in 1758 on the march to Ticonderoga, was set up by the province of

Massachusetts Bay; the Admiral Sir Charles Watson (d. 1757) was erected by the East India Company. Both are curiously un-architectural in design. The former has a semi-nude female figure, with a skin thrown round her shoulders, seated rather uncomfortably on a large tablet; in the latter, the admiral, scantily draped in a toga, is standing under a loggia of Doric proportions, but with columns transformed into palm trees, to one of which a Mongolian captive is tied, while a be-jewelled lady offers the riches of the East. The intention would seem to be exotic; in fact, the figures, like the palm trees, are classical at heart.

The tedious character of Scheemakers's work is often so great that his importance can easily be overlooked. The casts and garden figures which he made from his antique moulds not only had a wide sale, but must also have played a considerable part in forming the taste of the many younger artists who worked in his studio. He was prepared to carry out any commissions which came his way – busts of English poets for Frederick, Prince of Wales (now at Hagley Hall, Worcestershire), statues of English generals for the East India Company, chimneypieces, of which those in the Picture Gallery and Cabinet Room at Corsham Court, Wiltshire (1764), are perhaps the most distinguished;[12] and at the other end of the scale, small ledger tablets with no figures. He never fulfilled completely the promise he showed in the figure of Chamberlen on the Westminster Abbey monument; but the sheer quantity of work coming from his studio must have made him a major influence in his own day, and several of the leading sculptors of the next generation were among his pupils.

The practice, and for a time the association with James Stuart, was carried on by his son Thomas (1740–1808). The monument to the Freman family (c. 1773, Braughing, Hampshire), designed by Stuart and executed by Thomas, has a fine sarcophagus and three double medallion portraits. Other works of about the same date, for instance the monument to Jemmet and Elizabeth Raymond (Kintbury, Berkshire) have busts in his father's manner. His prettiest monument is that to Mary Russell (1787, Powick, Worcestershire; Plate 133B), which has a charming relief, quite uninfluenced by the rising neo-classicism of its time, showing the mother giving her child a music lesson.[13]

The later works of Henry Cheere, though numerous, are with rare exceptions less considerable in size than those he achieved before 1740, and he can never have aimed at becoming the leading sculptor of his day. Some part of his time, indeed, was given to activities outside sculpture, for in 1745 he became a Director of the Westminster Fire Office, and in 1749 was appointed Controller of Duties for the Free Fish Market in Westminster. The latter was no doubt a sinecure, but it suggests that he played some active part in the life of the borough, and he must have been known as a public figure rather than as an artist when, in 1760, he was chosen by the County of Middlesex to present a congratulatory address to George III on his accession. For this he was rewarded by a knighthood, and in 1766 was granted a baronetcy.[14] On the other hand, his relations with his fellow-artists were good, and in 1748, after the Treaty of Aix-la-Chapelle, he went with the painters Hogarth, Hudson, and van Aken for a trip to Paris and the Low Countries, a journey which is chiefly famous as being the occasion on which Hogarth was imprisoned as a spy. He was also concerned in the mid 1750s with abortive

attempts to found an Academy of Painting, Sculpture, and Architecture,[15] and was the first sculptor to be elected a Fellow of the Society of Antiquaries.

His most attractive later work, and perhaps his chief contribution to English sculpture, is the medium-sized Rococo monument with no effigy, though often with a bust. Free use is made of coloured marbles, and the design generally includes boys playing round an urn, wreaths of flowers, and a well-designed Rococo cartouche bearing the inscription. Several such monuments may be seen in Westminster Abbey: Sir Edmund Prideaux (d. 1741), Boulter, Bishop of Armagh (d. 1742), Cheere's cousin, Sir John Chardin (d. 1746), Captain Philip de Sausmarez (d. 1747; Plate 97A), and Dean Will-cocks, with its fine relief of the abbey of c. 1756. Other monuments, easily recognizable as by Cheere (some, but not all are signed), retain the pyramid background and have a bust set on a sarcophagus. Among them, the William Cust (d. 1747) at Belton, Lincoln-shire, has an agreeable arrangement of naval trophies fanning out on either side of a shell below the bust, though the bust itself is somewhat dull and lacks the vivacity of the rest of the design. An almost identical arrangement of trophies, with a bust of a different pattern, appears on the more elaborate monument to Vice-Admiral Henry Medley at York, made at about the same time.

In the busts on the later monuments the tricks seen earlier in the arrangement of draperies still appear; the folds are small and crumpled, the edges turn over, and, even when the bust has classical rather than modern dress (as in the John Scrope, d. 1752, Lewknor, Oxfordshire, which though not signed must certainly be his), the small and broken rhythms are very different from the larger, rounded folds of Scheemakers. Most of the busts are almost frontal, but in the David Polhill, made in 1755, at Otford, Kent,[16] he uses a pattern closer to Roubiliac, with the head turned over the wide shoulders, and the cloak coming down in a big diagonal to balance the twist of the head. In this monument the finely cut architectural detail, which includes scale and wave forms, seems almost to herald neo-classicism; but the play of curves in the base, the cartouche set high on the pyramid background, and the asymmetrical treatment of acanthus below (though this may have been increased by damage) link it still with the Rococo.

A comparable mixture of the antique and the Rococo can be seen in one of Cheere's rare late standing figures, that of Cholmley Turner of 1761 at Kirkleatham, Yorkshire.[17] The design of the cross-legged figure leaning on an urn goes back to Guelfi's Craggs, and the urn itself is severe, with no ornament except gadrooning. Turner's clothes are a curious mixture: a loose shirt, a toga-like cloak, knee breeches, bare legs, and Roman sandals. But though for some years this monument, like the earlier one in the same mausoleum, was thought to be by Scheemakers, the discovery of the payment to Cheere makes what was a puzzling figure completely explicable; for though this is palpably an exercise in the manner of Scheemakers, the handwriting is clearly that of Cheere. The small rhythms, the turned-back and slightly broken edges of drapery, even the modelling of the bare arms and legs with their rippling muscles, betray the approach of a Rococo artist. After Roubiliac (but a long way after Roubiliac) he is the chief exponent of the Rococo in England, and his charming, small monuments found their admirers and their imitators in many provincial centres.

Cheere is known to have had a number of apprentices in his workshop at Old Palace Yard, Westminster, the most important being Richard Hayward (1728–1800), who went to him in 1742 on the death of his first master, Christopher Horsnaile, and who later in life built up a considerable practice of his own.[18] Since his known independent works are all after 1760, it is possible that he continued to assist Cheere after he had served his time. The work coming from the Westminster yard after about 1740 is, as has been suggested, uneven in quality, and though the designs are likely to be by Cheere himself, the cutting, which may have been largely left to assistants, rarely reaches the quality of the Lord Raymond or the Admiral Sir Thomas Hardy of the 1730s.[19]

Henry Cheere's younger brother John (1709–87) emerges as an independent sculptor shortly before 1740 when, having worked for a time with Henry, he took over a yard at Portugal Row, Hyde Park Corner, from Anthony, a younger member of the Nost family.[20] With the yard John Cheere almost certainly acquired moulds for garden figures, notably that of the kneeling negro, which had been used by the elder John Nost;[21] and he went on to build up a considerable practice in this field. He was not only willing to supply 'the Gods of Athens and of Rome',[22] but also 'Punch, Harlequin, Columbine and other pantomimical characters; mowers whetting their scythes, haymakers resting on their rakes, gamekeepers in the act of shooting and Roman soldiers with firelocks . . .'.[23] In short, he was prepared to cater for all tastes, the classical, the Rococo-pastoral, or with his shooting gamekeepers, the English love of a practical joke. His figures were cast in lead, but according to J. T. Smith they were 'frequently painted with an intention to resemble nature'. Many of his figures still adorn the gardens for which they were made, but hardly any are painted, and so the full Rococo effect of figures like enlarged and rather clumsy Chelsea porcelain is lost.[24] Moreover, almost all his remaining identifiable figures are of classical subjects, such as the Augusta and Flora for Longford Castle, Wiltshire (1759), the River God made for Stourhead in 1751, followed by eight other gods and goddesses in 1766, or the series of figures bought up by Samuel Whitbread in 1812 and erected at Southill (Plate 107B).[25] Naturally in many cases they follow a known and popular classical prototype, often, however, slightly changed. For instance, his Longford Castle Flora, though based on the Farnese statue, is lighter and more slender than the original, with a long neck and small head; in other words, it has become more Rococo.

John Cheere also evidently had a considerable practice in the provision of plaster busts and statues, mainly of classical or English scholars, for libraries and staircases. His prices were reasonable, two guineas for a bust and about eight guineas for a statue, so furnishing in good taste was cheap.[26] On the other hand, surprisingly few commissions for monuments or portraits are known. Of the former, that to James Lawes (d. 1733) at Halfway Church, Jamaica, appears to be the only signed example, but the gilt bust of the 2nd Duke of Atholl (signed and dated 1748) at Blair Castle proves that he was not without some ability as a portraitist. The decorative quality of the dress, with a richly braided coat and the Order of the Thistle, is exploited to the full, as is the freely treated, wavy hair, and the features, if a little heavy in modelling, have the air of a good likeness.[27] His only known statue, however, outside the field of garden figures, that of

Robert Gordon, erected in 1753 on the Robert Gordon Hospital at Aberdeen, is with its twisted pose, broken draperies, and uneasy stance, an unhappy attempt to emulate the style of Roubiliac.[28] Like that of his brother, John Cheere's art is predominantly Rococo, but before his death in 1787 new forces – the development of organized academic training and the rise of the neo-classical movement on the Continent – were moulding English sculpture, and his work must already have appeared out of date.

CHAPTER 17

THE IMPACT OF THE FOREIGN SCULPTORS

THE consideration of the later works of the leading foreign artists has carried the history of English sculpture well into the second half of the eighteenth century. It will now be necessary to return to the 1720s and 1730s in order to examine the influence of these foreigners on English-born sculptors. As might be expected, it was very great.[1] Englishmen not only adopted the new types of monuments and, if they were lucky enough to get commissions for them, of busts, but they also imitated the foreigners' cutting. The general standard of sculpture had, indeed, risen so greatly by the 1730s that it sometimes comes as a surprise to find that a monument with a good effigy in antique dress is by an Englishman; and occasionally in the case of an unsigned and undocumented monument which closely follows a known foreign pattern, it is by no means easy to decide on the maker. For instance, the monument of the 3rd Earl of Dysart (d. 1727, Helmingham, Suffolk) takes over the reclining and seated figures from the Westminster tomb of John Sheffield, Duke of Buckingham,[2] though not the figure of Time; and the cutting, close to but not identical with the original, could be the work of an Englishman such as Thomas Carter or Joseph Rose. The impression made by the Flemish immigrants is particularly well demonstrated in the only two signed monuments by the latter artist. In the Sir John Packington (d. 1727, Hampton Lovett, Worcestershire), there is nothing of the new manner. The effigy, in contemporary dress, reclines on a gadrooned sarcophagus, and the treatment broadly speaking is that of the generation of Francis Bird. The tomb of Richard Ladbroke (d. 1730, Reigate, Surrey), on the other hand, is a much more ambitious affair, replete with coloured marble columns, a figure in Roman armour resting on a skull with a celestial crown in his hand, standing figures of Truth and Justice at the sides, and trumpeting angels above. The design, with the effigy silhouetted against a pyramid within the columns, must surely be derived from Gibbs and Bird's Newcastle monument; but the vigorous modelling of the main figure, and indeed the padded mattress on which he lies, is quite unlike Bird's handling, and must be the result of a careful study of Scheemakers's effigy on the Buckingham tomb.

For many English craftsmen, it would seem that the appearance of Gibbs's *Book of Architecture* in 1728, in which many designs for monuments were included, was even more influential than the sculpture produced by the foreigners by that date. Sometimes a design is fairly closely repeated; more often a Gibbsian frame encloses a somewhat naïve arrangement of figures. An extreme example of this can be seen in the monument to William Lytton Strode (1732, Knebworth, Hertfordshire), signed by John Annis, a London mason–sculptor. Here almost every detail of the pedimented frame supported on brackets is taken from Gibbs, but in front of it kneel two figures using the neat Gibbsian sarcophagus as a prayer-desk, while the front of the sarcophagus and the background above it are adorned with curiously pastoral family reliefs. Annis's

younger brother, James (*c.* 1709–75), was to carry on the mason's business into the second half of the century, but his rare monuments suggest that he was a sculptor of some accomplishment, and also indicate that the mason–sculptors and their patrons were happy to combine the old and the new. For instance, his signed monument to Sir George Fettiplace (d. 1743, Swinbrook, Oxfordshire; Plate 102A) has a fine bust in contemporary dress in which the lively treatment of the wig, the wide shoulders, and the careful diagonals of the drapery show that Annis knew something of the portrait busts of both Rysbrack and Roubiliac. The bust is, however, set under a canopy tied up with cords and revealing a glory of cherubim, a device which can be paralleled in Crutcher's Clayton monument of 1705 (Plate 50A), but not in the work of the immigrant sculptors in the 1740s.[3]

The man who illustrates perhaps most completely the transition from the semi-Baroque of Nost, which had lost all contact with the antique or with Italy, to the new manner derived from Gibbs and the Flemish sculptors is Andries Carpentière or Andrew Carpenter (*c.* 1677–1737).[3a] He may himself have been a Fleming, for he was for some years principal assistant to Nost, and carried on the latter's practice in lead garden figures. His known monuments are after 1720, and hesitate between the old and the new. The Sir John Thorneycroft (1725, Bloxham, Oxfordshire)[4] has a reclining bewigged figure in what is perhaps intended to be classical dress in front of a pyramid set between pilasters, but the pose and the flat looped folds running over the legs look back to Quellin's Tom Thynne. On the other hand, the year before this Carpenter had been working from the Gibbs design with two portrait medallions above a plain sarcophagus for the Montague Drake monument at Amersham, Buckinghamshire;[5] and he was to repeat this very closely, though with frontal and not profile medallion portraits, for Henry and Langham Booth (1727, Bowden, Cheshire). His most important monument, that to the Earl and Countess of Warrington (1734; Plate 100A) is in the same church; and its design, with figures of Learning and Truth seated on the sarcophagus, is a direct imitation of the Gibbs design, carried out by Rysbrack, for the Westminster tomb of Mrs Katherine Bovey (Plate 100B).[6] The proportions have been clumsily adjusted, presumably to fit the space available, and the figures are heavy and crude.

Another transitional and somewhat puzzling figure is William Palmer (1673–1739), who, after an apprenticeship to a minor mason–sculptor, James Hardy (*c.* 1655–*c.* 1721),[7] worked for a time with Nost. He is known to have erected Pierre Monnot's great Exeter tomb at Stamford when it arrived from Rome in 1704 and to have cut the inscription on it.[8] In 1706 he was working for a 'marble-setter' in London, and four years later had his own workshop in Red Lion Square, making chimneypieces and carrying out mason's work as well as tomb sculpture. It is difficult to believe that he cut the striking, twisted figure on the monument of the Hon. Margaret Rockingham (d. 1713, Rockingham, Northamptonshire),[9] which with its small head and mannered gestures has almost a suggestion of German Rococo art, and here again he may simply have been erecting imported work. The sources of his documented works of the 1720s are fairly obvious. The bust monument to Sir Charles Hussey and Lady Anne Brownlow (after 1720, Claythorpe, Lincolnshire) is palpably in the manner of Gibbs, with a male bust in

a soft cap, perhaps derived from Coysevox's Prior; but entirely without its vitality, for the bust is almost frontal, so that the cap frames the face like a clumsy halo. In 1726, however, he made the much more original monument to Lord Lexington (Kelham, Nottinghamshire; Plate 102B),[10] with two reclining figures, the man being in classical armour, set back to back on a padded mattress. Here the figures are broadly built and Palmer has clearly been looking at Scheemakers's reclining effigy of the Duke of Buckingham (Plate 55). Since, however, he had no pattern for the wife, she is more awkward than her husband. The cutting, though insensitive in the heads, is obviously imitated from that of the Flemings, but the unusual design appears to be his own. Palmer's lesser monuments, of which some fifteen or twenty are known, are less inventive. Several are tablets without figures; a few have undistinguished busts. Indeed, had it not been for the Lexington contract, which seems conclusive, it might have been easier to suppose that Palmer was primarily a marble-setter, occasionally carrying out small monuments on his own account. As it is, however, he must be accepted as an artist of some modest potentiality, who had learnt a good deal from better works he had seen.

There can be little doubt that the greatly increased popularity among minor sculptors of the medallion portrait was chiefly due to Gibbs's designs. He shows it suspended by ribbons from a pyramid, or as in the engraving of his design for Rysbrack's monument to John Smith (Westminster Abbey) held by a mourning lady, or in other plates, it is supported by boys. Such types were particularly dear to Thomas Adye, or Adey (worked 1730–53), who adapts the Gibbs motives with some competence. His monument to Charles Sergison (d. 1732, Cuckfield, Sussex; Plate 101B) takes the seated lady from the Smith monument, placing her on an almost identical sarcophagus, though the medallion is on her left instead of her right, and for good measure is also supported by a boy. The William Mitchell (d. 1745, Fowlmere, Cambridgeshire) is very similar, though here the boy holds an extinguished torch, and the portrait, instead of being in profile, is almost full-face and wears the loose cap probably borrowed from Roubiliac. The weeping boy with the torch appears by himself on the monument to Lane Harrison (d. 1740, Perivale, Middlesex); two boys hold a draped medallion with a profile portrait of Henry Hall (erected c. 1742, Bengeo, Hertfordshire); while a lady alone supports that of Sir James Hallett (d. 1733, Little Dunmow, Essex). The treatment of both figures and boys, the former with deeply cut draperies arranged in both large and small folds, suggests that Adye was modelling his style on that of Rysbrack, but his sense of the structure of the figure is weak. He must, however, have had a reputation above that of most of his fellow-countrymen, for he acted as sculptor for the Society of Dilettanti, and through them became one of the very few English sculptors in the first half of the century to obtain a commission for a portrait bust, that of the 1st Earl of Westmorland, which is known in two versions (Sir John Dashwood Collection and V. and A., the latter dated 1742).[11] The sitter wears a close-fitting Roman cuirass; his hair, though short, curls more richly than would be likely in a classical bust by Rysbrack, and the modelling of the face seems a little hesitant, notably round the eyes.

Busts on monuments had been common enough before the fresh impetus given by Gibbs's publication. Many of tedious quality were still to be produced, but if they were

set in a frame, the relation between the two tends to improve. Moreover, Gibbs had included a plate of the Prior monument at Westminster in his book, so that Coysevox's bust *en negligé* was known outside London. It does not, however, seem to have been much borrowed except by London artists. Christopher Horsnaile, Edward Stanton's partner, drew on it for his monument of Sir John Phillips (d. 1736, Haverfordwest, Pembrokeshire), and towards the middle of the century it was used with much greater vigour by Sir Robert Taylor (1714-88) in, for instance, the monument to William Phipps (d. 1748, Westbury, Wiltshire; Plate 103A). Taylor was the son of a mason of the same name who signs the tomb of Robert Deacon (d. 1721, Peterborough Cathedral), a work in the manner of Francis Bird, and a number of smaller monuments, none very high in quality. The son was apprenticed to Henry Cheere, and paid at least a short visit to Italy. Cheere's influence is very apparent in his pupil's monument to General Joshua Guest (1752, Westminster Abbey), commended by Vertue as the work of an Englishman who had improved himself in Italy.[12] It has pretty Rococo detail, but the bust, though a Rococo version of the antique in its design, has no liveliness in the modelling of the features. The more ambitious monuments to Mary Chetwynd (d. 1750, Grendon, Warwickshire) and Sir Henry Penrice (d. 1752, Great Offley, Hertfordshire; Plate 101A) have full-length figures, the former foolish in character, but the latter more successful in design, and again in the treatment of both drapery and decorative detail revealing the influence of Cheere.[13] Taylor is perhaps notable as the author of the largest piece of architectural sculpture of the middle of the century, the pediment of the Mansion House, London (1744-6), but its tedious design and clumsily modelled figures suggest that the scale was beyond him. He is, indeed, said to have left much of the work to assistants, and about 1753 he gave up his career as a sculptor and turned to architecture.[14] He was not the only sculptor who had links with architecture and who was also attracted by the bust *en negligé*. Roubiliac's busts, rather than Coysevox's Prior, must have been the main inspiration for William Halfpenny's monument to Mrs Anne Dash (d. 1750, Isleworth, Middlesex), for her bust, set in the centre on a small pedestal, has a scarf over the head, somewhat in the manner of Roubiliac's Lady Murray, while above on medallions tied to the ground are two further busts, both informally dressed.[15]

Among the most competent works in the new manner were those from the yards of Thomas (d. 1756) and Benjamin (d. 1766) Carter.[16] They had a flourishing business as makers of marble fireplaces, working sometimes in partnership and sometimes individually, but until Thomas's death it would seem that it was he and not Benjamin who produced monuments, though after 1756 the younger Thomas worked for a time on them with his uncle. As has been said,[17] Roubiliac is stated to have worked for a short time with one or other of the Carters when he first came to England, though precisely when or for which brother is uncertain. Thomas Carter I seems to have adopted the pyramid background, either from Gibbs's book, or from its use in the Westminster monuments of the foreign sculptors, before he was prepared to attempt the full classical manner. His bust of Sir Harry Every (d. 1709, but erected later, Newton Solney, Derbyshire) may well be an early work, for with the pyramid is a semi-nude reclining figure which descends, perhaps through Carpentière, from Quellin's Thomas Thynne.

Gibbsian detail again appears with two ably modelled reclining figures on the monument to Speaker Connolly (d. 1729, Celbridge, Co. Kildare), while in the next decade he was to use the bust *en negligé* for Sir Cecil Wray (d. 1736, Bramston, Lincolnshire). By this time he had assimilated the style of the foreign masters, and especially of Rysbrack, to a remarkable degree, as may be seen in the monument to Colonel Thomas Moore (after 1746, Great Bookham, Surrey; Plate 103B). This has a vigorous reclining figure in Roman armour, which must owe something to Rysbrack's Stanhope at Westminster, in front of a pyramid adorned with an elaborate military trophy in high relief. The cutting is coarser than Rysbrack's, but the same rounded forms occur. It is likely that Carter also made the adjacent monument to William Moore (d. 1746), which has a good profile medallion.

The work of the younger Thomas Carter is puzzling, for though he lived almost to the end of the century some of it remains surprisingly Baroque, while one work is of such high quality that it is hard to account for the relative incompetence of almost contemporary monuments. The fine but damaged monument to Colonel Roger Townshend (d. 1759, Westminster Abbey) was designed by Robert Adam and is therefore elegantly neo-classical in detail. It is signed by both Benjamin and the younger Thomas, and presumably they cut the handsome caryatids supporting the sarcophagus. Since Townshend was killed at Ticonderoga, they probably represent Red Indians, though they are in fact of no recognizable race, but simply 'noble savages'. The bold and rounded modelling of their limbs is, however, in spite of the association with Adam, still much in the manner of Rysbrack, while the mutilated relief of the death-scene, signed by a German assistant, John Eckstein, is for all its use of classical trappings extremely Rococo in handling.[18] A later work, the tablet to Mrs Benyon (1778, Englefield, Berkshire) is very strange, for it bears a theatrical relief of the lady contorted in her death agony tended by women frenzied with grief. The style and gestures seem almost a travesty of Bernini, and the bunched and twisted draperies are unexpected at so late a date. Deeply cut and complicated draperies also appear in the far more distinguished monument to Chaloner Chute (erected 1775, Basingstoke, The Vyne; Plate 106). In this memorial to the famous Speaker of the House of Commons (d. 1654) devised by his descendant who was an intimate friend of Horace Walpole, Carter's dramatic instinct has stood him in good stead. The striking figure owes much to its position and above all to its lighting, but nevertheless the quality of both design and cutting are so high that had Carter's bill not specifically included a payment for the figure, an early attribution to John Bacon would be more acceptable.[19] Again there is no hint of neo-classicism, but an assured naturalism for which it is hard to find a close parallel.

The activities of the Carter workshop have taken the discussion of the output of English-born sculptors far beyond the influence of Gibbs and the foreign immigrants. Many other instances of this could be quoted in the first half of the century. The two William Woodmans, father and son, have their roots in the seventeenth-century mason tradition, for the elder Woodman (*c.* 1654–*c.* 1731) finished the monument to the 4th Earl of Leicester (1704, Penshurst, Kent) begun by William Stanton. By about 1730,

however, in the larger monument to Lord and Lady Newhaven (Drayton Beauchamp, Buckinghamshire; Plate 104),[20] he and his son were using Gibbsian architecture and the pyramid background, and placing the lady seated at her husband's feet in what is, perhaps, a variant of the Scheemakers–Delvaux Buckingham tomb. The cutting is far more lively than that of a mason–sculptor of a slightly older generation, such as Thomas Green of Camberwell, and shows that the Woodmans were capable of learning much from the new work appearing in London. The younger Woodman has, indeed, in the monument of Daniel Dodson (d. 1741, Cheshunt, Hertfordshire) left a valuable record of the original appearance of Guelfi's Craggs, with its lost pedimented background. Though, however, the pose is almost exactly repeated, the treatment of, for instance, the arms and legs is less generalized and more detailed, and the drapery hangs in smaller, crumpled folds.

Charles (Simon Carl) Stanley (1703–61) was not English born, but is best mentioned here. He was trained in Denmark, the country of his birth, as a stuccoist, and much of the work he carried out in England between 1727 and 1746 lies in the field of interior decoration. He also made two tombs of some distinction, Thomas Maynard (1742, Hoxne, Suffolk) and the family piece to Lord Maynard (1746, Little Easton, Essex). In their use of antique dress they have links with the work of the Flemings, though the broken and rippling draperies are closer to the style of Cheere. The main standing figures are uneasily posed, but, as might be expected from Stanley's training, the reliefs, notably those on the Little Easton tomb, are handled with great fluency and charm. His work in stucco is even closer to the Rococo than his sculpture, for his portrait of the architect Colen Campbell, on a ceiling at Compton Place, Eastbourne (c. 1728; Plate 105A) is a typically Rococo transformation of the Baroque bust en negligé. Much fine work in stucco was also produced by Italian craftsmen, though not all of it can be considered as sculpture. The best known names are those of Artari and Bagutti, who worked with William Kent at Houghton, Norfolk, and elsewhere; but many attractive schemes of decoration, such as that at Barnsley Park, Gloucestershire (c. 1720–31; Plate 105B) are anonymous. They are, however, further proof of the variety of styles acceptable to English patrons, and of the fact already noted that the fashion for Palladio and the antique was combined with a taste for richness and even gaiety in decoration.

Sculptors trained outside London were naturally slower in assimilating new ideas, and even by the middle of the century, though they may borrow from Gibbs, they may still also retain seventeenth-century motives. Charles Mitley of York (1705–58) can be quoted as an example, for his monument to Mrs Ramsden (1755, Adlingfleet, Yorkshire) has a Gibbsian frame though no pyramid, and the standing figure of the lady herself seems a feeble daughter of the left-hand Muse in Gibbs's engraving of the Prior monument. Mitley also borrows from this the festoons and the cherub's head, but he treats the former naturalistically, almost in the manner of Nost, and his cherub's heads rise out of a frill of clouds, which has no parallel in the designs of Gibbs.

The Patys of Bristol, a firm whose activities extend over three-quarters of the century, produced better work. Thomas (1718–89) and his son William (1758–1800) were the most prominent sculptors of the name, and though their work is chiefly found in the

West Country they occasionally obtained orders from farther afield. Thomas Paty picked up the idea of the bust *en negligé*, and used it for his monument to William Hilliard (1735, Bristol, Lord Mayor's Chapel), but as with so many English-born sculptors, he does not understand the value of the turning movement of the Prior, and his frontal portrait, though competent, is therefore a little dull in design. Much of their work consists of good tablets without figures, generally in coloured marbles; but late in the century William was inevitably attracted by the current popular theme of mourning ladies with an urn.[21]

The growth of good provincial workshops was to be characteristic of the eighteenth century, but the other major firms, the Kings of Bath and the Fishers of York, came into being too late to be considered here.

PART FIVE

THE FIRST ROYAL ACADEMICIANS

CHAPTER 18

INTRODUCTION – JOSEPH WILTON – AGOSTINO
CARLINI AND WILLIAM TYLER – SOME CON-
TEMPORARY SCULPTORS

Introduction

In the first half of the eighteenth century, English sculptors, like English painters, were still largely dependent for training upon what they could learn in the studio of another artist. The St Martin's Lane Academy, which grew out of the Academy established by Sir Godfrey Kneller in 1711 and then taken over by Sir James Thornhill, provided some opportunity for drawing both from the life and from the antique, and was 'visited' by artists of distinction, such as Hogarth and Roubiliac. It was not, however, a school in which continuous instruction was given, but a society of artists who held regular meetings for their mutual benefit, and who became increasingly conscious that England lagged behind other countries in the absence of a central organization prepared to train young artists, to award prizes for works of merit, and to hold exhibitions at which paintings and sculpture could be seen by the public. The complicated story of the attempts made to obtain these objectives before they were finally achieved by the foundation of the Royal Academy in 1768 need not be discussed in detail here, though certain aspects of it, of special interest in the history of sculpture, must receive some attention.[1]

The foundation in 1754 of the Society for the Encouragement of Arts, Manufactures, and Commerce (now the Royal Society of Arts) gave incentives to young artists by the award of premiums, and a high proportion of the sculptors active in the later part of the century had, in their youth, benefited by these awards.[2] It was to this body that Sir Henry Cheere, who with Roubiliac and Joseph Wilton were the sculptor-members of the Society before 1764, presented in 1755 an abortive plan for an Academy of Painting, Sculpture, and Architecture which had the support of the Society of Dilettanti.

In 1760 the group of artists, led by Hogarth, who had been gratified by the public interest in the works they had given to the Foundling Hospital,[3] borrowed the rooms of the Society for an exhibition. Difficulties, however, arose about methods of admission, and in the next year the artists, who now called themselves the Society of Artists of

133

Great Britain, held a rival exhibition in a room in Spring Gardens. This Spring Gardens Exhibition of 1761 is of some importance in the history of English art not only because it was the first to be held under the management of artists, but also because it was clearly regarded by many of them as a direct challenge to the pretensions of the connoisseurs. Roubiliac, indeed, defended the position of the artists in verse, printed in the *St James's Chronicle* of 14 May 1761, and stuck up in the Exhibition Room:

> Prétendu Connoisseur qui sur l'Antique glose,
> Idolatrant le nom, sans Connoitre la Chose,
> Vrai Peste des beaux Arts, sans Goût sans Équité,
> Quitez ce ton pédant, ce mépris affecté,
> Pour tout ce que le tems n'a pas encore gaté.

> Ne peus tu pas, en admirant;
> Les Maîtres de la Grèce, & ceux de l'Italie
> Rendre justice également;
> A ceux qu'a nourris ta Patrie?

> Vois ce Salon, et tu perdras,
> Cette prévention injuste.
> Et bien étonné Conviendras
> Qu'il ne faut qu'un Mécenas
> Pour revoir Le Siècle d'Auguste.[4]

In this odd defence of the work of his adopted country Roubiliac's pen has not the pungency of his chisel, and cannot compare with Hogarth's tail-piece to the Exhibition catalogue, which shows a monkey dressed as a connoisseur watering dead trees. The verses are, however, a clear enough indication that, for all the sculptor's expressed admiration for Antiquity after his journey to Rome, he felt that the increased importation of antique works was a danger to the development of the art in England.

The quarrels of the Spring Gardens artists, who in 1765 obtained a Charter from the king and became the Incorporated Society of Artists, among themselves and with those younger artists who, hoping to obtain premiums from the Society of Arts, continued to exhibit with the latter, cannot be followed here, though the latter group, calling itself the 'Free Society of Artists', continued its exhibitions until 1774.[5] By then, owing chiefly to the energy of the architect Sir William Chambers, the problems were largely solved, for he obtained the support of George III for the foundation of the Royal Academy in 1768. Yearly exhibitions were now held, and the Academy Schools were founded.[6] Here, under the general control of the Keeper, students could study regularly from the model, advice being given to them by the Visitors, that is to say, the Academicians and Associates who were elected to serve for a month at a time. The system cannot be compared to the rigid discipline of State Academies on the Continent, but the Royal Academy has never been controlled or subsidized by the state; and the pupils at least had the benefit of contact with and criticism from the leading artists of the day, the general tenor of their instruction being indicated clearly enough in the *Discourses* delivered by Sir Joshua Reynolds, the first President, in which the precepts of art are

defined. Further, the Academy established a library of books and engravings which young artists could study and gave prizes which enabled some to travel abroad. How far the foundation of the Royal Academy was an unmixed blessing is a controversial question; but as far as sculpture is concerned it can perhaps be held that the general level of competence in the later part of the century is higher than before, though there are no individual sculptors whose work as a whole reaches the standard of Rysbrack and Roubiliac. The fact that the establishment of the Academy Schools was closely followed by the rise of neo-classicism led, inevitably, to a conformity of style far greater than anything that can be found in the first half of the century, and which, even in the hands of a talented man, quickly became lifeless and dull. Naturally, however, the effects of the new academic training were not immediately evident, and the work of the three sculptors, Joseph Wilton, Agostino Carlini, and William Tyler, who were Foundation Members of the Royal Academy, is still linked with the Rococo and even with the Baroque.

Neo-classicism, which will be discussed in a later chapter, was to take a slightly different form in England from that in any other country for, as has already been suggested, the exaggerated veneration for the antique which Roubiliac deplores in his poem was already strong. Indeed, up to the 1760s it was undoubtedly stronger in England than in any country north of the Alps. The middle years of the century saw a great increase in the trade in real, part-real, or completely false antiques which found their way into English collections. English artists living in Rome acted as agents, sometimes buying works discarded by the great Roman collectors such as Cardinal Albani, but more often newly excavated fragments, which were then 'restored' by Italian sculptors. The younger Matthew Brettingham, who bought for the Earl of Leicester (Holkham Hall, Norfolk), Lord Orford (Houghton Hall, Norfolk), and the Earl of Egremont (Petworth House, Sussex), was perhaps the leading Englishman concerned in the trade up to the mid 1750s; after that time negotiations were generally carried on through the painter Gavin Hamilton, or the much less reputable Thomas Jenkins. Both had a great and genuine knowledge of works of art, but whereas Hamilton was a man of integrity, Jenkins was not only prepared to line his own pockets to an outrageous extent, but also to sell to serious collectors for a high price, works which he knew to be made-up pieces. A characteristic example of his dealing is the Venus bought by William Weddell in 1765 and still at Newby Hall, Yorkshire, the torso of which was found by Gavin Hamilton in the cellars of the Barberini Palace in Rome and sold for a modest sum to Jenkins. A head was added, probably by Bartolommeo Cavaceppi, who had a large practice as a restorer, the whole figure was largely re-worked, and it was then sold for a very large price as an uninjured antique.[7] Naturally, some fine authentic pieces found their way to England, in spite of the competition of the great Roman collectors, but since the English were encouraged by Jenkins and his Roman associates to admire only unmutilated statues, very few complete works bought at this time can be regarded as beyond suspicion.

Not only was the trade in antiques enormous, but both Italian and English sculptors were commissioned by English patrons to make copies.[8] Eight such figures, bought by

Lord Malton for his father, the Marquess of Rockingham, are still at Wentworth Woodhouse, Yorkshire. Two are by Joseph Wilton, two by Simon Vierpyl, a pupil of Peter Scheemakers, one by Giovanni Battista Maini, two by Filippo della Valle (normally a Rococo sculptor of great charm), and one by the restorer, Cavaceppi. Horace Walpole, wishing to set up a monument to his mother in Westminster Abbey (Plate 107A), ordered a figure of a Roman matron from della Valle in the early 1740s,[9] and these works are so completely different from those normally produced by Italians at the time that they must reflect the taste of the patron rather than that of the artist.[10]

The formation of the great collections of antiques in the middle of the century must have profoundly affected the taste of many English patrons, though it does not necessarily follow that it gave untravelled artists a greater chance of studying antique works. One collector did, however, make an attempt to do something for such men. In 1758 the Duke of Richmond opened in his house in Whitehall a gallery of casts from which young artists could draw.[11] Joseph Wilton and his friend the decorative painter Giovanni Battista Cipriani were in charge, and for a time at least gave the student some instruction. Bills among the Goodwood Archives[12] show that some of the casts were supplied by Matthew Brettingham in 1756, while other bills were paid to Wilton, who had himself returned from Italy in 1755. The list includes many of the same well-known statues – the Dying Gladiator, the Apollo Belvedere, the Flora of the Capitol – that had appeared in Vertue's list for his ideal art school, or had been brought in cast form to England by Scheemakers.[13] The Apollo Belvedere was indeed a marble and not a plaster copy, made by Wilton for £100, and the same sculptor charged £150 for a marble copy of the 'Medicaen [sic] Faun'. More interesting than the predominance of stock antique pieces is the evidence that admiration for Italian Renaissance and even Baroque works was still alive. Casts were provided of Duquesnoy's S. Susanna, Giovanni Bologna's Samson and a Philistine, the relief and '3 colossal heads' from his Rape of the Sabines; a Ganymede by Cellini and the Bacchus of Sansovino; '2 large Women's Heads by Cav. Bernini'; '2 large hands by Legros' '2 casts of M. Angelo's David's feet, colossal', and his Bacchus (said by Edwards to be the only cast of the figure in England), which had to be mended on arrival; and a Triumph of Ariadne described as 'from Lorenzo Guiberti'.[14] So catholic a collection would have been unthinkable a generation later, when the works of Duquesnoy as well as those of Bernini were to be hurled into the limbo of 'false taste', from which they have only in this century been rescued. The duke's venture does not seem to have met with the success which it deserved, and was naturally, to some extent, superseded by the foundation of the Royal Academy Schools.[15] The gallery remained open until about 1790, and was chiefly used by members of the Incorporated Society of Artists, who were unwilling to accept favours from the Royal Academy. It was then apparently closed because of hooliganism;[16] and it is not possible to determine how far it affected the development of sculpture in England.

One further point must be briefly noted before the work of the first sculptor Academicians is discussed. George Vertue died in 1756, and there is no source for the second half of the century which can compare with the daily gossip of the studios recorded in his *Note-Books*.[17] In most cases the vivid personal details are, in future, lacking. Refer-

ences in letters or in the daily press are frequent enough, and much information was put together early in the next century by J. T. Smith in the brief lives of sculptors which he added to the second volume of his *Nollekens and his Times*, published in 1828. More is to be found in Allan Cunningham's *Lives of British Painters, Sculptors and Architects* of 1830, the third volume of which was reserved for sculptors. Both these books, however, reflect in their judgements the taste of a later age, and apart from the views of Sir Joshua Reynolds (and his *Discourse* on Sculpture was not delivered until 1780), it is hard to assess what artists themselves thought about sculpture between about 1750 and 1790. Their work, however, suggests that up to the mid 1770s, and later in some cases, the catholic taste reflected in the Duke of Richmond's cast gallery was agreeable to patron and artist alike.

Joseph Wilton

Joseph Wilton (1722–1803), the most important of the three sculptors who became Foundation Members of the Royal Academy in 1768, is a baffling and disappointing figure. He had a better training than any other English sculptor of the eighteenth century; his best work proves that he had genuine talent; and his position and opportunities were such that he might well have achieved a position of eminence and authority comparable to that of his friend, Sir William Chambers, in a rank only second to that of Reynolds himself. Wilton is, however, a most uneven artist, producing on occasions work which is feeble in design and totally uninspired in handling; and though in the late 1760s he had hardly a serious rival, his desire to become a social figure distracted him from his art, and he never attained the position of distinction which might have been his. Moreover, his style is ambiguous, hesitating constantly between the classical and the Baroque, and he never seems certain which way he is going. Nevertheless, his influence was considerable, and echoes of his handling may be seen in the work of many lesser men.

His father, a plasterer who had made money out of papier-mâché ornament, took him when he was quite young to study under Laurent Delvaux at Nivelles,[18] instead of apprenticing him to one of the successful foreign sculptors working in England. Delvaux had, on his return to Flanders, largely abandoned the classicizing style of his collaboration with Peter Scheemakers, and his best known late work, the pulpit of Time and Truth in the cathedral of Ghent, erected in 1745, is an elaborate and pictorial Late Baroque ensemble. Wilton must have seen this work in the studio, though if J. T. Smith (whose statements are not always reliable) can be believed, his training with Delvaux was only partial, and he did not learn to cut marble until he went to Paris in 1744 and became the pupil of Jean-Baptiste Pigalle. Some, at least, of his later work suggests, however, that the swinging curves and dramatic content of Delvaux's work was not forgotten. Under Pigalle, on the other hand, who had returned from Rome in 1739 and become a member of the Académie in the year Wilton joined him, the young man would have been encouraged to develop a more refined and less full-blooded style.[19] Pigalle had not yet become the favoured sculptor of Madame de Pompadour, for whom

he was to create his own peculiar and charming blend of the classical and the Rococo, but it must have been during his years in France that Wilton acquired a knowledge of that elegant type of female figure which is essentially French, and which he was to use to good effect in his Mountrath and Bedford monuments.

After three years in Paris, Wilton went on to Rome.[20] He was to remain in Italy for about seven years, the last four being spent in Florence. Relatively little is recorded of his activities, but he seems to have built up a connexion with English travellers, among them William Locke of Norbury, for whom he bought antiques, while for others he made copies.[21] In 1755 he returned to London in the company of William Chambers,[22] who was to remain his close friend, and of the painter Cipriani. He and the latter were shortly, as has been shown, to be associated as Directors of the Duke of Richmond's Cast Gallery.

Some part of Wilton's time in Italy must have been given to the study of Roman busts, for very soon after his return he proved himself to be a portraitist of no mean ability. His busts of Lord Chesterfield (1757, B.M.; Plate 108A) and of the elder William Pitt (1759, N.P.G. Scotland) are both distinguished essays in the Roman manner, far more lively than the classical busts of Peter Scheemakers. The Chesterfield, indeed, which shows the neck and the upper part of the chest only, without the full width of the shoulders, and has no drapery, is probably the first bust made in England to follow the uncompromising pattern of many Roman busts of the Republican period. In its detailed realism, however, it goes beyond any Roman bust. Veins in the temples, a wart on the right cheek, the soft folds of skin round the mouth, are rendered with veracity and a total absence of generalization, giving the head a freshness and naturalism, an almost painterly quality, which finds a fairly close parallel in some of the Rococo busts of Jean-Baptiste Lemoyne, for instance the Réaumur (Louvre) of 1751.[23] Beside it, the Pitt, far more static and with draped shoulders, is, for all its nobility, a much more conventional work.[24]

Wilton was also, at this stage in his career, capable of making a lively portrait which was not taken from life. His monument in Westminster Abbey to Vice-Admiral Temple-West (d. 1757; Plate 110) has a pleasant, unpretentious design of a bust in front of a pyramid, set above a well-managed trophy. The virile, unlined face (the admiral was only forty-four), with its firm, generous mouth and watchful eyes with pupils deeply incised, is as full of character, though of a very different kind, as the Chesterfield, while the Oliver Cromwell (V. and A.) is almost the equal of Roubiliac's portraits of seventeenth-century Englishmen.[25]

These busts, and with them must be included the brilliant and far more Rococo General Wolfe at Dalmeny House, West Lothian (Plate 108B), suggest an artist of such talent that the foolishness of his first major monument, that to Rear-Admiral Holmes (d. 1761) at Westminster, comes as a shock. The standing figure in Roman armour, whose slender proportions are no doubt based on those of the Apollo Belvedere, a copy of which Wilton had just completed for the Duke of Richmond, is theatrically posed with one hand on his hip and the other on a cannon, and though Wilton is said to have been proud of his knowledge of anatomy, the twisted stance is both unconvincing and

unclassical.[26] On the other hand the fold patterns both of the dress and of the large draped flag behind recall Wilton's studies of the antique, for the soft material falls in folds which are so small and shallow that they almost seem drawn on the surface, with none of that variety of contrast between rounded and flattened folds, interspersed with undercutting, which has been shown to be characteristic of Rysbrack's generation; nor is there anything here of the lively Rococo rhythms of Roubiliac and Cheere.

Wilton's friendship with Sir William Chambers quickly brought him royal patronage. He became Coach-carver to the King, and was responsible for some of the designs and carving of the famous Coronation Coach, which was first used at the coronation of George III, and in 1764 was appointed 'Sculptor to His Majesty'. In this capacity he made a statue, which was not much liked, of George III in Roman armour for the Royal Exchange;[27] and even before his appointment he carried out, at the expense of the Princess Dowager, the monument to Dr Stephen Hales, erected in 1762 in Westminster Abbey (Plate 111). This has two classically draped but unclassically posed figures, one seated and one standing, of Religion and Botany with a medallion portrait. The same very small, soft folds that appear in the Admiral Holmes run all over the surface, making a purely linear design, the effect of which is strengthened by the fact that the sculptor does not seem to have made up his mind whether the figures are in the round or in relief.[28]

By the mid 1760s Wilton was at work on his most famous monument, that to General Wolfe at Westminster (Plate 109), though it was not erected till 1772.[29] Here again, and to a far greater degree than in the Dr Hales, there is a combination of a relief style and figures in the round, and also an attempt to combine both the antique and a dramatic pictorial conception, based on the works of Roubiliac. The desire to outshine Roubiliac was no doubt deliberate, for just before his death the older artist had made a model for the monument in which the general, in contemporary dress, appeared dying in the arms of Victory, with a tent behind him.[30] Wilton took over the theme of the tent and the dying hero; but Wolfe dies nude, his uniform tumbled at his feet, and is supported by a grenadier in regimental dress, who directs his general's gaze to a Victory who floats downwards offering, for full measure, both laurel and palm. A second grenadier, the upper part of his body alone appearing in high relief, stands in the background holding a pike, the vertical of which plays some part in stabilizing the loose composition. Wilton is said to have insisted on the nude figure so that he could display his knowledge of anatomy; and he may well also have had in mind the antique theme of the dying Meleager, for the figure itself is not ill-conceived. In combination, however, with the extreme naturalism of the two soldiers and the Baroque allegory of the Victory, it borders on the grotesque, and here more than in any other work, the confusion, and perhaps also the pretentiousness of the artist is apparent.[31]

In the same decade, however, that Wilton was working on the Wolfe, in which the influence of Roubiliac was paramount, and also creating the Hales and Bath monuments with their semi-antique figures, he was, in collaboration with Chambers, to produce two monuments which are much more strongly Baroque. The first, and perhaps the most beautiful work in design and execution of its generation, is that to the 2nd Duke

of Bedford (d. 1711) erected in 1769 at Chenies, Buckinghamshire (Plate 112); the second and more Baroque is that to the Earl and Countess of Mountrath at Westminster, set up in 1771 after the death of the latter. Both are signed by the two artists. The Bedford monument has two kneeling youthful figures of great charm, the duchess, who had long outlived her husband, in an attitude of resignation, while he, like a young Apollo, looks up to the symbol of the Trinity exposed on rays and billowing clouds, with winged boys holding wreaths and palms above it. The bodies are almost in profile, and so preserve the front plane, but the device of the duke's gaze turning upwards and inwards towards the glory above matches the Baroque character of the clouds and flying boys. There is more of France than of Bernini in the two main figures, but it is the France of Poussin rather than that of Boucher, so that the Baroque is tinged with classicism, but with the creative classicism of the seventeenth century. Moreover, the boys are still in the Duquesnoy tradition. The Mountrath is more dramatic and less satisfying. The kneeling countess clasps the arm of a hovering angel who is, presumably, to carry her to join her dead husband; but the swirling clouds on which he is supported are curiously inflated, and though there is an attempt to suggest rapid movement by wind-tossed draperies, the ambitious design is not wholly successful. It is, however, the last major and unashamedly Baroque monument in the abbey, and it and the Bedford together are perhaps an indication of Wilton's true talent.

In the 1770s his interest in sculpture declined. His father left him something of a fortune, which he spent on a grand establishment and on bringing up his family with extravagant tastes. By 1786 he was forced to retrench by selling his property, including his stock of Carrara marble and a number of chimneypieces made as a speculation, and in 1793 he became bankrupt. He had, however, in 1790 succeeded the sculptor Carlini as Keeper of the Royal Academy, and he seems to have retained the friendship of his fellow-artists until his death in 1803.

His later works are varied in kind as well as in quality, and it is probable that the execution was largely that of assistants. This was certainly the case for the large amount of decorative sculpture produced under his name for Chambers's masterpiece, Somerset House, which included the statues of the Four Continents on the attic on the north side of the court, and four of the eight colossal masks of Rivers on the Strand front, together with vases, lions, and chimneypieces. According to J. T. Smith, Wilton never put a tool to any of them, and they were made by Nathaniel Smith and John Atkins from finished drawings provided by Cipriani.[32] His practice as a sculptor of busts had been snatched from him in the early 1770s by the far more industrious Joseph Nollekens, but he continued to accept a few commissions for monuments. The John Lockwood of 1778 at Lambourne, Essex, is a reduced version of the Earl of Bath at Westminster, using the urn and the standing Virtue only, here with the attribute of Hope. Later still, in the Bacon monument at Linton, Cambridgeshire, of 1782, perhaps under the influence of Reynolds's *Discourse on Sculpture*, delivered in 1780, he abandoned his favourite design of one standing and one seated figure in favour of two standing figures flanking an urn.[33] Two of his late monuments, however, show that the influence of his early training was sufficient to withstand the rising tide of neo-classicism. The Earl of Mex-

borough (erected 1780) at Methley, Yorkshire, reclines in contemporary dress, pointing upwards to heaven in a somewhat uninterested manner. Archbishop Tillotson at Sowerby, Yorkshire (1796; Plate 114A),[34] is a much more distinguished creation, for the full-length figure in his gown, standing in a niche with one hand thrown out, has a liveliness, partly achieved by the broken, crumpled, and deeply undercut draperies, which is rare in Wilton's work. His personality as an artist had never been strong enough to fuse the conflicting styles which he had learnt when young, and he hesitates through-out his life between the Baroque tradition of Delvaux, and a frank dependence on Antiquity. It was perhaps his misfortune that his lifetime saw the death of Baroque all over Europe, but though his years in Italy, his talents, and his friendship with the circle of Reynolds and Chambers might have made him the possible leader of neo-classicism in England, his tastes and perhaps his laziness prevented him from making the most of his opportunities.

Agostino Carlini and William Tyler

The fact that the other two sculptors, Agostino Carlini (worked *c.* 1760–d. 1790) and William Tyler (worked *c.* 1760–d. 1801), who were Foundation Members of the Royal Academy, are relatively unimportant figures suggests that the state of sculpture in Eng-land in the 1760s was much less healthy than it had been in the 1740s. Carlini was by no means a negligible artist, but little is known about him, and his output appears to have been small. He was born in Genoa, and judging from his ability in the cutting of marble must have received his first training in Italy, though nothing is known of his early life, nor of the date or circumstances of his arrival in England. His earliest known work, the statue of Joshua Ward (*c.* 1760, London, Royal Society of Arts; Plate 114B), is, how-ever, curiously un-Italian in its realism.[35] The bulky, pompous figure of the quack doctor is almost a caricature, and though the features and the wig are more generalized than would have been the case in a portrait by Roubiliac, the whole has considerable character, the design is vigorous, and the dress admirably handled. A similar tendency to caricature may be seen in the artist's bust of George III (1773, London, Royal Aca-demy), which, though the most forceful of all the busts of the king, is, with its fleshy face, obstinate mouth, and protruding eyes, by no means flattering. This may partly account for the fact that no other busts by Carlini are known; on the other hand the strong twist of the head, tilted slightly upwards, and the rich treatment of the curls, may have been too Baroque to find favour at this date.

His largest monument, that to the Earl and Countess of Dorchester (1775) at Milton Abbey, Dorset, is surprisingly but perhaps deliberately archaizing in its design, for the altar tomb with Gothic tracery bears a mattress rolled up at the head supporting a cushion.[36] The female effigy lies quietly on her back, while her husband is propped on one elbow behind her. Again, as in the statue of Ward, the management of the dress is very accomplished, a fact recognized in Carlini's day, for his obituary states that he 'possessed great celebrity for the skill and grace with which he executed drapery'.[37] Only a small number of other works are known, among them the monument to the Countess of

Shelburne (1771, High Wycombe, Buckinghamshire), which has an unhappy mixture of contemporary and classical dress.[38] Carlini must, however, have been held in some esteem by his fellow-artists, for he was made Keeper of the Royal Academy in 1783 and held the post till his death in 1790.[39]

William Tyler was a far less talented man. He studied under Roubiliac, but seems also to have been influenced, particularly in the design of his monuments and in his use of coloured marbles, by Sir Henry Cheere. The bust of Samuel Vassall (1766) in King's Chapel, Boston, U.S.A. (Plate 115B), with its wide shoulders and diagonally planned drapery, echoes the former's style, while other monuments, such as the Rev. Thomas Jones (d. 1770) in Southwark Cathedral, with its Rococo base and boys flanking a bust, or the Viscount Ashbrook (d. 1780) at Shellingford, Berkshire, with two boys wreathing an urn, seem dependent on Cheere. Other designs – the Sir John Cust (d. 1770) at Belton, Lincolnshire, or the Anne Yorke (1773) at Marchwiel, Denbighshire – have a seated female figure of gentle charm with crumpled draperies broken into small folds which again recall the work of Cheere. In the 1770s he abandoned the wide type of bust derived from Roubiliac for a longer, narrower pattern, the Dr Zachary Pearce in Westminster Abbey (c. 1777) being a typical example.[40] It is a solid and not unpleasing portrait, though a little tame. His limitations are clearly seen in the ambitious monument to General Lawrence (d. 1775), which stands as a pendant to Rysbrack's Admiral Vernon flanking the north door at Westminster, and is obviously designed in emulation of it. Tyler manages a winged Victory in movement even less satisfactorily than Rysbrack; and the arrangement of the whole, with a clumsy bust on a high pedestal, is very inept. From about 1779 he seems to have worked in partnership with a former pupil, Robert Ashton, several monuments being jointly signed. Of these, the most important is that to Dr Martin Folkes, erected at Westminster in 1788 (Plate 115A). The playing boys are still a feeble echo of the Duquesnoy tradition, but the seated, bowed figure of the scholar himself is not without dignity and pathos. Although the architectural detail in this, as in some of Tyler's other works, is neo-classical, the asymmetrical design and the broken, restless drapery patterns continue the style of Roubiliac. None, therefore, of the first generation of Royal Academicians were entirely willing to break with the past.

Some Contemporary Sculptors

One or two other sculptors, though not Academicians, can be briefly discussed here, since they carried on the style of Roubiliac and Cheere. Nicholas Read (worked c. 1749–d. 1787)[41] was apprenticed to Roubiliac and appears to have stayed on as an assistant, carving the figure of Death on the Nightingale monument, and taking over the studio after Roubiliac's death in 1762. In that year, and again in 1764, he won prizes at the Society of Arts, but he was evidently antipathetic to the Royal Academy and exhibited up to 1780 with the Free Society of Artists. Vertue had, in 1749, thought him a young man of great promise, and his bust monument of Francis Hooper (d. 1763, Trinity College, Cambridge)[42] shows him to have been an apt pupil, for in its handling of the gown, bands, and wig, as well as in the lively naturalism of the face, it follows patterns

established by Roubiliac. Unfortunately in his larger monuments he attempts to out-shine the pictorial style of his master, and ends in confusion. The Admiral Tyrrell (1766) at Westminster has been mutilated, but the tangle of rocks, figures, trees, trophies, and shipwreck can never have been easy to grasp, while the huge monument to Nicholas Magens (1779, Brightlingsea, Essex; Plate 116A) is an over-ambitious allegory of the riches of trade and the riches of heaven. Elsewhere he dramatizes the theme of grief. The Sir Gilbert Heathcote (d. 1768, Devizes, Wiltshire) has a tear-sodden lady holding a medallion with a finely modelled profile portrait, while the Mrs Anne Simmons (d. 1769, Lechlade, Gloucestershire) has a boy rubbing his eyes and screaming with rage or pain. On a much less pretentious scale, however, Read could produce work of con-siderable charm, as may be seen in the monument to John Kendall (d. 1750, erected later; West Horsley, Surrey), which has drapery knotted over an urn and a delicate relief of a rose-bush with its flower fallen beneath a knife.[43]

Charles Harris (d. 1795?), about whose training nothing is known, must surely have had some contact with Cheere's workshop. His most important commission, the monu-ment to the 3rd and 4th Dukes of Ancaster (d. 1778 and 1779, Edenham, Lincolnshire; Plate 116B) shows the younger duke standing cross-legged in Roman armour, and the older seated in peer's robes. Though the base and urns are in the neo-classical taste, the figures with their crumpled draperies with turned-back edges, and their mixture of naturalism with the familiar cross-legged pose used by Cheere in the earlier Ancaster monument, are still in the mid-eighteenth-century manner. A similar connexion with Cheere may be seen in the monument to Henry Hoare (1787, Stourton, Wiltshire) with its plump boys, one with crumpled drapery fluttering behind him while he struggles to wreathe the urn. The modelling is clumsier than that of Cheere, but the derivation from his style seems clear enough. Harris must have had some reputation to have obtained work from families who had patronized the leading sculptors of the previous generation.

The career of Richard Hayward (1728–1800) is better documented.[44] He came from the world of the mason–sculptors, and throughout his life was employed on decorative carving, both large and small. He went to Henry Cheere to finish his apprenticeship in 1742, and seems to have worked with him for some time; but he also spent a year in Rome in 1753, and was to remain in touch with the dealer, Thomas Jenkins.[45] Rome does not, however, seem greatly to have affected his style, which constantly shows the influence of Cheere, though he was clearly also impressed by the work of Wilton. He could, like Cheere, handle contemporary costume with skill. The standing figure of Sir William Pole (1746, Shute, Dorset),[46] made in all probability by Hayward in Cheere's studio, is lively in the cutting of the rich details of the embroidered clothes, though the head is somewhat dull. In the 1770s Hayward's practice was considerable, and it is not without interest that he, rather than Wilton, was chosen in 1772 to make a statue for Williamsburg, Virginia, of the recently deceased Governor, Lord Botetourt.[47] This, the oldest public statue in the United States, is a trifle awkward in stance – it has perhaps been too much influenced by Wilton's Admiral Holmes at Westminster – but it is redeemed by the skilful management of the robes.

In some of his later work, classical influence becomes stronger, especially in architectural detail, though he never entirely forgets the style of his youth. The monument to the Rev. Slaughter and Mrs Clark (1772, Theddingworth, Leicestershire) shows the lady seated in classical dress and the male figure in a doctor's gown; but though the design has some originality, the cutting is coarse. A pretty type devised by Hayward of an urn decorated with a Charity in relief and surmounted by a small figure, generally of Religion, was used with slight variants on more than one occasion;[48] but the most attractive of his works in his later manner is the font he made for his own village church (1789, Bulkington, Warwickshire; Plate 113, A and B), though it is a curious mixture of both style and iconography. The reliefs running round the bowl display, in the wide spacing of the figures silhouetted against a plain ground, some knowledge of the neoclassical taste by then current in England; but in the scene of the Baptism of Christ neither the proportions nor the drapery treatment are classical, and among the onlookers are two charming little girls in eighteenth-century dress who might have stepped out of a painting by Francis Wheatley.

PART SIX

NEO-CLASSICISM

CHAPTER 19

INTRODUCTION

THE rise of neo-classicism in Europe, which occurs shortly after the middle of the eighteenth century, is a movement of some complexity still awaiting its historian. To the men who were foremost in creating it, it appeared as a return to the purest style of Antiquity and pre-eminently to that of the Greeks, with a consequent rejection of the Baroque and the Rococo. No Greek originals of the first quality were, however, available in Western Europe; and the most influential writers and artists of the century had not visited Greece. Their views were therefore formed on antiques found in Italy, some of which are undoubtedly versions of Greek originals, but many of which are now recognized as the work of second-rate copyists. Further, the lip-service paid to Greek art is combined with a passionate concern with sentiment which is quite un-Greek. This in itself is linked with other ideas of an age which was turning away from the rationalism of the early eighteenth century, and which are now seen as some, at least, of the seeds from which the Romantic Movement (and also the French Revolution) was to spring. It is this duality which complicates any analysis of neo-classicism, for the historical results differ greatly from the aims of its originators, whose nostalgic attitude to the past was, whether they knew it or not, inherently Romantic. This is true for Rome itself; in England, with its continuous belief in the value of the imagination and of the individual, the expression of pre-Romantic ideas is widespread and early, antedating some of the most important neo-classical publications, and the Romantic elements in the latter were often the first to be seized and admired.

The impact of the new movement on English sculpture was scarcely felt before about 1775, though it had been apparent for some time in both architecture and painting.[1] This tardy recognition in that field of art in which the precise forms of Antiquity could most easily be reproduced is due to the fact that here neo-classicism seemed less of a novelty. The cult of antique sculpture had been far stronger in England in the second quarter of the eighteenth century than anywhere else in Europe; and, as has been shown, collectors had succeeded in importing ancient marbles in considerable quantity. In spite of papal prohibitions, this practice continued with perhaps increased fervour, and some of the most famous collections, notably those of the 1st Marquis of Lansdowne and of Charles Townley, date mainly from the 1770s.[2] The type of work most desired changes slightly, but not to a revolutionary extent. Moreover, English patrons had, since 1720,

been well satisfied with that combination of the Antique and the Baroque produced by Rysbrack and Scheemakers, and even by Roubiliac in his classicizing busts, and they were slow to demand anything different.

Even though the full tide of neo-classicism was late in reaching England, some consideration of its earlier origins in Rome is necessary for an understanding of it. Throughout the century, changes took place in the range and presentation of works of art available to artists and travellers. Antique sites were no longer regarded as convenient quarries for modern buildings, and a desire to conserve notable works for posterity in public museums rather than in private collections began to be seen. In this the papacy played a major part. The new conceptions originated with the Albani pope, Clement XI (1700–21), who not only re-inforced decrees forbidding export, and insisted that all discoveries should be reported to the Commissioner of Antiquities, Francesco Bartoli, and recorded in engravings, but also took steps to improve the arrangement of antiquities in the Vatican and at the Palazzo dei Conservatori on the Capitol. The Belvedere Court was cleared of bushes and the statues brought under cover; the pope planned, but did not carry out, the arrangement of a Galleria Lapidaria, in which pagan and Christian inscriptions should be conserved; he made the first attempt at creating a Museum of Christian Antiquities, and he acquired statues (notably two Barbarians) exposed to the weather in the gardens of the Palazzo Cesi, giving them to the Conservatori and enlarging a hall in which they could be shown. He was also, on his own account, an eager collector both of antique sculpture and modern drawings, thereby setting an example which was quickly followed by his young nephew, Cardinal Alessandro Albani.[3]

The work begun by Clement lapsed during the short pontificates of his two immediate successors, but was taken up with vigour by the Corsini pope, Clement XII (1730–40). He acquired part of the Albani Collection, mainly the series of Imperial busts, from Cardinal Albani, who was short of money, added to them such well-known pieces as the Dying Gladiator and the Cupid and Psyche, and transferred them with the works in the Conservatori to the palace opposite it on the Capitol, opening in 1734 what was indeed the first public Museum of Antiquities in Europe.[4] Another aspect of his care for antiquities is shown in his restoration of the Arch of Constantine, the sculpture of which was dealt with by Pietro Bracci, one of the best known Rococo sculptors in Rome. Benedict XIV (1740–58), one of the finest scholars ever to hold the Chair, again strengthened the decrees against export and bought lavishly for the Capitoline Museum, his gifts including the Capitoline Venus and twelve of the best marbles from the Villa d'Este, originally found at Hadrian's villa at Tivoli, among them the Praxitelean Satyr and the Cupid bending his Bow. He caused a catalogue of the museum to be made by the Keeper, Locatelli, and published in 1750, and a further description with engravings was made by the Abbate Guido Bottari, the first two volumes appearing in 1750, the third in 1755, and the fourth in 1782. The museum was open to all for purposes of study, though after 1753 anyone wishing to take a cast had to obtain a special permit. The need for such a regulation suggests that cast-taking was fairly extensive. One of the avowed objects of the Capitoline Gallery was to provide models for students of the Academy of

St Luke, but in 1754 Benedict gave further help to artists by the establishment on the Capitol of the Accademia del Nudo, where students were able to draw from the nude without payment, nude models till that time having been allowed only in the French Academy. Among his many other benefactions to art and learning was the enlargement of the Museum of Christian Antiquities, which was joined to the Vatican Library in 1755, and a first attempt to catalogue the vast collection of manuscripts in the Vatican.[5]

His work was continued, though on a reduced scale, by Clement XIII (1758–69); further additions were made to the Capitoline Museum and a Museum of Profane Antiquities opened at the Vatican in 1767. Clement's reign is, however, more interesting for his patronage of contemporary artists, above all Mengs and Piranesi, and for his appointment of Winckelmann as Commissioner of Antiquities in 1763, than for his personal activities as a collector.[6] Moreover, in his day all other collectors were overshadowed by Cardinal Albani. Papal concern with museums was not, however, dead. In 1772 the Ganganelli pope, Clement XIV (1769–75), planned a great enlargement of the Vatican antique galleries, the scheme coming to fruition under his successor, Pius VI (1775–1800), with the establishment of the Museo Pio-Clementino, which was joined to the Belvedere Collection; and the Vatican finally assumed its present position of the greatest museum of antiquities in the world by the building of the Braccio Nuovo by Pius VII between 1817 and 1821.

This increased availability of the finest antiques in Rome was naturally of paramount importance for artists, and the public museums were not the only place where they were displayed. Cardinal Alessandro Albani, described by the Comte de Caylus in 1755 as 'the greatest antiquarian in the world', spent many years building a villa near the Porta Salaria to house his ever-growing collections. These were not arranged as a museum; but the great array of statues, reliefs, busts, and lesser objects were used as decorations in the gardens or the porticoes and halls of the house, each section having its own character tuned to the most important piece in it. This combination of a garden and a house, with a view from the latter over the Campagna, this combination of nature and scholarship may, in its creator's mind, have rivalled the finest villas of the antique world (much of its contents had indeed come from Hadrian's villa at Tivoli) and its purpose as a background for life, rather than as an archaeological display, was very different from that of the Papal museums. It had, at the same time, a slightly nostalgic twist, for though the statues were not to be displayed simply as antiques, it was as antiques and as witnesses of the greatness of the past, that they were chiefly prized. The painted ceiling by Mengs of Parnassus in the Galleria Grande is proof enough that Albani and his librarian, Winckelmann, were trying to live in an idealized past rather than in the present.[7]

The past glories of Rome were presented in a somewhat different way by Giovanni Antonio Piranesi (1720–78), whose great books of etchings must have coloured the approach of many travellers, and have left an indelible mark on the imagination of subsequent generations. Though passionately convinced of the glory of Rome, Piranesi, who was Venetian by birth, was never a pure archaeologist. He presented the great ruins, their enormous size enhanced by dramatic contrasts of light and shadow, and by a deliberate reduction in the scale of human figures, with the full power of his romantic

imagination, fostered in the richly coloured tradition of Venice. The *Vedute di Roma* began to appear in 1748; *Le Antichità romana* in 1756, *Della magnificenza ed architettura de'romani* in 1761. None deal with sculpture, but their importance as propaganda for Rome itself is so great, and their romantic presentation so overwhelming, that their influence cannot be ignored. Piranesi's conception of Rome, like Claude's of the Campagna, had an irresistible appeal to the English gentleman, and his books were to be found in countless English libraries.[8] Indeed, Englishmen relied so much on his plates for their picture of Rome that Flaxman was disappointed with the ancient buildings when he first saw them. 'He found them on a smaller scale and less striking than he had been accustomed to suppose them after having seen the prints of Piranesi (All but the Colosseum).'[9]

It might appear that, when so much was being done to attract the artist and the traveller to Rome, her position as the single centre for antique studies would have become more unassailable than ever. This was not the case; and she had to meet challenges from both within and without Italy. Naples had suddenly assumed a new importance, for the uncovering of the cities buried by the eruption of Mount Vesuvius in A.D. 79 was revealing a mass of antiquities of all kinds and of high quality. Excavations at Herculaneum, begun in 1738, continued up to the 1780s, and the sumptuous publication of the finds, lavishly illustrated, began to appear under the patronage of the King of Naples in 1755. The interest of English travellers in the work was so great that five hundred copies were set aside for the English market. Pompeii was discovered in 1748 and systematic excavation begun in 1763, though there the major finds were not made until the nineteenth century. A visit to Naples henceforth became a major incident in the Grand Tour of English travellers, and Naples was further to gain at Rome's expense in 1787, when the Farnese Collections, inherited by the Bourbons, were moved from Rome, which had recently also lost the collections at the Villa Medici, sent to Florence after 1775.[10]

The new discoveries in the south led to changes in the character of collecting in the last third of the century. Marbles were no longer regarded as the only thing worth buying. Many of the most beautiful works found at Herculaneum were bronzes, and though the finest of them went to the Neapolitan Royal Collection and are still among the chief glories of the Naples Museum, other pieces were avidly sought after, above all by the English Ambassador at Naples, Sir William Hamilton. As well as bronzes he bought vases which had been made in the Greek colonies of South Italy. Their true origin was not, however, understood (though Winckelmann realized that the inscriptions on them were in Greek), and since it was recognized that they were not Roman, and many were found in Etruscan tombs, they were thought to be Etruscan.[11] Hamilton's collection, which was naturally known and admired by British travellers, was splendidly published by Pierre d'Hancarville in 1767, and in 1772 it was purchased by the British Museum.[12] The linear character inherent in vase-painting was by these means to find many echoes in English neo-classical art. Hamilton afterwards made a second collection, which was lost at sea in transit to England, but which had been engraved by the German artist Wilhelm Tischbein (whose most famous work is the portrait of Goethe in the Cam-

pagna). His publication, begun in 1791, is, however, of greater importance for the Continent than for England.

Far more serious to the prestige of Rome was the challenge of Greece. This had the authority of history, for Greece had long been recognized, though sometimes perfunctorily, as the cradle of European civilization. The Homeric legend had never died, and in eighteenth-century England had been given a wider popularity by Pope's translations of the *Iliad* and the *Odyssey*, begun in 1713. The names of artists such as Phidias, Apelles, and Lysippos, mentioned by classical writers, had been always spoken with reverence throughout the Renaissance and Baroque periods, though little was actually known about them, and none of their works could certainly be identified. Greece had for some three hundred years been in the hands of the Turks, and though some travel literature was available in English, it was not before the middle of the century exclusively concerned with Ancient Greece, but also covered the Byzantine Empire and modern Greece.[13] During the first half of the century a few travellers extended the Grand Tour to include a visit to the Levant, but the interest in Greece remained literary rather than archaeological. And the first published works to give a precise account of the architecture and sculpture of the Eastern Mediterranean were the result of a desire 'to read the Iliad and Odyssey in the countries where Achilles fought, where Ulysses travelled and where Homer sung'.[14] Before Robert Wood printed this statement in his *Essay on the Original Genius of Homer* (1767), he had been concerned with important architectural publications. With James Dawkins and an Italian artist, Borra, he had travelled extensively in the Levant, and had published the *Ruins of Palmyra* (1753) and the *Ruins of Baalbek* (1757). While in Athens they met another party consisting of James Stuart and Nicholas Revett who, under the auspices of the Society of Dilettanti, were making measured drawings of Greek monuments. Unfortunately they were extremely slow in publishing their results. The first volume of the *Antiquities of Athens* only appeared in 1762, and did not include the buildings of the Acropolis, though it has considerable importance for sculpture, since among its magnificent engravings are plates of the flying figures on the Tower of the Winds.[15] Though this book, in its precision, is a key-point in the development of English neo-classicism, its impact on the Continent was diminished by the work of Julian Davide Le Roy, who, having read Stuart and Revett's printed *Proposals* for their work in 1748, went to Athens, and under the patronage of the French king, anticipated their publication in his *Ruines des plus beaux monuments de la Grèce*, which appeared in 1758. It was this work which drew Piranesi to his further defence of Rome in his *Della magnificenza* of 1761.

These architectural publications, important though they were, for they had the authority of first-hand knowledge, would hardly by themselves have been enough to destroy the prestige of Rome and with it the Baroque tradition in sculpture. Some hint of a revaluation is, however, apparent in the Introduction to the Comte de Caylus's *Recueil d'Antiquités* (1752), where he divides the history of the arts in the ancient world into four phases – Egypt, where they were formed with all the character of grandeur; Etruria, where they acquired greater particularity, but at the expense of grandeur; Greece, where men knew how to combine them with the most noble elegance and

where they rose to their greatest perfection; and Rome, where nothing great was originated without the help of foreigners. But it still required a great scholar who was also a most persuasive writer to convince Europe of the over-riding importance of Greece.

Johann Joachim Winckelmann's name has already occurred in several contexts in this chapter, but since he is to a great extent the central figure in the neo-classical movement, some examination of his work and his ideas is now necessary.[16] He was born at Stendal in Brandenburg in 1717 of poor parents, but early showed a love of scholarship, especially of ancient literature, and was encouraged in his interest in the arts and in aesthetics by lectures he attended at Halle. About 1748, after a struggle as a village schoolmaster, he became librarian at Schloss Nöthenitz near Dresden, and for the next seven years studied the collections at Dresden with passionate enthusiasm. He is known to have read the chief seventeenth- and eighteenth-century theorists, including Bellori, Shaftesbury, and even Richardson, and much in his writings is derived from them. At Dresden there was little antique sculpture and certainly nothing that was Greek. For his knowledge of antique art he was mainly dependent on engravings of sculpture found in Italy and on his study of classical literature: and his taste was chiefly formed on the paintings of Poussin, the Carracci, Correggio, and above all Raphael's Sistine Madonna, which was acquired for Dresden in 1754. This was the material on which he based his first treatise, *Gedanken über die Nachahmung der griechischen Werke* (1755), which has a special importance for England, since in 1765 it was translated by Henry Fuseli as *Reflections on the Painting and Sculpture of the Greeks*. Since few, if indeed any, of the first generation of English neo-classical sculptors could read German, most of their knowledge of Winckelmann's ideas must have come through Fuseli's translation.

In this work, the central thesis of which is ideal beauty and the moral value of good taste, Winckelmann's views are basically those of Shaftesbury. He goes, however, much further than Shaftesbury in the prominence given to the Greeks. The English theorist had admitted that the arts and sciences originated in Greece; Winckelmann states categorically that 'Good taste was first formed under Greek skies'; his discussion of ideal beauty is bound up with his praise of the bodily beauty of the Greeks, but he makes it clear that outward beauty alone is not the sole purpose of art. 'Arts have a double aim: to delight and instruct.' Content therefore is of prime importance. This is implicit in the most famous of all his sentences: 'The last and most eminent characteristic of Greek works is a noble simplicity and calm grandeur in Gesture and Expression. As the bottom of the sea lies calm beneath a foaming surface, a great soul lies calm beneath the passions in Greek figures.'[17] He indicates how the moderns have failed to appreciate this: 'on nothing do they bestow approbation, but contortions and strange postures . . . contrast is the darling of their ideas'; and they neglect ideal beauty by their over-emphasis on detail – skin appears in 'little smart wrinkles' whereas in Greek art skin 'softly enhances the firm flesh', and the moderns use 'a crowd of small touches and dimples too sensibly drawn'. Above all, led by Bernini, they have adhered too strictly to nature, who 'could never bestow the precision of Contour, that characteristic distinction of the Ancients'. It is perhaps one of the most remarkable aspects of this early

work, written before Winckelmann had had any true opportunity of studying antique art, that he was able to perceive the significance of contour. 'This Contour reigns in Greek figures, even when covered with drapery, as the chief aim of the artist: the beautiful frame pierces the marble like a transparent Coan cloth.' All neo-classical sculptors must have paid deep attention to such passages, for contour was henceforth to become a prime factor in design.

In 1754 Winckelmann entered the Roman Church and in the next years left Dresden for Rome. Owing to the friendship he quickly formed with the painter Raphael Mengs, he mixed at once with the international circle of artists and scholars, and he spent many hours studying antique sculpture in the Belvedere and Capitoline Museums. Before the end of the decade he was to become Librarian to Cardinal Albani, living in his house as an intimate, and later combining work for the Cardinal with his duties as Commissioner of Antiquities to Clement XIII. In 1768, while he was hesitating as to whether he should undertake a journey to Greece, he was murdered at Trieste for the sake of gold medals he was carrying.

Winckelmann's writings in Rome are less concerned with the question of Good Taste. The central theme is now the deep feeling that should be experienced when contemplating an antique of the finest quality. His remarkable gift of description and of analysing and indeed creating emotion is displayed to the full in his essays on individual master-pieces such as the Apollo Belvedere, the Laocoon, and the Belvedere Torso.[18] Feature by feature, muscle by muscle, the perfection of male beauty is disclosed with the language of a lover, and the artists who created the works are credited with a far greater range of emotion and ability of expression than ever before. Though to modern eyes neither the Torso nor the Laocoon are characterized by 'noble simplicity and calm grandeur', Winckelmann's view already set forth in the *Gedanken* that in Laocoon 'the pain of the body and the greatness of the soul are equally balanced' was strengthened rather than weakened by his analysis of the work itself; and of the Torso he writes: 'Ask those who know the height of mortal beauty, if they have ever seen a side comparable to his left one.' He insisted that preparation of the heart and of the feelings were necessary for an appreciation of the beautiful, though he did not neglect the importance of training the eye. In the last, he continues to some extent ideas voiced by de Caylus, who had begged his readers to use the comparative method when studying antique works; but Winckelmann had developed a visual sensitivity far beyond that of any earlier writer.

His final achievement was the *Geschichte der Kunst des Alterthums* (1764),[19] in which he canalizes and extends all previous attempts to trace stylistic developments in the art of Antiquity, and also to view the history of art as part of the history of civilization, so that rewarding parallels can be drawn between literature and the visual arts. Though he is not a revolutionary thinker, his position is of peculiar importance, for with his enormous literary facility, he clarifies and enlarges much that had been said before, often obscurely; and he adds to it his personal emotion, stressing the over-riding value of feeling – and it is this above all else that makes him a key figure in eighteenth-century art history.[20]

Too many artists were led by his writings to believe that by a slavish imitation of the works he most admired, greatness would be attained; but in his insistence on feeling and the expression of it, in his recognition of the value of personal reactions rather than those derived from traditional theorists, he opens the way in his own country for the *Sturm und Drang* and, in a wider sense, heralds the Romantic Movement. Travellers to Rome in the last third of the eighteenth century are no longer, like Addison, chiefly concerned with sculpture as illustrations of the classical poets; they are interested in its effects on themselves. Boswell was well satisfied with his reactions in Rome: '20th April, 1765 . . . Then Belvedere. Meleager well enough. Laocoon supreme; equal to all ideas. Nerves contracted by it, so that beautiful Apollo could not be felt.' And three weeks later he wrote to Rousseau: 'I have viewed with enthusiasm classical sites and the remains of the grandeur of the ancient Romans . . . and I believe I have acquired taste to a certain degree.'[21] Boswell had spent some time in Germany, and may well have known Winckelmann's writings before Fuseli's translation of 1765. His attitude makes it clear that the world of Shaftesbury and Richardson has passed; for they believed that right feeling could be attained only by an acceptance of their standards of good taste, standards which were based on a set of fixed rules which could be learnt. Though it is certain that Winckelmann knew and admired the writings of Shaftesbury, to him (and to those who read him) feeling was of over-riding importance; and was chiefly dependent on the impact of works of art themselves, irrespective of any knowledge of theory or rules. Here he differs from Shaftesbury, who could never have accepted the notion that even the ignorant could be moved to fine feeling by the sight of beautiful works.

It was this emphasis on personal feeling and not on rules alone which made the new approach sympathetic to many Englishmen. Indeed, the writings of Winckelmann reinforced ideas both on the supremacy of Greece and on the importance of feeling which already existed in England, though in much vaguer form. The importance of the English novel of sentiment, and the part which it played in the creation of 'sensibilité' in France, is well known. Sensibility, and its correlative, simplicity, were much in vogue in England. It is only a short step from the admiration of simplicity to an admiration of the primitive, and though Rousseau's 'noble savage' is not specially relevant for English sculpture, a nostalgic admiration for the primitive civilization of Greece, oppressed first by Rome and afterwards by the Turk, had already appeared in much English poetry. In such works as Mark Akenside's *Pleasures of the Imagination* (1744), or Thomas Warton's *Pleasures of Melancholy* (1747), Greece is evoked mainly as a vague and blissful Arcadia, but James Thomson in his *Liberty* (1734–6) apostrophizes the most famous antiques in Rome (which he had seen) in terms which come near to anticipating Winckelmann, though with greater brevity. Of the Apollo Belvedere he writes:

> '. . . The bloom of gods
> Seems youthful o'er the beardless cheek to wave:
> His features yet heroic ardour warms;
> And sweet subsiding to a native smile.
> Mixed with the joy elating conquest gives,
> A scattered frown exalts his matchless air.'

Many passages could be quoted from the English poets to show that pleasing and often melancholy sentiments as well as good morals were accepted as the natural results of contemplation of Antiquity;[22] but after the middle of the century these strains are combined with a more passionate sense of the value of imagination. Burke's view of the Sublime, argued at length in his *Enquiry into the Origins of our Ideas of the Sublime and the Beautiful* (1756), was to have an increasing effect in England and on the Continent. To him the sublime and the beautiful can never be the same. The sublime, which engenders feelings on the highest level, consists of vastness, strangeness, and all that inspires awe. The beautiful is small and smooth and pleasant, and is appreciated by good taste, whereas admiration for the sublime requires something more, namely the powers of the heart and the imagination. At first sight this would seem a direct contradiction of Winckelmann's belief in the sublime beauty of Greek sculpture: yet Burke and Winckelmann are at one in their assessment of the importance of feeling.

Moreover, in England it was not antique art alone which had the power of moving a sensitive spectator. In his *Anecdotes of Painting*, first published in 1762, Horace Walpole wrote: 'One must have taste to be sensible of the beauties of Grecian architecture; one only wants passions to feel Gothic.'[23] The sublimity of Gothic ruins, real or false, hardly concerns sculpture; but Gothic art, with its love of line, was to be an added inspiration to a generation of artists already attracted by Winckelmann's views on contour and by Greek vases to rhythmic line as a basis of design. Gothic and Greek may not now seem very closely allied, but in the late eighteenth century both were seen as alternatives to Rome, and as the noble and simple art of primitive peoples. Indeed, as early as 1754, the painter Allan Ramsay had in his *Discourse on Taste* maintained the superiority of the Greek style in architecture (about which he knew nothing at first hand) to the Roman, and declared his preference for Gothic over Renaissance architecture, which was only a travesty of Roman.[24] Walpole and Ramsay, with their acknowledgement both of the serene and rational beauty of Greek art, and their admiration for the strange and imaginative quality of Gothic, are perhaps fair examples of the duality of English opinion. By the end of the century the art and writings of William Blake, in open conflict with the rule of reason, which to him spelt death to the imagination, mark the culmination of a phase which can only be described as 'Pre-Romantic'.

In spite, however, of the rising value placed on feeling, there was still in eighteenth-century England a solid body of academic opinion which accepted Winckelmann's neo-classical theory only in so far as it meant a rejection of what appeared as the bad taste of the Baroque. This was most clearly voiced by Sir Joshua Reynolds in his *Discourse on Sculpture* delivered in 1780.[25] The students were warned against Bernini's supposed rejection of ideal beauty, his 'injudicious quest for novelty', and the 'folly of attempting to make stone sport and flutter in the air'. All Baroque sculpture had failed because it endeavoured 'to copy the picturesque effects, contrasts and petty excellencies of whatever kind, which not improperly find a place in the inferior branches of Painting'; whereas sculpture should borrow only from the Grand Style, that is, the style of Raphael, the Carracci, and Poussin. 'The grave and austere character of Sculpture requires the utmost formality in composition; picturesque contrasts have here no place;

everything is carefully weighed and measured, one side making an almost exact equipoise to the other; a child is not a proper balance to a full-grown figure, nor is a figure sitting or stooping to an upright figure.' These solemn rules of design had their effect on earnest Academy students – a tedious symmetry creeps into English sculpture and the fine freedom and balance of Rysbrack's best monuments never returns.

Reynolds is less insistent than Winckelmann on the importance of contour, though his desire that drapery shall not confuse the figure implies that he recognizes its value. He has, on the other hand, extremely definite views about reliefs, and above all about the unsuitability of attempting perspective either by the diminution of figures or by the use of architecture on a diagonal plane. And he is emphatic in his condemnation of contemporary dress as unworthy of the 'dignity and gravity' of sculpture. Most of Reynolds's advice was put into practice during the last twenty years of the century, and some of the more foolish examples of the use of classical dress may be due to his influence. On the other hand, the convention of antique dress had been current in England since at least 1720, and it is misleading to lay its failures entirely on Reynolds.[26] Moreover, the desire for naturalism which is often a characteristic of early Romanticism led Flaxman to adopt contemporary dress for most of his major monuments, including those to Lord Mansfield and Lord Nelson.

At one point Reynolds appears to differ sharply from Winckelmann. He does not agree that sculpture 'is to be valued and take its rank only for the sake of a still higher object; that of conveying sentiment and character, as they are exhibited by attitude, and expressions of the passions: but we are sure, from experience, that the beauty of form alone, without the assistance of any other quality, makes of itself a great work, and justly claims our esteem and admiration'. It may, however, be that Reynolds is here still echoing older theory and thinking of the late-seventeenth-century controversy between the Ancients and the Moderns in France, and expressing views which are anti-Le Brun rather than anti-Winckelmann.

Although the *Discourse on Sculpture* is not the most impressive of the *Discourses*, perhaps because Reynolds was speaking of an art which was not his own, it is of value since it is the only considered statement concerning sculpture by an English artist of his generation, and also because it gives some indication of the independence of English thought. For Reynolds, in spite of his love for antique dress, was not prepared to acquiesce blindly in the perfection of Antiquity: 'The Apollo, the Venus, the Laocoon, the Gladiator, have a certain composition of action, have contrasts sufficient to give grace and energy in a high degree; but it must be confessed, of the many thousand antique statues which we have, that their general characteristic is bordering at least on inanimate insipidity.'[27]

Unfortunately, 'inanimate insipidity' is also characteristic of much neo-classical sculpture. The Apollo Belvedere himself, probably the most admired of all ancient pieces, has grace, but in imitation becomes insipid. The intrusion of sentiment often adds to the insipidity. It gives a twist to the taste of patrons, many of whom preferred the sweeter rather than the more noble works of Antiquity, and to the work of sculptors such as Nollekens, who were willing to pander by the supply of discreetly sensual

Venuses. Moreover, changing conditions in the studio furthered the general lack of individuality. The desire for sentiment and the admiration for all that was regarded as Greek were, alas, all too easily reduced to a formula perfectly suited to the type of instruction given in the Academy Schools; and the old system whereby an apprentice learnt the rudiments of his art in the workshop of his master, and then gave a new direction to his master's style by adding something of his own, gradually disappears. Further, the introduction by John Bacon of better pointing equipment for transferring the model to the marble meant that much more was done by assistants; and indeed by 1800 very little work on the marble was done by the master himself. A smooth, highly finished and somewhat soapy surface was now universally admired, and this could conveniently be achieved by assistants, for it left little scope for personal handling. This trend in surface treatment is partly due to the desire to imitate the smooth handling of the Apollo Belvedere, and partly also to the quantity and type of engravings available for study. In the volumes illustrating the finds at Herculaneum, and also in Stuart's *Antiquities of Athens*, a technique of cross-hatching is used all over the figures, generalizing the forms, and suggesting always a continuous and smoothly rounded surface. The contrast between this engraving technique and that used in a Baroque book is very great. For instance in Bartoli's *Admiranda Romanorum Antiquitatum* (1693), the swell of the muscles and the movement from one form to another is much more evident, and there is no overall mesh of cross-hatching to suggest continuity of surface. The use of engravings probably also led to an increased interest in contour, independently of the fact that its value had been praised by Winckelmann; for tracings are known to have been made from Stuart's *Athens* by Flaxman, and he is unlikely to have been the only young sculptor thus to record illustrations in books he could not afford to buy.[28] Such tracings would almost certainly have been in outline only, and would therefore have developed the habit of thinking in such terms. The Herculaneum engravings (and indeed the Apollo Belvedere) may also have been influential in another direction, for the proportions are always slightly elongated, and the figures are shown with slender and elegant limbs. The Venuses of Nollekens were to demonstrate to his younger contemporaries the charm and success of this interpretation of Antiquity; and the cult of the elegant, that last legacy of the Rococo, was ultimately to lead Flaxman to rate the Apollo Belvedere higher than the Theseus of the Parthenon.

Nevertheless, the combination of sentiment and the love of clean contour did lead to a new and noteworthy development in the design of English monuments, especially those created by the most sincere artists of the end of the century, Thomas Banks and John Flaxman. Elaborate allegories, in all but the largest monuments, go out of fashion, and a more direct and simpler treatment of the theme of grief is devised, often with a more personal reference to the interests of the deceased. There is indeed a great increase of small monuments. Some are tediously repetitive; the theme of a woman mourning over an urn replaces the ubiquitous mourning boys of the earlier generation, and is reproduced on every scale; for when once the type had been devised (it appears almost simultaneously in the work of Bacon and Banks in the 1780s) it was copied endlessly with variations up and down the country. Middle-class patrons who before might have

ordered a plain tablet, or one with mourning boys, now adopt such types. Moreover, there are signs that the practice of sculpture was changing, especially in the provinces. Far more men sign their work; though this unfortunately does not mean that it has originality, or that it was necessarily cut by the man who signs it; for firms (rather than studios) of local monumental masons spring up, above all in industrialized districts, and replace the older London workshops.

It is useless to pretend that English sculpture of the last quarter of the eighteenth century has the same liveliness and variety as that of the second quarter. The best small monuments of Banks, Flaxman, and even of Bacon have, however, true originality and beauty of design; sometimes those of little known or anonymous sculptors are unexpectedly good; and in portraiture the abiding English interest in character forced sculptors to keep in touch with reality, and even with the tradition of Roubiliac, and so to avoid the vacuous noble images of their Continental contemporaries.

Finally it should be noted that far more first-hand information is available about sculpture towards the end of the century. The *Diary* of the painter, Joseph Farington,[29] covers the years from 1793 to 1821, and provides the kind of information lacking since the death of Vertue in 1756. Farington's interests were narrower than those of Vertue, but he was an extremely active Royal Academician, and gives full records of Academy opinion and of Academy intrigue. The early-nineteenth-century collections of *Lives* by J. T. Smith and Allan Cunningham have already been mentioned, and are naturally more reliable and more interesting in the cases of sculptors known personally to the writers than for earlier eighteenth-century figures. A further source of lively, though generally biased, information for the later part of the period is the *Autobiography* of Benjamin Robert Haydon, the history painter; and reviews of Royal Academy Exhibitions in the contemporary press are also useful as records of taste.

CHAPTER 20

JOSEPH NOLLEKENS

IN Flaxman's *Address on the Death of Thomas Banks* of 1805, he singles out Joseph Nollekens (1737–1823) as the only English sculptor before Banks who had 'formed his taste on the antique and introduced a purer style of art'.[1] Nollekens would, in fact, almost certainly have followed any fashion which he thought would bring him patrons, for the over-riding interest of his life was to make money, and in this he was remarkably successful. J. T. Smith's biography, *Nollekens and his Times*, published in 1828, which is among the most spiteful books ever written, gives an unforgettable picture of the ruses adopted by Nollekens and his deplorable wife to avoid spending money; but Smith, who was one of the sculptor's executors, was infuriated at receiving a legacy of only £100 out of a fortune of some £200,000.[2] Since Nollekens can have inherited little or nothing from his father, his wealth at his death is an impressive tribute to his industry; and even Smith, who misses no opportunity of ridiculing the sculptor's eccentric personal habits and the squalor in which he lived, is unable to suggest that he neglected his work, and grudgingly admits that as a maker of busts, at least, he was without a rival.

On the other hand, the many references to Nollekens in the Farington Diary give a somewhat different impression. In the early years of the nineteenth century Nollekens was obviously much respected as a hard-working artist of great practical knowledge and experience, whose opinions were not to be despised. There is no hint that he was objectionable to his fellow-Academicians, and indeed, it would seem that Farington, so jealous for the reputation of the Academy, was genuinely fond of him. Moreover, though there was within the Academy some difference of opinion as to the relative merits of Nollekens and Banks, most artists would have agreed with Flaxman's statement quoted at the beginning of this chapter, and all were unanimous in praising the brilliance of his busts. Today it is more difficult to see him as a serious neo-classicist, though his first-hand knowledge of the antique is unquestionable and it must always be remembered that his style was formed long before Canova swept the Roman stage in the 1790s. His busts are superb, and his gifts in this field have been much underrated.

Nollekens was the most distinguished member of a family of artists who originally came from Antwerp. Both his father and his grandfather were painters, the former having settled in France after living in England. The latter worked in London from 1733, where he produced small conversation pieces. Joseph was apprenticed to Peter Scheemakers in 1750, and by the end of the decade had shown his talent by gaining three premiums at the Society of Arts. In 1760 he went to Rome, where he was to stay for ten years. Smith, who in addition to his personal spite, expresses opinions which are coloured by his association with archaeological circles in the early nineteenth century, abuses Nollekens for his lack of interest in the historical development of antique sculpture, and for the fact that, later in life, he was not inclined to 'descant upon the sublimity

157

of thought, the grandeur of the composition, nor the energetic expression of the Lao-
coon, the Apollo Belvidere [sic], the Farnese Hercules, the Niobe, the Venus de'
Medici . . .'.[3] In other words, while in Rome he had not given much attention to the
theories of Winckelmann. Smith admits, however, in the same passage, that Nollekens
had notebooks filled with sketches of the antique 'with their mutilations and measure-
ments'. 'Their mutilations' may well have been of special interest to him, for it is
entirely in character that he should have worked for Thomas Jenkins in the provision
of unmutilated antiques for the English market. In Rome he made many friends among
English collectors, to whom he supplied not only restored antiques or copies such as the
Castor and Pollux (V. and A.), made for Lord Anson in 1768,[4] but also terracottas said to
be by Michelangelo, Giovanni da Bologna, or Duquesnoy. The fact that he retained
some of the latter till his death suggests perhaps that he was a man of finer taste than
Smith would wish us to believe. Many of his patrons thus acquired were to give him
later commissions, notably Lord Yarborough and Charles Townley, to whom he
seems to have acted as a permanent technical adviser on his great collection of antiques.
Nollekens purchased Roman terracottas for Townley, bringing them back to England
in 1770, and about ten years later restored the arms of the small Townley Venus, Smith
posing as the model.[5]

In Rome, too, he began to build up his reputation as a maker of busts. His first sitter
was Garrick, who remembered him as a prize-winner at the Society of Arts and, out of
kindness, commissioned a bust. This early bust (Althorp, Northamptonshire) is of the
head and neck only, with no drapery, and seems certainly derived from the idealized
type of Early Imperial bust. The modelling is strong though generalized, and the hand-
ling surprisingly assured. The bust of Lawrence Sterne (1766, N.P.G.; Plate 120), also
made in Rome, is on the same pattern; but since Sterne's features did not lend them-
selves to idealization, his portrait is the more lively of the two, with a more sensitive
modelling of the lean face. It is noticeable that in both Nollekens uses the deeply incised
eyeball, not only cutting the circle for the iris, but hollowing the pupil and leaving a
small dot of marble within it to catch the light. This method had been in use in Late
Antiquity, but had been much developed by Baroque sculptors. Like his great con-
temporary, Houdon, Nollekens preferred it to the blind eyeball, and used it almost
invariably to give the lively expression that can be achieved by a directed glance.

Both the Garrick and the Sterne follow antique patterns: the bust of Edward, Duke
of York (1766, H.M. the Queen), reveals, however, that even while in Rome Nollekens
was also willing to follow contemporary fashion. It is, indeed, far nearer to the style of
Roubiliac than anything he could have seen in the studio of his master, Scheemakers;
for it is a wide bust, showing the sitter in armour, with a great scarf over the left shoul-
der, the head being turned in the other direction. The features are more generalized than
in Roubiliac's work; but the not very intelligent face is given considerable character,
indicating clearly enough the real bent of the sculptor's talents. Though he was never
again to create a bust so uncompromisingly Baroque, he was, as will be seen, prepared
throughout his life to use Baroque principles of design if they suited the character of
his sitter.

These activities in Rome ensured a good future for Nollekens on his return to England in 1770. An excellent opportunity awaited him, for though Wilton was at the height of his reputation during the next few years, he was soon to give less and less time to sculpture; and John Bacon, a less talented man, had hardly yet made his name. Nollekens was elected an A.R.A. in 1771 and a full Academician in the next year. He was to exhibit regularly till 1816.

He was quickly overwhelmed with commissions for busts, for statues, and for monuments. Though eager to accept all that came his way, there is no doubt that it was the statues, particularly those of goddesses, which pleased him most. The best remaining examples are the Venus, Diana, Minerva, and Juno at Wentworth Woodhouse, Yorkshire, dating from 1773 to 1778[6] (Plate 118B), and the Venus chiding Cupid (Usher Art Gallery, Lincoln; Plate 118A) made for Lord Yarborough in 1778.[7] None can be considered serious neo-classical works, and all have a certain archness which suggests that Nollekens was well aware how to tickle the palates of his clients. The Diana and Venus at Wentworth Woodhouse are not, however, without charm. The former runs rapidly forward, turning her head to discharge an arrow as she goes; the latter is perched elegantly on a tree-trunk, tying her sandal. Her general build, and above all her sloping shoulders, give the impression that she is the Venus de'Medici re-posed; but the overall air of elegance and the tapering legs have some resemblance to Florentine Mannerist sculpture, and it may be recalled that Nollekens owned terracottas which he claimed were works of Giovanni da Bologna. Lord Yarborough's Venus is less agreeably formed, for her torso is longer and her legs too short; but Nollekens was partial to this group, and no doubt the sentimental content of the goddess and the infant Cupid was thought very pleasing. It is a little surprising that such works were admired by Flaxman, for they are neither noble nor grand; but in their inherent frivolity are poles apart from the serious, if sometimes clumsy, neo-classicism of Banks.

Nollekens's classical statues date from the early part of his career; his work as a maker of monuments continued throughout his life, at least eighty signed works being extant. It is therefore not surprising that many, especially of the later works, are repetitive. He was in the habit of keeping numerous sketches, showing variations of his most usual themes, to show to mourning relatives, so that he could rush them into an order 'when the tear's in the eye'.[8] On the whole, he was content to follow rather than to create fashion, though occasionally, as in the monument to Sir Thomas and Lady Salusbury (1777, Offley, Hertfordshire; Plate 117B) with its two standing figures in classical dress, greeting each other under an oak tree, he produces a design of some originality; and his work often has charm.

In many of his smaller monuments of the 1770s he continues to use variations of the type popularized by Rysbrack and Scheemakers of the winged boy holding a medallion portrait in front of a pyramid background. Among these may be quoted two monuments to the Cunliffe family at Bruera, Cheshire (1778; Plate 119A), or the Cavendish monument at Cartmel, Lancashire, which is astonishingly Rococo in the quick movement of the child and the curling drapery over the medallion. The type persists after the turn of the century, for the Viscount Bateman at Shobdon, Herefordshire, is as late as

1804. The Charles Stuart of 1781 at Westminster has no pyramid, and perhaps because it was for a London and not a country church it makes more concessions to neo-classical taste. The boy is not winged, nor has he the ruffled curls of Baroque children; he is swung round into relief with cleanly-cut contours seen against the drapery he holds, which is itself arranged in small, repeated classicizing folds. Nollekens was, however, to cling to the mourning boy theme, though his modelling becomes increasingly summary. One child mourns over a classical urn on the monument to Dr John Crossley of 1790 (Abingdon, Berkshire), and three are grouped round the portrait, now placed on an urn rather than on a medallion, of John, Duke of Dorset (1802, Withyham, Sussex).[9] One of the most successful of Nollekens's smaller monuments is that at Westminster to Oliver Goldsmith (d. 1774), which is a simple draped medallion with a fine head, cleanly cut and beautifully set in low relief on the plain ground, while below there is a well-devised trophy of books, laurels, and a player's mask. Not all Nollekens's monuments have such dignity, and in many the portrait seems too large for the frame.

Inevitably many of the later monuments exploit the theme of the mourning lady. Nollekens is not, at first, entirely happy with it, and in spite of his long stay in Rome he is unable to resist his love of complicated draperies. The lady leaning on the urn in General Bennett Noel's monument (1787, Exton, Rutland) is muffled from head to foot in heavy draperies whose large, deep folds owe little to the antique. The medallion portrait of Mary, Countess Talbot (d. 1787, Great Barrington, Gloucestershire), is carefully displayed on an austere pedestal by a lady whose scanty draperies are far from austere. After the turn of the century there is an increase in sentiment, and at the same time figures are silhouetted more sharply against the ground. Maria, Countess of Dysart's monument (Helmingham, Suffolk), erected after her death in 1804 by her 'afflicted and disconsolate husband', has, in high relief against a large rectangular tablet, a seated lady who neglects her book and gazes mournfully at an urn, while on the other side is a weeping child with a lamb; and the Viscount Irwin and his wife (erected 1810, Whitkirk, Yorkshire) has a female figure with a strikingly Greek profile, bowed with clasped hands over a fine, fluted urn. Nollekens could vary the theme endlessly; but he is perhaps more attractive when he does not pay even lip-service to neo-classicism. The portrait of John, Earl Spencer (d. 1783, Great Brington, Northamptonshire), is daintily suspended by an elegant and somewhat scantily clad female supported on billowing clouds, a cornucopia spilling its riches at her feet;[10] and the monument to the 4th Earl of Gainsborough, his wife, and her second husband (1790, Exton, Rutland; Plate 119B) also has the cornucopia, with a charming lady reclining on a most elegant carved and fluted sarcophagus and pointing to portrait medallions held by one boy and mourned by another. Many other instances of all these types, with variations, could be given. Most are competent, many are pleasing within their limits, but few are distinguished. The next generation, inevitably, despised them: 'He was but a timid adventurer in the regions of taste, and walked with the pretty and the neat.'[11] To Allan Cunningham, writing in 1830, these were deplorable qualities – but the elegant prettiness of the Gainsborough monument has a sweetness, both of conception and of design, which gives it a charm totally absent in its arid nineteenth-century counterparts.

Very occasionally, Nollekens brings that remarkable feeling for character, which will shortly be discussed in his busts, to bear on a monument. Two at Ossington, Nottinghamshire, commemorate William (d. 1782) and Robert Denison (d. 1785). Both show standing figures in contemporary dress, William slow and ponderous leaning on a tree-trunk and holding a scroll, Robert clearly a more active character, in the cross-legged pose which goes back to Guelfi's Craggs. The theme has travelled a long way, and had been given new life by Gainsborough's portraits. Now it is used with a naturalism which, with the contemporary clothes, seems to herald the naturalistic trend which develops side by side with the classical in the work of nineteenth-century sculptors such as Chantrey, and therefore reveals Nollekens in a different light from the works so far discussed.

There is no doubt that the sculptor was most successful when he was least ambitious. His largest monument, that to three naval captains, William Bayne, William Blair, and Lord Robert Manners (Westminster Abbey), is a tedious affair, and shows the confused state of English sculpture in the 1780s. The Government commission for the work was in 1782 put in the hands of the Royal Academy, who chose Nollekens as the sculptor, though Smith asserts that Reynolds made a sketch 'which was certainly attended to by the Sculptor in his composition'.[12] The result is an elaborate though frozen allegory, but without the symmetry which Reynolds had advocated in his *Discourse on Sculpture* delivered two years earlier; for Neptune, reclining uncomfortably on a sea-horse, is balanced by a standing Britannia, who gazes mournfully at the medallion portraits of the three naval heroes. These are being hung on a rostral column by a little flying Genius, while above stands a disproportionately small figure of Fame. Some attempt has been made to place the figures in parallel planes and to avoid violent and three-dimensional movement: Britannia is a calm, Minerva-like figure and Neptune based on the traditional antique river-god pattern. Even so, the work as a whole, backed by a pyramid, is still in the pictorial tradition of Roubiliac, and much play is made with pretty picturesque detail of waves and flags. This dull design of many disparate parts makes a striking contrast to the terracotta sketch (V. and A.), presumably for a separate monument, showing Lord Robert Manners dying in the arms of Victory. Here the two figures are integrated by a spiral movement running through the group; the forms are broadly indicated with a swift, loose handling. Indeed, here and in other terracottas in the same museum, Nollekens is very far from neo-classicism, and very close to his Baroque predecessors.

His statues and monuments alone would hardly secure for him a place of any great distinction in the history of English sculpture. His busts, however, are often of the first rank. He is known to have modelled them in clay from the life, often having some eight sittings; and when a cast had been made and the marble worked from it by an assistant to an advanced stage, he liked another sitting when he would finish the marble himself from the life.[13] His practice was enormous; replicas were often made, though they may differ by a few years in date, while the copies of his two most famous busts, those of Charles James Fox and the younger Pitt, sold at £120 each and gave him a steady income.[14]

Up to about 1800 the pattern he uses is often but not always fairly wide at the shoulders, with considerable liveliness in the arrangement of the drapery, and usually with the head slightly turned. Many of the later busts are smaller, with no shoulders or drapery, and rounded off below the neck. If the larger type is still used, the head tends to be posed frontally, though the turned head never entirely disappears. On the whole, the later busts are simpler in modelling, slightly more generalized, and the planes of the face broadened, whereas in the earlier works it is the curve of cheeks and brow that are stressed. It would, however, be rash to make too dogmatic a statement; Nollekens was above all eager to achieve a likeness of his sitter which, according to Smith, he sought in a study of the eyes, nose, and mouth rather than in the bones of the head,[15] cutting more deeply than in life if the sitter was dark.[16] Even in his late busts this variation in cutting may be seen; and at all times a plump man naturally received different treatment from a lean one. It is not surprising that his work was greatly in demand; before 1800 he was able to increase his price from one hundred to one hundred and fifty guineas (Garrick had paid him twelve guineas for the model he had made in Rome); and a comparison of this fee with the thirty-five guineas charged by Rysbrack in the 1730s gives some indication of the changed value now placed on sculpture.

The early busts have many elements in common with those of Rysbrack, Scheemakers, and Roubiliac. The George III (1773, London, Royal Society; Plate 128A) is perhaps closest to the manner of Scheemakers, for the drapery, in fairly heavy classicizing folds, is caught but not brooched on the right shoulder. The head, however, with incised eyeballs to the slightly protruding eyes, and a carefully modelled mouth, is more alive than any bust by Nollekens's master, and gives an admirable portrait of the earnest dignity of the young king. The Earl of Mansfield (1779, Iveagh Bequest, Kenwood), the 2nd Marquess of Rockingham (c. 1784, Earl of Rosebery and Birmingham City Art Gallery; Plate 123), and the William Weddell (1789, Newby Hall and Ripon Cathedral) are among those with draperies thrown more freely round the shoulders and with the head slightly turned and looking down. Mansfield's strong, firm features are deeply cut and roundly modelled; the more nervous and more sensitive faces of Rockingham and Weddell have smaller modulations; their sharp chins and long, straight noses, together with the set of the head on the neck, suggest reserve in contrast to Mansfield's force. All are classicizing in their use of drapery, and Mansfield's hair is short in the antique manner; the other two (and the George III) compromise, for small curls, presumably of a short wig, appear behind the ears. That Nollekens could, if required, compromise to a far greater extent, is shown by the charming and almost Rococo bust of Sophia Aufrere, Mrs Pelham (Earl of Yarborough; Plate 122), who wears a scarf threaded through her hair and twisted round her neck, and by the Dr Charles Burney (1802, B.M.; Plate 124B), who wears academic dress and bands. This is both one of the finest and least classical of Nollekens's busts, comparable in its sense of character to a late portrait by Reynolds such as the Joshua Sharpe, and inherently Baroque with its strong diagonals and directed glance.

The sculptor's masterpiece in the Baroque manner is, however, beyond question the earlier of his two busts of Charles James Fox (1791; Plate 121), though the existence of

many replicas has perhaps tended to dull its interest.[17] The flamboyance of Fox's character has been seized to perfection and the grossness of his physique has been emphasized rather than ignored. The swift turn of the head with the curls jutting from it, and the piercing eyes are all the more impressive against the bulk of the shoulders. Here is a man who could dominate the House of Commons, infuriate the Tories by the dangerous liberality of his views, and command the unswerving loyalty of his friends. The second bust, made in 1803, is also a splendid portrait, though the head, which has no wig, is almost frontal, and so the ferocious energy of the sitter is less strongly revealed by the design.[18]

It is inevitable that a comparison should be drawn between the busts of Fox and of his great rival, the younger Pitt. The latter refused to sit to Nollekens, according to Smith because of the sculptor's presumption in approaching George III about the epitaph for the Three Captains' monument; but Nollekens took a death-mask in 1806, and from it created a bust and the statue of Pitt in the Senate House at Cambridge.[19] Though the Pitt bust (Plate 124A), like the second Fox, has no wig, and like it has a drapery thrown round the shoulders, the resemblance goes no further. The proportions are entirely different and very revealing. The narrow, proud head of Pitt is reared arrogantly on a long neck above the slender shoulders; it is austere where the Fox is florid. That coldness, that lack of human sympathy which was basically a lack of imagination are apparent in the design as well as in the face, but so also is the strength which carried the cares of government for twenty years.

Changing fashion which led to the disappearance of the wig and the introduction of side-whiskers presented Nollekens with a problem which did not daunt him. No doubt he recalled Late Imperial busts with sprouting beards which could serve as a prototype; but there is nevertheless something a little ridiculous in, for instance, the round-faced, whiskered 5th Duke of Bedford (1803, Holkham Hall, Norfolk) with his bare neck and no drapery. Small undraped busts without shoulders seem to have been popular among Nollekens's clients in the first decade of the nineteenth century (a number can be seen at Woburn), and though the design is occasionally varied by a twist of the head, the necessity for giving interest through the features alone sometimes leads to an over-stressing of idiosyncrasy which borders on caricature. That Nollekens could, however, create an impressive portrait with the minimum of display is shown by the bust of Charles Townley (1802, B.M.; Plate 125A), which, apparently by the sitter's desire, has a plain, herm-like form.

Generally speaking Nollekens's modelling during the last years of his active life (he gave up working shortly before 1820) is at once more summary and more fleshy than in his early busts. Even the spare, aquiline features of the Duke of Wellington (1813, Apsley House and replicas elsewhere) have become a little gross; and the Prince Regent (1815, Belvoir Castle) with his long tousled hair, double chin, and loose drapery is singularly unmasculine and looks like an elderly actress in her dressing-room. Occasionally, however, he seems to have found a heavily-built sitter whose strong features fitted well enough with his late, broad style; and the Samuel Whitbread (1814, London, Drury Lane Theatre; Plate 125B) is a masterpiece of characterization.

Nollekens's reputation as a sculptor has suffered both from Smith's venomous por-trait of the artist as a man, and also from Flaxman's misdirected praise quoted at the beginning of this chapter. He has been measured by the serious standards of neo-classical art and has been reduced to a frivolous, indeed to a comic figure. His stature as a por-traitist has been almost completely ignored. The very fact that he was not an intellectual artist enabled him to treat each sitter as he found him and to create his busts with no rigid formula of design. He was beyond question the leading portrait sculptor of his day; he spans, unchallenged, the period between Roubiliac and Chantrey, and the quantity and variety of his work in this field are as impressive as its quality.

CHAPTER 21

JOHN BACON AND SOME CONTEMPORARIES

John Bacon

JOHN BACON (1740–99) must be regarded as a neo-classical sculptor by accident of date rather than by inclination. Unlike the majority of sculptors of the second half of the eighteenth century, he never went to Rome; neither his training nor his temperament led him to that intellectual interest in antique art displayed by both Banks and Flaxman; nor did his early background provide the impetus, presumably given to Nollekens in Scheemakers's studio, to build his career on the traditional study abroad. Such neo-classical trends as appear in his style are pale reflections of the work of his more travelled contemporaries – a question of fashion rather than of conviction. His success was, however, considerable; he had a very large practice, and carried out important public commissions as well as innumerable small monuments. His career is additional proof that English patrons were slow to demand truly neo-classical art, and were well contented with a combination of sentiment with Rococo charm.

Bacon's origins were modest.[1] His father was a cloth-weaver, with strong religious feelings which he passed on to his son, who was to become a pillar of Dissent, and whose character shows the strength and failings usually found in such men. The boy was apprenticed at the age of fourteen to Nicholas Crisp, who, though a jeweller by trade, also owned a porcelain factory. Here Bacon developed the talent for modelling the pretty detail characteristic of porcelain groups which was to leave a permanent mark on his style. He also probably saw clay models sent by sculptors to the factory for firing, and from 1759 he submitted models of his own to the Society of Arts, and received a number of premiums for them. After nine years at the factory the owner went bankrupt; Bacon obtained some employment from Wedgwood and from the Crown Derby factory, but about 1769 he began to work for the Coade Artificial Stone Manufactory in Lambeth.[2] This firm, which was to flourish for some seventy years, was founded in 1769 by George Coade and his wife Eleanor, but after George's death in the next year the business appears to have been largely run by a daughter, also named Eleanor (1733–1821), who was herself a modeller. The many references in the late eighteenth and early nineteenth centuries to 'Mrs Coade' are more probably to the daughter than to the mother, under the courtesy title then normally given to an unmarried woman in business. The Coade factory produced an immense amount of work – decorative detail of all kinds as well as statues and monuments – in a material of remarkable permanence. The method of production was a jealously guarded secret, which does not seem to have been entirely revealed by modern technical analysis, though it is evident that kaolin (china clay) was an integral part of the compound used, and that the objects when modelled demanded highly skilful firing.[3] Bacon was to be the chief designer to the

165

factory for thirty years, and was almost certainly responsible for the privately circulated series of designs published between 1777 and 1779, which include a River God based on an engraving by William Blake, of which examples in Coade stone remain at Ham House, Surrey, and in the Terrace Gardens at Richmond. The factory became so prosperous that by 1799 a permanent Exhibition Gallery was opened fronting on Westminster Bridge Road, having a porch with caryatids and an allegorical group showing The Attempts of Time to destroy Sculpture and Architecture defeated by the Vitrifying Aid of Fire, all from Bacon's designs. Much of the work produced is merely signed 'Coade of Lambeth', but Bacon's hand can clearly be detected in such figures as the Faith, Hope, Charity, and Meekness in the ante-chapel at Greenwich Hospital; and probably also in the agreeable plaques and keystones which once adorned many eighteenth-century London houses, but which are fast disappearing. The standing, and also the enterprise of the Coade factory is shown by the fact that, in addition to Bacon, whose models were still in use as late as 1834, other leading sculptors, such as Flaxman, Banks, and Charles Rossi, were occasionally to be employed; Sir John Soane used the firm for caryatids and other decorations for his own houses at Pitzhanger Manor, Ealing, and in Lincoln's Inn Fields, and John Nash for some of the friezes, vases, and figures on the garden and courtyard fronts of Buckingham Palace.[4]

At almost the same time as the beginning of his work for Mrs Coade, Bacon entered the newly-opened Royal Academy Schools, and won the first gold medal awarded to a sculptor with his gesso-relief of Aeneas and Anchises.[5] In 1770 he became an A.R.A. and an Academician eight years later. His first marble statue, a Mars exhibited in 1771, though admired by Benjamin West, was to be damned with faint praise by Cunningham, who found it correct but deficient in heroic sentiment.[6] It was, however, the means of gaining for Bacon an important commission, for it pleased the Archbishop of York, who arranged that the sculptor should make a bust of George III for the hall of Christ Church, Oxford. Bacon's care to behave in a becoming manner at the sittings greatly pleased the king,[7] who ordered three replicas of the bust, which was exhibited at the Royal Academy in 1774 (Plate 128B).[8] The extreme softness of the modelling, the care lavished on the ermine robes and Garter chain, make an interesting contrast to Nollekens's much more virile and more ruthless classicizing bust of 1773, and it is easy to see why Bacon became a favourite artist of the king, and possibly also why the king commended him for having learnt his art in England, without the help of study abroad.

There is no doubt that Bacon had great natural talents, and when he was willing to use them unpretentiously and in works that did not become stale with endless repetition, he could produce sculpture of considerable quality. His masterpiece is the monument to Thomas Guy (1779, London, Guy's Hospital; Plate 126), a large pictorial relief with two life-sized figures set under a round arch. The founder of the hospital, in rich contemporary dress, is bending to help a half-nude emaciated man, who gazes up at him, hoping for his pain to be relieved. Behind, in very low relief, appears the courtyard of the hospital. The sick man has loose drapery over his back and legs, but there is nothing classical in the design or treatment. The legs of the seated figure hang downwards over the inscription, breaking through the plane established by the surrounding arch; the

two figures are linked diagonally, not only by their arms, but by the intensity of their glance; the swinging lines of the drapery, arranged in heavy, curling folds, and the sharp perspective of the buildings behind all proclaim this to be a very late work in the Baroque tradition, completely untouched by neo-classical ideas.[9] Later in life Bacon was to make another, but much smaller relief, now with the theme of succouring a prisoner, for the base of his statue of John Howard (1795, St Paul's Cathedral), but by then, probably owing to the example of Banks, he was trying to follow Roman models, and the result is much less sympathetic than the Thomas Guy.

It is difficult to write with any enthusiasm of Bacon's largest commission, the monument to William Pitt, Earl of Chatham (1779–83, Westminster Abbey; Plate 129B), which he gained largely through the favour of the king.[10] This vast pile of white marble, some thirty feet high, is a collection of not entirely unpleasing parts, put together with curiously little feeling for design. In a niche dug awkwardly out of the tall blunt-headed pyramid background, Chatham stands with his hand raised as if addressing the House. Below in tiers are five allegorical figures which, as Cunningham explains, show that Chatham is 'extending the sway of Britannia by means of Prudence and Fortitude over Earth and Ocean'. It is therefore not surprising that 'there was much in the design to please the King'. Each single figure is competently posed, and there is some pretty detail in the riches of Earth or the dolphin of Ocean, but the whole lacks any kind of inspiration. Indeed, though Bacon was not the choice of the Royal Academy, he produced a most academic piece, and one which must surely reflect the views on design that Reynolds was to put forward in his Discourse of 1780 when he advocated symmetrical grouping.[11] Almost alone among the abbey monuments before Flaxman's Mansfield, Bacon's Chatham adopts Reynolds's ideas, not to its advantage.[12] Bacon was paid more than £6,000 for the Chatham monument; Roubiliac was said to have had £1,400 for that of the Duke of Argyll, and to have lost £300 on it. The cost of marble had presumably risen, and the Chatham has more figures; but even so the difference in price is very marked, and is perhaps an indication of the new scale of values accepted for public commissions after the foundation of the Royal Academy.[13]

Bacon's other chief public undertaking about this time was the sculpture for the new Somerset House. Between 1778 and 1789 he designed the colossal figures on the Strand front showing Fame and the Genius of England, a group on the river front of two tritons, and the bronze group in the courtyard of George III and the River Thames. Queen Charlotte was disappointed with the last, and indeed George III in his toga appears about to drop food to an expectant lion, and the Thames is not much more than Chatham's Ocean in reverse.

In the last decade of Bacon's life he found it necessary to adopt a Roman manner for his public monuments. His inability to understand the principles of antique sculpture is most lamentably evident in the three standing figures, all over life-size, in St Paul's Cathedral.[14] The Dr Johnson (Plate 164B) and the John Howard were unveiled early in 1796;[15] the Sir William Jones was completed three years later. The Johnson and the Jones are semi-nude; the Howard wears a short chiton. All are inept in stance, but while the Johnson and the Jones are over-consciously posed, Howard's feeble limbs have

no direction and the work no unity. Johnson, who looks like a tired pugilist, is probably the worst of Bacon's larger figures, and it is perhaps as well that Reynolds, who had given him the commission, did not live to see it completed.

Bacon's talents were totally unsuited to such work; he is far more agreeable when he is less pretentious and not trying too hard to compete with true neo-classicists such as Banks. His seated figure of Sir William Blackstone (1784, Oxford, All Souls College; Plate 132) uses the judge's robes and wig with skill; and the model (c. 1784, V. and A.) for the important statue to be erected to Lord Rodney in Spanish Town, Jamaica, also uses contemporary dress in a pleasing design. But the Royal Academy felt a more heroic style was needed, and the executed statue is a foolish production in classical dress.

It is, however, for his smaller monuments that Bacon is chiefly remembered – inevitably so, perhaps, for he turned them out in great quantities, and they may be seen in endless village churches. A number were also exported, for after the Rodney commission he obtained several orders from the West Indies.[16] Their pretty and relatively unpretentious style is quickly recognizable; but they become a little boring, since stock themes are endlessly repeated with very slight variations, and the cutting, though competent, is a little mechanical, for Bacon's new pointing machine enabled him to leave much of the work to his assistants. Moreover, if a medallion or bust portrait is introduced it has never the virility and sense of character to be seen in similar works by Nollekens.

Though Bacon was all through his life to continue to use the boys, winged or unwinged, of the earlier part of the century (Earl of Halifax, 1782, Westminster; Lady Eardley, 1795, Berkswell, Warwickshire), his most favoured motive was the elegant female figure with flowing draperies. This could be put to a number of uses. An extremely popular design shows two ladies looking outwards, with a pedestal and urn or an altar between them. It is probable that the design was first made for the monument of Mrs Elizabeth Draper (Bristol Cathedral), the model of which was exhibited at the Royal Academy in 1780.[17] The left-hand lady holds the torch of Genius (Mrs Draper was a poetess); the right with her head bent is Benevolence, carrying a bird's-nest with the pelican and her young. The design had a great success. It was used for the monuments of Mr and Mrs Ashley (1785, Ashby St Ledgers, Northamptonshire) and for Ann Allardyce (1791, Aberdeen, St Nicholas). Benevolence with her pelican, clearly an appealing figure, is constant, but the attributes of the other lady vary. For the Egerton monument (1792, Rostherne, Cheshire; Plate 129A) Bacon used the same ladies, though now they are Hope and Patience, but set them farther apart, and elaborated the design with a sarcophagus, urns, and reliefs of mourning boys. The Benevolence figure, with slightly altered draperies and her hand on her breast, leans on the pedestal supporting the bust of Sir Richard Cust (1797, Stamford, St George); while the left-hand one alone rests on an urn in the monument to John Johnson (1786, Leicester Cathedral). Mrs Rosa Palmer (1794, Montego Bay, Jamaica) has a sister to these ladies, leaning forward over a wreathed urn, the pelican and her nest neatly deposited like a basket at the foot of the pedestal. Not all Bacon's ladies stand or lean; sometimes they sit either with a medallion (Thomas Gray, 1771, Westminster) or with an urn (Thomas Wyld, 1791, Speen, Berk-

JOHN BACON

shire). The decorative detail is always charming, for Bacon knew well enough how to model on a small scale. His Westminster monuments with ladies are, on the whole, more ambitious and therefore less pleasing than those in less prominent places. The limbs of the figure who grieves over the coffin of General Hope (1793) are not very convincingly articulated, but the drapery and the floral detail of the beaver (the General was Governor of Quebec) are agreeably planned. Miss Ann Whytell (1791; Plate 130A) has a variant of the design of two ladies (now Innocence and Peace) but they are both almost frontal, and more antique in their dress than their pretty country cousins. The work is competent within its limits, but these rather dainty figures would be more appropriate as mantelpiece ornaments, perhaps holding a gilt clock, than on the scale of an Abbey monument.

Very occasionally in the 1790s Bacon discarded his by now stereotyped designs, and, probably in emulation of Banks, attempted something in a different manner. The monument to the 5th Earl Waldegrave (1796, Upper Chapel, Eton College, Bucks), drowned in the Thames, shows three boys in scholars' gowns in high relief on a plain stele, whose pedimented top encloses Bacon's favourite pelican. The group is carefully designed, though more clumsily placed than in any comparable monument by Flaxman, and though Bacon appears to have tried to simplify his surface modelling to achieve the smoother surfaces now becoming admired, he only succeeds in making it heavy and dull.[18]

Bacon's last important design, that for the monument to Samuel Whitbread (Cardington, Bedfordshire; Plate 127), was exhibited at the Royal Academy in the year of his death, and finished by his son. Here there is a more open attempt to rival Banks, for the death-bed scene must surely be linked with the latter artist's much admired Margaret Petrie of 1795 (Plate 141B).[19] That Bacon was trying to think in classical terms is revealed by the semi-nude figure of the dying man, resting on an antique couch. His pose is contorted and is not parallel to the plane, largely because his head and shoulders are supported by a figure of Faith, who has hurried to his assistance (one foot has not yet touched the ground) and points upwards to a glory appearing between curtains above him. At his feet is the ubiquitous figure, now perhaps Charity, with the pelican, crouched in mourning. The forms are everywhere much smaller than those of Banks, and the draperies do not fall in straight, solemn folds, but are crumpled and twisted, breaking up the surface, and confusing the design. To the end, Bacon's training as a modeller is apparent.

Like most of his contemporaries, he made busts, all relatively static in design, but careful in modelling. The Jeremiah Milles (London, Society of Antiquaries) is perhaps the most lively in characterization; but it must have been generally recognized that Nollekens was greatly his superior in portraiture, for Bacon got far fewer commissions in this field.

Bacon's invention of the new and easily handled pointing machine and the consequent size of his practice naturally meant that he had a large workshop, which was carried on after his death by his second son, John Bacon the Younger (1777–1859), up to about 1830, after which it seems to have been run by the latter's pupil, Samuel

Manning, for the mass production of wall-monuments.[20] The younger Bacon had little originality, and many of his works are slightly classicized and sentimentalized variants of his father's themes. He obtained a great number of commissions, ranging from groups with several figures to small tablets with reliefs, but a work such as the Bariatinsky monument (Sherborne, Dorset) shows that his contemporaries were right in thinking him deficient in his knowledge of the antique. Indeed, like his father, he was a neo-classical artist by accident rather than desire, and the equestrian statue of William III (1807, London, St James's Square), designed by the elder and carried out by the younger Bacon, is clear testimony of this; for it is still in the Baroque tradition, and might well be mistaken for a work of the 1730s.

Some Contemporary Sculptors

Bacon and Nollekens were by no means the only sculptors working in the last quarter of the eighteenth century whose style shows a semi-digested knowledge of neo-classicism. Peter Matthias Vangelder (1739–1809) came to England from Amsterdam as a young man, worked for Thomas Carter, and entered the Royal Academy Schools in 1769. His finest work is the monument to Mary, Duchess of Montagu (1775, Warkton, Northamptonshire; Plate 131). The group of figures, set in a large and elegant niche designed by Robert Adam, offer, both in sentiment and handling, an instructive contrast to the Roubiliac tombs in the same church (Plate 80B), erected some twenty-five years earlier. In the latter, allegory is of prime importance, and there is little direct appeal to sentiment. Vangelder's duchess, who was noted for her charity, is shown leaning exhausted upon an urn, with a child on her lap and another at her feet. An elderly woman attends her, while on the other side of the urn an angel directs her dying eyes to Heaven. The whole is at once appealing and edifying. Though, however, all the figures wear classical dress, the handling of the angel's draperies is far from neo-classical; for large loops of the garments are allowed 'to sport and flutter in the air' in a way which must have been most displeasing to Reynolds; and the deep cutting of the folds as well as the strong diagonals of the composition make a somewhat surprising contrast to Adam's chaste, low-relief decoration of the niche.

Vangelder does not seem to have worked with Adam on other occasions, though his not inconsiderable practice included chimneypieces as well as monuments. His work was probably too naturalistic to fit the Adam pattern; for he was noted for his carving of foliage, and the tablet to Mrs Frampton (d. 1782, Moreton, Dorset) is surrounded by trails of flowers of astonishing reality for their date.[21] Moreover, the relief on the monument to Major André (1780, Westminster Abbey) is still fully pictorial. In some of his later monuments, such as that to Lord Northwick (d. 1800, Blockley, Gloucestershire), with its lady mourning over an urn and a boy with inverted torch, the influence of John Bacon can be seen; but even here the tall pyramid background of the earlier generation is retained.

The work of John Francis Moore, who came to England from Hanover about 1760 and died in London in 1809, also presents some confusion of style. Perhaps its most sur-

prising feature, at a time when only the cold contrast of white marble set against black or dark grey was thought in good taste, is his constant use of coloured marbles. His early statue of the elder William Beckford (*c.* 1767, London, Ironmongers' Hall) still has links with the Baroque in its twisted pose,[22] and a description of a chimneypiece with scenes from the *Iliad*, made for Beckford about 1772, with groups showing the more remarkable deaths in very high relief, intermingled with minor tragedies in low relief, suggests something very far from neo-classicism.[23] On the other hand, his monument to Beckford in his Lord Mayor's robes (1772, London, Guildhall; Plate 133A) has two placid seated ladies in classical dress which clings tightly to their bodies; and the Lord Ligonier (1773, Westminster Abbey) mixes a vast pile of trophies with a neo-classical vase in the manner of Robert Adam, and the Junoesque lady who holds the scroll bearing the list of Ligonier's battles has nothing left of the Baroque. The flags and the lady's draperies are treated with the fine small folds introduced by Wilton in, for instance, the monument to Dr Stephen Hales (Plate 111), but Moore has a less sophisticated sense of form; and this figure and the urn, if detached from the rest of the design, would take its place as the work of a second-rate neo-classical sculptor.[24]

The elder Richard Westmacott (1747–1808), father of a more famous son of the same name, falls within this group of transitional artists. His finest monument, that to James Dutton (1791, Sherborne, Gloucestershire; Plate 134) is of exceptionally high quality, but curiously mixed in style and design: for a large winged angel shelters medallion portraits under a falling diagonal drapery, and tramples the grinning skeleton of Death beneath her feet. The figure hesitates between the Christian and the classical, for it is palpably female, with a classical garment slipping from one breast, and the large wings seem somewhat inappropriate. The more than competent modelling, however, reveals that Westmacott was by no means a negligible artist, though none of his other works are so distinguished in design.[25]

The relatively early death of James Hickey (1751–95) deprived England of a promising artist, and also was the cause of one of Westminster Abbey's more surprising monuments. Hickey was trained in Dublin, but entered the Royal Academy Schools in 1776, and ten years later was appointed sculptor to the Prince of Wales. His elaborate monument to the Hawkins family (1782, Abingdon, Berkshire; Plate 117A) has a wealth of pretty detail somewhat in the manner of John Bacon, and the seated lady also owes much to the same artist. The four busts arranged round her seem, however, to be stronger and more classical, and the apparently disparate elements are skilfully welded into a pleasing whole. Shortly before his death Hickey was given, through the influence of his fellow-countryman, Edmund Burke, the important commission for a monument to Garrick at Westminster. It can hardly be doubted that, had he lived, he would have produced something more successful (though perhaps less dramatic) than the work finally executed in 1797 by Bacon's pupil, Henry Webber (1754–1826; Plate 130B). In spite of the fact that Webber, like Flaxman, had undergone the discipline of working for the Wedgwood factory, and had been sent to Rome by the firm, he seems to have profited little by his opportunities. The figure of the actor pushing aside the curtains is strikingly conceived, and executed in the manner, though without the skill, of Roubiliac's Handel

monument close by. The strangely misproportioned Muses below, however, are related uncertainly to their background and reveal that though Webber had heard of the value of contour, he could not control it, nor had he Hickey's ability to produce a coherent design.

The Irishman Christopher Hewetson (1739–98) falls into a different category, for most of his working life was spent in Rome.[26] He was therefore untouched by the cross-currents of style apparent in England; and though he worked for a number of English travellers and was in touch with English artists in Rome, it is hard to say how far his work was influential. He was in Rome by 1765, and his early busts (Charles Townley, 1769, Lady Mary Strachey Collection; William Henry, Duke of Gloucester, 1772, Windsor Castle) are at least as competent as those of Nollekens at about the same date, and present an equal willingness to use a modified Baroque formula. Before 1776 he made at least three busts of Pope Clement XIV which follow the type already used by Pietro Bracci in his bust of Pope Clement XII (Rome, Borghese Gallery). His modelling at this time is strong, but detailed, with an excellent sense of character. By the end of the decade, however, he came into contact with Anton Raphael Mengs, and his style changes. His busts of Mengs (1779, Rome, Institut de France; 1781, Rome, Protomoteca Capitolina), of Mengs's friend, Don José d'Azara (1779, Rome, Institut de France), and of Gavin Hamilton (1784, University of Glasgow; Plate 139B) have no drapery, and though the characterization is still perceptive, the forms are more generalized and the modelling smoother. A version of the Hamilton bust was exhibited at the Royal Academy in 1786; its reticence must surely have been noted, and its form, narrow and herm-like, may perhaps have influenced Nollekens's later busts, though he does not appear to have adopted this pattern until after 1800.

Hewetson's only recorded work, apart from busts, in the British Isles is the monument to Dr Baldwin (1784, Trinity College, Dublin). This has a fine group of three figures in the round, silhouetted against a red granite stele and carefully arranged so that the movement is parallel to the plane. The dying man is supported by a seated Muse, while an angel comforts him with the sight of a laurel crown. There is, perhaps, more fluttering movement in the angel's garments than might be expected in a neo-classical monument; but Hewetson in his description of his design states that the figure has 'just descended', and so perhaps it was inevitable that in the curling edges of the draperies in movement he could not entirely escape the memory of the innumerable Baroque angels visible in Rome.

As in the earlier part of the century, good work was produced by workshops, now becoming firms, outside London. That established by Thomas King of Bath (1741–1804) lasted about a hundred years, and turned out well-designed small monuments, many making use of coloured marbles, which may be found widely dispersed over the south of England, and farther afield in India and the West Indies. The earlier works of the firm, one of the most distinguished being the monument to James Quinn (1761, Bath Abbey), still look back to the Baroque tradition in general design and in the type of the medallion portrait; later, well-cut neo-classical tablets, and also chimneypieces, were produced by this active firm.[27]

The workshop of the Fishers of York lasted for about the same period, though John Fisher the Elder (1736–1804) was more ambitious and more accomplished than Thomas King, and his statue of Sir George Savile (1784, York Minster),[28] which suggests the influence of Joseph Wilton, is the equal of much London work. Broadly speaking, however, the output of the firm follows much the same pattern as that of the Kings of Bath; for coloured marbles are used surprisingly late, in conjunction with neo-classical detail. A large amount of work of all kinds in the North of England was produced by the three generations of this family, some of it being of high quality.

One other very English genre, that of animal sculpture, must be mentioned here. Anne Seymour Damer (1749–1828) might perhaps have been forgotten but for the devotion of Horace Walpole.[29] She was the daughter of his intimate friend, Field Marshal Conway. He doted on her delicacy and her talent, which he grossly over-praised, and at his death left her his greatest treasure, his house at Strawberry Hill. She was, however, rather more than a gifted amateur, and there seems no doubt that after some instruction from Ceracchi and from Bacon, she cut marble herself and did not leave it to a craftsman. She was extravagantly praised for the heads of the Rivers Thames and Isis (1785) which decorate the bridge at Henley-on-Thames, and which are, at least, an unusual achievement for a young lady of quality. She executed a number of busts, mainly though not entirely of her relatives and friends, all of whom would seem to have possessed noble classical features, but strangely little animation, and she had 'a singular talent for catching the characters of animals'.[30] Here her position as an artist reflects well enough the many cross-currents at work in English eighteenth-century art, and links her on the one hand with the painters of sporting pictures, and on the other with the rising taste for rustic genre, that early form of Romanticism to be seen in the stable scenes of George Morland. Mrs Damer's dogs (Plate 135B) are as naturalistic as her busts are classicized, and though it is necessary to be indulgent to Walpole's praise of them as the equal of Bernini or the best antique sculpture, they have a freshness and competence which cannot be denied.

Her fame, surprisingly, was not confined to England, for when the painter Joseph Farington visited the Tuileries in 1802, he saw on a table her busts of Charles James Fox and Nelson, which she had presented to Napoleon.[31] The episode is an interesting reflection of Whig politics, and perhaps also of Napoleon's attitude to the English; while Farington's other reference to her, in a man's coat, hat, and shoes, stumping about the fields with a hooking stick,[32] places her clearly enough among the agreeable eccentrics of her class.

Long before Mrs Damer ceased to exhibit, another animal sculptor, George Garrard (1760–1826), appeared, whose work points directly to the Romantic Movement. Garrard was an animal painter as well as a sculptor; he married the daughter of Sawrey Gilpin, one of the best known of English animal painters, and so comes within the circle of artists whose work was to excite Géricault during his visit to England in 1820–2. Garrard's best work was shown at the Academy earlier than this, for his remarkable relief of Duncan's maddened horses, used as an over-door at Southill, Bedfordshire (Plate 135A), was exhibited in 1797.[33] Possibly a plaster of it, or of the companion relief

of bison fighting, might still have been available in London at the time of Géricault's visit, for it seems certain that Garrard did sell small plasters of his naturalistic animal figures, some of which are still at Southill. He was less successful on a more ambitious scale. The models he submitted, in vain, for government commissions for equestrian statues of Sir John Moore (1812, Southill) or the Duke of Wellington (1815, Birmingham, City Art Gallery) show a greater control of the anatomy of the horse than of the rider, and his busts, which follow the current neo-classical fashion, are, except perhaps in the case of his father-in-law (1803, Burghley House, Northamptonshire), not much more successful in their characterization than those of Mrs Damer.[34]

CHAPTER 22

THOMAS BANKS

THERE was little doubt in the minds of the contemporaries and immediate successors of Thomas Banks (1735–1805) that he was a great artist. Reynolds regarded him as 'the first British sculptor who had produced works of classic grace', and whose 'mind was ever dwelling on subjects worthy of an ancient Greek';[1] John Flaxman thought his 'best works may be considered standard in sentiment and execution';[2] Sir Richard Westmacott said he had 'successfully stemmed the torrent of false taste';[3] Robert Southey, writing shortly before Banks's death under the pseudonym of Don Manuel Alvarez Espriella, was even more emphatic: 'England has produced few good sculptors; it would not be incorrect if I should say none, with the exception of Mr. Banks, a living artist, whose best works are not by any means estimated according to their merit'.[4] Posterity has dealt more hardly with Banks; several of those works most admired by his contemporaries have vanished, others are in disagreeable condition or hard to see, his reputation has dwindled before the greater charm of Flaxman, and he is often judged by his least successful performances. That he was an artist of sincerity and originality is without question, nor can his place as the first true English neo-classicist be disputed, but the works which remain are very uneven in quality and leave an uneasy sense that his ambitions outran his talents.

Banks was born in London, but spent his childhood in the West Country, for his father was gardener and surveyor to the Duke of Beaufort at Badminton.[5] At the age of fifteen he was sent to London and apprenticed to an ornamental carver whose shop was close to the studio of Peter Scheemakers. The boy made friends with Scheemakers's pupils, and obtained permission to draw and model in the studio in the evenings. He would no doubt have seen some of the casts of antiques brought from Rome by Scheemakers, and the general trend of the studio would naturally have been towards the classical rather than the Baroque. Little is known of his early manhood except that when he was twenty-three he began to draw from the life at the St Martin's Lane Academy, presumably also in the evenings. Unlike Flaxman, however, he never acquired much facility as a draughtsman, and later in life relied chiefly on clay models.[6] His earliest works appear to have been entirely of classical subjects – reliefs of the Death of Epaminondas (1763), the Redemption of the Body of Hector (1765), a figure of Prometheus (1769), all of which won him premiums at the Society of Arts, and in 1770 a relief of the Rape of Proserpine which gained a gold medal at the Royal Academy. Unfortunately none of these nor of other early works exhibited at the Free Society of Artists or the Royal Academy have survived, and it is therefore impossible to judge how far his style was formed before the Royal Academy granted him a Travelling Studentship to Rome in 1772. Since by then he had married a wife with private means, he was able to stay in Rome for seven years. From his time in Rome dates his life-long friend-

ship with Henry Fuseli which was of the greatest importance in the formation of his art.[7] Fuseli had already been in Rome for more than two years, and before going there he had made his translation of Winckelmann's *Gedanken*. He was therefore well equipped to initiate Banks into neo-classical doctrines, and his own expressive art, which draws from Italian Mannerist sources as well as from Antiquity,[8] must have been a revelation to the less experienced, though older artist. Indeed, it is almost certainly the association with Fuseli which gives to some of Banks's works an intensity lacking in those of the more gentle Flaxman, but which is paralleled, though far outstripped, by the works of Blake.

No sketch-books remain to reveal what Banks chiefly studied in Rome, but the works he created while there are proof of his absorption of Winckelmann's ideas, and of his special interest in antique sarcophagi. The Death of Germanicus (1774, Holkham Hall, Norfolk; Plate 136) is perhaps the first truly neo-classical work created by an English sculptor. The figures, in fairly high relief, are set against a plain ground, the slight indication of an architectural setting being reserved to the top of the block, above the heads of the group, and set parallel to the eye, so that no diagonal perspective disturbs the simple planar design. The group round the dying hero is bound together by strongly felt linear rhythms, the draperies clinging close to the forms, so that the contours, rising sharply from the ground, are clean and unbroken. This could, however, never be mistaken for an antique work. The proportions are elongated, and the forms, particularly of the man kneeling and speaking to Germanicus, are contorted to enhance the emotional drama. Already there is something of Fuseli in the pointing hands, and the intensity of the glance.[8a] A comparison between this work and any classical relief by Rysbrack, even those copied from engravings of the Arch of Constantine, quickly reveals the difference of approach. Rysbrack's contours are not so clean, his relief does not rise so sharply from the ground, but sometimes softly, so that the edges are blurred. His forms are far more varied and less evenly rounded, so that light and shade ripples over the surface, the whole effect being far more pictorial. Banks's Caractacus before Claudius, begun about the same time and finished by 1777 (Stowe School, Buckinghamshire), is in higher relief, and borrows more openly from antiquity than the Germanicus, but there is again emotional contortion in the grief-stricken women, and a Fuseli-like gesture of the hands of Caractacus himself.[9]

The impact of Fuseli can, however, most clearly be seen in the relief Banks began in Rome, probably in 1778, and left unfinished at his death, of Thetis and her Nymphs rising from the Sea to console Achilles for the Loss of Patroclus (V. and A.; Plate 137).[10] Considered by Flaxman to be 'of the epic class', it is, like the Germanicus, built up on linear rhythms, though the relief varies much more in depth. The composition is, as Flaxman notes, highly original, the rising swirl of nymphs being fitted into the oval form with considerable skill, the strong diagonal of the group of Achilles and Thetis thrusting into the curve like an arrow into a bow. The nude figure of Achilles suggests careful study of antique models, and the nymphs, with their floating trails of drapery, are no doubt derived from nereid sarcophagi. But the elongation, the gesticulation, and the inflated bodies of the nymphs, with protruding buttocks and large breasts, have their

origin in the erotic art of Fuseli.[11] The younger John Bacon was later to suggest that Banks might have been a finer artist if he had never settled in Rome;[12] it is certainly true that he would have been a different artist if he had not seen Rome with Fuseli by his side.

Unfortunately, the work created by Banks in Rome which was most admired by his fellow-artists is now completely lost. This was a Cupid catching a Butterfly on his Wing which Flaxman regarded as 'highly interesting to the mind by its philosophical allusion to the power of love, divine or natural, on the soul' – in other words, its content as well as its form was important. It was rejected by the Bishop of Derry, and Banks, bringing it back to England in 1780, showed it at the Royal Academy in 1781. He was, however, to find little employment, for Nollekens and Bacon held the field, and he went to Russia taking the Cupid with him. It was bought by the Empress Catherine and set up in the grounds of Tsarskoe Selo, but had disappeared before the Russian Revolution. His stay in Russia was brief, for he failed to obtain the commissions for which he had hoped, he disliked the climate, and returned to England in 1782.

His reputation was by now growing, especially among his fellow artists, and on the recommendation of George Dance the architect (who with his own strong leanings towards neo-classicism would naturally have admired Banks's work) he was in 1784 given the commission by the East India Company for the monument to Sir Eyre Coote to be erected in Westminster Abbey. This was not finished till 1789. It is a curious work, which seems to fall between two stools. The artist shows a surprising willingness to design in what may almost be called the eighteenth-century Westminster Abbey tradition, and however much Roubiliac's style may by now have been despised, his influence can surely still be seen; for an asymmetrical group set in front of a truncated pyramid represents in allegorical form 'a province of the East preserved to this country by the victories of Sir Eyre Coote'.[13] The province of the East is shown in the form of a seated Hindu captive, weeping beside a trophy, the spoils of the East falling from his cornucopia into a shield of Britannia. Behind him a Victory, who has erected the trophy, decorates a palm tree growing out of it with a medallion portrait of the general. Banks seems somewhat embarrassed by the character of his design. The palm tree and the trophy can be safely treated in a neo-classical manner in sharply cut high relief against the plain ground, but the Victory, who is moving both forwards and inwards, is uncomfortably twisted in an attempt to swing herself into a parallel plane, and her draperies are designed with the double purpose of suggesting movement and emphasizing a linear rhythm on the main plane. These draperies are, naturally, treated in an antique and not a Rococo manner, but this pretentious figure is far less successful than the nude Hindu on the right.

Banks was clearly convinced that the nude was the most serious subject for the sculptor's art. In 1784 he sent a colossal model of a Mourning Achilles to the Royal Academy, which added greatly to his reputation. It too has now disappeared, but the descriptions suggest a complex, dramatic pose and a violence of gesticulation which probably still showed the influence of Fuseli.[14] By the end of the year Banks was elected an A.R.A., and, very unusually, became an R.A. within three months. His Diploma piece, The Falling Titan (London, Royal Academy of Arts), was later said by his

daughter to be derived from drawings which he and Fuseli had made in Italy. This work is in conception probably nearer to Burke's view of the Sublime than any other piece of English sculpture. The horrid theme of the giant and the rocks crashing into the abyss, and about to destroy the innocent pastoral life of the satyr and the goats, must have given a shiver of pleasure, but the originality of the design and the assurance of handling must have been even more impressive. Indeed, thirty-five years later, J. T. Smith was to rate it 'a work far superior to any before produced in England, and which, perhaps, will never be surpassed'.[15] Had it been a life-sized work, it might have been easier to assess it fairly, but since it is on a small scale it fails, like so much of the artist's work, to be convincing.

The one remaining statue in the classical manner completed by Banks belongs to the end of this decade. The Thetis dipping the Infant Achilles in the River Styx (V. and A.; Plate 138) was made for Colonel Johnes, a scientific agriculturalist, scholar, and traveller who may have met Banks in Rome, for his house at Hafod, where it fortunately escaped the disastrous fire of 1807 which destroyed at least three busts by Banks and the valuable library. The statue, in which the heads of Thetis and the infant Achilles are portraits of Mrs Johnes and her daughter, has considerable originality, for neither in subject nor in treatment is it simply a pastiche of the antique. The linear rhythms of the body and drapery of Thetis are finely contrived, but the effect is marred by a clumsiness which is characteristic of much of Banks's later work, and which is here apparent in the thickness of the legs and the over-large hands and feet. The elongations, the tapering limbs, and the distortions derived from Fuseli have now disappeared, and in spite of its heaviness the work has a sincerity and absence of sentimentality which give it a certain dignity.

Banks had, by the beginning of the 1790s, completed a number of small monuments, some of them a little commonplace, but one at least of great novelty. The earliest, that to Dr Isaac Watts at Westminster, was made in 1779, immediately after the sculptor's return from Rome, and in its relief of a flying muse inspiring the pensive figure of the poet it shows, as might be expected, much of Fuseli's influence. Bishop Newton's monument formerly in St Mary-le-Bow, but destroyed in the Second World War,[16] departed from convention in having, apparently, no background, and the figure of Faith with clean-cut outlines told almost as a high relief against the wall. By far the most successful of Banks's early monuments, and indeed one of the most beautiful of its time, was that to Mrs Hand formerly in St Giles, Cripplegate (1785; Plate 143A). The lady had died suddenly in her husband's arms, while still young. Banks's design is highly original. Two closely integrated figures, the young wife with her head on her mourning husband's knees, are set on a rounded sarcophagus, with the inscription on a simple tablet on the wall above. On the front of the sarcophagus, isolated within a circle, is a child with a sickle which he uses on a flower-bush, and the words: 'She cometh up and is cut down like a flower.' The design has a simplicity and directness which is very moving. It antedates, by more than ten years, any comparable work by Flaxman, and it is sad that Banks never again created anything so unpretentious and so beautiful. Several of his monuments (Dean Smith, d. 1787, Chester Cathedral; the 3rd Earl of Hardwicke, d. 1790, Flitton, Bedfordshire, and at Wimpole, Cambridgeshire) show variants of the

lady and urn theme. In the first two she mourns, in the last she wreathes the urn with flowers. Bishop Law (d. 1787, Carlisle Cathedral) has a variant, for here the figure is Faith, leaning on a colossal mitre, but the drapery has something of the feeling for rhythm which can be seen in the Thetis. Though, however, in such monuments Banks was using a theme common to all sculptors of his generation, his treatment differs from that of Nollekens and Bacon. There is no echo of Rococo grace in his female figures; they are broadly built, with big classical features, and his drapery patterns are larger, simpler, and heavier.

Two of Banks's monuments of the 1790s were specially admired. The earlier is that of Penelope Boothby (1793, Ashbourne, Derbyshire; Plate 141A). Such was its pathos that when it was shown in the Royal Academy before erection Queen Charlotte and the princesses wept, as did the child's father, Sir Brooke Boothby, when he visited Banks's studio. Winckelmann himself could hardly have asked for more. But, in spite of the patent sincerity of the artist, there is something inherently disquieting in the monument. The child lies sleeping on a thick padded mattress laid upon the top of a beautifully designed classical sarcophagus, adorned with wave and honeysuckle patterns. Her muslin dress, tied with a broad sash of ribbon, is carefully arranged in long straight folds in the antique manner, fluting out at the feet, which are themselves very large. The whole is smoothly worked, and very highly polished. It is perhaps the forcing of naturalism, especially of the mattress and the dress, into a classical mould that is uncomfortable; but it was clearly much to contemporary taste. It marks, indeed, the beginning of a new epoch, for it is drenched with sentimentality. As in the Martha Hand, allegory is abandoned; but here the child is not dead but alive and sleeping, and the theme of Innocence is exploited to the full. It is perhaps the first truly Romantic work by an English sculptor; though in its neo-classical handling it reveals the academic barrier which Banks could not overcome.

The monument most praised by Flaxman was, however, that to Mrs Petrie (1795, Lewisham, London; Plate 141B). Here Banks has created a large relief, showing the lady dying on a couch, attended by Faith, Hope, and Charity, all in antique dress. He is somewhat surprisingly willing to break the strictest canons of Antiquity, for the scene is divided by a partition in perspective, and beyond it sits a mourning youth.[17] Nevertheless, the general reference to Antiquity is overwhelmingly strong; the figures have a grace which is rare in Banks's work, and the slender Hope and Charity, moving slowly forward towards the dying woman, are memorable in their quiet beauty. It was about the time of this design that Flaxman told a fellow artist that he thought the works of Banks equal to those of Canova.[18]

None of Banks's monuments have the quality of piety which is so strong in those of Flaxman, even when they do not employ Christian symbolism. Though towards the end of his life he became, according to his daughter, a strict Dissenter, it is probable that in the nineties, his religious views tended towards atheism. He was a supporter of the French Revolution, an intimate of the circle of Horne-Tooke, and was indeed in 1794 arrested with Tooke on a charge of high treason, but was immediately released.[19] It seems doubtful whether Banks's political activities were a danger to society; he was

essentially a simple-minded man, his surviving letters do not suggest that he had any command of words, and his art was never used for propaganda purposes. Other and greater artists found ways of using the heroic art of Antiquity in support of the new doctrines of Liberty, but Banks was neither a David nor a Blake, though his known democratic views prevented him from obtaining the Librarianship of the Royal Academy in 1794 and were also at times a hindrance to gaining commissions.[20] His revolutionary views were not, apparently, anti-Imperialist (the British conquest of India was presumably still regarded as beneficent), nor was he so whole-hearted a classicist as to refuse to make a statue in contemporary dress. His figure of Lord Cornwallis (1795–1800), paid for by public subscription and sent out to Madras, is in itself less interesting than the fact that both it and the two preliminary models were in contemporary dress, though both the sculptor and Fuseli disagreed with Benjamin West's desire for it.[21]

Banks was, however, to achieve his wish for heroic classicism in his last two important monuments, those to Captain Richard Burgess (1802; Plate 140) and Captain George Westcott (1805; Plate 160A) in St Paul's Cathedral.[22] Both have been moved from their original positions and both have lost their plinths, but though the latter may have damaged the proportions of the monuments, it does not materially affect the conception. In both cases Banks has taken over from Flaxman's Mansfield Monument at Westminster[23] the idea of a free-standing oval base for the figures, with no background; but the resemblance goes no further, for Banks rejects Flaxman's standing figures at the sides, building up to the central effigy. Instead, he devises allegorical groups of two free-standing figures. Burgess, practically nude, but be-whiskered, and with scanty drapery falling from one shoulder, is greeted by a newly-alighted Victory; Westcott, in a short chiton which leaves half the torso bare, is collapsing on the arm of a Victory with a wreath, though she appears to have difficulty in supporting him. Neither can be considered a successful or moving composition (though the dying Westcott has some pathos); and though Southey admired Burgess's Victory when he saw it in the studio, even Flaxman felt bound to admit that, though there were 'beams of light', these were 'mixed with much imbecility'.[24] Allan Cunningham, writing in 1830, takes a shrewd, and not unfair view: 'Banks had long desired to introduce a more poetic style of art into our national monuments . . . He thought he could compound the matter between the plain and visible realities of life and the loftier conceptions of poetry.' He therefore 'tried a style of composition of a mixed nature, which wants alike the dignity of the ancient, and the palpable act-of-parliament reality of modern art – and so, possessing the full charm of neither, pleases few'. Moreover 'naked naval officers destroy historic probability and are not strictly poetic, for their heads are modern and their bodies antique'.[25] By far the most poetic part of the monuments lies in the reliefs on their bases. That on the Burgess, who had been killed in the battle of Camperdown, has a man-of-war, and an aged, tired seaman in classical dress in front, with groups of captives running round the curved ends (Plate 142). These figures have a beauty and dignity of design which far outshines that of the main group above them. The Westcott base is less original; he died at Aboukir, so the well-known figure of the Nile with children playing over it in the Vatican is turned into a relief, though it is noticeable that Banks

slightly alters the proportions of the figure and the position of the children to make a more pleasing linear design. The cutting is also inferior, but Banks was by now a sick man, and probably was unable to follow his usual practice of finishing the marble himself.[26]

Banks is also known to have made some thirty busts, but few of them have survived. They show him as a more sensitive portraitist than might, perhaps, have been expected, and they also reveal a surprising willingness to work in different conventions, though there can be little doubt that he preferred the antique manner. His early bust of Isaac Watts (1779) on the monument at Westminster cannot have been made from the life, for Watts had died in 1748, but the deep-set eyes and sensitive mouth give a convincing image of a poet. For this bust, Banks compromised between contemporary dress – for the doctor is wearing bands – and a semi-antique drapery over the shoulders. For William Woollett, the engraver (1791, Westminster Abbey cloisters), he uses a surprisingly Baroque type. The dress is contemporary, with the soft cap so much loved by Roubiliac, and the bust wide at the shoulders. It makes, in fact, an unhappy marriage with the relief below it, in which Woollett is seen at his engravers' desk, surrounded by Muses and Geniuses, in Banks's most classical manner. The Alderman Boydell (1791, London, St Margaret Lothbury; painted plaster, V. and A.) may not have been cut by Banks himself, since the marble is inscribed 'Banks del. F. Smith sc.', but it is again a naturalistic portrait, the face very lively in modelling, and much play being made with the richness of the Lord Mayor's chain and robes. That Banks was capable of a naturalism which almost equals that of Nollekens in his treatment of a head may be seen in such busts as the 1st Marquis Cornwallis (1796 or 1800, Major J. Warde Collection) or the Anthony Addington (1791, Viscount Sidmouth Collection). Both are clearly admirable portraits, Cornwallis the determined man of action, Addington a scholarly type, said to have been made from a death-mask, but alive with nervous eagerness. In both antique drapery is used, though in neither case is it of the stereotyped pattern brooched on one shoulder and falling in repeating folds over the chest. Banks's only remaining female bust, that of Mrs Johnes (1792, Rev. H. Lloyd-Johnes Collection), which was fortunately saved from the fire at Hafod, has again a general reference to Antiquity, particularly in the treatment of the curled hair. But the curls are less stylized than in the Capitoline Poppaea, and judging by this and the Thetis, Jane Johnes had a serene beauty which lent itself to portraiture in the classical manner.

By far the most distinguished of Banks's busts is that of Warren Hastings (Plate 139A), for whose character he had a profound admiration. That this may well have been strengthened by the artist's mistrust of the Government, and his sympathy with Hastings's ordeal in the long-drawn-out trial is perhaps borne out by his daughter's testimony. For she wrote that he had constantly spoken of 'the fine expression of his features, and more particularly of the uncommonly grand form of his forehead, which, with that of Horne-Tooke, he considered the finest he had seen in modern heads'.[27] Whatever may have been Banks's reason for seeing Hastings as the contemporary equivalent of one of the heroes of Antiquity, they enabled him to create one of the noblest of English busts. Profound and penetrating in character, with its sad air of uncrushed

dignity, it is perhaps his most compelling work, and suggests that, had he given more time to portraiture and less to what he regarded as higher forms of art, he might have outshone Nollekens in his own field.

Banks cannot be regarded as an entirely successful artist, though he is most movingly sincere. His technical equipment does not, however, seem to have equalled his aspirations, and therefore he falls too easily into the bathos of Penelope Boothby or Captain Burgess. He is, however, never contemptible, and his seriousness won the admiration of many. He was 'the first of our native sculptors whose aims were uniformly lofty and heroic, and who desired to bring poetry to the aid of all his compositions . . . the bearing of the Gods was familiar to his dreams . . . and it was not his fault if he aspired in vain to be the classic sculptor of his age and nation'.[28] Cunningham, writing in 1830, after Flaxman's work was done, and Westmacott and Chantrey, whose technical accomplishment far outstripped that of Banks, had created most of their finest monuments, could afford to be a little indulgent to the father of English neo-classicism, and to blame his age rather than himself. It is not quite a true judgement.

CHAPTER 23

JOHN FLAXMAN

JOHN FLAXMAN (1755–1826) occupies a unique position in English sculpture. His name is far more widely known than that of any other sculptor; he is among the very small band of English artists whose work has been influential abroad (though this influence was not primarily in the field of sculpture); unlike most English sculptors he practised more than one art; and his integrity gained for him a position not granted to any sculptor before his time, his achievement being recognized by the foundation of the Chair of Sculpture at the Royal Academy in 1810, which he was to occupy till his death.

Whether he was in fact the most talented of English sculptors is another question; for Chantrey, and even Westmacott when he tried, were to show a stronger sense of form. Neither, however, had Flaxman's great gift of linear design, and here he stands very high. There can indeed be little doubt that many of his smaller monuments, in which this gift is chiefly displayed, are among the finest things in English sculpture. He was greater as a designer than as an executant, though this was partly the result of the common practice of his day, under which the sculptor worked mainly on the clay model, and the final work was cut by assistants with the aid of Bacon's improved pointing machine. Indeed, as far as quality was concerned, Flaxman was perhaps the first victim of the 'industrial revolution' resulting from this machine. Moreover, as has been said, a high polish, easily achieved by assistants, based on such admired works as the Apollo Belvedere and strengthened by the prestige of the works of Canova, was now regarded as the height of good taste. Much English sculpture – and not only that of Flaxman – suffers from the fact that the lively surface modelling of the Baroque and the Rococo had fallen out of fashion. Flaxman cannot therefore be entirely blamed for the fact that he had no interest in texture. He had, of course, ample opportunities of seeing the best Baroque sculpture in Rome, but neither the writings of Winckelmann nor the training he received at the Royal Academy Schools would have led him to rate lively, and above all broken surfaces very high, for they were not expressive of ideal but of common nature. Smoothly rounded limbs, and delicate clean contours, the heritage of the antique as he knew it and also of Raphael, were what he and his patrons most admired. That he was able to adapt the style to so many different designs, some with a strong contemporary flavour, is a measure of his strength and originality as an artist. His sentiment is that of his age, drenched with nostalgia for the past; but again he applied it to the present with a freshness, a lack of self-consciousness that gives him a special place among neo-classical artists, for few have his innate sincerity and charm.

Flaxman was born in York, but his father, who was a maker of models and casts, very shortly moved to London.[1] There the elder Flaxman was employed as a model maker by both Roubiliac and Scheemakers and later, like his more famous son, by Josiah Wedgwood, but he also made at least some casts from the antique.[2] The child, who was

183

extremely delicate and could only walk with crutches, spent much time drawing in his father's shop, though the artists who visited it do not seem to have given him much encouragement. He also read avidly, and attempted to teach himself Latin. While doing so he had the good fortune to attract the attention of the Reverend Henry Mathew, whose wife, a member of the circle of 'blue-stockings' which included Mrs Montagu and Mrs Chapone, befriended the boy, inviting him to her house, where he heard readings from Homer and Virgil and 'discourse upon sculpture and verse'. Through these learned ladies, therefore, Flaxman was introduced to one of his main sources of inspiration throughout his life, the world of classical Antiquity: if Cunningham is right in saying they discoursed of sculpture as well as of verse, it is almost certain that they would have owned and shown him books of engravings, among them in all probability James Stuart's *Antiquities of Athens*, the first volume of which, appearing in 1762, gave at least some information, hitherto lacking, about sculpture which was indubitably Greek. The Mathews were, however, clearly in touch with all the artistic enthusiasms of their day, for in 1784 Smith records that Flaxman returned their kindness by decorating their library with models of figures in niches in the Gothic manner, while other artists helped by painting the window in imitation of stained glass, the bookcases, tables, and chairs being ornamented 'to accord with the appearance of those of antiquity' – antiquity here presumably meaning the Middle Ages.[3] Though the room can hardly have been comfortable, it was no doubt considered extremely elegant.

Flaxman's health improved, and by 1767, when he was only twelve years old, he began to exhibit plaster models of classical figures and reliefs at the Free Society of Artists,[4] none of which appear to have survived. In 1770 he entered the Royal Academy Schools. Not all his early work was classical in intention, for he exhibited a number of small wax portrait medallions such as that of his sister holding a doll (*c.* 1772, V. and A.).[5] The forms are simple and rounded, as the subject demands, but the whole is naturalistic, tender, and playful with none of the emphasis on line so characteristic of his later work.

While at the Royal Academy, however, his imagination was to be stimulated by his friendship with William Blake and Thomas Stothard. According to Cunningham, '. . . in the wild works of the former he saw much poetic elevation, and in those of the latter that female loveliness and graceful simplicity which have given his name a distinguished place among the worthies of art. With Blake, in particular, he loved to dream and muse, and give shape and sometimes colour to those thick-coming fancies in which they both partook.'[6] This somewhat highly-coloured statement needs some editing, for Blake had hardly begun his great series of imaginative works in the 1770s (the *Songs of Innocence*, the earliest and the simplest example, did not appear till 1789), and Stothard's immensely popular book illustrations and Shakespearian scenes are also later. Nevertheless, Cunningham's interpretation of Flaxman's friendship with these two artists, which began at this time, is not unperceptive, and the realization that he was from the first allied with this early phase of Romanticism is crucial for the understanding of his art. He was never to follow Blake in his hatred of the Royal Academy and all that the latter believed it stood for, but he was (and this was recognized by Sir Richard Westmacott in his *Oration on the Death of Flaxman*) to have a profound belief in the value of the

poetic, and he was later himself to state: 'Sentiment is the life and soul of fine art.'[7] The seeds from which Flaxman's attitude to his art were to grow were undoubtedly sown during these formative years; and the trend was to be strengthened by his growing friendship after 1775 with George Romney, then newly returned from Rome.[8] The most immediate effect of his friendship with Blake was, however, almost certainly, the creation of his interest in medieval art; for Blake was by the end of the 1770s working for the engraver Basire, drawing the tombs in Westminster Abbey which were to illustrate Gough's *Sepulchral Monuments* of 1786. Medieval art was to prove as attractive to Flaxman as it was to Blake, though like Blake he was to transmute its motives into his own idiom.

He won a silver medal at the Royal Academy in 1771, but to his disappointment failed to gain the gold medal in the next year. This might, as it did in the case of Banks, have led to a travelling scholarship; but it may well have been an advantage to Flaxman that he was not able to go to Rome when he was still so young. It meant, however, that when he had finished his time in the Academy Schools, he found that he was unable to support himself by sculpture alone, and joined his father in working for Wedgwood's pottery factory.[9] This was to prove of considerable value in the development of his style. The discipline of making designs that could be reproduced in the difficult medium of Wedgwood's jasper ware, with its white figures in relief on a coloured ground, was no bad thing for an idealistic but inexperienced young artist, and the need for thinking in terms of silhouette combined with low-relief modelling was useful and in no way distasteful to him. Some of his designs were for portrait medallions; the more famous are of classical subjects, but it is not easy to be certain how much these had to be altered in execution. The well-known plaque of the Dancing Hours of 1778[10] is characteristic of his style. The design is a free adaptation of the Borghese Dancers (Louvre), a classical relief known to Flaxman through the plate in Bellori's *Admiranda Antiquitatum Romanorum*. But the grave, slow movements of the antique dancers are tuned to a quicker rhythm, they are linked by a more continuous undulating line, and their dance is gayer; in other words the Rococo is not dead. Similarly, the Cupids with a Goat, of the same year, is a close echo of the art of Clodion and has not entirely lost the naturalism of his early work in wax.

In some of his designs, however, the contours are cleaner, the modelling drier, and the forms more elongated. The design of the Apotheosis of Homer (also known as 'The Crowning of a Kitharist'; B.M.) may have been derived from an engraving of a relief in the Palazzo Colonna, but the type of the figures and their disposition against the ground is surely influenced by the study of Greek vase-painting. The sumptuous publication by d'Hancarville of the first part of Sir William Hamilton's collection in 1767 may perhaps have been too expensive a book to have come Flaxman's way, but the collection itself was bought by the British Museum in 1772, and soon after that he must have had the possibility of studying Greek vases in the original. There is, indeed, evidence that he neglected no opportunity; for in 1784 he asked permission from the Society of Dilettanti to model a fragment of the Parthenon frieze, showing a horseman, which had been brought to England by Thomas Chandler.[11] In the next year he designed a set of

chessmen for Wedgwood, using the horseman as the basis for the knight, but drawing on medieval sculpture for the figure of the bishop.[12]

By the mid 1780s Flaxman, who had moved from his father's house after his marriage in 1782, was beginning to get commissions for monuments, the field in which all his most distinguished sculpture is to be found. His first attempts show already a certain novelty of conception, and differ from the work of his contemporaries in their Christian content. Their style, however, reveals the same mixture of influences, not yet perfectly assimilated, which appears in his work for Wedgwood. The monument to Mrs Morley (1784, Gloucester Cathedral; Plate 143B) was so greatly admired by Cunningham for its poetic effect ('it elevates the mind, and not without tears') that he appears to have overlooked its confusion of style.[13] Mrs Morley died in childbirth while at sea: she and her infant are seen rising from the waves, assisted by angels, one of whom points to the text 'The sea shall give up the dead', inscribed on the enclosing arch. This arch, which is part of the monument, is Gothic, as are the colonnettes which support it: the angels are no longer the winged boys of the Baroque tradition, still at this date being used by Nollekens and Bacon, but the young sexless adults with large wings of the thirteenth-century spandrels in the transepts of Westminster Abbey. Their draperies, however, and their bare arms and legs, are not Gothic, and have close resemblances to the engravings in Stuart's *Antiquities of Athens* of the flying figures on the Tower of the Winds. Flaxman's figures are in very bold relief, indeed the angels have almost the effect of being in the round set in front of the ground, and in this too they resemble the figures in the Athenian engravings. On the other hand, the lower part of the monument, with its curling, unconvincing waves (perhaps Flaxman had never seen the sea) and clouds billowing above them, is conceived in the pictorial terms of Roubiliac and Wilton. The monument to Thomas Ball (erected 1786, Chichester Cathedral), with its mourning widow comforted by an angel, points towards Flaxman's later style, since the two figures are bound together by linear methods; but the draperies are somewhat confused and meaningless in their design, their edges are blurred in places, and there is an uncertainty over the depth of the relief. Flaxman has not yet developed his full control of contour as a weapon of design and his mastery of both high and low relief, and there is still an echo of the pictorial handling of the generation of Wilton.

The sculptor had been warned by Reynolds, an inveterate bachelor, that the cares of marriage would ruin him as an artist, and make study impossible. He and his wife determined that this should not be so, lived frugally, and saved enough money to go to Rome in 1787. They intended to stay two years, but owing to the fact that Flaxman found patrons, were able to stay in Italy until 1794. During these seven years his style and his creed as an artist were finally formulated, and at least three-quarters of the material he used in his Lectures on Sculpture, delivered at the Royal Academy after 1810, must have been collected during the Italian visit. Although, however, soon after the end of his journey Flaxman was to rank among the leading neo-classical artists of Europe, his interests while he was in Italy were by no means confined to classical art. His two Italian sketch-books (V. and A.) and his journals reveal a great, and often surprising curiosity about works of many different periods.[14] His taste for medieval art,

already created by his friendship with Blake, and by his own natural piety, was quickened by the sight of Trecento frescoes in Florence and Pisa, and by Dugento mosaics in Rome, which he regarded as Early Christian. He also drew works by Donatello, but reduced the panels in the pulpits of S. Lorenzo to purely linear design, concentrating on the main figures only, and eliminating the pictorial elements. Like all Englishmen, he studied Michelangelo; one of his most beautiful drawings is of the head of Cellini's Perseus; and, most surprising of all, he drew several of the Baroque papal tombs in St Peter's. Indeed it would seem that the stimulus of what he saw led him to draw works which the taste of his day encouraged him to dislike. No one could have condemned Baroque art more roundly than he was to do in 1805: 'the countenances simper affectedly, and are deformed by low passions; the poor and vulgar limbs and bodies are loaded with draperies of such protruding or flying folds as equally expose the unskilfulness of the artist [i.e. Bernini] and the solidity of the material in which he worked; . . . the basso-relievos . . . represent such aerial affects as break down the boundaries of painting and sculpture and confound the two arts.'[15] He condemned Mochi's equestrian statues at Piacenza, regarding the artist as a scholar of Giambologna, who had been condemned by Winckelmann as 'the destroyer of art'; but he made drawings of the Rape of the Sabines. Moreover, his sensibility was sufficiently acute to lead him to the choice of different media when drawing different types of works. The majority of the Trecento drawings are in pencil, used in a somewhat hesitant manner; those of Renaissance art are as a rule in ink, the Perseus head being notable for the firm line suggesting the contours, but the Baroque tombs are in very soft pencil with large blocks of shadow broadly hatched.[16] Flaxman was, however, concerned not only with appearance, but with content. 'He saw, he said, that the mistress to whom great artists of Italy had dedicated their genius was the Church – that they were unto her as chief priests, to interpret her tenets and her legends to the world in a more brilliant language than that of reliques and images. . . . Flaxman perceived the extravagance and error thus nourished, and conceived the design of serving the Protestant Church by a far different application of the resources of art.'[17]

This moral purpose lies at the heart of all Flaxman's work. Like every other artist in Rome of his day, he spent much time in the study of the antique, drawing sculpture on public exhibition and also in private collections, such as that at the Villa Albani; he visited Naples and the surrounding antique sites, saying of the temples of Paestum that 'the simple greatness of their effect elevated and delighted my mind more than all the other architecture I have seen in Italy'; he saw Sir William Hamilton's second collection of vases, he studied gems and antique paintings (in which he thought there was 'little intelligence in the outline drawing'), and above all he studied antique sarcophagi. Some of his most beautiful and most vigorous drawings are of these, and he was later specially to commend them to the students of the Royal Academy as 'a magnificent collection of compositions from the great poets of antiquity, Homer, Hesiod, Aeschylus, Euripides and Sophocles – the systems of ancient philosophy, with Greek mysteries, initiations and mythology. The study of these will give the young artist the true principles of composition, with effect and without confusion, to produce the chief interest of his

subject by grand lines of figures, without the intrusion of useless, impertinent or trivial objects; by carefully observing them he will accustom himself to a noble way of think-ing, and consequently choose whatever is beautiful, elegant and grand, rejecting all that is mean and vulgar; by thus imbibing an electric spark of the poetic fire, he will learn to choose fit subjects for the employment of his talents, and to convert the beauty and grace of ancient poetry to the service of the morals and establishments of our own time and country.'[18] This suggestion that artists should be the evangelists of their day is new, and though it is very different in tone from the normal theories of Romanticism, it does imply a conscious belief that the special gifts of the artist can be used to lead, and not simply to pander to, the taste of the community.

In addition to wide study, Flaxman was engaged in many activities in Rome. He be-came a member of the Academy of St Luke,[19] he carried out a little work for Wedg-wood and superintended other work being done for the factory by John Deveare,[20] he bought casts for Romney;[21] he joined with other English artists in Rome in a petition to the Duke of Sussex to use the royal interest for the removal of import duty on casts of the antique and on their own works brought back to England,[22] and he obtained several commissions for sculpture. In 1790 he was working on the models for the Cephalus and Aurora (Lady Lever Gallery, Port Sunlight; Plate 144B) and the Fury of Athamas (Ickworth House; Plate 144A).[23] The former is the more agreeable work, but neither is entirely successful. Cephalus and Aurora, made for Thomas Hope, the banker, writer, and collector,[24] is a small group about four feet high, of a nude male and a draped female figure in which the artist has clearly drawn on the best classical models, but has failed to infuse them with life. In spite of this the group has a certain lyrical character which is within the artist's range, and it is therefore not a tragic failure, like the Fury of Athamas. This ambitious work was commissioned by the Earl of Bristol, Bishop of Derry, to whom Flaxman was recommended by Canova. The price agreed and paid was £600, but the sculptor had greatly underrated the cost of the marble and the work involved, and in the end found himself badly out of pocket. The grim subject, taken from Ovid's *Metamorphoses*, of Athamas tearing his children from their mother and dashing one to death fell obviously within the category of the Sublime, and was conceived on the scale of the Laocoon. The most careful study of Laocoon and of the Niobids could not, however, ensure success. Flaxman's intellectual equipment was not enough to distil the drama to the minimum terms, as, for instance, David had done in The Oath of the Horatii, and his technique, though wonderfully matured by his contact with classical sculpture, was not sufficiently controlled to cope with design on so large a scale. In spite of the care obviously devoted to the welding together of the figures, the group remains loose and undisciplined, with none of the tautness of outline of Canova's Hercules and Lichas, which increases the drama by means of the design.[25] Even less suc-cessful was his attempted restoration of the Belvedere torso as a full-sized group of Hercules and Hebe, and this he himself apparently recognized later in life.[26] Flaxman's patrons, however, seem to have been highly satisfied with his work, Lord Bristol writing in 1792 that he 'will probably rise to be the first sculptor in Europe – exquisite Canova not excepted'.[27]

Flaxman's work in Rome did, indeed, raise him to the foremost rank of neo-classical artists, but not in the field of sculpture. A series of illustrations to the *Iliad* and the *Odyssey* were commissioned by Mrs Hare-Naylor, an Englishwoman who had eloped to Rome with a canon of Winchester. Flaxman's drawings were engraved by an Italian, Piroli, and issued in 1793. An English edition appeared in 1795, a German in 1804, and there were many subsequent editions, both in Europe and America. The Homer was followed by an Aeschylus, commissioned by the Dowager Countess Spencer in 1792 and published in 1795, and by a Dante, commissioned by Thomas Hope in Rome, but not published till 1802. Later Flaxman was to design illustrations to Hesiod, the plates of which were engraved by William Blake in 1817.[28] These book illustrations, enormously influential and greatly admired by many artists, including Ingres, are an epitome of Flaxman's style, though a detailed analysis would be out of place in a book on sculpture. In them, he could use his great gifts for linear design to full advantage; his profound reverence for the poets of Antiquity gives them an earnestness which is sometimes childish and often a little mawkish, but the medium in which he worked, demanding the utmost simplicity of statement, was far better suited to his temperament than large-scale sculpture.[29]

While in Italy he was also working on two English monuments not erected until after his return.[30] That of the poet William Collins (erected 1795, Chichester Cathedral) is the first of his many monuments to show his favourite theme of a figure reading. Though it is far more accomplished in design than the earlier Ball monument, there is still some hesitancy in the handling of relief, partly because both chair and reading desk are on the diagonal plane, though the figure is carefully posed in silhouette. The other was his first major work in England, the large monument to the 18th Earl of Mansfield in Westminster Abbey (signed and dated 1801; Plate 146).[31] The design was clearly the subject of deep thought and, indeed, of consultation with Sir William Hamilton;[32] and the result was something new. Instead of the traditional Westminster monument of a group of figures backed by a pyramid, still used in the 1780s by Bacon and Banks, Flaxman created the first free-standing or 'insulated' monument in England. Owing to alterations in the abbey, its original effect cannot be judged, but its significance can be guessed by the rapidity with which the idea of the free-standing design was taken up by the sculptors making the national monuments in St Paul's at the turn of the century.[33] The Lord Chief Justice is seated in his robes on a high plinth, which is flanked by standing figures of Wisdom and Justice. There is no action, each figure is detached and self-sufficient, and decorative elements, beyond a shield with a sword and fasces resting on drapery, are reduced to the minimum. Flaxman could not, however, entirely resist some appeal to sentiment and at the back is a finely designed seated figure of a condemned youth, his head bowed over an inverted torch. There can be little doubt that the whole conception is derived from seventeenth-century papal tombs in St Peter's (it may be partly for that reason that Flaxman made drawings of them), though the proportions are altered and the symbolism inevitably changed. The work has dignity, notably the figure of the judge, whose head is based on a portrait by Reynolds, and which is the only place where Flaxman himself worked on the marble. The rest, left as

was by now his usual practice to assistants, is a trifle dull; and the handling suffers further from his habit, noted by Cunningham as a weakness, of making only a small model, and leaving this to be enlarged by workmen. In other works, this was to reveal basic weaknesses in a design originally conceived on a different scale; here it is responsible for much insensitive modelling, especially in the arms and hands of the two female figures.

The Mansfield monument was the turning point in Flaxman's career, for it finally established his reputation as a sculptor. He was elected an A.R.A. in 1797, and an R.A. in 1800. His practice became enormous; about one hundred and fifty commissions are recorded in his account-book between 1795 and 1810, some of them for large works, though the majority are for small monuments, and a few are for busts; but his prices were reasonable, his generosity was well-known, and though his practice was maintained almost to the end of his life, he did not die a rich man. Almost the whole of his life was now to be spent in London, working ceaselessly at his studio near Fitzroy Square. In 1802, after the Peace of Amiens, like many of his fellow-artists, he visited Paris, mainly to see the loot collected in the Louvre by Napoleon, and is said to have repulsed the civilities of David (who might well have wished to honour the author of the *Homer* illustrations), since he was an atheist whose hands were dyed in blood.[34] Some ten years later, he and his wife made two picturesque tours, visiting the Yorkshire abbeys, and the famous castles and abbeys near Edinburgh.[35] Outside his art, his chief interest seems to have lain in religion. Like Blake, he was attracted by the mysticism of the Swedenborgians, though he remained an active member of the Church of England.

The times in which he lived, which nurtured patriotism, and his own feeling that an artist should serve the community, encouraged his desire for large-scale works, though these were fundamentally unsuited to his talent. In 1799, when there was a proposal to raise a Naval Pillar to commemorate the Battle of the Nile, he put forward a scheme for a figure of Britannia, more than 200 feet high, to be set on the top of Greenwich Hill. The model in the Soane Museum, with its heavy figure accompanied by a crouching lion, is a pathetic classical nightmare, from which Wren's domes had a happy escape.[36] His major public works are to be found among the national monuments in St Paul's, those to Earl Howe (1803–11; Plate 160B) and Lord Nelson (1808–18; Plates 147 and 148) being the most important. His sense of propriety refused to countenance the absurdity of Banks's nude naval heroes, but as Cunningham says, 'he had a serious leaning towards allegory, and dealt largely in British Lions, Victories and Britannias'. Victories, after all, had classical authority and Britannia was only Minerva without her aegis; for Lions he had the example of Canova's tomb of Clement XIII. None of his great piles of figures is very happy, probably again because they were designed on a small scale, and though in each monument there are parts that are well planned, for instance the figures of Victory and History to the left of Earl Howe, the grouping of the whole is clumsy.[37] The Nelson is an odd mixture of the contemporary and the allegorical. The admiral in uniform, his breast resplendent with orders, and a fur-lined cloak over his shoulders, is standing on a high plinth decorated with melancholy nude marine gods with the names of his naval victories inscribed above them. To this history lesson a maternal Britannia conducts two small boys in tight jackets and long trousers (Plate

148), described by Cunningham as 'young seamen'. Flaxman's tenderness towards children just saves the group from bathos, but the whole remains curious rather than grand.

He was not much more successful with commemorative statues. The Sir Joshua Reynolds (1803-13, St Paul's Cathedral),[38] standing with his finger-tips resting on a broken column bearing a profile medallion of Michelangelo, is timid in pose, and the robes are clumsy in their lines, though the head of the man Flaxman had known quite well has a certain life. In the William Pitt (1812, Glasgow Art Gallery; Plate 149B) Flaxman has drawn on Nollekens's bust for his likeness, but the pose, with the right hand weakly extended, has no fire, and the meagre figure, with its long thin legs in tight breeches, is strangely unimpressive. The Robert Burns (1822, N.P.G. Scotland; Plate 149A), like much of the sculptor's later work, is more robust in proportion; and though stiffly posed, with the arms, one hand holding the mountain daisy and the other a scroll, folded across the body, it is a slightly happier combination of the contemporary with the classical studies of Flaxman's youth, for the plaid has been seen as a toga, and its straight falling lines on the right give dignity and volume to the figure.

It is not in these more ambitious works that Flaxman shows his stature as a sculptor. His true gift lay in relief design, both high and bas-relief, and the fact that he chose a relief, Apollo and Marpessa, for his Diploma work suggests that he himself was not unaware of his talents in this field. Flaxman's designs have almost no ancestors, but they had far too many children, dull, silly, and sometimes even deformed. Nineteenth-century monumental masons seized his patterns and produced endless travesties of them, and it is therefore often difficult to appreciate the true stature of the original. Even so, the best of his works, seen in a good light, can still cause a sudden lifting of the heart. Moreover, a large number of the original models, less mechanical in handling than the finished marbles, have been preserved. A few are in the Soane Museum, but a far larger collection was presented by Flaxman's sister-in-law and adopted daughter, Maria Denman, to University College, London. Many have, unfortunately, been built in to the walls, not always in a satisfactory light, but others, and among them some of the best, are still movable.[39]

Although inevitably with so large a practice Flaxman was, on occasions, to repeat a design, his work shows a wonderful fecundity of invention. He drew on his knowledge of antique and of medieval art, but often used a contemporary theme with surprising directness; and though, like all sculptors of the time, he could not avoid mourning women, a brief comparison of the variety of his types with the endless repetitions of boys and ladies and urns by Nollekens and Bacon is enough to show the conventionality of the two latter artists.

Some of Flaxman's best and most original small monuments were made in the ten years following his return from Rome, and are therefore contemporary with his large works already discussed. Few have any architectural setting, except occasionally a plain round arch. Some take the form of a stele, with an unmoulded triangular or rounded top; in others the relief is enclosed in a simple rectangular frame, again below an un-moulded pediment, or one decorated by an anthemium or a Greek acroterion. Some-

times the inscription occupies the centre of the design, and figures in relief, or occasionally in the round, stand on either side. Many are inscribed with texts from the Bible.

One of the best known is the monument to Mary Lushington[40] (1799, Lewisham, London; Plate 145), erected by her mother, on which, under a round arch, a female figure lies prostrate with grief, while an angel floats above her pointing to the text: 'Blessed are they that mourn for they shall be comforted.' The figures are in high relief, but the contours, rising sharply from the plain ground, are much cleaner than in the Morley monument at Gloucester, made before the visit to Rome. And the type and drapery of the angel has changed completely, for the set of the head on the shoulders, the folded wings, and the long clinging garment falling from neck to feet are all derived from Flaxman's drawings of Trecento art. Moving though this monument is, however, in its direct Christian theme, the figures, each beautiful in itself, are less well combined with each other or with the frame than in many other works. A few years later Flaxman was to experiment again with the lunette shape, and in the monument to Isaac Hawkins Browne (1804, Trinity College, Cambridge) to produce an elegant flowing arrangement of three female figures strewing flowers over the inscription.

Perhaps the most distinguished of all his designs is that of the small monument to Agnes Cromwell (1800, Chichester Cathedral; Plate 150), inscribed 'Come thou blessed', in which the dead girl, her hands joined in prayer, is borne upwards by two female figures, while a third floats above. These attendant figures are not Trecento angels but nymphs whose curving draperies, cut in very low relief, are closer to Flaxman's drawings of nereid sarcophagi than to Christian art. The figure of the praying girl, however, dominates the beautifully contrived design, and thus illustrates Cunningham's statement about the artists's wish to use the resources of art in the service of the Protestant Church. The model at University College (Plate 151) is even finer than the marble, for it shows a far greater intensity of feeling, notably in the right supporting figure (whose pose was changed in execution), and serves as a reminder that Flaxman had retained his sympathy with the expressive art of Banks, Fuseli, and Blake.[41] A further design of rising female figures, now in higher relief, was used for the monument to Elizabeth Knight (c. 1806, Milton, Cambridgeshire) and repeated with slight variations after 1817 in the Hawkins monument at Kingsbridge in Devon.

Perhaps slightly less accomplished in design, but even more original in conception, is the relief commemorating the botanist and traveller Dr John Sibthorp (1799–1802, Bath Abbey; Plate 154B). Here there is no Christian symbolism, but a moving reverence for Antiquity. Sibthorp, dressed as a Greek traveller, with a hat slung on his back and carrying a bunch of flowers, is stepping from the prow of Charon's boat towards a distant temple. The figure is in strict profile, the boat and temple are reduced almost to plain silhouettes, the modelling is simple, the only detailed passages being the fine portrait head and the crisply cut flowers. There is no rhetoric, but the tribute to Sibthorp's scholarship is unmistakable.

Yet another form of monument devised by Flaxman has figures almost in the round against a nearly plain ground. The earliest and most original of these is to the orientalist Sir William Jones (1798, University College, Oxford; Plate 153A) (whose statue in St

Paul's Cathedral had unfortunately been made by Bacon),[42] in which a stele is set on a sarcophagus bearing the band of figures. The group shows Jones seated at a desk, palm trees in low relief behind him, writing his *Digest of Hindu and Mohammedan Laws*, while facing him three Eastern figures sit on the ground. These last are compactly designed, with sharp, clear outlines standing out in very high relief against the ground, at this end plain, and therefore to be seen as sky.[43] The whole monument is novel and distinguished in design, and the relief attractive in its direct treatment of the man's activities; but it did not please Cunningham, who noted that 'Flaxman was far from excelling in works of this kind; he seldom had the art of giving grace and beauty to modern dresses, or to modern looks'.[44]

The fashion for 'grace and beauty' did not, however, fortunately prevent Flaxman from creating a number of monuments showing purely contemporary, indeed almost genre scenes, though inevitably these are elevating in tone. The charming relief on that to Dr Warton, Headmaster of Winchester College (1804, Winchester Cathedral; Plate 152), shows the doctor in wig and gown holding a book from which he is instructing his scholars, busts of Aristotle and Homer standing above him. The group of boys in contemporary dress has a most pleasing freshness and simplicity, and in it Flaxman proves that, for all his study of classical art, he was a forerunner of romantic naturalism. He was to use the same theme after 1815 for the monument to Dr Lion (Harrow, Middlesex) but there the design is less agreeable, the proportions of the figures less child-like, and more attempt has been made to treat their clothes as clinging classical draperies. Between the two lies the Edward Balme (*c.* 1810, Bradford, Yorkshire; Plate 153B), with the text: 'Instruct the Ignorant.' This is a tightly planned group of three figures only, the elderly teacher in classical dress and sandals, seated reading between a boy and a girl, both intent on the book, and in clothes which are a compromise between the classical and the contemporary. Not all Flaxman's genre scenes were concerned with teaching: in the Yarborough family monument (1803–6, Campsall, Yorkshire) two of the daughters are shown giving alms to a group of poor families, beneath the legend: 'Blessed are they that consider the Poor'; and the missionary Christian Schwartz (*c.* 1805, Tanjore, India) is shown on his death-bed, with a fellow missionary, and Indian friends and boys attending him. The quiet and direct naturalism of the last is very different in tone from another death-bed scene, that of Lady Shuckburgh-Evelyn (1798, Shuckburgh, Warwickshire), where the figures are in classical dress and the frenzied grief of husband and child is not comforted by the sight of an elegant angel floating over the death bed.[45]

A large number of designs show standing figures flanking the inscription. These are sometimes free-standing, sometimes in relief; there may be single figures each side, or groups; they may be allegorical, like the Faith and Hope on the monument of Charles and Maria Colmore (1807, Hendon, Middlesex), or contemporary, like the seamen for Admiral Sir Charles Thompson (1802, Fareham, Hampshire) or the mourning family of Frances, Lady Hoare (1801, Beckenham, Kent). It is indeed in the endless variety of his designs, even when he is using the stereotyped theme of mourning ladies and urns, that Flaxman shows a talent which lifts him far above his contemporaries. His relatively rare

bust monuments (e.g. General Paoli, 1798, Westminster Abbey; Matthew Boulton, 1809, Handsworth, Birmingham; Plate 154A) suggest that he had some gifts as a portraitist, though his lack of commissions in this field must either mean that such work did not greatly interest him, or that the reputation of Nollekens and later of Chantrey was too strong to be broken. In addition to the stream of monuments, he undertook a certain amount of decorative sculpture, such as friezes for Covent Garden Theatre when it was rebuilt in 1809, or chimneypieces for Wedgwood and Samuel Rogers, made a small number of busts (John Hunter, 1805, Royal College of Surgeons), and in the second decade of the nineteenth century made models for Rundell and Bridge, a leading firm of silversmiths.[46] Of the last, by far the most famous was his reconstruction, nine feet in circumference, from the description in the *Iliad* of the Shield of Achilles (1818). Immensely learned in conception, with groups designed with great fluency, it is perhaps too complex and overloaded with detail to please modern eyes, but it was enormously admired by Flaxman's contemporaries, and is, even more than his work for Wedgwood, done when he was young and unknown, of interest as an early example of a leading artist working for something near industrial design, for a number of copies were made.[47] The rich intricacy of the silver-gilt versions must have been very attractive to Regency taste, which loved opulence combined with elegance.

Some of Flaxman's later sculpture reveals that he, who always thought deeply about his art, was able and willing to change his style and improve his sense of form. His most important late free-standing monument, that to Lady Fitzharris (1817, Christchurch Priory, Hampshire; Plate 156) is a closely knit group of a mother seated with one child on her lap and two more standing at her knees. Once more the favourite theme of reading is introduced. The figures are more boldly modelled than in some of the earlier works, the group is finely conceived, and infused with a tender sentiment. The beautiful group of Charity for the monument of Countess Spencer, who had commissioned the Aeschylus illustrations (1819, Great Brington, Northamptonshire) has an equal tenderness, and in the model at least (Plate 157), unusual strength of form, though much of its broad and simple dignity has been lost in the marble.

Towards the end of his life Flaxman realized the mistake of working from small models, and his important commission for Lord Egremont, Satan overcome by St Michael (1822; Plate 155A) was modelled full-size. The model is at University College, London, the marble and that of the Pastoral Apollo, made for the same patron two years later, are still at Petworth House. In these works Flaxman returns to the classical manner of his Cephalus and Aurora, but in the St Michael his greatly increased experience may be seen in the handling of the complicated design of two figures. He has, perhaps unconsciously, drawn on the art of Giambologna as well as on Antiquity; for the group is well-planned from more than one angle, and the model combines firmness and virility with elegance of pose. Much of the firmness is lost in the marble, but even so, it is a far stronger work than the somewhat insipid Pastoral Apollo. It seems to have set the seal on the sculptor's career, for Cunningham was surely only voicing general opinion when he described it as '. . . a work of the highest merit – the conception is epic – the grouping grand, and the action godlike'.[48]

From 1810 onwards Flaxman had been delivering his Lectures on Sculpture at the Royal Academy.[49] They make tedious reading; for he had little gift for turning a phrase, and they were evidently tedious to hear, since his delivery was dull. At all points, however, they reveal the earnestness of his character, and his desire to instruct the students so that they should feel the responsibility of their art. He ranged over the whole history of sculpture, making it clear that he was aware of the differences between archaic and classical art (though his opinions were naturally formed on a limited range of examples and his values were those of his time), and that he knew something of Egyptian sculpture, interest in which had been increasing since Napoleon's Egyptian campaign. Naturally he spoke with appreciation of English Gothic sculpture,[50] but found little to praise in post-medieval England; for while he admitted that the works of foreigners such as Scheemakers and Roubiliac were 'justly admired for life and nature', he found their value diminished by 'epigrammatic conceit and frequent meanness of parts'. His thought is often as confused as his sentences, but everything that he had seen and drawn in Italy or read in ancient literature is used to reinforce his belief in the moral value of art. 'The real ends of painting, sculpture and all other arts are to elevate the mind to a contemplation of truth.'[51]

Few English artists have been more deeply devoted to their art than this simple-minded man. In 1795 he had written to his friend Hayley, 'Sculpture is a jealous lady and will not be courted by halves'[52] – and success never made him slacken his attention. Devotion and a sense of poetry are not, however, in themselves enough to make a sculptor of the first rank, and Flaxman's intellectual and technical equipment (except in the field of linear design) were never quite sufficient. He is, all the same, a figure of great significance. He not only broke new ground in his creation of small monuments totally unlike those of the mid eighteenth century, but in his treatment of so wide a range of subjects, his nostalgia for the past, and his awareness of the contemporary, he reflects, perhaps better than any European sculptor of his day, the cross-currents of taste affecting artists at the opening of the nineteenth century.

THE EARLY NINETEENTH CENTURY

CHAPTER 24

INTRODUCTION

IN December 1812, the painter Benjamin Robert Haydon, so foolish but so genuinely concerned for the dignity of the arts in England, wrote in his *Autobiography*: 'You lavish thousands upon thousands on sculpture without effect. You refuse all assistance, all public support, all public opportunities to painting. You load your churches, your halls, and your public buildings with masses of unwieldy stone, and allow not one side or one inch of your room for pictures. Is this fair? is it just? is it liberal?. . . . In no country has sculpture been so favoured, fed and pampered as in this country. In no country under heaven has such patronage been met by such shameful, disgraceful indolence as in this. Masses of marble scarcely shaped into intelligibility; boots, spurs, epaulettes, sashes, hats and belts huddled on to cover ignorance and to hide defects. Surely you are bound to divide your favours and affections. If you shower thousands on Sculpture and fatten her to idleness with one hand, scatter hundreds into the lap of painting also. . . . No; year after year, and day after day, monuments and money are voted in ceaseless round, without discrimination and without thought.'[1]

Since Haydon was a history painter whose ceaseless hope of public commissions was never to be realized, his views are inevitably distorted. Nevertheless, his passage is revealing, and to a large extent true. Between 1802 and 1812 at least £40,000 of public money had been voted by Parliament for national monuments to soldiers, sailors, and statesmen, and very large sums had also been spent by the Corporation of London and by subscriptions raised in other cities. Much more was to be spent before 1830.

This drastic change in patronage is crucial in the history of English sculpture. As public patronage grew, private patronage declined and also changed hands. The few really large monuments to private individuals erected in the first thirty years of the nineteenth century, such as Chantrey's monuments to Mariamne Johnes (begun 1811, Hafod, Glamorgan; destroyed) or to David Pike Watts (1826, Ilam, Staffordshire), were commissioned by self-made men. The aristocracy no longer wanted lavish memorials. Although many great families were extremely rich, money tended to be tighter during the Napoleonic Wars, and there were other and perhaps more interesting ways of spending it than on elaborate tombs. Further, many family chapels were getting over-full of monuments; the vaults below them could be enlarged but not, as a rule, the building, and so relatively small tablets, often with a single figure or a relief, were used

to commemorate the recent dead. Such monuments, which have already been discussed in connexion with Bacon, Nollekens, and Flaxman, were greatly multiplied in the early nineteenth century, and became even more stereotyped. Bust monuments were still sometimes commissioned and, more rarely, a single standing figure or an altar tomb with a reclining figure. The large composition with several figures, erected in many village churches throughout the eighteenth century, now largely disappears; but the ambitions of sculptors to create such works were amply met by the new public patronage.

National monuments to men who had served the country were not, of course, entirely a novelty. What was new was the quantity and the method of award to the sculptor. Some at least of the eighteenth-century monuments at Westminster had been erected by Parliament, but the ways of choosing the sculptor had varied greatly. The earliest, that to Captain Cornewall by Sir Robert Taylor (erected in 1744 in the nave, re-set in the cloister, but mutilated) appears to have been a direct commission, no doubt obtained by some personal influence.[2] A competition was held for the Wolfe monument,[3] Bacon was given the commission for the Chatham at the desire of George III, and the choice of sculptor for Nollekens's Captains Bayne, Blair, and Lord Robert Manners was left to the Royal Academy. Flaxman appears to have obtained the commission for the Captain Montague (1798–1804) through the influence of Lady Spencer.[4]

As early as 1773 an attempt had been made by Sir Joshua Reynolds and other members of the Royal Academy to obtain permission 'to adorn St Paul's with monuments of famous men, like Westminster Abbey, and also to put up history pictures, as there are in the church at Rome, as it will be greatly for the encouragement of the Arts'. It was suggested that the first monument should be either to Sir Christopher Wren, or to Alexander Pope, and that Academicians should give a piece of their work, 'and to prevent poor things it must first be voted by the Academy as worthy of a place there'.[5] The Dean of St Paul's was much in favour, but the Bishop was violently opposed, and the project lapsed.[6] Moreover, there was evidently some difference of opinion about who was worthy of the first monument. It was well-known that Wren had regarded the cathedral itself as his monument,[7] and Pope had been a Roman Catholic. When, however, in 1791 a further application was made for permission to erect a statue to the philanthropist John Howard, the case was impeccable and permission was given, 'under proper restrictions' and on condition that 'no monuments should be erected without the design having been first approved of by a Committee of the Royal Academy, that nothing might be done that would not correspond with or contribute to the ornament of the building'.[8]

At first it would seem that the matter was handled relatively informally, and Bacon's Dr Johnson (Plate 164B), at least, was largely controlled by the wishes of Reynolds.[9] In 1796, however, after money had been voted for Parliament for monuments to certain military and naval heroes, some of whom had perished in the battle of 'the glorious first of June' in 1793, a committee was elected by the Academy, consisting of the architects Smirke, Wyatt, and Dance, the painter Barry, and Banks and Bacon.[10] The Dean and Chapter of the cathedral were curiously unresponsive, perhaps because the whole ques-

tion of the Academy's participation 'was owing to something settled between Sir Joshua Reynolds and the Bishop of London'.[11] This committee approved the design of Bacon's statue of Sir William Jones, though with some reluctance, since it had little reference to his important public work in India, though 'emblems of his private pursuits and amusements were heaped about him'.[12] They were also responsible for the earliest of the larger monuments, Banks's Captain Burgess (finished 1802; Plate 140) and John Charles Rossi's Captain Faulknor (finished 1803). Neither, however, was to give much pleasure.[13] Banks's scanty drapery had to be lengthened to satisfy the demands of decency, and Rossi's highly rhetorical piece of the captain in a short chiton, falling from rocks into the arms of Neptune, was a foolish design, and was considered poor in execution. Even before these works were commissioned in 1797 there seems to have been some uneasiness at leaving the spending of public money in the hands of the Academy; for Charles Long, the Paymaster, had implied at the Academy Dinner in 1796 that control should rest with the Treasury.[14] The prestige of the Academy had dropped sharply after the death of Reynolds in 1792. His successor as President, Benjamin West, was unpopular and undistinguished, and there was a strong anti-Academy party among the connoisseurs, led by Richard Payne Knight, an influential member of the Society of Dilettanti and a collector of bronzes,[15] who were all too ready to suggest that artists, many of whom had not travelled, were incapable of making judgements which were in good taste. Further, the casualty lists of the French Wars were ceaselessly adding to the number of men whom a grateful country wished to commemorate, and outstanding figures of an older generation, such as Lord Heathfield (d. 1790) and Lord Rodney (d. 1792), still had no memorials, though these had been proposed in 1794.[16]

It is therefore perhaps not surprising that the Government, genuinely anxious for monuments which would reflect the glory of British achievement, decided that the easiest way of reducing argument and getting work done with the minimum of interference and trouble to itself was to appoint a committee to handle the matter. In March 1802, therefore, the Treasury appointed seven gentlemen to act as a Committee of National Monuments.[17] They were to be responsible for allocating money, selecting designs, determining such matters as size and projection from the wall, and authorizing payments. Since the original letter from the Prime Minister, Henry Addington, was sent to Payne Knight, with copies to his colleagues, it looks as if he had been the moving spirit against the Royal Academy. The Rt Hon. Charles Long (afterwards Lord Farnborough), then Paymaster, was, however, elected chairman, other leading members being Sir George Beaumont, Charles Townley (both connoisseurs), and Henry Bankes, a Member of Parliament and a Trustee of the British Museum. No artist was a member and the Royal Academy was not represented.[18] Moreover, when about 1806 the committee was enlarged, the new members were chiefly collectors and connoisseurs – Thomas Hope, the Marquis of Stafford, Lord Carysfoot, Lord Dartmouth, Lord Egremont, and Lord Hawkesbury – and the secretary who was then appointed was Robert Gillam, who was also secretary to the British Institution, a new exhibiting body viewed with much suspicion by the Academy. It is, indeed, clear that from the first the flavour of the new committee was recognized. In the year of its inception it was referred to in

the *Gentleman's Magazine* as 'the Committee of Taste',[19] and by 1806 that name, rather than the official title, appears in the Treasury Letter Books.

How far the committee lived up to their name is now hard to judge with fairness. The monuments erected in St Paul's between 1802 and 1825 are not among the most attractive works of English sculpture. This is not necessarily the fault of the committee, who appear to have discharged their duties conscientiously, and however much Joseph Farington, that industrious recorder of Academy opinion, may have grumbled at them, there is no reason to suppose that the Academy itself would have produced better results.[20] The position in 1802 was not, indeed, an easy one. Two large monuments, each to the value of six thousand guineas (the price fixed for those of Commanders-in-Chief), were to be erected to Lord Howe and General Abercromby, and two more for four thousand for Captain Westcott and jointly to Captains Mosse and Riou. John Bacon had died in 1799 and Nollekens was no longer interested in work of this kind. Beyond Flaxman and the ageing and somewhat unpredictable Banks, there was hardly a sculptor of sufficient experience. Flaxman was awarded the Howe (Plate 160B), which he did not finish till 1811, and Banks the Westcott (Plate 160A), but for the others the committee had to turn to less experienced men. The Abercromby (Plate 158) was given to the young Richard Westmacott (1775–1856), whose family connexion and training in Canova's studio no doubt stood him in good stead, and for the Mosse and Riou (Plate 159) Rossi was given another chance.

The designs for these first four monuments chosen by the committee betray the weaknesses that are constantly apparent throughout the series: the inability of English sculptors to manage a large-scale group of several figures, and the dullness of much of their modelling. They also reveal something of the cross-currents still affecting English style. Flaxman's Howe is a static group, the figures tightly fitted into a pyramid, with an allegorical rather than a narrative content, and though the admiral himself is in uniform, the Victory and History on the left are of a very pure neo-classical kind. Banks, in his pathetic last work, attempts action, but his unconvincing death-scene is that of a classical rather than a modern hero. Rossi, perhaps because of the criticism levelled at his earlier monument, plays for safety with a timid design of two half-nude allegorical figures, almost Rococo in their slender proportions, holding medallions. But Westmacott is far more daring. He casts aside the principles of neo-classical design in which he had been trained, and creates a surprisingly Baroque group in which the Abercromby collapses from a rearing horse into the arms of a soldier who rushes forward to support him. Only the half-nude figure, fallen beneath the horse, has any classical reference,[21] for the impassive sphinxes at the sides are there simply to show that the general fell in Egypt.

Westmacott's highly successful career must be discussed in greater detail later. John Charles Rossi (1762–1839), in spite of a promising start as a gold medallist at the Royal Academy Schools, was never to gain the position which he thought was his due. He was, in fact, a mediocre sculptor. In 1806 Flaxman referred to one of his St Paul's monuments as 'rather mason's work than that of a sculptor', and said that Rossi had 'by employing ordinary men at low wages, got much money by it, but had greatly suffered in reputation'.[22] Rossi was clearly a difficult man, jealous of his rivals and of younger

members of the Academy, who, he said, 'treated him with disrespect'; but he was poor with a large family, and there were times when he almost despaired. In 1815 he was reduced to complaining to Farington that the change in architectural style had led to the introduction of such plain chimneypieces that sculptors could no longer get more than from four to fifteen pounds for them, whereas formerly they could have had fifty or sixty;[23] and in the next year he was tempted to accept an invitation from King Christopher of Haiti to go and work in the West Indies. Although he was awarded two more large monuments in St Paul's, Lord Cornwallis (finished 1811) and Lord Rodney (finished 1815; Plate 161B), as well as the statue of Lord Heathfield (1823–5), his practice remained small.[24] The Cornwallis and the Rodney are less summary in modelling than the Mosse and Riou, and the seated figure in the Rodney shows signs that Rossi had paid some attention to the Elgin Marbles in his drapery patterns; but they reveal a poverty of invention, for both show the main figure standing in contemporary dress with standing or seated allegories ranged at the sides. Since Cornwallis died while he was Governor General of Bengal, his attendant figures have an Indian flavour, but beyond that there is nothing in either monument of immediate human interest, and little that is lively in style.

It is indeed clear that all the sculptors of the larger monuments, with the single exception of Westmacott in the Abercromby, were anxious to avoid a realism which might be held to lack nobility; and so although the main figure might be shown in uniform, the others must suggest ideas of patriotism and sacrifice rather than the reality of war. Flaxman's Nelson monument alone (Plate 147) has a sincerity which almost breaks the icy barrier which surrounds most of its fellows, but the glory of Nelson had moved the whole nation, and Flaxman, whatever his failings may have been, was capable of both feeling and conveying the sentiment of the country.

It is not possible to say how far the general tenor of the St Paul's monuments was affected by the views of the Committee of Taste, but since artists were allowed to submit both drawings and models, and alternatives if they wished, it should not too easily be assumed that the heroic style was entirely imposed. In fact, the committee was willing to accept a fairly wide variety of design; for though most of the larger monuments are roughly pyramidal in grouping,[25] two, Westmacott's Lord Collingwood (1813–17; Plate 162A) with the corpse borne on an antique prow, and the younger Bacon's Sir John Moore (1810–15; Plate 162B), which shows the general being lowered into his grave, have no central emphasis. Bacon was unpopular with his fellow-artists, who never elected him even to an Associateship of the Royal Academy, and who clearly felt with Flaxman that his works were flimsy, and that he had neglected the pure standards of sculpture.[26] Nevertheless, there is a pathos about the Moore monument which makes it more approachable than most of its fellows, though the sculptor's weakness in handling the male nude is disturbing.

In addition to the large standing monuments, a number of tablets with reliefs were set into the walls of the transepts of the cathedral.[26a] Few of these were given to outstanding sculptors, though Westmacott executed that to General Brock (d. 1812) and Bacon that to Generals Crauford and Mackinnon (d. 1812). The others went mainly to minor

artists, Charles Manning and Josephus Kendrick (Plate 163B), whose ambition certainly outran his talent. The majority of the reliefs (Westmacott's excepted) are stock allegorical designs, generally of two figures leaning inwards against a plain ground. Three of them however, suggest a fresher approach. The memorials to General Hoghton, General Bowes (Plate 163A), and Colonel Cadogan were all awarded to Francis Chantrey (1781–1841). All show a scene of vigorous action, uniformed men fighting and falling, and only the first includes any allegorical figure. Moreover the design runs right up to the top of the frame, and in the two later works (Bowes and Cadogan) the ground is almost entirely covered by overlapping figures, half seen in profile behind each other. Apart from the very personal talent of the sculptor, which must be discussed later and at length, these works suggest an entirely new impetus to the problem of relief sculpture – surely that of the Parthenon frieze.[27]

Finally, when most of the spaces available for large monuments or reliefs were filled, the committee decided that standing figures must serve as memorials (Plate 164A). These were commissioned in 1816 and 1823, and indicate the growing acceptance of contemporary dress. Such figures, though cheaper than the grander monuments (the fees varied from fifteen hundred to two thousand guineas), must have pleased Benjamin Robert Haydon even less than the 'masses of unwieldy stone'; for there is little about them to improve the mind or suggest the glory of England. Nor were the sculptors uniformly happy with the new form of monument. Westmacott, as will be seen, had little feeling for the contemporary, and though Chantrey in his General Gillespie attacks the problem with his usual vigour, the pose of the general suggests an administrator rather than a soldier who fell in battle. These figures perhaps deserve more attention than they receive, but they are overshadowed by the empty, frozen rhetoric of the larger monuments. No doubt the sculptors and the Committee of Taste carried out their task to the best of their ability, and it was not their fault that their ability was channelled into the shallow waters of neo-classicism. It is sad, however, that the greatest Baroque building in England should not be adorned by Rysbrack's Newton or Roubiliac's Argyll, but should be compelled to house monuments whose virtues, such as they are, are dwarfed rather than aided by the quality of their surroundings.

The committee did not confine its interests to the naval and military monuments in St Paul's, but was also responsible for some of those to statesmen which, by common consent, were still erected at Westminster,[28] though it was only consulted over those raised by the direction of Parliament. It was also concerned with official statues in London, such as Westmacott's George Canning (Plate 165A) in Parliament Square. The demand for public monuments was, however, widespread, and large sums were raised by subscription in many different places, above all for monuments to Nelson, who was killed in October 1805, and Pitt, who died in January 1806. This again is new, for it is extremely rare to find public patronage of this kind in the eighteenth century. The Corporation of London provides an exception, with the vast pile of figures in Guildhall erected in 1782 by John Bacon to the memory of Chatham. Naturally the City wished to honour both Nelson and Pitt, though perhaps because both monuments were commissioned in 1806, they were not prepared to pay high prices. The Nelson, finished in

1810, went to James Smith (1775–1815), who had worked for Flaxman on the Mansfield monument, and the Pitt, finished in 1813, to James Bubb (1782–1853) over the head of his former master, Rossi. Neither was really capable of producing satisfactory work on a scale over life-size; some of Smith's detail is well cut, but Bubb's work is a tedious echo of the St Paul's style of Rossi.[29] No doubt Haydon knew of both these designs for Guildhall monuments when he made his lament in 1812.

Outside London the taste was for statues rather than for groups, and selection was in the hands of local committees. Liverpool was perhaps the first in the field with plans for a memorial to Nelson, since a subscription list was opened less than a month after Trafalgar, William Roscoe, the collector of Italian primitives and biographer of Lorenzo de'Medici, playing a leading part in the project. In spite of large contributions from companies such as Lloyds and the West India Association, it was, however, to be eight years before the memorial was finished.[30] Birmingham completed its tribute first, for Westmacott's monument in the Bull Ring was unveiled in October 1809. Dublin erected a column and a statue of Nelson as early as 1808, and the fashion for memorials to him was continuous almost up to the middle of the nineteenth century.[31] Statues of Pitt were only slightly less popular than those of Nelson. Flaxman's figure in Glasgow (Plate 149B) was up by 1808, and again the demand was surprisingly lasting; for Chantrey was to make his statue in Hanover Square, London, in 1831 (Plate 165B) and that in George Street, Edinburgh, two years later. Sometimes local and national interest combined in quick action to fulfil the new conviction that a statue was a fitting expression of public mourning. Within ten days of the assassination of the Prime Minister, Spencer Perceval, in May 1812, a meeting was held in his constituency, Northampton, and a subscription list opened, which in less than a year had reached a sum of over £2,000. The statue, made by Chantrey, was finished in 1817, and erected in All Saints' Church, for Northampton was short of open spaces (it is now in the Town Hall).[32] Though the great majority of public monuments honoured servants of the state, the royal family was not entirely forgotten. The jubilee of George III was commemorated at Liverpool by a statue ordered in 1809, anticipating the event by a year, and Chantrey's George III was made for the Corporation of London in 1811.[33] George IV, also by Chantrey, may be seen at Brighton, to whose prosperity he had so greatly contributed, and at Edinburgh and elsewhere. Moreover, there can be little doubt that it was partly the nature of the patronage, as well as the special talent of the most-favoured sculptor, Chantrey, that caused almost all the statues mentioned to show the figure in contemporary dress. Commercial enterprise, which created the money which paid for the work, had little taste for classical dress or allegory and preferred their great men to be easily recognizable, and in the attitudes they might have adopted in life.

Royal patronage, however, even when it was extended to a semi-public building, was still prepared to accept the classical convention. Marble Arch, designed by John Nash about 1828 as the main entrance to George IV's new Buckingham Palace, was originally conceived by the king as a memorial to the victories of Trafalgar and Waterloo, surmounted by a figure of Britannia with a portrait of Nelson on her shield, and with a lavish display of reliefs in the classical manner of both allegorical and historical subjects.

The Britannia was indeed begun by Flaxman before his death in 1826, but since the scheme was abandoned for one to include an equestrian figure of George IV (Plate 192), the head of Nelson was subsequently removed from her shield, she was transformed into Minerva, and placed on the east end of the National Gallery.[34] Some of the reliefs by Westmacott and Edward Hodges Baily are still on the Arch in its present position in Hyde Park; but the more ambitious friezes showing the Death of Nelson, the Meeting of Wellington and Blücher, and Patriotism encouraging Youth in Martial Exercises, which were none of them on the Arch before the death of George IV in 1830, were later set by Blore on the parapets of the courtyard and garden fronts of Buckingham Palace.[35]

Moreover, though taste may have fluctuated slightly during the years when England was largely cut off from the Continent, there was, after 1815, a renewed interest both in classical art, and in its presentation in the works of Canova. Many Englishmen, both patrons and artists, visited Paris in 1815 to gaze at the loot from Italian museums and collections assembled by Napoleon, and many of them then met Canova, who was particularly friendly to the English owing to the part played by Wellington and Castlereagh over the restoration to Italy of these works. At the end of the year Canova was to visit England, where he was much fêted, and he was to make some return for the compliment by sending works for exhibition at the Royal Academy of 1817. Canova's reputation was probably at its highest point about this time. Even before his visit he had many English patrons, including the Prince Regent, Lord Cawdor (who had been a constant patron since 1789), Lord Lansdowne, and the Duke of Bedford. Some thirty pieces made for English collectors appear in the chronological list of Canova's works published by Melchior Missirini in 1824, two years after his death, and though the majority of these were made after 1815, some, among them Lord Lansdowne's replica of the Uffizi Venus, were commissioned at the height of the Napoleonic Wars.[36] Indeed, in 1806 there was talk of employing Canova for the statue of Pitt (finally executed by Nollekens) for the Senate House at Cambridge.[37] Important works by Canova can still be seen in England, notably at Buckingham Palace and Chatsworth;[38] his signed monument commissioned by the English widow of the Margrave of Anspach at Speen, Berkshire (Plate 171B), is less well-known, and appears to be undocumented, but in its incisive handling provides an interesting comparison with similar themes treated by his English contemporaries. Canova's influence on English sculpture was enormous, and was strengthened after his death by the appearance of the three volumes of *The Works of Antonio Canova engraved in Outline by Henry Moses* (1822–4); on the other hand there is some evidence that even before his death certain English travellers were transferring their admiration to the more frigid Thorwaldsen.[39] Gradually Canova came to be despised by intellectuals as 'an accurate depictor of a certain low species of nature, voluptuous, addressed to the comprehension of the animal part of our nature',[40] and by the middle of the century, George Jones, the Keeper of the Royal Academy and one of Chantrey's executors, was to think it higher praise to equate Chantrey with Thorwaldsen than with Canova.[41]

The antique was to remain, however, throughout the period to 1830 the keystone of

the training of young artists. Casts were in special demand during the years before 1815 when few could travel; and though there were often complaints that Royal Academy students maltreated the casts from which they drew, the Academy was assiduous in attempting to replace them.[42] Moreover, when the pope, in gratitude for England's help over the return of Napoleon's loot, presented the Prince Regent in 1816 with twenty-six fine casts of major pieces in the Vatican Museum, these were at once passed on to the Academy.[43]

This coincided almost exactly with a new phase in the relations between England and Antiquity, and indeed with a crucial moment in public as opposed to private collecting; for in the summer of 1816 the sculpture from the Parthenon was bought for the nation.[44] For the first time a large collection of sculpture, indisputably Greek, was available in Western Europe. Its impact was tremendous, for it shook many preconceived ideas concerning antique art and added a new meaning to the word 'nature'; and, as will be seen, some men brought up in the tradition of Winckelmann were so puzzled by what it revealed that they had difficulties in accepting the new standard.

Although the story of the Elgin Marbles has often been told, it will perhaps bear repetition here owing to its importance as evidence of the English attitude to sculpture; and the statements of English sculptors about the Marbles must, of necessity, be closely examined. The Earl of Elgin, who had been appointed Ambassador at Constantinople in 1799, 'intended to make his appointment beneficial to the progress of the Fine Arts in Great Britain by procuring accurate drawings and casts of the valuable remains of sculpture and architecture scattered throughout Greece, and particularly concentrated in Athens'.[45] This, admittedly written after the event, when his motives had been challenged, suggests that he had not been fired only with the idea of private collecting; though he certainly must have known that another English ambassador, Sir William Hamilton, had sold a large collection to the nation. At first he met with many difficulties, but in 1801, after the defeat of Napoleon in Egypt, the English became more popular with the Turks, and permission was granted him to draw, model, and remove, and also to excavate. The work was done at his own expense, for though he asked Pitt's government for a grant before he left England, this was refused. Little was known in England of the extensive use Elgin was making of his permit until 1802, when fifteen cases containing sculpture, probably from the metopes, arrived at Plymouth. Even then it can hardly have been realized that almost the whole of the Parthenon sculpture had been removed, and so saved from the neglect it was suffering at the hands of the Turks. Charles Townley then wished to give Elgin the support of the Society of Dilettanti, and led him to hope that this would be financial as well as moral, but nothing was done, presumably owing to the opposition of Payne Knight, who was to become the central figure in the subsequent controversy.[46]

In 1803 Lord Elgin was arrested in France and so was unable to take charge of the main cargo of fifty cases when it arrived later that year. On his release in 1806 he took a house in Park Lane, and the Marbles were arranged there by his secretary, William Hamilton.[47] From that time onwards, artists were able to obtain permission to draw from the Marbles, the public was admitted to the Gallery on Saturdays and Sundays,

and casts were made of parts of the frieze and also of other sculpture in Athens and else-where from moulds sent by Lord Elgin's craftsmen in Greece. Very soon after the Gallery was arranged, Flaxman was consulted about the possibility of the restoration of the much damaged works. He advised against it, saying that it would cost more than £20,000, that the execution of the restored work would inevitably be inferior to the original parts, and that 'it would be a source of dispute among Artists, whether the restored attitudes were correct or otherwise'. This is a welcome shift of opinion from the eighteenth-century attitude which demanded restoration, whether it was good or bad, and it is greatly to Flaxman's credit that he admitted it at this date. He was also of the opinion that the Gallery was 'very far superior in the value of its contents to what Paris can boast'. This assessment was, naturally, based on what had been seen in Paris at the time of the Peace of Amiens in 1802, and not on what would be seen by 1815; but in view of later arguments, and indeed of some of Flaxman's own later evidence, it is not without interest. Other artists held varying views. Benjamin West, the Presi-dent of the Royal Academy, spoke of the marbles as 'sublime specimens of the purest sculpture', contradicting his fellow-painter Ozias Humphry, who had said that 'though there was something great and of a high stile of Sculpture', the whole was 'a mass of ruins'.[48] Benjamin Robert Haydon and Henry Fuseli were, as might be expected, more positive in their opinions. Fuseli strode about saying, 'De Greeks were Godes! De Greeks were Godes'; and though Haydon's many references to the Marbles cannot be quoted in full, his first impression of 1808 is worth recording for its Romantic over-tones: 'I saw, in fact, the most heroic style of art combined with all the essential detail of actual life, the thing was done at once and for ever. . . . I felt for the future, I foretold that they would prove themselves the finest things on earth, that they would overturn the false beau-ideal, where nature was nothing, and would establish the true beau-ideal, of which nature alone is the basis. . . . I felt as if a divine truth had blazed inwardly upon my mind and I knew that they would at last rouse the art of Europe from its slumber in the darkness'.[49] He was never to deviate from this view, and was later to become violent in their defence.

By 1809 Lord Elgin, who had spent very large sums on the acquisition of the Marbles, found it necessary to consider selling his house, and the beginning of the long negotia-tions for the purchase of the collection for the nation dates from the next year. At first the chances seemed favourable. Mr Planta, the Librarian of the British Museum, was sympathetic and urged Lord Elgin to approach the Government. The letter to Charles Long in which this was done has its place in the history of the public attitude to the arts; for it states that artists and men of taste 'look to the establishment of such a school as this assemblage would furnish for the study of art and the formation of taste, as the means of giving to this Country those rational advantages, the importance of which has been of late so much brought into evidence, by the many Collections of ancient art so studiously concentrated in Paris'. The letter was accompanied by a statement of the expenses incurred, which including interest had amounted to £62,440. Parliament refused to discuss details and offered Lord Elgin £36,000, which he refused in May 1811.

The Marbles were then moved to temporary quarters lent by the Duke of Devon-

shire at Burlington House, but eighty further cases of sculpture arrived in 1812, so that the display became horribly overcrowded, and in 1815 Burlington House was sold to Lord George Cavendish, who wished to use the yard at the back for building. The position was now desperate. Lord Elgin offered to deposit the Marbles temporarily at the British Museum, the Trustees of which appointed a committee consisting of Charles Long, Payne Knight, and Lord Aberdeen to discuss purchase. Since the two last were known to belittle the Marbles, Elgin was finally persuaded to ask the government to appoint a Committee of the House of Commons to investigate the value of the collection, which he himself, since the arrival of the last cases, now estimated at £73,600. It was perhaps as well that the question was shelved owing to Napoleon's escape from Elba. After Waterloo his former secretary, Hamilton, played a considerable part in the negotiations between Castlereagh and Canova over the return from Paris of the papal plunder, and knowing that Canova was about to visit England, he was able to write to Lord Elgin in October 1815 that the Italian 'is prepossessed with a most favourable idea of what he is to see. Indeed, he professed to be coming chiefly to see your collections'. It was, indeed, not only Hamilton who had encouraged Canova to think the visit worth while. The great antiquary Ennio Quirino Visconti, formerly Director of the Capitoline Museum, had been to London in 1814, and had told Canova that 'until he had been to London he had seen nothing'. Canova's visit took place at the end of 1815. His letter to Lord Elgin, written before he left, was submitted as evidence at the Parliamentary Enquiry which was to take place early in the next year, and clearly carried great weight. In it he expressed his gratification at having seen the Marbles and affirmed that he had given every moment he could to the contemplation of them. 'I admire in them the truth of nature united to the finest forms. Everything here breathes life, with a veracity, with an exquisite knowledge of art, but without the least ostentation or parade of it, which is concealed by consummate and masterly skill. The naked is perfect flesh, and most beautiful in its kind.'[50] Much later, in 1836, Hamilton was to write: 'Canova indeed had the modesty to say, when I first introduced him to your Lordship's collection: "Oh that I had but to begin again! to unlearn all that I have learned – I now at last see what ought to form the real school of sculpture." '[51] Poor Canova – but still more, poor Winckelmann!

The Select Committee appointed by the House of Commons, under the chairmanship of Henry Bankes, was at last set up in February 1816. It was to inquire if it was expedient that Lord Elgin's collection should be purchased for the nation, and if so, what price would be reasonable. Its sittings, occupying about eight days, were spread over a fortnight; and in addition to Lord Elgin and those immediately associated with him, artists, travellers, dealers of repute, and connoisseurs were called to give evidence. None of the artists were willing to give a valuation in terms of money, but a considerable part of their evidence consisted of comparisons with the Phigalian Marbles,[52] which the British Museum had recently purchased for £15,000, and with the Townley Collection, bought some ten years earlier for £20,000. And all were asked to compare the Elgin Marbles with the most famous of classical pieces, the Apollo Belvedere and the Laocoon.

Five sculptors, Nollekens the doyen sculptor Academician, Flaxman, Westmacott,

Chantrey, and Rossi, and two painters, Benjamin West and Sir Thomas Lawrence, were asked for their opinions.[53] All spoke strongly in favour of purchase. Their chief opponent was Payne Knight, whose campaign of denigration had led him to the foolish statement that the Marbles were not Periclean but Hadrianic, who shifted his ground when it was proved that he had twisted the statements of antique writers, and who valued the Townley Marbles more highly, since the surface was perfect, and they had been well restored and were 'perfectly adapted for the decoration and almost for the ornamental furniture of a private house'. Indeed, his prejudice was so great that he considered the best of the Phigalian Marbles (which, though of the fifth century B.C., are provincial in handling) worth more than the Parthenon metopes 'because they are in a state of preservation to be used as furniture'. In other words, he was still an eighteenth-century connoisseur, thinking in terms of private collecting; he could not or would not use his eyes, nor would he accept a different standard.

The evidence of the artists was far more liberal-minded. All were convinced of the prime importance of the Marbles as materials for study (some, as has been suggested, had already benefited in this way); all were aware of the value of museums and were intensely anxious that their own country should not neglect this unparalleled opportunity. Their exact assessment of the works, however, varied considerably. They all saw, naturally, that the style of the Parthenon sculpture differed very greatly from that of the smooth elegance of the Apollo Belvedere, but Flaxman could not abandon what he had learnt in his youth, and so asserted that, even though he held the Apollo to be a copy of a bronze original, it still had more of ideal beauty than any other statue, and so was much superior to the Theseus of the Parthenon.[54] On the other hand, he rated the Theseus higher than the Torso Belvedere, but he was less enthusiastic about the female figures. It may well have been that their contours were not clean enough for his taste. He was also somewhat half-hearted about the relief sculpture. He thought more highly of the metopes than of the frieze, 'inasmuch as the heroic style is preferable to that of common nature', but his blindness to the quality of the frieze was no doubt partly due to its corroded surface, and partly to the fact that its style was not sufficiently linear to please him. The infinite gradations of relief so marvellously displayed were very different from those of the antique sarcophagi he had admired in Rome, and which he had tried, not unsuccessfully, to imitate in his own work. It is perhaps surprising that Nollekens, who was older than Flaxman, and who had spent much time in restoring antiques, should have been the more enthusiastic of the two. But Nollekens was little given to theorizing, and his constant attention to the human face must have given him a more earthy view of nature than that of the poetic Flaxman.

The younger men, Westmacott and Chantrey, were far more perceptive. Both rated the Theseus more highly than the Apollo Belvedere, Westmacott stating the 'Theseus has all the essence of style with all the truth of nature; the Apollo is more an ideal figure'. They had, moreover, looked at the works with fresher eyes, and like Haydon had seen their mastery of the human body in action and repose. Westmacott said 'the back of the Theseus was the finest thing in the world; and that the anatomical skill displayed in the front of the Ilissus, is not surpassed by any work of art'. Chantrey saw in the Marbles

'nature in the grand style, not the simplicity of the composition visible in every part; but simplicity and grandeur are so nearly allied, it is impossible to make a distinction'. To men of this generation (and to the sculptors must be added Sir Thomas Lawrence), the particular character of Phidian sculpture, which is at once heroic and naturalistic, was overwhelmingly apparent.

By the end of the Enquiry it was clear that a recommendation of purchase must be made. Aspersions had, however, been voiced as to the propriety of Lord Elgin's action, not on the grounds that it had been wrong to remove the Marbles from their setting, but because he was thought to have exploited his diplomatic position to do so, and had perhaps also resorted to bribes. Though his *firman* from the Turkish authorities was submitted, so that all could see that permission had been granted, a faction in the House of Commons still believed that he had obtained the Marbles dishonestly – and the price offered, and accepted in despair, was only £35,000, that is to say, less than half of his estimated expenditure. The removal of the Marbles to the British Museum began immediately, and after January 1817 they could be seen at any time.[55]

It is perhaps worth quoting the peroration to the report presented by the committee to Parliament. It was not written by artists, but by a body of men who were primarily administrators and civil servants, and it is revealing in its attitude to the arts – an attitude which would have been unthinkable before the Napoleonic Wars, but which was to be re-affirmed in many different ways in nineteenth-century England:

'Your Committee cannot dismiss this interesting subject without submitting to the attentive reflection of the House, how highly the cultivation of the Fine Arts has contributed to the reputation, character and dignity of every Government by which they have been encouraged, and how intimately they are connected with the advancement of everything valuable in science, literature and philosophy. In contemplating the importance and splendour to which so small a republic as Athens rose, by the genius and energy of her citizens, exerted in the path of their studies, it is impossible to overlook how transient the memory and fame of extended empires and mighty conquerors are. . . . But if it be true, as we learn from history and experience, that free governments afford a soil most suitable to the production of native talent, to the maturing of the powers of the human mind, and to the growth of every species of excellence, by opening to merit the prospect of reward and distinction, no country can be better adapted than our own to afford an honourable asylum to these monuments of the school of *Phidias* and of the administration of *Pericles*; where secure from further injury and degradation, they may receive that admiration and homage to which they are entitled, and serve in return as models and examples to those, who by knowing how to revere and appreciate them, may learn first to imitate, and ultimately to rival them.'

This complacent statement, if it were not sincere, could be dismissed as pure humbug, and no doubt it was so dismissed by many Members of Parliament. But it is at least a public tribute to the value of the arts, and a public confession of the use to the community of the provision of facilities for artists. Unfortunately, the moment for this was passing. The series of public monuments in St Paul's was almost completed, and no comparable opportunity was to be offered to sculptors until the Albert Memorial in 1864. By then many other forces were at work.

The most immediate public impact of the Marbles is therefore seen in the work under-

taken for the Prince Regent. William Theed's fine group of Hercules taming the Thracian Horses on the pediment of the Riding House of Buckingham Palace (Plate 166A) must be one of the earliest examples, for Theed died in 1817.[56] Not only are the horses directly inspired by the Parthenon sculpture, but the torso of Hercules is more fleshy and less dry in its articulation than would have been possible without a study of the pediment figures. The Parthenon frieze was the source used by the younger John Henning (1801–57) for the frieze he made in 1828 with his father and brother for Decimus Burton's screen at Hyde Park Corner (Plate 166B), conceived as part of the Triumphal Way to the new Buckingham Palace. The same sculptor was almost immediately to repeat the Parthenon design even more closely for the frieze of the Athenaeum in Pall Mall. It is, however, worth nothing that the style is sharpened and flattened. The figures are silhouetted more clearly against the ground, and so the whole becomes more linear. It is, in fact, classical Greek sculpture seen through neo-classical spectacles. The frieze, again, serves as the inspiration for Westmacott's version of the Battle of Waterloo on the great vase, fifteen feet high, now in the garden of Buckingham Palace (Plate 167).[57]

The influence of the style rather than the motives of the Elgin Marbles on the greater sculptors of the period is more difficult to assess. Westmacott, for all the sensibility of his evidence concerning them, rarely loses the elegant neo-classical manner he had learnt in Canova's studio, though his admiration for the back of the Parthenon Theseus can perhaps be traced in his treatment of the river-god on Lord Collingwood's monument (1813–17; Plate 162A) in St Paul's. Chantrey, however, was no doubt encouraged by the soft and subtle modelling of the Marbles to develop his own broad and fleshy style. The great majority of sculptors, however, though they constantly paid lip-service to the Marbles by borrowing a pose, and occasionally a drapery pattern, were inclined to rely on the simpler, smoother modelling and more linear manner of design derived from the late-eighteenth-century tradition. It was, after all, a much less exacting method, and one which could safely be carried out in workshops both in London and in the provinces.[58] On the other hand, the prestige of the antique was enormously increased by the presence of the Marbles in London, and this may well have been a contributing factor to the absence of a Baroque revival in England comparable to that which colours Romantic sculpture in France. Moreover, though the early phase of the Gothic Revival had a profound effect on English architecture long before 1830, it had no comparable influence on sculpture.

SIR RICHARD WESTMACOTT

SIR RICHARD WESTMACOTT (1775–1856) is one of the most puzzling, and in the last analysis, one of the most disappointing of English sculptors. His best work borders on greatness; indeed, Canova, after seeing the figure of the negro on the Fox monument in the sculptor's studio, 'assured Lord Holland that neither in England, nor out of England, had he seen any modern work in marble which surpassed it'.[1] Even allowing for a generous master who finds a pupil succeeding in a field outside his own range, this is a considerable tribute, and not totally undeserved. But the occasions on which Westmacott reached this standard are lamentably rare, and most of his very considerable output is far more commonplace. He had, when he chose to use it, a much greater feeling for form than Flaxman, but none of the latter's supreme gift for linear design, nor his fertility of invention. Work poured from his studio, but much of it is repetitive, careless in modelling, and, at its worst, extremely naïve in design. On the other hand, some though not all of his important commissions have great distinction, but even these are sometimes marred by an over-facile handling of certain parts.

Richard Westmacott had an exceptionally good start. His father,[2] a man of some education, had built up a good practice as a sculptor, gave his son a first training, and in 1793 sent him to Rome, where he entered Canova's studio. He did well, winning a gold medal of the Academy of St Luke in 1795. His later sculpture suggests that he was greatly attracted by Canova's sensuous, semi-Rococo style, as seen, for instance, in the Venus and Adonis (1795, Possagno) or the first Hebe (1796, Berlin), and that he saw the antique in these terms. In 1797, after an eventful journey, he returned to England, and quickly built up a practice of his own. The Royal Academy seems to have been somewhat suspicious of him. He had not, of course, been through the Academy schools, and was regarded as a protégé of the architect James Wyatt, who was never a popular figure.[3] His first major commission, the General Abercromby at St Paul's (Plate 158), met with a good deal of unfriendly criticism, and even after 1805, when after a certain amount of argument Westmacott was elected an A.R.A., there was still talk of his 'deficiency of execution', one Academician condemning his work as 'mannered and without form; dabs for extremeties [sic] rather than anything made out'.[4]

It must, however, have been evident to the Committee of Taste, and also to other patrons, that the young Westmacott was a far better sculptor than Rossi, and that, indeed, between about 1802 and 1817 he was Flaxman's only serious rival in the field of large commissions. His monuments at St Paul's have already been discussed, but the memorial to Pitt in Westminster Abbey (Plate 168A) ranked in importance with that to Nelson, and for this Westmacott was chosen. The commission was given in August 1807, the price being six thousand guineas, but the work was not finished till 1813.[5] The task was not an easy one, for the monument is high above the west door, the figures

should appear majestic from a distance, and Pitt himself, whose tall thin form was well known, had to be given weight without losing truth. Westmacott's final design shows Pitt, his figure enveloped in a gown, one immensely long arm outstretched, declaiming to an unseen audience. His words, however, are not lost; for History records them on her tablets, while Anarchy, chained, writhes at their effect.[6] It is not an entirely successful piece; Pitt is too rigid, and the whole too contrived. But the male nude is competently done, and the drapery of History departs completely from Canova's rhythmic patterns and appears to be modelled on the Elgin Marbles.

The other Westminster monument made by Westmacott for Parliament, that to Spencer Perceval (erected 1816), is a curiously uncomfortable composition. The murdered Prime Minister lies on a rolled-up mattress (a convention presumably adopted from much earlier Westminster monuments), with a seated mourning figure of Power at his head and Truth and Temperance standing at his feet. None of the allegories are, however, individualized, and were it not for contemporary descriptions, their meaning would be hard to guess. Moreover, the half-nude Truth is a sentimentalized, weakened version of Canova's Venus leaning on the shoulder of Adonis. The monument is backed by a relief of the murder, much smaller in scale and not very happy in conception; but Westmacott had little ability for the representation of figures in contemporary dress.

Westmacott's abbey monuments for private patrons are more interesting, and more successful. The earliest is the monument to Addison (1803–9) erected by Lord Bradford in the Poets' Corner.[7] Addison, a respectable but somewhat commonplace representation of a classical poet, stands on a high circular base adorned by figures of the Muses (Plate 170A). Here Westmacott proclaims himself clearly as the pupil of Canova, for his figures have the long legs and tightly clinging draperies, following and revealing the forms, of his master's Hebe or his Danzatrici. There is, however, a marked difference in character, for instead of the lively, almost pert expressions of the Italian's faces, the Englishman's are languid, their movements (even those of Terpsichore) are slower, and their forms less opulent. Westmacott had looked with care and admiration both at the works of Canova and also at antique works – indeed the whole conception of the figures set against the round drum was presumably derived from an antique well-head – but his Muses have a nostalgia which reveals them immediately as northern, and basically Romantic. Canova had his roots in the Rococo, and he saw Antiquity, and above all the nude, with Venetian eyes. Westmacott's yearning figures suggest a very different approach, one which looks forward to Burne-Jones rather than backward to the gay sensuality of the Rococo.

The memorial to Charles James Fox (1810–23; Plates 168B and 169), now in the nave, is probably Westmacott's masterpiece,[8] and has a greater nobility of composition than any monument in St Paul's. Fox, the great Whig, dies in the arms of Liberty, while Peace bends, mourning, at his feet. In front kneels the famous negro, gazing at the man who had spoken so strongly in the defence of his race.[9] The figures are tightly knit into a group, with none of the looseness of the Pitt and Perceval designs. The modelling is bold and powerful. It is, indeed, a most impressive work, and it is only when the first impact has died that the excessive elongation of the figure of Liberty becomes apparent.

Seated, she is the climax of the closely integrated group; were she to stand, she would dwarf the other figures. But perhaps Fox would not have minded.

The remaining abbey monument in which Westmacott proves that, when he chose, he had a feeling for broad, strong modelling, is that to Mrs Warren (d. 1816; Plate 170B).[10] The widow of a bishop, her epitaph stresses her benevolence, especially towards 'the Virtuous who had fallen from prosperity', and the single seated figure, 'The Distressed Mother', doubtless belongs to this class. The woman, with hair falling to her shoulders, a homespun cloak over her scanty garments, and bare feet, sits nursing her child with a bundle beside her on the ground. Her air of weariness proclaims her need for charity, but she has fine features and her child is well nourished. Here, perhaps, Westmacott is challenging Chantrey in his great success in pathos, the 'Sleeping Children' in Lichfield Cathedral, erected in 1817. 'The Distressed Mother' is, indeed, an attempt by a sculptor whose bent is towards neo-classicism to break into the contemporary, and though the attempt is a little obvious, it is not entirely unsuccessful. He is willing to abandon the fine, small folds which he preferred for a broader treatment, and even to indicate the weave of the rough cloak, and though, like most sentimental works of the period, it is a trifle mawkish, it is, nonetheless, an original work, and one which doubtless gave great satisfaction.

It does not appear that Westmacott's strongly modelled work belongs to any one period of his life; indeed, it is hard to find any clear development in his style, and in view of the number of his commissions, and the amount that must inevitably have been left to assistants, it is logical to suppose that in many cases he did little himself beyond a preliminary drawing or sketch model. Two of his smaller monuments can be taken as showing his work at its best. The early memorial to the Hon. John Yorke (1801, Wimpole, Cambridgeshire; Plate 172) has a poetry of conception which brings it close to Flaxman, though without Flaxman's Christian reference. Erected by his children, it shows a young man and woman, in very high relief against a simple stele, standing hand in hand with a child at their feet, and gazing mournfully at a butterfly, the symbol of the transience of human life, which has alighted on the plain urn. The figures with fine Roman profiles are in semi-classical dress which is simply treated, and there is nothing trivial to break the mood of noble resignation. It is less spontaneous and much less linear than any design of Flaxman's, but it has a calm dignity that makes it one of the most impressive monuments of its time.

A more surprising and original work is the circular relief on the monument to the 7th Earl of Bridgewater (d. 1823; Plate 173) at Little Gaddesden, Hertfordshire. Here Westmacott has surely turned not to Antiquity but to Florentine Renaissance art for his inspiration.[11] The tondo form, with the Madonna-like figure, must surely be a recollection of Michelangelo, but the woman, the sleeping child, and, indeed, the old man with the staff, seem closer in type to paintings by Raphael. Only the younger man on the left, in a smock, his hand resting on the tools of his trade, has no source in Renaissance art. Again, however, as in 'The Distressed Mother', there is a sentiment which betrays its time, for the yearning gaze of the young father towards his sleeping child is very far removed from the calm detachment of High Renaissance art, and the noble profile

of this young labourer has, again, an overtone of nineteenth-century philanthropy.[12]

The great majority of Westmacott's smaller monuments, however, are variants on stereotyped patterns, and are no better, and indeed are sometimes feebler, than those of his contemporaries. One of the earliest made after his return from Rome, that to William and Olivia Barker at Sonning, Berkshire (Plate 171A), with its lady dropping roses on a classical altar, is one of the most agreeable in design, and the sharp cutting of the small folds is much in the manner of Canova. All too soon, however, Westmacott becomes more slovenly, and takes no trouble with form, especially with hands and feet. The design of the Philip Yorke (d. 1804, Marchwiel, Denbighshire) is pretty enough, with its crouching figure, broken column, and weeping plant, but the hand and leg of the lady are clumsy and coarse. Sometimes an attractive figure stales by repetition. His small standing Charity, one child at her breast and another hiding in her cloak, appears on the tablets to Elizabeth Pinder (d. 1799, St John's, Barbadoes), James (d. 1811) and Elizabeth Barnard (d. 1805, Crowcombe, Somerset), and to the 5th Duke of Ancaster (d. 1809, Swinstead, Lincolnshire). In the last it is combined with a death-bed relief, but in all there is the same weakness of wrists and ankles. Charity was a popular theme, impeccable in sentiment, and Christian without being popish. She appears flanked by pelicans, though clumsier than those of Bacon, in a lunette on the monument to the Earl of Ilchester (d. 1802, Farley, Hampshire), while impassive figures of Faith can be seen on the Job Staunton (c. 1807, Staunton-in-the-Vale, Nottinghamshire) and on the free-standing William Burgh monument (1808, York Minster). Hope is shown on the Charlotte Baker (d. 1818, Orsett, Essex), and with Faith on the rather more elaborate monument to Sarah Countess of Mexborough (d. 1821, Methley, Yorkshire). The last is unusual in having a relief of a religious subject, the Raising of Lazarus, but the figures are curious in proportion, and very summary in modelling. Occasionally, and it would seem chiefly in his later monuments, Westmacott tries a type of figure with curling, floating draperies which suggests a borrowing from Flaxman, but they generally cover unconvincing forms. Examples of such work are the Elizabeth Mallet (d. 1827, Hampton, Middlesex) or the Grace Bagge (d. 1834, Stradsett, Norfolk; Plate 175B), the latter design with its two intertwined angels being repeated with a truly Victorian sentimentality for Sir John Williams (1835, St Asaph Cathedral).

It would not, on the other hand, be fair to dismiss Westmacott's small monuments without recording the fact that he had a much wider range of invention in this field than either Bacon or Banks, and that some of his designs are well conceived. Mrs Chichester (d. 1830, Derby Cathedral), reclining on a bed, fits beautifully into the oval frame, and the sleeping pilgrim, used for Sir Nelson Rycroft (d. 1827, Farnham, Hampshire) is an attractive invention.[13] It makes an instructive comparison with Flaxman's pilgrim on the Sibthorp monument at Bath; for though the silhouette is more important than in most of Westmacott's works, the relief is much higher and the sentiment more trite.

Not all Westmacott's monuments adopt the common tablet form; occasionally he was commissioned to make something rather more elaborate. The Andrew Newton (1806, Lichfield Cathedral) has a forbidding standing woman in classical dress, while another leans over the stele bearing a portrait, and, on the other side, the frigid banality

is redeemed by two seated children. It is, however, a collection of isolated figures, rather than an integrated design, and the same applies to the Robert Biddulph (d. 1814, Ledbury, Herefordshire), with its clumsy mourning woman in the round, and pretty but entirely disconnected figures of children in relief. Westmacott, indeed, seems to alternate between these heavy classical figures, with badly articulated limbs, which are, in a sense, a development of his dignified style seen at its best in the John Yorke at Wimpole, and a softer, more linear arrangement of figures in relief, which attempts a combination, seldom successful, of the styles of Canova and Flaxman.[14] Only very rarely does he create a figure of any warmth, such as the reclining Duchess of Newcastle (d. 1822, Markham Clinton, Nottinghamshire) with her two infants, but even there it is combined with one of his soft and boneless reliefs.

It seems probable that Westmacott accepted the many commissions for monuments to keep his studio going, and that his few classical commissions must have given him more pleasure. In 1814 the Ladies of England began to organize a subscription for a monument to the Duke of Wellington to be made out of cannon taken in his battles, and it was then decided that it should take the form 'of one of the horses on Monte Cavallo at Rome'.[15] In 1822 the *Literary Chronicle* recorded: 'The public gaze and the public laugh for the last week have been the statue of a naked man, eighteen feet high in Hyde Park, to do honour to the Duke of Wellington.'[16] The so-called 'Achilles' statue, made by Westmacott, is indeed an imitation of one of the Dioscuri on Monte Cavallo, though without the horse, and competent though it may be, it is not, perhaps, a great tribute to the sculptor's taste. It would seem, however, that he was very sure of his own judgement. In 1823 he made a relief for the Earl of Egremont, still at Petworth House, of A Dream of Horace (Plate 174), and went down to see where it should be placed. A visitor described him as 'a pompous, conceited little man, and very much occupied with his own fame. He gave himself great airs, and offended Lord Egremont, who, from his great deference for whatever is Greek, called him *Westmacotteles*'.[17] There is remarkably little that can be described as Greek in Westmacott's relief, for, if it resembles anything, it is Graeco-Roman work of a sentimental and pictorial character. The immensely long-limbed goddesses perhaps owe something to Canova, and Westmacott has taken more care over the structure and modelling of their bodies than in many of his works, but the design as a whole is confused, the interest frittered away into small parts, and for one who had perceived and admired the observation of nature in the Elgin Marbles the position of the sleeping boy is singularly ill-conceived.[18]

Lord Egremont, though irritated by Westmacott's pretensions, was aware that Westmacott's training had fitted him to produce classical figures suitable for the Petworth sculpture gallery, and in 1827 bought a Nymph and Cupid (Plate 155B). It is a pretty enough group, competently designed with a long spiral movement. It still has clear echoes of Canova, particularly in the liveliness of expression, but the frank sensuality of the Italian is absent. Cupid is a chubby child, not a male adolescent, carried in a sling on the girl's back, the curves of her body are less opulent, and her drapery is modestly arranged. The Pandora (1822) and the Cupid (1823) at Woburn show the same concession to English taste.

Westmacott was also in considerable demand as a maker of memorial statues. For these, he preferred classical to contemporary dress, and was far more successful when he used it. The 5th Duke of Bedford (1809, London, Russell Square) is not a well-managed figure, for his long tight trousers make his legs too meagre in comparison with the upper part of the figure, swathed in a heavy cloak.[19] Charles James Fox (1816, London, Bloomsbury Square), seated in the guise of a Roman Senator, is a far stronger figure, while in the George Canning (1832, London, Parliament Square; Plate 165A) Westmacott uses Roman dress to create an image of great dignity.[20] His output of busts was very small, but at the beginning of his career he could not have competed with Nollekens, and after Chantrey's sudden rise to fame with the bust of Horne-Tooke in 1811, even those patrons who were most in sympathy with Westmacott's classical style went to Chantrey for their portraits. Nevertheless, Westmacott enjoyed a highly successful career. He was elected an R.A. in 1811, was appointed Sculptor to the New Board of Works in 1816,[21] became Professor of Sculpture in 1827 after the death of Flaxman, and was knighted by William IV. Although he was to live to 1856, he did little work after the 1830s, his practice being carried on by his son (1799–1872), who signs his works 'Richard Westmacott, Junr.'. They are, indeed, a pale reflection of those of his father, and not, unfortunately, of his father at his best.[22]

SIR FRANCIS CHANTREY

SIR FRANCIS CHANTREY (1781–1841) competes with Flaxman for the title of the greatest of English sculptors. A man of immense natural talent, he had a far stronger sense of form than Flaxman, but on the other hand he had less imagination and therefore less originality of invention, and a much weaker sense of design. Neither was at his best in large compositions, but while Flaxman far outstrips Chantrey in the beauty and variety of his smaller monuments, the younger man's single statues, and above all his busts, are among the finest works ever produced in England.

Chantrey is a peculiarly English phenomenon, in that he was largely self-taught, had no period of study in Italy, and, like many English artists, had exceptional gifts as a maker of portraits.[1] He was born near Sheffield in very modest circumstances, of a family of small tenant farmers, though his father, who died when the boy was twelve, also worked as a carpenter. After attending the village school, apparently somewhat irregularly, he was sent to work with a grocer in Sheffield, a relation of his mother's second husband; but soon, in 1797, at his urgent request, he was apprenticed to a carver and gilder in the town. His master, Robert Ramsay, also dealt in prints and plaster models, his shop being 'by far the best repository of works of art then or since in that town'. Ramsay's work occasionally took him to a great house, and the boy is said to have accompanied him on professional visits to Renishaw Hall and Wentworth Woodhouse. He also worked as a picture cleaner, a task which does not seem to have interested the boy, though he spent much of his time in drawing, encouraged first by a medal engraver, Jonathan Watson, and then by the more distinguished draughtsman and mezzotinter John Raphael Smith. After he had served less than five of his seven years' apprenticeship, he became tired of wood-carving and broke his indentures, the penalty of fifty pounds being apparently paid by friends. He wished now to devote himself to portrait painting, and appears in 1802 to have visited London and also to have gone for a short time to Ireland, where he had a severe illness. The exact sequence of his movements during the next five or six years is not clear. He was fairly constantly in Sheffield, painting portraits, modelling busts which were executed in plaster, and listening to the conversation of William Carey on painting.[2] But he also worked from time to time in London, partly for a wood-carver, for whom he carried out some figures for Thomas Hope and a table for Samuel Rogers, the poet; and he was at the same time an intermittent student at the Royal Academy Schools.[3] He must, however, have had opportunities of seeing good sculpture in London, and though there was little in the neighbourhood of Sheffield, he certainly visited Newby Hall (though perhaps not before 1807) and is said to have been much impressed with the antiques there.

By 1805 his talent as a maker of busts was recognized in Sheffield, and he was given an important local commission – the monument, which was to include a bust, of the rector

of Sheffield, the Rev. James Wilkinson (Sheffield Cathedral). It was stipulated that the work must be done in Sheffield, under the eye of those who had commissioned it. This was the first time that Chantrey had attempted a work in marble, and according to his biographer, Holland, the first time a marble bust had been made in Sheffield. Though obviously immature, the monument is interesting, for it shows how little Chantrey had been attracted by the neo-classicism current in London. The bust is set against a tall pyramid, which is itself backed by a great looped marble curtain. Indeed, all the upper part of the monument follows patterns used by men influenced by Roubiliac, such as Nicholas Read, more than twenty-five years earlier. Only the tablet below, with its fluted pilasters and slightly misapplied guttae, has anything of neo-classicism. The bust, which is fairly long, shows the rector in robes and bands, therefore with strong vertical lines, but even in this early work Chantrey proves his competence in handling problems of drapery, for he has inserted a diagonal below the falling bands. The head is strictly frontal and slightly dropped, unlike many of Chantrey's later busts, and the features are strongly modelled but a little laboured. Yet it is a great achievement for an untrained man.

Soon after this, Chantrey appears to have settled in London, and by 1809 he had married his cousin, Mary Ann Wale. Her mother and father were in the service of Sir Hans Sloane's granddaughter, who had taken a fancy to the young man, allowing him to work in her house and almost certainly contributing to the substantial dowry his wife brought with her. With it he paid his debts and bought a house in Belgrave Place, where he was to live for the rest of his life.

He was beginning to make a name for himself. He submitted a design for the monument to Sir John Moore in St Paul's Cathedral to the Committee of Taste in 1809, and though he was unsuccessful, it is clear he must have been thought a rising man. A commission for four colossal heads of admirals for Greenwich Hospital may not in itself have been of great importance; but it must have brought him into touch with influential people, and by April 1810 he had been to Windsor to see the king.[4] In spite of this, he later asserted that he had not made more than £5 by modelling before his first major success with the bust of the Rev. J. Horne-Tooke (Cambridge, Fitzwilliam Museum; Plate 176), exhibited in the Royal Academy of 1811.[5] This remarkable work, which remains one of Chantrey's masterpieces, made so great an impression on Nollekens that he had one of his own busts moved so that it should have a better place.[6] It at once reveals that the admiration Chantrey was later to own for the busts of Roubiliac was sincere. The writer is shown, like Roubiliac's Handel, in a coat buttoned on the chest and with a soft cap on his head. It has, however, none of the lively movement of a Roubiliac. The head is not turned, and the eyes, set under heavy brows and with deeply cut pupils, gaze fixedly at the spectator.[7] The flesh is firm but soft. Already here Chantrey displays that remarkable ability to convey in marble the quality of flesh for which he was to be so constantly praised. Although he was to make many striking busts during the next twenty years, few of them are more brilliant than this.

The success was immensely rewarding. According to his own statement, it brought him commissions worth £12,000, and further, his contact with the sitter appears to have contributed much to his education. He was never to become a learned man, in the sense

that Flaxman, with his knowledge of classical languages, was learned; but Tooke, when Chantrey consulted him about the deficiency in his early education, which he was no doubt beginning to realize, encouraged him to read classical authors in the best translations and also to study the English poets.[8] There is little doubt that Chantrey followed this advice, and though to the end of his life his manners were simple, he acquired enough education to be an acceptable (and possibly an entertaining) visitor in great houses, and also to produce a few reliefs of classical subjects.

Before discussing Chantrey's later busts, it will be convenient to consider some of his other important commissions, one of which must have followed immediately on his Royal Academy success. In the same year he was introduced by Stothard the painter to Mr Johnes of Hafod, the former patron of Banks, who needed a monument to his young daughter, Mariamne. It may well be that Stothard had some hand in the design.[9] Unfortunately, the monument, which showed the dying girl on a couch, with her mother seated at her feet and her father standing behind her, was destroyed by fire in 1932. It was very large, indeed too large for exhibition at the Academy, and was shown instead in 1812 at Spring Gardens.[10] It undoubtedly marked an important stage in the breakdown of the eighteenth-century tradition; for it had no allegory, but was instead a semi-realistic treatment of a death-scene, on a scale never so far attempted. There was some concession to current taste in the dress of the figures, for though it was not truly classical, it was not frankly contemporary. Its character can now best be judged by Chantrey's one remaining work of the same type, the monument to David Pike Watts (1817–26, Ilam, Staffordshire; Plate 177), though the years between the two must have given him increased assurance in handling. Again it is a death-bed scene fraught with sentiment, for the old man raises himself from his pillows to bless his daughter, Mrs Watts Russell, who has brought her children to say farewell to their grandfather. The old man has immense nobility, and there is no straining after effect in his grave and loving gesture. The character of the children, too, is caught with great skill. Only the backs of the two elder ones are normally visible, but their attitudes and above all the tilt of their heads suggest the curiosity of children towards illness rather than grief. The daughter alone jars; for here sentiment is given too free a rein. Moreover, though the dying man is shown in the night-clothes he might have worn, Chantrey has thought it necessary to give Mrs Russell a loose classical garment which leaves one shoulder bare, and her hand, pressed in sorrow to her breast, appears also to restrain the garment from falling. All Chantrey's strength and insight into human character are, however, displayed in the old man and the children; and no English sculptor could have produced a group so finely modelled and so simple in theme.[11]

The Pike Watts monument, grand though it is, did not apparently repeat the sensation Chantrey had caused at the Academy Exhibition of 1817 with his model of 'The Sleeping Children' (Plate 178B), commemorating the daughters of Mrs Robinson, to be erected in Lichfield Cathedral, where her father had been dean. 'Such was the press to see these children . . . that there was no getting near them: mothers with tears in their eyes, lingered, and went away, and returned; while Canova's now far-famed figures of Hebe and Terpsichore stood almost unnoticed by their side.'[12] Chantrey had taken a

death-mask from the second child to die, but as he was to state later, he only regarded death-masks as a general guide to the bones of the head, and his children, like Banks's Penelope Boothby, are not dead but sleeping.[13] The treatment is, however, far more naturalistic than that of Banks, and the bunch of snowdrops in the smaller child's hand was regarded as immensely poetic. Indeed, George Jones in his defence of Chantrey against those who thought him less poetic than Flaxman, returns again and again to such details, and to his whole treatment of children, which he felt gave the lie to the critics. Chantrey was himself an unsophisticated man, but on the other hand his highly neurotic age was easily and pleasurably moved to tears, and he can hardly be blamed for seizing the opportunity to create an appealing work. If today its appeal is less, it is not his fault; and praise at least is due to the competence of the modelling, though the high, waxy polish of the marble is also now somewhat distasteful.

By now Chantrey was not only making a considerable income (he had had many commissions for busts, statues, and smaller monuments which must be considered in their turn), but had also persuaded the Academy that a man of no training was worthy of inclusion in their ranks. In 1816 he was elected an A.R.A., Nollekens stating roundly that he 'was the best sculptor of the whole set of sculptors', and, unusually, became a full Academician in the next year.[14] In 1815 he and his wife had paid a visit to Paris with Stothard and Daniel Alexander, the patron who had given him the early commission for the Greenwich colossal busts. Most of his time is said to have been given to studying the paintings in the Louvre.[15] Four years later he made a brief journey to Italy, this time with John Jackson the painter. It seems probable that, though George Jones wrote his *Recollections* many years later, he had heard Chantrey discuss his impressions of Italy, and part of them, at least, are worth quoting, since they show his independence of mind and the gulf which separates him from eighteenth-century visitors: '... He was not prepared to go to the length of travellers in Italy with respect to the ruins and antiquities of Rome; he selected and intensely admired a few; and they were admired by him for their perfection – not from association of ideas or from historical or classical reminiscences – they were admired solely as works of art.'[16] He liked the painting of Michelangelo better than his sculpture; he found the Moses 'extravagant', but the unfinished Madonna at Florence 'a work of wonderful promise'. Nor was he greatly impressed with the Capitoline Museum, for he complained that the busts were numerous and most of them very bad, and though there were about a dozen statues, including the Gladiator and the Antinous, which were worthy of notice, they had been in Paris in 1815. Jones's summing up of the value of the Italian journey may perhaps be justified; Chantrey was already a mature sculptor who knew what he wanted to do, and probably also knew his own limitations; and it is interesting as a statement of what Jones, and perhaps Chantrey himself, regarded as the strength of his own style: 'Chantrey's journey through Italy seems to have been in furtherance of his desire to learn what to avoid rather than what to adopt. His view of his art was of so pure a character that it was of necessity very limited, but it was always grand: few and uninterrupted lines, large and unbroken forms, the lights and shadows massive and few; everything he did told, and he never estimated labour that did not speak forcibly to the eye and intellect.'[17]

Chantrey's love of 'large and unbroken forms, the lights and shadows massive and few' was to grow throughout his life. Inevitably, it increased his distaste for classical drapery, with its small, repeated folds, and gave him a preference for contemporary dress, which could often be much simplified. Of his many statues, the most distinguished are those in which the dress demanded little or no decoration, or when a cloak could be used to fall in broad and simple lines. The series begins directly after the success of the Horne-Tooke bust; for he was immediately commissioned by Alexander Maconochie, later Lord Meadowbank, for the first of his statues erected by public subscription in the Parliament House at Edinburgh. The Lord President Blair (1815) is a dignified seated figure with a virile head, wrapped in a voluminous cloak. The Viscount Melville (1818; Plate 180A) is less successful, for the furred gown enforced more surface decoration, and its fullness compelled the sculptor to employ smaller folds than he liked. The master-piece of this series is beyond doubt the Robert Dundas of Arniston (1824; Plate 180B). Here the dress is treated with the utmost simplicity, though the texture of the gown is retained. The pose is so easy as to be almost intimate, yet the handsome head has immense dignity and firmness of expression.

Another extremely successful figure in which he has used academic dress to great advantage is that of Francis Horner (1820, Westminster Abbey; Plate 181A). Here the folds made by the slashed sleeves serve to break the verticals and to contrast with the simplicity of the tight-fitting coat and trousers beneath the gown. The head, with its large features and thick, curling hair, lent itself admirably to Chantrey's style, and helps to make this one of his most attractive statues. His own preference, however, was for his figure of James Watt (1824, Handsworth, Birmingham; Plates 182 and 183). Like Robert Dundas of Arniston, Watt is seated; but this is also a church monument, new, intimate, and informal in type, well suited to one of the new men who had laid the foundations of Victorian prosperity. Watt, deep in thought, has sheets of paper spread over his knees and measures the diagram on them with the dividers in his right hand. The device of the paper enables the sculptor to use the large, simple forms he loved, for it ties the legs together, and the coat, which might otherwise have been needed for this purpose, can fall back in straight folds on either side of the chair. The head is one of Chantrey's noblest creations – strong, dignified, and utterly convincing. Even Haydon, who was not normally sympathetic to Chantrey's work, which he thought lacked poetry and invention, was impressed by it when he saw it in 1841: 'It is Chantrey's *chef d'œuvre*. As I came home, the booming rattle of the train seemed like the spirit of Watt still animating inert matter. The statue is very fine, and contains the essence of Chantrey's peculiar power.'[18]

Chantrey was, naturally, also much in demand for public statues, and, indeed, made far more than can be mentioned here. The bronze figures of George IV at Brighton (1828) and Edinburgh (1831) have, inevitably, a richer surface pattern than most of the marbles, since the king is wearing the Garter cloak. It is arranged, however, in heavy masses, though without destroying the animation of the pose.[19] The same is the case with the Pitt, of which there are again two versions (1831, London, Hanover Square, Plate 165B, and 1833, Edinburgh, George Street). Chantrey's Pitt is therefore almost

contemporary with Westmacott's Canning (Plate 165A), and a comparison of the two reveals instantly the fundamental difference between the two sculptors. Both are impressive statues, for Westmacott uses all his knowledge of classical art to design a commanding figure. Chantrey's Pitt, with the head thrown up and the heavy cloak gathered round him, is, however, a livelier and more original creation.[20]

By about 1830 Chantrey had, like Westmacott, been compelled to set up his own bronze foundry, close to his house in Pimlico, for he was dissatisfied with the work done by professional casters.[21] In it were cast not only the figures discussed above but a bronze of Sir Thomas Munro for Madras, and two equestrian statues, the George IV made for Marble Arch and now in Trafalgar Square (Plate 192), and the Duke of Wellington outside the Royal Exchange, the latter being completed after Chantrey's death by his assistant, Henry Weekes (1807–77). It is characteristic of the sculptor that he decided to show the horse in repose, although he gave the king a number of alternative sketches of small equestrian figures, which pleased him very much. He approached the problem with his usual commonsense, saying to Sir Henry Russell that moving horses were unsatisfactory, because 'You cannot give a lasting duration to that which is in its nature transitory'.[22] No doubt he also wished for the distinction of creating something new in equestrian sculpture. He did not, however, like working in bronze, which he thought unsuitable for the English light, which was not strong enough to develop so dark an object, and so the sculptor had to rely only on a clear and expressive contour.[23] His practice during the twenties and thirties was enormous, and he must have relied much on Allan Cunningham, who had come to him much earlier as a stone-cutter, and became his foreman, secretary, and confidential adviser. Unfortunately Cunningham only outlived his master by a year, and so had no opportunity of adding Chantrey's biography to the series he had already published.

Chantrey's late statues, such as the John Dalton (1837, Manchester, Royal Institution) or the William Roscoe (1840, Liverpool), show an increased breadth of handling, though they lack the humanity of the James Watt of 1824. One of the most impressive from the point of view of design is the Duke of Sutherland (1838, Trentham, Staffordshire; Plate 181B); for the heavy drapery covering the Victorian dress is reduced to simple triangular and vertical forms, and richness of surface is concentrated in the head. Very different, but clearly much admired, was the group of Mrs Jordan with two of her children (1834, Earl of Munster; Plate 179), made for William IV.[24] It is a beautiful and tender invention, the children, especially the sleeping baby, having great charm; and though Chantrey may have said, 'I hate fine words, especially mawkish words like sentiment',[25] this group alone would be sufficient to prove that he understood and could express simple, human emotions.

Naturally, he got many commissions for small monuments. They are the least interesting part of his work, and with so large a practice some are inevitably repetitive. On the other hand, a few introduce new and original patterns, and though in his desire to make his figures solid he often made them clumsy, they are never meretricious, like some of the similar work by Westmacott. As might be expected, very few include strictly allegorical figures. An early tablet to George Duckworth (d. 1811, Topsham,

Devon) shows the colonel in regimentals balanced by a Victory. Her drapery is of thin material, falling in swirling folds over her feet in patterns which do not reappear in Chantrey's later work. Occasionally, but very rarely, he introduces an angel, as in the William Hoare (1825, Bristol Cathedral), here a fine, grave kneeling figure holding a medallion portrait. A much favoured design shows two female figures and an urn. The daughters of Arabella, Duchess of Dorset (d. 1825, Withyham, Sussex), both kneel and mourn her loss; the monuments to Viscount Curzon (d. 1820, Penn, Buckinghamshire) and Richard Bateman (d. 1821, Derby Cathedral) have one seated figure, her face covered by her hands, and a standing figure behind her, but, though very close, they are not identical in design.[26] In all the relief is bold, and though the costume is, loosely speaking, classical, it is simple, occasionally bulky, and the design is made by the forms of the limbs rather than by the lines of the drapery.

Many of Chantrey's tablets, which are usually of stele form with neo-classical ornament at the top, show one female figure only, or a mother and an infant. The widow of the Earl of Plymouth (1835, Tardebigge, Worcestershire; Plate 184B) is very similar to the seated figures in the Curzon and Bateman monuments, but since this is a later work, the drapery forms are broader. In the Charlotte Bradshaw (d. 1820, Whittlebury, Northamptonshire) Chantrey attempts a figure rising from the grave with floating draperies, but is much less successful than Flaxman; the kneeling figure on the Lady Ellenborough (1821, North Cray, Kent), the Susan Warre (1821, Epsom, Surrey) with one infant, or the Thomas Vernon (1837, Hanbury, Worcestershire) with two, are more solid and more convincing. Many other examples of these, or of single women in high relief, such as the Lady Mary Seymour (1827, Orton Longueville, Huntingdonshire) or the Hon. Elizabeth Poyntz (1838, Easebourne, Sussex), the latter with a Gothic cresting, could be quoted. Though not exciting, they are seldom trivial, and they are far less summary in modelling than late works of the same kind by Westmacott.

By no means all Chantrey's monuments in relief show mourning ladies. Sometimes he uses a seated male figure in contemporary dress with admirable effect. The Isaac Brown (d. 1819, Badger, Shropshire) shows something of the same skill in the use of a large book and a falling coat as the James Watt; the Henry Bengough (1823, Bristol, Lord Mayor's Chapel; Plate 184A) wears his furred alderman's gown and reads from a scroll. Both show the figures in profile, and are better managed than the Lord Chief Justice Ellenborough (d. 1818, London, Charterhouse), where the figure is twisted into an almost full-face view, and is dwarfed by the voluminous robes. Perhaps the most successful of the seated men, because the most informal, is the John Phelips (d. 1834, Wells Cathedral), who is quite frankly shown in a dressing-gown.

Others, again, have death-bed scenes. The Sir Simon Taylor (d. 1815, Edington, Wiltshire), being a fairly early work, is a little small in its drapery patterns, and somewhat overcharged with emotion, with two women tending the dying man. More beautiful and far simpler in handling is the young man kneeling by his dying wife and child on the monument to Anna Maria Graves (d. 1819, Waterperry, Oxfordshire; Plate 178A), a similar design being used about the same time for Hannah Roberts at Stoke Doyle, Northamptonshire. One of the most impressive of these monuments is

the single figure, almost in the round, of the Earl of Malmesbury (1823, Salisbury Cathedral; Plate 185), lying on a bed, apparently about to speak of the book he has been reading. Its naturalism and breadth of handling, together with the firm and noble characterization of the head, place it among Chantrey's best works.[27] He was less uniformly successful in his single figures of women in the round, perhaps because convention made it difficult for him to convey such strength of character as they may have possessed. The kneeling Lady St Vincent (1818, Caverswall, Staffordshire) died young, and though care has been given to the design, it is not much more than an exercise in ideal beauty. The seated Countess of Liverpool (1825, Kingston-on-Thames, Surrey), with her hand supporting her head, is an unusually foolish figure, and the Lady Charlotte Digby (1825, Worcester Cathedral) is uncomfortably massive. On the other hand, Lady Frederica Stanhope (1823, Chevening, Kent) and Mrs Boulton (1834, Great Tew, Oxfordshire),[28] prove that Chantrey was capable of producing female figures of great distinction.

Although it would be tedious to discuss all Chantrey's many types of monument, some reference must be made to those of bishops, for here he broke new ground and created a pattern that was to be loved by later generations. Eighteenth-century bishops had reclined on their tombs, often in indeterminate clerical dress; Chantrey's kneel as in life, their hands joined in prayer or resting on a book. Moreover, he seems to have enjoyed exploiting the contrast between the soft, crinkled folds of the lawn sleeves, and the broader, heavier masses of the silk gown. Some, including Bishop North (1826, Winchester Cathedral), Archbishop Stuart (d. 1822, Armagh Cathedral), and Bishop Barrington (1830, Durham Cathedral) are in full relief against a plain ground with, appropriately, a Gothic cresting. Bishop Heber (d. 1826, St Paul's Cathedral; Plate 186, A and B) and Bishop Ryder (1841, Lichfield Cathedral),[29] both strikingly handsome men, and wearing their own hair instead of the wigs which Chantrey disliked, are freestanding figures. They do not today, perhaps, look particularly revolutionary; but like the James Watt in Handsworth church they are evidence of the movement from classicism to naturalism which sets Chantrey apart from his contemporaries.[30]

As has been suggested, Chantrey's practice for statues and monuments was both large and distinguished; but it was as a maker of busts that he was chiefly admired in his own day. Haydon spoke of him in 1837 as 'the greatest bust-maker on earth';[31] J. T. Smith valued his busts 'for their astonishing strength of natural character, for the fleshy manner in which he has treated them, which every real artist knows to be the most difficult part of the Sculptor's task'.[32] It is, indeed, this astonishing ability to express in marble the softness of flesh, while at the same time retaining the sense of the bones beneath, which raises Chantrey's finest busts above all others produced in England. Nollekens's later busts (Plate 125B) are soft, but they have a slightly pulpy quality, and for all the brilliance of his Charles James Fox (Plate 121), there is not the same difference in feeling between the forehead, where the bones are near the surface, and the folds of flesh under the chin, as Chantrey would have achieved. Nollekens was, in fact, at his most successful with a thinner face, such as that of the Marquis of Rockingham (Plate 123), where the small modulations of bone and muscle were more marked. Roubiliac, whose busts Chantrey

is known to have admired,[33] was deeply conscious of both bony structure and of the forms which covered it; but even in an old and fleshy face, like that of Fountaine or Folkes (Plates 86A and 87B), he stresses small incidents of light and shadow, and he has not Chantrey's exceptional gift for working the whole surface together to give it life. Chantrey had perfected this technique early in his life, for it appears already in the Horne-Tooke of 1811. Jones implies that he had learnt much from the fleshy quality of the Elgin Marbles;[34] but his technical mastery and his ability to train his assistants to achieve the effect he needed must have been the result of a combination of innate talent and sheer hard work, and his sense of character owes nothing to Greece.

He liked to study a sitter informally, watching him in conversation, and preferred to have a third person present. He himself was an easy talker, amusing and instructive, and could therefore break through the barrier of self-consciousness caused by the act of sitting for a portrait. He first made three drawings, profile, three-quarter, and full-face, with the aid of a *camera lucida*, and then took six or seven sittings for working on the clay model, sometimes taking a cast of the mouth, where he found the colour of the lips interfered with form by producing in itself a misleading effect of light and shade. The model might be purely frontal, but at the last stage Chantrey would cut it at the neck, and turn it till he was satisfied with the position. A cast was then made, and assistants worked up the marble using a pointing machine, which Chantrey claimed he had improved even further; and the sculptor himself then worked, perhaps from only one more sitting, on the final bust.[35] As his practice increased, so his prices rose. For three years after the Horne-Tooke he got eighty or one hundred guineas for a bust, and from then till 1822 one hundred and twenty to one hundred and fifty. By that time, he had more commissions than he could execute, and raised his price to two hundred guineas, while George IV, when he sat in 1822, wished the price to be three hundred guineas.[36] It will be remembered that Nollekens had charged one hundred and fifty guineas about 1800.

More than one hundred busts by Chantrey are known, some existing in several versions, often all of high quality, since they were presumably made under the sculptor's own supervision. Obviously only a handful can be discussed and illustrated here, and these must serve as an indication of the wide variety of pattern. It would be hard to suggest any clear chronological development, or, indeed, to say categorically that the finest examples fall within any one period. It is perhaps true that before about 1820 the modelling is very slightly tighter, and forms of hair and drapery are more detailed than in the later busts; and several of the finest busts do in fact date from between about 1818 and 1828; but both before and after that decade Chantrey produced superb portraits of many types, the pattern being adjusted to his idea of the character of the sitter.

The great majority are on broadly classical lines, in so far as the sitters are bareheaded and without the stocks they would normally have worn round their necks. Many, but by no means all, have loose drapery over the shoulders, but it is very rare to find Chantrey using classical drapery on a strictly classical and basically symmetrical pattern. Though he does occasionally adopt the convention of a cloak brooched on one shoulder, in for instance the George IV (1822),[37] the folds are arranged in a strong diagonal instead of in loops, which increases the vitality given by the lift of the head. In

other cases the drapery is more informal, simply a cloth thrown over the shoulders, but pulled into broad and often flattened folds. Such an arrangement is specially effective for sitters who have long narrow heads and aquiline features, such as William Hunter Baillie (1823, London, Royal College of Surgeons; Plate 191A) or the famous Duke of Wellington of 1828, of which replicas of high quality exist. Sometimes there is little drapery, even in the case of a public figure. Viscount Castlereagh (1821; Plate 187B),[38] a notoriously handsome man, was said to have willingly bared his chest; as a result the neck rises superbly out of the shoulders of the noble, large bust, the lower edge and the right shoulder only being covered with drapery. In this bust the mouth seems the most vital feature of the face; in others, it is inevitably the eyes. This is strikingly so in the busts of his fellow-artists, Joseph Nollekens (1817, Duke of Bedford; Plate 190B), and Benjamin West (1818, London, Royal Academy).[39] The Nollekens is a remarkable portrait of a shrewd and humorous old man who has lost his teeth, but there is no hint of the grossness of which he has been accused. Age and frailty of another kind are shown in the astonishing bust of Chantrey's early benefactor, John Raphael Smith (1825, V. and A.; Plate 187A). This, which like the Horne-Tooke, shows the sitter in a cap, a feature very rare in Chantrey's mature busts, may have been modelled earlier, and it received special admiration, for Smith was deaf, and is shown with his head turned and his mouth slightly open, trying to catch what is said.

Chantrey could give an even greater dignity than Roubiliac to a heavy face. Few of his busts have more character than that of Sir Joseph Banks (1818, London, Royal Society; Plate 188), the great naturalist who had been President of the Royal Society for forty years. No greater contrast could be found than that between this bust, the heavy herm-like shape being no doubt deliberately chosen to suit the character, and the Antinous-like almost half-length nude of the young and handsome Edward Johnstone (Birmingham City Art Gallery; Plate 190A) made in the next year. That Chantrey was, however, equally capable of making a striking portrait of a handsome old man is shown by the Baron Hume (1832, Edinburgh, Sessions House; Plate 191B), a late bust with the broad and simplified drapery of his later statues.

Chantrey's sitters were drawn from all ranks of life. He is probably the only sculptor to have made busts of four reigning sovereigns, George III, George IV, William IV, and the young Queen Victoria. Statesmen, artists, and distinguished professional men, as well as members of the aristocracy, sat to him for their portraits, but perhaps the most loved of all his busts was that of Sir Walter Scott (1820, Abbotsford; Plate 189). Chantrey himself recorded that Scott, whose writings were creating the new world of Romanticism, was the only man he had ever asked for a sitting. In his own day it was regarded as the most remarkable of his busts, and though he himself had about forty-five casts made for the poet's most ardent admirers, thousands of bad casts were made and sold by Italian craftsmen in London.[40] The bust, indeed, in its straightforward dignity, shows Chantrey's art at its best, for the keenly observed head is full of character, and the use of the plaid as shoulder drapery, reminiscent of an antique pattern, makes it at once intimate and commanding.

Chantrey was knighted by William IV in 1837 and died suddenly in 1841, a very rich

man. His fortune of £150,000 was left to Lady Chantrey for her life, and at her death to the Royal Academy for the purchase of works by British artists for the nation.[41] In 1842 Lady Chantrey gave all the models of Chantrey's works which were in his studio to the Ashmolean Museum, Oxford, where parts of them still remain.

It is not easy to assess Chantrey's position fairly. He stands between two worlds, but his finest work holds the balance between classicism and naturalism. Indeed, it was the naturalism of the Elgin Marbles, rather than the stylization of the Apollo Belvedere, which constituted, for him, the authority of Antiquity. During his lifetime and for many years after his death, some English sculptors, notably John Gibson and Matthew Cotes Wyatt, were to follow to the best of their ability the tenets of neo-classicism. Others, above all Samuel Joseph, were to be freed by the example of Chantrey from its dead hand, and were to create monuments such as the Wilberforce of 1838 (Westminster Abbey) which would have been unthinkable without Chantrey's James Watt.

The fact that at his death in 1841 opinion was divided as to the merit of his work is clear proof of the conservatism of English taste. In an article on 'The Genius of Chantrey', the critic of the *Art Union* in 1842 wrote: 'It is impossible to speak of his genius and character as an artist without some reservation: they cannot receive from any just historian entire and unqualified praise. In one department of the Arts, unquestionably, he had no rival; and has not left an equal – but that department is not the highest. In "bust-modelling" he was a giant; but in works of invention merely a dwarf. The modelling of busts will hardly preserve his memory beyond the age embellished by his chisel; while the names of Banks and Flaxman – the latter especially – will become greater as time rolls onward. Chantrey was a man of tact and observation; Flaxman an epic poet.'[42]

Chantrey himself was well aware of the genius of Flaxman and paid tribute to it. But he knew well enough where his own talents lay, and, what is more, his statement to Sir Henry Russell about the uses of allegory is a sure sign that to an original and highly gifted artist the eighteenth-century vision was dead: 'I hate allegory, it is a clumsy way of telling a story. You may put a book on the lap of one female and call her History; a pair of compasses in the hand of another, and call her Science, and a trumpet to the mouth of a third, and call her Fame, or Victory. But these are imaginary beings that we have nothing in common with, and dress them out as you will for the age, they can never touch the heart; all our feelings are with men like ourselves. To produce any real effect, we must copy man, we must represent his actions and display his emotions.'[43]

Few English artists of the nineteenth century dared to think so clearly or so independently; and English nineteenth-century realism was to find its true expression in the novel rather than in the arts.

LIST OF THE PRINCIPAL ABBREVIATIONS

Arch. Journ.	*Archaeological Journal.*
Archit. Review	*Architectural Review.*
B.M.	British Museum, London.
Burl. Mag.	*Burlington Magazine.*
Cunningham, *Lives*	Allan Cunningham, *Lives of the Painters, Sculptors and Architects* (1830).
D.N.B.	*Dictionary of National Biography.*
Farington	*The Diary of Joseph Farington* (ed. J. Greig, 1922–8).
Gunnis, *Dict.*	R. Gunnis, *Dictionary of British Sculptors 1660–1851* (1953).
Journ. W. and C.I.	*Journal of the Warburg and Courtauld Institutes.*
N.P.G.	National Portrait Gallery, London.
N.P.G. Scotland	National Portrait Gallery of Scotland, Edinburgh.
R.C.H.M.	Royal Commission on Historical Monuments, London.
R.I.B.A. Journ.	*Journal of the Royal Institute of British Architects.*
Vertue, i, etc.	The Notebooks of George Vertue, i, *Walpole Society*, XVIII (1930); ii, *ibid.*, XX (1932); iii, *ibid.*, XXII (1934); iv, *ibid.*, XXIV (1936); v, *ibid.*, XXVI (1938); Index, *ibid.*, XXIX (1942); vi. *ibid.*, XXX (1950).
V. and A.	Victoria and Albert Museum, London.

A date preceded by d. means that the date of erection of a monument is unknown, and only the death date can be given. In such cases the monument may be earlier or later.

NOTES TO PART ONE

CHAPTER I

p. 1 1. For the alabaster industry in the late Middle Ages, see L. Stone, *Sculpture in Britain: The Middle Ages* (1955), 179–80, 198–200, 216–19; F. H. Crossley, *English Church Monuments, 1150–1550* (1921); A. Gardner, *Alabaster Tombs* (1940). For the sixteenth century see P. Chatwin, 'Monumental Effigies in the County of Warwick', *Birmingham Arch. Soc. Trans.*, XLVII (1921), 35; XLVIII (1922), 134; XLIX (1923), 26; LVII (1935), 102; S. Jeavons, 'Monumental Effigies of Staffordshire', *ibid.*, LXIX–LXXII (1951–3, reprinted 1955). J. G. Mann, 'English Church Monuments, 1536–1625', *Walpole Soc.*, XXI (1932–3), 1, is useful for its discussion of materials and has a good selection of plates. E. Mercer, *English Art, 1553–1625* (1962), 217–52, has an interesting account of types. Of the numerous writings of Mrs K. A. Esdaile, her early book, *English Monumental Sculpture since the Renaissance* (1927), though superseded at many points by her own research, is more reliable than her *English Church Monuments* (1946).

p. 2 2. J. Summerson, *Architecture in Britain: 1530–1830*, 4th ed. (1963), 15.

3. L. Cust and M. Hervey, 'The Lumley Inventories', *Walpole Soc.*, VI (1917–18), plate ix. These fountains have recently been identified by Mr Martin Biddle with those at Nonsuch (J. Dent, *The Quest for Nonsuch* (1962), 115).

p. 3 4. H. A. Tipping and C. Hussey, *English Homes*, III, 1 (1922), 210.

5. E. Mercer, *op. cit.*, 255.

6. L. Cust, *Walpole Soc.*, VI (1917–18), 15.

7. *Cat. R.A. Exhib., British Portraits* (1956–7), 29–31; E. Mercer, *op. cit.*, plate 94. A similar bust of Sir Gilbert Talbot is in the V. and A.

8. For the development of the chimneypiece, see E. Mercer, *op. cit.*, 115–20.

9. *R.C.H.M. City of Cambridge*, I (1959), 115 and plates 182–90.

CHAPTER 2

p. 4 1. Throughout this chapter I am greatly indebted to Professor Sir Anthony Blunt, who has generously encouraged me to use material from his unpublished lectures on foreign influences in English sixteenth-century sculpture and decoration, given at the Courtauld Institute in 1953.

2. For a summary of Mazzoni's career, see A. F. Blunt, *Art and Architecture in France: 1500–1700* (1953), 14.

3. For the contract, see *Archaeologia*, LXVI (1915), 366.

4. *R.C.H.M. Westminster Abbey* (1924), plate 28. p. 5 The wooden frame has Gothic detail, and may not be by Torrigiano.

5. F. Grossmann, 'Holbein, Torrigiano and some portraits of Dean Colet', *Journ. W. and C.I.*, XIII (1950), 222. Torrigiano also made a design for an elaborate tomb for Henry VIII, which was to have an equestrian figure of the king as well as recumbent effigies, and many statues of Prophets, Apostles, Virtues, etc., the description of which caught the fancy of Flaxman, since he repeated it to the Royal Academy students (*Lectures on Sculpture*, 2nd ed. (1838), 47). This was not executed, and the king took over the half-finished tomb for Cardinal Wolsey, designed by Benedetto da Rovezzano, which was never completed, and was broken up and sold in 1646. The black marble sarcophagus was eventually used for the monument to Lord Nelson (St Paul's Cathedral, crypt) and the bronze candelabra bearing the royal arms are in the cathedral at Ghent. The tomb of Dr Yonge, Master of the Rolls (1516, London, Public Record Office), with its painted terracotta effigy, is certainly Florentine, and often ascribed to Torrigiano, though not all of it is in his manner (N. Pevsner, *Buildings of England: London*, I (1957), plate 27).

6. For his major undertaking, see previous note.

7. *R.C.H.M. Middlesex* (1937), plates 77, 78. Similar roundels were made for the so-called Holbein Gate at Whitehall Palace (c. 1532), two of them probably surviving in a house at Hanworth, Middlesex (*ibid.*, 52, and plate 77).

8. For the employment of Italians at Gaillon, which was built between 1501 and 1510, see A. F. Blunt, *op. cit.*, 7.

p. 5 9. The other Italians mentioned by name as receiving payments from Henry VIII, such as Toto del Nunziata, appear to have been painters (A. E. Popham, 'Holbein's Italian contemporaries in England', *Burl. Mag.*, LXXXIV (1944), 12; E. Auerbach, *Tudor Artists* (1953), chapter 2 and appendix 2).

10. The precise date of Sutton Place is unknown. The estate was given to Weston in 1521 and Henry VIII was entertained in the house in 1533. The work is likely, therefore, to be of the 1520s. The mouldings of the windows are also of terracotta, and mix Italianate flowers, dolphins, balusters, etc., with Gothic tracery and profiles, in a way which can be closely paralleled in France.

11. Henry, 1st Lord Marney (d. 1523), was Lord Privy Seal, and therefore, like Sir Richard Weston, in close touch with Cardinal Wolsey. The 2nd Lord Marney (d. 1525) evidently continued the house (his will refers to part as newly-built) and the cresting with shell heads seems to have been put up by his daughter Catherine before her marriage in 1527 or 1529. Again Professor Sir Anthony Blunt has found close links with France, both for the types of ornament and the flattened handling. Similar windows, no doubt by the same craftsmen, are found in Suffolk, i.e. at Shrubland Old Hall and the near-by churches of Henley, Barham, and Barking (N. Pevsner, *The Buildings of England: Suffolk* (1961), 387 and plate 50B).

p. 6 12. The precise dating of the whole group must be approached with caution. Though the 1st Lord Marney seems a likely man to have employed foreign craftsmen, his son-in-law, Sir Edmund Bedingfeld, had also been in France, where he was knighted in 1523, and might have been the prime mover in the establishment of the workshop. Neither of the Marney tombs was finished at the death of the 2nd Lord Marney in 1525, though the effigy of the 1st Lord was then completed, and both tombs, ordered under their wills, were to include effigies of their wives (*Essex Arch. Soc. Proc.*, IV (1869), 147). These do not appear on the executed tombs, which may have been finished by Bedingfeld. The Bedingfeld Chantry was founded in 1514, and though Sir Edmund did not succeed his elder brother Thomas till 1538, he may have caused the work to be done before that time. The Jannys cannot, on heraldic grounds, be earlier than 1532 (*Norfolk Arch. Soc.*, XXII (1923–5), 243), and there appears to be some doubt if the Wymondham example, which is clumsily put together, is in fact

that of Elisha Ferrers, who was abbot till 1539 and then rector. It is to be hoped that Mr Donovan Purcell, who has kindly given me information about the restoration of the Bedingfeld Chantry, will uncover further facts, material or historical, about this puzzling group.

13. A. F. Blunt, *op. cit.*, plate 13.

14. I.e. Earl Delaware (after 1536, Broadwater); Ernle tomb (c. 1545, West Wittering). There are also a few later examples farther west in Dorset and Devon.

15. See J. Lieure, *La Gravure dans le livre et l'ornement* (Paris and Brussels, 1927), plates iii, iv, and ix–xi, for illustrations of Books of Hours by Simon Vostre and Geoffroy Tory published in Paris between 1513 and 1531.

16. An almost identical tomb was made for Sir p. 7 Anthony Browne's mother and stepfather, Sir Thomas Fitzwilliam, at Tickhill, Yorkshire.

17. Professor Sir Anthony Blunt has done much to clarify the hitherto confused statements about these tombs. Up to the Dissolution Thetford Priory, Norfolk, was the family burial place, and in 1539 the 3rd Duke of Norfolk asked Henry VIII to spare the priory, as he was then erecting tombs there for Henry, Duke of Richmond (d. 1536), and himself. Fragments at Thetford correspond with parts of both tombs, now in the family chapel at Framlingham, the latter being begun shortly before 1547 and apparently still unfinished at the 3rd Duke's death in 1554. It is therefore likely that these two tombs were moved from Thetford to Framlingham and completed by the 4th Duke.

18. For the Orleans tomb see A. F. Blunt, *op. cit.*, plate 12.

19. The effigies on the 3rd Duke's tomb are identical in style with those of the 4th Duke's wives, and have the same masons' marks. J. G. Mann, 'English Church Monuments, 1536–1625', *Walpole Soc.*, XXI (1932–3), 7, notes that they are close to those on the tomb of the 2nd Earl of Huntingdon (d. 1561, Ashby-de-la-Zouch, Leicestershire). They may therefore be from the same shop, which supports the claim that the tombs were completed by the 4th Duke in the 1560s. The niched type of the 3rd Duke's tomb reappears in the tomb of Lord Cobham (1561, Cobham, Kent), but the apostles are replaced by kneeling children in front of, and not within, the niches (E. Mercer, *English Art, 1553–1625* (1962), plate 77A). It is difficult to find stylistic parallels to the apostles in England, though some of the large array of saints on the

walls of Henry VII's chapel at Westminster (completed *c.* 1519) show similar links with Northern Europe (*R.C.H.M. Westminster Abbey* (1924), plate 205), and it is conceivable that members of this workshop were still in England in the 1530s.

p. 8 20. J. Dent, *The Quest for Nonsuch* (1962), prints most of the known descriptions of the palace, though the recently discovered and important account of it in 1590 is not fully transcribed; and gives a general description of the recent excavations. The full excavation report is still awaited, but no important sculpture was found. Some stucco fragments are illustrated in Dent, plate 13. The only other decoration found was carved slate, cut in guilloche and wing patterns.

21. For the drawing, which cannot now be traced, see O. Kurz, 'An Architectural design for Henry VIII', *Burl. Mag.*, LXXXII (1943), 80; and J. Summerson, *Architecture in Britain: 1530–1830*, 4th ed. (1963), plate 8A. There is no proof that it was for Nonsuch, and it may have been connected with a gallery Henry was apparently contemplating at St James's (A. B. Chamberlain, *Hans Holbein*, II (1913), 333, quoting a letter from the English ambassador to France and recommending Bellin).

22. The statement about foreigners is made on the engraving after Hofnagel's drawing of Nonsuch, published in G. Braun and F. Hogenburg, *Civitates Orbis Terrarum*, V (1582). In fact the only foreigners whose names are known are Nicholas Bellin and William Cure (for the latter, see Chapter 3). There is no foundation for the legend that Holbein worked at Nonsuch.

23. For Somerset House, see J. Summerson, *op. cit.*, 16, and plate 12.

24. For Floris, whose main work was published between 1548 and 1554, see R. Hedicke, *Cornelis Floris*, 2 vols (Berlin, 1913).

25. The chantry was erected under Gardiner's will, but is likely to have been completed before the accession of Queen Elizabeth I, when chantries were no longer permitted. The architectural detail with its wave and double guilloche motives has counterparts at the Carnavalet, at Écouen, and at the Louvre, and the putti which support the fanvault are close to those from the altar at Écouen.

26. The Mason tomb was executed after his death in 1559, and is therefore slightly later than the Gardiner chantry. It possibly had two superimposed Ionic orders, with perhaps a sculptured back panel, thus to some extent resembling the Brézé tomb at Rouen (A. F. Blunt, *op. cit.*, plate 52). Another work perhaps connected with this group is the Worsley tomb at Godshill, Isle of Wight (*c.* 1565–7).

27. The tables are dateable, for Sharington died p. 9 in 1553, and they bear the initials of his third wife, whom he married in 1550. For the finer of the two, see J. Summerson, *op. cit.*, plate 9A.

28. Chapman had been working for Sharington in 1553, and was at Longleat in 1554 and 1558. For Lacock, see H. A. Tipping and C. Hussey, *English Homes*, II, i (1924), 375; and for Longleat, M. Girouard, 'The Development of Longleat House', *Arch. Journ.*, CXVI (1959), 200. The latter shows that a French sculptor, whose name was anglicized to Allen Maynard, made fireplaces at Longleat in 1562 and 1566 (plates xxiiib and xxvii). The style of his work does not seem close to any of the monuments discussed, but it is at least evidence of a French craftsman in England.

29. For Fantuzzi, see R. Berliner, *Ornamentale Verlage-Blätter*, I (Leipzig, 1926), 110 f. Close parallels for the architectural details and the alternating rectangular and oval pattern on the under side of the canopy can be traced in France (Carnavalet; tomb of Francis I; Chapel of Sainte-Croix, etc.).

30. Bontemps was a Protestant, and had been forced to flee from Paris in 1562. The date of his return is unknown, but there is no evidence that he came to England. The poses, though lively for England, are much more rigid in design than the fine reclining figure of Philippe Chabot (Louvre) ascribed to Bontemps, but this could be due to an order for lying and not half-seated figures. Details similar to those of the Hoby tomb appear on the sarcophagus of the Duchess of Suffolk (d. 1563, Westminster Abbey), but her effigy is of the traditional English type.

31. J. G. Mann, *loc. cit.*, plate xiv, b and c. p. 10

32. Although the heads have been destroyed, it appears to have shown the Northern motive of the Dead Christ upheld by the Father, and not the Italian type of the Virgin supporting her son (see J. G. Mann, *ibid.*, plate ii).

33. Another late tomb with a religious scene, in this case the Last Judgement, is the Babington tomb (*c.* 1540, Kingston-on-Soar, Nottinghamshire); K. A. Esdaile, *English Church Monuments, 1510–1840* (1946), plate 37.

34. For what little is known of the industry and its craftsmen, see P. Chatwin, 'Monumental Effigies in the County of Warwick, III', *Birming-*

ham Arch. Soc. Trans., XLVIII (1922), 136; S. A. Jeavons, 'Monumental Effigies of Staffordshire, II', *ibid*, LXX (1952), 1.

p. 10 35. L. Stone, *Sculpture in Britain: The Middle Ages* (1955), plates 191–2.

p. 11 36. *H.M.C. Rutland MSS.*, IV (1905), 340; P. Chatwin, *loc. cit.*, 142, shows that Parker probably lived till 1571.

37. For a list of other tombs of this phase, see J. G. Mann, *loc. cit.*, 9.

38. Richard Royley, father of Gabriel, and also known as Cartwright, died in 1589 (P. Chatwin, *loc. cit.*, 141).

39. For the Fermor tomb at Somerton, see J. G. Mann, *loc. cit.*, plates x and xiib. The latter plate demonstrates the degradation of Renaissance ornament, and a diagram showing other examples appears in Chatwin, *loc. cit.*, 139.

One craftsman outside the Midland area who picked up and debased Renaissance ornament was John Guldon of Hereford. His signed tombs of John Harford (1573, Bosbury) and Richard Willison (1574/5, Madley) have flat, crude vases and leaf patterns, though in the former the sarcophagus is, most unusually, supported on lions. In the unsigned monument to Richard Harford (1578, Bosbury), clearly from the same workshop, vegetation is rampant (E. Mercer, *op. cit.*, 223, 233, and plate 79b).

CHAPTER 3

p. 12 1. It is possible that some, like Maximilan Colt of Arras, came from farther south and had fled to Holland before coming to England, but the distinction does not seem of much importance for their styles. For the parallel effects on English painting, see E. K. Waterhouse, *Painting in Britain: 1530–1790* (1953), chapter 3.

2. Vredeman de Vries's *Architectura* (1578) is probably his best known collection of plates, but the *Scenographiae*, with engravings of imaginary architecture and fountains by H. Cock, appeared in 1560, and a number of other designs for furniture, grotesques, and gardens during the 1570s and 1580s. The work of Cornelis Floris was naturally also known and used by the Netherlandish sculptors.

3. For instance in the tomb of the Duke and Duchess of Berry (early fifteenth century, Bourges), that of Charles VIII (d. 1498, Saint-Denis, destroyed), and that of Cardinal d'Amboise (begun 1520, Rouen).

4. Cf. the Hoby tomb at Bisham, p. 9.

5. E.g. the Sir Edward Seymour (d. 1613, Berry Pomeroy, Devon), or the Sir Edward Fettiplace (d. 1613, Swinbrook, Oxfordshire), both having three figures set one above the other. Many other tombs with one or more figures could be quoted.

6. Act IV, Scene ii, lines 148 f. Performed by 1614, but not published till 1623. It should perhaps be noted that no tombs of English princes, in the narrowest sense of the word, of this type are known before 1614.

7. See the contract for the tomb of James p.13 Montague, Bishop of Winchester (1618, Bath Abbey) in T. Dingley, *History from Marble* (Camden Soc., 1857), II, 154, or that for Sir Richard Kingsmill (1600, Highclere, Hampshire), P.R.O., *S.P. Supp.*, 46/23, f. 137.

8. E.g. the effigy of Ambrose Dudley, Earl of Warwick (d. 1590, Warwick), or the statue of James I on a fireplace at Hatfield, Hertfordshire.

9. Some of these, as well as better examples, are discussed by J. G. Mann, 'English Church Monuments, 1536–1625', *Walpole Soc.*, XXI (1932–3), 11.

10. Mrs K. A. Esdaile's various writings on the workshop were summarized in a posthumous paper, 'Some Fellow-Citizens of Shakespeare in Southwark', *Essays and Studies*, N.S. V (1952), 26, with further notes by her son, Mr Edmund Esdaile.

11. *H.M.C. Rutland MSS*, IV (1905), 396, 397, p. 14 402.

12. Iron railings ('grattes') were made at the p. 15 same time, but have now disappeared. The contracts quoted in Note 7 require the sculptors to colour the effigies and blazon the shields, but perhaps at Bottesford this was done by the local man.

13. Gerard made his will in July 1611, being then 'sicke in body', and is not recorded thereafter (K. A. Esdaile, *loc. cit.*).

14. Prices had evidently risen, for though Nicholas's tomb is no more elaborate than those of his father, and has no figures of children, he was paid £150 for it. The Rutland family appears to have remained faithful to the Netherlandish sculptors, for in spite of the association of the 6th Earl (d. 1632) with Charles I and the Duke of Buckingham, his tomb with its arched coffered canopy is still in the traditional Southwark style, though the maker is unrecorded.

15. There was some trouble about the costume of John Gage's two wives, for the inscriptions on

the drawings note that their gowns must be altered. They were to be made loose, without farthingales, and were to cover part of the feet.

16. Originally erected at Midhurst, Sussex, but removed and re-erected in a mutilated state at Easebourne in 1851. A drawing of 1780 shows the former state with the obelisks (H. E. Hinkley, *Easebourne, its Church and Priory* (1948), illus.).

17. Two contracts exist which show him collaborating with other workshops, i.e. with Nicholas Stone for the tomb of Thomas Sutton (1615, London, Charterhouse; see p. 25), and with William Cure II for that of Bishop Montague at Bath Abbey (see Note 7 above).

p. 16 18. The monument to Shakespeare's friend, John a Combe (d. 1614), with a recumbent effigy, is probably from this workshop. The 'scholar-type' perhaps orginated with the monument to Dean Colet in Old St Paul's of *c.* 1520 (F. Grossmann, 'Holbein, Torrigiano and some portraits of Dean Colet', *Journ. W. and C.I.*, XIII (1950), 202), but was not common till the early seventeenth century (E. Mercer, *English Art, 1553–1625* (1962), 239).

Among other recorded work of the studio was a marble and alabaster chimneypiece (1595) for Arthur Throckmorton's house at Paulerspury, Northamptonshire (A. L. Rowse, *Ralegh and the Throckmortons* (1962), 196), and a large marble basin for a fountain at Hatfield (1611–12) for which Garret Christmas (see p. 33) provided a statue (L. Stone, 'The Building of Hatfield House', *Arch. Journ.*, CXII (1955), 127).

19. 'Letters of Denization and Acts of Naturalization for Aliens in London', ed. W. Page, *Proc. Huguenot Soc.*, VIII (1893), 69. He also worked at Somerset House (J. Summerson, *Architecture in Britain: 1530–1830*, 4th ed. (1963), 17).

20. K. A. Esdaile, 'The Part Played by Refugee Sculptors', *Proc. Huguenot Soc.*, XVIII (1949), 255. Unfortunately the name of the son-in-law is not recorded, but some of the tombs which seem related to those of the Cure studio may be his work.

21. A letter from Lord Burghley recommending him for the post of Master Mason states that he 'hath sen much worke in forrein places' (Cambridge University Library, Ee 3/56/94). I am grateful to Mr Lawrence Stone for this information. For Cure and Burghley, see Note 26.

22. See Note 20, and K. A. Esdaile, 'Three Monumental Drawings from Sir Edward Dering's Collection', *Arch. Cantiana*, XLVII (1935), 232.

23. *Ibid.*, 'William Cure II and his work at Trinity College, Cambridge', *Burl. Mag.*, LXXX (1942), 21. Cure's name appears in the Royal Accounts on several occasions for minor work, being sometimes written 'Euer'.

24. Gough Maps 45, No. 63. Cure was paid in 1573 for drawings for a tomb for Henry VIII (E. Mercer, *op. cit.*, 230). These have not survived, but the Edward VI design may be of about the same time.

25. These convincing attributions were made by Sir John Summerson in an unpublished lecture. The Blount monument was later doubled, using the same pattern, by Sir Michael Blount.

26. A Bodleian Library drawing apparently from p. 17 the Cure workshop (Gough Maps 44, No. 249) of two effigies with hands joined in prayer, is endorsed in Lord Burghley's hand as for himself and his lady, but fits neither his tomb, nor that of Lady Burghley (d. 1589), who is buried at Westminster with her daughter. The wall-monument at Stamford with kneeling figures of Lord Burghley's parents, erected apparently after his death, is probably from the same shop. The tomb of Sir William Cordell (d. 1580, Long Melford, Suffolk) is close to that of Lord Burghley, but with four small, competently cut Virtues behind the effigy.

27. For payments see *Pell Records, James I*, ed. F. Devon (1836), 168, 190.

28. See p. 20.

29. The authority for Cure as the designer is the *Gentleman's Magazine* (1800), 105, and D. Lysons, *Middlesex Parishes* (1800), 287. On analogy with it K. A. Esdaile, *Temple Church Monuments* (1933), 75 and plate vi, attributed the Richard Martin (d. 1615, London, Temple Church, destroyed 1941), with a kneeling effigy in painted plaster, to William Cure. No evidence seems known for her attribution to him of the 1st Earl of Bedford (d. 1555, Chenies, Buckinghamshire); see *Records of Bucks*, XV (1947), 34, and *Proc. Huguenot Soc.*, XVIII (1949), 257. An abortive contract with Cure was made for the tomb of the 2nd Earl (d. 1585) by the latter's executor, Sir Francis Walsingham (G. Scott-Thomson, *Family Background* (1949), 143), but the inscription shows the tomb was erected by his grandson, afterwards the 4th Earl, in 1619. It is, however, just possible that it and two other tombs at Chenies erected by the 4th Earl are late works of the Cure studio. I have to thank Miss G. Scott-Thomson for confirmation of the documentary material.

p. 17 30. The contract for this was copied by Vertue, ii, 74 and iv, 143. See also K. A. Esdaile, *Essays and Studies*, v (1952), 26 f. Stevens probably made the tomb of Frances, Countess of Sussex (d. 1589, Westminster), and must have had some reputation, since his will shows that in 1592 he was making a tomb for Sir Christopher Hatton in Old St Paul's. As, according to the inscription (W. Dugdale, *History of St Paul's* (1656, ed. 1818), 82), it was finished in 1593, it was probably Stevens's design, and not something of his own which was shown by Colt in his drawing in the Bibliothèque Nationale (J. Lees-Milne, *Tudor England* (1951), plate 81).

31. K. A. Esdaile, *Country Life*, CVII (1950), 464.

p. 18 32. A military relief of much the same character can be seen on the tomb of Sir Michael Dormer (d. 1616, Great Milton, Oxfordshire) (J. G. Mann, *loc. cit.*, plate xxia). James almost certainly made the tomb of Bridget, Countess of Bedford (d. 1600, formerly Watford, now Chenies, Buckinghamshire), with two figures kneeling on either side of the effigy, since it was erected by the same Lord Norris who had ordered his grandfather's tomb at Westminster.

33. Vertue, v, 38, where the phrase is used in connexion with a brass to John Owen of about 1633 in Old St Paul's. *Ibid.*, IV, 23, refers to the interest of his brother, Alexander, in art, and the *Gentleman's Magazine* (1818), 596, states that he was a pupil of Richard Stevens. Much work on this artist was done by Mrs K. A. Esdaile, and will be found scattered in several articles, though most of it is summarized in 'The Gorges Monument in Salisbury Cathedral', *Wiltshire Arch. Mag.*, L (1942–4), 53. Important new information has recently been published by M. Jurgens, 'Quelques actes inédits concernant Epiphanius Evesham', *Bull. de la Société de l'histoire de l'art français* (1960), 175, to which Professor E. K. Waterhouse kindly called my attention.

34. 'Nouvelles Archives de l'art français', 3ᵉ ser., *Revue de l'art français* (1884), 4. I am indebted to Mr Francis Watson for this reference.

35. A useful corpus of plates of remaining examples of French sixteenth- and early-seventeenth-century sculpture will be found in P. Vitry and G. Brière, *Documents de sculpture française, Renaissance*, II (n.d.). Plates cxxxvi, clxxv, clxxxiii, clxxxix show life-sized kneeling figures (now Louvre) from Paris tombs which Evesham probably knew when he made the Poyanne monument.

36. K. H. Jones, 'The Hawkins Monument by Epiphanius Evesham at Boughton-under-Blean', *Arch. Cantiana*, XLV (1933), 205.

37. The Sir Adrian Scrope (North Cockering- p. 19 ton, Lincolnshire), with a good reclining effigy, probably borrowed from French patterns, seems in style to fall between the Hawkins and Teynham tombs.

38. K. A. Esdaile, 'The Monument of Lord Rich at Felsted', *Essex Arch. Soc. Trans.*, N.S. XXII (1940), 59. Robert Rich, Earl of Warwick, directed his executors to erect his grandfather's tomb within eighteen months of his own death. The Felsted tomb, which is too cramped to photograph adequately, has at the foot a nude flying figure of Fame, probably derived from that by Pierre Biard (*c.* 1597, Louvre). The monument to John Troughton (d. 1621, Ingatestone, Essex) is similar to that of Robert Rich, Earl of Warwick, and has an identical frame (N. Pevsner, *The Buildings of England: Essex* (1954), plate 36A).

39. In a Return of 1635 Maximilian stated he had been in England 'about forty years' (*Cal. S.P. Dom., Charles I, 1635*, 592–3). See also Vertue, ii, 86, and K. A. Esdaile, *Proc. Huguenot Soc.*, XVIII (1949), 259. D. Piper, *ibid.*, XX (1960), 217, shows that in 1604 he married a daughter of the painter Marcus Gheeraerts I and Susannah de Critz, then saying he came from Utrecht.

40. In 1605 a Warrant was issued to Viscount p. 20 Cranborne (i.e. Salisbury) for the necessary sums for finishing a tomb for Queen Elizabeth (*Cal. S.P. Dom., James I, 1603–10*, 201); Colt was paid £150 in 1605 (*Issues of the Exchequer Records*, ed. F. Devon (1836), 21–2), £570 in 1607, John de Critz then being paid £100 for painting (B.M. Add. MSS. 23069, f. 11, and 36970, f.12v), and a further £165 in excess of his contract for £600 before the end of that year (*H.M.C. Hatfield*, III, app., 264). I must thank Mr Lawrence Stone and Dr Roy Strong for information about these payments.

41. R. Strong, *Portraits of Queen Elizabeth I* (1963), 152. Nicholas Hilliard, the miniature painter, may have had some hand in the colouring (E. Auerbach, *Nicholas Hilliard* (1961), 37). A drawing of the tomb, probably by Colt, is in the Bibliothèque Nationale (J. Lees-Milne, *op. cit.*, frontispiece).

42. A model was shown to the earl in 1609, but the work only seems to have been put in hand after the latter's death in 1612, and in 1614 Simon Basil, the King's Surveyor, was ordered to estimate the cost (H. A. Tipping and C. Hussey, *English Homes*,

III, 2 (1927), 322). Colt had already made for Lord Salisbury the plaster statue of James I (1609), painted to imitate bronze, on the chimneypiece in King James's Drawing Room at Hatfield House, and probably the marble chimneypiece in the Van Dyck Room (Plate 15). The relief in the centre is not part of the original. He had also made a statue for Salisbury's New Exchange in the Strand (L. Stone, 'Inigo Jones and the New Exchange', *Arch. Journ.*, CXIV (1959), 112).

43. For the tombs of Francis of Brittany and Louis XII see A. F. Blunt, *Art and Architecture in France: 1500–1700* (1953), plates 12b and 14. *Gisants* were rare in England in the sixteenth century, but one had been included in the Colet monument in Old St Paul's.

44. N. Pevsner, *The Buildings of England: London*, I (1957), plate 33b. Later in the century the pattern is used by an unknown sculptor for the tomb of Sir John Hotham (d. 1689, Dalton, Yorkshire), which has an armoured effigy on a bier supported by the four Cardinal Virtues, and originally a *gisant* beneath, though this has now disappeared. I am grateful to Mr Gunnis for information about this monument.

45. *Cal. S.P. Dom., James I, 1603–10*, 449, 469.

46. N. Pevsner, *op. cit.*, plate 33a.

47. *P.R.O. Declared Accounts*, A.O.I. 2419/41; 2421/54. I am indebted to Sir John Summerson for these references.

48. W. St John Hope, 'On the Funeral Effigies of the Kings and Queens of England', *Archaeologia*, LX, 2 (1907), 557. For Jones's design for the catafalque, see J. A. Gotch, *Inigo Jones* (1928), plate xiii.

49. See p. 35.

50. I am indebted to Mr John Harris for telling me that the contract and a drawing signed 'Max Coult' are at the University of Wilmington, Delaware, U.S.A.

51. An MS. at the College of Arms (I. i) titled 'The Booke of Monuments, 1619' (see K. A. Esdaile, *Illustrated London News*, 18 August 1934, 242) contains eight coloured drawings for the hearse of Queen Anne of Denmark (d. 1619) and the monuments to Edward, Earl of Shrewsbury (d. 1617, Westminster Abbey), Sir Edward Carre (d. 1619, Sleaford, Lincolnshire), the Grantham family of Lincolnshire (almost identical with the

last), James Ley of Teffont (d. 1618) (a tablet only), Martha St George (d. 1617), Mirable Craddock of Wickhambrook, Suffolk (d. 1631), and, inserted, Levinus and Anna Buskin (dated on back 28. Jany. 1620) of Otham, Kent. The drawings appear to be by the same hand as those of Lord Chancellor Hatton and Queen Elizabeth I referred to in Notes 30 and 41, but are much more crude in colour and draughtsmanship than the reproductions of them in J. Lees-Milne, *op. cit.*, or K. A. Esdaile, *English Church Monuments* (1946), plate I, would suggest. The larger tombs follow well-known Southwark patterns with the effigies under a coffered arch; the monument to Martha St George has, however, a kneeling figure with long fair hair. The book is a record kept in compliance with an order made in 1618 by the Commissioners for the office of Earl Marshal, under which painters and carvers were forbidden to set up Arms without the approbation of the Kings of Arms. As Master Sculptor to the Crown Colt would no doubt have had to comply, but there is nothing in the book to compare with the Salisbury tomb, or to support Mrs Esdaile's attribution to him (*Country Life*, C (1946), 714) of the interesting Resurrection monument of Sir John Denham (d. 1638, Egham, Surrey) (I. Nairn and N. Pevsner, *The Buildings of England: Surrey* (1962), plate 24b).

John Colt's son of the same name worked first under his uncle and then for Hubert Le Sueur (K. A. Esdaile, *Proc. Huguenot Soc.*, XVIII (1949), 259), and petitioned Charles II in 1660 to succeed Le Sueur as Sculptor to the Crown (*ibid.*, 'New Light on Hubert Le Sueur', *Burl. Mag.*, LXVI (1935), 177). His only signed work appears to be a tablet without figures to Dorcas Smyth (d. 1633, Toppesfield, Essex).

52. *Ibid.*, 'The Interaction of English and Low Country Sculpture in the Sixteenth Century', *Journ. W. and C.I.*, VI (1943), 80, and S. Jeavons, *Birmingham Arch. Soc. Trans.*, LXXI (1953), 2, where a number of further attributions are made. Lord Spencer has kindly confirmed that the receipt at Althorp is signed: Jasper Holymans, but that on a receipt in the B.M. (Add. MSS. 25079) his name appears both as Jesper Hollimance and Jasper Hollemans. A Garrett Hollyman was paid in 1592 for two chimneypieces (destroyed) at Kyre Park, Worcestershire, with reliefs of Susannah and of Mars and Venus (J. Summerson, *op. cit.*, 26). Another foreigner to settle out of London was the Theodoricus de Have (in King's Lynn in 1562),

who must be the Theodorus Haveus who executed the rather coarse monument to Dr Caius (d. 1573, Caius College, Cambridge).

p. 21 53. E. Mercer, *op. cit.*, 244 and plate 87b.

p. 22 54. W. Dugdale, *History of St Paul's* (1658, ed. 1818), 71.

55. K. A. Esdaile, 'Post Reformation Monuments in Derbyshire', *Derbyshire Arch. Soc.*, LX (1939), plate ii.

56. J. G. Mann, *loc. cit.*, plate xxvib. It is possible that the tomb has been re-set and the busts misplaced.

NOTES TO PART TWO

CHAPTER 4

p. 23 1. For a discussion of such types, see E. Mercer, *English Art, 1553–1625* (1962), 241 f.

p. 24 2. The notebook and account book, now in the Soane Museum, were edited by W. L. Spiers and printed in full in *Walpole Soc.*, VII (1919). A comparison of the two for the period for which they coincide shows that neither is complete, therefore during the early part of the sculptor's life, covered by the notebook only, he may have carried out more commissions than are there recorded. A somewhat controversial list of works, mainly architectural, was added to the account book by Stone's great-nephew, Charles Stoakes, a friend of George Vertue, who acquired the manuscripts from him.

3. For Hendrik de Keyser, see E. Neurdenburg, *De Zeventiende Eeuwsche Beeldhouwkunst in de Noordelijke Nederlanden* (Amsterdam, 1948), 27.

4. E. Neurdenburg, *op. cit.*, 93. Other somewhat dubious attributions are also made to Stone.

p. 25 5. *Walpole Soc.*, VII (1919), 3.

6. *Ibid.*, 34 and plate ii; K. A. Esdaile, 'Three Monumental Drawings from Sir Edward Dering's Collections in the Library of the Society of Antiquaries', *Archaeologia Cantiana*, XLVII (1935), 219. The tomb was originally erected in the church of St Mary-within-the-Castle, Dover, but moved in 1696 to the chapel of Trinity Hospital, Greenwich, which had been founded by Northampton. The effigy is now in the chapel; the Virtues and seated boys bearing shields from the canopy, all much damaged, are in the adjoining cloister.

7. See p. 15.

8. F. Saxl and R. Wittkower, *English Art and the Mediterranean* (1948), 43. The Virtues, about 4 ft 6 ins. high, are much worn and in places clumsily mended. It is hard to say how much of the Arundel Collection was in England by 1615, the year of the contract for this tomb. Some pieces may have been acquired during Arundel's journey to Italy in 1612, and much was bought on the longer journey of 1613–14, when he was accompanied by Inigo Jones. By 1616 his interest in antiques was well-known, and gifts were made to the collection by

Sir Dudley Carleton and Lord Roos. The Sculpture Gallery at Arundel House was apparently built by that year (M. Hervey, *Life of Thomas Howard, Earl of Arundel* (1921), 64, 84, 101, 102).

9. For the receipt signed by the three men see *Walpole Soc.*, VII (1919), 41. Kinsman was a mason, who was later to work with Stone at St Paul's Cathedral. The price (£400) was £100 less than Stone and James had received for the Northampton tomb, and the small bust monument to John Law in the same chapel was included in the price. The Sutton tomb, though more elaborately sculptured, is mainly of alabaster, whereas the Northampton was of black and white marble, which presumably accounts for the substantial difference in price.

10. K. A. Esdaile, *English Church Monuments* (1946), 82, was of the opinion that the effigy must have been made by Johnson, since he signed the contract first. It is, however, in many ways, and especially in the draperies with broad, dented folds, related to the Orange tomb at Delft, and Stone's entry in his notebook, though ambiguous, could be taken to mean that all the 'carven work' on the Sutton tomb was his.

11. J. Woodward, 'The Monument to Sir Thomas Bodley in Merton College Chapel', *The Bodleian Library Record*, v (1954), No. 2, 69; M. D. Whinney and O. Millar, *English Art 1625–1714* (1957), 107 and plate 28a.

12. *Walpole Soc.*, VII (1919), plate vi, c and d. p. 26

13. *Ibid.*, 75, 120, and plate xxxiii.

14. *R.C.H.M. Middlesex* (1937), plate 177; *Connoisseur Period Guides, Stuart* (1957), plate 41b. Stone was to use curtains pulled back by angels on the monument to Lady Knatchbull (1626, Mersham, Kent) (*Walpole Soc.*, VII (1919), plate xxvia), and falling from the wall as a background to figures kneeling at the ends of the sarcophagus of Sir Charles Morison (1619, Watford, Herts) (*ibid.*, plate x). They were also used in the workshop of Edward Marshall (see p. 32).

15. Inigo Jones must have known the Medici p. 27 tombs, but no drawing of his remains, and Stone does not seem to have been on intimate terms with him.

p. 27 16. Other fairly early examples are the monuments to Col. William Rudhall (d. 1651, Ross-on-Wye, Herefordshire) and Edward St John (d. 1645, Lydiard Tregoze, Wiltshire). The latter, unusually, is gilt bronze, but seems too coarse to be the work of a court sculptor. For H. Le Sueur's use of a standing effigy, see p. 36.

17. Possibly the theme was influenced by a sermon, *The Parable of the Sower*, by Thomas Taylor, published in 1623 (A. M. Hind, *English Engraving*, II (1955), plate 242), though the title-page has no connexion with Stone's design. He used it again for the monument to Joyce Clerke (1626, Southwark Cathedral).

18. *Walpole Soc.*, VII (1919), 57; J. E. Price, *A Descriptive Account of the Guildhall of the City of London* (1886), 147; K. A. Esdaile, *Country Life*, XCV (1944), 162. A drawing of 1810 at the Guildhall shows the figure on the porch of the chapel, flanked by two other figures, apparently Edward VI and Charles I, which survive in the Museum. The latter was attributed by Mrs Esdaile (*Archit. Review*, CII (1947), 174) to Stone's brother-in-law, Andreas Kearne. Neither are of such good quality as the Queen Elizabeth.

19. A. H. Scott-Elliot, 'The Statues from Mantua in the Collection of King Charles I', *Burl. Mag.*, CI (1959), 218. A series of drawings, bound later and now in the Royal Library, Windsor Castle, were sent to the king from Mantua by Daniel Nys in January 1628/9; the Office of Works accounts for 1629–30 include under St James's Palace an item: 'for mending statues damaged by sea' (P.R.O., A.O.1.2426/60). It is not specified by whom this work was done, but Stone had been paid in the previous year for mason's work at St James's, and even if he did not mend the sculpture himself, would certainly have had an opportunity of seeing it.

p. 28 20. I.e. the Earl of Arundel, see Note 8 above.

21. H. Peacham, *The Compleat Gentleman*, 2nd and enlarged ed. (1634; ed. 1661), 107.

22. *Ibid.*, 108. Le Sueur was sent to Italy in 1631 to obtain 'moulds and patterns of certain antiques there' (P.R.O., E 404/52; *Exchequer of Receipt Issue Warrants*, 1630–1); but the Borghese Warrior must have been earlier, since a pedestal for it was made for the Privy Garden at St James's in 1629–30 (P.R.O., A.O.1.2426/60). For its subsequent history see M. D. Whinney and O. Millar, *op. cit.*, 120, n. 4.

23. Buckingham had been murdered in 1628, but in 1634 his collection was still at York House. For this purchase see W. N. Sainsbury, *Original Unpublished Papers . . . of Rubens* (1859), 65, 70, 71, 84.

24. The statue had been given to Charles, Prince of Wales, when he was in Spain in 1623, and by him to Buckingham. For its history see J. Pope-Hennessy, *Samson and a Philistine*, V. and A. Monographs, VIII (1954). It does not seem to have been widely known in seventeenth-century England, though it was much copied in the eighteenth century.

25. *Walpole Soc.*, VII (1919), 85, 86, 90, and plate xxxviia. The chapel built by Stone to hold the monument has been rebuilt and some of the figures appear to have been damaged and mended.

26. *Ibid.*, 48, 60, and plates x, xi, xix, xx. The p. 29 contract for the second tomb is printed in full. The price was £400, the considerable difference between it and that of the earlier tomb (£260) being no doubt due to the use of marble, which had to be imported.

27. *Ibid.*, plates xxxi, xxxiii.

28. *Ibid.*, plates xxvi, xxxiv.

29. *Ibid.*, 81, 93, 104. Stone also shipped English alabaster to Holland.

30. Willem came to England about 1621, married an Englishwoman, and went back to Amsterdam in 1640. He returned in 1658 and was here until at least 1674. The younger Hendrik, who also married an Englishwoman, was here from 1634 until 1647. No reference to Willem appears in Stone's account book of 1631–42, and he may by then have been working on his own. He was a sculptor of some ability, as his relief on the tomb of van Tromp (1655–7) at Delft shows, but no evidence appears to exist for any work of his in England (*Walpole Soc.*, VII (1919), 32, 33, 116; E. Neurdenburg, *op. cit.*, 143, 145, 203).

31. The agreement (*Walpole Soc.*, VII (1919), 89) states that the craftsman Anthony Goore was to carry out the work as 'described on a bord wharon the sayed tombe is all ridy drane'. If Stone was in the habit of following the medieval tradition of providing working drawings on board it is not surprising that none have survived.

32. For details of all these payments see *Walpole Soc.*, VII (1919).

33. Stone's work for the Pastons included tombs, p. 30 masonry work, and statues at Oxnead running from 1631 to 1641 (*ibid.*, 68, 96, 97, 98, 128, 129,

130). I am indebted to Dr Pamela Tudor-Craig for information from an inventory of Oxnead in 1687 (B.M., Add. MSS. 36988) which describes the statues and busts in the Great Hall and on the staircase. Stone also made the tombs of Sir William Paston's mother (1629) and father (Sir Edmund Paston, 1635) at Paston, Norfolk.

34. A much weathered copy of the monument, erected by the nephews of Lord Belhaven (d. 1639), an official of the Royal Household, stands at the base of the north-west tower of the abbey of Holyrood. According to Vertue (i, 98) it was made by John Schorman, who had carved the arms on Stone's Spencer tomb. A somewhat similar effigy may be seen on the tomb of the 1st Lord Coventry (d. 1639, Croome d'Abitot, Worcestershire), though this has seated Virtues related to Stone's Digges monument. It must surely have been made by a member of Stone's workshop.

35. For John Stone see *Walpole Soc.*, VII (1919), 138–43. This only records his monuments from 1650 to 1657. By about the latter date, Caius Gabriel Cibber (see p. 48) became his foreman; his health broke down in 1660 when he was staying in Holland, and Cibber had to go and bring him home. He was apparently also something of an architect (H. Colvin, 'Chesterton, Warwickshire', *Archit. Review*, CXVIII (1955), 115).

36. The diary, rebound, is in the B.M. (Harl. MS. 4049), and is printed in full in *Walpole Soc.*, VII (1919), 158 f.

31 37. For the bust of Charles I, which disappeared after the fire in Whitehall Palace in 1698, see R. Wittkower, *Bernini* (1955), 200; and pp. 36, 114.

38. Vertue, i, 90, states that Francis Bird (see p. 74) owned models of the Laocoon and the Apollo and Daphne made by Nicholas Stone II in Rome.

39. D. Knoop and G. P. Jones, *The London Mason in the Seventeenth Century* (1935), 34. John Clarke was probably the mason–contractor for Lincoln's Inn Chapel (1619–24).

40. See p. 63.

32 41. M. D. Whinney and O. Millar, *op. cit.*, plate 29a.

42. Donne had posed in a shroud for a portrait from which his executor had the effigy made (*Walpole Soc.*, VII (1919), 64).

43. See p. 63.

44. The Marshalls were certainly employed for the tomb of another of the Duchess's daughters,

Lady Frances Kniveton (d. 1663, London, St Giles-in-the-Fields) (*Miscellanea Genealogica et Heraldica*, v, 132), and almost certainly for that of a third, Lady Katherine Leveson (d. 1674, Lilleshall, Shropshire). The Duchess's tomb may well be the earliest of the series. I am indebted to Mr Rupert Gunnis for information about these family tombs.

45. See p. 33.

46. L. Stone, 'The Verney Tomb at Middle Claydon', *Records of Bucks*, XVI (1955–6), 67. No negotiations with Wright seem to have taken place, and the design was made by Marshall's former pupil, Thomas Burman (see p. 245, Note 12). Verney was dissatisfied with it and hoped to employ an Italian or a Frenchman. It is probable that the existing tomb was designed as well as executed by Edward Marshall.

47. William Wright carried out monuments with unshrouded figures at Brocklesby, Lincolnshire (1630), and Ecclesfield, Yorkshire (1641), and also made the tomb of Cromwell's son-in-law, Henry Ireton, with two effigies at Westminster (destroyed at the Restoration) (R. W. Ramsey, *Henry Ireton* (1949), 201). Mrs K. A. Esdaile, 'William Wright of Charing Cross, Sculptor', *Assoc. Arch. Soc. Rep.*, XLII (1936/7), 221, suggested that the shrouded monument mentioned by Verney with a 'greate Childe of White Marble' is the Deane tomb (1633, Great Maplestead, Essex) but the standing shrouded figure is a woman and there is no child.

48. The monument to Mrs Brocas (d. 1654, St p. 33 Margaret's, Westminster) repeats the pattern.

49. Other signed monuments by Edward Marshall include those to Thomas Playter (d. 1638, Sotterly, Suffolk) and Francis Williamson (d. 1659, Walkeringham, Nottinghamshire), both somewhat old-fashioned with kneeling figures, and the interesting but coarsely-cut bust monument to Dame Dorothy Selby (d. 1641, Ightham, Kent), which combines the theme of angels pulling back curtains with small figures in relief of Time and Death.

50. It is possible that the related bust of Samuel Danyell (d. 1619) at Beckington, Somerset, is also by Marshall. The architectural detail suggests a date in the 1630s, and it might therefore well have been made at about the same time as that of his fellow poet.

51. F. Saxl and R. Wittkower, *British Art and the Mediterranean* (1948), 43, suggest a derivation from Michelangelo's Brutus. It is hard to know how Marshall could have known this, and though the type of profile is similar, the proportions are very

different. A common source in antiquity seems more probable.

p. 33 52. For William Stanton, see p. 64, and for Edward, p. 65. A full discussion of the Stanton workshop appears in K. A. Esdaile, 'The Stantons of Holborn', *Archaeol. Journ.*, LXXXV (1928), 149, where a number of undocumented works are assigned to the family.

53. Vertue, iv, 138.

54. M. D. Whinney and O. Millar, *op. cit.*, plate 29b. For the contract with Dame Jane Bacon see *H.M.C. Verulam MSS.* (1906), 54. Stanton had £300 for the tomb, and Dame Jane was responsible for carriage from Ipswich (where it had presumably been sent from the London studio), delivery at the church, and the provision of additional materials necessary for the setting up. Thomas also started the workshop tradition of large tablets without figures, e.g. the signed monument to Sir Thomas and Lady Lyttelton (1666, Worcester Cathedral).

p. 34 55. Thorpe, *Registorum Roffensi* (1769), 731. I am grateful to Mr Rupert Gunnis for this information. For an early work by Gerard Christmas, see p. 235, Note 18. The Christmas brothers appear still to have been living in the parish of St Giles's, Cripplegate, in 1650, when Sir Balthazar Gerbier lodged with them (K. A. Esdaile, *Walpole Soc.*, XXI (1933), 106).

56. J. Burke, 'Archbishop Abbot's Tomb at Guildford', *Journ. W. and C.I.*, XII (1949), 179. It was erected by the archbishop's brother, a merchant of the City of London, which probably accounts for the choice of sculptors.

57. The probable meaning of the iconography in relation to Abbot's career as a scholar and churchman are discussed by Professor Burke, *loc. cit.*

58. A similar monument to Temperance Browne (d. 1634) is at Steane, Northamptonshire.

59. Their masterpiece as carvers was the decoration of the *Sovereign of the Seas*, launched in 1637, which showed King Edgar the Peaceful trampling kings underfoot, cavalcades of warriors, and wild beasts (G. Callender, *The Portrait of Peter Pett and the Sovereign of the Seas* (1930), 6).

CHAPTER 5

p. 35 1. Some confusion about Le Sueur and Fanelli was caused by unsound attributions made by Horace Walpole and his nineteenth-century editor, James Dallaway, which have been continued

by some later writers. It seems possible, however, on the grounds of documented works to distinguish their hands.

2. H. Peacham, *Compleat Gentleman* (1634, ed. 1661), 108, his statement being repeated by Vertue and Walpole, assumes that Giovanni Bologna (d. 1608) went to France, which is untrue. L. Cust (*D.N.B.* and *Burl. Mag.*, XX (1912), 192) states, without quoting his authority, that Le Sueur was a pupil of Tacca, but the latter did not go to France with the equestrian statue. The chief artist concerned with its erection was Pietro Francavilla (Pierre Francheville), whose Slaves (Louvre) for the base of the statue were set up in 1618, three years after his death in France. Le Sueur's name does not appear among those of the artists generally cited as setting up the statue, which was destroyed in the French Revolution.

3. G. Webb, 'Notes on Hubert Le Sueur', *Burl. Mag.*, LII (1928), 10, 81.

4. P.R.O., *Declared Accounts*, A.O.1.2425/57, October 1626–September 1627. K. A. Esdaile, 'New Light on Hubert Le Sueur', *Burl. Mag.*, LXVI (1935), 177, suggests that he was here by 1619, since his wife witnessed a baptism in that year, but this hardly seems to tally with his French appointments. He was more probably encouraged to come by the Duke of Buckingham, who was in Paris in 1625. The drawing for the catafalque by Jones is at Worcester College, Oxford, though it seems to have been altered in execution.

5. He was paid for 'the moulding, making and fashioning' of the figures, so they may have been of wax, or more probably of plaster. Jones had the caryatids below them made of plaster of Paris and the drapery 'of white callico, which was very handsome and very cheap, and shewed as well as if they had been cut out of white marble' (J. Aubrey, *Brief Lives*, ed. A. Powell (1949), 115). The use of plastered material to imitate marble was also noted by Nicholas Stone II on statues in Florence Cathedral (*Walpole Soc.*, VII (1919), 160).

6. The Lennox tomb, which was in place by 1628 (*Cal. S.P. Dom., 1628–9*, 329), is not documented, but is undoubtedly by the same hand as the Buckingham, which is attributed to Le Sueur by E. Chamberlayne, *Angliae Notitia* (ed. 1687), pt ii, 303. Buckingham was assassinated in 1628, and his tomb is likely to have been made fairly soon. It has since been much damaged, probably under the Commonwealth, when Buckingham was still a much hated memory.

7. The Fame is a draped version of the nude Fame by Pierre Biard (Louvre, *c.* 1597).

p. 36 8. Family tradition asserts that the Pembroke was based on a drawing by Rubens. No such drawing exists, and the pose suggests closer links with Late Mannerist court portraits, such as those produced in France by Pourbus.

9. For the contract see Rev. S. Shaw, *Hist. and Antiquities of Staffordshire* (1801), II, 158. The tomb was dismembered during the Civil War, but two bronze putti also remain, now awkwardly placed on the plain pedestal.

10. The Oxford figures were commissioned by Archbishop Laud (*Cal. S.P. Dom., 1633–4*, 43); those at Winchester, which adorned a screen designed by Inigo Jones and now dismembered, were the gift of the king (W. N. Sainsbury, *Original Unpublished Papers . . . of Rubens* (1859), 319).

11. *Cal. S.P. Dom., 1629–31*, 121, 165, 167. The statue, for which Le Sueur was to be paid £600, was commissioned by Lord Treasurer Weston for his garden at Roehampton, but owing probably to Weston's death in 1635 remained in the artist's workshop, from which it was sold to a founder under the Commonwealth (Vertue, i, 22). Instead of melting it down he buried it, and it was set up at Charing Cross about 1667 on a pedestal executed by Joshua Marshall, probably from a design by Wren.

12. C. C. Stopes, 'Gleanings from the Records of the Reigns of James I and Charles I', *Burl. Mag.*, XXII (1922), 282.

13. See p. 28.

14. L. Cust, *Burl. Mag.*, XX (1912), 192, suggested that the marble, which was bought for the museum about 1912, had been made for the King of France, but quoted no evidence. Among other bronzes on this pattern are those at Windsor, Woburn, and Wentworth Woodhouse, the last being of good quality and traditionally a present from the king to the Earl of Strafford. It was probably again copied after the Restoration, since Mr Rupert Gunnis owns one which is a pair to a Charles II, both perhaps the work of one of Le Sueur's assistants, possibly Peter Besnier (see p. 39). Other repeats may be eighteenth- or nineteenth-century work.

15. O. Millar, 'Abraham van der Doort's Catalogue of the Collections of King Charles I', *Walpole Soc.*, XXXVII (1960), 70. The bust was originally gilt, but has since been darkened. The type appears to be derived from the bust of

Henri IV, made for the Belle Cheminée at Fontainebleau (P. Vitry and G. Brière, *Documents de sculpture française, Renaissance*, II (n.d.), plate clxxx.

16. R. Wittkower, *Bernini* (1955), 200. A tame copy of it, possibly by Francis Bird, is at Windsor (K. A. Esdaile, *Burl. Mag.*, XCI (1944), 9–14). Another record of it appears in Vertue's self-portrait (Vertue, i, frontispiece).

17. *Cal. S.P. Dom., 1636–7*, 325. He also made p. 37 for the king the over life-size bust of James I, now in the Banqueting House, Whitehall.

18. The Richardson is signed and dated. The contract with Lord Cottington is dated 1634 (*Cal. S.P. Dom., 1634–5*, 158); L. Cust (*D.N.B.*, 'Le Sueur') states that the male effigy was completed by Fanelli, but gives no authority. Earlier than these, but not signed, is the coarse bust of Peter Lemare, dated 1631 (St Margaret's, Lothbury). It was erected, originally in St Christopher-le-Stock, by Lemare's brother-in-law, Sir Francis Crane, who as manager of the royal tapestry factory at Mortlake was a likely patron for Le Sueur. The bust monument of Sir William Godolphin (d. 1636, Bruton, Somerset) is probably from Le Sueur's workshop (G. Webb, *Burl. Mag.*, LII (1928), 88). Two assistants, Peter Besnier (see p. 39) and the younger John Colt, are known to have worked for him, but in the latter case there seems too little evidence to support the attributions made by K. A. Esdaile, *Burl. Mag.*, LXVI (1935), 179.

19. J. Pope-Hennessy, 'Some Bronze Statuettes by Francesco Fanelli', *Burl. Mag.*, XCV (1953), 157. Further small pieces have since been identified at Buckingham Palace and Windsor.

20. M. D. Whinney and O. Millar, *English Art 1625–1714* (1957), plate 31a.

21. *R.C.H.M. London, Westminster Abbey* (1924), plate 66.

22. M. Hervey, *Thomas Howard, Earl of Arundel* (1921), app. II, 460.

23. The tomb is neither signed nor documented. Le Sueur's authorship has always been assumed, because he made the equestrian statue of Charles I for Weston.

24. J. Evelyn, *Diary*, 9 June 1662, states the work p. 38 was by Fanelli. The Duc de Monconys, *Voyage d'Angleterre* (Paris, 1695), 158, describes it in 1663 as a two-tiered fountain in a marble basin, the boys being ranged above the sirens. A drawing of the school of Sir Peter Lely (O. Millar Collection) shows the shells set between the sirens, presumably

to receive the water spouted from the fish held by the boys above. For the recasting about 1714 see E. Law, *History of Hampton Court* (1891), III, 139, 202.

p. 38 25. According to d'Argenville, *Vie des plus fameux architectes et sculpteurs* (Paris, 1787), II, 169, François Anguier, the well-known French sculptor, spent some years of his early life in England, but no work is known. The two seated figures over the central window of the south front of Wilton House, Wiltshire, have a decidedly French appearance, but their date is uncertain (H. Colvin, 'The South Front of Wilton House', *Arch. Journ.*, CXI (1954), 181) and they are possibly by the garden designer, Isaac de Caux.

26. Both busts came from the collection of Thomas Howard, Earl of Arundel, and were seen by George Vertue at Norfolk House, St James's Square, about 1729 (Vertue, ii, 66).

27. 'Memoirs of the Mission to England of the Capuchin Friars . . .', trans. in T. Birch, *The Court and Times of Charles I* (1849), II, 310; M. D. Whinney and O. Millar, *op. cit.*, 123.

28. Dieussart left England about 1641 and settled in Holland, where he was referred to by the painter Honthorst as a good sculptor (D. F. Slothouwer, *De Paleizen van Frederik Hendrik* (1945), 333, 335, 337, 349, 351). His four statues of Princes of the House of Orange (formerly Potsdam, Orangery) show a valiant but not entirely successful attempt to combine a Baroque twisted pose with a figure in complete armour. His bust of Charles II in exile (Bruges Town Hall) is a more distinguished work, superior to that of the same sitter attributed to him in the Rijksmuseum, Amsterdam. Two busts of Elizabeth, Queen of Bohemia (1641), and the Electress Sophia as a child (the Earl of Craven Collection) are probably his. I am indebted to Dr K. Fremantle for references to Dieussart's work for the House of Orange.

CHAPTER 6

39 1. K. A. Esdaile, 'New Light on Hubert Le Sueur', *Burl. Mag.*, LXVI (1935), 177.

2. The plaster bust of Sir William Fermor at Easton Neston, dated 1658, is possibly by Besnier but seems closer to the style of Dieussart. No marble version is known.

40 3. He had taken over the post from his elder brother, Isaac, in 1643. His duties included the care and custody of the king's sculpture and casts, and he was therefore probably concerned with such work as the setting up of statues, including a version of the Spinario, in the vestibule to the queen's staircase at Windsor about 1680. He does not, however, seem to have received any major commissions from the Crown.

4. Nothing is known of Honoré Pelle, the maker of the extravagantly Baroque bust of Charles II (1684, V. and A.; a version of 1682 is in the courtyard of Burghley House). A bust, said to be of William III, but possibly of James II, on the Leconfield Institute, Petworth, Sussex, may also be his.

Though a number of foreigners were to work at Windsor, none had previously gained much distinction (see pp. 53, 54, 59).

5. See J. W. Stoye, *English Travellers Abroad, 1603–1667* (1952).

6. The sketch-books of the painter Charles Beale (*c.* 1680, B.M.) have drawings of small Duquesnoy figures, female figures by Giambologna, and a few of heads of Roman Emperors (E. Croft-Murray and P. Hulton, *Cat. British Drawings*, 1 (1960), i, 148–98; ii, plates, 158–77).

7. The writer owns a copy of the *Admiranda* inscribed 'J. Sotheby 1687'. The title page bears no date, but is otherwise identical with that of the dated edition of 1693. There is no reason to suppose that the interests of the purchaser differed from those of his class.

41 8. This last was understood and deplored by Sir Christopher Wren (*Wren Soc.*, XI, 74; M. D. Whinney and O. Millar, *English Art, 1625–1714* (1957), 319).

9. *London in 1710, from the Travels of Zacharias Conrad von Uffenbach*, trans. W. H. Quarrell and M. Mare (1934), 93.

10. The notebooks, from which Horace Walpole drew the material for his *Anecdotes of Painting* (1762), now at the B.M. and Worksop Priory, have been published in full by the Walpole Society: i, XVIII (1930); ii, XX (1932); iii, XXII (1934); iv, XXIV (1936); v, XXVI (1938); Index, XXIX (1947); vi, XXX (1952; pub. 1955), and are here referred to as Vertue, i, ii, etc.

11. The chief source for Bushnell is the information given to Vertue by his sons (Vertue, i, 29, 58, 86, 90, 128; ii, 8). See also K. A. Esdaile, 'John Bushnell', *Walpole Soc.*, XV (1927), 21; 'Additional Notes on John Bushnell', *ibid.*, XXI (1933), 105, though some of her attributions are controversial.

12. For Burman's connexion with the Verney p. 42 monument at Middle Claydon, Buckinghamshire, see p. 241, Note 46. His other known works are the monument with two busts to Mr and Mrs Beale (1672, Walton, Buckinghamshire) (Vertue, iv, 169) and the statue of the Countess of Shrewsbury (1671, gate of St John's College, Cambridge) (R. Willis and J. W. Clark, *Architectural History of the University of Cambridge* (1886), II, 320). By the time he made the latter he had some confused ideas about Baroque drapery patterns.

13. Vertue's statements about the length and sequence of Bushnell's journey are confused. He first says he was away twenty-two years (i, 86) but later in two separate entries mentions ten (i, 90, 128); and it is not clear whether he went to both France and Flanders before going to Italy.

14. 'An Account of a Journey made thro' Part of the Low-Countries, Germany, Italy and France', by Philip Skippon Esq., M.A., in *A Collection of Voyages and Travels* (ed. Churchill, 1752), VI, 519. See also Vertue, ii, 9; iv, 152.

15. The reliefs cannot now be compared with any of Bushnell's English works, but he attempted an equally pictorial effect in the (mutilated) monument to Sir Palmes Fairborne (1680, Westminster Abbey), which had 'relievos of Moorish towns' (Gunnis, *Dict.*, 73) now unfortunately lost.

16. Temple Bar, designed by Wren and executed by Joshua Marshall, was removed in the nineteenth

century to Theobalds Park, Hertfordshire. At the time of writing its return to the City of London, as part of the St Paul's Cathedral Precinct scheme, is under consideration. The kings are easily recognized; the queen may be Elizabeth I, who was much venerated, but since she and Charles II are crowned and the other kings bare-headed, it is more likely that she is Charles II's wife, Catherine of Braganza.

p. 43 17. Vertue, ii, 8. The Charles I and Charles II were on the main entrance front, and the Gresham on the south front. Within the courtyard a further series of royal figures were planned and executed by other artists for the niches on the first floor over the loggia. Beneath the loggia were two additional figures of Sir Thomas Gresham and Sir John Barnard. When the Royal Exchange was burnt in 1838 only the three Bushnell statues from the exterior of the building survived. See also pp. 45, 46.

p. 44 18. Removed to a vault in 1872, but recorded in a drawing (B.M. Burrell 5675, f. 33, 56; see K. A. Esdaile, *English Church Monuments* (1946), plate 56).

19. His only other known public commissions (all now vanished) were statues of Charles II for Southwark Town Hall, and St Peter and St Paul for Somerset House Chapel (Gunnis, *Dict.*, 74).

20. W. M. Myddelton, *Chirk Castle Accounts, 1666–1763* (priv. printed, 1931), 63, 68, 114, 117, 119.

21. Vertue, ii, 8. No nude figures by Bushnell are known, but the semi-nude kneeling figure on the monument to Robert Pierrepont (d. 1669, West Dean, Wiltshire) is almost certainly his, and is fleshy and exaggerated in modelling. The more elegant figure on the monument to Sir Ralph Bovey (Longstowe, Cambridgeshire) has also been attributed to him (K. A. Esdaile, *Walpole Soc.*, XXI (1933), 107).

22. Vertue, i, 86.

p. 45 23. W. St John Hope, 'On the Funeral Effigies of the Kings and Queens of England', *Archaeologia*, LX (1907), 561. Wax had been used for the effigy of Cromwell (D. Piper, 'Some Contemporary Portraits of Cromwell', *Walpole Soc.*, XXXIV (1952–4), 41). For an earlier use of plaster for funeral ceremonies, see p. 242, Note 5.

24. In addition to Gunnis, *Dict.*, 296, information concerning his career will be found in D. Knoop and G. P. Jones, *The London Mason in the Seventeenth Century* (1935), 25, n. 4; R. L. Poole, 'Edward Pierce the Sculptor', *Walpole Soc.*, XI (1923),

34; J. Seymour, 'Edward Pearce: Baroque Sculptor of London', *Guildhall Miscellany*, I (1952), 10. Both forms of his name appear in contemporary documents: the busts of Cromwell are signed 'Pierce'.

25. For his father's work, see E. Croft-Murray, *Decorative Painting in England*, I (1962), 39, 41, 206.

26. He was one of the chief contractors for St Paul's Cathedral from 1679 to 1690, and also built five of the City churches. His finest wood-carving, that in the vestry of St Lawrence Jewry, was destroyed in the Second World War.

27. Vertue, i, 106. Elsewhere Vertue refers (iv, 179) to a statue of Gresham by Cibber (illus. in H. Faber, *C. G. Cibber* (1926), 24), but this was presumably the second statue under the loggia inside the building. Vertue is not entirely reliable about these figures, since he states those in the courtyard were 'mostly done by Cibert', which is now known to be untrue; but the careful correction of his entry is worth consideration.

28. It is not known which of the Companies p. 4 commissioned Bushnell for the six figures which he never finished, but by 1685, when Pierce was paid by the Skinners' and the Fishmongers', it was probably already apparent that Bushnell's work would never be done.

29. Drawing by John Carter in the possession of the Royal Exchange Assurance Company; J. Seymour, 'Edward Pearce . . .', *Guildhall Miscellany*, I (1952), plate 3. Pierce may have known of the failure of Nicholas Stone's Elizabeth I (see p. 27), a figure which had survived the Great Fire.

30. For the making of life-masks in England, see S. Pepys, *Diary*, 10 February 1669, where he describes his pleasure at having his taken; and D. Piper, *The English Face* (1957), 116. For the Cromwell life-mask, said on insufficient evidence to have been made for his family in 1655, see K. Pearson and G. M. Morant, 'The Portraiture of Oliver Cromwell', *Biometrika*, XXVI (1935), 91 and plates lxii–lxiv; E. S. de Beer, 'Notes on the Portraits of Cromwell', *History*, XXIII (1928), 129; D. Piper, 'Contemporary Portraits of Cromwell', *Walpole Soc.*, XXXIV (1952–4), 41. The last suggests that the life-mask is either a study for or a cast from the bronze bust. Several copies of the bronze, perhaps of later date, exist (N.P.G.; R. J. Haentjens Dekker Collection, Amsterdam; etc.); and some of the many eighteenth-century busts of Cromwell appear to use it as a pattern.

31. *Wren Soc.*, XVIII, 177. Wren was a good p. 4 draughtsman and could easily have shown Pierce

the character of a Baroque bust by a sketch. For the Bernini bust, see R. Wittkower, *Art and Architecture in Italy: 1600–1750* (1958), plate 55B.

32. The Hamey was wrongly attributed by Mrs Esdaile to Bushnell (*Walpole Soc.*, xv (1927), 39 and plate xiib), but the subsequent publication of the *Diary of Dr Robert Hooke* (ed. H. W. Robinson and W. Adams (1935), 148, 178) proves it to be by Pierce. A drawing for it by the sculptor is in the Ashmolean Museum, Oxford.

33. For the Buckingham drawing, which is inscribed in John Talman's hand 'Designed by Edwᵈ Pierce', see E. Croft-Murray and P. Hulton, *Cat. of British Drawings*, I (1960), i, 451–5; ii, plate 242. The other drawings will be discussed under John Nost, see p. 60. The *Gentleman's Magazine* (1818), 596, ascribes the monument of Lord and Lady Maynard (Little Easton, Essex) to Pierce. This, which must have been erected long after the death of Lord Maynard in 1640, has two figures in semi-classical dress beside an urn, as used by Gibbons at Bottesford (see p. 56), but is livelier in cutting.

34. Crutcher held a variety of offices in the Masons' Company, ending with the Mastership in 1713 (Gunnis, *Dict.*, 117).

35. *H.M.C. Marquis of Bath*, II, 179. Also printed in *Wren Soc.*, XVII, 4.

CHAPTER 7

p. 48 1. M. D. Whinney and O. Millar, *English Art, 1625–1715* (1957), 142, 207, 225, 229, 281.

2. For this work see K. Fremantle, *The Baroque Town Hall of Amsterdam* (Utrecht, 1959), chapters v and vi.

3. For the work of John Stone, see p. 30.

4. H. Faber, *C. G. Cibber* (1926), prints most of the relevant material, though some attributions (notably for the statues at Hampton Court) have since been corrected.

5. Vertue, i, 99.

p. 49 6. The Gresham Committee was a joint committee of the Corporation of London and the Mercers' Company, and was responsible for the rebuilding of the Exchange. Manchester's letter is printed in Faber, *op. cit.*, 31.

7. Reproduced, *ibid.*, 20, 22.

8. There is no payment to Cibber for these figures, and Thomas Cartwright (see p. 64) had first made statues for Bedlam Gate (*Diary of Dr Robert Hooke*, ed. H. W. Robinson and W. Adams

(1935), 183; M. I. Batten, 'The Architecture of Dr Robert Hooke', *Walpole Soc.*, xxv (1937), 92). However, Vertue (i, 99), writing in 1713, included them in a list of Cibber's works given him by Charles Stoakes, who, being a relative of John Stone, must have known Cibber; and Pope, in the *Dunciad* (ed. J. Sutherland (1943), 271), referring to Colley Cibber the dramatist, speaks of the Madnesses as 'by his fam'd father's hand', and as 'Great Cibber's brazen, brainless brothers ...'. These last references seem reasonably conclusive. The figures are of Portland stone, but may have always been painted to imitate bronze. They were 'restored' in the early nineteenth century by John Bacon II, but how much he did to them appears to be unrecorded.

9. A terracotta model for the 'Raving' in Berlin p. 50 was for many years attributed to Tacca (H. Faber, *op. cit.*, 45).

10. C. J. Phillips, *History of the Sackville Family* (1929), I, 420.

11. By 1678 Cibber had five assistants, and except for one who is specified as an Italian, their names suggest they were Dutch or Flemings (D. Knoop and G. P. Jones, *The London Mason in the Seventeenth Century* (1935), 25).

12. Faber, *op. cit.*, 48; K. A. Esdaile, 'Aubrey's Notes on London and Surrey', *Times Literary Supplement*, 5 July 1947. An engraving showing the fountain appears in Stow's *Survey of London* (1755 ed.), II, 660.

13. For instance the figure of Juno outside the Rijksmuseum, Amsterdam, attributed to Rombaut Verhulst, or the signed garden figure by the same artist at Otterloo.

14. Lady V. Manners, 'Garden Sculpture by p. 51 Caius Cibber', *Country Life*, LXVIII (1930), 382. The tomb discussed in this article was eventually made by Gibbons (see p. 56).

15. F. Thompson, *History of Chatsworth* (1949), 36, 67, 86, 91, 124, 126.

16. *Wren Soc.*, V, 22. It is, however, possible that the statues on the tower of the chapel of Trinity College, Oxford (built between 1691 and 1694), are his (*R.C.H.M. Oxford* (1939), 110 and plate 52).

17. The statues in the East Terrace garden at Windsor formerly thought to be by Cibber (H. Faber, *op. cit.*, 58, and Gunnis, *Dict.*, 103) are not his (A. Scott-Elliot, 'The Statues by Francavilla in the Royal Collection', *Burl. Mag.*, XCVIII (1956), 77).

p. 51 18. E. Wind, 'Julian the Apostate at Hampton Court', *Journ. W. and C.I.*, III (1940), 127.

19. *Wren Soc.*, XV, 38, 50, 62.

20. Lead figures of Faith, Hope, and Charity at Copenhagen from the outside of the Danish Church (now destroyed) in Wellclose Square, said to have been designed by Cibber in 1694 (Faber, *op. cit.*, 61), are probably from his studio, but of the wooden figures retained in the Danish Seamen's Mission church in Poplar only two, the Moses and the St John the Baptist, could conceivably be his. The St Peter and the St Paul show stronger links with wood sculpture in Antwerp than with any of his work.

21. For instance, the work at Chatsworth is now known to be by Samuel Watson (F. Thompson, *op. cit.*, 36, 125–7, 135, 149–50, etc.). The problem will be discussed in the forthcoming book on Gibbons by David Green.

p. 52 22. Vertue, V, 59.

23. J. Evelyn, *Diary*, 18 January; 1, 8, and 19 March 1671.

24. Reproduced in *Country Life*, LVIII (1925), 694. A similar relief after Rubens's Battle of the Amazons, with an almost identical frame, is at Warwick Castle.

p. 53 25. Though still in the artist's studio at the time of his death, it was probably an early work, since Vertue says it was made at Deptford, and Gibbons moved to Bow Street, Covent Garden, in 1677 (Vertue, V, 34).

26. Vertue, i, 125.

27. *Wren Soc.*, V, 52 and plate xliii. Wren's estimate for the building includes £5,000 for the group, the number of figures being specified. It appears that Wren may not have known who was to execute the work, since he merely quotes £1,500 as a gratuity 'for an excellent statuary'. For Windsor Gibbons also made the pedestal of the equestrian statue of Charles II (W. St John Hope, *Windsor Castle* (1913), 1, 318–20), given by Tobias Rustat, Yeoman of the Robes (J. Evelyn, *Diary*, 24 June 1680). The statue is signed on the hoof 'Josias Jback Stadti Blarensis 1679 fudit', but the designer is unknown. Wren, in 1682 (*Wren Soc.*, V, 22), stated that 'the horse at Windsor was first cut in wood by a German and then cast by one Ibeck a founder in London'. Wren might possibly have thought Gibbons was German, but had he designed the statue, Evelyn would surely have recorded it.

28. *Memoirs of the Verney Family*, ed. M. M. Verney, IV (1899), 235. The work is damaged and badly restored, but the quality can never have been high.

29. Both Arnold's father and his cousin who p. 54 worked in Antwerp signed themselves Artus, but are also recorded in contemporary documents as Arnoldus (T. Levin, 'Handschriftliche Bemerkungen von Erasmus Quellinus', *Zeitschrift für bildende Kunst*, XXIII (1888), 174). The son of Artus I (with whom we are mainly concerned) appears as Arnold in the Wardens' Accounts of the Grocers' Company (1681/2), but is referred to as 'Artus III' in J. Gabriels, *Artus Quellien de Oude* (Antwerp, 1930), 268. The spelling of the surname gave much trouble in England, and appears in various documents as Colein, Collen, Collynes, and Queline, while he himself wrote Quiling. Arnold's younger brother, Thomas, also came to England (Vertue, iv, 35), and in 1689 was making wooden figures for the royal armoury (N. Blakiston, 'Notes on British Archives, iv', *Burl. Mag.*, XCIX (1957), 57). He left shortly for Denmark and subsequently worked in Germany.

30. Arnold appears in 1678 as servant to John Vanderstaine, carver, who made an elaborate royal throne, with large figures of Slaves, a Justice, and two Fames (Gunnis, *Dict.*, 407), and in 1679 as servant to Gibbons (N. Blakiston, *loc. cit.*).

31. The Cash Book at the Royal College of Physicians for 1683 records the payment of £80 to Quellin (he had received £83 from the Grocers' for their Cutler), but does not specify for what the payment was made. Some years before (5 February 1674/5), Hooke, the architect of the College of Physicians, had spoken to Pierce about a statue of Cutler (*Diary of Dr R. Hooke*, ed. H. W. Robinson and W. Adams (1935), 145), but there is no evidence that this was carried out, and the two Physicians' figures are now so weathered that attribution is useless.

32. M. D. Whinney and O. Millar, *op. cit.*, plate 72A. The family name is, and always has been, Thynne. It is difficult to know why the inscription shows 'Thynn'.

33. N. Luttrell, *A Brief Historical Relation of State Affairs, 1678–1714* (ed. 1857), 1, 164.

34. Vertue, iv, 25. p. 55

35. E. Chamberlayne, *Angliae Notitia* (ed. 1687), pt ii, 301.

36. Louis XIV liked the figure so much that the patron, the Marshal de la Feuillade, gave it to him,

and it was taken to Versailles in 1683. A different statue of the king being crowned by Victory was set up in the Place des Victoires in 1686. The head of the Versailles figure was renewed in 1816. P. Lami, *Dictionnaire des sculpteurs français; Règne Louis XIV* (1906), 151; L. Hautecoeur, *L'Architecture classique en France* (1948), II, ii, 604.

37. Vertue i, 61, 106; iv, 50 (with the towns reversed). *Ibid.*, v, 58 for the contract with Rustat. Laurens is identifiable with Laurens van der Meulen of Malines, who appears among the foreigners working at Windsor, and who returned to Flanders in 1691.

On the other hand, Vertue's further statement (i, 89) that the James was made by Thomas Bennier has recently been supported by the inscription on a drawing by William Stukeley, dated 1722 (sold Sotheby's, 19 February 1963, Lot 412). Since Thomas Bennier (Beneir or Besnier), perhaps a son or younger brother of Peter (see p. 39), is known as a modeller in wax (Gunnis, *Dict.*, 50), he may either have made a small model, or had some hand in the casting. The situation encourages caution over the tangled subject of Gibbons's studio. Five B.M. drawings (E. Croft-Murray and P. Hulton, *Cat. British Drawings*, I (1960), i, 333–6; ii, plates 135–6) perhaps but not certainly by Gibbons are studies related to both the Chelsea Charles II and the James II, and possibly to the lost Royal Exchange figure. It is therefore likely that all three were close in date. No contemporary evidence has been traced for the oft-repeated statement that the Chelsea Charles II was erected at Whitehall and moved to Chelsea after his death in 1685. P.R.O. *Chelsea Accounts*, 1466, No. 5 (1687–92) record that the statue was brought out of 'the Hall' (i.e. at Chelsea) and set up in the court; a misreading of this may account for the error.

38. K. A. Esdaile, 'Arnold Quellin's Charles II', *Archit. Review*, CII (1947), 174. He also made four other figures for the Royal Exchange (now lost): Henry VI for the Armourers'; Henry VII for the Tallow Chandlers'; Edward IV for the Ironmongers'; and Edward V for the Leathersellers' (K. A. Esdaile and M. Toynbee, 'More Light on "English" Quellin', *Trans. London and Middlesex Arch. Soc.*, XIX, pt i (1956), 34).

39. J. Evelyn, *Diary*, 29 December 1686. See also *Wren Soc.*, VII, 238; XI, plate xxix.

56 40. The chapel was dismantled after James's flight in 1688, but the sculpture, after being sent to Hampton Court for use in the chapel, was given by Queen Anne to Westminster Abbey. The angels and cherubs were made into an altar (see engraving from Neale's *Westminster Abbey* (1822), reproduced in *Wren Soc.*, VII, 236), which remained until the nineteenth century, but the statues were not included (Vertue, iv, 57).

41. The contract appears first to have been given to Cibber (see p. 247, Note 14), but Gibbons was paid £100 for two tombs in 1686 (*H.M.C. Rutland MSS.*, II, 67), possibly as an interim or a final payment. For the Exton tomb, see Vertue, iv, 25, where the very high price of £1,000 is recorded.

42. M. D. Whinney and O. Millar, *English Art, 1625–1714* (1957), 176.

43. Since it was given by an anonymous donor, no bills are in the parish records, nor does Gibbons's name appear there in connexion with it (*L.C.C. Survey of London*, XXIX (1960), i, 45; ii, plate 23). The attribution to Gibbons rests on the title of George Vertue's engraving of 1717, which shows the font with an elaborate cover having a large flying angel. p. 57

44. R. Willis and J. W. Clark, *Architectural History of the University of Cambridge* (1886), II, 546; M. D. Whinney and D. Millar, *op. cit.*, plate 70C.

45. Gunnis, *Dict.*, 168 and plate x.

46. *Wren Soc.*, V, frontispiece. The drawing at All Souls College, Oxford, shows two alternatives, one with twisted columns which seem in this decade to have returned to favour, for they were used by Wren for the baldacchino of St Paul's, and by Nost in the Windham tomb at Silton, Dorset (c. 1692).

47. E. Croft-Murray and P. Hulton, *Cat. British Drawings*, I (1960), i, 333; ii, plate 137.

48. Almost identical figures may be seen in a design for the decoration of the Saloon at Blenheim with statues in niches of about 1707 (D. Green, *Blenheim Palace* (1951), plate 30).

49. The tomb was erected in St George's Chapel, Windsor, and moved to Badminton in 1874.

50. The admiral rose from cabin boy and gained great distinction in the French wars, especially in the Battles of Beachy Head and La Hogue and the capture of Barcelona in 1705. He was lost with four ships in a fog off the Scilly Isles in 1707. (M. D. Whinney and O. Millar, *op. cit.*, plate 72B.) p. 58

51. J. Addison, 'Reflections in Westminster Abbey', *Spectator*, No. 26, 20 March 1710/11. A tomb with a similar naval relief erected by Lady Shovell to Sir John Narborough (Knowlton,

Kent), Sir Cloudesley's old commander, is probably by Gibbons. Other late works which show the same clumsy classicism are the tomb of Lady Newdigate (1693, Harefield, Middlesex), Mary Beaufoy (1705, Westminster Abbey), and James Brydges, Duke of Chandos (1717, Whitchurch, Middlesex). For the last see C. and M. I. Baker, *James Brydges . . .* (1949), 413.

p. 58 52. M. D. Whinney, *Grinling Gibbons at Cambridge* (1948), 25.

53. Described in Strype's ed. of Stow's *Survey of London* (1720), II, bk. vi, 89.

p. 59 54. According to the *D.N.B.* Rustat had the monument in his house for eight years before his death. The death date was clearly added to the inscription, since it is out of centre and in a slightly different lettering from the rest. The Ferrars monument (Tamworth, Staffordshire) has features in common with the Rustat, and though ordered from Gibbons may well have been cut by Quellin (D. Stewart, 'Some unrecorded Gibbons Monuments', *Burl. Mag.*, CV (1963), 125).

55. I have to thank Mr Gunnis for details of these contracts, which are in private possession.

56. A drawing for the Admiral Churchill monument and a letter from Gibbons about it are in the Westminster Public Library (*Wren Soc.*, XV, plates xciv, xcv). Another documented monument without figures is that to Dorothy, Lady Clarke (d. 1695, Fulham, London).

57. For further lists of these commissions see Gunnis, *Dict.*, 169. The small number of commissions for standing figures after Quellin's death is revealing. Before 1686, in addition to the works already discussed, Gibbons had made four further figures for the Royal Exchange, i.e. Queen Mary I, Edward VI, James I, and James II, mutilated fragments of some of which may survive in the garden of Purbeck House, Swanage, Dorset. His rare later figures include the Sir John Moore (1698) for Christ's Hospital (now re-erected at Horsham), over which there was a good deal of trouble because of the poor likeness (*Wren Soc.*, XI, 77), and the Sir Robert Clayton (1701, London, St Thomas's Hospital), which is less inept than some of his work, though it is perhaps significant that Clayton did not choose Gibbons to make his own tomb (see p. 47).

58. He first appears as John Oastes, servant to John Vanderstaine (see Note 30), his fellow-servant being Arnold Luellan (Quellin) (Gunnis, *Dict.*, 407; N. Blakiston, 'Notes on British Archives, iv', *Burl. Mag.*, XCIX (1957), 57). His name was in all

probability Van Ost, but it soon became anglicized, and he signs himself 'Nost'. His marriage to Quellin's widow is recorded by Vertue, iv, 35.

59. See p. 248, Note 29. For N. van den Eynden, p. 6
J. Gabriels, *Artus Quellien de Oude* (1930), plate lx.

60. G. Beard, *Country Life*, CXI (1952), 1408. He is previously recorded as a carver of wooden horses for the royal armoury in the Tower of London (N. Blakiston, *loc. cit.*). A monument of about the same date which may well be his work is that to Sir John Roberts (d. 1692, Bromley-by-Bow, St Mary; *R.C.H.M. East London* (1930), plate 93).

61. Statues of King William and Queen Mary were ordered in January 1694/5 and set up in October of that year (N. Luttrell, *A Brief Historical Relation of State Affairs, 1678–1714* (ed. 1857), iii, 532). They were lost in the Royal Exchange fire of 1838, but the terracotta models are in the V. and A. (K. A. Esdaile, 'A Statuette of William III at South Kensington', *Burl. Mag.*, LXXVI (1940), 123).

62. For the drawings in the B.M. and the Soane Museum, see E. Croft-Murray and P. Hulton, *Cat. of British Drawings*, I (1960), i, 451–5; ii, plates 242–5; *Wren Soc.*, XVII, plates xxii–xxiv (wrongly ascribed to William Talman). Further unpublished drawings are in the V. and A. The style of draughtsmanship is quite un-Flemish, and appears to be identical with that of the Ashmolean Museum drawing for Pierce's bust of Hamey.

63. C. Gilbert, 'A Newly Discovered Monument by John Nost in Leeds', *Leeds Art Calendar*, L (1962), 4; *ibid.*, LI (1963), 4. I am grateful to Mr Gilbert and Mr Geoffrey Beard for information about this tomb.

64. The tomb was reset in 1961 and the relief removed.

65. Sir John Withers was a member of the Fishmongers' Company, so his son who erected the monument might well have given the commission to Pierce, whose work for the Company would have been known to him (see p. 46). Another monument of the group is that to Lady Warburton (d. 1693, Chester, St John), for the unusual design of a skeleton holding up a cloth appears in a drawing probably by Pierce at the V. and A. It also has a relief of skulls and leaves, close to but not identical with the Withers and Irwin panels.

66. M. D. Whinney and O. Millar, *op. cit.*, plate 73a. The earl's second wife was Rachel Windham, a member of the same family as Sir Hugh, whose monument at Silton Nost had already made. The

tomb was probably erected in her lifetime, for the inscription recording the date of her death, though in the same lettering as the rest, is more clumsy and looks as if it had been added by a less skilled hand.

67. The decoration, which includes a skull, forms a link with the group just discussed, and the cutting of the earl's head is close to that of the Withers male bust.

p. 61 68. Child had been a member of the Gresham Committee which had ordered the statues of William III, Queen Mary II, and Queen Anne from Nost for the Royal Exchange (see K. A. Esdaile, 'The Royal Sisters, Mary II and Anne in Sculpture', Burl. Mag., LXXXIX (1947), 254). Two other West Country monuments, those of Thomas Strode (d. 1698/9, Beaminster, Dorset) and Charles Steward (erected 1701, Bradford-on-Avon, Wiltshire) are close in style and must be by Nost. An interesting monument at Coxwold, Yorkshire, to the Hon. Henry Belasyse (d. 1647), and his son Thomas, Earl Fauconberg (d. 1700), in which the father, long dead, is shown in classical costume and the son in contemporary dress, may well also be his.

69. Gunnis, Dict., 281, suggests that it was ordered after the death of the duchess in 1709. I am indebted to Mr Howard Colvin for a photograph of the drawing for the tomb (Bodleian Lib. MS. Gough Drawings, a.2.f.132), presumably by Nost, and very different in style from the Pierce drawings discussed in Note 62 above. A wooden model is in the possession of the Duke of Buccleuch; but the baldacchino with twisted columns which stands in front of it was apparently not designed by Nost.

70. Nost carried out a good deal of work in the gardens at Hampton Court, including pedestals for Hubert Le Sueur's bronze figures (see p. 28), which had been moved from St James's. The charming lead groups of boys bearing baskets of fruit on the gateposts at the end of the Board Walk are his.

71. I am indebted to Professor R. Wittkower for help in the identification of these sources. The Cupid shaping his Bow was made for the Prince of Orange (Sandrart, Academie . . ., ed. A. R. Peltzer (1925), 232), and was later in Berlin; the figure with the horn was also in Berlin, but both are known in several versions.

p. 62 72. Since the engravings show the four groups isolated from their settings, it is possible that Nost thought the originals were in the round.

73. Nost executed much garden sculpture else-

where, both vases and figures (see Gunnis, Dict., 280).

74. See Chapters 12 and 13.
Another sculptor, apparently English, who was employed on garden sculpture at Hampton Court and elsewhere was Richard Osgood (worked 1691–1728), but little is certainly known of his work (J. Harris, 'The Building of Denham Place', Records of Bucks, XVI (1957/8), 194; Gunnis, Dict., 284).

CHAPTER 8

1. K. A. Esdaile, 'The Stantons of Holborn', p. 64 Arch. Journ., LXXXV (1928), 157.

2. A terracotta model for the female figure on the tomb of Richard and Isabella Shireburn (1699) is in the V. and A. The payment for this tomb is to Edward Stanton, but he was then only his father's apprentice, so it is almost certain that the design is William's. William was paid for the monument to the younger Richard Shireburn in 1703. A tomb closely similar in style to that of the elder Shireburns is that to Jane Done, Mary Crewe, and Mary Knightley (erected 1698, Tarporley, Cheshire) (F. Crossley, 'The Post Reformation Effigies of Cheshire', Trans. Hist. Soc. Lancs. and Cheshire, XCI (1939), 23, 95, and frontispiece).

3. Even greater conservatism appears in the tomb of Earl Rivers (1694, Macclesfield, Cheshire), with curtains hanging from a straight architrave, and tied to the columns in the same manner as Nicholas Stone's Knyvett monument at Stanwell, Middlesex, of 1623.

4. For Woodman, see p. 129.

5. Cartwright was Master of the Masons' Company in 1673 and again in 1694 (D. Knoop and G. P. Jones, The London Mason in the Seventeenth Century (1937), 38). His documented tombs are those of Sir John Langham (1676, Cottesbrooke, Northamptonshire) and Sir John Lewys (1677, Ledsham, Yorkshire). He also carved four figures of cripples for St Thomas's Hospital.

6. Latham, who worked at St Paul's Cathedral, was a good craftsman, but late in life became so eccentric that even the patient Wren could no longer rely on him (Wren Soc., IV, 73). He was also involved in the curious history of the equestrian figure of Charles II erected by Sir Robert Vyner near the site of the present Mansion House, London, and now at Newby Hall, Yorkshire. This was first commissioned in Rome as a statue of John Sobieski; sufficient money was not forthcoming,

and it was brought to England and transformed by Latham into a Charles II (Vertue, i, 129; Gunnis, *Dict.*, 234).

Abraham Storey, also one of Wren's masons, made the tomb of Lord Crofts (*c.* 1678, Little Saxham, Suffolk) with two recumbent effigies set above each other which show some attempt at animation (Gunnis, *Dict.*, 374 and plate xxiii; D. Knoop and G. P. Jones, *op. cit.*, 21). Among men of this class outside London Samuel Carpenter of York (1660–1713) made the monument to Lady Elizabeth Stapleton (1683, Snaith, Yorkshire) with a large impassive bust, and was later to execute much of the architectural ornament at Castle Howard (Gunnis, *Dict.*, 82; J. B. Morell, *York Monuments* (n.d.), 39 and plate xxv).

p. 65 7. Catterns was in 1678 in the workshop of John Thompson, who carried out decorative carving for Wren (Gunnis, *Dict.*, 89, 391), but it is hard to see why the Earl of Nottingham employed him to make this monument to his friends. Portraits by Carlo Dolci, formerly in the possession of the Finch family and later belonging to Sir Thomas Barlow, were clearly used for the features of Finch and Baines, but the hair and the dress are changed.

8. *Wren Soc.*, XI, 74.

9. See p. 74.

10. K. A. Esdaile, Note 1 above and 'Some Annotations on John Le Neve's "Monumenta Anglicana"', *Antiquaries Journ.*, XXII (1942), 176.

11. The monument to Sir John Strode (d. 1707) in the same church, though not signed, must be from the same workshop.

12. Horsnaile (worked *c.* 1700–42) carried out a good deal of masons' work in London. His son of the same name was also a mason and carver (Gunnis, *Dict.*, 209). He used William Stanton's Elmley Castle pattern for Sir Jacob Garrard (*c.* 1730, Langford, Norfolk) but with two standing sons instead of Virtues. Some of his work of this decade, however, suggests he was aware of newer designs (see p. 128).

13. See p. 76. p. 66

14. Stayner's career is mysterious, for he made the tomb of Sir Ralph Winwood (Quainton, Buckinghamshire) in 1691, but nothing else is known until 1714 (Gunnis, *Dict.*, 369).

15. A much earlier Kentish monument, that by Nicholas Stone to Lady Digges (1631, Chilham), has also four seated Virtues and may have suggested the pattern.

16. See p. 47.

NOTES TO PART FOUR

CHAPTER 9

p. 67 1. J. Richardson, 'Discourse on the Science of a Connoisseur', *Works* (ed. 1792), 192, 195.

2. W. T. Whitley, *Artists and their Friends in England*, I (1928), 8.

3. Vertue, ii, 153.

4. See p. 28. References to casts from the antique in England before this date are rare, though the sketch-books of Charles Beale in the B.M. (see p. 245, Note 6) suggest that some, not necessarily made in England, were available, and the catalogue of a sale held at John Nost's house on 17 April 1712 includes a few lead figures such as the 'Faunus' and the Hercules Farnese, which are specified as 'Antick'. Dutch cast-makers about 1710 were selling Laocoon, Mars, Mercury, Apollo, Flora, and a Gladiator, as well as reliefs and busts of Roman emperors (C. von Uffenbach, *Reizen*, II, 369, 420; III, 372, 395, 423, 535, 652). These may well have been available to Antwerp sculptors such as Rysbrack and Scheemakers before they came to England. I am indebted to Dr. K. Fremantle for the above reference.

p. 68 5. J. Addison, 'Remarks on the Several Parts of Italy, 1701–3', *Works* (ed. Bohn, 1901), I, espec. 356 ff.

6. R. L. Brett, *The Third Earl of Shaftesbury* (1951). Much valuable information is to be found in J. Sweetman, *Shaftesbury and the Arts in Eighteenth Century England* (University of London, unpub. Ph.D. thesis, 1955). I am indebted to Dr Sweetman for permission to use his work.

7. Shaftesbury, *Characteristics*, I (1711), 217.

p. 69 8. J. Richardson, 'Theory of Painting', *Works* (ed. 1792), 94.

9. *Idem*, 'Discourse on the Science of a Connoisseur', *ibid.*, 195.

10. L. Cust, *History of the Society of Dilettanti* (1914).

11. J. Evans, *History of the Society of Antiquaries* (1956).

p. 70 12. F. Saxl and R. Wittkower, *English Art and the Mediterranean* (1948), 56; R. Wittkower, 'Lord Burlington and William Kent', *Arch. Journ.*, CII (1947), 151.

13. For a discussion of the complex state of sculpture in Rome, see R. Wittkower, *Art and Architecture in Italy: 1600–1750* (1958), chapter 18.

14. The antique source is almost certainly the tomb of Alexander Severus and Giulia Mammaea in the Capitoline Museum, engraved by P. Santi Bartoli, *Gli Antichi Sepolchri* (1697), plate 81, and used by Montfaucon for his vol. v, plate 23. The tomb as originally ordered seems to have been even larger, with five great statues and one little one as well as the two effigies (L. Pascoli, *Vite de'Pittori, scultori ed architetti moderni* (1736), II, 491. I must thank Mr Gunnis for this reference.

15. Monnot's allegories have strong links with those on Algardi's tomb of Leo XI in St Peter's, though their draperies are more Baroque and their proportions have the elegance of late-seventeenth-century sculpture in Rome, especially that of French artists (see R. Wittkower, *op. cit.*, 288). A similar style was developed in France in the 1690s by Coysevox, notably in the figure of Prudence on the tomb of Cardinal Mazarin (1692).

16. N. Pevsner, *The Buildings of England: London*, I (1957), 263 and plate 40.

p. 71 17. E. Coudenhove-Erthal, *Carlo Fontana* (1930), plates 32, 33.

18. R. Wittkower, *op. cit.*, 290, 379, n. 8. He had also made a design for the tomb of Innocent XI in St Peter's (*ibid.*, 379, n. 18).

p. 72 19. R. Wittkower, *Bernini* (1955), 218.

20. Portrait medallions had been added to the pyramids on the Chigi tombs in 1652 (R. Wittkower, *loc. cit.*).

21. Montfaucon, *Antiquity Explained*, Suppl. (1725), v, plates 122–5.

22. In France the tomb of Turenne, made for Saint-Denis but now in the Invalides, with the Marshal dying in the arms of Victory, and two figures of Abundance and Valour standing at the ends of the sarcophagus, is perhaps the best remaining example. The tomb of François Michel Le Tellier in Saint-Gervais, Paris, which showed his wife sitting at his feet, and two seated Virtues at

the sides, has been mutilated, as has that of the Duc de Créqui, made for the Capucines, but now in Saint-Roch, of which only the effigy remains (F. Ingersoll-Smouse, *La Sculpture funéraire en France* (Paris, 1912), 50, 51). The figure of the wife on the Le Tellier tomb, not recorded by F. Ingersoll-Smouse, is described in the Rev. W. Cole, *A Journal of my Journey to Paris in 1765* (ed. F. G. Stokes, 1931), 176. The Créqui and the Turenne both had pyramid backgrounds. For a Flemish example, see H. Gerson and E. H. Ter Kuile, *Art and Architecture in Belgium: 1600–1800* (1960), plate 14a. Other examples could be quoted.

p. 72 23. It is not without significance that the only bust commissioned by an Englishman in Italy about the turn of the century, that of the 5th Earl of Exeter by Pierre Monnot (Burghley House, Stamford), is in antique dress. The cutting is entirely Baroque, but the close-cropped hair in the antique fashion is unknown in Italian busts, and must have been used on instructions from the sitter (H. Honour, 'English Patrons and Italian Sculptors', *Connoisseur*, CXLI (1958), 220). The work was sent to England soon after completion; but it is hard to say how influential it may have been.

p. 73 24. Examples are legion, and can be studied in A. Michaelis, *Ancient Marbles in Great Britain* (1882), and F. Poulsen, *Greek and Roman Portraits in English Country Houses* (1923), though the latter is primarily concerned with authentic examples.

25. Vertue, iii, 45.

CHAPTER 10

p. 74 1. Vertue, iii, 45.

2. Bird seldom signed and dated his monuments. For information about them we are chiefly dependent on Vertue, who knew him, and on a relatively short list of his works, which he gave to the antiquary John Le Neve, and which appears in the latter's *Monumenta Anglicana*, 5 vols (1717–19). See K. A. Esdaile, 'Some Annotations on John Le Neve's "Monumenta Anglicana"', *Antiquaries Journ.*, XXII (1942), 176.

3. Vertue, iii, 18, 34. It is difficult to identify Bird's Flemish master. Thieme-Becker, *Künstlerlexikon*, records a Jan Cosyns who worked on the funerary chapel of the Counts of Thurn and Taxis in the church of the Sablon at Brussels, and a Henry Cosyns who had worked in England (where nothing of him is known) and died in Brussels in 1700. No records appear to exist of any work of the

latter. Pierre Le Gros did not go to Rome until 1690, and became a Master there in 1696. Vertue may perhaps have confused Bird's first two journeys.

4. *Cal. S.P. Dom., July–Dec., 1695*, 78.

5. *John Talman's Letter Book* (Bodleian, *MS. Engl. Letters*, e. 34), 193.

6. Vertue, iii, 18; *R.C.H.M., Westminster Abbey* (1924), plate 97.

7. *Ibid.*, v, 72.

8. *Wren Soc.*, xv, 146. p. 75

9. H. Walpole, *Anecdotes of Painting*, ed. Wornum (1888), II, 253.

10. The original, much weathered, is at Holm- p. 76 hurst near Hastings, Sussex (Gunnis, *Dict.*, 54). Conrad von Uffenbach, who visited the workshops at St Paul's in June 1710, saw the small model in plaster and wood, and the large statues partly finished (*London in 1710, from the Travels of Z. C. von Uffenbach*, trans. W. H. Quarrell and M. Mare (1934), 35).

11. For the Roman type, see R. Wittkower, *Art and Architecture in Italy: 1600–1750* (1958), 207. Both Bird's monuments are listed in Le Neve's first volume, which records works set up between 1700 and 1715. The monument at Goudhurst, Kent, to William Campion (d. 1702) has a lively bust with hands, and though not signed, must surely be by Bird.

12. Mrs K. A. Esdaile repeatedly stated (*Records of Bucks*, xv (1947), 34, and elsewhere) that she had proof that the work was by Bird. Inquiries and a search in family papers have failed to reveal her authority; but the style seems conclusive. The tomb has no inscription, perhaps because the 2nd Duke died suddenly in 1711 and was succeeded by a child, and it cannot therefore be precisely dated.

13. Again in Le Neve, I, though not under p. 77 Bird's name. Both, however, are signed.

14. In *A Book of Architecture*.

15. The Dr Robert South repeats the rectangular Busby base, but its position suggests it was made as a pair.

16. K. A. Esdaile, *Johnson's England*, II (1952 ed.), 72, states that there is a receipt for £50 for it at Welbeck.

17. Vertue, ii, 50 and Gibbs, *loc. cit.*, 111. Early-nineteenth-century writers – J. T. Smith and R. Redgrave – state that Rysbrack was also employed on the monument but there appears to be no con-

temporary evidence for this (M. I. Webb, *M. Rysbrack* (1954), 49).

p. 78 18. Vertue, iii, 108.

19. *Ibid.*, 43.

20. Among them are the Cardinal Wolsey on Tom Tower, statues for the Clarendon Building, and a Henry VI at Eton College (Gunnis, *Dict.*, 54). None is very distinguished.

21. Vertue, iii, 49.

CHAPTER 11

p. 79 1. Vertue, i, 91, 101 and iii, 106. Vertue is mistaken in referring to him as 'Francis'; he signs 'D. Plumier'.

2. *Book of Architecture* (1728), 116.

3. G. Keller-Dorian, *Coysevox* (1920), I, 22 and plates 31, 32. The tomb of François Michel Le Tellier also had a reclining effigy with the widow seated at his feet (see p. 253, Note 22).

p. 80 4. See H. Gerson and E. H. ter Kuile, *Art and Architecture in Belgium: 1600–1800* (1960), 43 and plate 28A.

5. A few other works, including a Hercules, a Time and Truth, and a Reclining Venus, are recorded as having been made in England, but none is apparently extant (Gunnis, *Dict.*, 309).

6. M. I. Webb, 'Giovanni Battista Guelfi', *Burl. Mag.*, XCVII (1955), 139, 260.

7. Letter printed by Mrs Webb, *loc. cit.*, 140.

p. 81 8. Among others by Henry Cheere in 1728 (Mold, Flintshire; see p. 99); by Rysbrack in 1749 (Sherborne, Gloucestershire; see p. 117); and by William Woodman II, with the original background (*c.* 1741, Cheshunt, Hertfordshire; see p. 130). Many other variants exist.

9. The nearest figure appears to be that of the cross-legged Mercury with his hand on his hip (Uffizi Inv. 250) which has been in Florence since at least 1550 (G. A. Mansuelli, *Galleria degli Uffizi, Le Sculture*, I (1958), plate 29A). An Apollo leaning on a tree-stump (Montfaucon, I, 25) may also be relevant, but though his head rests, like that of Craggs, on one hand, the other is not on the hip.

10. A terracotta model of the figure is in the Soane Museum.

11. A drawing by Gibbs for a similar monument is in the V. and A., but the architectural detail of the executed work is more in Kent's manner (M. I.

Webb, 'Architect and Sculptor', *Archit. Review*, CXXIII (1958), 330).

12. M. I. Webb, 'Busts of Sir Isaac Newton', *Country Life*, CXI (1952), 216; *ibid.*, *M. Rysbrack* (1954), 147.

13. Vertue, iii, 73. Another monument of which p. 82 the figure at least seems to be by Guelfi is that of Brigadier Michael Richards (d. 1721, Charlton, near Greenwich), for it was erected by his nieces, who were the daughters of James Craggs. It has a stiff figure in contemporary armour, the treatment of the head being close to that of Craggs. Another foreigner working in England from *c.* 1706–22 was the Burgundian, Claude David, who in 1695 had finished Pierre Puget's St Bartholomew in S. Maria in Carignano, Genoa, and was still working there in 1699 (K. Lankheit, *Florentinische Barockplastik, 1670–1743* (Munich, 1962), 149, 306). His best-known work is the monument to the Hon. Philip Carteret (d. 1710, Westminster Abbey) (Gunnis, *Dict.*, plate viii), loosely designed with a small, Berninesque figure of Time. He also made a Prometheus at Narford Hall, Norfolk, and a series of statues now on the stables at Longleat, Wiltshire.

CHAPTER 12

1. For a full account of Rysbrack's life and work p. 83 see M. I. Webb, *Michael Rysbrack* (1954).

2. Verbrecht was also a nephew of Michael Rysbrack's master, Vervoort.

3. J. T. Smith, *Nollekens and his Times* (1828), II, 111 states that Rysbrack's master was Theodore Balant, who cannot be identified (M. I. Webb, *op. cit.*, 22). The apprenticeship to Vervoort is recorded in C. Rogers, *Prints in Imitation of Drawings* (1778), and is supported by Rysbrack's style.

4. For these see H. Gerson and E. H. ter Kuile, *Art and Architecture in Belgium: 1600–1800* (1960), plates 17, 26, and 27. Vervoort's second tomb at Malines, to Count Prosper de Precipiano (1711), shows even stronger antique influence.

5. M. I. Webb, *op. cit.*, 38. p. 84

6. Vertue, iii, 19.

7. Prior had been Secretary at the British Embassy in Paris, and the bust is said to have been a present to him from Louis XIV (G. Keller-Dorian, *Coysevox* (1920), II, 28 and plate 63).

8. Gibbs, *Book of Architecture* (1728), 112. p. 85

9. Vertue, iii, 17.

p. 85 10. Kneller's own design in the B.M. shows a frontal bust of vaguely classical character, without a cap (E. Croft-Murray and P. Hulton, *Cat. of British Drawings*, 1 (1960), i, 395; ii, plate 181). The executed monument originally had a large drapery falling from a canopy, and stood on the floor at the west end of the north aisle, but was moved to its present position, high up above the monument to Sir Cloudesley Shovell, about 1848.

p. 86 11. No exact prototype known to be in England can be named, but a Caesar at Wilton House, bought by Lord Pembroke in 1720, has a strong resemblance in features and proportions of the head, though the eyes are incised and the dress is not identical (*A Description of the Curiosities at Wilton House* (1786), plate 20). There is no evidence that Rysbrack went to Wilton, but the purchase from the Valetta Collection, of which this was a part, might well have been shipped through London. For the addition of drapery by restorers, see p. 73.

12. For instance the bust of van Caverson in the Musée Royal at Brussels (M. I. Webb, *op. cit.*, plate 5).

13. The Kneller is not dated, but follows the pattern of van Dyck's triple portrait of Charles I sent to Bernini. Nottingham had bought works of art in his youth and built an unusually classical house for its date (1694–1705) at Burley-on-the-Hill, Rutland, but there is no evidence that he collected antiques. He was a moderate Tory, but had joined hands with the Whigs in 1714, becoming Lord President of the Council, and may well have regarded this as an heroic role. He may also have seen Monnot's classicizing bust of the 5th Earl of Exeter (see p. 254, Note 23). It is not known if he commissioned the bust direct from Rysbrack, or if Kneller acted as intermediary.

14. Vertue, iii, 57.

15. Occasionally plaster casts were also made. Some of the terracottas which appear to conform with Vertue's list bear later dates: e.g. the George II at Windsor of 1738 and the Newton in the Library of Trinity College, Cambridge, of 1739. In the latter case a marble had almost certainly been made before 1730 (M. I. Webb, *op. cit.*, 82). It would seem, therefore, that a date on a terracotta is not an infallible record of the first creation of a bust.

p. 87 16. Vertue, iii, 84.

17. M. I. Webb, *Country Life*, cxx (1956), 1182.

18. Another marble without a wig, also signed and dated 1726, is in the Radcliffe Camera, Oxford.

19. Two other standing figures in much the same pose, the George I (finished 1739, Law Library, Cambridge), and the 3rd Earl of Strafford (Wentworth Castle, Yorkshire), were made about this time. The former is a variation from a design by Kent in the V. and A. (M. I. Webb, 'Architect and Sculptor', *Archit. Review*, cxxiii (1958), 330. The Queen Anne in the Library at Blenheim (finished 1738) is also a static figure.

20. Vertue, iii, 70. In 1745 he again visited Stowe p. 88 and gives a fuller list, which in addition to those already quoted, included busts of Pope, Sir Thomas Gresham, Inigo Jones, King Alfred, Edward, Prince of Wales (presumably the Black Prince), Sir Walter Raleigh, Sir Francis Drake, John Hampden, Sir John Barnard (*ibid.*, 133). It is not certain if all were by Rysbrack, but other versions of many are known (M. I. Webb, *op. cit.*, 135 and appendix II for present whereabouts of other versions). Monuments by Rysbrack to Ben Jonson and Milton (1738) are in Westminster Abbey; the latter has a fine bust and the former a portrait in relief. For further discussion of Rysbrack's historical portraits, see K. A. Esdaile, *The Art of J. M. Rysbrack in Terracotta*, illus. cat. to exhib. at Spink and Son Ltd (1932), which also prints letters written by the sculptor in 1756–66 to his patron, Sir Edward Littleton (reprinted M. I. Webb, *op. cit.*, appendix I), giving much interesting information about Rysbrack's working methods and prices.

21. For a discussion of the versions possibly known to Rysbrack, see M. I. Webb, *op. cit.*, 102.

22. Gibbs, *Book of Architecture* (1728), 122, 115.

23. This work, executed by Le Gros, Monnot, and Rusconi, was certainly known to Gibbs. Another tomb, perhaps by Gibbs and Rysbrack, is that to Lord Barnard, at Shipbourne, Kent. A drawing for it by Gibbs is in the Ashmolean Museum, Oxford (Gibbs, iii, f. 86), and the cutting of the two seated figures in contemporary costume suggests the hand of Rysbrack.

24. See p. 93. p. 8

25. For Rysbrack's busts of Newton, and his use of the death mask, see M. I. Webb, *op. cit.*, 78 ff. A fine terracotta sketch of the reclining figure on the monument is in the V. and A.

26. Vertue, iii, 65; D. Green, *Blenheim Palace* (1951), 160.

27. Kent must have known the former, and p. 9 might by this time have heard descriptions of the latter.

28. It is possible that this monument, which has excellent decorative detail, and an unusual form of pyramid, was designed by an architect. Hawksmoor had worked for Lord King, but there is no evidence that he was connected with the monument. It is not signed, but two models were in Rysbrack's Sale in 1767 (M. I. Webb, *op. cit.*, 219).

29. This and the monument to Nicholas Rowe were originally in the south transept, but were removed to the triforium when two important medieval wall-paintings were uncovered in 1936.

p. 91 30. P. Francastel, *Girardon* (1928), plate li.

31. For fireplaces, see M. I. Webb, *op. cit.*, 129 ff.

32. Vertue, iii, 37.

33. *Ibid.*, 61, 66, 72, 75 gives a full account of the making of the clay model, the plaster, and finally of the casting and chasing.

34. Rysbrack had a plaster model of the Girardon (M. I. Webb, *op. cit.*, 141).

CHAPTER 13

p. 92 1. See p. 79.

2. *Nollekens and his Times* (1828), II, 100.

3. M. I. Webb, *M. Rysbrack* (1954), 64, questions the Danish journey, mainly on grounds of time, and suggests that Smith has confused Peter with his brother Henry (see p. 98), who, so far as is known, did not arrive in England until about 1726.

4. Vertue, iii, 36. Flaxman, who when a boy had known Scheemakers, stated in 1805 that he worked for Bird on the pediment of St Paul's, and had also made one of the figures of saints on the parapet (Farington, III, 44).

5. Scheemakers signs first, but of the three extant payments, two are to Delvaux alone and one to 'Delveaux and partner' (Gunnis, *Dict.*, 126).

p. 93 6. G. Willame, *L. Delvaux* (1914), 41, stated that a copy of this rare sale catalogue was in the possession of M. Delvaux de Cartier at Walfergem, Belgium.

7. Vertue's statements are confusing. Chamberlen died in 1728, but when Vertue records the erection of the monument in 1731 (iii, 53) he says one of the standing figures was by Delvaux and the other and the effigy by Scheemakers. But a year before this (iii, 45) he had stated that: 'Mr. Scheemakers had begun a model for a monument to Dr. Chamberlen'. Delvaux's figure must presumably have been made before 1728, and it is possible that Chamberlen had then ordered his tomb and the effigy only was made after Scheemakers's return. The model referred to may be the fine terracotta in the V. and A.

8. Vertue, iii, 44. p. 94

9. See p. 67.

10. It is not possible to be sure in some cases from which versions of these well-known works Scheemakers's casts were taken. He must, however, have drawn on the Vatican collections for the Laocoon; on the Capitoline, the Farnese (which was then still in Rome), and on the Borghese for the 'Egyptian' statue (which Vertue elsewhere calls the 'Zingara'), i.e. the standing figure called Diana (now Louvre, No. 462).

11. Vertue, iii, 44, 139.

12. It and a group of Apollo and Venus, said by G. Willame, *op. cit.*, 41, 53–5, to be a joint work with Scheemakers and which also appears in their 1726 Sale catalogue, were transferred to Stowe at some date before 1773; and the Vertumnus was probably in the Stowe Sale of 1921, though the 1922 Sale catalogue lists it, but illustrates the Apollo and Venus (which by the time it appears at Stowe is wrongly called Venus and Adonis). I have to thank Mr Terence Hodgkinson for this information. In 1957 the Venus and Adonis reappeared in the possession of Mr A. K. Loveday of Ware, Hertfordshire (*Country Life*, CXXII (1957), 267).

13. As late as 1767 Delvaux was paid for carving p. 95 a fireplace for Nostell Priory (M. Jourdain, *English Interior Decoration, 1500–1830* (1950), 54).

14. Vertue, iii, 116.

15. See p. 91.

16. M. I. Webb, *op. cit.*, 135.

17. This bust is close to, but not identical with, p. 96 the bust on the monument in Lamport church, though in reverse. It may have been made about the same time (1737).

18. Vertue, iii, 94. The figure is stone, but coloured in imitation of bronze.

19. The three-quarter length painting now at Windsor is known to have been formerly a full-length, though it is not by Holbein.

20. T. S. R. Boase, 'Illustrations of Shakespeare's Plays in the Seventeenth and Eighteenth Centuries', *Journ. W. and C.I.*, x (1947), 83.

21. Vertue, iii, 101. Dr Mead, a well-known p. 97 physician, was a great patron of the arts.

22. The reading is unusual, and was perhaps arranged by Pope.

23. The 'Chandos' portrait had been in the hands of actors until the early eighteenth century, when it was bought by James Brydges, Duke of Chandos. In 1740 it belonged to the latter's son-in-law, the Duke of Buckingham. Kneller had copied it for Dryden (this copy was used by Rysbrack); Vertue engraved it, and Reynolds copied it for Roubiliac.

24. Rysbrack's Shakespeare, for which he also used a cast of the Gerard Johnson bust on the Stratford-on-Avon monument, is in the collection of Mrs Alston-Roberts-West; Roubiliac made several variants, including a statue for Garrick, and a terra-cotta bust (B.M.). Scheemakers later made casts from his model for the monument (see letter of 1749 from John Smibert to Arthur Pond, saying that the sculptor had given him one, in W. T. Whitley, *Artists and their Friends in England*, I (1928), 65).

CHAPTER 14

p. 98 1. M. I. Webb, 'Henry Cheere, Henry Scheemakers and the Apprenticeship Lists', *Burl. Mag.*, XCIX (1957), 115; *ibid.*, 'Henry Cheere, Sculptor and Businessman and John Cheere', *loc. cit.*, C (1958), 232, 274.

2. Vertue, iii, 122. Mr Rupert Gunnis has kindly informed me that in the will of Sir John Chardin, Bt, of 1755, Henry Cheere is referred to as 'my cousin'. The relationship cannot have been very close, but Sir John's father was among the most distinguished of the Huguenots settling in England after the Revocation of the Edict of Nantes in 1685. Further, Cheere's wife, Helen, the daughter of Sauvignion Randall, may well have been of Huguenot descent.

3. Hartshorne had himself been trained in the Stanton workshop. His major monument, that to Sir Thomas Powys (1720, Thorpe Achurch, Northamptonshire) (Gunnis, *Dict.*, plate xiii), uses the Stanton pattern of a reclining figure and standing Virtues with considerable liveliness and competence.

4. M. I. Webb, *loc. cit.*, 119. It is possible that Cheere had had some connexion with the elder Nost after he had finished his apprenticeship. Mrs Esdaile stated (verbally) that she had proof of this, but never published her source. Cheere's style makes this not impossible.

5. Gunnis, *Dict.*, 341.

6. Mrs Webb (*loc. cit.*) notes that Scheemakers p. 99 signs the Page monument *fecit*, but the Bradbury *invent et Fecit*, and suggests that Cheere may have designed the former. She also records the interesting fact that in the Page an *L* is cut on the soles of both left feet, as a guide to the local masons who were to set it up.

7. It was designed by Westby Gill, the Deputy p. 100 Surveyor General, a drawing for it being among the Wilson Filmer Archives, Kent County Archives.

8. E. K. Waterhouse, *Painting in Britain: 1530– p. 101 1790* (1953), 131 and plate 101.

9. K. Downes, *Nicholas Hawksmoor* (1960), frontispiece.

10. Roubiliac was probably in Cheere's workshop at the time (see pp. 102–3) and may possibly have had some hand in this bust.

11. Two monuments to the Borrett family at Shoreham, Kent, are before 1740, and so is that to Sir Alexander and Lady Denton at Hillesden, Buckinghamshire.

CHAPTER 15

1. The *Dictionnaire des artistes lyonnais*, II (1919), p. 102 gives his birth date as 31 August 1702; at the time of his marriage in 1735 he gave his own age as thirty. Vertue, iii, 84 (writing in 1738), states that Roubiliac was a Frenchman born in Switzerland, but had been many years in France; *ibid.*, 145, that he was born in Normandy; and *ibid.*, 152, that he was trained at Liège. There is no doubt that the family was Lyonnais, and Vertue's statements are so conflicting that it is easier to credit none of them and to assume that the sculptor was born in Lyons. The name appears as Roubillac in some French documents, but on the many signed works it is always Roubiliac. The chief modern work is K. A. Esdaile, *L. F. Roubiliac* (1928), a full biography which is controversial at many points.

2. J. T. Smith, *Nollekens and his Times* (1828), II, 96.

3. A. de Montaiglon, *Procès-verbaux de l'Académie Royale, 1648–1793*, V (1875–1909), 76, 89.

4. Mrs Esdaile, accepting family tradition that he made the Wrighte monument (before 1725, Gayhurst, Buckinghamshire) and the Dormer monument (*c.* 1726, Quainton, Buckinghamshire), assumed he was in England by the mid 1720s, which is difficult to reconcile with his presence in France in 1730 and 1731. The Wrighte monument

appears to be good mason–sculptor's work; the Dormer, much finer, is more puzzling, but neither the style nor the date make it acceptable as a work of Roubiliac.

5. See p. 128. Thomas Carter's signed monument of Sir Cecil Wray (d. 1736) at Bramston, Lincolnshire, has a good bust *en negligé* which could perhaps have been cut by Roubiliac.

6. J. Northcote, *Memoirs of Sir Joshua Reynolds* (1813), 29; J. T. Smith, *op. cit.*, II, 93, 96; A. Cunningham, *Lives* (1830), III, 33 f.

7. For the possibility that Roubiliac had some hand in Cheere's bust of Nicholas Hawksmoor, see p. 258, Note 10. The monument to Bowater Vernon (d. 1735) at Hanbury, Worcestershire, ascribed by Mrs Esdaile (*op. cit.*, 56) to Roubiliac, might well also have been produced in Cheere's studio. On the other hand, an almost identical figure of Sir George Cooke (d. 1740) now at Stoke Park, Northamptonshire, and formerly in the gardens of Harefield House, Middlesex, has reliefs on the base which are very close in style to Roubiliac's relief on the Argyll monument at Westminster, designed in 1745.

8. It has frequently been stated, following K. A. Esdaile, *op. cit.*, 40, that Roubiliac was paid the large sum of 300 guineas for the work. This sum is mentioned in the *London Daily Post*, 18 April 1738, as the probable cost of the statue and a marble niche, but the latter was never executed and the figure was set up in a 'kind of alcove of verdure' and later moved to the centre of the semicircle of supper-boxes. The exact cost of the statue itself does not seem to be known.

9. For Gravelot see T. S. R. Boase, 'Illustrations to Shakespeare's Plays', *Journ. W. and C.I.*, x (1947), 89; E. K. Waterhouse, 'English Painting and France', *Journ. W. and C.I.*, xv (1952), 128; idem, *Painting in Britain: 1530–1790* (1953), 136–7.

10. K. A. Esdaile, *op. cit.*, 40.

11. These sitters are recorded in Vertue, iii, 105. The terracotta of Handel at the Foundling Hospital has been painted over and appears at first sight to be plaster. I am indebted to Mr John Kerslake for information concerning its material. The small unsigned terracotta of Handel at the N.P.G., thought by Mrs Esdaile to be the model for the Windsor marble, is of a different pattern. The bust of Isaac Ware, included in Vertue's list, appears to be lost (H. Colvin, 'Roubiliac's Bust of Isaac Ware', *Burl. Mag.*, XCVII (1955), 151).

12. Vertue, iii, 105.

13. Mrs Esdaile, *op. cit.*, 47, was mistaken in her assumption that the terracotta, then in the possession of Mr A. H. Hallam Murray, was dated 1741. No record appears to exist of Pope's sitting, nor is it certain by whom a bust was originally commissioned. The Temple Newsam version (1738) has no history earlier than 1932, when it was in the possession of the late Mr G. D. Hobson at 1, Bedford Square, London (*Country Life*, LXXI (1932), 152), then sold at Sothebys (17 November 1933, lot 63). This and Lord Fitzwilliam's bust (1740), also unrecorded until this century, might be the two marbles listed in Roubiliac's sale (K. A. Esdaile, *op. cit.*, 185). The Gateshead bust, formerly in the possession of Lord Lambton, was in the possession of the Garrick family in the eighteenth century, but is unlikely to have been commissioned by the actor in 1741, when he was still making his way. Lord Rosebery's bust (1741), which retains its original polish to a greater degree than any of the others, is said to have been commissioned by Lord Bolingbroke, though the first record of it is in a sale of 1795. A plaster, also based on Mrs Copner's terracotta, is among those given to the B.M. by Dr Maty (see p. 111). The lettering of the inscriptions on the four marbles is not identical, but the quality of all four is so high that they can hardly be studio work. Moreover it is unlikely that Roubiliac would have had assistants at this early date. I have to thank the Countess of Rosebery, Lady Proby, Mr Terence Hodgkinson, and the staff of the National Portrait Gallery for help and information.

14. F. Ingersoll-Smouse, *La Sculpture funéraire en France au xviiiᵉ siècle* (1912), 33 ff.

15. Asymmetrical designs comparable in date are J. B. Lemoyne's tomb of Mignard (begun 1735, engraved 1743) in the Jacobins, Paris, and Michel-Ange Slodtz's tomb, made in Rome, for the Cardinal de la Tour in 1747 in the cathedral of Vienne.

16. Vertue, iii, 148. According to Joseph Wilton Roubiliac asked £1,200 for the monument, was paid an additional £200, but still lost £300 by the commission beyond his labour (Farington, I, 133).

17. Roubiliac is known on two occasions only to have worked from an architect's designs, i.e. in the monuments to Bishop Milles (d. 1740), now in the new church at Highclere, Hampshire, and to Lady Lyttelton (erected 1748) at Hagley, Worcestershire. Both were designed by Sir Charles Frederick, but neither is very distinguished (M. I. Webb, 'Architect and Sculptor', *Archit. Review*, CXXIII (1958), 329).

p. 106 18. N. Pevsner, *Buildings of England: London*, I (1957), 386.

19. M. I. Webb, 'The French Antecedents of L. F. Roubiliac', *Gaz. des Beaux-Arts*, 6th ser., XLIX (1957), 84, links the figure of Pallas with Tuby's Abundance on Colbert's monument in Saint-Eustache, Paris.

20. Vertue, iii, 148.

21. *Ibid.*, 145.

22. Cunningham, *Lives*, III, 46.

p. 107 23. F. Ingersoll-Smouse, *op. cit.*, 115 ff.

24. E. K. Waterhouse, 'English Painting and France in the Eighteenth Century', *Journ. W. and C.I.*, XV (1952), 122.

25. K. A. Esdaile, *op. cit.*, 72, states that he wept when he saw how his work was skied, but gives no source.

26. Models for both, found in the triforium of Westminster Abbey, are now in the Abbey Muniment Room, and a further model for the duke's monument is in the V. and A. The supervision of the duke's monument was left to Dr Martin Folkes, the duchess taking no interest in the design (Letter of 8 September 1750, B.M. Add. MSS. 35397).

p. 108 27. Vertue, iii, 162.

28. *Ibid.*, 161.

29. J. Northcote, *op. cit.*, 44.

30. A play of convex against concave curves appears, however, in the pedestal of the Duke of Montagu's monument, before the Roman journey.

p. 109 31. The seated female figure is repeated almost exactly on the sculptor's monument to George Lynn (d. 1758) at Southwick, Northamptonshire, below a pyramid with a medallion portrait.

32. K. A. Esdaile, *op. cit.*, 116; M. I. Webb, *loc. cit.*, 85. The two figures in the Le Brun design (executed by J. Collignon and J. B. Tuby) appear always to have been set against the wall and somewhat loosely connected. For early descriptions of the tomb, which apparently had no pyramid background, see G. Brice, *Histoire de Paris* (1742), IV, 714; Rev. W. Cole, *A Journal of my Journey to Paris in 1765* (1931), 189.

p. 110 33. J. Wesley, *Journal*, 16 March 1764; 25 March 1771 (quoted in full in K. A. Esdaile, *op. cit.*, 157).

34. See Chapter 18.

35. The terracotta model for the executed work is in the Ashmolean Museum; another recently discovered terracotta (Gerald Coke Collection) shows the first design to have been more intimate and less

theatrical, with an unflattering figure of Handel in profile with a pen in his hand (M. D. Whinney, 'Handel and Roubiliac', *Musical Times*, February 1961).

36. K. A. Esdaile, *op. cit.*, 48, 103, and for the Sale p. 11: Catalogue, 218. The British Museum was founded in 1753.

37. For his methods, see M. I. Webb, 'Roubiliac Busts at Wilton', *Country Life*, CXIX (1956), 804.

38. *Ibid.* The Fountaine, of which there is a terracotta at Narford, Norfolk, is signed and the bill for £30 for the marble is at Wilton. The 9th Earl of Pembroke is not signed, but there is a bill for the monument with a similar bust in Wilton church. Another replica is in the City Art Gallery, Birmingham (Plate 88).

39. Vertue, iii, 152. p. 11

40. At Dettingen, 1743.

41. M. I. Webb, 'The French Antecedents of p. 11 L. F. Roubiliac', *Gaz. des Beaux-Arts*, 6th ser., XLIX (1957), 86.

42. K. A. Esdaile, *Roubiliac's Work at Trinity College, Cambridge* (1924), 37. Terracotta models for five of the ten busts – Ray, Willoughby, Bentley, Barrow, and Cotton – are in the B.M., and there is a further signed marble of Ray in the Saffron Walden Museum, Essex.

43. K. A. Esdaile, 'Two Busts of Charles I and p. 11 William III', *Burl. Mag.*, LXXII (1938), 164.

44. J. V. G. Mallet, 'Some Portrait Medallions by Roubiliac', *Burl. Mag.*, CIV (1962), 153.

45. Both were posthumous portraits. I have not seen the Molyneux and judge it only from photographs.

46. Newton's death-mask was almost certainly p. 11 taken by Rysbrack (M. I. Webb, *M. Rysbrack* (1954), 78), but Roubiliac owned two copies of it, one now at Trinity College and the other in the possession of the Royal Society (K. A. Esdaile, *Roubiliac's Work at Trinity College* (1924), x, 41; *ibid.*, *L. F. Roubiliac* (1928), 170).

CHAPTER 16

1. The most notable commission for busts late in p. 11 his life came from Sir Edward Littleton, for whom between 1756 and 1766 he made a series of English worthies, as well as portraits of the patron and his wife (M. I. Webb, *M. Rysbrack* (1954), app. I, 192, where the letters concerning them are printed in full; for illustrations see Cat. Exhib. Spink and Son,

by K. A. Esdaile, *The Art of Rysbrack in Terracotta* (1932)).

2. W. T. Whitley, *Artists and their Friends in England* (1928), i, 87.

3. Vertue, iii, 115, 121.

4. Vertue states that the statuettes were 'about two feet high'. The Rubens in Lord Harrowby's Collection is 24½ ins., but the two statuettes sold at Sotheby's are 21½ ins. They may not therefore be the originals, but part of one of the sets Rysbrack afterwards made and sold for seven guineas (Vertue, iii, 135). For other versions, see M. I. Webb, *op. cit.*, app. II; and F. J. B. Watson, 'A Bust of Fiammingo by Rysbrack Rediscovered', *Burl. Mag.*, CV (1963), 441, where the known versions are summarized, and a number of busts connected with these statuettes, and close to them in date, are also discussed. For the use of a version of the Duquesnoy with figures of Inigo Jones and Palladio (with the head of Rubens) carved in ivory by Verskovis on the cabinet made for Horace Walpole (V. & A.), see M. I. Webb, *op. cit.*, 112.

5. A marble of the Hercules was ordered by Henry Hoare in 1756 for the temple at Stourhead; Rysbrack left him the terracotta in his will.

p. 117 6. Vertue, iii, 121.

p. 118 7. M. I. Webb, *op. cit.*, 186.

p. 119 8. During the years after 1740 Rysbrack continued to provide reliefs for chimneypieces, including those at Woburn Abbey of 1755 showing the Sacrifices to Apollo and Diana, taken from the Arch of Constantine, and so repeating patterns used at Houghton in the 1730s, and made a fireplace at Hopetoun Hall, West Lothian, in 1756 (M. I. Webb, *op. cit.*, figure 65) which combines motives drawn from Duquesnoy and Antiquity. He also carried out much further work for Henry Hoare at Stourhead, including a statuette of Bacchus, now lost, and a Flora, based closely on the Farnese Flora (terracotta ex-Littleton Collection, sold Spink's, 1932). A fair number of monuments of varying size and importance also date from these years.

9. Mead had apparently also been a direct patron of the sculptor's, for busts of Shakespeare, Milton, Pope, and Alexander the Great, and one of his casts from the antique, were in Mead's sale in March 1755 (Gunnis, *Dict.*, 342).

p. 120 10. The monument of John Bullock (d. 1740) at Faulkbourne, Essex, is a variant of this pattern, with the widow holding an inscribed instead of a portrait medallion.

11. See p. 70. Since, as in the Stamford tomb, the figures are backed by a pyramid, it seems likely that the two are immediately connected, though Scheemakers, like Monnot, would have known the antique prototype for the reclining couple, i.e. the tomb of Alexander Severus and Giulia Mammaea; and also the engravings of it. The unsigned tomb of George and Catherine Strode (after 1753, Beaminster, Dorset) is even closer to the Stamford model. It can confidently be assigned to Scheemakers not only on style, but because Catherine Strode was the daughter of Richard Brodrepp of Mapperton in the same county, whose monument (Plate 67A) he had made in 1739.

12. M. I. Webb, 'Chimney-pieces by Scheemakers', *Country Life*, CXXI (1957), 491. p. 121

13. Prince Hoare (d. 1769), the brother of William Hoare the painter, was in the Scheemakers studio in the early 1740s, and after some years in Italy made a name for himself in the neighbourhood of Bath. It may have been his Italian trip which gave him a taste for coloured marble, and also for a pictorial handling of relief. Both may be seen in his monument to Bishop Maddox (1743, Worcester Cathedral) with its relief of the Good Samaritan. He also made a few busts, as well as garden statues and chimneypieces.

14. For these and other activities see M. I. Webb, 'Henry Cheere, Sculptor and Businessman and John Cheere', *Burl. Mag.*, C (1958), 232, 275.

15. For the various efforts leading ultimately to the foundation of the Royal Academy in 1768, see Chapter 18. p. 122

16. The contract for £600 for this monument is among the Polhill papers in the Public Library, Sevenoaks, Kent.

17. The bill for the second instalment of the £262 due to Cheere from Cholmley Turner's brother has been traced by Mr Gunnis.

18. For Hayward's work, see p. 143. p. 123

19. Cheere's studio continued to produce fireplaces for a considerable number of houses, including Longford Castle, Wiltshire (1741/2), Kirklington Park, Oxfordshire (1746), Kimbolton Castle, Northamptonshire (1747), and Kilnwick Hall, Yorkshire (1752). For a list of his apprentices and a discussion of his workshop, see M. I. Webb, *loc. cit.*

20. M. I. Webb, *Burl. Mag.*, XCVI (1954), 25. The elder John Nost's practice had been, to a large

extent, inherited by his nephew, John II, who seems to have been an unreliable and indolent character (Vertue, iv, 35). He settled in Dublin about 1750, where he executed several commissions (Gunnis, *Dict.*, 282). It is not possible to say if Henry Cheere had any interest in the Hyde Park Corner yard. An order from Henry's patrons, the Fellows of All Souls College, Oxford, in 1749 for twenty-five vases and twenty-four busts for the Codrington Library was executed there and not at Westminster, but possibly Henry had passed this commission on to his brother.

p. 123 21. The 'blackmore' made by John Cheere for Okeover Hall, Staffordshire, in 1743 was probably from Nost's mould.

22. R. Lloyd, 'The Cits Country Box', *The Connoisseur*, iv (1756), 234.

23. J. T. Smith, *Streets of London*, i (1846), 16.

24. Bills remain at Blair Castle for the following, supplied by John Cheere to the 2nd Duke of Atholl in 1754: male and female gardeners and haymakers, Harlequin, Columbine, Pantaloon, Dancing Sailor, seated Dutchman and Dutchwoman, piper, fiddler, and Highland Lassie, the last being the most expensive and costing £33. In the previous year John Cheere had supplied a 'gamekeeper shooting', and sent with it a note saying that it had been 'painted in ye proper colours' and that 'once in two years it should be washed very clean and oyled over with Lintseed oyle'. None of these figures can be identified among the damaged examples still existent at Blair. A gamekeeper painted green, known locally as 'the green man', was, however, until recently in the possession of Vice-Admiral B. C. B. Brooke, whose family came from Perthshire. It may therefore possibly be one of the figures from Blair. Mr R. Hutchison, who has kindly provided this information, states it has been moved to Frome House, near Dorchester.

25. These were the remains of John Cheere's yard. See the chapter on sculpture by M. I. Webb in *Southill, A Regency House* (1951), 54.

26. For a long list of such works made by John Cheere, see Gunnis, *Dict.*, 99 f. Many further bills have since become known, including one of 1762, paid by the architect Carr of York, for busts of Newton and Shakespeare at two guineas apiece for Lord Fairfax's house in York, payments by Sir Matthew Featherstonhaugh for busts (probably those on the staircase at Uppark, Sussex), and one of 1747/8 for busts and lead figures for Alscot Park, Warwickshire.

27. I must thank Mr Gunnis for information about this hitherto unknown bust (and also for particulars of unpublished documents quoted in Notes 16, 21, and 24), and Mrs Tritton of Balcombe, Sussex, for kindly allowing me to have the use of her photograph. The bust is of hard metal, gilt.

28. Dr Peter Murray first drew my attention to p. 12 this statue, and kindly made inquiries for me about it. The hospital also owns a terracotta model of the figure.

CHAPTER 17

1. The number of competent sculptors is con- p. 12 siderable, and not all their known works, which often vary surprisingly in quality, have been photographed. A complete survey is therefore impossible, and only general trends and types will be discussed. For biographical information see the relevant entries in Gunnis, *Dict.*

2. See p. 79 and Plate 54B.

3. The tied canopy, though without the glory, p. 12 had, however, the authority of Gibbs, since it appears in his *Book of Architecture*, 118, and the type of bust is closely paralleled in *ibid.*, 122.

3a. Vertue, iii, 83.

4. Gunnis, *Dict.*, plate iv.

5. Gibbs, *Book of Architecture*, 121.

6. *Ibid.*, 115. Carpentière also made a marble statue of Queen Anne for the Guildhall at Leeds about 1712 (Vertue, iii, 111; K. A. Esdaile, 'The Royal Sisters, Mary II and Anne in Sculpture', *Burl. Mag.*, LXXXIX (1947), 254), and was considered as a maker of statues for St Paul's Cathedral in 1716/17, though no payment for such work appears to be recorded (*Wren Soc.*, XVI, 128). For his work as a maker of garden figures at Castle Howard, Wrest Park, etc., see Gunnis, *Dict.*, 83. He also worked for the Duke of Chandos at Canons (C. H. and M. I. Baker, *James Brydges, 1st Duke of Chandos* (1949), 142, 413).

7. Hardy, who was Master of the Masons' Company in 1711, was one of the sculptors who gave lists of works to John Le Neve (K. A. Esdaile, 'Some Annotations on John Le Neve's "Monumenta Anglicana"', *Antiquaries Journ.*, XXII (1942), 176). He appears to have made little beyond tablets, though a few of his monuments have undistinguished busts.

8. This does not necessarily mean, as Mrs Esdaile concluded (*loc. cit.*), that Palmer had worked with

Monnot in Rome. Indeed, what is known of his early career makes this unlikely (Gunnis, *Dict.*, 287).

9. It appears without comment in the lists published by Le Neve (Esdaile, *loc. cit.*).

127 10. Erected by Bridget, Countess of Rutland. Mr Gunnis has kindly informed me that the contract for £345 6s. is in the Belvoir Archives (No. 377).

11. L. Cust, *History of the Society of Dilettanti* (1914), 31. Sir Francis Dashwood, ancestor of the present owner, was a leading member of the Society (see p. 69).

128 12. Vertue, iii, 161.

13. Cheere's influence may also be seen in a type of which several variants exist, which include a boy, generally with too large a head, and a spray of oak, and a skull (e.g. Joseph Townsend, d. 1763, Honington, Warwickshire).

14. J. Summerson, *Architecture in Britain: 1530–1830*, 4th ed. (1963), 218; H. Colvin, *Dictionary of British Architects, 1660–1840* (1954), 601.

15. The monument was damaged in the Second World War. What remains of the decorative detail suggests the influence of Cheere rather than of Roubiliac. William Halfpenny, alias Michael Hoare (worked 1742–85), is chiefly known as a writer of architectural books (H. Colvin, *op. cit.*, 260).

16. Since the publication of his *Dictionary*, Mr Gunnis's further research has enabled him to trace the death dates of the brothers and to show that the yard was continued by Thomas II (d. 1795), at first with the help of his uncle, Benjamin. The later monuments ascribed to Thomas in Gunnis, *Dict.*, 85, are therefore the work of Thomas II (R. Gunnis, 'The Carters, Georgian Sculptors', *Archit. Review*, CXXIII (1958), 334).

17. See p. 102.

18. John Eckstein (1735–1818) worked in Eng- p. 129 land for some seven years about 1760 and then for Frederick the Great. In 1794 he settled in America (Gunnis, *Dict.*, 139).

19. For Carter's bills and the attributions to Bacon (1789) and Banks (1804) see Gunnis, *Dict.*, 86. The attribution to Bacon, printed in the lifetime of both artists, is perplexing, but the bills seem conclusive, and it is improbable that as late as 1774 Bacon would have been working for another sculptor. The not dissimilar figure of Bernard Brocas (d. 1777, Bramley, Hampshire) may also be by Carter II.

20. Mr Gunnis has kindly informed me that the p. 130 work was begun soon after Lord Newhaven's death in 1728, but was completed by the younger Woodman after the widow's death in 1732, her figure being entirely his work.

21. In the last decade of the century William p. 131 Paty was, like John Bacon, to build up a connexion with the West Indies. For this and for the use of mourning ladies with urns, see pp. 155, 168.

NOTES TO PART FIVE

CHAPTER 18

p. 133 1. For a detailed but prejudiced account of the rise and activities of the Royal Academy, see J. Pye, *Patronage of British Art* (1845). See also N. Pevsner, *Academies of Art* (1940), 183.

2. E. Edwards, *Anecdotes of Painters* (1808), xi; H. T. Wood, *History of the Royal Society of Arts* (1913). Premiums were at first given only to boys and girls, but soon also to more mature artists.

3. W. T. Whitley, *Artists and their Friends in England* (1928), I, 163; E. K. Waterhouse, *Painting in Britain: 1530–1790* (1953), 123, 131.

p. 134 4. E. Edwards, *op. cit.*, xxvi. The somewhat illiterate rendering has been corrected, and accents added, to make it intelligible.

5. They were not held at the rooms of the Society of Arts after 1764 (*ibid.*, xix).

6. S. Hutchison, 'The Royal Academy Schools, 1768–1830', *Walpole Soc.*, XXXVIII (1960–2), 123, prints the clauses in the Instrument of Foundation which governed the Schools, and also lists of students admitted up to 1830. The second and third Keepers, Carlini and Wilton, were both sculptors. Four Chairs (Painting, Architecture, Perspective and Geometry, and Anatomy) were established in 1768; the Chair of Sculpture was created in 1810, John Flaxman being the first Professor.

p. 135 7. A. Michaelis, *Ancient Marbles in Great Britain* (1882), chapter ii, is still the standard work on English eighteenth-century collecting. See also T. Ashby, 'Thomas Jenkins in Rome', *Papers of the British School in Rome*, VI (1913), 487; J. Fleming, 'Some Roman Cicerones and Artist-Dealers', *Connoisseur Year Book* (1959), 24. Jenkins was an important figure to English artists in Rome, who spoke of him as 'our patron, the great Mr. Jenkins' ('Memoirs of Thomas Jones', *Walpole Soc.*, XXXII (1948), 56). For Hamilton's activities see D. Irwin, 'Gavin Hamilton: Archaeologist, Painter and Dealer', *Art Bulletin*, XLIV (1962), 87.

8. H. Honour, 'English Patrons and Italian Sculptors', *Connoisseur*, CXLI (1958), 220; *ibid.*, 'Filippo della Valle', *Connoisseur*, CXLII (1959), 172.

p. 136 9. Owing to a misreading, probably by Peter

Cunningham, which was repeated in the Toynbee edition of the *Letters of Horace Walpole* (1903), I, xli, the maker of the statue appears as Valory. In a letter to Horace Mann in the same volume (p. 370), he is, however, referred to as La Vallée. This reading has kindly been confirmed by Mr W. S. Lewis, to whom I am further indebted for a photograph of his drawing by Rysbrack of the statue set in a pedimented frame. Though the statue arrived in England in 1743, it was not erected by Rysbrack for Horace Walpole until 1754, and now stands on a pedestal with no frame.

10. H. Honour, *Connoisseur*, CXLI (1958), 220, makes the interesting suggestion that the taste of English patrons had a considerable effect on the rise of neo-classicism in Italy.

11. E. Edwards, *Anecdotes of Painting* (1808), xv; W. T. Whitley, *Artists and their Friends in England* (1928), I, 237.

12. The Duke of Richmond's archives have been transferred from Goodwood House to the West Sussex County Archives Office, Chichester. I am indebted to Mr John Hayes for transcripts of these bills.

13. See pp. 67, 94.

14. This was one of the reliefs on the base of the Idolino (Florence, Mus. Arch.) which were for long attributed to Lorenzo Ghiberti or his son, Vittore (U. Middeldorf, *Burl. Mag.*, LXXII (1938), 253; C. F. Bell, *ibid.*, LXXXIV (1944), 97). It is possible that in the eighteenth century this base was used for some other statue, since J. Richardson (*An Account of the Statues . . . in Italy, France, etc.* (1722), 46) states that it was under a Bacchus 'supported on the back of a Tyger'. I am indebted to Dr O. Kurz for help here.

15. As early as 1761 the painter Thomas Jones notes: 'This noble Institution was now on the Decline, and the two gentlemen who were appointed to superintend had resigned' ('Memoirs of Thomas Jones', *Walpole Soc.*, XXXII (1948), 8).

16. W T. Whitley, *op. cit.*, 237–8.

17. E. K. Waterhouse, *op. cit.*, 157.

18. For Delvaux, see p. 92. A surviving work p. by Wilton's father is the fine plaster ceiling of the

Court Room of the Foundling Hospital, re-erected at 40, Brunswick Square, London.

19. When in Paris he was able to pass as a Fleming (Whitley, *op. cit.*, 96).

. 138 20. J. T. Smith, *Nollekens* (1828), II, 164, is wrong in saying he went to Rome with Roubiliac, whose journey took place in 1752; but the two sculptors may possibly have met in Florence.

21. His copies of the Medici Venus and of a faun at Wentworth Woodhouse, Yorkshire, mentioned above, were made in Rome about 1750 (H. Honour, 'English Patrons and Italian Sculptors', *Connoisseur*, CXLI (1958), 224, 226).

22. Chambers had gone to Rome at the end of 1750, and had probably met both Wilton and Reynolds there, and the latter again in Florence. Wilton also met Robert Adam in Florence in 1755 (J. Fleming, *Robert Adam* (1962), 133).

23. L. Réau, *Les Lemoyne* (1927), plate lii. The Chesterfield is signed and dated 1757, and inscribed: *ad vivum*. J. T. Smith (*op. cit.*, 172), who admired the bust, which in his day was on the chimneypiece of the Print Room in the B.M., said that it had been carved by his father, Nathaniel Smith. Although the latter was to work for Wilton towards the end of the 1760s, he was apprenticed to Roubiliac in 1755, and was still with him at his death in 1762. It seems impossible, therefore, that he could have had any hand in the Chesterfield bust.

24. Wilton exhibited a further bust of Chatham, said to have been made from a death-mask, at the R.A. in 1779 (W. T. Whitley, *op. cit.*, II, 397), which is perhaps that signed and dated 1780 at Belvoir Castle, Leicestershire.

25. The Cromwell is undated, but its vigorous style suggests that it is an early work. Though it is said by Smith (*op. cit.*, 172) to be modelled on 'the famous mask at Florence', i.e. the clean-shaven head made by Simon for the funeral effigy (D. Piper, 'Contemporary Portraits of Cromwell', *Walpole Soc.*, XXXIV (1952), 31 and plate xiii), it does not follow this, but is closer to the pattern with a moustache represented by the 'life-mask' at Chequers (K. Pearson and G. M. Morant, 'The Portraiture of Oliver Cromwell', *Biometrika*, XXVI (1935), plates lxii–lxix) and the bust by Edward Pierce in the London Museum (see p. 46), though with a far livelier movement.

139 26. The same slender proportions, again combined with a twisted stance, appear in the curiously jaunty figure of George II (1766) in the University Library, Cambridge, made as a pair to Rysbrack's

George I (J. W. Goodison, *Cambridge Portraits* (1955), I, 27 and plate ix), and described by Horace Walpole as 'most vile' (*Anecdotes*, v, ed. F. W. Hilles and P. B. Daghlian (1937), 156).

27. Smith, writing in 1829 (*op. cit.*, 172), speaks of the statue as 'lately taken down'. If it was re-erected, it must have perished in the fire of 1838.

28. Specifications and payments are in the Royal Archives, Windsor Castle, No. 55475. Another Westminster monument, that to William Pulteney, Earl of Bath (erected 1767), has one seated and one standing allegory, but these are in the round, and slightly better managed than those on the Hales.

29. A Frenchman, Grosley, saw it in his studio in 1765, and did not think much of it (W. T. Whitley, *op. cit.*, I, 208).

30. For Roubiliac's model, which is lost, but which was engraved as the frontispiece of the *Gentleman's Magazine*, 1789, see K. A. Esdaile, *L. F. Roubiliac* (1928), 161. Other artists submitting designs for the Wolfe monument included Sir Henry Cheere and William Tyler (K. A. Esdaile, *loc. cit.*), Robert Adam, and possibly Agostino Carlini. For the controversy concerning the use of contemporary dress in Benjamin West's painting of the *Death of Wolfe* (1771), see E. K. Waterhouse, *Painting in Britain, 1530–1790* (1953), 201.

31. J. T. Smith (*op. cit.*, 173) says his father worked for three years cutting the marble figures of Wolfe and his attendants. The bronze relief on the base, which shows the siege of Quebec at which Wolfe met his death, was designed and executed by an Italian, Capitsoldi or Capizoldi, who is said to have come to England with Wilton in 1755. C. F. Bell, *Annals of Thomas Banks* (1938), 20, suggests that this artist was Giovanni Battista Capezzuoli. who was in Florence about 1760 and again in 1777. No other works executed by him in England are known.

32. J. T. Smith, *op. cit.*, 176. p. 140

33. For Reynolds's *Discourse on Sculpture* see p. 153. Wilton was not, however, willing to bow completely to Reynolds's view that a standing figure should not be balanced by one seated, as may be seen in his late Westminster monument to General Sir Archibald Campbell (1795).

34. Professor Pevsner has kindly informed me p. 141 that the model for the statue is at Field House, Sowerby.

35. Ward, who was a friend of Carlini's, is said to have given him the commission because he

acked employment and thought of leaving England (H. Walpole, *Anecdotes* (*op. cit*), v, 140, quoting the *Public Advertiser*, 4 March 1762). Apparently Ward also hoped it would help advertise his nostrums (Gunnis, *Dict.*, 81).

p. 141 36. The tomb-chest was designed by Robert Adam (M. I. Webb, 'Architect and Sculptor', *Archit. Review*, CXXIII (1958), 329).

37. H. Walpole, *Anecdotes* (*op. cit.*), v, 141.

p. 142 38. Three of the keystones with colossal heads representing the rivers Dee, Tyne, and Severn and the two centre statues on the Strand front of Somerset House are his. The eight statues he made for the Customs House, Dublin, were destroyed in 1916. For the few further known works, see Gunnis, *Dict.*, 81. Two other Italians in England about this time also worked at Somerset House. Joseph Ceracchi (1751–1801), a Roman, was in England from 1773 to 1791 and made the two outer figures on the Strand front (J. T. Smith, *op. cit.*, II, 117). His bust of Sir Joshua Reynolds (1778, R.A.), modelled on the pattern of the Caracalla, is a work of some distinction. He subsequently went to America, where he carried out a good deal of work, and was finally guillotined in France for anti-Bonapartist activities.

John Baptist (Giovanni Battista) Locatelli (*c.* 1735–1805), of Verona, who was in England from 1775 to 1796, made a chimneypiece for Somerset House and one for Robert Adam at Harewood House. His nude Venus (Stratfield Saye, Hampshire) may be the figure which was also reproduced in Coade stone (Gunnis, *Dict.*, 240).

39. According to J. T. Smith (*op. cit.*, I, 147) Carlini did not control the students sufficiently, but allowed them to take liberties with their superiors which would later have met with expulsion.

40. Dr Pearce died in 1774; the monument is not dated, but the bust was exhibited in the R.A. in 1777.

41. His birth date is unknown, but may well have been about 1730. Vertue (iii, 152) refers to him as 'a young man' in 1749, and his obituary in the *Gentleman's Magazine* (Gunnis, *Dict.*, 316) implies that he was not old when he died.

42. K. A. Esdaile, *Roubiliac's Work at Trinity College, Cambridge* (1924), plate xix.

43. Roubiliac's other apprentice, Nathaniel p. 14 Smith (*c.* 1741–after 1800), the father of J. T. Smith, the biographer of Nollekens, worked first for Wilton and then for Nollekens, doing little on his own. One of his few signed works, the monument to Sir Merrick Burrell (1787) at West Grinstead, Sussex, has a medallion portrait backed by a drapery, the pattern coming from Roubiliac's Harvey monument (see pp. 110–11) and the handling being not far from that of Nicholas Read. Wilton also used this pattern for his monument to Bishop Hoadley (d. 1761) in Winchester Cathedral.

44. See Gunnis, *Dict.*, 194; M. I. Webb, 'Henry Cheere, Sculptor and Businessman', *Burl. Mag.*, c (1958), 275. For his work with Cheere, see p. 123.

45. His continued interest in Rome is shown by a list (B.M. Print Room) he compiled of Englishmen, chiefly artists, who were there between 1753 and 1775.

46. M. I. Webb, *loc. cit.*, 277.

47. Gunnis, *Dict.*, plate xi.

48. For the Ladies Elizabeth and Sophia Newdi- p. 1 gate (1776, Harefield, Middlesex); Samuel Phillipps (d. 1774, Shepshed, Leicestershire). The mixture of style on these is strange, for the groups of Charity go back to the Flemish tradition, but they are flanked by much more classical and static figures, almost Greek in type.

NOTES TO PART SIX

CHAPTER 19

I am much indebted to Professor L. D. Ettlinger and Dr Peter Murray for advice over this chapter. They should not, however, be held responsible for the statements it contains.

145 1. For the impact of neo-classicism on architecture, see J. Summerson, *Architecture in Britain: 1530–1830*, 4th ed. (1963), 245 ff; for painting, E. K. Waterhouse, 'The British Contribution to the Neo-Classical Style in Painting', *Proc. Brit. Acad.*, XL (1954), in which the classical history pieces painted by Gavin Hamilton in Rome from 1758 onwards are fully discussed; *idem, Painting in Britain: 1530–1790* (1953), 197 f.

2. A. Michaelis, *Ancient Marbles in Great Britain* (1882), 96–9, 104–6. The Lansdowne Collection was sold at Christie's, 5 March 1930; part of Townley's collection was purchased by the British Museum in 1805 and the rest in 1814. See also p. 269, Note 5.

146 3. For Clement XI, see L. Pastor, *History of the Popes*, Eng. ed., XXXIII (1941), 501 ff. For Cardinal Albani, C. Justi, *Winckelmann* (Leipzig, 1872), II, 297 ff. New information about the cardinal's contacts with English collectors and politicians can be found in L. Lewis, *Connoisseurs and Secret Agents* (1961). See also Note 7.

4. The original pieces given by Sixtus IV in the late fifteenth century were transferred to the new Museum, which is henceforth referred to as the Capitoline. For Clement XII's work, see Pastor, *op. cit.*, XXXIV, 494 ff.

147 5. Many of the most famous works in the Capitoline Museum record on their bases the dates of Benedict XIV's gifts, most of them between 1748 and 1752. For Benedict XIV see Pastor, *op. cit.*, XXXV (1950), 157 ff.

6. For Clement XIII, *ibid.*, XXXVI (1950), 176 ff. A. Michaelis, *op. cit.*, 94, underrates the value of Clement's patronage, though it is true that he caused statues which he thought indecent to be covered.

7. For descriptions of the Villa Albani, see S. Morcelli, 1785; C. Justi, *Winckelmann* (1872), II, 306. A précis of the latter appears in L. Pastor, *op.*

cit., XXXVI (1950), 180, and a short description, with plates, of the Villa today in L. Lewis, *op. cit.*, 199. The Villa was plundered by the French in 1797, and only the Antinous relief was returned. The rest of the collection was sold, many of the best pieces being now at Munich. The magnificent collection of Italian drawings inherited by Cardinal Albani from Clement XI had already been sold by him to George III, through James Adam, in 1762 in order to help pay for the Villa and are now in the Royal Library at Windsor. The Mengs ceiling, still *in situ*, is a major example of the new neo-classical taste, since it avoids all sense of Baroque illusionism. (See F. Novotny, *Painting and Sculpture in Europe: 1780–1880* (1960), plate 1A.)

8. R. Wittkower, *Art and Architecture in Italy: 1600–1750* (1958), 236; monographs by A. M. Hind (1922) and A. H. Mayor (New York, 1952). p. 148

9. Farington, I, 123.

10. Flaxman noted, in a letter to Romney of May 1788, that the removal of both collections was still in progress (W. G. Constable, *John Flaxman* (1927), 33).

11. Josiah Wedgwood's pottery factory, opened about 1768 near Stoke-on-Trent, perpetuated the misconception by taking the name 'Etruria'. Robert Adam's 'Etruscan decoration' (i.e. at Osterley and 20 Portman Square), like Wedgwood ware, makes use of Greek vase motives.

12. The British Museum had originated in 1753, through a bequest from Sir Hans Sloane, as a collection of 'Books, manuscripts, coins, medals and other curiosities and rarities', but the rapid and steady growth of archaeological knowledge quickly changed its character, and prevented it from remaining a *Wunderkammer*.

13. The most important work was Sir George p. 149 Wheler and Jacob Spon, *A Journey into Greece* (1682). It remained the standard book for several generations. Lady Mary Wortley-Montagu's *Letters* were not published till 1763, but those from Greece were written in 1716–18, and were known privately. Her interest was mainly in Constantinople, though she was also curious about Homeric Greece. A convenient summary of what was known in

England about Greece will be found in T. J. B. Spencer, *Fair Greece, Sad Relic* (1954).

p. 149 14. The Addisonian interest in art as an illustration of literature was very much alive in the middle of the century, for Joseph Spence's *Polymetis: An Enquiry concerning the agreement between the works of the Roman Poets and the Remains of the Ancient Artists* (1747) was a sufficiently influential book for Lessing to attack it in his *Laocoon* (1766).

15. The second volume was not published till 1789, though dated 1787; and the third, which used Stuart's drawings, appeared in 1795, seven years after his death.

p. 150 16. The classic work on Winckelmann is still C. Justi, *Winckelmann, sein Leben, seine Werke und seine Zeitgenossen*, 3 vols (Leipzig, 1872). Little that is useful has been written in English, though Walter Pater's essay, added to *The Renaissance* in 1873, is still worth reading. The quotations used in the text are mainly taken from Fuseli's translation of the *Gedanken*. I am especially indebted to Professor L. D. Ettlinger for help over Winckelmann's theories.

17. Fuseli used the word 'sedate' instead of the more modern and more usual rendering, 'calm'.

p. 151 18. Fuseli also translated the description of the Torso in the *Annual Register* of 1765.

19. No English edition appeared till 1850, when it was translated by G. H. Lodge as *The History of Ancient Art among the Greeks*. A French translation, however, appeared in 1802.

20. For a summary of Winckelmann's position, see L. D. Ettlinger, *Art History Today* (1961), 6 f.

p. 152 21. *Boswell on the Grand Tour: Italy, Corsica and France, 1765–6* (ed. 1955), 70, 85.

p. 153 22. A number of modern books have been built round quotations from both poets and travellers: M. L. Clarke, *Greek Studies in England 1700–1830* (1945); T. Spencer, *op. cit.*; B. Stern, *The Rise of Romantic Hellenism in English Literature* (Menasha, Wisconsin, 1940); S. Larrabie, *English Bards and Grecian Marbles* (Columbia, 1943). Though all are useful, they intentionally isolate Hellenism from other aspects of English thought, and so give an incomplete picture of the complexity of the neo-classical movement.

23. H. Walpole, *Anecdotes of Painting* (ed. R. Wornum, 1888), I, 119.

24. Ramsay's essay was first published under the title of *The Investigator, No. 332*, and republished in 1762 with other essays under the general title of

The Investigator (A. Smart, *The Life and Art of Allua Ramsay* (1952), 91). His dislike of Renaissance architecture seems to be primarily anti-Palladian.

25. For the most recent discussion of Reynolds's theories, and in particular of his links with both classicism and romanticism, see the Introduction to R. R. Wark's ed. of the *Discourses* (Huntington Lib., California, 1959). Unfortunately for the purposes of the present book, there is no special reference to his views on sculpture.

26. K. A. Esdaile, *English Monumental Sculpture p. 15. since the Renaissance* (1927), 64, over-emphasizes the part played by Reynolds here.

27. The high position given to 'grace' is not new, but in Reynolds's day it had been strengthened by the views of Anton Raphael Mengs, which had been plagiarized by Daniel Webb in *An Enquiry into the Beauties of Painting* (1760). See L. Salerno, *English Miscellany*, II (1951), 285. Dr Salerno suggests that almost all the anti-classical ideas in neo-classicism are derived from England, though he appears to over-rate the independence of the 'man of taste' of the first half of the century, whose main object was to conform to the standards laid down by Burlington, Shaftesbury, and Richardson rather than to think for himself.

28. Flaxman could not afford to buy Stuart's p. 15. book until 1796, when he gave his tracings from it to his pupil, Thomas Hayley (Letter from Thomas Hayley to his father, 14 November 1796: West Sussex County Archives, Chichester).

29. The published edition of the Farington Diary p. 15. (ed. J. Greig, 8 vols, 1922–8) omits much important material. A full transcript of the original in the Royal Library at Windsor Castle is deposited, by gracious permission of Her Majesty the Queen, in the Department of Prints and Drawings, B.M., and has an admirable index. References given here are to the printed edition, unless marked 'unpub.', in which case the page reference of the B.M. transcript is quoted.

CHAPTER 20

1. J. Flaxman, *Lectures on Sculpture*, 2nd ed. p. 157 (1838), 291.

2. John Thomas Smith (1766–1833), son of the sculptor Nathaniel Smith (see p. 266, Note 43), worked as a boy in Nollekens's studio from 1778 to 1781. He then became an engraver, notably of topographical subjects; and from 1816 to his death was Keeper of the Print Room at the British Museum.

158 3. Smith, I, 250.

4. For the history of the antique Castor and Pollux, now in the Prado, see A. Blanco, *Museo del Prado, Catálogo de la Escultura* (1957), no. 28. It appears to have gone to Spain before Nollekens arrived in Rome, but a cast was in the French Academy there by 1758 (Montaiglon, *Correspondence*, XI, 226) and other casts may well have existed. I am indebted to Mrs Frankfort for information about this group.

5. Smith, I, 172, 246. The second passage includes a detailed description of the Townley collection, one of the most important of its day. The best pieces are shown in the painting by Zoffany of *Townley in his Study* (Burnley Art Gallery, Lancashire).

159 6. The Venus was exhibited at the R.A. in 1773, the Juno in 1776, and the Diana in 1778.

7. The model was shown in 1775 and the marble in 1778. It bears no resemblance to the seated group of Venus and Cupid shown in Thomas Rowlandson's cruel drawing of Nollekens in his studio, which seems to be lost. For other drawings by Rowlandson of Nollekens, see R. Baum, 'Joseph Nollekens: A Neo-classic Eccentric', *Art Bulletin*, XVI (1934), 385. The Venus anointing her Hair, said by Cunningham (*Lives*, III, 170) to have been Nollekens's favourite Venus, seems to have disappeared since it was bought at the sculptor's sale in 1823 by Russel Palmer for 220 guineas. The Lincoln Art Gallery also owns a seated Mercury, made for Lord Yarborough in 1783.

8. Smith, II, 13.

160 9. A drawing for this is in the V. and A.

10. The design was in fact made by Cipriani, whose drawing for it is at Althorp, but it must have been much to Nollekens's taste (B. Bailey, 'London Sculptors of the Eighteenth Century in Northamptonshire', *Northamptonshire Antiquarian Soc.*, LXII (1958/9), 34).

11. Cunningham, *Lives*, III, 149.

161 12. Smith, I, 389; II, 42, where it is stated that the monument remained for nearly fourteen years in the studio waiting for the inscription, until the exasperated sculptor petitioned the king.

13. Cunningham, *Lives*, III, 196. His description of Nollekens's methods is borne out by several references in Smith.

14. More than seventy replicas of the Pitt are said to have been made, and at least fifty of the second version of the Fox.

15. Smith, II, 55. p. 162

16. Cunningham, *Lives*, III, 196.

17. The first bust is said to have been created for p. 163 the Empress Catherine the Great, and was exhibited at the R.A. in 1791. The family version in the possession of the Earl of Ilchester is dated 1793; that at Holkham Hall (Plate 121) is of 1792. Many other replicas exist.

18. A signed and dated example is at Castle Howard, Yorkshire, and another in the V. and A.

19. The bust in the possession of H.M. the Queen is dated 1807. Smith, II, 43 states that at least seventy-four replicas in marble and 600 casts in plaster were made, 120 guineas being charged for the marbles (of which the assistants who worked on them got 24), and 6 guineas being the price of the casts. The University paid £4,000 for the statue, the marble for which, owing to Nollekens's economical methods of using pieces cut from the corners of busts, and from between the legs for the head, did not ultimately cost more than £20. Smith indeed asserts that Nollekens made £15,000 by the portraits of Pitt. Further contemporary records of the bust of Pitt are given by Farington, III, 162, 174, 231, 238, 304; IV, 145, and of the Cambridge statue, which was admired by Flaxman, VII, 89, 137.

CHAPTER 21

1. The fullest account of his life is the short p. 165 monograph by A. Cox-Johnson, *St Marylebone Society Publications*, IV (1961). The Rev. R. Cecil, *Memoirs of John Bacon, Esquire, R.A.* (1801), is largely concerned with the sculptor's activities as a pillar of the Methodist church. Other early accounts of his work appear in J. T. Smith, *Nollekens*, II (1828), 153; A. Cunningham, *Lives*, III (1830), 200. See also R. Gunnis, *Dict.*, 24.

2. The best modern account of the factory, which quotes earlier references, is S. B. Hamilton, 'Coade Stone', *Archit. Review*, CXVI (1954), 295. Gunnis, *Dict.*, 105, lists a large number of signed works, but was unaware of the part played by the younger Eleanor.

3. Before about 1824 the parts of the figures, cast separately, were joined by bronze dowels run in with lead; thereafter iron rods were used. The 'stone' itself is practically impervious to weather, but damp can play havoc in the joints.

p. 166　4. For the last, see H. Clifford-Smith, *Buckingham Palace* (1931), 62, 64. Bacon's place as permanent designer was taken in 1799 by John de Vaere, who modelled the large allegorical group for the Pelican Life Insurance Office, Lombard Street, now at the Geffrye Museum (Hamilton, *loc. cit.*, figure 12). De Vaere, who was born in France in 1755, had previously worked for Wedgwood, and left England for Ghent about 1810, having also produced some marble sculpture (Gunnis, *Dict.*, 128).

5. Bought by Sir William Chambers for a fireplace for his own house, and now at The Royal Society of Medicine, 1 Wimpole Street, London.

6. Cunningham, *Lives*, III, 205. It did not find a purchaser, but was presented to the Society of Arts, with a Venus, in 1778. A copy of the Mars was, however, later commissioned by Lord Yarborough.

7. He used a silver syringe to wet his clay, instead of spouting water from his mouth, and treated his sitter much more obsequiously than Nollekens, to whom he had sat in 1773.

8. One replica, dated 1775, and made for the Prince of Wales, is in the Royal Collection; another was presented to the University of Göttingen, and the third to the Society of Antiquaries.

p. 167　9. The artist was so pleased with the dramatic pathos of the seated figure that he deposited a marble study for it, entitled 'Sickness', as his Diploma work at the Royal Academy in 1778.

10. The monument was erected by the Government, and the Royal Academy had the right to nominate the sculptor. They might certainly have considered the claims of Banks and Nollekens, but Bacon completed a model, obtained an audience with the king, and got it accepted, apparently without the knowledge of the Academy (Cunningham, *Lives*, III, 218).

11. See pp. 153–4.

12. At about the same time Bacon made the equally ambitious monument in the Guildhall, London, in which Chatham is shown as a Roman Senator among a throng of allegorical figures.

13. For the general change in sculptors' charges, see also under Nollekens, p. 162.

14. For the opening of St Paul's Cathedral to monuments, see p. 198 ff.

15. Bacon had wished to make a group of two figures for the Howard monument, but was prevented by the Royal Academy, who wished it to balance the Johnson, in which they were interested

(A. Cox-Johnson, *loc. cit.*, 35 f.). Both were in hand in 1791, so Cunningham (*Lives*, III, 240) is wrong in stating there is ten years' difference between them.

16. F. Cundall, 'Sculpture in Jamaica', *The Art* p. 1◦ *Journal*, March 1907. I am also indebted to Mrs Lesley Lewis for information about the Jamaica monuments.

17. A drawing for this belongs to the Royal Academy, and suggests that it is the first appearance of the design, and the others were variants of it. The monument to James Marwood (d. 1767, Widworthy, Devon), which uses it, is undated, and may well be after 1780.

18. Since the work was commissioned in 1794 p. 1◦ there can hardly be much Flaxman influence in the design.

19. See p. 179.

20. Gunnis, *Dict.*, 28 f. For the younger Bacon's p. 1◦ work in St Paul's Cathedral, see p. 201.

21. Naturalistic flowers also appear on the monument to Catherine Jekyll (d. 1773, Arthingworth, Northamptonshire), though the rest of the detail is neo-classical and the mourning angel has draperies in the style of Wilton.

22. Gunnis, *Dict.*, plate xv.　　　　　　p. 1◦

23. *Ibid.*, 273.

24. The large monument to Earl Ferrers (1775, Ettington, Warwickshire) is again neo-classical in detail, though not in colour, or in its rather stodgy figures, one being in frankly contemporary dress and the other two in a compromise between contemporary and classical.

25. His fine relief, fully pictorial in treatment, of Aurora after Guido Reni on a chimneypiece at Cobham Hall, Kent (1778), reveals his innate sympathy with the Baroque.

26. For a full account of his work, see T. Hodg- p. 1◦ kinson, 'Christopher Hewetson, an Irish Sculptor in Rome', *Walpole Soc.*, XXXIV (1952–4), 42. All the works referred to here are illustrated in this article.

27. Gunnis, *Dict.*, 229.

28. J. B. Morrell, *York Monuments* (n.d.), 82, 83, p. 1◦ and plate lxv.

29. References to her abound in Walpole's letters. For some of the more interesting, see *The Letters of Horace Walpole*, ed. Toynbee (1905), XII, 187, 262; and H. Walpole, *Anecdotes of Painting*, ed. Wornum (1888), xx. For a list of her works, see Gunnis, *Dict.*, 120.

30. Her best-known work is the marble group of sleeping dogs at Goodwood (*c.* 1784) (Gunnis, *Dict.*, plate vii), the terracotta of which belonged to Walpole. The terracotta at Chillington Hall, Wolverhampton (Plate 135B), is signed in Greek letters; but Mrs Damer was well-educated, since David Hume had been her tutor.

31. Farington, II, 20.

32. *Ibid.*, I, 233.

33. *Macbeth*, Act IV, Scene ii. The relief is said to have been 'from a sketch by Mr. Gilpin'. For an account of Garrard's works at Southill, see the chapter by Mrs M. I. Webb in *Southill, A Regency House* (1951), 57 and app. 2.

p. 174 34. For a further list of works, see Gunnis, *Dict.*, 163.

CHAPTER 22

p. 175 1. Quoted in A. Cunningham, *Lives* (1830), III, 86.

2. 'Address on the Death of Thomas Banks', 1805, in J. Flaxman, *Lectures on Sculpture*, 2nd ed. (1838), 272. In conversation Flaxman admitted that Banks's works were unequal, and that he sometimes became heavy (Farington, III, 54).

3. Westmacott's 'Oration on the Death of Flaxman', in J. Flaxman, *op. cit.*, VI.

4. *Letters from England by Don Manuel Alvarez Espriella* (1807; ed. 1951), 128. The passage must have been written after the erection of Flaxman's Mansfield monument (see p. 189).

5. For full documentary evidence concerning the sculptor's life and work with good plates, see C. F. Bell, *Annals of Thomas Banks* (1938). There is some additional information in R. Gunnis, *Dict.*, 37–40. Cunningham must be wrong in saying he was a pupil of William Kent, who died in 1748.

6. Letter from the sculptor's daughter to Allan Cunningham (C. F. Bell, *op. cit.*, 7).

p. 176 7. In a letter to Nathaniel Smith, dated 1773, Banks speaks of meeting several English artists including Romney, but says: 'Among the students of painting, Fuseli cuts the greatest figure' (*ibid.*, 16).

8. For Fuseli see F. Antal, *Fuseli Studies* (1956).

8a. I am indebted to Professor E. K. Waterhouse for the suggestion that Banks was also perhaps influenced by West's painting of the Death of Wolfe, which had created a sensation shortly before he left England. The compositions have points of similarity, but Banks would never have used contemporary dress.

9. The terracotta of Caractacus was given by Banks's daughter to Sir John Soane in 1834 and is now in the Soane Museum.

10. Possibly commissioned by the Earl Bishop of Derry and left on the sculptor's hands. The terracotta is in the Soane Museum.

11. An exact parallel can be found in drawings p. 177 made by Fuseli in Rome, such as the *Translation of the Body of Sarpedon* (1778, Zürich) (A. Federman, *J. H. Füssli* (Zürich, 1927), plate 50).

12. C. F. Bell, *op. cit.*, 8.

13. *European Magazine*, XVIII (July 1790), 24.

14. For the history and descriptions of the work, see C. F. Bell, *op. cit.*, 60–6. The model for an Achilles arming (V. and A.), though simpler in conception than the Mourning Achilles, shows clear influence of Fuseli in its proportions and tense gestures.

15. J. T. Smith, *Nollekens* (1828), II, 192. p. 178

16. C. F. Bell, *op. cit.*, plate vii.

17. The arrangement of the couch and the cur- p. 179 tain over the partition are strangely reminiscent of Poussin's Death of Germanicus.

18. Farington, I, 90.

19. His bust of Horne-Tooke is lost (C. F. Bell, *op. cit.*, 99–102, 137–8).

20. *Ibid.*, 98, 100. p. 180

21. *Ibid.*, 105, 111, 135, and plates xxxiii and xxxiv. Banks had not heard Reynolds's *Discourse* on sculpture, since he was in Rome in 1780, but he would certainly have agreed with it.

22. For the opening of St Paul's for monuments see p. 198 ff. Banks had also hoped to make the monument to Earl Howe, the commission for which eventually went to Flaxman (*ibid.*, 131, 151). His model for it (*ibid.*, plate xxxviii), in the Soane Museum, is clumsy but original in design, and includes a standing frontal female figure with one arm extended, which must be based on Canova's tomb of Clement XIII (1792). Banks could not have seen this, but Flaxman, and probably other English artists, had brought back drawings of it.

23. See p. 189.

24. Farington, III, 230.

25. A. Cunningham, *Lives*, III, 113, 114.

26. For an account provided by Banks's daughter p. 181 of her father's methods of work, see C. F. Bell, *op. cit.*, 7.

27. *Ibid.*, 81.

28. A. Cunningham, *Lives*, III, 120. Banks also p. 182 made some designs for the Coade factory, carried

out a little architectural sculpture for Chambers and Soane, and cut a few chimneypieces, including one of great beauty with a frieze of grecianized Oriental figures for Warren Hastings at Daylesford House (C. F. Bell, *op. cit.*, 88, 102, 143, and plates xxi–xxiii). For this he is said (G. Cumberland, *Critical Catalogue* (1827), 19) to have borrowed the theme from a Persian miniature, but to have given it more expression and grace, 'grecianizing these Persian Peruginos'. I am indebted to Mr F. T. Cummings for this information. A general parallel for the use of Near Eastern and Oriental models can be found in some works by Blake (A. F. Blunt, 'Blake's Pictorial Imagination', *Journ. W. and C.I.*, VI (1943), 205, and *The Art of William Blake* (New York, 1959), 38, 80). A number of Banks's models, some for work not carried out, are in the Soane Museum.

CHAPTER 23

p. 183 1. For contemporary accounts of Flaxman's work and life, see Sir Richard Westmacott's 'Oration on the death of Flaxman' in J. Flaxman, *Lectures on Sculpture*, 2nd ed. (1838), iv; J. T. Smith, *Nollekens* (1828), II, 441; A. Cunningham, *Lives* (1830), III, 274. The most useful modern works are W. G. Constable, *John Flaxman* (1927); Gunnis, *Dict.*, 147.

2. Gunnis, *Dict.*, 147 (John Flaxman the Elder).

p. 184 3. J. T. Smith, *A Book for a Rainy Day* (1854, ed. W. Whitten, 1905), 98; I. A. Williams, 'An Identification of some Early Drawings by John Flaxman', *Burl Mag.*, CII (1960), 246.

4. An invaluable chronological list of his work is given by W. G. Constable, *op. cit.*, as appendix I, p. 79. Additions, mainly in the field of monuments, will be found in Gunnis, *Dict.*, 149.

5. Constable, *op. cit.*, frontispiece.

6. No original oil paintings by Flaxman now seem to be known, but Cunningham goes on to state that one of his works had recently been sold as a Domenichino. His copy of a fragment of the lost Raphael cartoon at one time owned by Jonathan Richardson, executed in distemper, is in the Soane Museum.

p. 185 7. J. Flaxman, *op. cit.*, 163.

8. For a discussion of the romantic side of Romney's art, especially as seen in his drawings, see A. Crookshank, 'The Drawings of George Romney', *Burl. Mag.*, XCIX (1957), 42.

9. W. G. Constable, *op. cit.*, 8, 82, and appendix II, 104, gives the best account of this part of Flaxman's work.

10. *Ibid.*, plate II. In addition to the collection from the original models in the Etruria Museum, Stoke-on-Trent (i.e. at the Wedgwood factory), examples of Wedgwood ware from Flaxman's designs may be seen in the V. and A., the B.M., and an excellent collection is at the Lady Lever Gallery, Port Sunlight.

11. L. Cust, *History of the Society of Dilettanti* (1914), 105. The cast then made by Flaxman was still in his studio in 1795, when it was copied by his pupil Thomas Hayley (Letter in West Sussex County Archives, Chichester). The fragment itself is now joined to the Elgin Marbles in the B.M.

12. W. G. Constable, *op. cit.*, plate VIII. p. 186

13. A. Cunningham, *Lives*, III, 293.

14. The sketch-books have never been fully published, but a resumé of their contents will be found in M. D. Whinney, 'Flaxman and the Eighteenth Century: A Commemorative Lecture', *Journ. W. and C.I.*, XIX (1956), 269; for the journals see D. Irwin, 'Flaxman: Italian Journals and Correspondence', *Burl. Mag.*, CI (1959), 212.

15. 'Address on the Death of Thomas Banks, p. 187 1805', printed in J. Flaxman, *op. cit.*, 278.

16. It is likely that the drawings of papal tombs, which are on consecutive pages of one of the sketch-books, were made fairly late in the Italian visit, since they include Canova's tomb of Clement XIII, which was erected in 1792. The Tuscan drawings may be early, since Flaxman went to Rome via Milan and Florence (D. Irwin, *loc. cit.*), but he possibly passed through Florence again on his return and certainly went to Venice. Since drawings of the Scaliger tombs at Verona and of the tomb of Maximilian I at Innsbruck are in the same book as the majority of the Florentine drawings, it is dangerous to date the drawings conclusively from their position in the books.

17. A. Cunningham, *Lives*, III, 295.

18. *Lectures on Sculpture* (2nd ed., 1838), 232. p. 188

19. M. Missirini, *Memorie per servire alla storia della romana Accademia di S. Luca fino alla morte di Antonio Canova* (1823).

20. W. G. Constable, *op. cit.*, 110. For Deveare (or Devaere), see p. 270, Note 4.

21. W. G. Constable, *op. cit.*, 33. An earlier letter to Romney (*ibid.*, 30) gives interesting in-

formation about collections of vases and casts then being sent to England.

22. *Morning Chronicle*, 24 May 1794. I am indebted to Mr Brinsley Ford for the reference.

23. Both are referred to in letters to his parents of this year (B.M. Add. MSS. 39780 f.47v. and 50v.). I am greatly indebted to Dr David Irwin for his generosity in giving me these and other references to Flaxman's unpublished correspondence.

24. Thomas Hope (?1770–1831), one of the most distinguished of English connoisseurs, was a member of an Amsterdam banking house, who settled in England in 1796. He was widely travelled, collected on a large scale (A. Michaelis, *Ancient Marbles in Great Britain* (1882), 279), and himself designed rooms at his house at Deepdene, Surrey, after classical and oriental models. He patronized a number of leading neo-classical artists, and published works on the furniture, decoration, and costume of the Ancients. His romance, *Anastasius*, was ascribed to Byron, who wept because he had not written it.

25. For this comparison, and for other points, I am indebted to an unpublished lecture by Dr T. S. R. Boase.

26. The subject for the restoration was suggested by d'Hancarville, and Thomas Hope wished Flaxman to carry it out in marble (W. S. Childe-Pemberton, *The Earl Bishop* (1925), II, 438). This apparently was not done, and Cunningham, *Lives*, III, 304, states that Flaxman caused the group to be destroyed some time before his death 'and there is no great reason for lamenting it'. A cast, however, must have been made, and this is now at the Slade School, University College, London.

27. W. S. Childe-Pemberton, *ibid*.

. 189 28. For a list of the various editions and the whereabouts of the original drawings, see W. G. Constable, *op. cit.*, 98. The drawings, especially those for the Homer, are much superior to the engravings, since they show a variation of thin and thick line which is lost in reproduction. He was also to design illustrations for *The Eight Acts of Mercy*, and The Lord's Prayer; his unpublished illustrations include those for an allegory (*The Knight of the Burning Cross*, 1796) and a Milton, Wieland's *Oberon* and the *Pilgrim's Progress*.

29. For a contemporary estimate of the illustrations, see Cunningham, *Lives*, III, 296, 307; for a modern assessment, T. S. R. Boase, *English Art*, *1800–1870* (1959), 136.

30. The essential source for Flaxman's work between 1794 and 1810 is E. Croft-Murray, 'An Account Book of John Flaxman, R.A.', *Walpole Soc.*, XXVIII (1939–40), 51. Since all the work there is fully annotated, with bibliographical references as well as those to drawings and models, such information will not be repeated here.

31. The commission had been given to Flaxman before he went to Italy (Constable, *op. cit.*, 53), the money for it having been bequeathed by an admirer of Mansfield's, and some studies for the seated figure appear in one of the Italian sketchbooks. The first payment of the total price of £2,500 was made in 1795, and the first model exhibited at the Royal Academy in 1796. It was moved to its present position in 1933.

32. Letter from the 2nd Lord Mansfield to Flaxman, 1793 (B.M. Add. MSS. 36652 f.123).

33. It is possible that at a preliminary stage the work was not planned as a free-standing monument, since in a letter to Sir William Hamilton (3 July 1793, in possession Messrs Maggs 1930; transcription in Whitley Papers, B.M. Print Room) Flaxman speaks of a crown with the swords of Justice and Mercy as above Mansfield's head. No figure is described holding them, so they must, presumably, have been attached to a background. Information about letter kindly given by Dr David Irwin.

34. A. Cunningham, *Lives*, III, 330. p. 190

35. Letters from Mrs Flaxman to her sister-in-law, 1813 (B.M. Add. MSS. 39780, pp. 340, 341, 344, 345). Farington, VII, 137, records Flaxman's admiration of Lincoln Cathedral on his journey.

36. A more modest but equally rigid group of a standing Britannia with a lion is used on the tomb of the 2nd Earl of Guilford (1799–1805, Wroxton, Oxfordshire).

37. Cunningham, *Lives*, III, 326, relates that owing to the use of the small model the figure of Howe was found to be badly out of proportion, and many months were spent after erection in chiselling it down. A less well-known insulated memorial with a Victory and two unhappy lions is the Captain James Montague (1798–1804) under the north-west tower at Westminster, probably the last naval monument erected in the abbey. For further discussion of the St Paul's monuments, see p. 200.

38. For its history, see W. G. Constable, *op. cit.*, p. 191
60.

39. The college also owns a fine collection of

Flaxman's drawings purchased from Miss Denman's collection in 1862. A selection of both models and drawings was exhibited at King's College, Newcastle-upon-Tyne, in 1958, when an illustrated catalogue was issued, and at the time of writing models are on loan to the V. and A. An unpublished catalogue of the drawings is at the college, and a catalogue of the models is (in 1963) in course of preparation.

p. 192 40. She was in fact Mrs Blackshaw, but no record of her marriage is included in the epitaph (E. Croft-Murray, *loc. cit.*, 62).

41. Dr John Shearman has pointed out to me that the idea is based on the iconography of the Assumption. It may therefore be a conscious transformation of a Catholic theme to Protestant use, but treated in the classical style of some of Flaxman's Roman drawings. The design was closely followed for the monument to Mary Harford (Stapleton, near Bristol) and was reproduced, without the top figure, and with the two supporters as angels, in that to Mrs Harriot Peach (d. 1825) at Ketteringham, Norfolk, perhaps by Flaxman's brother-in-law, Thomas Denman, who was still using the pattern after 1837 in the monument to Mrs Elizabeth Kelsall (Fareham, Hampshire).

p. 193 42. See p. 167.

43. A comparable arrangement of figures against the ground can be seen in the monument of the 1st Marquis Cornwallis (1807–13, Penang, Malaya), one of several works by Flaxman sent overseas. This uses Nelson's Britannia, but she shepherds an Indian boy, and an Indian woman is seated on the ground. See Croft-Murray, *loc. cit.*, plate XVIIa.

44. *Lives*, III, 321.

45. For these and the types discussed in the following paragraph see Croft-Murray, *loc. cit.*, plates XIV, XV, XVI, and XVIII.

46. For a silver vase designed by Flaxman and p. 19 belonging to H.M. the Queen, see T. S. R. Boase, *English Art, 1800–1870* (1959), plate 36b.

47. Silver-gilt versions were made for the king, the Duke of York, Lord Lonsdale, and the Duke of Northumberland. Bronze and plaster casts were also taken, examples of the latter being now owned by the Royal Academy and University College, London. For a description, see Cunningham, *Lives*, III, 352.

48. *Ibid.*, 355.

49. The *Lectures on Sculpture* were first printed p. 19 in 1829; the second edition of 1838 also includes the Addresses on the deaths of Thomas Banks (1805) and of Antonio Canova (1822).

50. Farington, III, 230 records an interesting conversation with Flaxman in May 1806, when he compared the sculpture on the Eleanor Cross at Waltham Abbey with that of Nicola and Giovanni Pisano, 'who in sculpture may be compared with Giotto in painting: grace and undulation being expressed, though much remained wanting'.

51. Flaxman, *Lectures*, 188.

52. Unbound letter, Fitzwilliam Museum MSS. Reference kindly given me by Dr David Irwin.

CHAPTER 24

p. 197 1. *Autobiography of B. R. Haydon*, ed. A. Huxley (1926), I, 148.

p. 198 2. Earlier still, the monument to Sir Cloudesley Shovell had been erected by the desire of Queen Anne, but it hardly falls into the category of public monuments erected by Parliament.

3. See p. 139.

4. Farington, I, 7 (though the description is not precise).

5. W. T. Whitley, *Artists and their Friends in England, 1700–1799* (1928), II, 294.

6. In 1782 Dean Newton left £500 in his will for a monument in St Paul's, but it was not permitted and was erected by Banks in St Mary-le-Bow (W. Dugdale, *History of St Paul's*, ed. H. Ellis (1818), 195; C. Bell, *Annals of Thomas Banks* (1938), 52 and plate vii).

7. His grave in the crypt is covered by a plain black slab, and on the wall above is the splendid epitaph: 'Si monumentum requiris, circumspice'.

8. Dugdale, *loc. cit.*

9. For Bacon's statues of Howard, Jones, and Johnson, see pp. 167–8.

10. Farington, unpub., 798.

p. 199 11. *Ibid.*, 848.

12. *Ibid.*, 862.

13. Banks was asked to meet the Academy Committee at St Paul's in May 1798 (C. Bell, *op. cit.*, 118). Unfortunately Cunningham (*Lives*, III, 115) who records the criticism of Banks's monument, does not say exactly when the alteration was made. He is, however, wrong in saying that the Burgess was commissioned under the same circumstances as the Westcott of 1802–5. Many of the monuments have been moved from their original positions.

14. Farington, unpub., 590.

15. For a discussion of Payne Knight's relation to the arts, see N. Pevsner, 'Richard Payne Knight', *Art Bulletin*, XXXI (1949), 293.

16. *Gentleman's Magazine* (1794), 201. The Rodney monument was not to be commissioned until 1810 and the Heathfield waited till 1823. Except in the cases of Nelson and Pitt, for which there would have been a swift public demand, it is hard to find any reason for the order in which commissions were given.

17. P.R.O. *Treasury Letter Book*, T.27/53.400. Reports from the committee can be found in *Treasury Minutes*, e.g. T.29/505.527, and its activities easily followed in the *Index to Treasury Letters* for each year. I am indebted to the staff of the Public Record Office and also to Mr J. Sainty for help in tracing these papers.

18. According to Farington (unpub., 2026) West was invited to attend, but appears never to have done so, presumably out of pique.

19. *Gentleman's Magazine* (1802), 967. p. 200

20. In 1805 (Farington, III, 133), the Academy determined to re-assert its influence by offering to meet the committee to discuss positions for various monuments, including that of Nelson, Farington then expressing the opinion that the committee, though composed of 'able men in other respects, had very little knowledge of art'. A joint meeting was in fact arranged, but the Academy did not get its way at all points (P.R.O. T.1/977.4572). As late as 1816 Academicians were still lamenting the death of Reynolds, which in their view had made it possible for the committee to obtain so much power (Farington, VIII, 53).

21. The figure was apparently inserted because Flaxman and Rossi said Westmacott had not proved his ability to execute a nude (Farington, unpub., 2536).

22. Farington, III, 238. It is not clear if Flaxman was referring to the Faulknor or to the Mosse and Riou.

23. Farington, VIII, 3. For Rossi's life and other p. 201 works, see Gunnis, *Dict.*, 326.

24. The Rodney affords one of the few instances of the direct influence of the committee, for when it was accepted in 1811 Rossi was asked to 'alter the figure of Lord Rodney to give the action greater spirit' (Farington, unpub., 5807).

25. In addition to the large monuments in this form already mentioned, that to General Sir Thomas Picton (Plate 161A), commissioned in 1816

from Sebastian Gahagan, has a bust on a pedestal above Genius and Valour rewarded by Victory.

p. 201 26. Farington, III, 55. For other works by the younger Bacon, see pp. 169–70.

26a. The earliest of these, that to Capt. R. Willett Miller by Flaxman, had been commissioned in 1801, before the establishment of the Committee of Taste.

p. 202 27. The influence of the Elgin Marbles can also be seen in the monument begun by William Theed and finished by Edward Hodges Baily to General Sir William Ponsonby (1816–20), where the treatment of the horse, and especially of its mane, makes an instructive contrast to that in Westmacott's Abercromby (T. S. R. Boase, *English Art, 1800–1870* (1959), 131 and plate 49a).

28. For the Pitt monument, see p. 211.

p. 203 29. For the Academicians' disgust at the decisions of the Corporation, see Farington, II, 229; IV, 1.

30. Picton, *Memorials of Liverpool* (1875), I, 269.

31. The Nelson Column in Trafalgar Square, which was the final solution to a wide variety of proposals for a national monument, was not erected until 1839–42.

32. I am indebted to Mr Bruce Bailey for the loan of cuttings from *The Northampton Mercury* between 1812 and 1819 concerning the statue. Many other examples of civic patronage could be quoted; for instance, the citizens of Shrewsbury erected a Coade stone figure designed by Joseph Panzetta to Lord Hill in 1817, and a column and relief by E. H. Baily to General Sir Thomas Picton was set up at Carmarthen in 1816. Public subscription also provided the statues by Chantrey in the Parliament House at Edinburgh (see p. 221), and a number of statues of this class were sent to India.

33. Destroyed in the Second World War.

p. 204 34. Gunnis, *Dict.*, 148.

35. H. Clifford Smith, *Buckingham Palace* (1931), 58–64.

36. M. Missirini, *Della vita di Antonio Canova* (1824), 500–13.

37. Farington, III, 231, 261, 304; IV, 56. In 1815 there appears to have been a rumour that Canova would be employed on the Government monuments (*ibid.*, VIII, 30).

38. F. J. B. Watson, 'Canova and the English', *Archit. Review*, CXXII (1957), 403.

39. Farington, VIII, 286. In June 1821 Sir Thomas Lawrence confirmed that 'an English party cried

up Thorwaldsen, but he was much inferior to Canova'.

40. *Memoirs of Old Friends, being Extracts from Journals and Letters of Caroline Fox*, ed. H. N. Pym (1882), 67. Passage written 3 March 1840.

41. G. Jones, *Sir Francis Chantrey* (1849), 23.

42. In 1801 Flaxman and Banks bought fourteen p. 205 casts at Romney's Sale for the Academy, and a further but unsuccessful attempt was made to buy a collection of good casts in 1813 (W. T. Whitley, *Art in England, 1800–1820* (1928), 18, 212).

43. *Ibid.*, 262; Farington, VIII, 94, 108.

44. The most complete survey of the acquisition, first by Lord Elgin and then by the nation, of the Marbles is A. H. Smith, 'Lord Elgin and his Collection', *Journ. of Hellenic Studies*, XXXVI (1916), 163. The *Report of the Select Committee on the Earl of Elgin's Collection of Sculptured Marbles etc.* (1816) gives the evidence heard at the inquiry in full, and is essential for the opinions of individuals. A useful summary of the history and present arrangement of the Marbles is *An Historical Guide to the Sculptures of the Parthenon* (British Museum, 1962).

45. *Report*, pt 1.

46. Smith, *loc. cit.*, 294/5.

47. Hamilton was a man of some distinction, who was to be Under-Secretary of State for Foreign Affairs in 1809, and after a career in the diplomatic service was to become a Trustee of the British Museum in 1838. A fine drawing by the architect C. R. Cockerell (Smith, *loc. cit.*, figure 10) shows Elgin's Gallery about 1810.

48. Farington, V, 46. p. 206

49. *Autobiography of B. R. Haydon*, ed. A. Huxley (1926), I, 67–8, and for his active part in the controversy over purchase, 230–9.

50. *Report*, 68. An account of Canova's visit to p. 207 the Marbles is also given by Haydon, *op. cit.*, 224–6.

51. *Second Letter to the Earl of Elgin, on the propriety of adopting the Greek style of Architecture to the new Houses of Parliament* (1836), 25 (from Smith, *loc. cit.*, 333).

52. These, the sculptures from the temple of Apollo Epikourios at Bassae, built by the same architect as the Parthenon, are uneven in quality. They had been discovered by a party of English and Bavarian travellers, including C. R. Cockerell, in 1811 and bought by the British Museum in 1814.

53. Flaxman was asked more questions than any p. 208 other artist. His evidence covers more than three

pages in the *Report*, roughly the same as that of Payne Knight.

54. The Theseus, sometimes also referred to at the Enquiry as the Hercules, is the seated figure from the east pediment, now often called Dionysus. The other figure most discussed was the reclining figure, still called Ilissus, from the west pediment.

. 209 55. Conditions at the Museum had steadily improved. Up to 1810 admission was by ticket only and visitors were shown round in parties; after 1810 it had been opened free on three days of the week (W. T. Whitley, *op. cit.*, 261). Special arrangements had been made in 1808 for students at the Royal Academy Schools, under the superintendence of an Academician, to study the antiques during the summer months (Farington, V, 68).

. 210 56. The Riding School dates from 1764, but was re-fronted by John Nash before he began his main work on the Palace. William Theed (1764–1817) had begun life as a painter, and then had modelled first for Wedgwood and then for the silversmiths, Rundell and Bridge. He was elected an R.A. in 1813. His output as a sculptor was relatively small, but its quality is good.

57. The Waterloo Vase was begun in Milan at the order of Napoleon, brought to England unfinished, and decorated for George IV. William IV presented it to the nation, and it stood for a long time in the National Gallery. Its great weight made it an undesirable exhibit, and it was offered by the Trustees to Edward VII, and moved to its present position in 1906 (H. Clifford Smith, *op. cit.*, 65).

58. The Parthenon sculpture was not the only part of Lord Elgin's collection to be influential. He had also brought back one of the caryatids from the Erechtheum, which was copied in Coade stone by Rossi for the porch of St Pancras parish church (1819–22).

CHAPTER 25

211 1. J. P. Neale, *Westminster Abbey*, II (1823), 210.

2. For the elder Westmacott, see p. 171.

3. As early as 1794 Farington thought that Wyatt, who had the king's ear, might push 'the young man now abroad' for the commission for the Captain Montague at Westminster (Farington, I, 59).

4. Farington, IV, 176, 286; unpub., 3914, 3773.

5. P.R.O. T1/1009.6247.

6. Westmacott's first design must have had three p. 212 figures. It was not to the taste of Payne Knight, who is said to have described it as 'a figure speaking what another figure was recording, and two other figures sat like persons weary of hearing it' (Farington, IV, 97).

7. Lord Bradford had inherited the property of Addison's daughter, who had died when about ninety, and decided to spend £1,000 on the monument. In February 1803, Rossi hoped for the commission (Farington, II, 80). J. Neale, *op. cit.*, II, 256 gives the date of erection as 1809.

8. It was originally erected in 1823 in the north transept (Neale, *loc. cit.*, 302), but moved to its present position about 1848. It was paid for by public subscription, to which the Prince Regent contributed one thousand guineas.

9. It has been suggested (H. Honour, 'Count Giovanni Baratta and his brothers', *Connoisseur*, CXLII (1958), 173) that the head of the negro is derived from Baratta's Freeing of the Slaves (1710–17) in S. Ferdinando at Leghorn. While it is possible that Westmacott had seen and remembered this work, his negro is so powerful a creation that it must, surely, have been modelled from life.

10. The monument, erected by her sister, is p. 213 signed but not dated. Since a replica of the figure was made for Lord Lansdowne in 1822 it was probably finished by then. It was presumably this figure, referred to as 'Charity', of which J. T. Smith spoke with approbation for the contrast between the beautiful flesh and the 'coarse dowlas drapery' (*Nollekens*, I (1828), 254). A companion group, 'The Happy Mother', was made in 1825, but was still unsold in 1834 (T. K. Hervey, *Illustrations of Modern Sculpture* (1834), plate 1).

11. He had been elected a member of the Academy in Florence in 1795, so must presumably have worked there as well as in Rome.

12. The theme of philanthropy to agricultural p. 214 classes is also used for the relief on the tablet to the 11th Earl of Pembroke (d. 1827, Wilton, Wiltshire; Plate 175A), though here the figures are shown in semi-antique dress, the group is more loosely designed, and the modelling weaker.

13. Westmacott's clients clearly admired it, for it was repeated at least half-a-dozen times.

14. A pretty but feeble example of the softer p. 215 style appears in the two kneeling ladies holding a medallion on the tablet to the 2nd Earl of Upper

Ossory (d. 1818, Grafton Underwood, Northamptonshire).

p. 215 15. Farington, VII, 268.

16. *Literary Chronicle* (1822), 476 (from the Whitley papers, Department of Prints and Drawings, B.M.).

17. *Journal of Henry Edward Fox, 1818–30*, ed. the Earl of Ilchester (1923), 184.

18. Fox thought the boy too much like an Infant Hercules, and said that the 'Venus is a portrait, but he is bound to secrecy as to the original's name. It is the mistress of some man about in society'.

p. 216 19. The base of the Bedford is more attractive than the statue, for it is adorned with a charming series of children symbolizing the four seasons, and with well-designed reliefs of rustic occupations, referring to the duke's interest in agriculture. One of these includes the old man with a staff who reappears on the Pembroke and Bridgewater monuments.

20. This monument, in hand by 1828, was raised by subscription, the supervision being in the hands of the Committee of Taste (P.R.O. T1/4029). Westmacott had his own bronze foundry. Another dignified classical statue of about this date is the marble Lord Erskine (1830, Lincoln's Inn).

21. Farington, unpub., 6958.

22. Sir Richard's practice was even more extensive than has been indicated here (see Gunnis, *Dict.*, 423) and included fireplaces early in his life, the most notable being the Dragon Fireplace in the Pavilion at Brighton; an equestrian statue of George III (1831, Windsor Great Park); and the pediment sculpture on the British Museum (finished 1847). Two of his brothers, George (worked 1799–1827) and Henry (1784–1861), were also sculptors, though before 1830 the latter seems to have been mainly employed as a mason (Gunnis, *Dict.*, 421).

CHAPTER 26

p. 217 1. There are two early biographies of Chantrey: G. Jones, *Sir Francis Chantrey, R.A., Recollections of his Life, Practice and Opinions* (1849), and J. Holland, *Memorials of Sir Francis Chantrey* (Sheffield, 1851), which are to some extent complementary. Jones, who was Keeper of the Royal Academy and one of Chantrey's executors, knew the sculptor well in later life, and his book sets out to confute the critics who after Chantrey's death claimed he was merely

a maker of busts and greatly inferior as an artist to both Banks and Flaxman. Holland, filled with local patriotism, stresses Chantrey's early life and corrects some of Jones's statements concerning it. My chapter on Chantrey is much the poorer through the death in February 1962 of Mrs M. I. Webb, for her long illness prevented her from completing the book on which she had been working for many years. I am deeply grateful to Professor Geoffrey Webb for his generous permission to make use of her photographs; but I have not drawn on Chantrey's Ledgers at the Royal Academy, since I hope that he will shortly be completing his wife's work on them.

2. Carey became a fairly well-known writer on art, and also advised collectors (see D. Hall, 'The Tabley House Papers', *Walpole Soc.*, XXXVIII (1962), 62).

3. His name does not appear in the Royal Academy Registers, so he cannot have worked sufficiently regularly to have been admitted as a *bona-fide* student.

4. The visit may have been in connexion with the statue commissioned by the Corporation of London, who would not pay the prices of established sculptors, for George III's jubilee (see p. 203). His pathetic bust of the king, the last portrait made of him, at the Royal College of Surgeons, London, is dated 1814, but it seems unlikely, in view of George III's relapse into madness after 1810, that he had a further sitting. p. 21

5. A replica in the Ashmolean Museum, Oxford, was presented by Lady Chantrey in 1842. It is not possible to say which version was shown in the Academy.

6. Holland, *op. cit.*, 260.

7. In the interesting account of Chantrey's method of working, added by Sir Henry Russell, who sat in 1822, to Jones's biography (*op. cit.*, 275 f.), the sculptor is said to have stated that on some occasions he incised the eyes because 'In the expression of some faces the eyes are the feature that takes the lead. When that is the case, I mark the pupils, when it is otherwise I do not.' Russell had noticed that the eyes of the Duke of Wellington were incised and those of George IV were not; and Chantrey's decision here would seem to support impressions of the characters of these two sitters.

8. Holland, *op. cit.*, 317. p. 2

9. The modern work on Hafod (E. Inglis Jones, *Peacocks in Paradise* (1950), 225 and illus., 226) states

categorically that it was designed by Stothard. Chantrey's early biographers are silent on this point, but in view of their violent denials of Stothard's help over 'The Sleeping Children' this silence may be revealing.

10. It was not paid for by the father's death in 1814, or by the mother's in 1833, and was ultimately taken to Hafod by the 4th Duke of Newcastle, who had bought the estate (*ibid.*, 225, 244).

11. Mrs Watts Russell paid £5,000 for the work (Farington, VIII, 168). It is of some interest that here as in other works Chantrey was willing to use Gothic tracery in the panels of the base, though other details are neo-classical.

12. Holland, *op. cit.*, 270. This was the year in which Canova sent works to the Exhibition in gratitude for his treatment in England (see p. 204). For an assessment of the work, see T. S. R. Boase, *English Art, 1800–1870* (1959), 141.

p. 220 13. Chantrey had borrowed the drawings and original designs for Penelope Boothby from Banks's daughter (P. Cunningham, 'New Materials for the Life of Thomas Banks, R.A.', *The Builder*, XXI (1863), 4), and there seems little doubt that Stothard had had some hand in the design. Holland (*op. cit.*, 270–5) records that Chantrey said much later that he had made a model 'nearly as executed', and that from it Stothard had made a drawing to show to the mother. Stothard's drawing was also seen by B. R. Haydon (*Autobiography*, ed. A. Huxley (1926), I, 368).

14. Farington, VIII, 79, 98, 108, 112. He was reported as being 'a plain man, of good sense, and showing nothing to create apprehension of his being disagreeable to the Society'.

15. Jones, *op. cit.*, 16. He also states that Chantrey had paid an earlier visit to Paris in 1802, but that no record remained of the journey. Holland, who appears better informed about Chantrey's early life, does not mention this, and it is hard to see how Chantrey could have afforded it.

16. *Ibid.*, 31.

17. *Ibid.*, 36. The journey also had a practical value, for Chantrey visited the Carrara quarries, where his fame had preceded him, and was able to order marble of high quality. His insistence on good-quality material is a marked characteristic of his work, though J. T. Smith (*Nollekens* (1828), I, 261) notes that at the time of writing most leading sculptors used large blocks of marble instead of piecing figures together as Nollekens had done.

p. 221 18. *Autobiography* (*op. cit.*), II, 711. Chantrey had

made a seated figure of Dr Anderson for Madras in 1819, which Holland thought 'one of his very best statues' (*op. cit.*, 276). It was clearly a form he liked, for when his friend the painter James Northcote, R.A., had left money for a monument, the design to be of Chantrey's own choice, he made the beautiful seated figure (1841, Exeter Cathedral) of the painter with his palette in his hand, though he said the money was too much for a bust but too little for a monument.

19. The Edinburgh George IV was designed to stand against a wall, and Jones held that it was injured by its position in George Street, where too much of the back is seen (*op. cit.*, 80).

20. Even twenty-five years after his death Pitt p. 222 was still regarded as the embodiment of Toryism, and when his statue, which had cost £7,000, was being erected during the agitation for the Reform Bill, reformers attempted to pull it down, but were foiled by the precautions of Chantrey's workmen (Holland, *op. cit.*, 302).

21. These foundries are evidence of the changed position and wealth of the sculptors, who were, in fact, now *entrepreneurs* employing a variety of craftsmen, as well as artists.

22. Jones, *op. cit.*, 115, 288.

23. *Ibid.*, 84. He was reluctant to use decoration on the robe of the bronze George IV at Brighton, until he was assured of the good effect of the rich surfaces of the bronze statues round the tomb of the Emperor Maximilian at Innsbruck.

24. William IV, who ordered it in 1831, intended it to be erected as a monument in Westminster Abbey, but this was thought improper, and it passed on his death to the Earl of Munster, his eldest son by Mrs Jordan (*Cat. R.A. Exhib.*, *British Portraits* (1956–7), 533).

25. Jones, *op. cit.*, 289.

26. A rather less successful variant of this design, p. 223 with the figures, here semi-nude, arranged on either side of the urn, appears in the monument to Generals Gore and Skerrett (1825, St Paul's Cathedral), which is signed 'W. Tallimache inv./F. Chantrey sc.'. Tallimache was a very minor architect, and I know of no other example of Chantrey collaborating in this way with another artist.

27. For an appreciation by a German visitor in p. 224 1844, see Holland, *op. cit.*, 285.

28. Gunnis, *Dict.*, plate V; T. S. R. Boase. *op. cit.*, 142 and frontispiece.

29. Boase, *op. cit.*, plate 50A.

p. 224 30. Chantrey also made a number of small tablets with fine neo-classical decoration and profile heads in low relief, e.g. Thomas Tomkins (d. 1816, Chiswick, Middlesex), and a few bust monuments, including a couple in St Chad's, Shrewsbury. There are also some essays in reliefs of a neo-classical type, e.g. the monument to the Earl of Pomfret (1819, Easton Neston, Northamptonshire) and panels of Hector and Penelope (1828, Woburn Abbey, Bedfordshire), in which his heavy figures compare unfavourably with similar works by his contemporaries.

31. *Autobiography* (*op. cit.*), II, 620. Haydon was discussing the appointment of the Council for the new School of Design (a topic outside the range of this book), and added that Chantrey was 'the most incompetent person to judge of principles of Art'.

32. *Nollekens* (1828), I, 254.

p. 225 33. Jones, *op. cit.*, 164. A bust signed by Chantrey of Thomas Coke, Earl of Leicester (Holkham Hall, Norfolk), is inscribed: 'from a model by Roubiliac'.

34. *Ibid.*, 160–1.

35. The main account of Chantrey's methods is that given by Sir Henry Russell (Jones, *op. cit.*, 275–301), but some details are added by Holland (*op. cit.*, 295).

36. Jones, *op. cit.*, 8.

37. Several versions of this exist, among them those at Chatsworth (1822), the Royal College of Surgeons, London (1823), and Windsor Castle (1828).

38. The family version from Londonderry p. 226
House, dated 1821, and a replica dated 1828, were sold at Sotheby's, 16 November 1962 (29, 30). Further replicas are at Apsley House, the N.P.G., and Windsor Castle.

39. A version of the Nollekens with the neck draped is in the B.M.

40. Chantrey stated (Jones, *op. cit.*, 253) that the only marble copy he made of the bust of 1820 was for the Duke of Wellington (Stratfield Saye, Hants). A different bust of Scott was made in 1828, when the bust of 1820 was given as an heirloom to Abbotsford, and in 1838 the later bust was presented to Sir Robert Peel. This has now disappeared, but marble copies must have been pirated, such as the one at the Lady Lever Art Gallery, Port Sunlight.

41. Works bought by the Chantrey Bequest are p. 227
deposited at the Tate Gallery.

42. *The Art Union* (January 1842), 13. I owe this quotation to Mr Rupert Gunnis.

43. Jones, *op. cit.*, 301.

BIBLIOGRAPHY

I. GENERAL

A. EARLY SOURCES

CUNNINGHAM, ALLAN. *Lives of the British Painters, Sculptors and Architects.* 6 vols. 1830.

> Vol. III includes lives of the leading eighteenth-century sculptors, but much of the information is second-hand. Also an important source for early-nineteenth-century taste.

FARINGTON, JOSEPH. *Diary.* 8 vols. Ed. J. Greig, 1922–8.

> Covering the years 1793–1821. The published edition is incomplete, but a full transcript of the manuscript, which is in the Royal Library at Windsor Castle, is deposited by gracious permission of Her Majesty the Queen in the Print Room, B.M. The work contains much first-hand information.

GIBBS, JAMES. *A Book of Architecture.* 1728.

> Includes many designs for monuments.

LE NEVE, JOHN. *Monumenta Anglicana.* 5 vols. 1717–19.

> Includes lists of works by contemporary sculptors.

SMITH, JOHN THOMAS. *Nollekens and his Times.* 2 vols. 1828.

> In addition to the main account of Nollekens, short biographies of other artists, not always reliable, are added to vol. II.

VERTUE, GEORGE. *Notebooks*, 1713–46. Published in full in *Walpole Society*, XVIII (1930); XX (1932); XXII (1934); XXIV (1936); XXVI (1938); XXIX, Index (1942); XXX (1950).

> Invaluable first-hand information about late-seventeenth- and eighteenth-century sculptors.

WALPOLE, HORACE. *Anecdotes of Painting*, 1762. Ed. J. Dallaway and R. N. Wornum, 1888, with an additional volume, ed. F. W. Hilles and P. B. Daghlian, New York, 1937.

> Much of Walpole's information was drawn from Vertue's *Notebooks*, which he owned, but more is added, and the book is a major source for taste as much as for information.

B. MODERN WORKS

ESDAILE, K. A. *English Monumental Sculpture since the Renaissance.* 1927; *English Church Monuments, 1530–1840.* 1946.

> The former, though out-of-date at many points, was the pioneer work; the latter is less reliable.

GUNNIS, R. *Dictionary of British Sculptors, 1660–1851.* 1953.

> The standard book of reference.

WHITLEY, W. T. *Artists and their Friends in England, 1700–1799.* 2 vols. 1928; *Art in England, 1800–1820.* 1928.

> Both contain information drawn chiefly from contemporary sources, and more is contained in the fourteen volumes of *Notes and Cuttings* in the Print Room, B.M.

SAXL, F., and WITTKOWER, R. *English Art and the Mediterranean.* 1948.

C. COLLECTING

MICHAELIS, A. *Ancient Marbles in Great Britain.* 1882.

Eighteenth Century

ASHBY, T. 'Thomas Jenkins in Rome', *Papers o, the British School in Rome*, VI (1913), 487.

HONOUR, H. 'English Patrons and Italian Sculptors', *Connoisseur*, CXLI (1958), 224.

IRWIN, D. 'Gavin Hamilton: Archaeologist, Painter and Dealer', *Art Bulletin*, XLIV (1962), 87.

Nineteenth Century

Report of the Select Committee on the Earl of Elgin's Collection of Sculptured Marbles, etc. 1816.

SMITH, A. H. 'Lord Elgin and his Collection', *Journ. of Hellenic Studies*, XXXVI (1916), 163.

II. SPECIAL PERIODS

A. TUDOR AND JACOBEAN

MANN, J. G. 'English Church Monuments; 1536–1625', *Walpole Soc.*, XXI (1933), 1.

ESDAILE, K. A. 'Three Monumental Drawings from Sir Edward Dering's Collection', *Arch. Cantiana*, XLVII (1935), 219; 'The Inter-action of English and Low Country Sculpture in the Sixteenth Century', *Journ. W. and C.I.*, VI (1943), 80; 'The Part played by Refugee Sculptors', *Proc. Huguenot Soc.*, XVIII (1949), 255; 'Some Fellow-Citizens of Shakespeare in Southwark', *Essays and Studies*, n.s. V (1952), 26.

MERCER, E. *English Art, 1553–1625 (Oxford History of English Art,* VII). 1962.

B. SEVENTEENTH CENTURY

KNOOP, D., and JONES, G. P. *The London Mason in the Seventeenth Century.* Manchester, 1935.

WHINNEY, M. D., and MILLAR, O. *English Art, 1625–1714 (Oxford History of English Art,* VIII). 1957.

C. EIGHTEENTH CENTURY

ESDAILE, K. A. 'Some Annotations on John Le Neve's "Monumenta Anglicana"', *Antiquaries Journ.*, XXII (1942), 176.

WEBB, M. I. 'Architect and Sculptor', *Archit. Review*, CXXIII (1958), 330.

D. NINETEENTH CENTURY

BOASE, T. S. R. *English Art, 1800–1870 (Oxford History of English Art,* X). 1959.

III. TOPOGRAPHICAL

Early county histories, in which small pieces of information can often be found, are too many to be listed, but the two following on single buildings are of importance:

DUGDALE, W. *History of St Paul's.* 1658. Ed. H. E. Ellis, 1818.

NEALE, J. *Westminster Abbey.* 2 vols. 1823.

A. MODERN WORKS (COUNTIES)

Berkshire

ESDAILE, K. A. 'English Sculpture in some Berkshire Churches', *Berkshire Arch. Journ.*, XLV (1941), 45, 86; XLVI (1942), 22, 69.

Buckinghamshire

ESDAILE, K. A. 'Renaissance Monuments of Buckinghamshire', *Records of Bucks*, XV (1947), 32.

Cheshire

CROSSLEY, F. H. 'Post-Reformation Effigies of Cheshire', *Trans. Hist. Soc. Lancashire and Cheshire*, XCI (1939), 1.

Derbyshire

ESDAILE, K. A. 'Post-Reformation Monuments, mainly in Derbyshire', *Derbyshire Arch. Soc. Journ.*, LX (1939), 84.

Gloucestershire

ROPER, I. M. *Monumental Effigies of Gloucestershire and Bristol.* Gloucester, 1931.

Kent

GUNNIS, R. 'Signed Monuments in Kentish Churches', *Arch. Cantiana*, LXII (1949), 57.

Somerset

FRYER, A. C. 'Monumental Effigies in Somerset, 16th century', *Somerset Arch. Soc. Proc.*, LXXII (1926), 23; LXXIV (1928), 10; LXXVI (1930), 28.

Staffordshire

JEAVONS, S. A. 'The Monumental Effigies of Staffordshire', *Birmingham Arch. Soc. Trans.*, LXIX (1951), i; LXX (1952), 1; LXXI (1953), 1.

Warwickshire

CHATWIN, P. 'Monumental Effigies in the County of Warwick, Part III', *Birmingham Arch. Soc. Trans.*, XLVIII (1922), 136.

Yorkshire

ESDAILE, K. A. 'Sculpture and Sculptors in Yorkshire', *Yorkshire Arch. Journ.*, XXXV (1940–3), 363; XXXVI (1944–7), 78, 137.

B. MODERN WORKS (TOWNS)

Bristol

FRYER, A. C. 'Monumental Effigies by Bristol Craftsmen', *Archaeologia*, LXXIV (1925), 1.

Cambridge

ESDAILE, K. A. 'English Sculpture in Cambridge from the Sixteenth to the Eighteenth Century', *Proc. Cambridge Antiquarian Soc.*, XXXIV (1934), 1.

London

ESDAILE, K. A. *Temple Church Monuments.* 1933.

York

MORRELL, J. B. *York Monuments.* n.d.

IV. INDIVIDUAL ARTISTS

BACON, JOHN

Cecil, Rev. R. *Memoirs of John Bacon, Esquire, R.A.* 1801.

Cox-Johnson, A. 'John Bacon', *St Marylebone Society Publications*, IV (1961).

BANKS, THOMAS

Bell, C. F. *Annals of Thomas Banks.* 1938.

Flaxman J. 'Address on the death of Thomas Banks', *Lectures on Sculpture*, 2nd ed. 1838.

BUSHNELL, JOHN

Esdaile, K. A. 'John Bushnell', *Walpole Soc.*, XV (1927), 21; 'Additional Notes on John Bushnell', *ibid.*, XXI (1933), 105.

CARTER, BENJAMIN AND THOMAS

Gunnis, R. 'The Carters, Georgian Sculptors', *Archit. Review*, CXXIII (1958), 334.

CIBBER, CAIUS GABRIEL

Faber, H. *C. G. Cibber.* 1926.

Manners, Lady V. 'Garden Sculpture by Caius Gabriel Cibber', *Country Life*, LXVIII (1930), 382.

CHANTREY, SIR FRANCIS

Jones, G. *Sir Francis Chantrey, R.A., Recollections of his Life, Practice and Opinions.* 1849.

Holland, J. *Memorials of Sir Francis Chantrey.* Sheffield, 1851.

CHEERE, HENRY

Webb, M. I. 'Henry Cheere, Henry Scheemakers and the Apprenticeship Lists', *Burl. Mag.*, XCIX (1957), 115; 'Henry Cheere, Sculptor and Businessman, and John Cheere', *ibid.*, C (1958), 232, 274.

CHRISTMAS, GERARD, JOHN, AND MATTHIAS

Burke, J. 'Archbishop Abbot's tomb at Guildford', *Journ. W. and C.I.*, XII (1949), 179.

DELVAUX, LAURENT

Willame, G. *L. Delvaux.* Brussels, 1914.

Devigne, M. *Laurent Delvaux et ses élèves.* Brussels, 1928.

EVESHAM, EPIPHANIUS

Vallance, A. 'The Ropers and their Monuments in Lynsted Church', *Arch. Cantiana*, XLIV (1932), 147.

Jones, K. H. 'The Hawkins Monument by Epiphanius Evesham at Boughton-under-Blean', *ibid.*, XLV (1933), 205.

Esdaile, K. A. 'The Tomb of Lord Rich at Felstead', *Essex Arch. Soc. Trans.*, n.s. XXII (1940), 59; 'The Gorges Monument in Salisbury Cathedral', *Wiltshire Arch. Mag.*, L (1942–4), 53.

Jurgens, M. 'Quelques Actes inédits concernant Epiphanius Evesham', *Bull. de la Soc. de l'histoire de l'art français* (1960), 175.

FANELLI, FRANCESCO

Pope-Hennessy, J. 'Some Bronze Statuettes by Francesco Fanelli', *Burl. Mag.*, XCV (1953), 157.

FLAXMAN, JOHN

Flaxman, J. *Lectures on Sculpture.* 2nd ed. 1838.

Constable, W. G. *John Flaxman.* 1927.

Croft-Murray, E. 'An Account Book of John Flaxman, R.A.', *Walpole Soc.*, XXVIII (1940), 51.

Whinney, M. D. 'Flaxman and the Eighteenth Century', *Journ. W. and C.I.*, XIX (1956), 269.

Irwin, D. 'Flaxman: Italian Journals and Correspondence', *Burl. Mag.*, CI (1959), 212.

GUELFI, GIOVANNI BATTISTA

Webb, M. I. 'Giovanni Battista Guelfi', *Burl. Mag.*, XCVII (1955), 139, 260.

HEWETSON, CHRISTOPHER

Hodgkinson, T. 'Christopher Hewetson, an Irish Sculptor in Rome', *Walpole Soc.*, XXXIV (1952–4), 42.

LE SUEUR, HUBERT

Webb, G. 'Notes on Hubert Le Sueur', *Burl. Mag.*, LII (1928), 10, 81.

Esdaile, K. A. 'New Light on Hubert Le Sueur', *ibid.*, LXVI (1935), 177.

MARSHALL, EDWARD

Stone, L. 'The Verney Tomb at Middle Claydon', *Records of Bucks*, XVI (1955–6), 67.

NOLLEKENS, JOSEPH

Smith, J. T. *Nollekens and his Times*. 2 vols. 1828.

Baum, R. 'Joseph Nollekens: A Neo-Classic Eccentric', *Art Bulletin*, XVI (1934), 385.

NOST, JOHN

Weaver, L. 'Some English Leadwork, v, Garden Statues, vi, Portrait Statues', *Burl. Mag.*, VII (1906), 385; IX (1906), 104.

Esdaile, K. A. 'A Statuette of William III at South Kensington', *Burl. Mag.* LXXVI, (1940), 123; 'The Royal Sisters, Mary II and Anne in Sculpture', *ibid.*, LXXXIX (1947), 254.

Gilbert, C. 'A Newly-discovered Monument by John Nost in Leeds', *Leeds Art Calendar*, L (1962), 4; *ibid.*, LI (1963), 4.

PIERCE, EDWARD

Poole, R. L. 'Edward Pierce the Sculptor', *Walpole Soc.*, XI (1923), 34.

Seymour, J. 'Edward Pearce: Baroque Sculptor of London', *Guildhall Miscellany*, I (1952), 10.

QUELLIN, ARNOLD

Esdaile, K. A. 'Arnold Quellin's Charles II', *Archit. Review*, CII (1947), 174.

Esdaile, K. A., and Toynbee, M. 'More Light on "English" Quellin', *Trans. London and Middlesex Arch. Soc.*, XIX, pt i (1956), 34.

ROUBILIAC, LOUIS FRANÇOIS

Esdaile, K. A. *Roubiliac's Work at Trinity College, Cambridge.* 1924.

Esdaile, K. A. *L. F. Roubiliac.* 1928.

Webb, M. I. 'Roubiliac Busts at Wilton', *Country Life*, CXIX (1956), 804.

Webb, M. I. 'The French Antecedents of L. F. Roubiliac', *Gazette des Beaux-Arts*, 6th ser., XLIX (1957), 84.

RYSBRACK, MICHAEL

Webb, M. I. 'Busts of Sir Isaac Newton', *Country Life*, CXI (1952), 216.

Webb, M. I. *Michael Rysbrack.* 1954.

Watson, F. J. B. 'A Bust of Fiammingo by Rysbrack Rediscovered', *Burl. Mag.*, CV (1963), 441.

SCHEEMAKERS, PETER

Webb, M. I. 'Chimney-pieces by Scheemakers', *Country Life*, CXXI (1957), 491.

STANTON, EDWARD, THOMAS, AND WILLIAM

Esdaile, K. A. 'The Stantons of Holborn', *Arch. Journ.*, LXXXV (1928), 149.

STONE, NICHOLAS

'The Note-book and Account Book of Nicholas Stone', ed. W. L. Spiers, *Walpole Soc.*, VII (1919).

Woodward, J. 'The Monument to Sir Thomas Bodley in Merton College Chapel', *The Bodleian Library Record*, V (1954), no. 2, 69.

THE PLATES

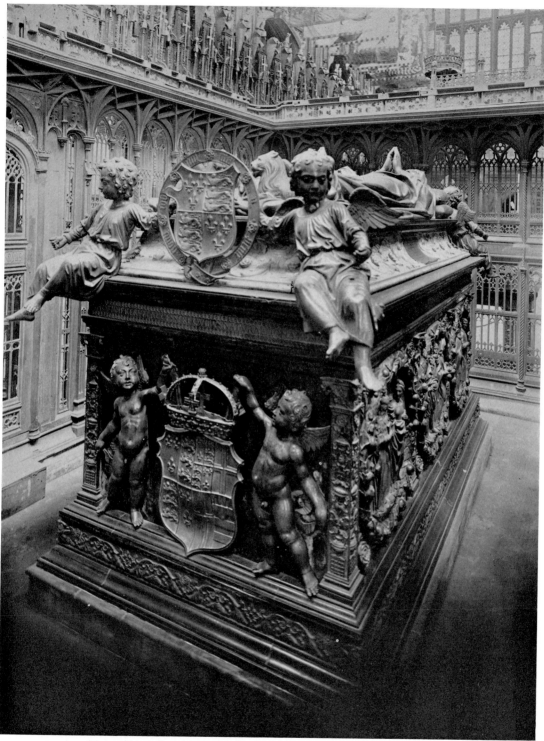

Pietro Torrigiano: Tomb of Henry VII, 1512–18. *Westminster Abbey*

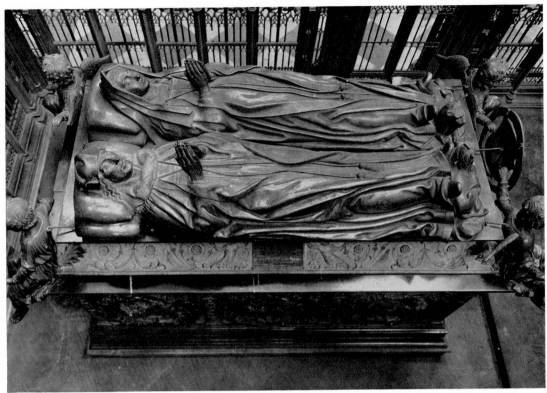

(A) Pietro Torrigiano: Effigies of Henry VII and Elizabeth of York, 1512–18. *Westminster Abbey*

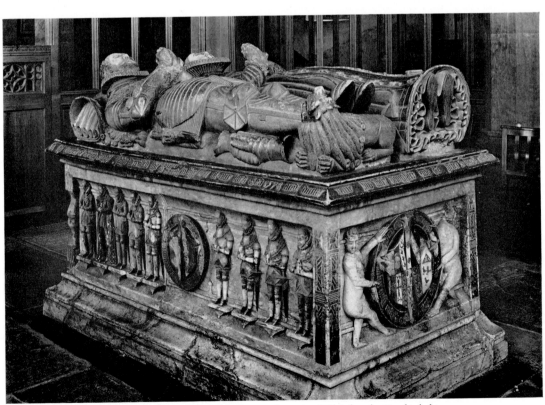

(B) Tomb of Sir John Salusbury, d. 1578. *Whitchurch, Denbighshire*

2

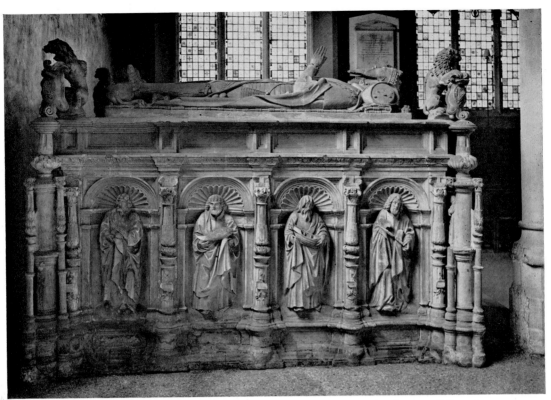

(A) Tomb of the 3rd Duke of Norfolk, *c.* 1560. *Framlingham, Suffolk*

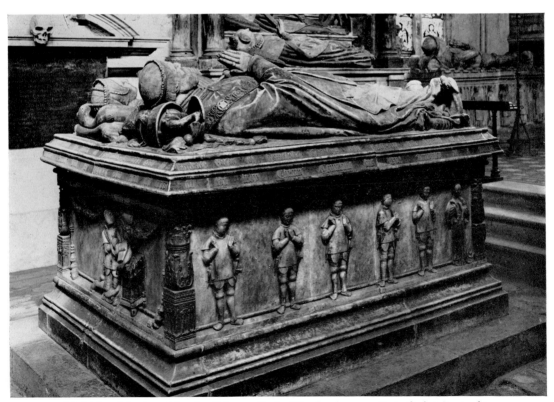

(B) Richard Parker: Tomb of the 1st Earl of Rutland, 1543. *Bottesford, Leicestershire*

3

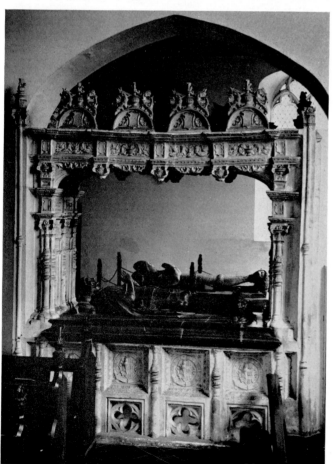

Tomb of the 1st Lord Marney, c. 1530. *Layer Marney, Essex*

4

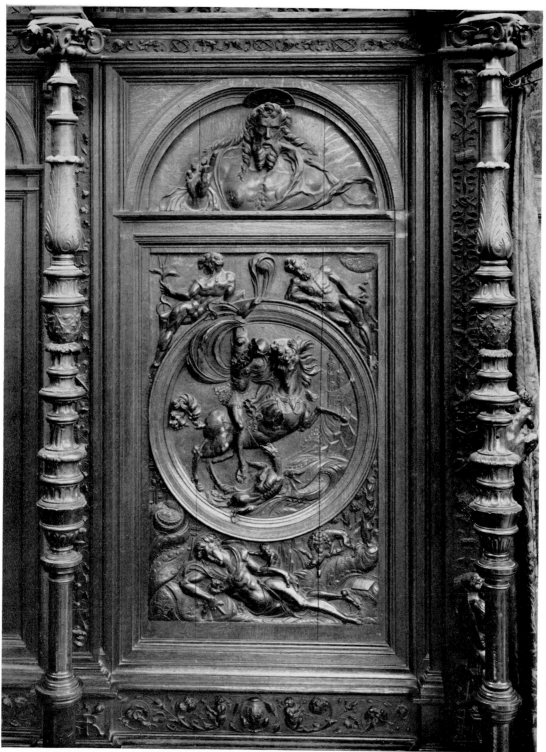

Provost's stall, 1536–8. *Cambridge, King's College*

(B) Chantry of the 9th Earl Delaware, c. 1532.
Boxgrove, Sussex

(A) Fragments from tomb of Thomas Mason, d. 1559.
Winchester Cathedral

6

Tomb of Sir Philip and Sir Thomas Hoby, c. 1566. *Bisham, Berkshire*

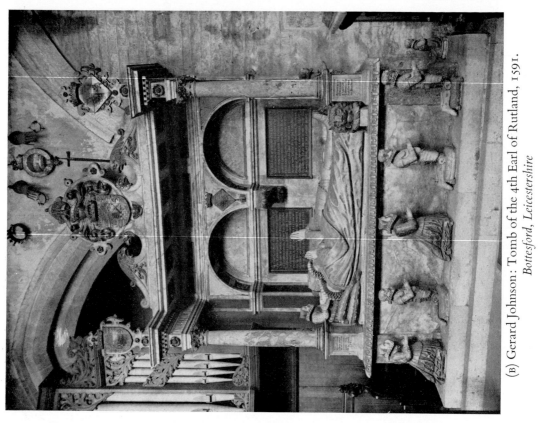

(B) Gerard Johnson: Tomb of the 4th Earl of Rutland, 1591.
Bottesford, Leicestershire

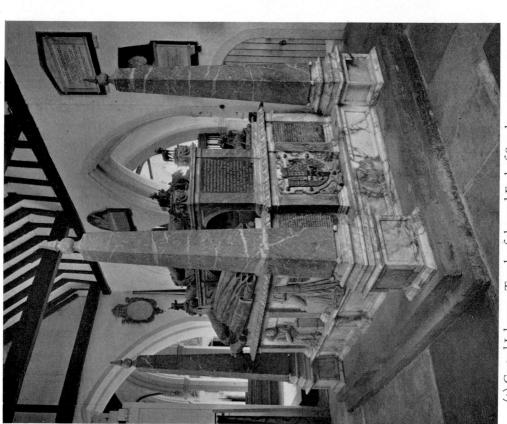

(A) Gerard Johnson: Tomb of the 2nd Earl of Southampton, 1592.
Titchfield, Hampshire

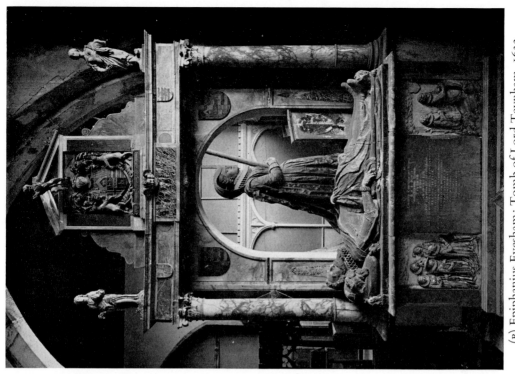

(B) Epiphanius Evesham: Tomb of Lord Teynham, 1632.
Lynsted, Kent

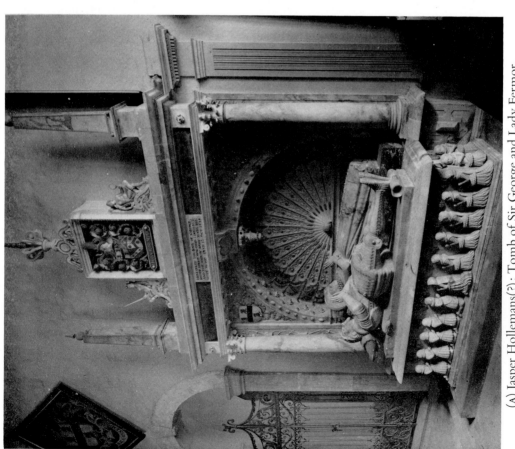

(A) Jasper Hollemans(?): Tomb of Sir George and Lady Fermor,
d. 1612 and 1628. *Easton Neston, Northamptonshire*

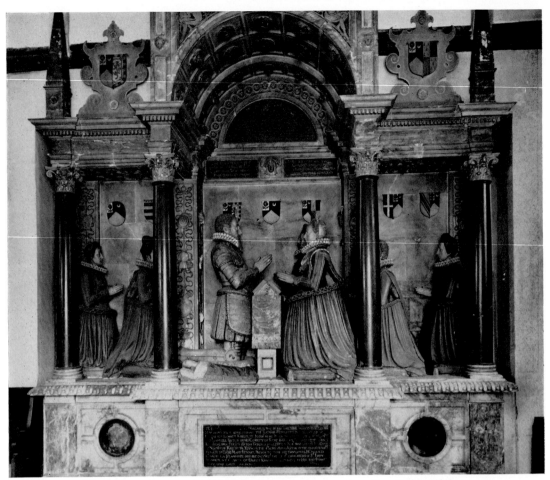

(A) William Cure II: Tomb of Sir Roger Aston, 1612. *Cranford, Middlesex*

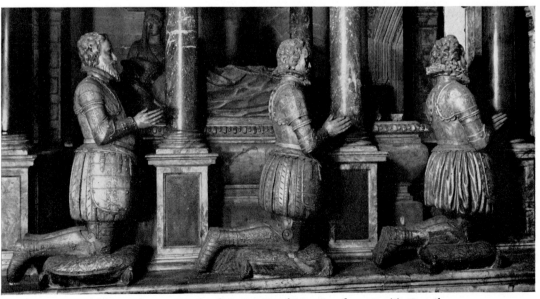

(B) Isaac James: Tomb of Henry, Lord Norris, after 1606(?). Detail.
Westminster Abbey

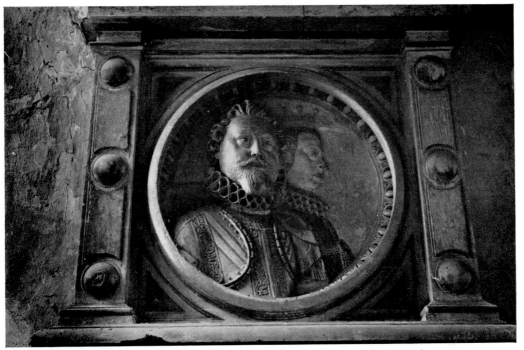

(A) Epiphanius Evesham: Monument to Robert Rich, Earl of Warwick, *c.* 1619.
Snarford, Lincolnshire

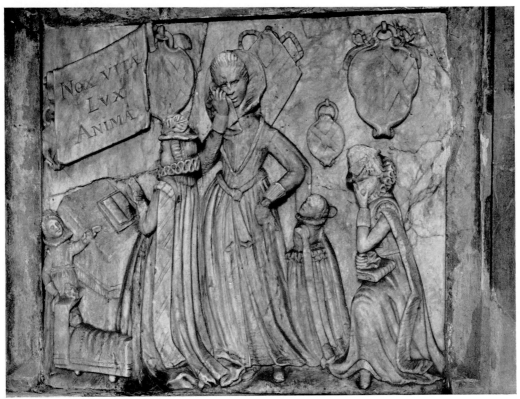

(B) Epiphanius Evesham: Tomb of Sir Thomas Hawkins, 1618. Detail.
Boughton-under-Blean, Kent

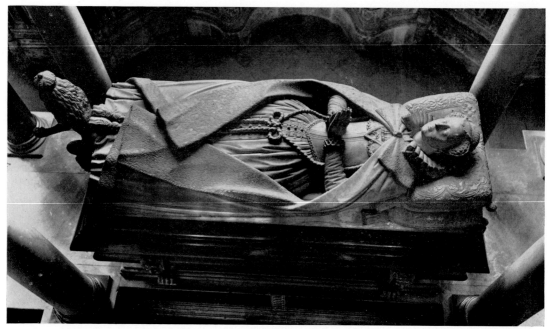

(A) William Cure II: Effigy of Mary, Queen of Scots, 1607–12. *Westminster Abbey*

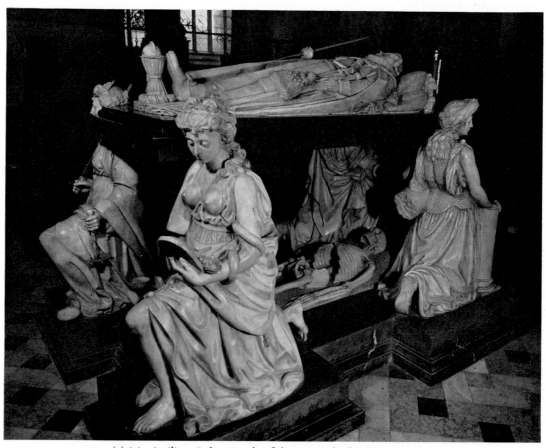

(B) Maximilian Colt: Tomb of the 1st Earl of Salisbury, 1612.
Hatfield, Hertfordshire

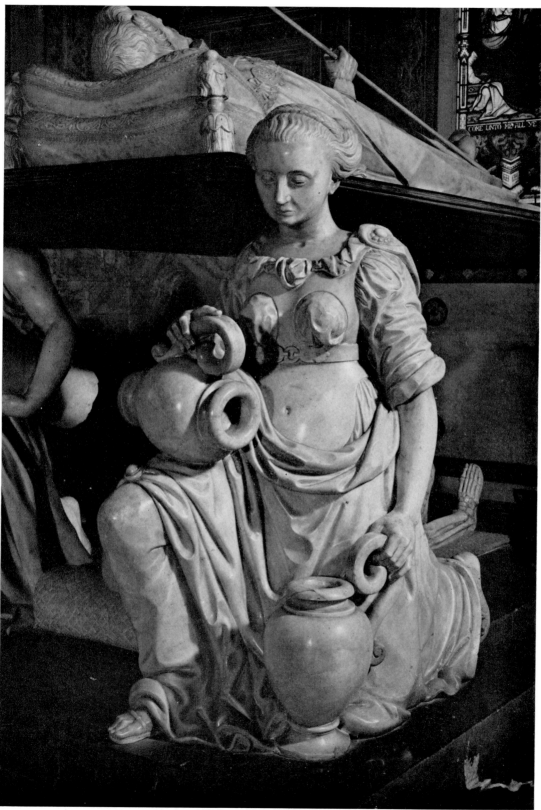

Maximilian Colt: Tomb of the 1st Earl of Salisbury, 1612. Detail.
Hatfield, Hertfordshire

13

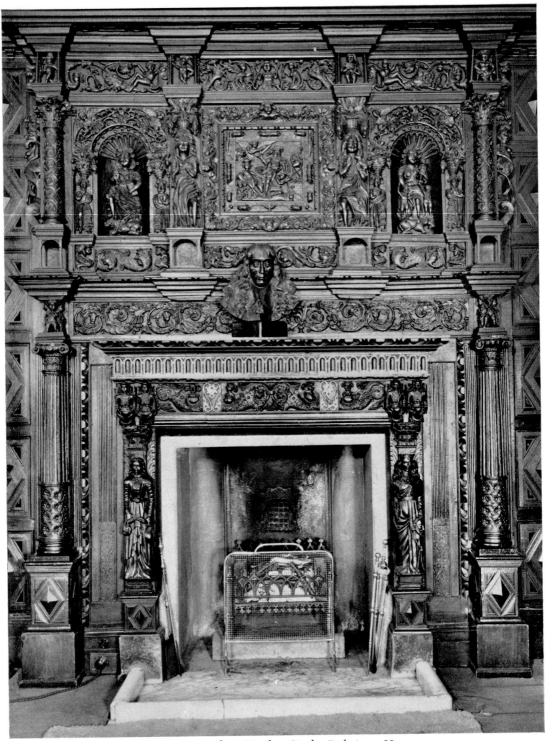

Chimneypiece from Raglan Castle. *Badminton House,*
Gloucestershire

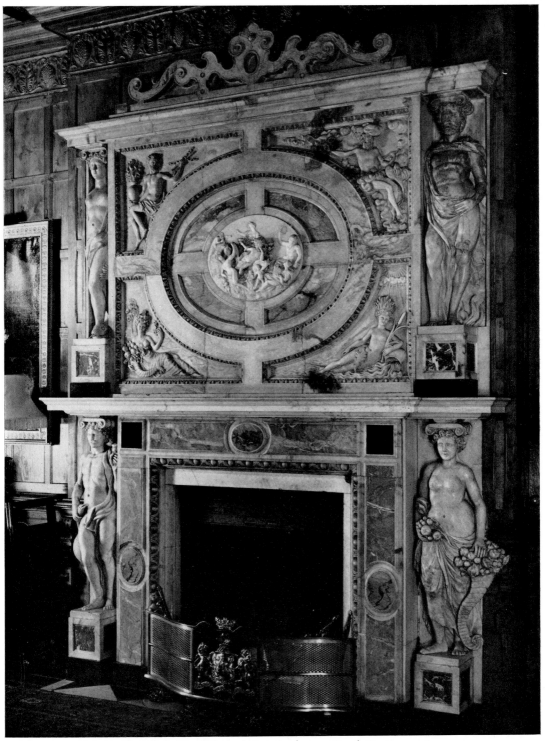

Maximilian Colt (?): Chimneypiece in the van Dyck Room, *c.* 1610.
Hatfield, Hertfordshire

Nicholas Stone: Tomb of Lady Carey, 1617/18. Detail.
Stowe-Nine-Churches, Northamptonshire

16

Nicholas Stone: Tomb of Sir William Curle, 1619.
Hatfield, Hertfordshire

(B) Nicholas Stone: Tomb of Sir Charles Morison, 1619.
Watford, Hertfordshire

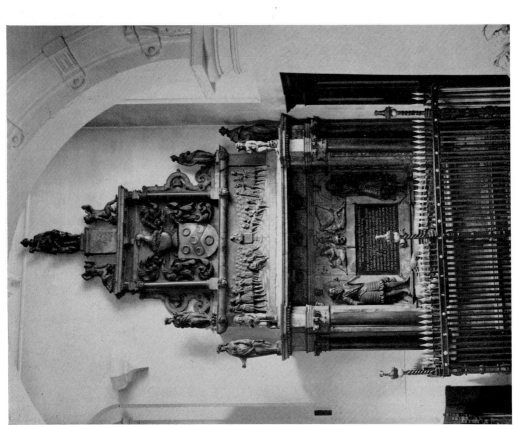

(A) Nicholas Stone and Nicholas Johnson: Tomb of Thomas Sutton, 1615.
London, Charterhouse

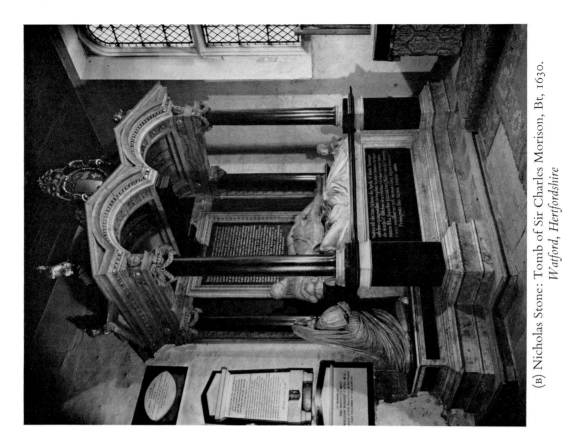

(B) Nicholas Stone: Tomb of Sir Charles Morison, Bt, 1630.
Watford, Hertfordshire

(A) Nicholas Stone: Monument to Edward Pinchon, d. 1625.
Writtle, Essex

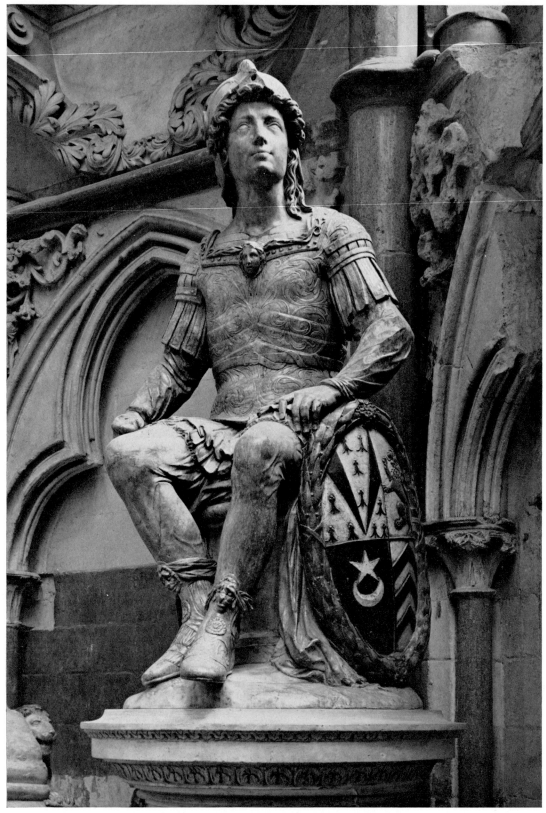

Nicholas Stone: Monument to Francis Holles, d. 1622.
Westminster Abbey

20

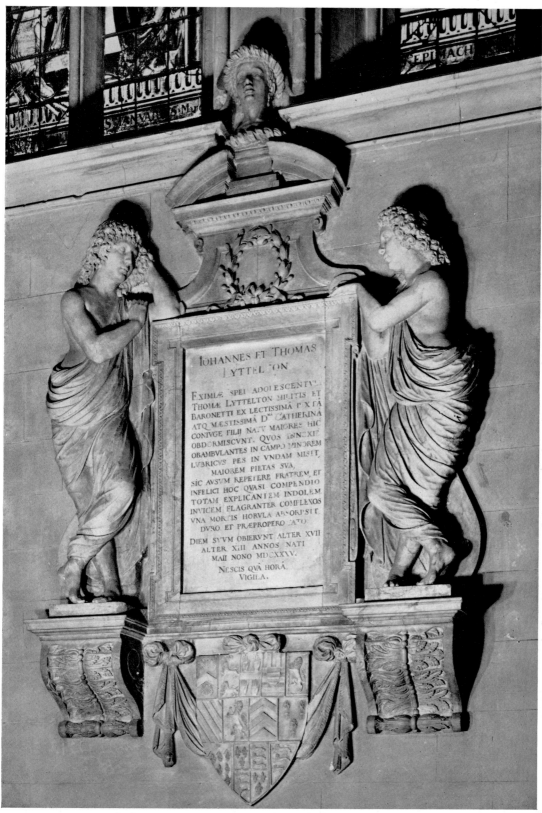

Nicholas Stone: Monument to John and Thomas Lyttelton, 1634.
Oxford, Magdalen College

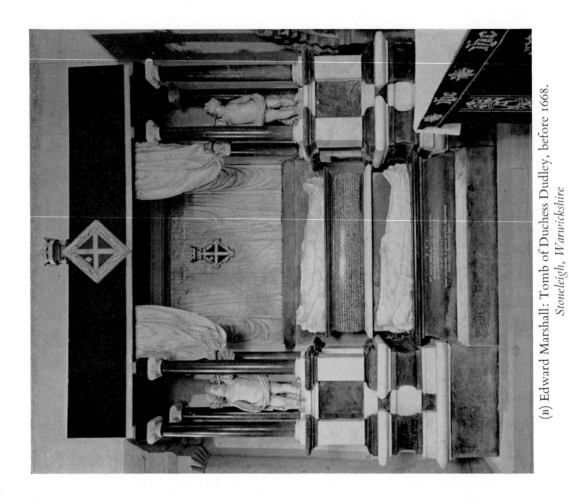

(B) Edward Marshall: Tomb of Duchess Dudley, before 1668.
Stoneleigh, Warwickshire

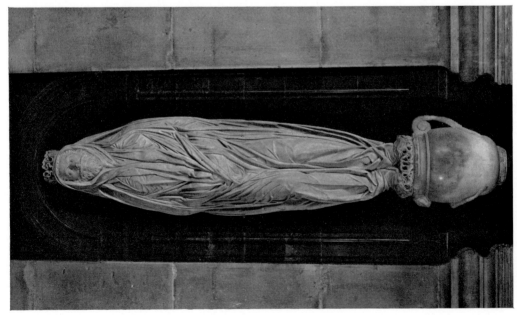

(A) Nicholas Stone: Monument to Dr Donne, 1631.
London, St Paul's Cathedral

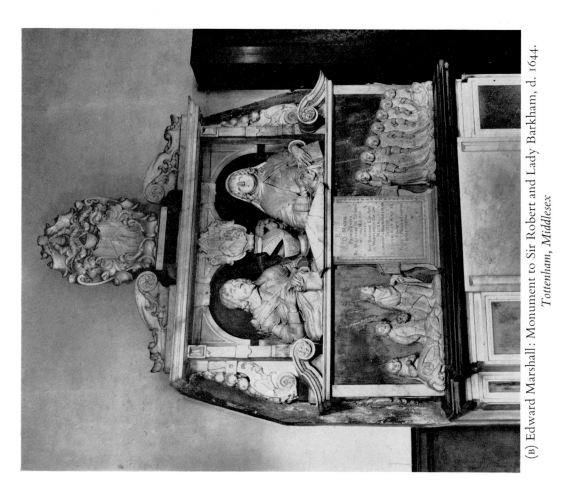

(B) Edward Marshall: Monument to Sir Robert and Lady Barkham, d. 1644.
Tottenham, Middlesex

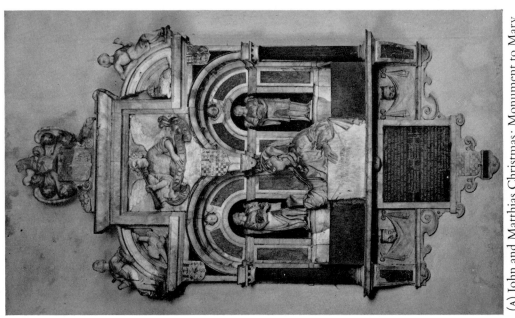

(A) John and Matthias Christmas: Monument to Mary
Calthorpe, 1640. *East Barsham, Norfolk*

23

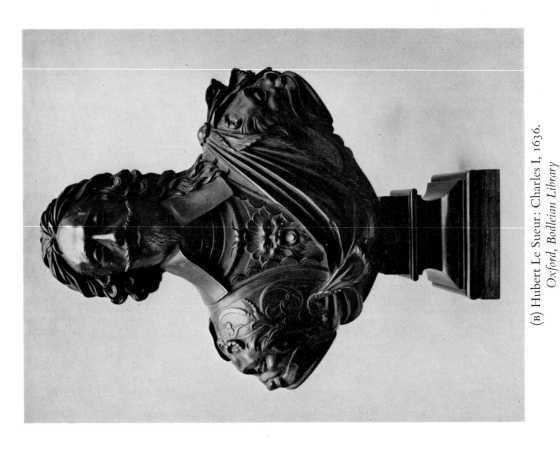

(B) Hubert Le Sueur: Charles I, 1636.
Oxford, Bodleian Library

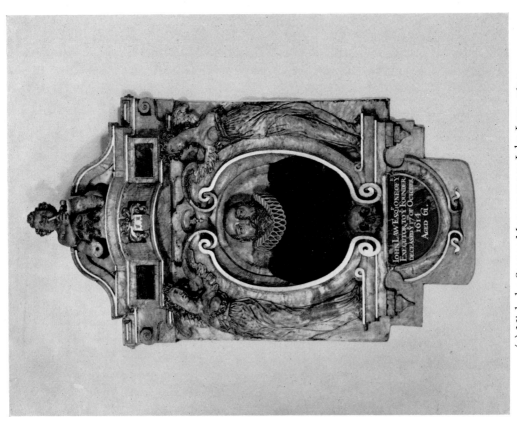

(A) Nicholas Stone: Monument to John Law, 1615.
London, Charterhouse

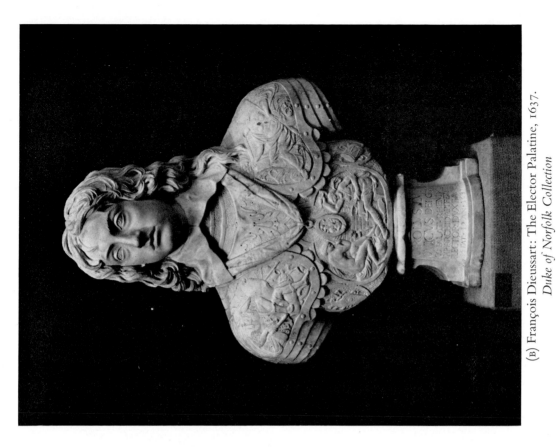

(B) François Dieussart: The Elector Palatine, 1637.
Duke of Norfolk Collection

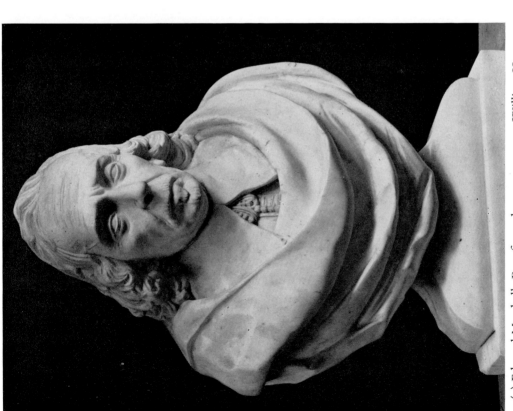

(A) Edward Marshall: Bust from the monument to William Harvey,
d. 1657. *Hempstead, Essex*

25

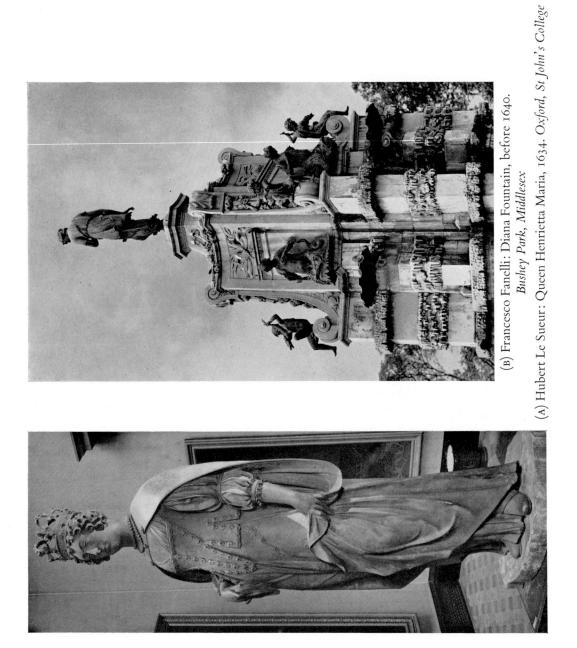

(B) Francesco Fanelli: Diana Fountain, before 1640. *Bushey Park, Middlesex*

(A) Hubert Le Sueur: Queen Henrietta Maria, 1634. *Oxford, St John's College*

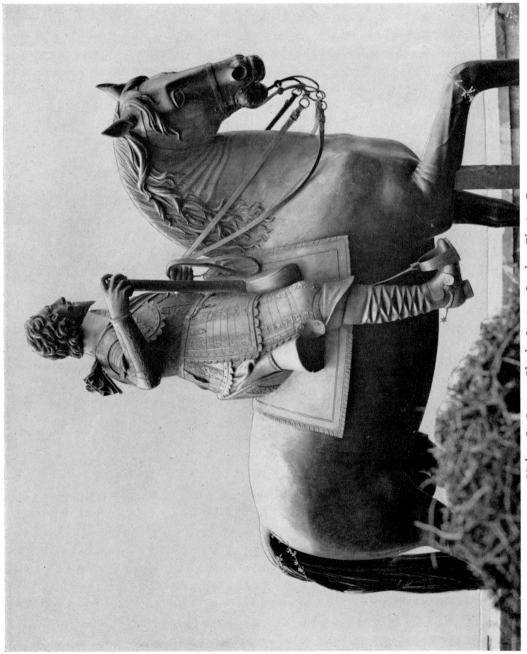

Hubert Le Sueur: Charles I, 1633. *London, Charing Cross*

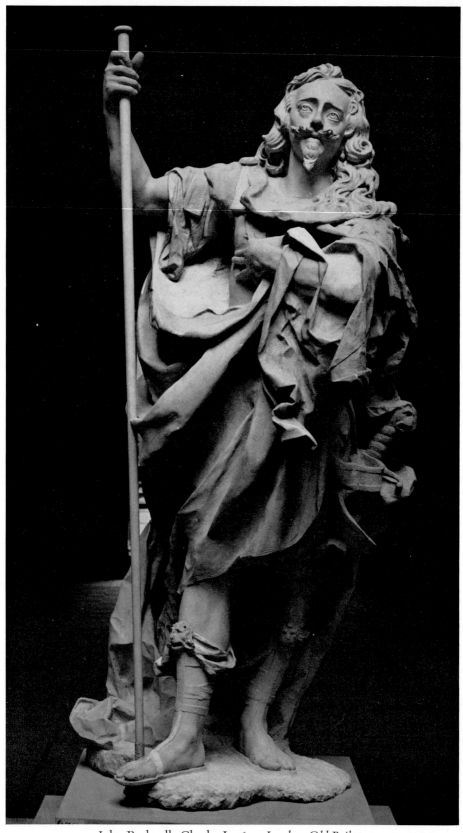

John Bushnell: Charles I, 1671. *London, Old Bailey*

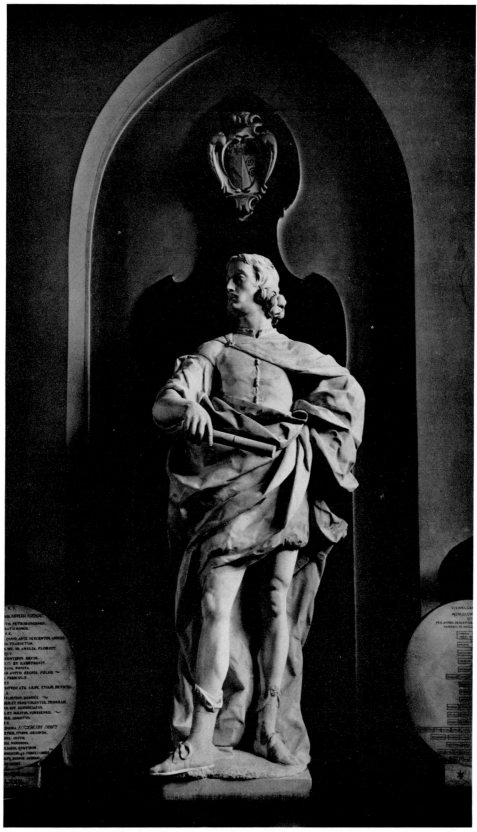

John Bushnell: Monument to Lord Mordaunt, d. 1675. *Fulham, London*

29

John Bushnell: Monument to Alvise Mocenigo, 1663. *Venice, S. Lazzaro dei Mendicanti*

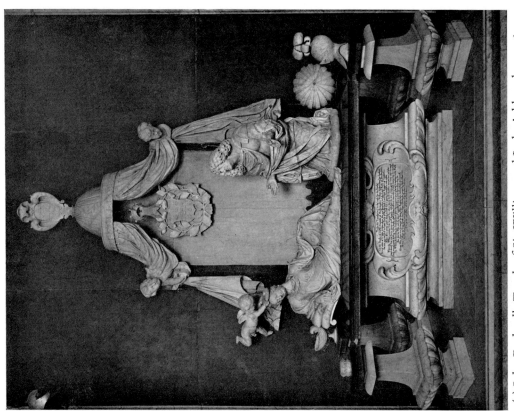

(B) John Bushnell: Tomb of Sir William and Lady Ashburnham, 1675. *Ashburnham, Sussex*

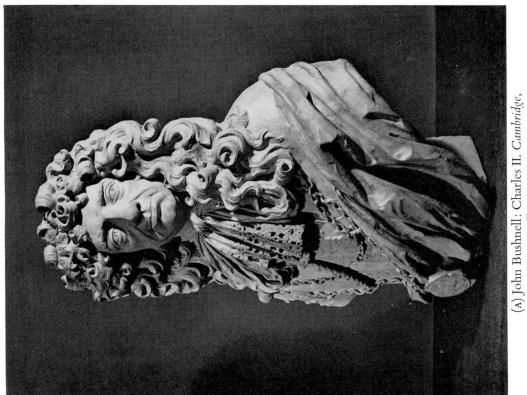

(A) John Bushnell: Charles II. *Cambridge, Fitzwilliam Museum*

31

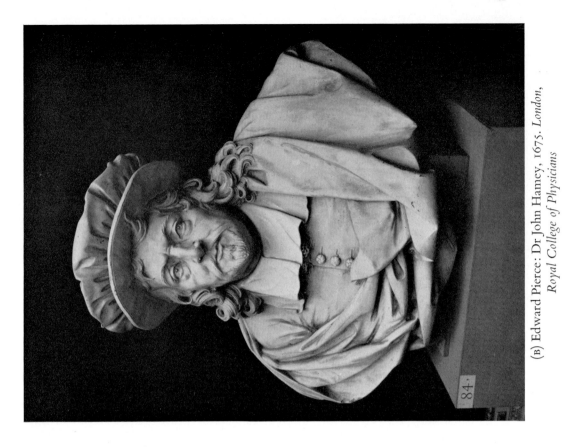

(B) Edward Pierce: Dr John Hamey, 1675. *London,*
Royal College of Physicians

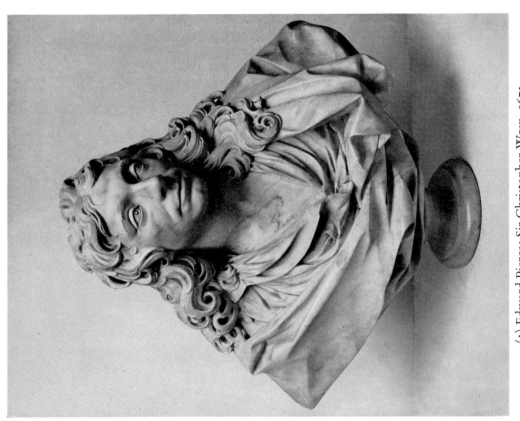

(A) Edward Pierce: Sir Christopher Wren, 1673.
Oxford, Ashmolean Museum

32

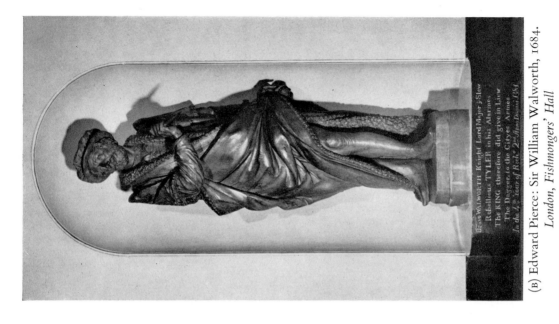

(B) Edward Pierce: Sir William Walworth, 1684.
London, Fishmongers' Hall

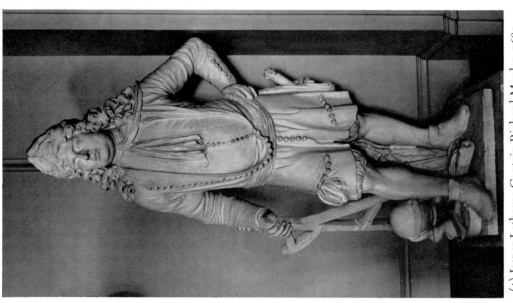

(A) Jasper Latham: Captain Richard Maples, 1683.
London, Trinity House

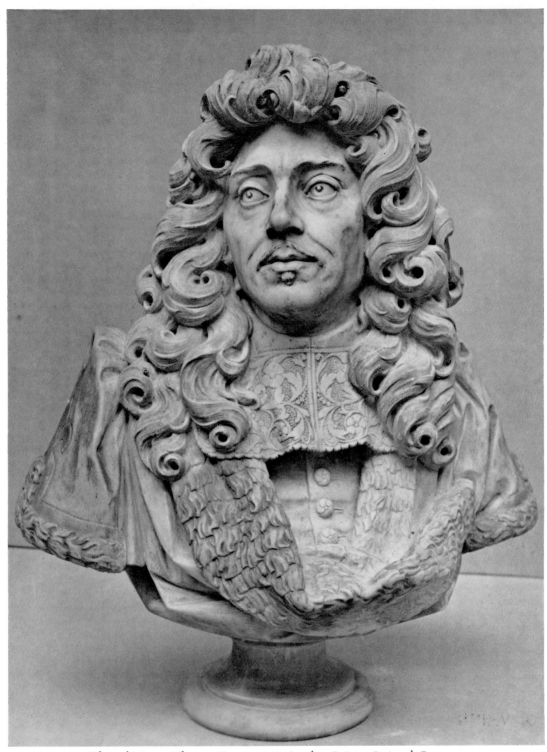

Edward Pierce: Thomas Evans, 1688. *London, Painter-Stainers' Company*

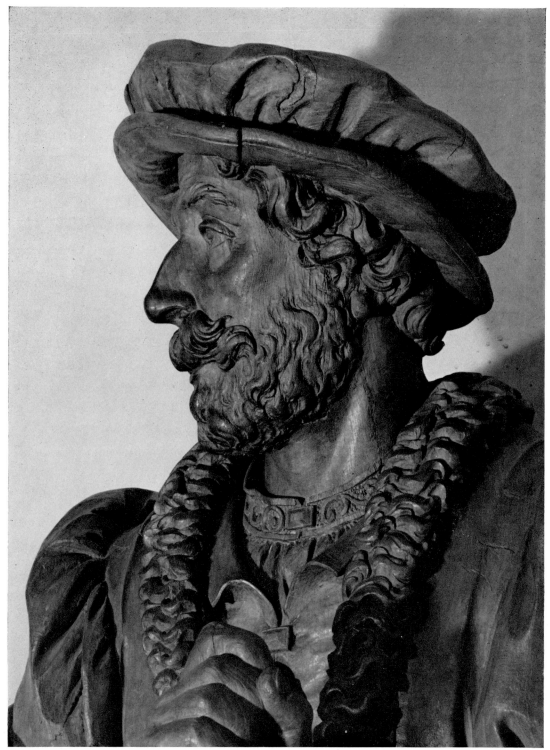

Edward Pierce: Sir William Walworth, 1684. Detail. *London, Fishmongers' Hall*

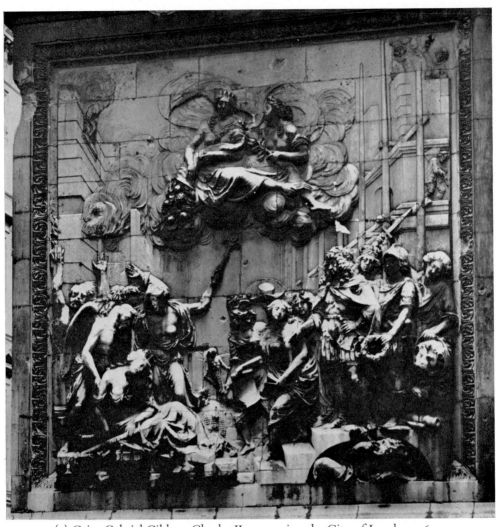

(A) Caius Gabriel Cibber: Charles II succouring the City of London, 1674.
London, The Monument

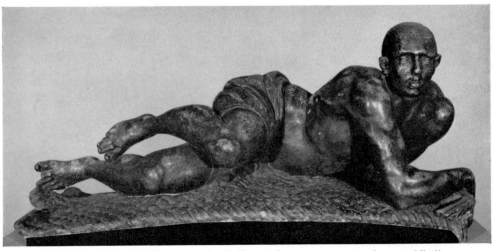

(B) Caius Gabriel Cibber: Melancholy Madness, *c.* 1675. *London, Guildhall*

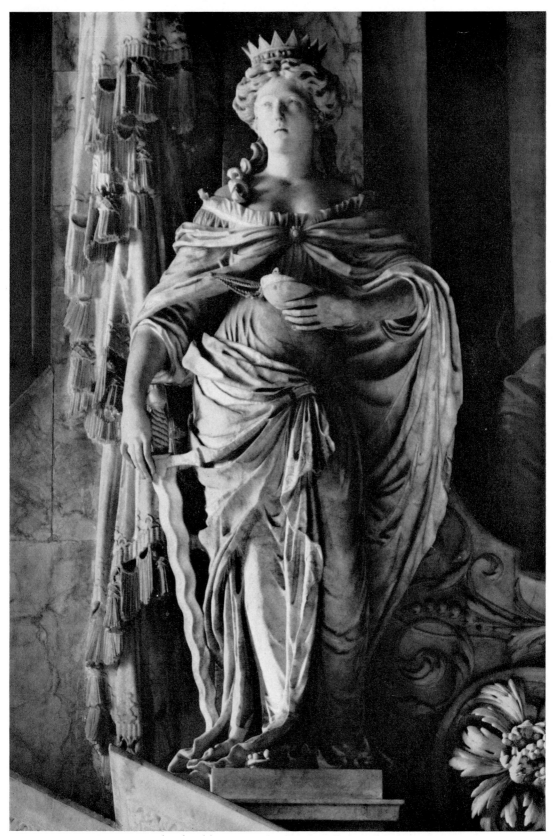

Caius Gabriel Cibber: Justice, 1688–91. *Chatsworth, Derbyshire*

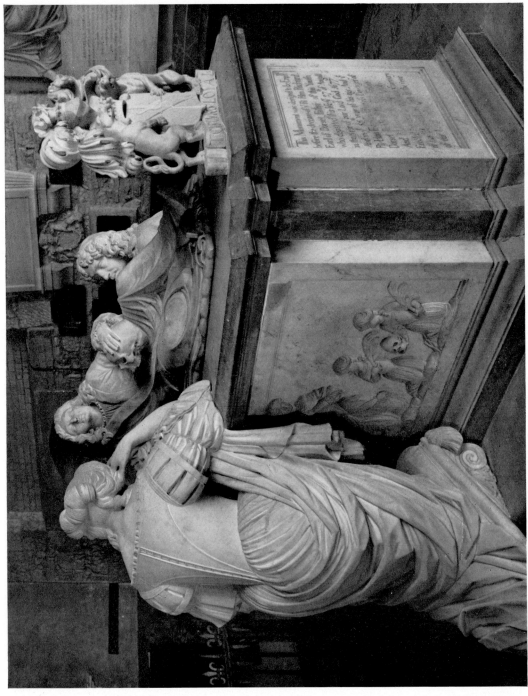

Caius Gabriel Cibber: Tomb of Thomas Sackville, 1677. *Withyham, Sussex*

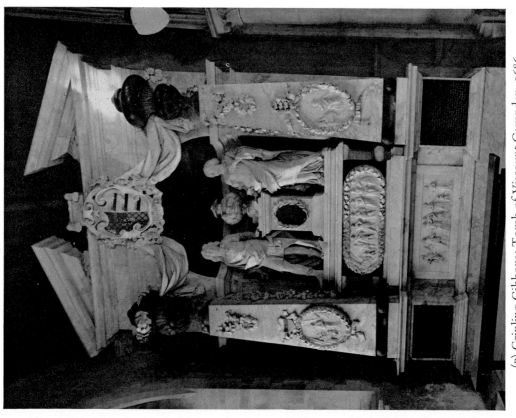

(B) Grinling Gibbons: Tomb of Viscount Campden, 1686.
Exton, Rutland

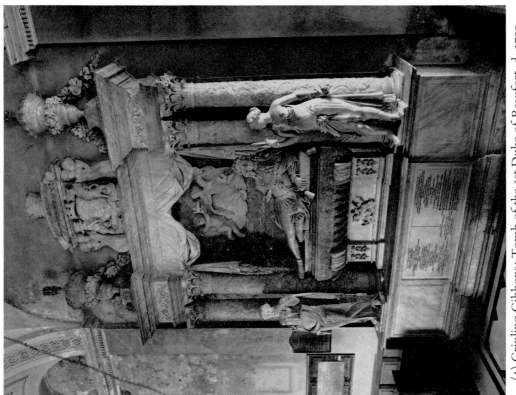

(A) Grinling Gibbons: Tomb of the 1st Duke of Beaufort, d. 1700.
Badminton, Gloucestershire

Grinling Gibbons: The Stoning of Stephen, *c.* 1671–7. *London, Victoria and Albert Museum*

(A) Arnold Quellin(?): Angel from the altar in Whitehall Palace, 1686. *Burnham, Somerset*

(B) Grinling Gibbons: Tomb of Viscount Campden, 1686. Detail. *Exton, Rutland*

(B) Arnold Quellin: Charles II, 1685.
London, Soane Museum

(A) Grinling Gibbons: James II, 1686.
London, National Gallery

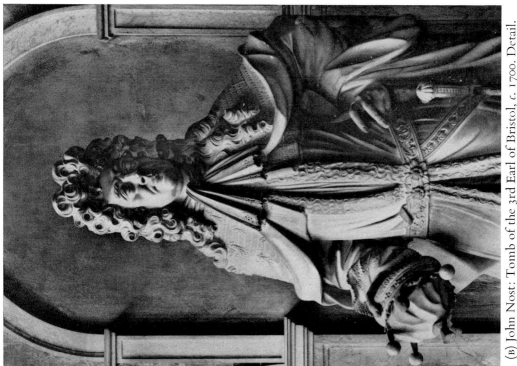

(B) John Nost: Tomb of the 3rd Earl of Bristol, c. 1700. Detail.
Sherborne Abbey, Dorset

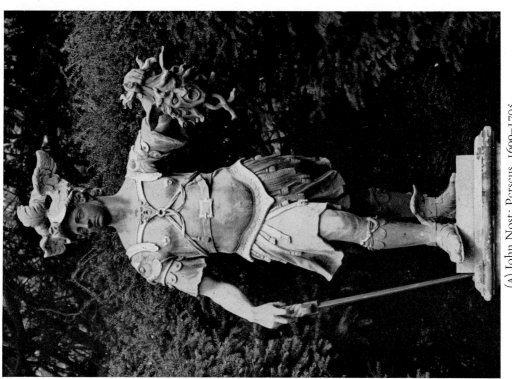

(A) John Nost: Perseus, 1699–1705.
Melbourne Hall, Derbyshire

43

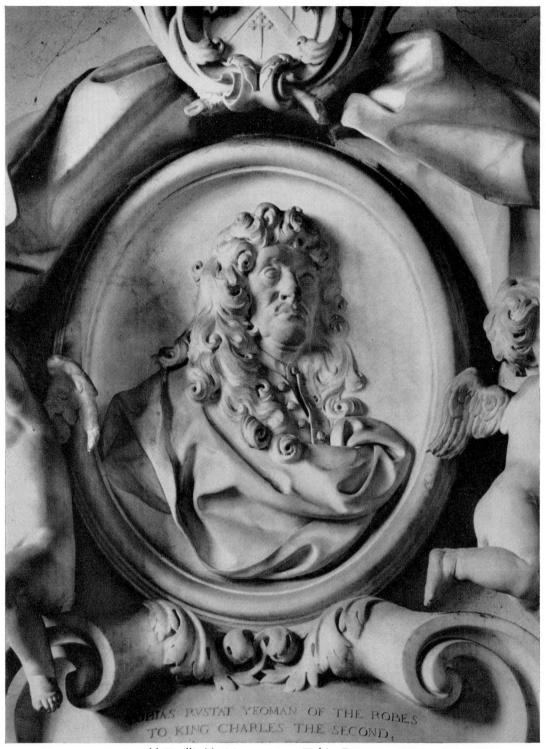

Arnold Quellin(?): Monument to Tobias Rustat, *c.* 1685.
Cambridge, Jesus College

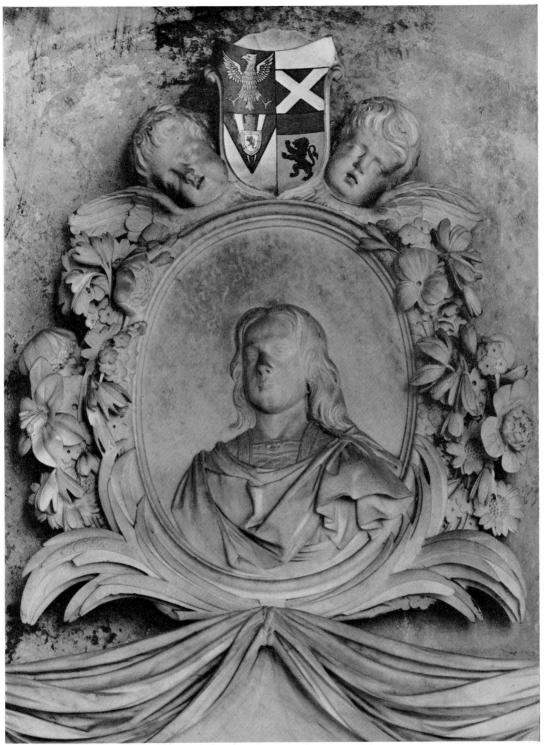

Grinling Gibbons: Monument to Robert Cotton, d. 1697.
Conington, Cambridgeshire

(A) and (B) John Nost: Garden figures, 1699–1705. *Melbourne Hall, Derbyshire*

John Nost: The Car of Venus, c. 1700. Detail of chimneypiece in the Cartoon Gallery.
Hampton Court Palace, Middlesex

William Stanton: Tomb of Richard and Isabella Shireburn, *c.* 1699. *Mitton, Yorkshire*

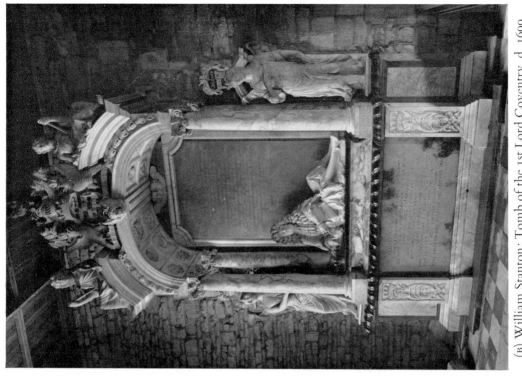

(B) William Stanton: Tomb of the 1st Lord Coventry, d. 1699. *Elmley Castle, Worcestershire*

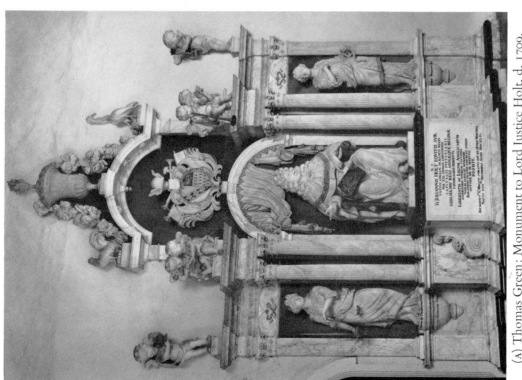

(A) Thomas Green: Monument to Lord Justice Holt, d. 1709. *Redgrave, Suffolk*

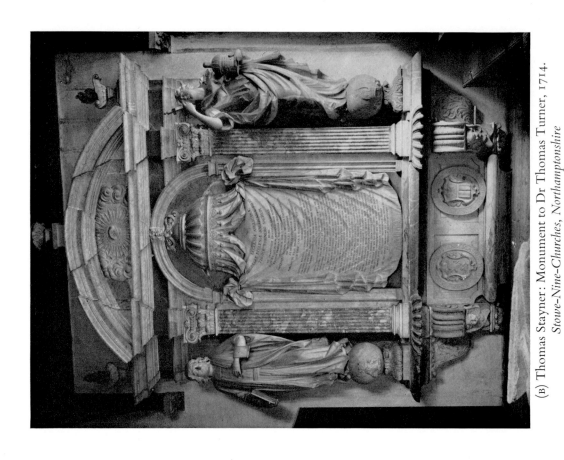

(B) Thomas Stayner: Monument to Dr Thomas Turner, 1714.
Stowe-Nine-Churches, Northamptonshire

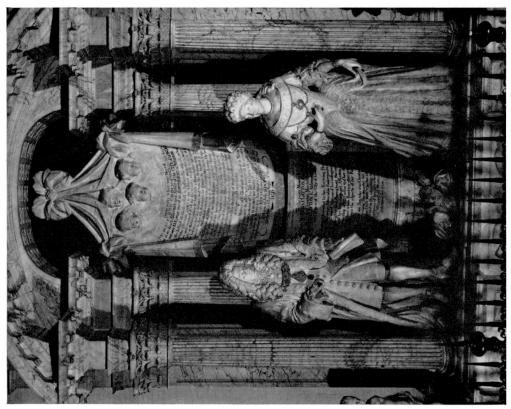

(A) Richard Crutcher: Monument to Sir Robert Clayton, 1705.
Bletchingley, Surrey

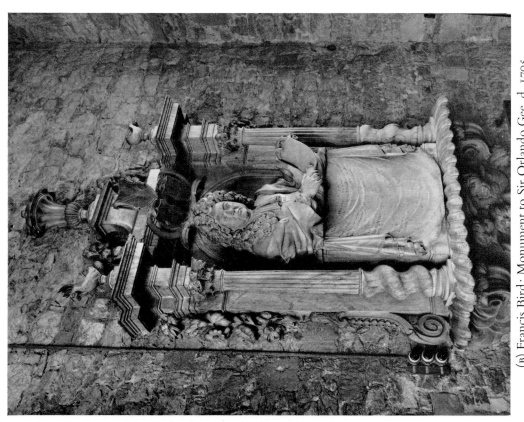

(B) Francis Bird: Monument to Sir Orlando Gee, d. 1705.
Isleworth, Middlesex

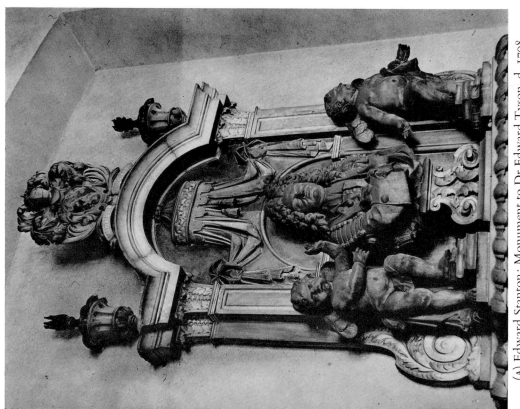

(A) Edward Stanton: Monument to Dr Edward Tyson, d. 1708.
Twickenham, Middlesex, All Hallows

51

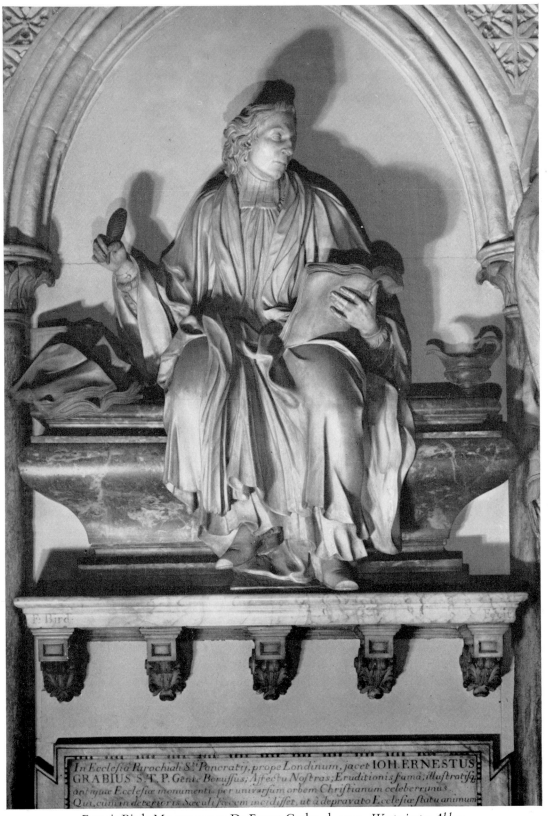

Francis Bird: Monument to Dr Ernest Grabe, d. 1711. *Westminster Abbey*

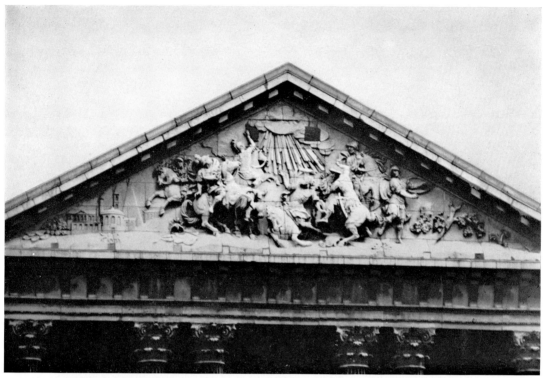

(A) Francis Bird: The Conversion of St Paul, 1706. *London, St Paul's Cathedral*

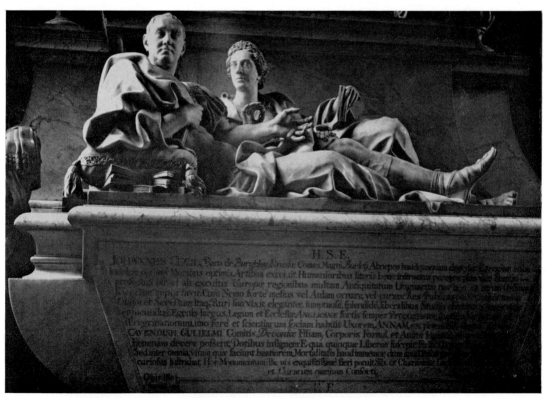

(B) Pierre Monnot: Monument to the 5th Earl of Exeter, 1704. Detail.
Stamford, Lincolnshire, St Martin

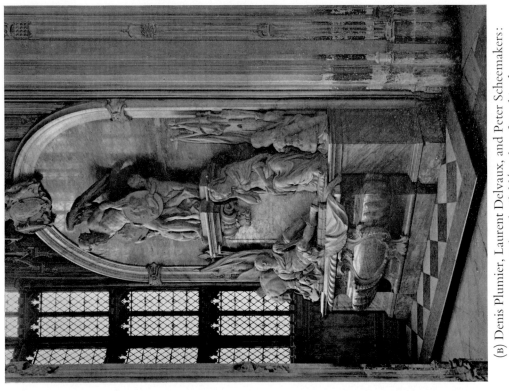

(B) Denis Plumier, Laurent Delvaux, and Peter Scheemakers:
Monument to John Sheffield, Duke of Buckingham,
c. 1721. *Westminster Abbey*

Statesman yet Friend to Truth, of Soul sincere
In Action faithful and in Honour clear
Who broke no Promise, serv'd no private end
Who gain'd no Title, and who lost no Friend
Ennobled by Himselfe, by All approv'd
Prais'd, wept, and honour'd by the Muse he lov'd
A. POPE.

(A) Giovanni Battista Guelfi: Monument to James Craggs, 1727.
Westminster Abbey

54

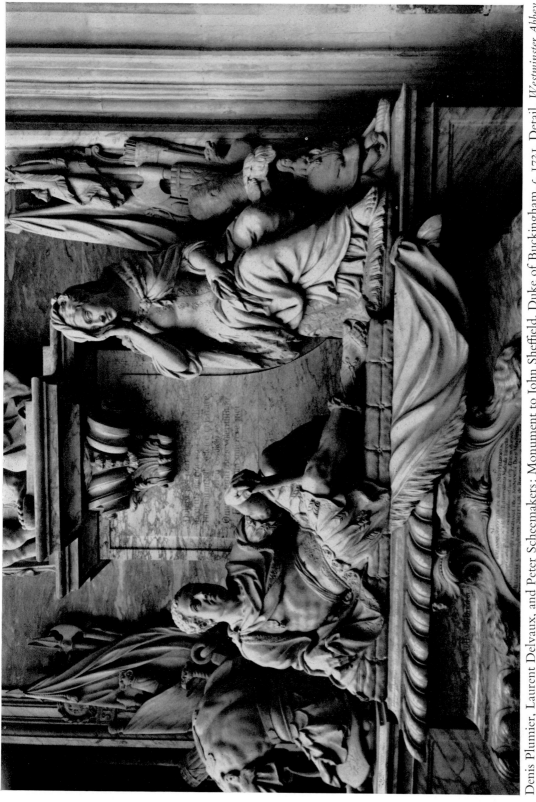

Denis Plumier, Laurent Delvaux, and Peter Scheemakers: Monument to John Sheffield, Duke of Buckingham, *c.* 1721. Detail. *Westminster Abbey*

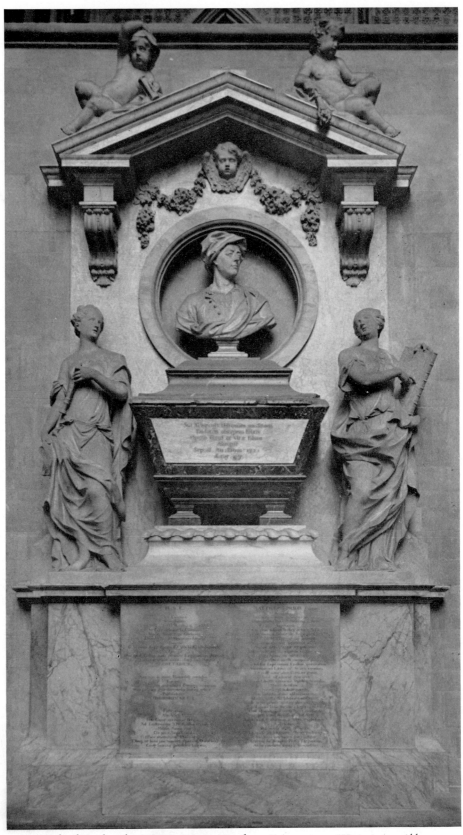

Michael Rysbrack: Monument to Matthew Prior, 1723. *Westminster Abbey*

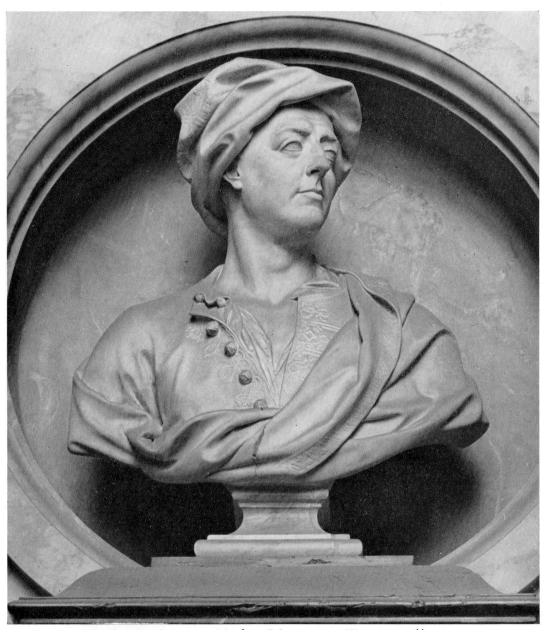

Antoine Coysevox: Matthew Prior, *c.* 1700. *Westminster Abbey*

(B) Pietro Santi Bartoli: Relief in the Palazzo Sacchetti, Rome, from Bellori's *Admiranda Romanorum Antiquitatum*, 1693

(A) Michael Rysbrack: *A Roman Marriage*, 1723. *London, Kensington Palace. Reproduced by gracious permission of Her Majesty the Queen*

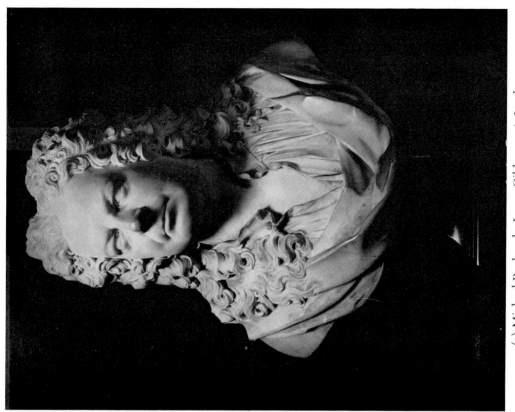

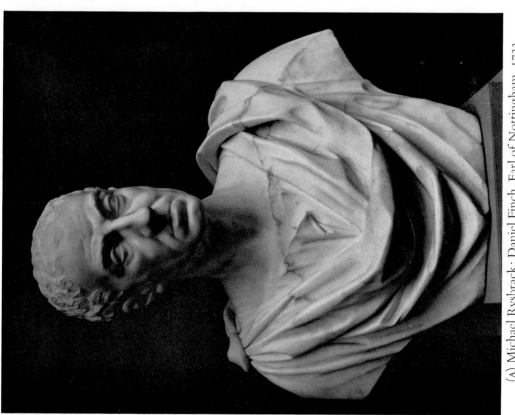

(B) Michael Rysbrack: James Gibbs, 1726. *London,*
St Martin-in-the-Fields

(A) Michael Rysbrack: Daniel Finch, Earl of Nottingham, 1723.
G. S. Finch Esq., Ayston Hall, Rutland

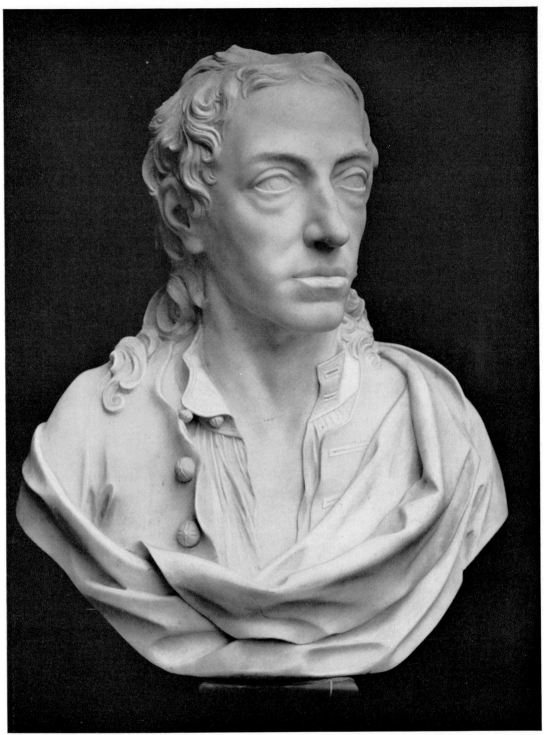

Michael Rysbrack: Alexander Pope, 1730. *London, The Athenaeum*

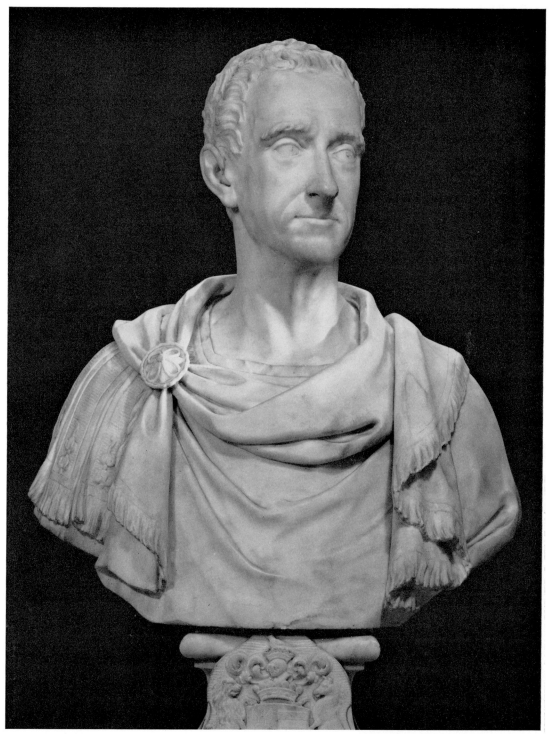

Peter Scheemakers: Viscount Cobham, *c.* 1733. *London, Victoria and Albert Museum*

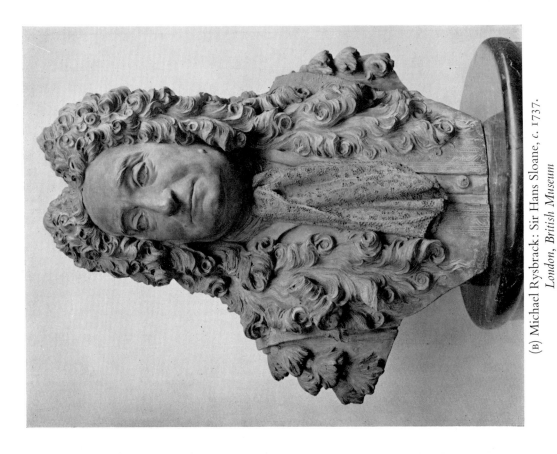

(B) Michael Rysbrack: Sir Hans Sloane, c. 1737.
London, British Museum

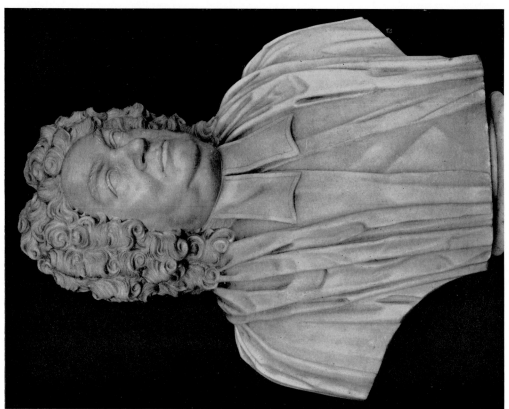

(A) Michael Rysbrack: Dr Harbin, before 1732.
Marquess of Bath, Longleat, Wiltshire

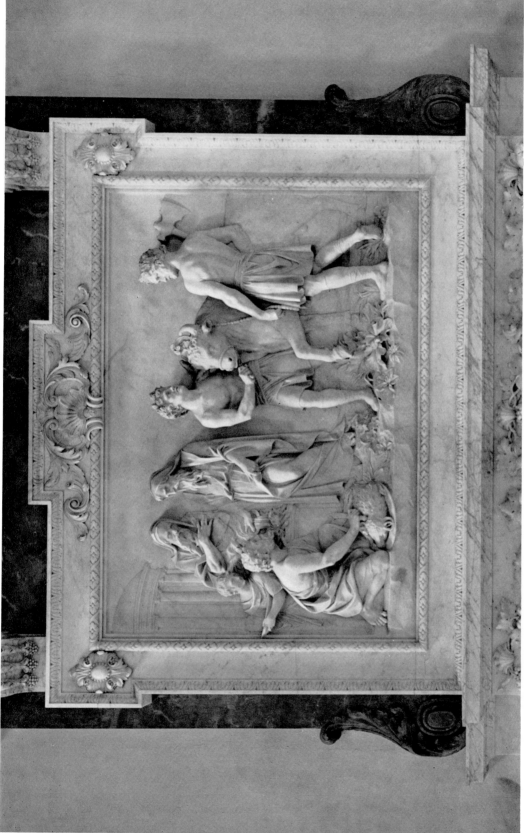

Michael Rysbrack: Chimneypiece, *c.* 1730. *Clandon Park, Surrey*

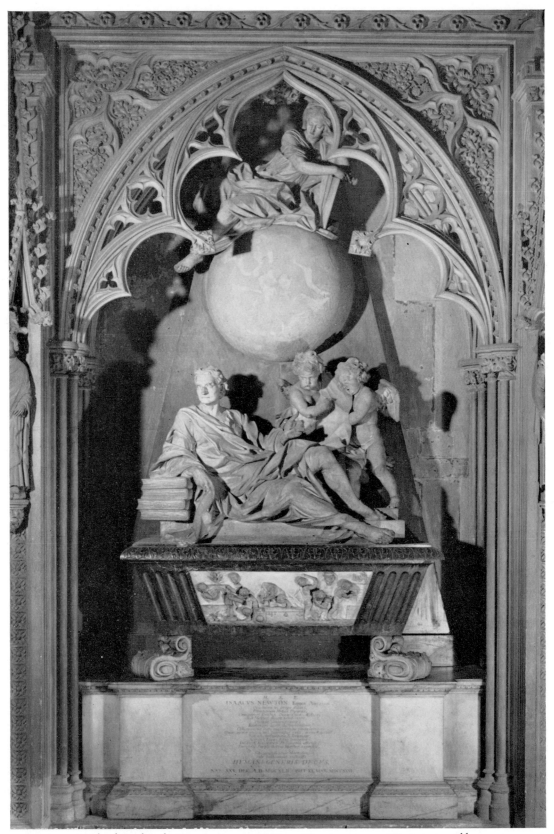

Michael Rysbrack: Monument to Sir Isaac Newton, 1731. *Westminster Abbey*

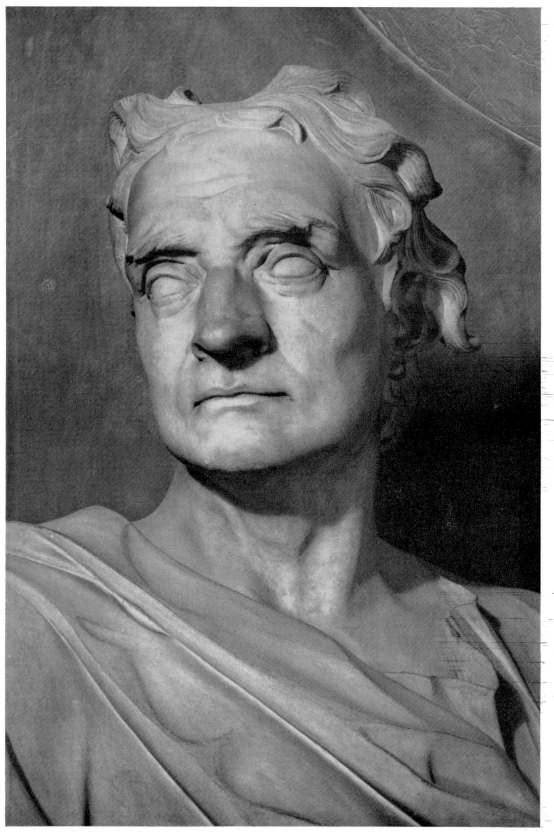

Michael Rysbrack: Monument to Sir Isaac Newton, 1731. Detail. *Westminster Abbey*

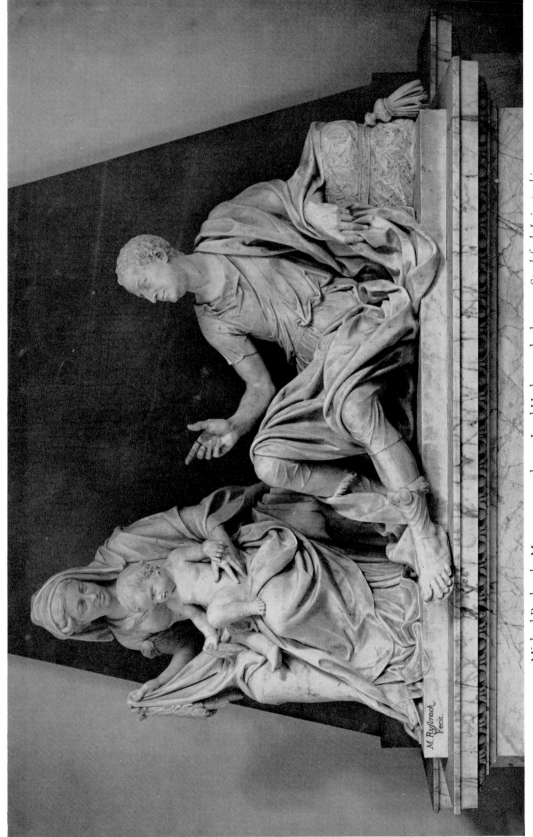

Michael Rysbrack: Monument to the 1st Lord Harborough, d. 1732. *Stapleford, Leicestershire*

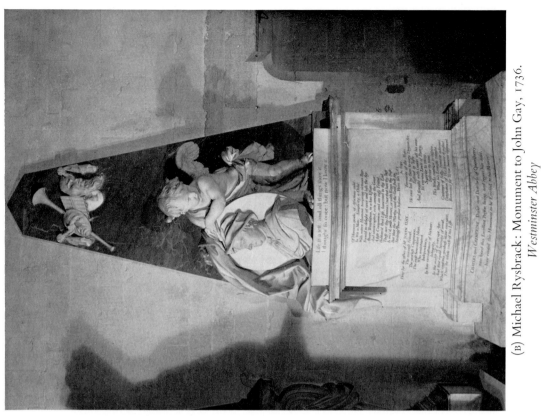

(B) Michael Rysbrack: Monument to John Gay, 1736.
Westminster Abbey

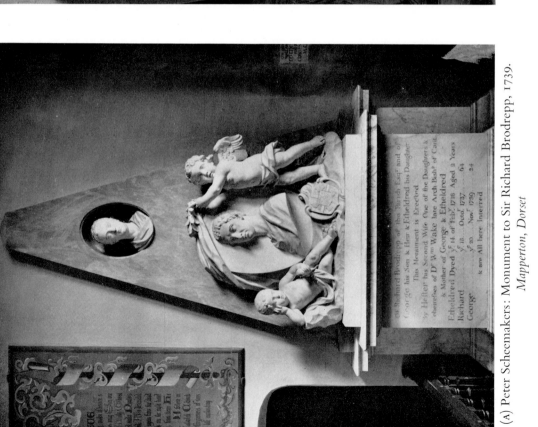

(A) Peter Scheemakers: Monument to Sir Richard Brodrepp, 1739.
Mapperton, Dorset

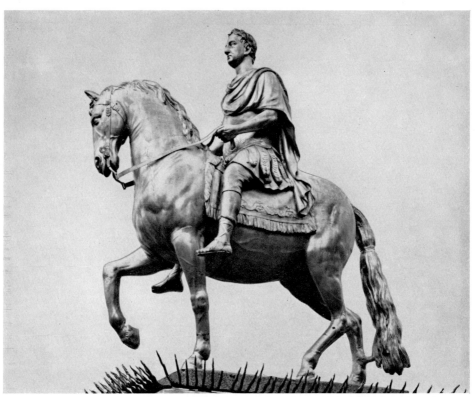

(A) Peter Scheemakers: William III, 1735. *Hull, Yorkshire, Market Place*

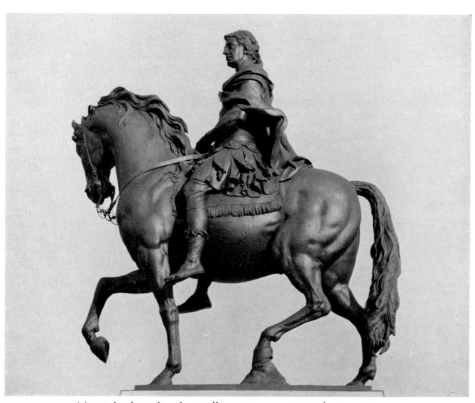

(B) Michael Rysbrack: William III, 1735. *Bristol, Queen Square*

Laurent Delvaux: Vertumnus and Pomona, *c.* 1726. *London, Victoria and Albert Museum*

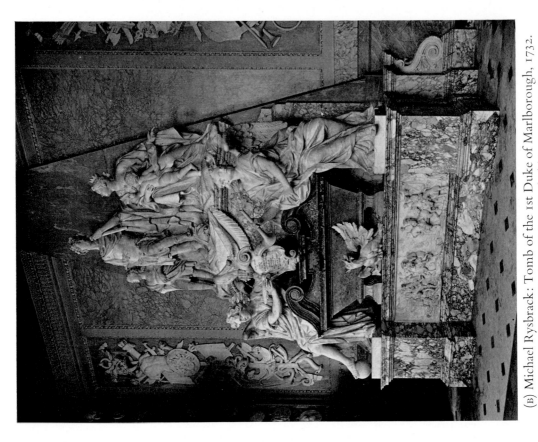

(B) Michael Rysbrack: Tomb of the 1st Duke of Marlborough, 1732.
Blenheim Palace, Oxfordshire

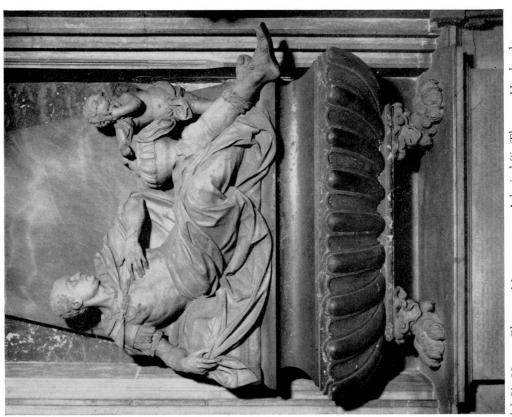

(A) Sir Henry Cheere: Monument to Admiral Sir Thomas Hardy, d. 1732.
Westminster Abbey

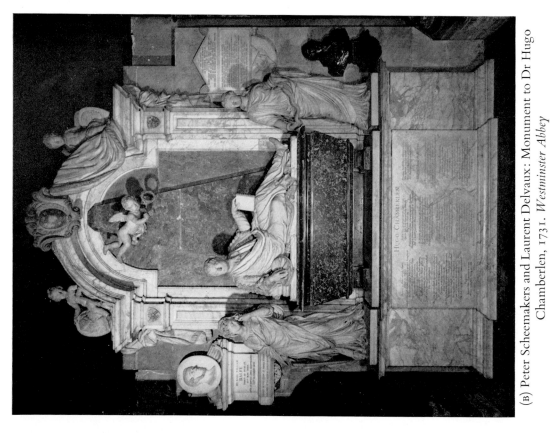

(B) Peter Scheemakers and Laurent Delvaux: Monument to Dr Hugo Chamberlen, 1731. *Westminster Abbey*

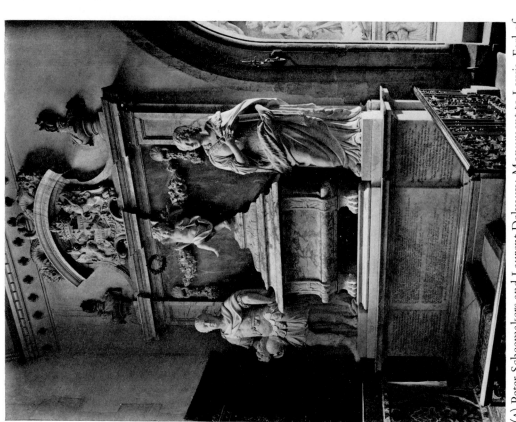

(A) Peter Scheemakers and Laurent Delvaux: Monument to Lewis, Earl of Rockingham, 1725. *Rockingham, Northamptonshire* (Copyright Country Life)

Sir Henry Cheere: Christopher Codrington, 1732.
Oxford, All Souls College

72

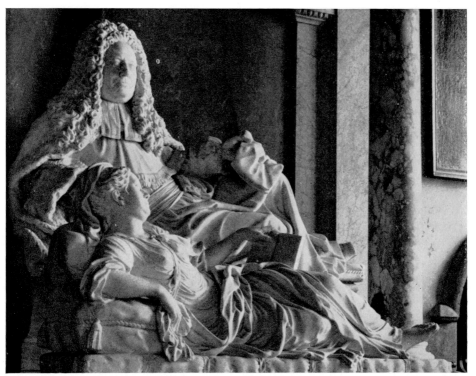

(A) Henry Scheemakers: Monument to Sir Francis and Lady Page, *c.* 1730. Detail.
Steeple Aston, Oxfordshire

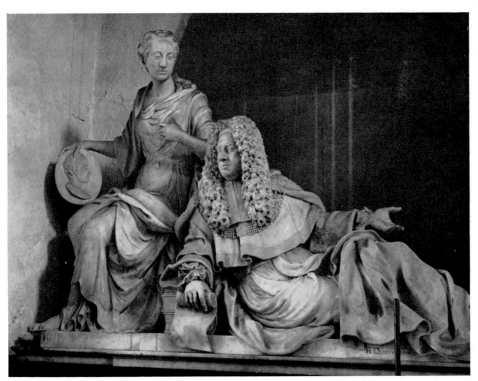

(B) Sir Henry Cheere: Monument to Lord Justice Raymond, d. 1732. Detail.
Abbots Langley, Hertfordshire

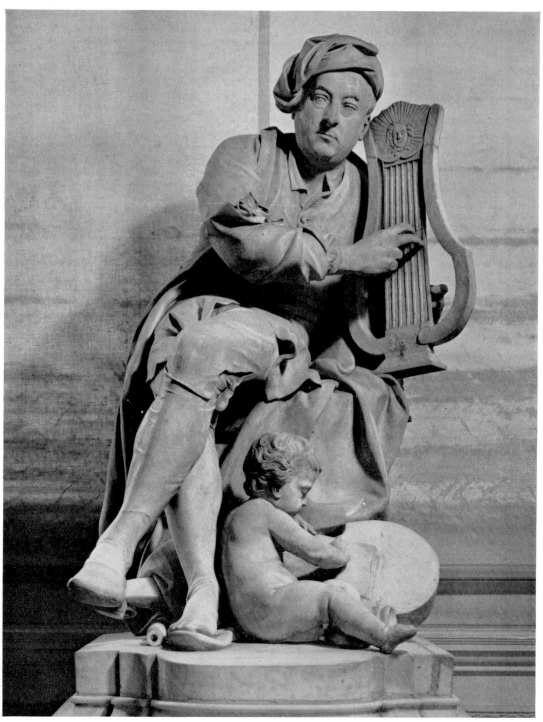

Louis François Roubiliac: George Frederick Handel, 1738. *London, Messrs Novello*

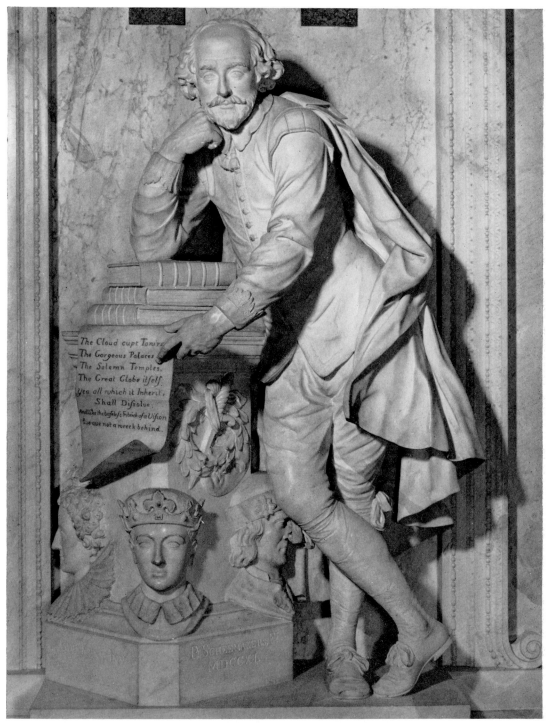

The Cloud cupt Tonirs
The Gorgeous Palaces
The Solemn Temples,
The Great Globe itself,
Yea all which it Inherit,
Shall Dissolve,
And like the baseless Fabrick of a Vision
Leave not a wreck behind.

Peter Scheemakers: Monument to William Shakespeare, 1740. *Westminster Abbey*

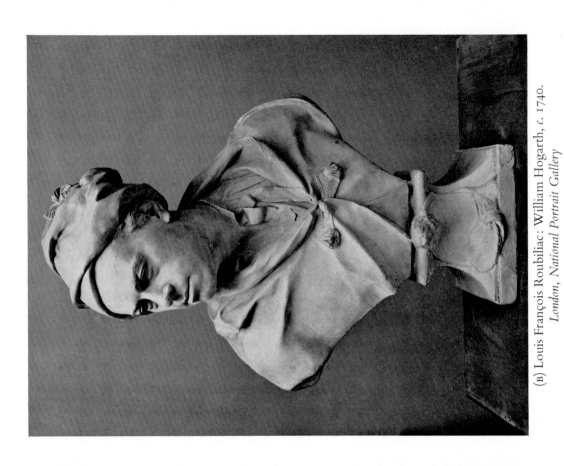

(B) Louis François Roubiliac: William Hogarth, c. 1740.
London, National Portrait Gallery

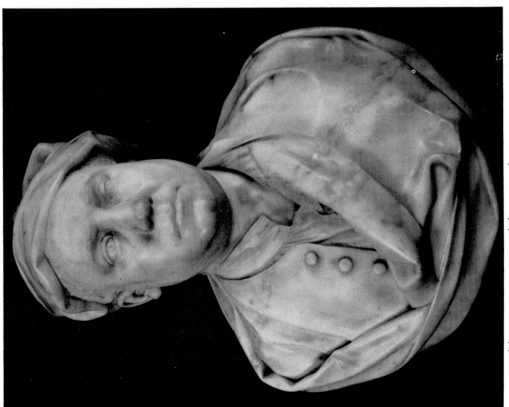

(A) Louis François Roubiliac: Jonathan Tyers, c. 1738.
Birmingham, City Museum and Art Gallery

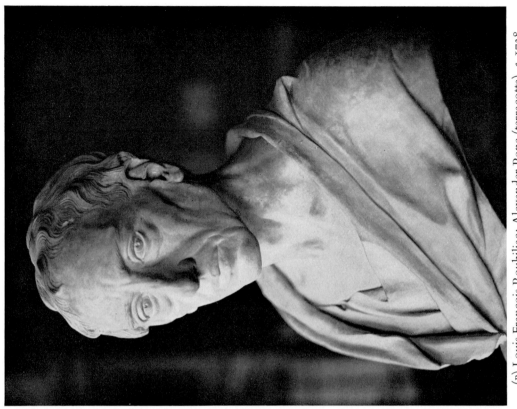

(B) Louis François Roubiliac: Alexander Pope (terracotta), c. 1738.
Mrs M. Copner

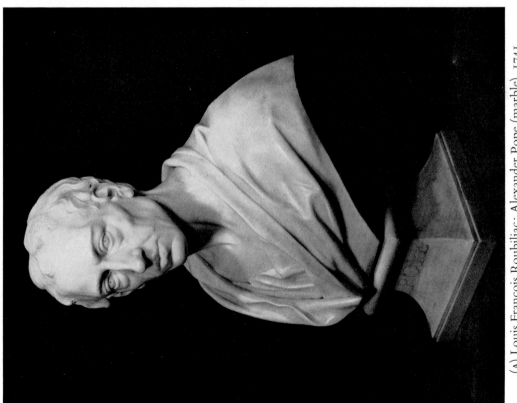

(A) Louis François Roubiliac: Alexander Pope (marble), 1741.
Earl of Rosebery Collection

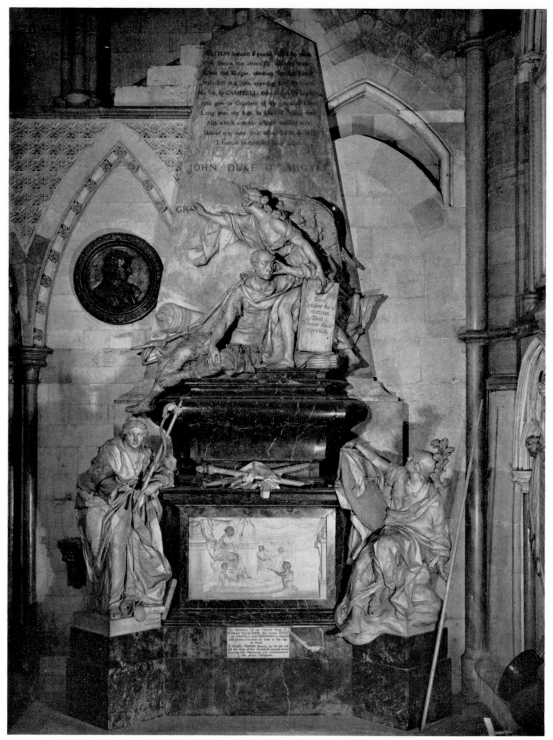

Louis François Roubiliac: Monument to John, Duke of Argyll, 1745–9.
Westminster Abbey

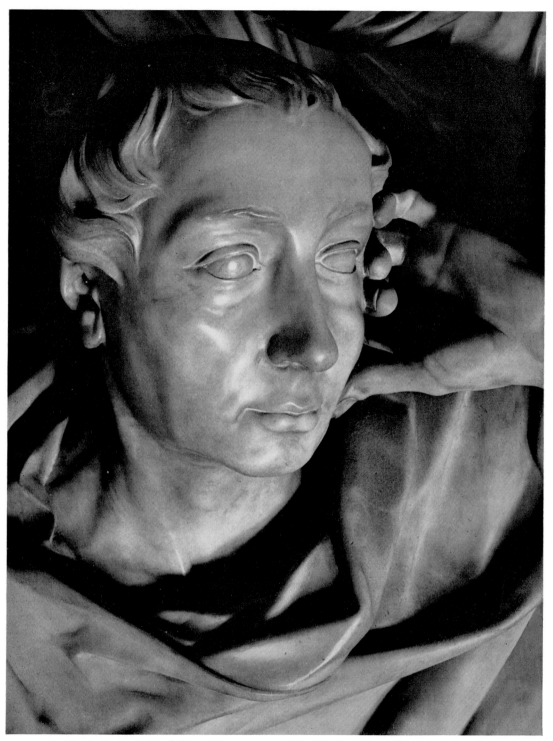

Louis François Roubiliac: Monument to John, Duke of Argyll, 1745–9. Detail.
Westminster Abbey

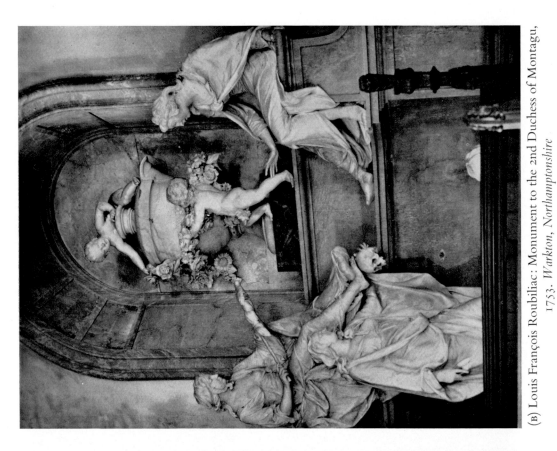

(B) Louis François Roubiliac: Monument to the 2nd Duchess of Montagu, 1753. *Warkton, Northamptonshire*

(A) Louis François Roubiliac: Monument to Bishop Hough, 1746. *Worcester Cathedral*

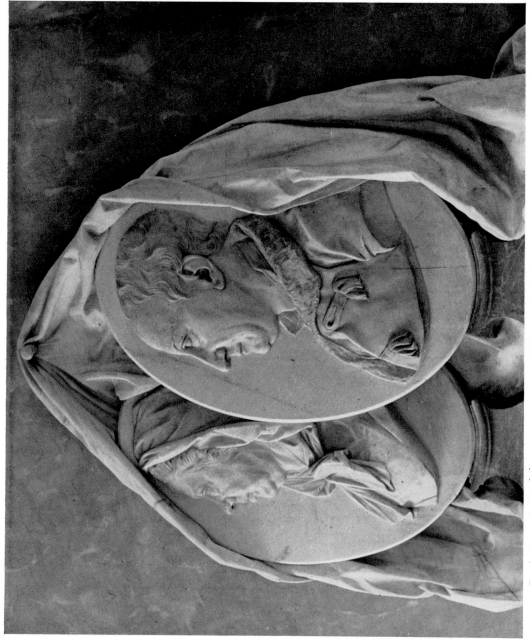

Louis François Roubiliac: Monument to William and Elizabeth Harvey, 1753. *Hempstead, Essex*

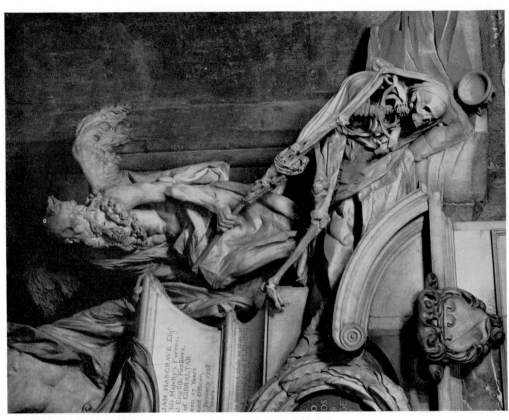

(B) Louis François Roubiliac: Monument to General William Hargrave, 1757. Detail. *Westminster Abbey*

(A) Louis François Roubiliac: Monument to General William Hargrave, 1757. *Westminster Abbey*

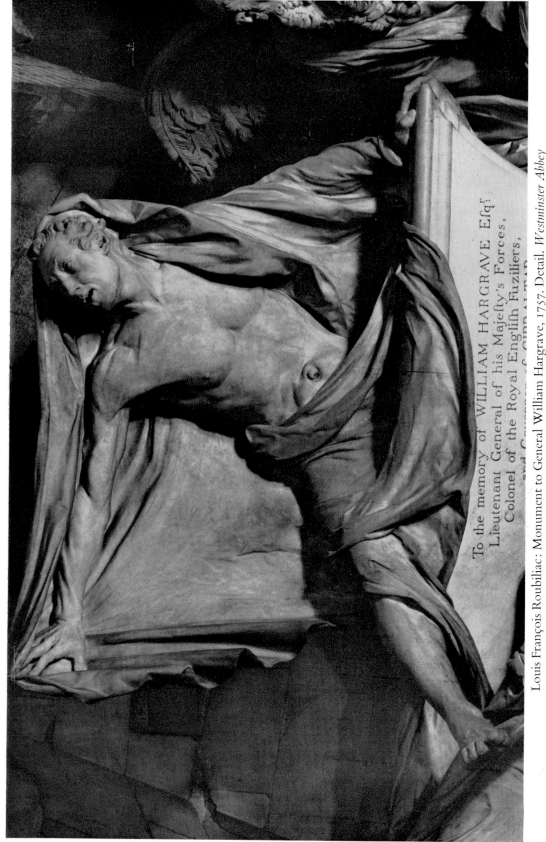

To the memory of WILLIAM HARGRAVE Esq.ʳ Lieutenant General of his Majesty's Forces, Colonel of the Royal Engliſh Fuziliers,

Louis François Roubiliac: Monument to General William Hargrave, 1757. Detail. *Westminster Abbey*

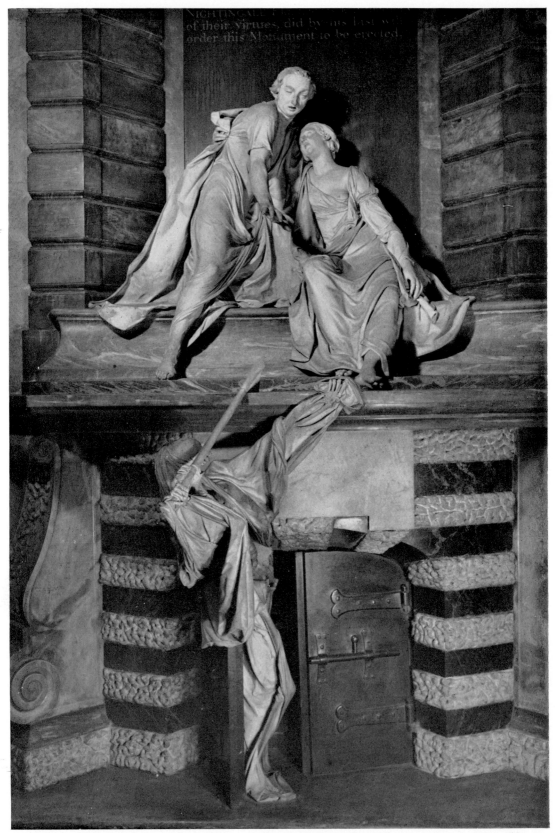

Louis François Roubiliac: Monument to Lady Elizabeth Nightingale, 1761. *Westminster Abbey*

84

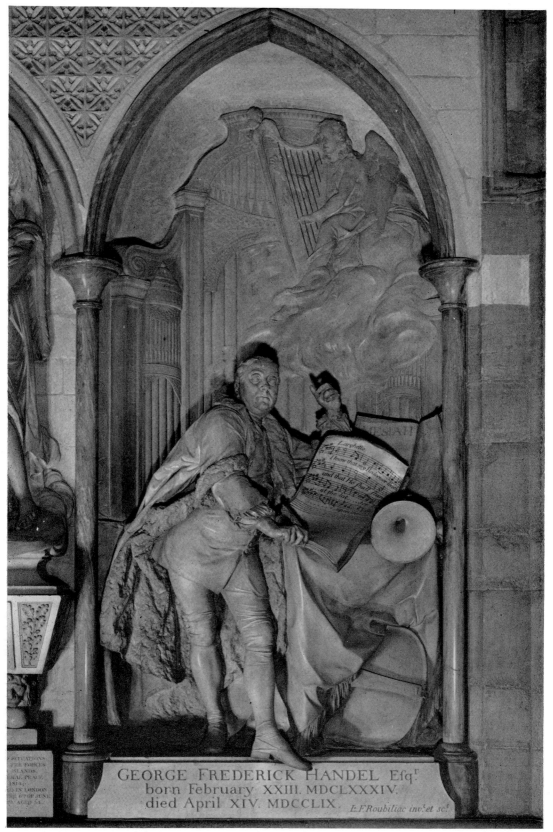

Louis François Roubiliac: Monument to George Frederick Handel, 1761. *Westminster Abbey*

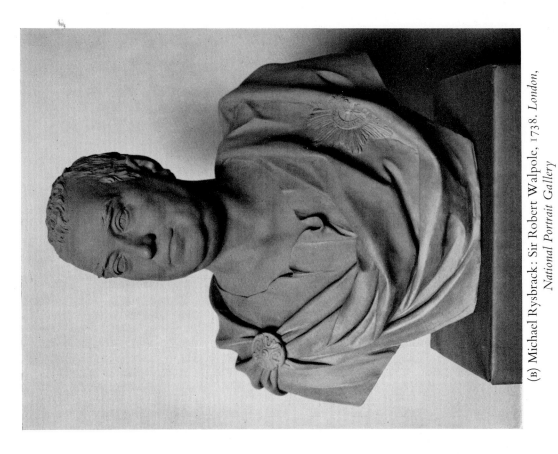

(B) Michael Rysbrack: Sir Robert Walpole, 1738. *London, National Portrait Gallery*

(A) Louis François Roubiliac: Sir Andrew Fountaine, 1747. *Earl of Pembroke, Wilton House, Wiltshire*

86

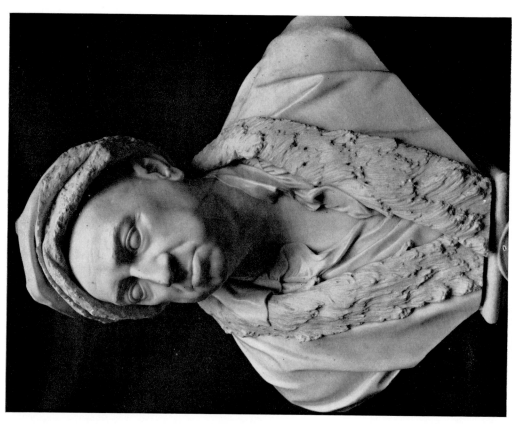

(B) Louis François Roubiliac: Dr Martin Folkes, 1749.
Earl of Pembroke, Wilton House, Wiltshire

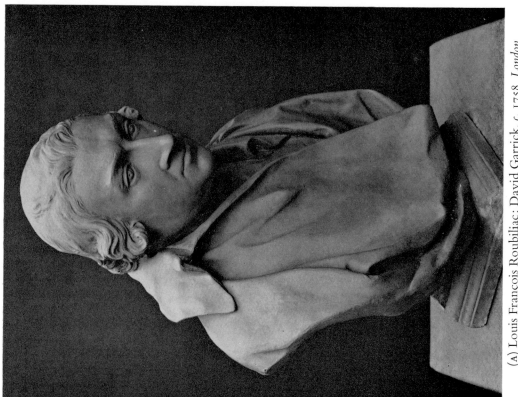

(A) Louis François Roubiliac: David Garrick, c. 1758. *London,
National Portrait Gallery*

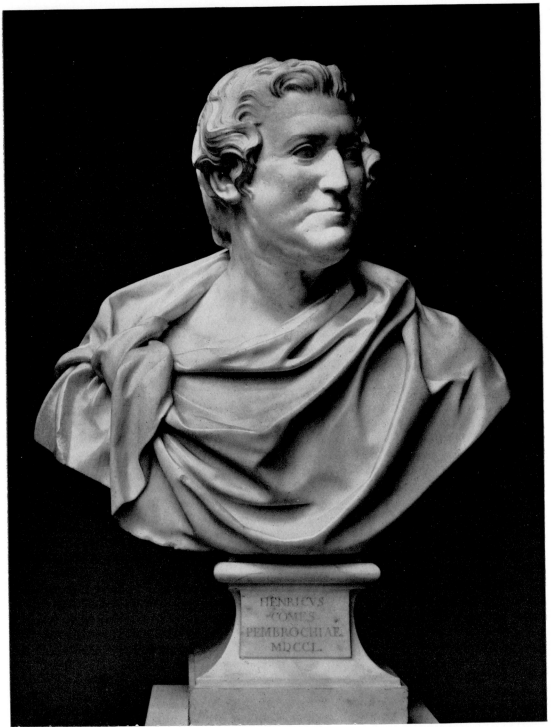

Louis François Roubiliac: The 9th Earl of Pembroke, 1750.
Birmingham, City Museum and Art Gallery

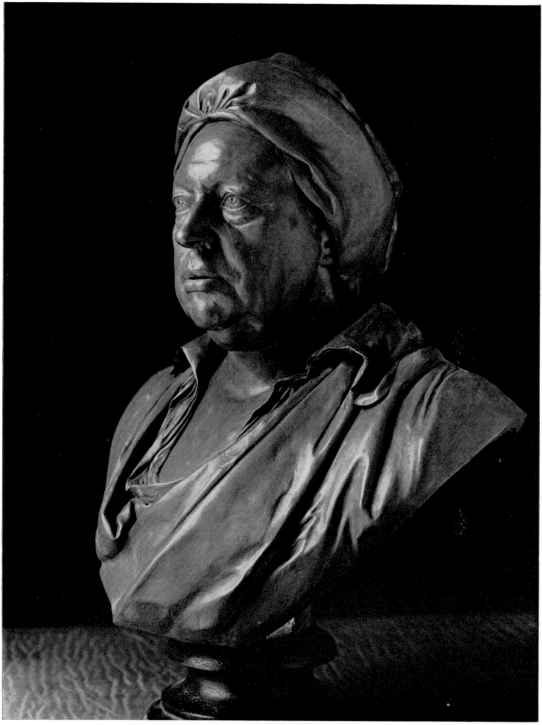

Louis François Roubiliac: Dr John Belchier. *London, Royal College of Surgeons of England*

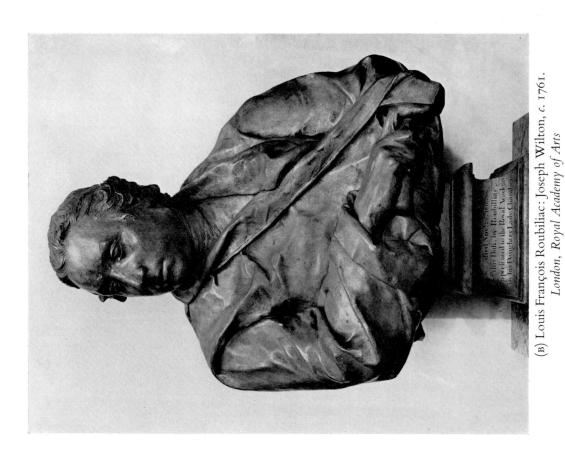

(B) Louis François Roubiliac: Joseph Wilton, c. 1761.
London, Royal Academy of Arts

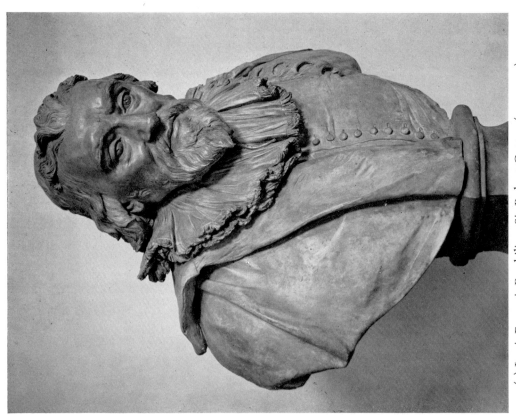

(A) Louis François Roubiliac: Sir Robert Cotton (terracotta), 1757.
London, British Museum

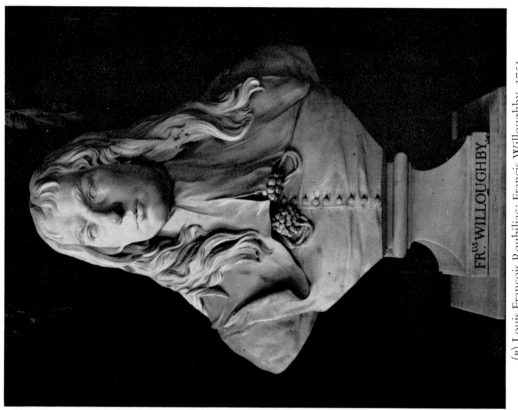

(B) Louis François Roubiliac: Francis Willoughby, 1751.
Cambridge, Trinity College

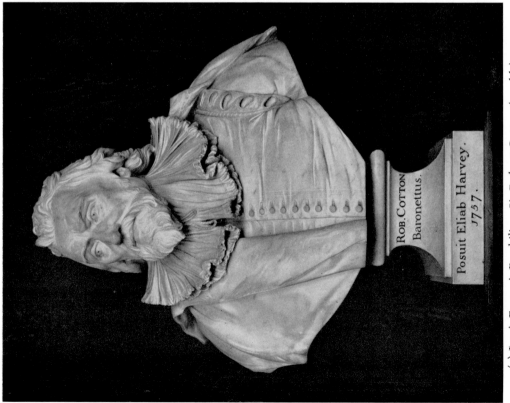

(A) Louis François Roubiliac: Sir Robert Cotton (marble), 1757.
Cambridge, Trinity College

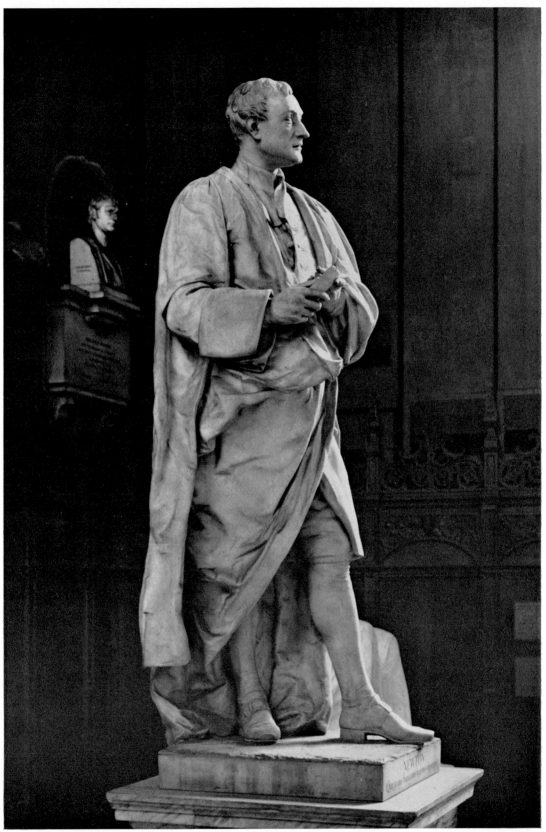

Louis François Roubiliac: Sir Isaac Newton, 1755. *Cambridge, Trinity College*

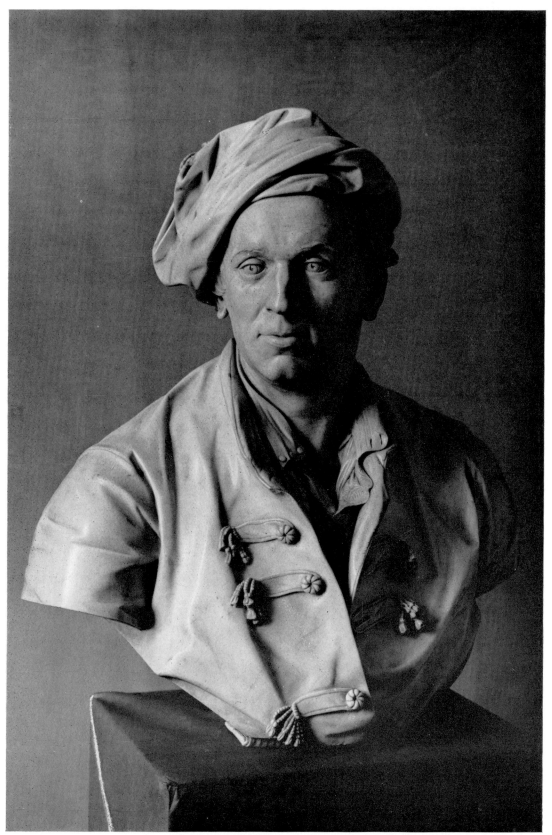

Louis François Roubiliac: Self-portrait. *London, National Portrait Gallery*

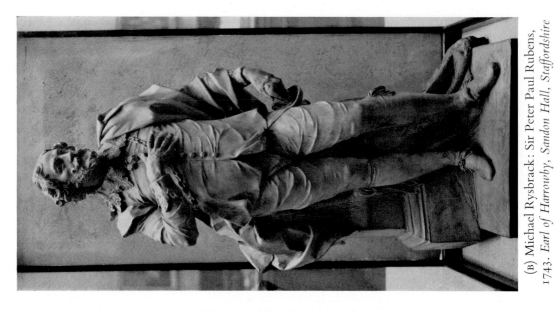

(B) Michael Rysbrack: Sir Peter Paul Rubens, 1743. *Earl of Harrowby, Sandon Hall, Staffordshire*

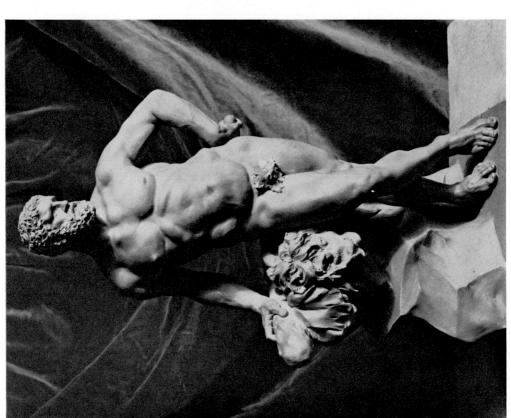

(A) Michael Rysbrack: Hercules, c. 1743. *The National Trust, Stourhead, Wiltshire*

94

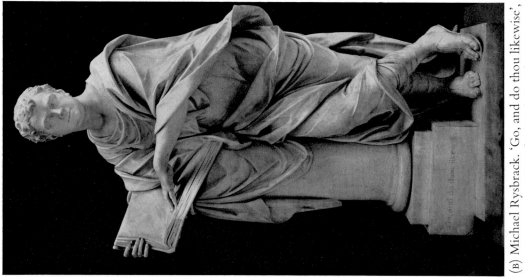

(B) Michael Rysbrack. 'Go, and do thou likewise', 1763. *Brussels, Musée Royal*

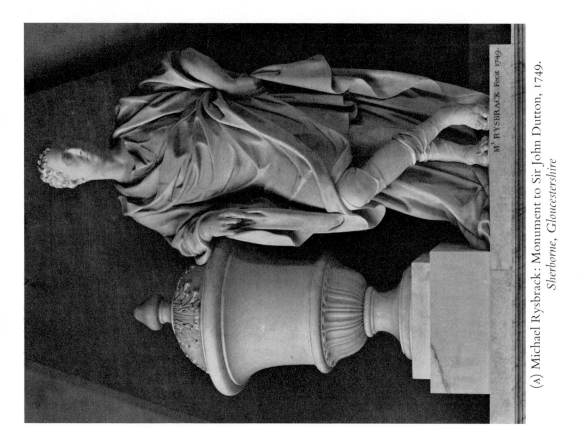

(A) Michael Rysbrack: Monument to Sir John Dutton, 1749. *Sherborne, Gloucestershire*

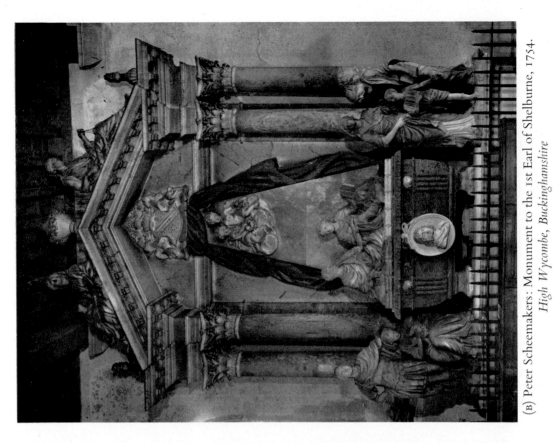

(B) Peter Scheemakers: Monument to the 1st Earl of Shelburne, 1754.
High Wycombe, Buckinghamshire

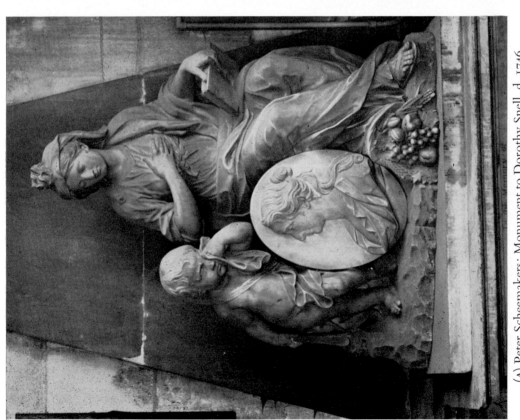

(A) Peter Scheemakers: Monument to Dorothy Snell, d. 1746.
Gloucester, St Mary-le-Crypt

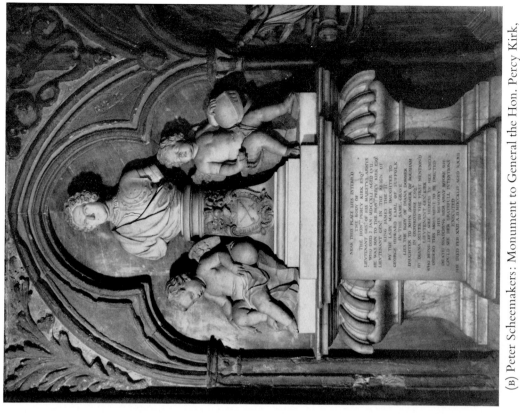

(B) Peter Scheemakers: Monument to General the Hon. Percy Kirk, after 1743. *Westminster Abbey*

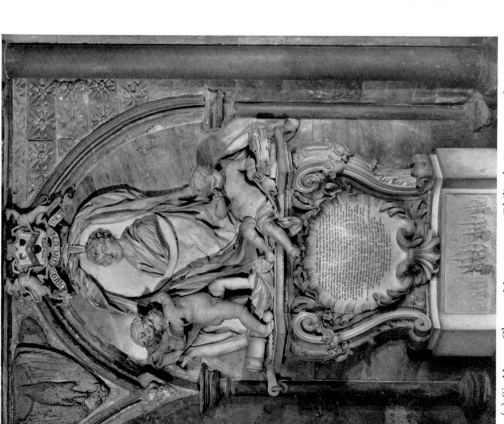

(A) Sir Henry Cheere: Monument to Philip de Sausmarez, d. 1747. *Westminster Abbey*

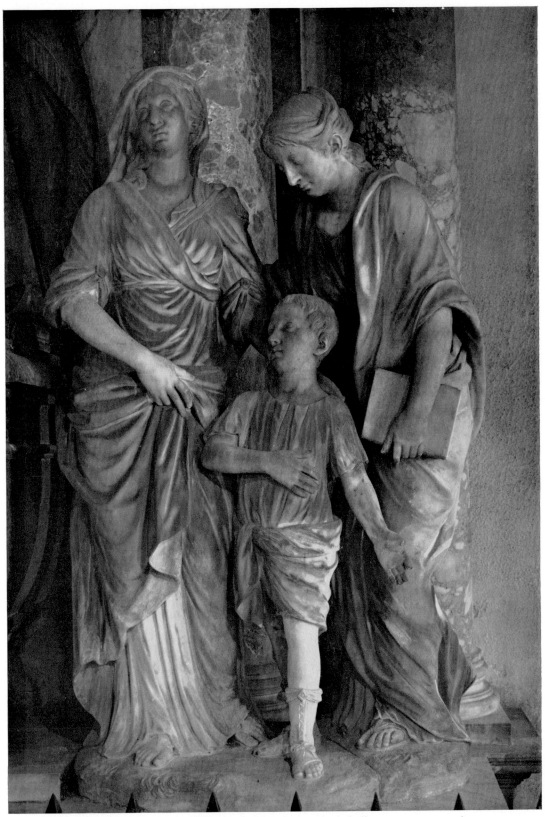

Peter Scheemakers: Monument to the 1st Earl of Shelburne, 1754. Detail.
High Wycombe, Buckinghamshire

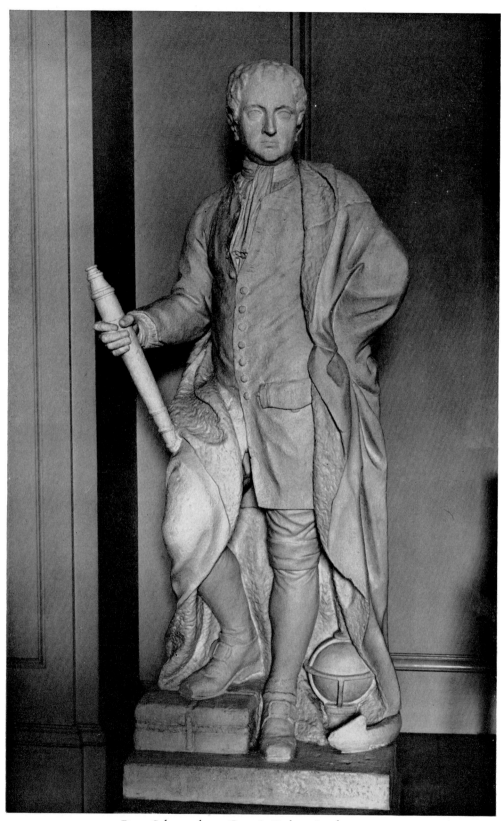

Peter Scheemakers: Captain Robert Sandes, 1746.
London, Trinity House

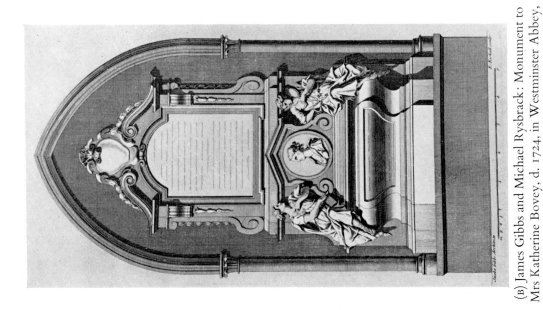

(B) James Gibbs and Michael Rysbrack: Monument to Mrs Katherine Bovey, d. 1724, in Westminster Abbey, from James Gibbs, *Book of Architecture*, 1728

(A) Andries Carpentière: Monument to the Earl of Warrington, 1734. *Bowdon, Cheshire*

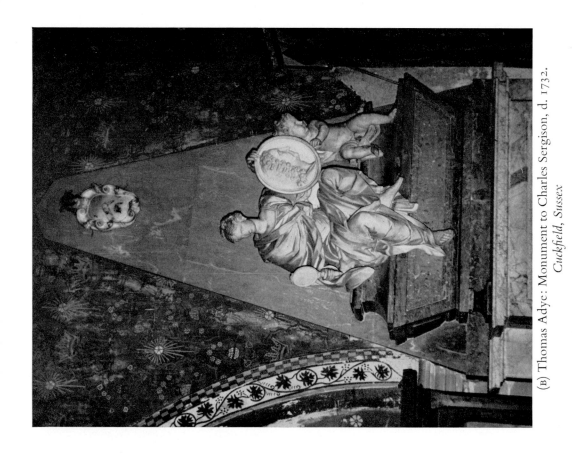

(B) Thomas Adye: Monument to Charles Sergison, d. 1732.
Cuckfield, Sussex

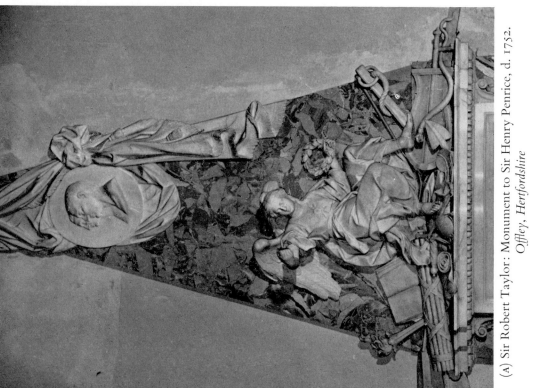

(A) Sir Robert Taylor: Monument to Sir Henry Penrice, d. 1752.
Offley, Hertfordshire

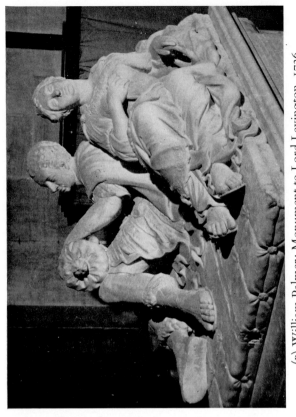

(B) William Palmer: Monument to Lord Lexington, 1726.
Kelham, Nottinghamshire

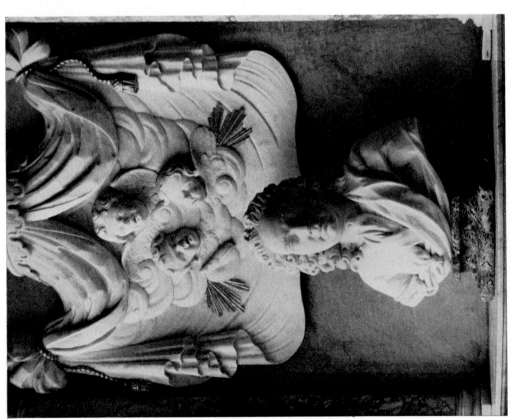

(A) James Annis: Monument to Sir George Fettiplace, d. 1743.
Swinbrook, Oxfordshire

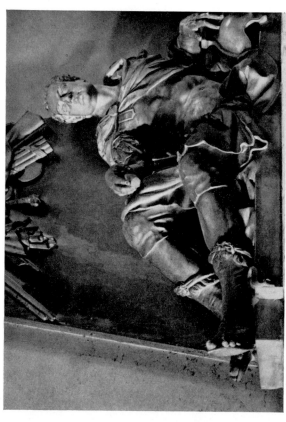

(B) Thomas Carter I: Monument to Colonel Thomas Moore, after 1746.
Great Bookham, Surrey

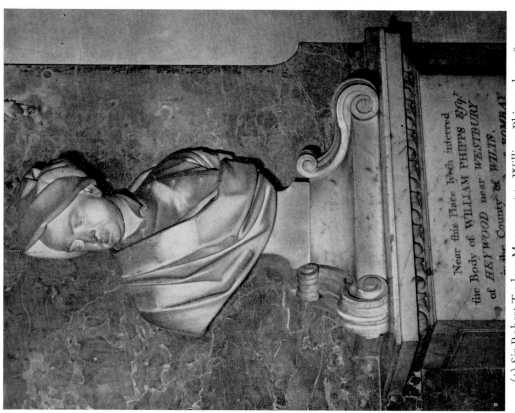

(A) Sir Robert Taylor: Monument to William Phipps, d. 1748.
Westbury, Wiltshire

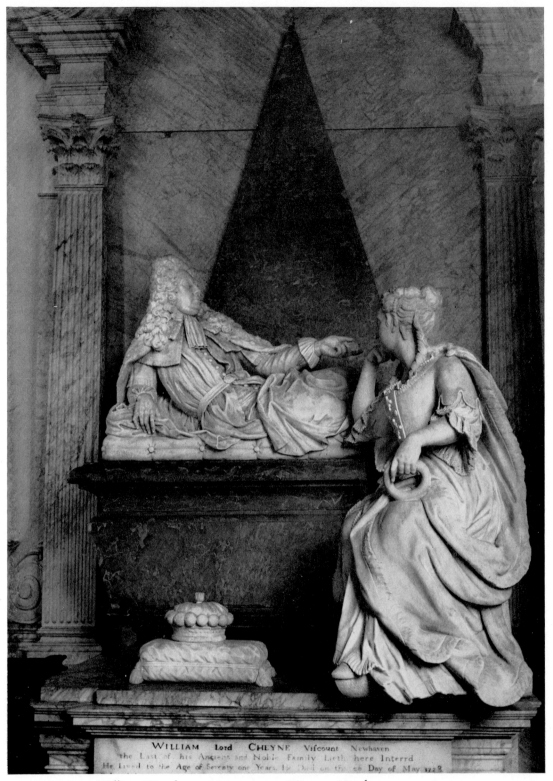

William Woodman: Monument to Viscount Newhaven, *c.* 1728–32.
Drayton Beauchamp, Buckinghamshire

(A) Charles Stanley: Ceiling with portrait of Colen Campbell, *c.* 1728.
Compton Place, Eastbourne, Sussex (Copyright Country Life)

(B) Anonymous Italian: Plaster Chimneypiece, *c.* 1720–31. *Barnsley Park, Gloucestershire*

Thomas Carter II: Chaloner Chute, 1775. *Basingstoke, Hampshire, The Vyne*

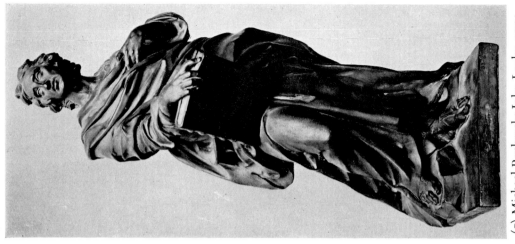

(c) Michael Rysbrack: John Locke, 1755. *London, Victoria and Albert Museum*

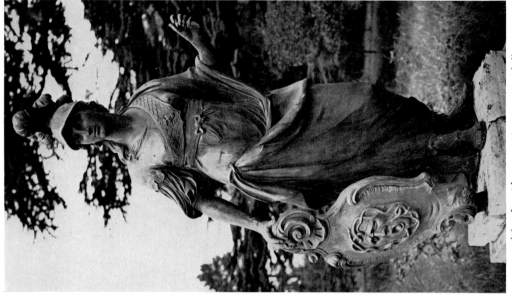

(b) John Cheere: Minerva. *Southill, Bedfordshire*

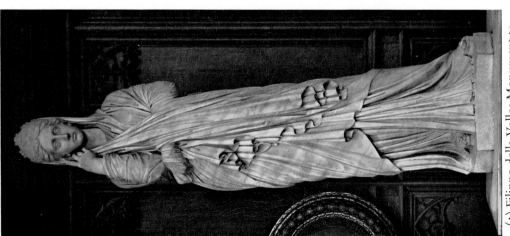

(A) Filippo della Valle: Monument to Lady Walpole, 1743. *Westminster Abbey*

107

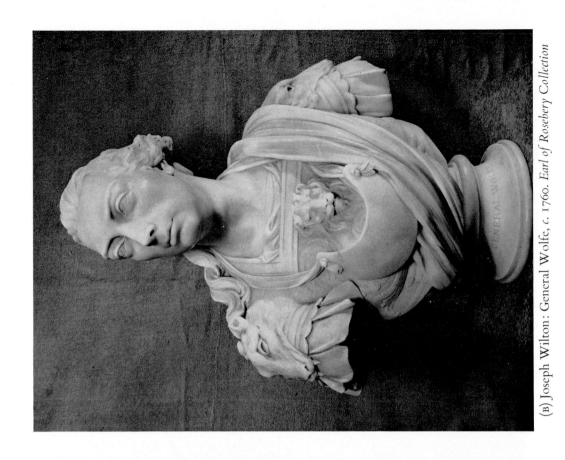

(B) Joseph Wilton: General Wolfe, *c.* 1760. *Earl of Rosebery Collection*

(A) Joseph Wilton: The Earl of Chesterfield, 1757.
London, British Museum

108

Joseph Wilton: Monument to General Wolfe, 1772. *Westminster Abbey*

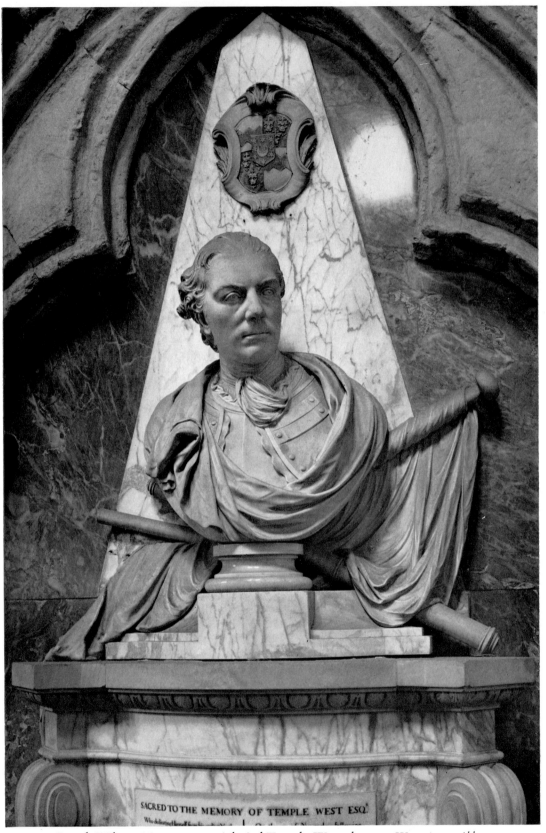

SACRED TO THE MEMORY OF TEMPLE WEST ESQ.

Joseph Wilton: Monument to Admiral Temple-West, d. 1757. *Westminster Abbey*

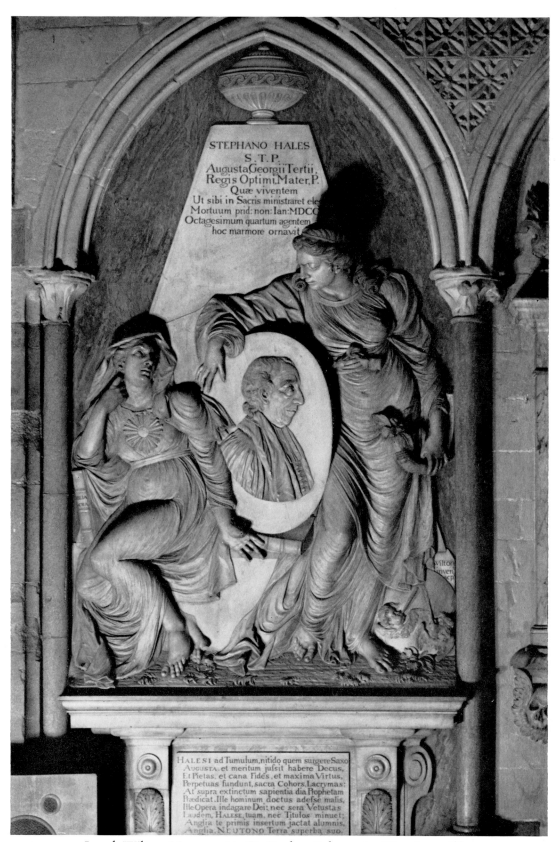

Joseph Wilton: Monument to Dr Stephen Hales, 1762. *Westminster Abbey*

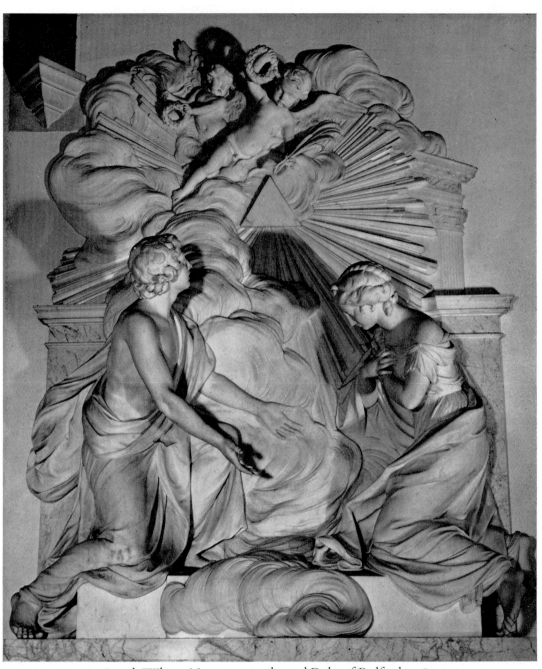

Joseph Wilton: Monument to the 2nd Duke of Bedford, 1769.
Chenies, Buckinghamshire

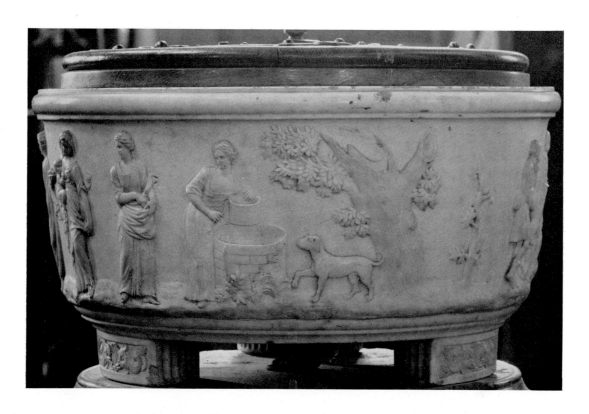

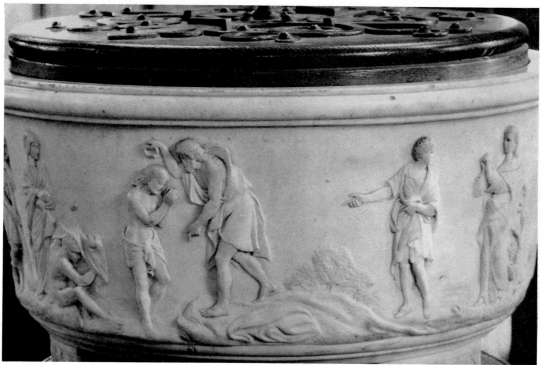

(A) and (B) Richard Hayward: Details of font, 1789.
Bulkington, Warwickshire

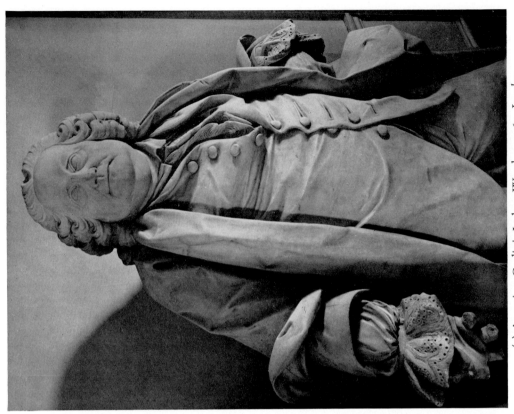

(B) Agostino Carlini: Joshua Ward, *c. 1760. London, Royal Society of Arts*

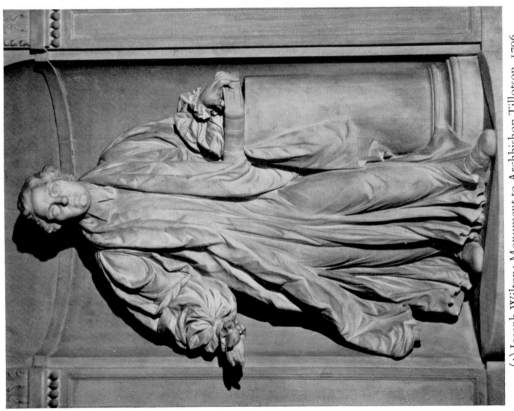

(A) Joseph Wilton: Monument to Archbishop Tillotson, 1796. *Sowerby, Yorkshire*

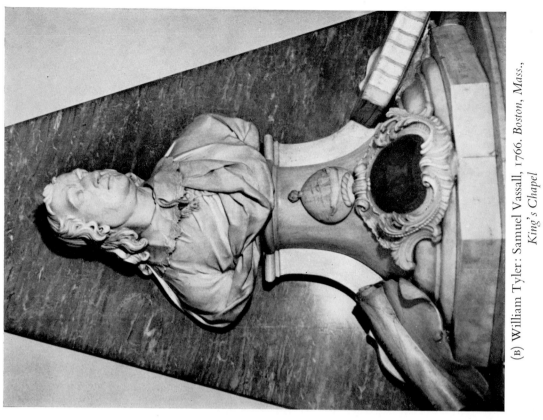

(A) William Tyler and Robert Ashton: Monument to Dr Martin Folkes, 1788. Detail. *Westminster Abbey*

(B) William Tyler: Samuel Vassall, 1766. *Boston, Mass., King's Chapel*

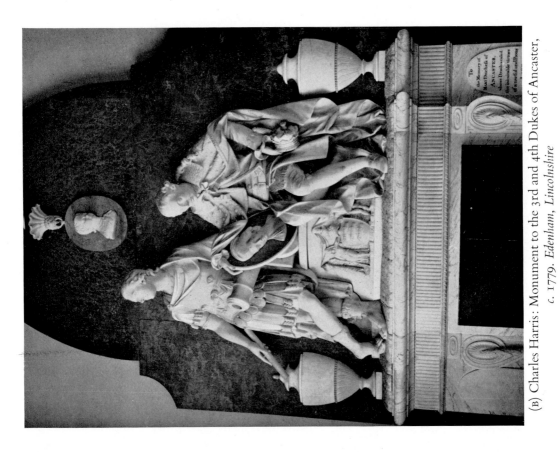

(B) Charles Harris: Monument to the 3rd and 4th Dukes of Ancaster, *c*. 1779. *Edenham, Lincolnshire*

(A) Nicholas Read: Monument to Nicholas Magens, 1779. *Brightlingsea, Essex*

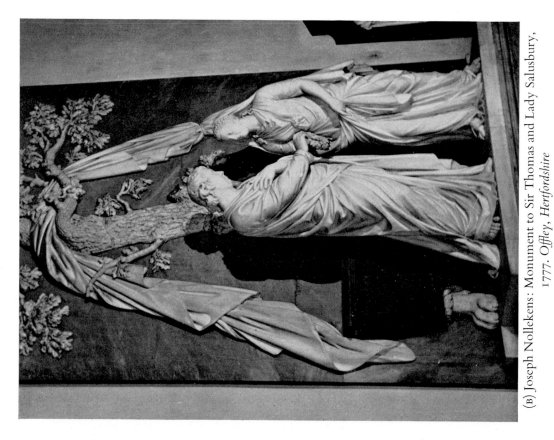

(B) Joseph Nollekens: Monument to Sir Thomas and Lady Salusbury, 1777. *Offley, Hertfordshire*

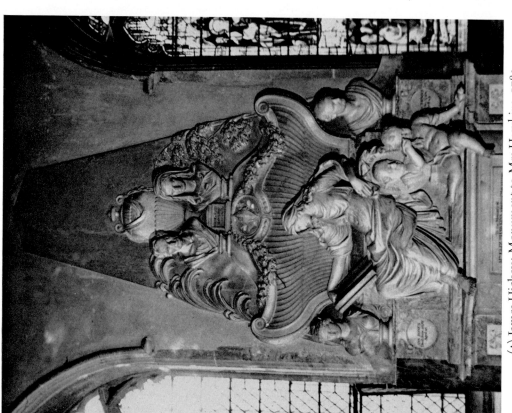

(A) James Hickey: Monument to Mrs Hawkins, 1782. *Abingdon, Berkshire*

(B) Joseph Nollekens: Venus tying her Sandal, 1773. *Wentworth Woodhouse, Yorkshire*

(A) Joseph Nollekens: Venus chiding Cupid, 1778. *Lincoln, Usher Art Gallery*

118

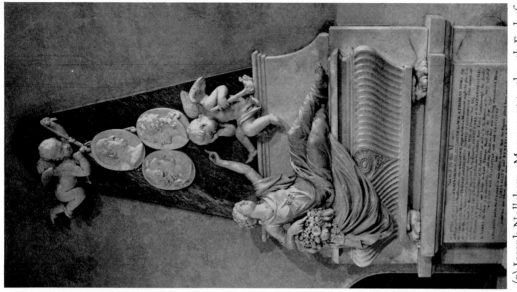

(B) Joseph Nollekens: Monument to the 4th Earl of
Gainsborough, 1790. *Exton, Rutland*

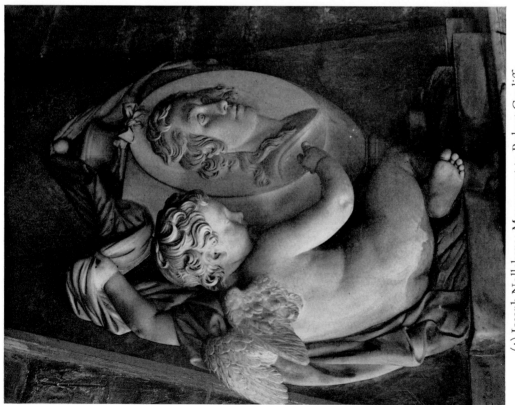

(A) Joseph Nollekens: Monument to Robert Cunliffe,
1778. *Bruera, Cheshire*

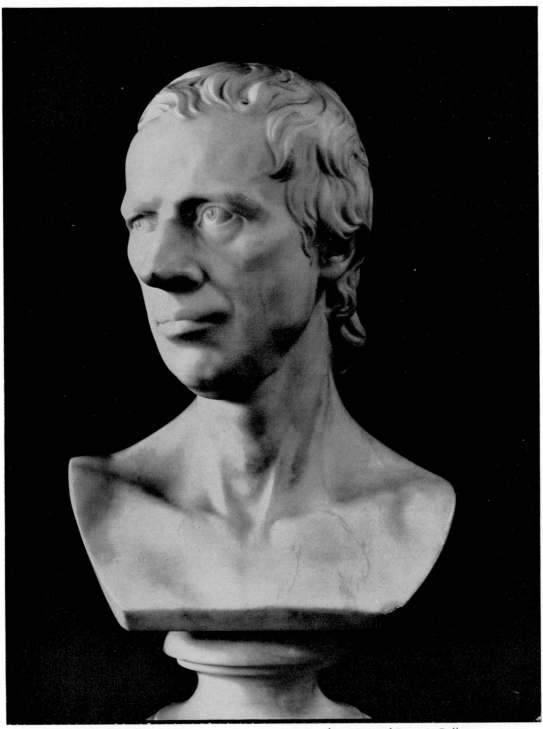

Joseph Nollekens: Lawrence Sterne, 1766. *London, National Portrait Gallery*

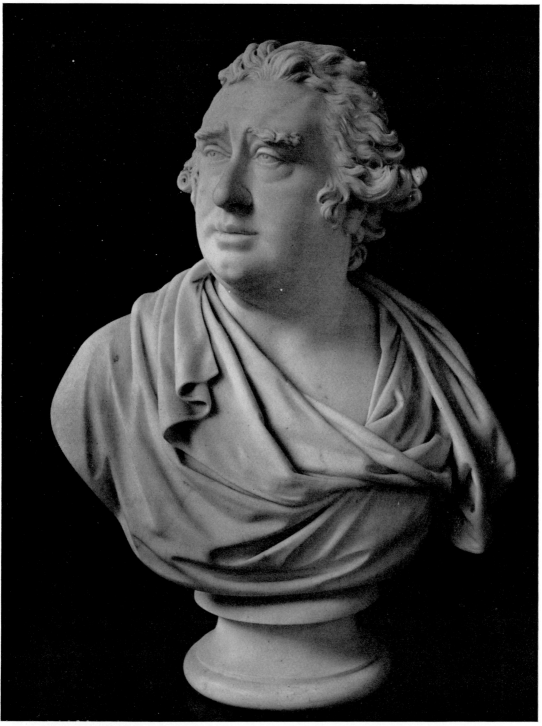

Joseph Nollekens: Charles James Fox, 1792. *Earl of Leicester, Holkham Hall, Norfolk*

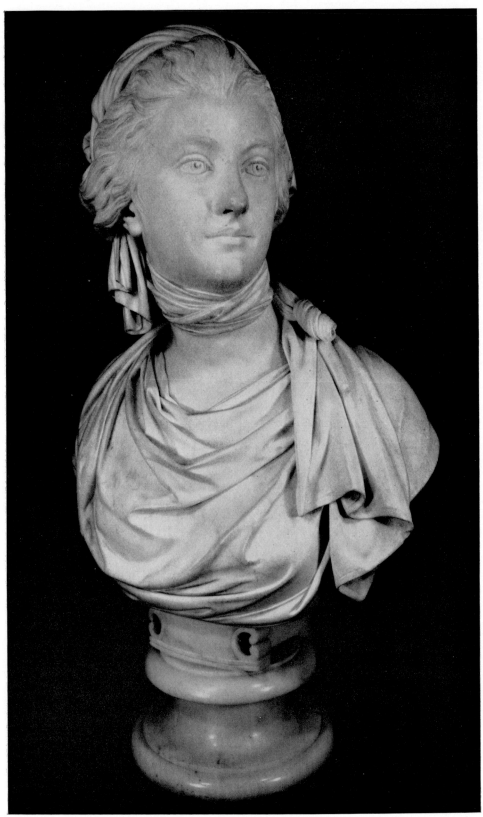

Joseph Nollekens: Mrs Pelham, *c.* 1778. *Earl of Yarborough,*
Brocklesby Park, Lincolnshire

122

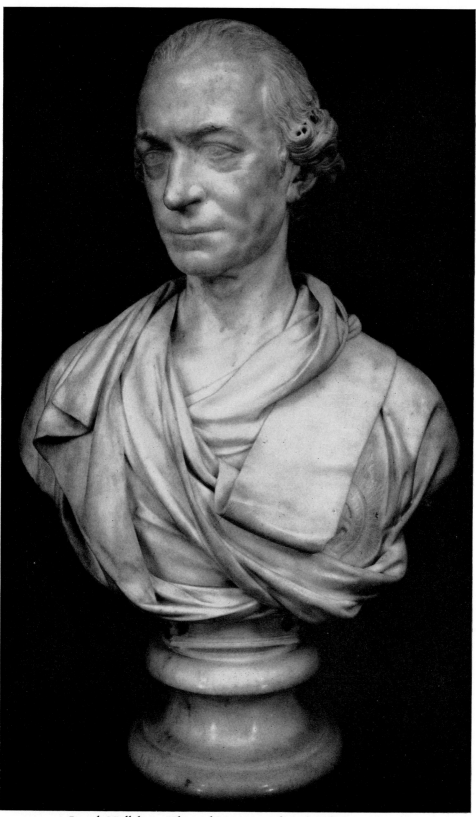

Joseph Nollekens: The 2nd Marquess of Rockingham, *c.* 1784.
Birmingham, City Museum and Art Gallery

123

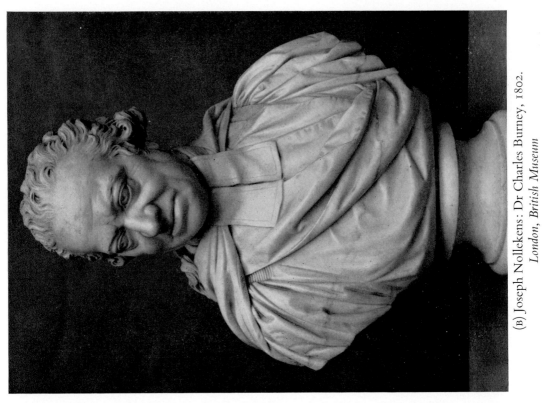

(B) Joseph Nollekens: Dr Charles Burney, 1802.
London, British Museum

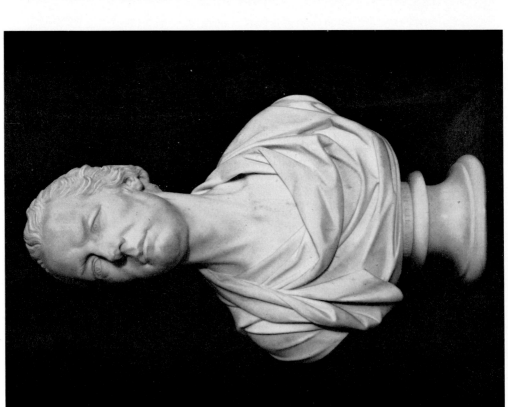

(A) Joseph Nollekens: William Pitt, 1807. *Windsor Castle, Berkshire.*
Reproduced by gracious permission of Her Majesty the Queen

124

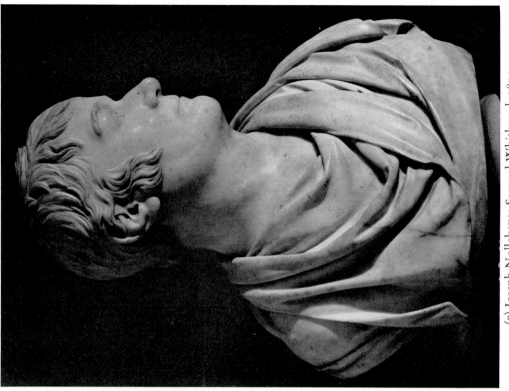

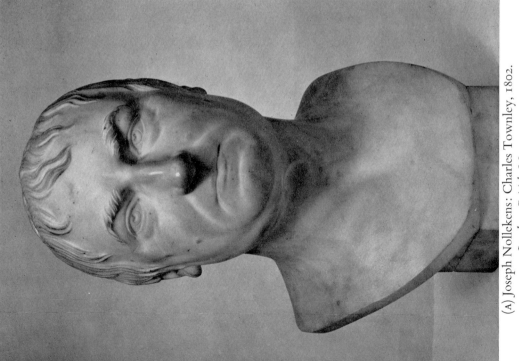

(A) Joseph Nollekens: Charles Townley, 1802.
London, British Museum

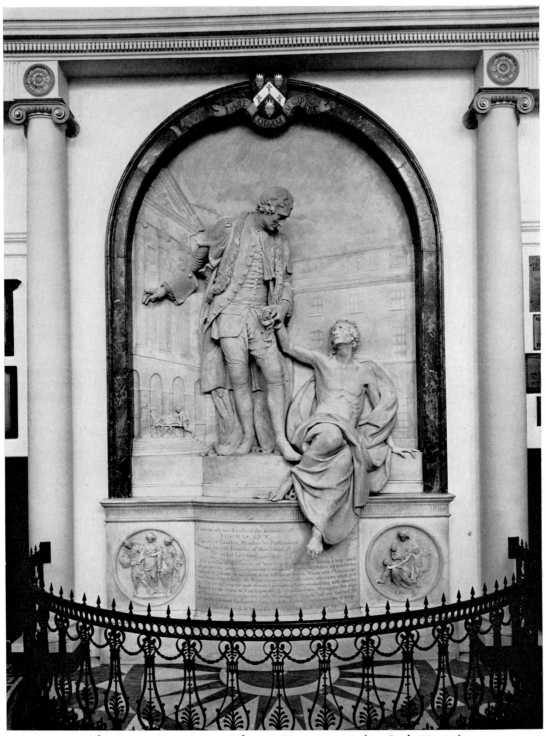

John Bacon: Monument to Thomas Guy, 1779. *London, Guy's Hospital*

126

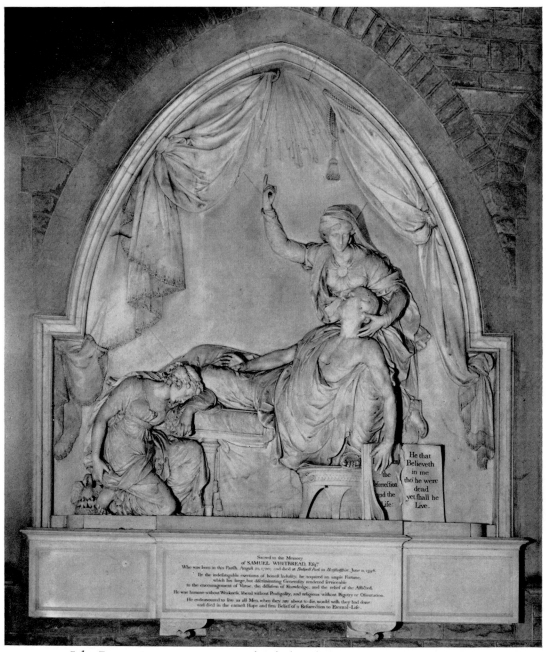

Sacred to the Memory
of SAMUEL WHITBREAD, Eſq.ʳ
Who was born in this Pariſh, Auguſt 30, 1720; and died at Bedwell Park in Hertfordſhire, June 11, 1796.

By the indefatigable exertions of honeſt Induſtry, he acquired an ample Fortune,
which his large, but diſcriminating Generoſity rendered ſerviceable
to the encouragement of Virtue, the diffuſion of Knowledge, and the relief of the Afflicted.

He was humane without Weakneſs, liberal without Prodigality, and religious without Bigotry or Oſtentation.

He endeavoured to live as all Men, when they are about to die, would wiſh they had done;
and died in the earneſt Hope and firm Belief of a Reſurrection to Eternal-Life.

I am the Reſurrection and the Life:

He that Believeth in me tho' he were dead yet ſhall he Live.

John Bacon: Monument to Samuel Whitbread, 1799. *Cardington, Bedfordshire*

127

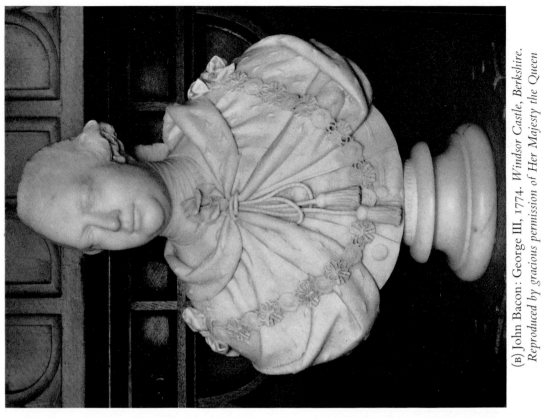

(B) John Bacon: George III, 1774. *Windsor Castle, Berkshire.* *Reproduced by gracious permission of Her Majesty the Queen*

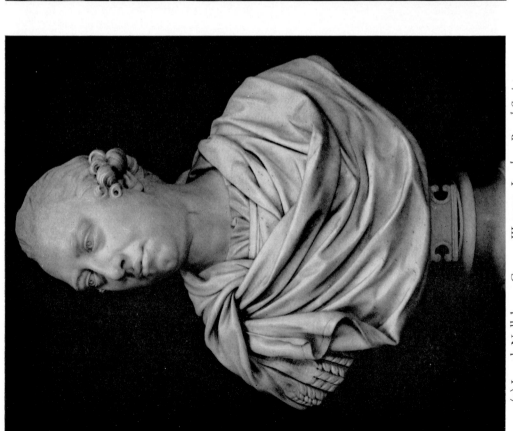

(A) Joseph Nollekens: George III, 1773. *London, Royal Society*

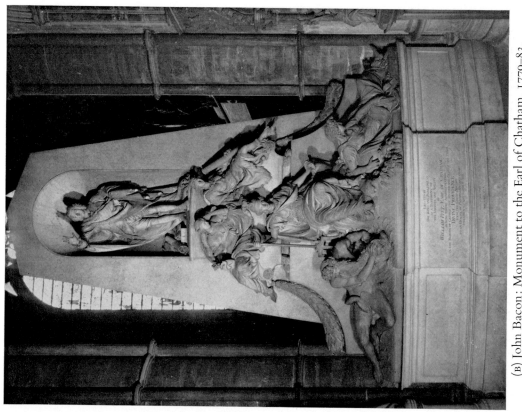

(B) John Bacon: Monument to the Earl of Chatham, 1779–83.
Westminster Abbey

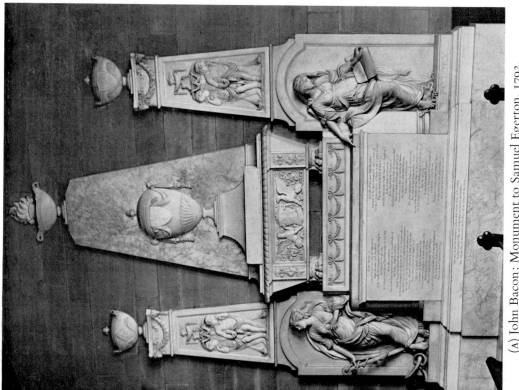

(A) John Bacon: Monument to Samuel Egerton, 1792.
Rostherne, Cheshire

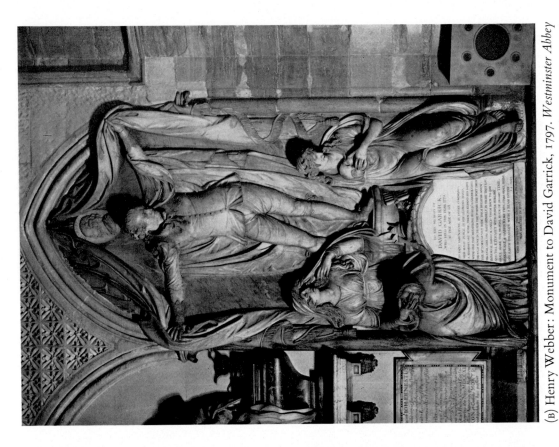

(B) Henry Webber: Monument to David Garrick, 1797. *Westminster Abbey*

(A) John Bacon: Monument to Ann Whytell, 1791. *Westminster Abbey*

130

Peter Matthias Vangelder: Monument to the 3rd Duchess of Montagu, 1775. *Warkton, Northamptonshire*

John Bacon: Sir William Blackstone, 1784. *Oxford, All Souls College*

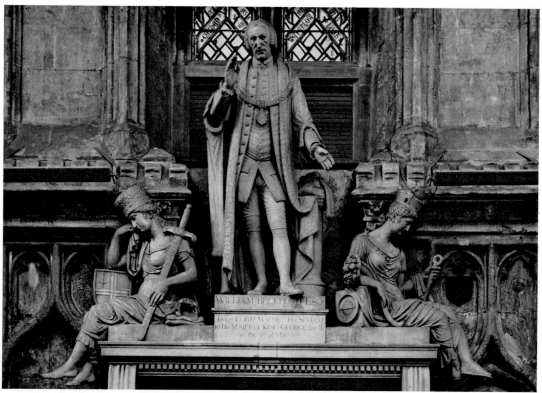

(A) John Francis Moore: Monument to William Beckford, 1772. *London, Guildhall*

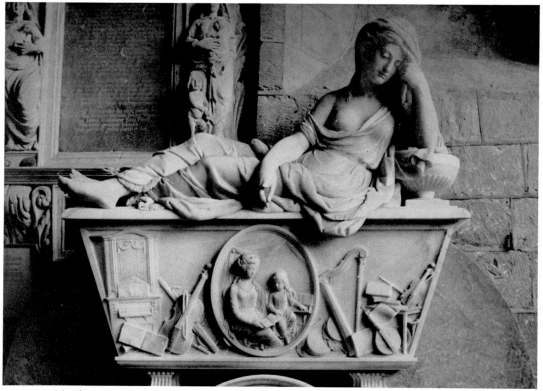

(B) Thomas Scheemakers: Monument to Mary Russell, 1787. *Powick, Worcestershire*

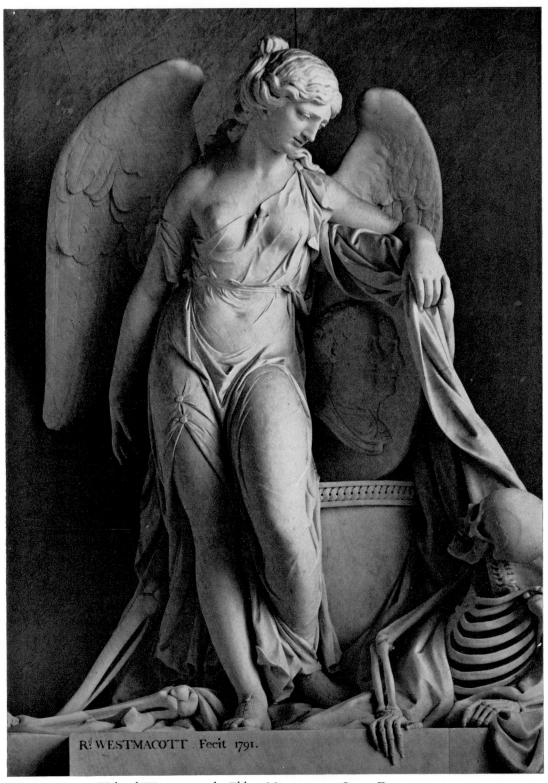

Richard Westmacott the Elder: Monument to James Dutton, 1791.
Sherborne, Gloucestershire

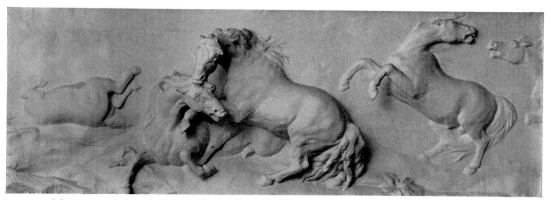

(A) George Garrard: Duncan's maddened Horses (plaster), 1797. *Southill, Bedfordshire*

(B) Anne Seymour Damer: Dog, *c.* 1784. *Mrs T. Giffard,*
Chillington Hall, Staffordshire

Thomas Banks: The Death of Germanicus, 1774. *Earl of Leicester, Holkham Hall, Norfolk*

Thomas Banks: Thetis and her Nymphs rising from the Sea to console Achilles for the Loss of Patroclus, 1778. *London, Victoria and Albert Museum*

Thomas Banks: Thetis dipping the Infant Achilles in the River Styx, *c.* 1788. *London, Victoria and Albert Museum*

(B) Christopher Hewetson: Gavin Hamilton, 1784.
University of Glasgow

(A) Thomas Banks: Warren Hastings, 1799. *London,*
Commonwealth Relations Office

139

Thomas Banks: Monument to Captain Richard Burgess, 1802.
London, St Paul's Cathedral

(A) Thomas Banks: Monument to Penelope Boothby, 1793. *Ashbourne, Derbyshire*

(B) Thomas Banks: Monument to Mrs Petrie, 1795. *Lewisham, London*

Thomas Banks: Monument to Captain Richard Burgess, 1802. Detail.
London, St Paul's Cathedral

(A) Thomas Banks: Monument to Martha Hand (destroyed), 1785.
London, St Giles, Cripplegate

(B) John Flaxman: Monument to Mrs Morley, 1784. *Gloucester Cathedral*

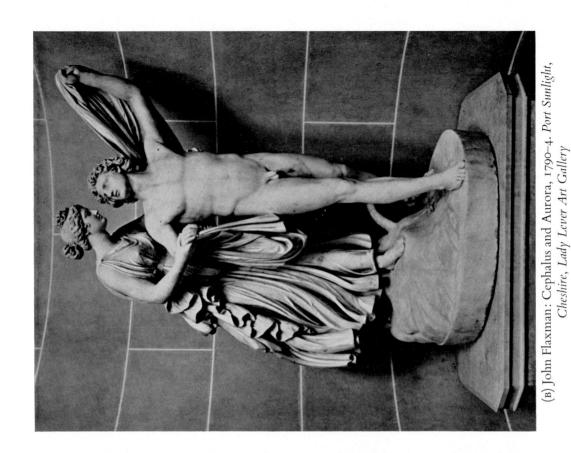

(B) John Flaxman: Cephalus and Aurora, 1790–4. *Port Sunlight, Cheshire, Lady Lever Art Gallery*

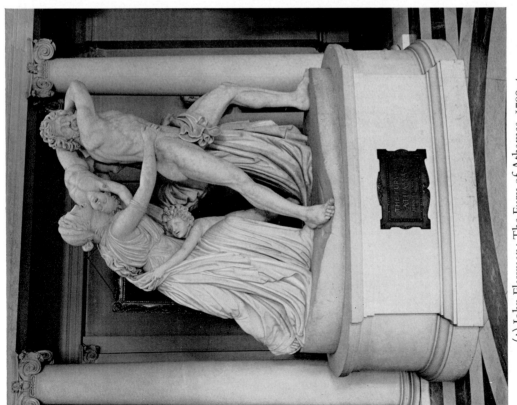

(A) John Flaxman: The Fury of Athamas, 1790–4. *The National Trust, Ickworth, Suffolk*

144

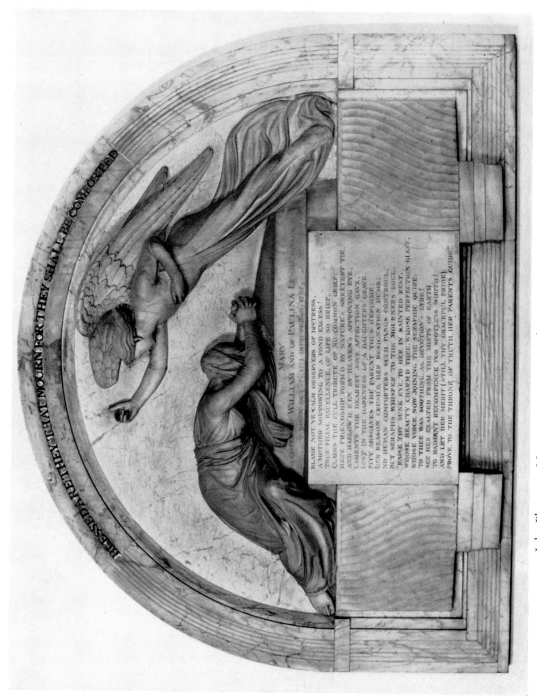

John Flaxman: Monument to Mary Lushington, 1799. *Lewisham, London*

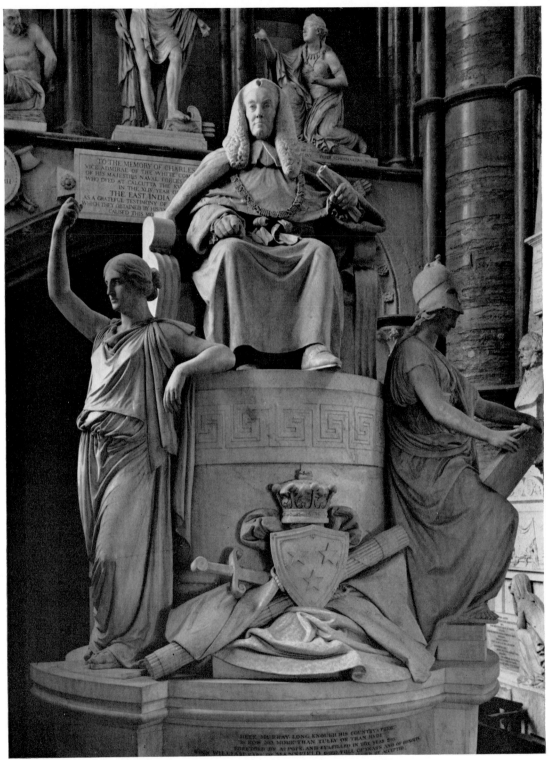

John Flaxman: Monument to the 18th Earl of Mansfield, 1795–1801.
Westminster Abbey

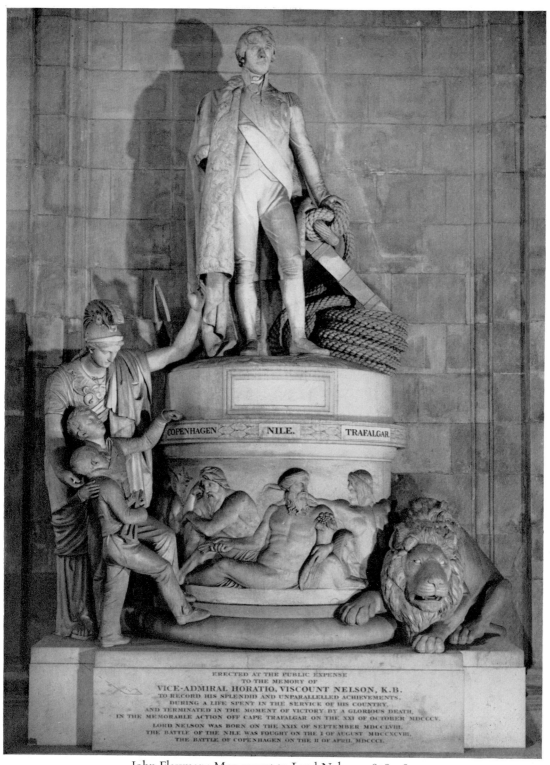

John Flaxman: Monument to Lord Nelson, 1808–18.
London, St Paul's Cathedral

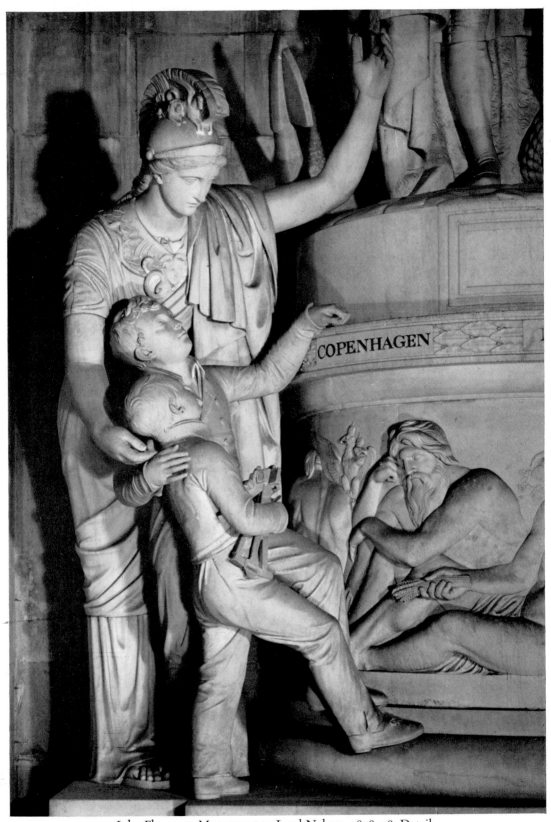

John Flaxman: Monument to Lord Nelson, 1808–18. Detail.
London, St Paul's Cathedral

(A) John Flaxman: Robert Burns, 1822.
*Edinburgh, National Portrait Gallery
of Scotland*

(B) John Flaxman: William Pitt, 1812.
Glasgow Art Gallery

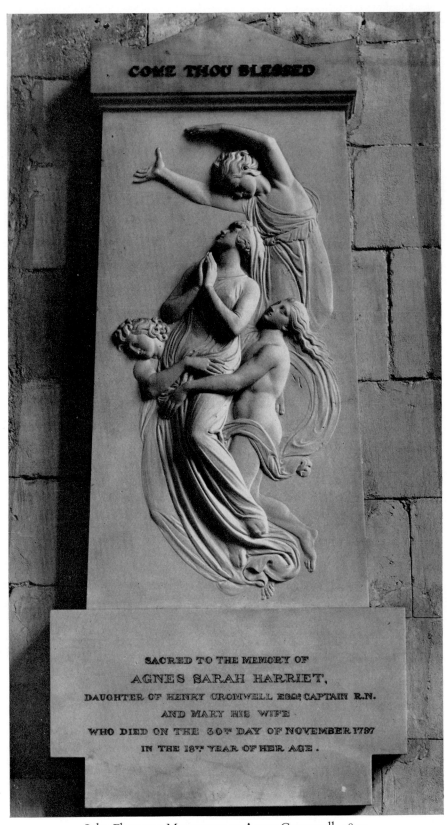

John Flaxman: Monument to Agnes Cromwell, 1800.
Chichester Cathedral

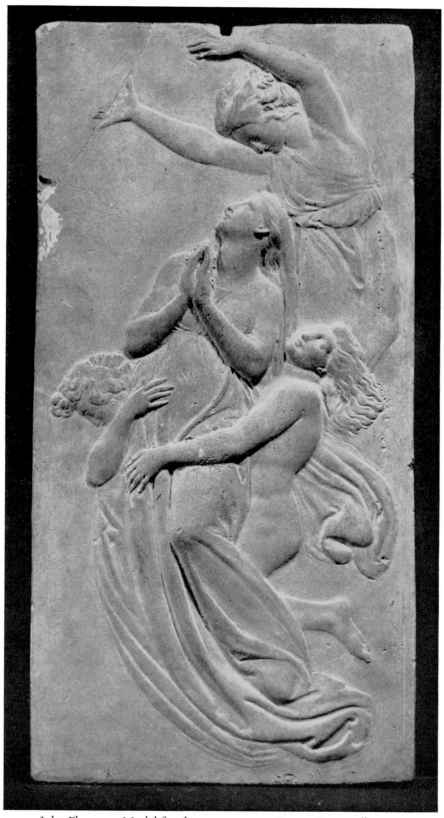

John Flaxman: Model for the monument to Agnes Cromwell, 1800.
London, University College

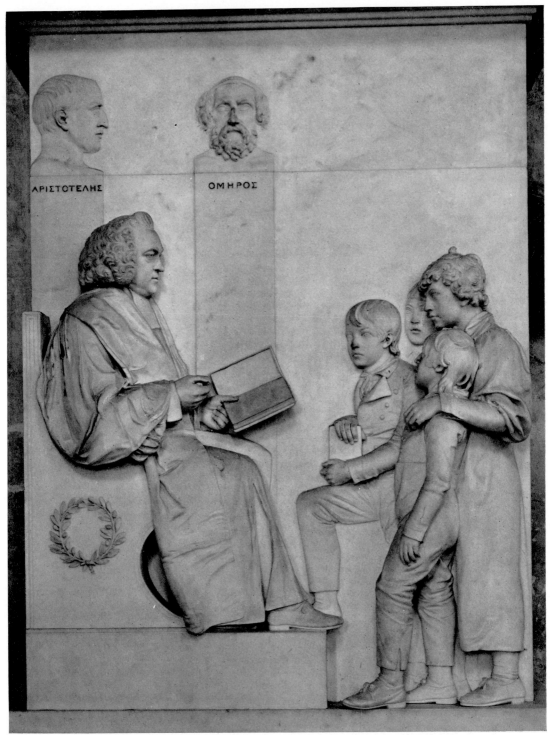

John Flaxman: Monument to Dr Joseph Warton, 1804. *Winchester Cathedral*

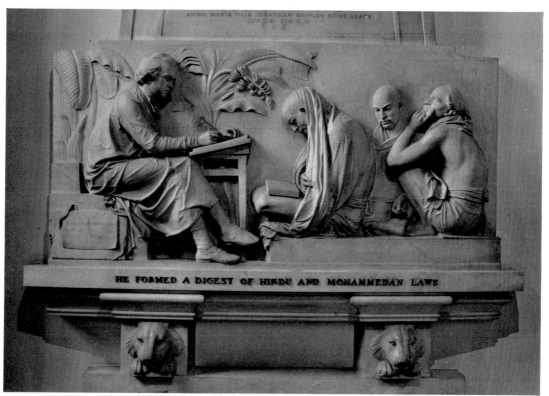

(A) John Flaxman: Monument to Sir William Jones, 1798. *Oxford, University College*

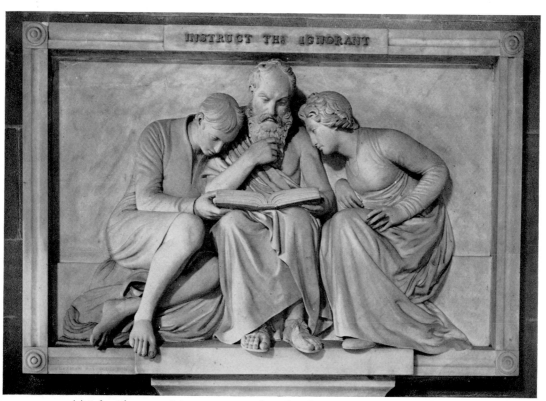

(B) John Flaxman: Monument to Edward Balme, *c.* 1810. *Bradford, Yorkshire*

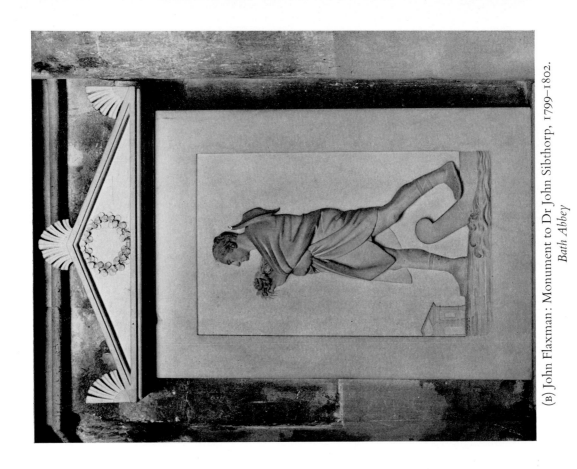

(B) John Flaxman: Monument to Dr John Sibthorp, 1799–1802.
Bath Abbey

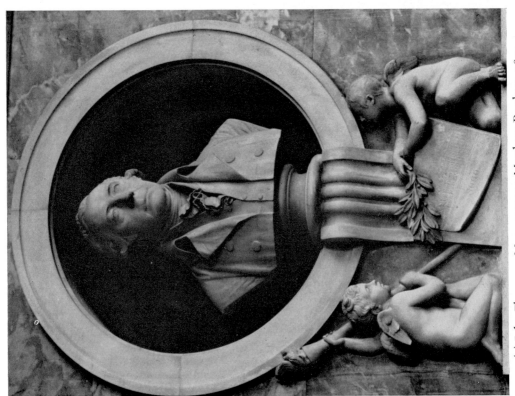

(A) John Flaxman: Monument to Matthew Boulton, 1809.
Handsworth, Birmingham

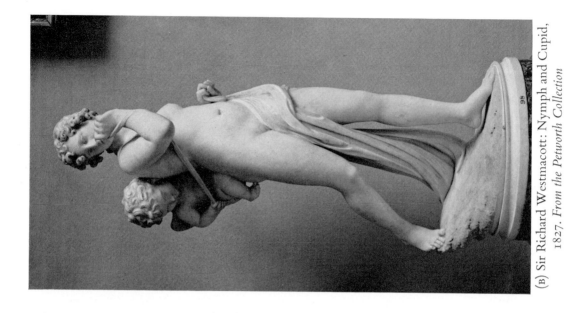

(B) Sir Richard Westmacott: Nymph and Cupid, 1827. *From the Petworth Collection*

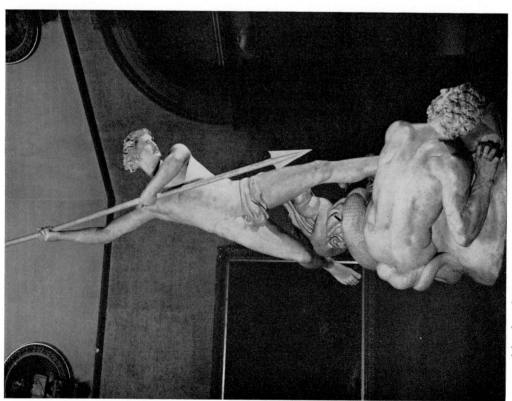

(A) John Flaxman: Satan overcome by St Michael, 1822. *From the Petworth Collection*

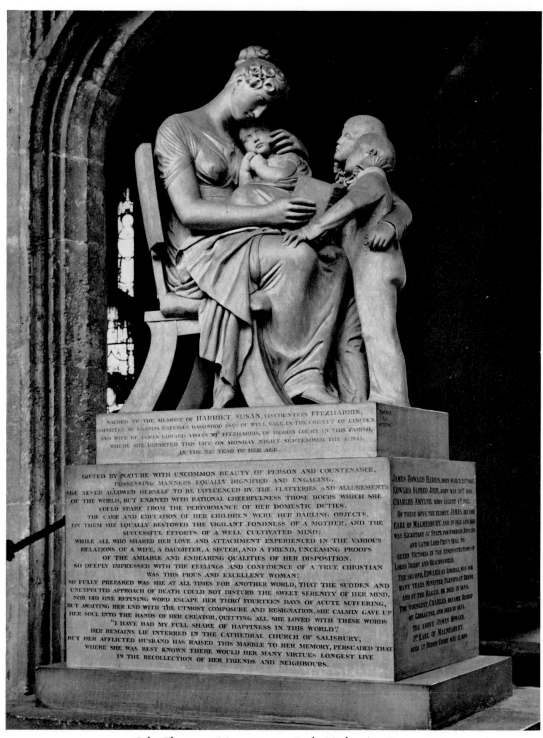

John Flaxman: Monument to Lady Fitzharris, 1817.
Christchurch Priory, Hampshire

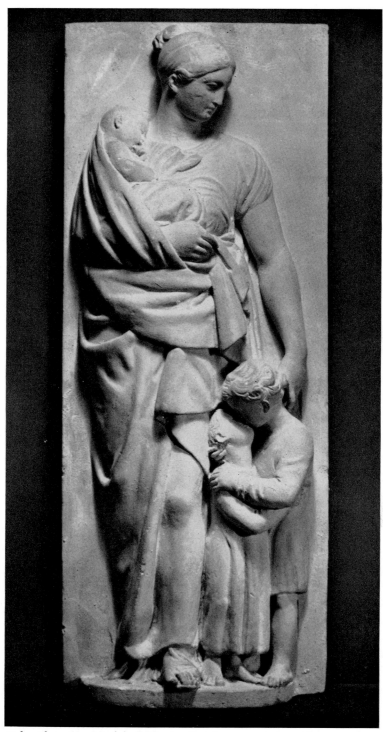

John Flaxman: Model of Charity for the monument to the Countess
Spencer, 1819. *London, University College*

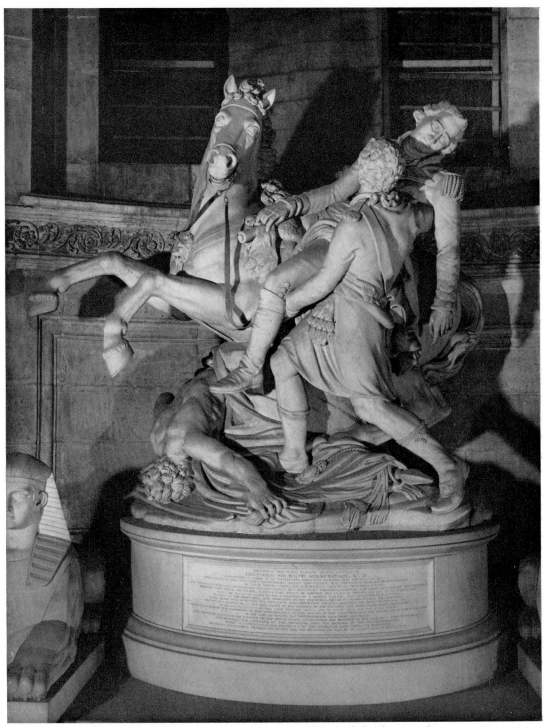

Sir Richard Westmacott: Monument to General Sir Ralph Abercromby, 1802–5.
London, St Paul's Cathedral

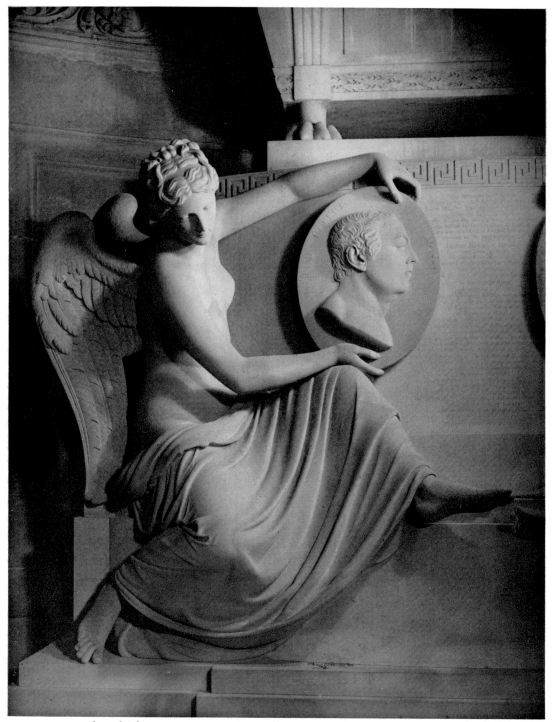

John Charles Rossi: Monument to Captains Mosse and Riou, 1802. Detail.
London, St Paul's Cathedral

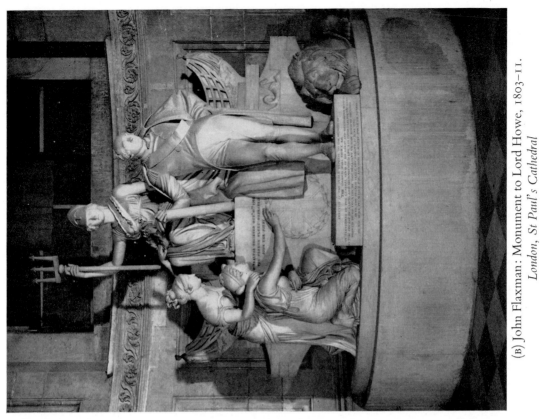

(B) John Flaxman: Monument to Lord Howe, 1803–11.
London, St Paul's Cathedral

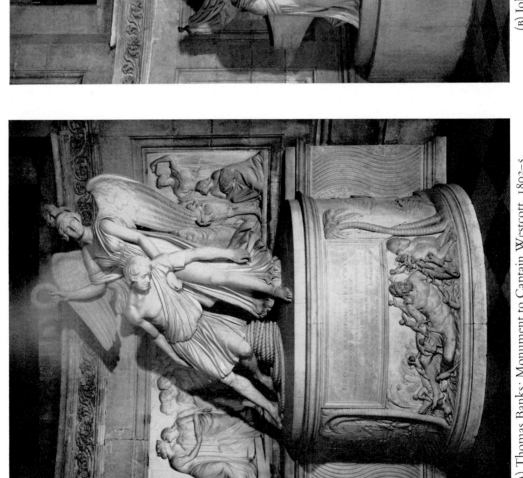

(A) Thomas Banks: Monument to Captain Westcott, 1802–5.
London, St Paul's Cathedral

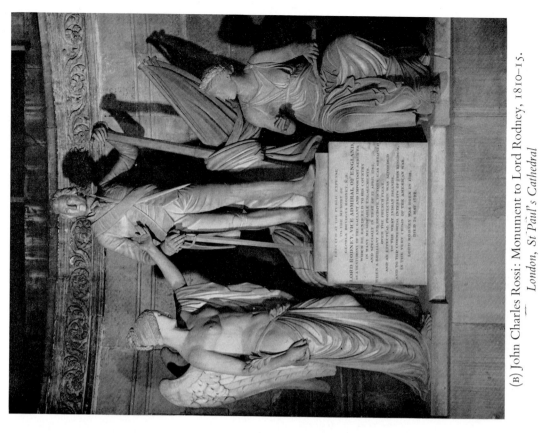

(B) John Charles Rossi: Monument to Lord Rodney, 1810–15.
London, St Paul's Cathedral

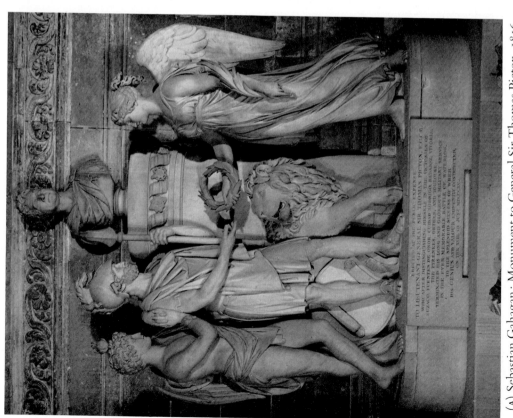

(A) Sebastian Gahagan: Monument to General Sir Thomas Picton, 1816.
London, St Paul's Cathedral

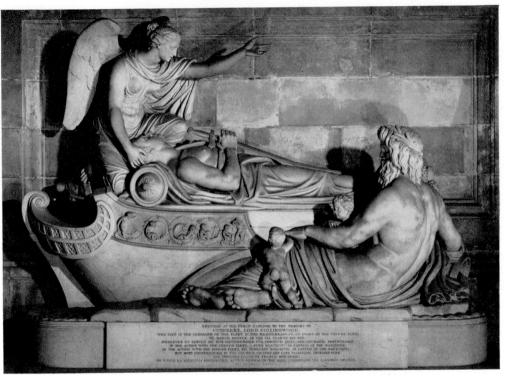

(A) Sir Richard Westmacott: Monument to Lord Collingwood, 1813–17.
London, St Paul's Cathedral

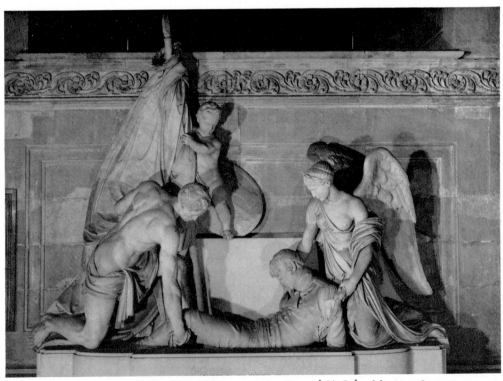

(B) John Bacon the Younger: Monument to General Sir John Moore, 1810–15.
London, St Paul's Cathedral

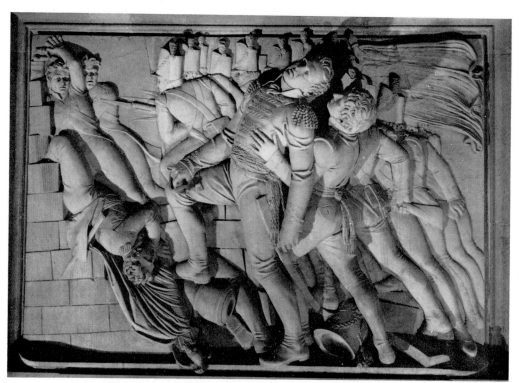

(A) Sir Francis Chantrey: Monument to General Bowes, *c.* 1811.
London, St Paul's Cathedral

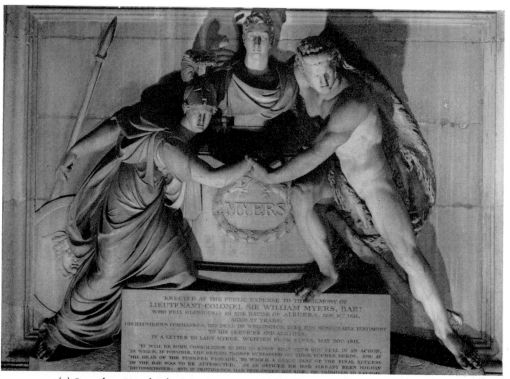

(B) Josephus Kendrick: Monument to Colonel Sir William Myers, *c.* 1811.
London, St Paul's Cathedral

(B) John Bacon: Monument to Samuel Johnson, 1796. *London, St Paul's Cathedral*

(A) Sir Richard Westmacott: Monument to Generals Pakenham and Walsh, 1823. *London, St Paul's Cathedral*

(B) Sir Francis Chantrey: William Pitt, 1831.
London, Hanover Square

(A) Sir Richard Westmacott: George Canning, 1832.
London, Parliament Square

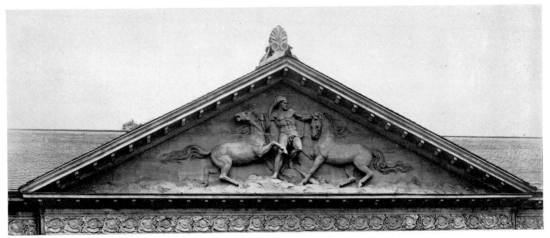

(A) William Theed: Hercules taming the Thracian Horses, *c.* 1816.
London, Buckingham Palace, Royal Mews

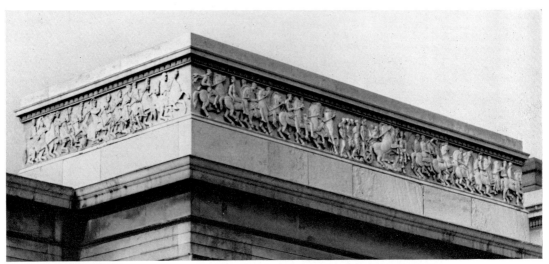

(B) John Henning: Frieze on the Arch, 1828. *London, Hyde Park Corner*

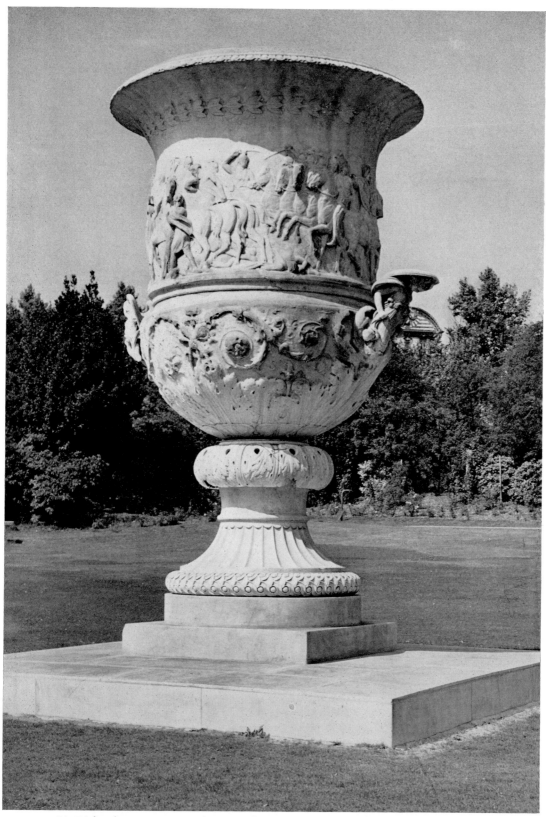

Sir Richard Westmacott: The Waterloo Vase, *c.* 1830. *London, Buckingham Palace.*
Reproduced by gracious permission of Her Majesty the Queen

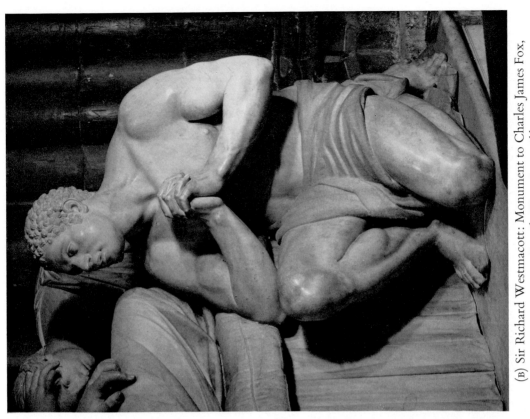

(B) Sir Richard Westmacott: Monument to Charles James Fox, 1810–23. Detail. *Westminster Abbey*

(A) Sir Richard Westmacott: Monument to William Pitt, 1807–13. *Westminster Abbey*

168

Sir Richard Westmacott: Monument to Charles James Fox, 1810–23. *Westminster Abbey*

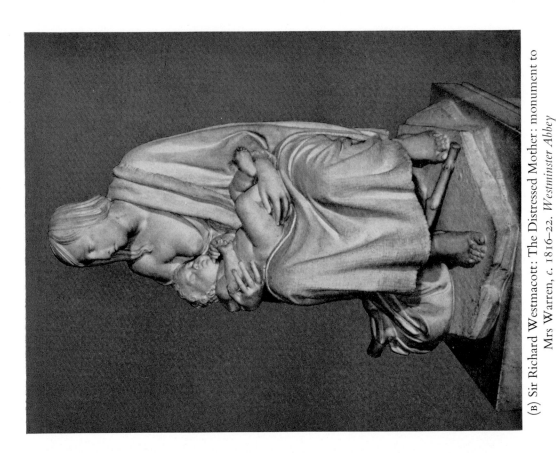

(B) Sir Richard Westmacott: The Distressed Mother: monument to Mrs Warren, c. 1816–22. *Westminster Abbey*

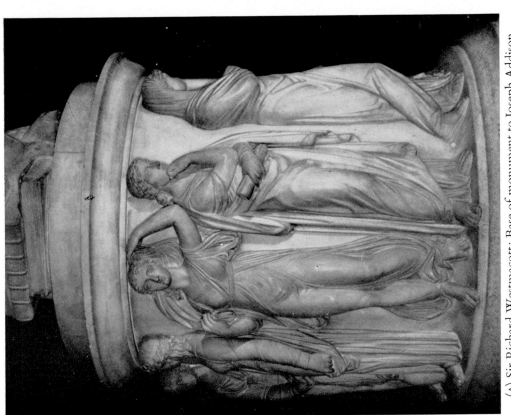

(A) Sir Richard Westmacott: Base of monument to Joseph Addison, 1803–9. *Westminster Abbey*

170

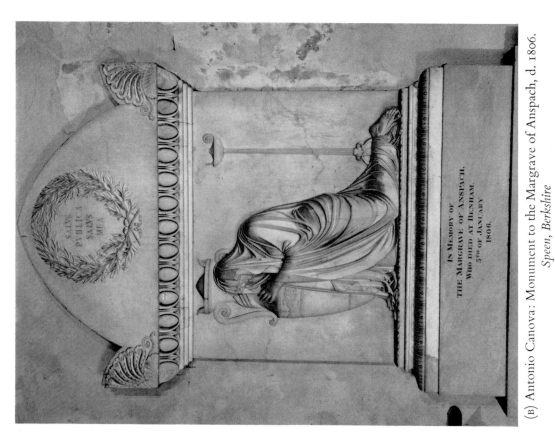

(B) Antonio Canova: Monument to the Margrave of Anspach, d. 1806.
Speen, Berkshire

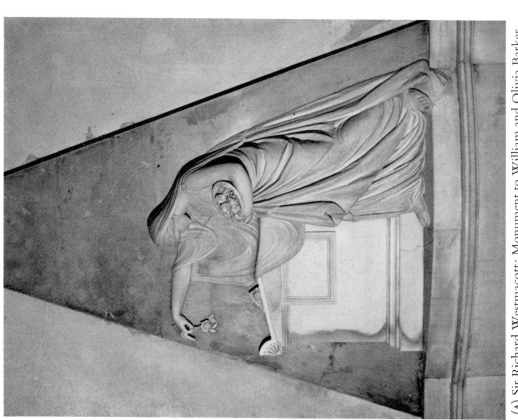

(A) Sir Richard Westmacott: Monument to William and Olivia Barker,
c. 1800. Sonning, Berkshire

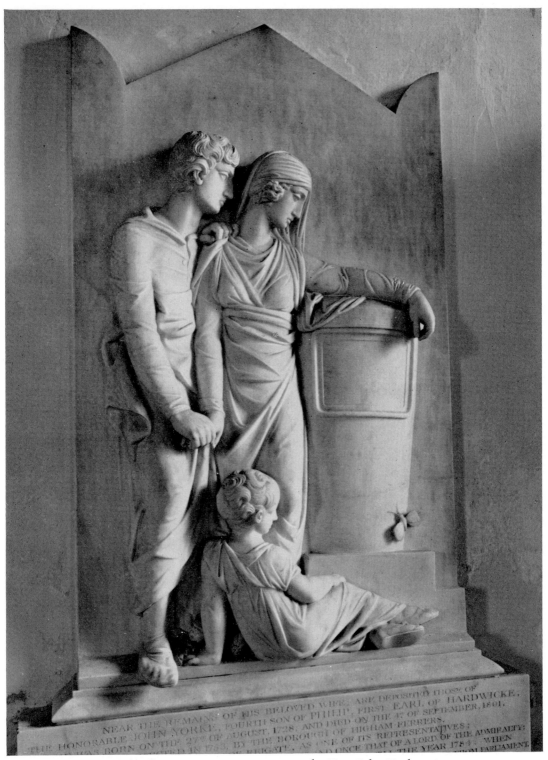

Sir Richard Westmacott: Monument to the Hon. John Yorke, 1801.
Wimpole, Cambridgeshire

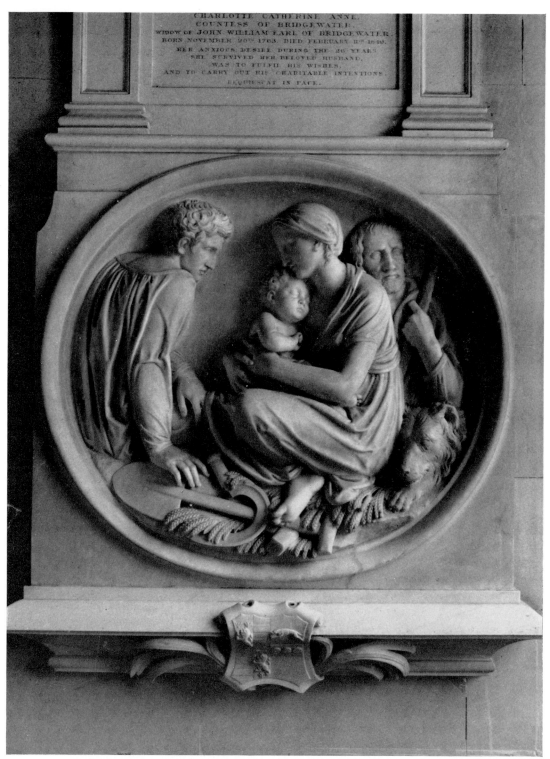

Sir Richard Westmacott: Monument to the 7th Earl of Bridgewater, d. 1823.
Little Gaddesden, Hertfordshire

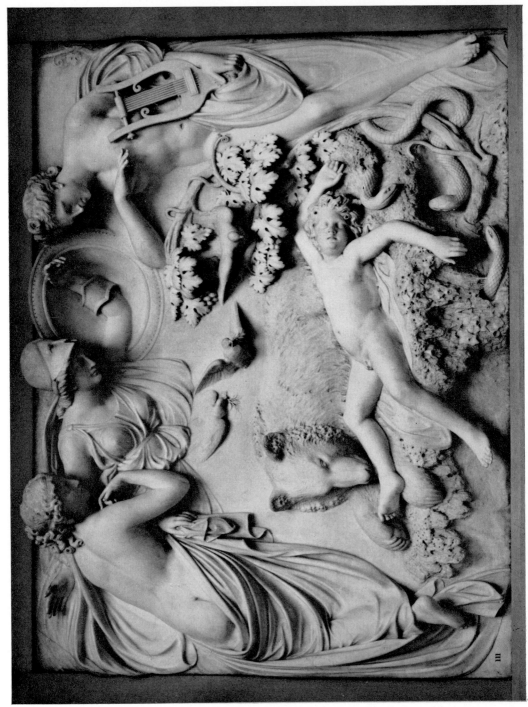

Sir Richard Westmacott: A Dream of Horace, 1823. *From the Petworth Collection*

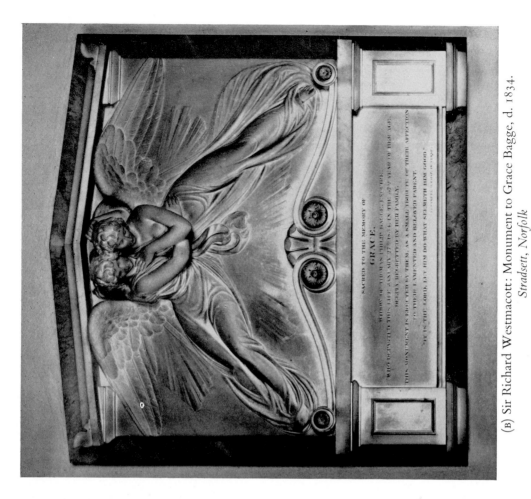

(A) Sir Richard Westmacott: Monument to the 11th Earl of
Pembroke, d. 1827. *Wilton, Wiltshire*

(B) Sir Richard Westmacott: Monument to Grace Bagge, d. 1834.
Stradsett, Norfolk

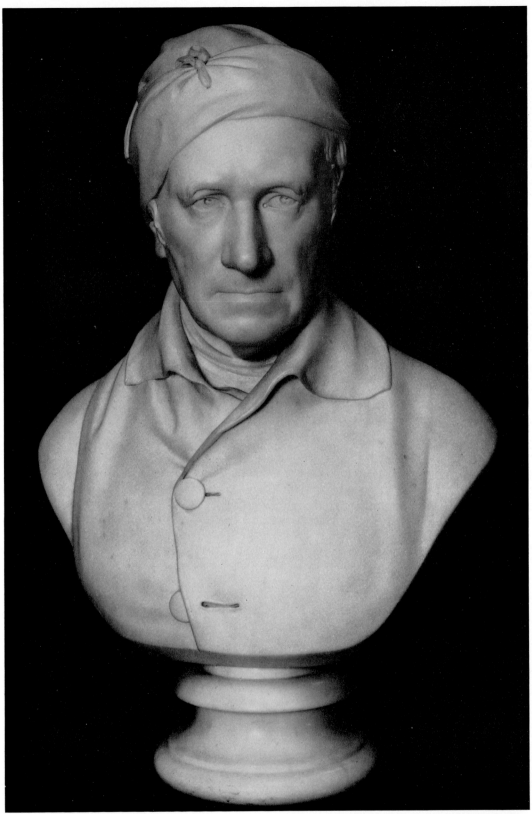

Sir Francis Chantrey: Rev. J. Horne-Tooke, 1811. *Cambridge, Fitzwilliam Museum*

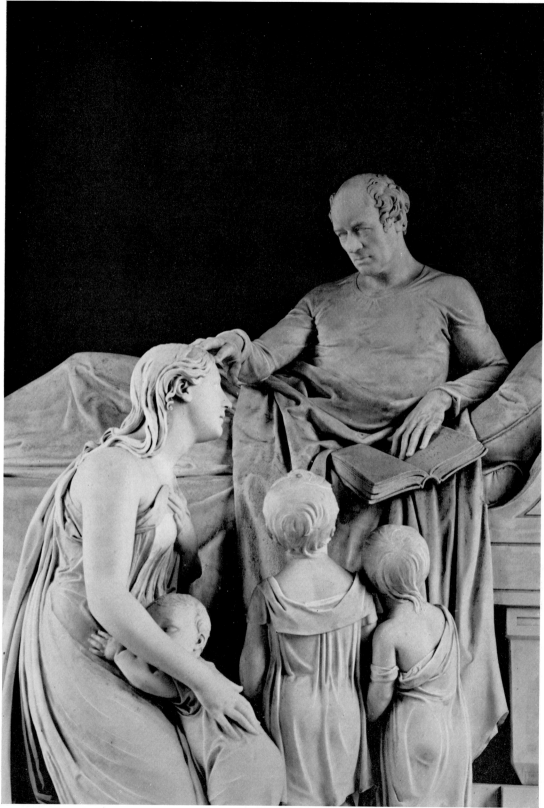

Sir Francis Chantrey: Monument to David Pike Watts, 1817–26. Detail. *Ilam, Staffordshire*

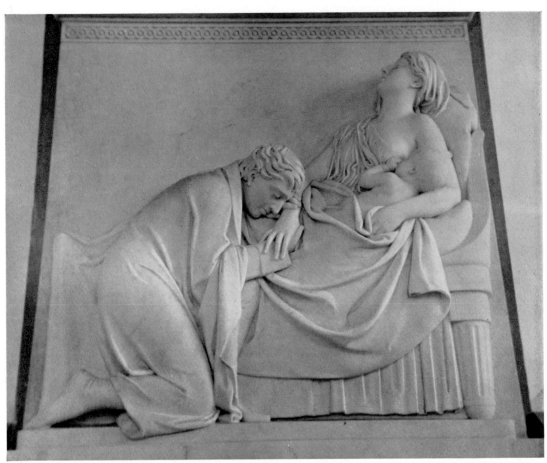

(A) Sir Francis Chantrey: Monument to Anna Maria Graves, d. 1819. *Waterperry, Oxfordshire*

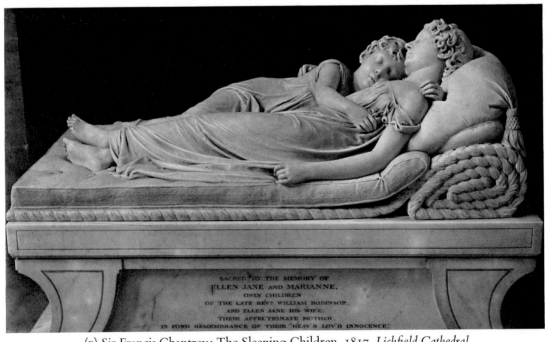

SACRED TO THE MEMORY OF
ELLEN JANE AND MARIANNE,
ONLY CHILDREN
OF THE LATE REVᴰ WILLIAM ROBINSON,
AND ELLEN JANE HIS WIFE,
THEIR AFFECTIONATE MOTHER,
IN FOND REMEMBRANCE OF THEIR "HEAV'N LOV'D INNOCENCE"

(B) Sir Francis Chantrey: The Sleeping Children, 1817. *Lichfield Cathedral*

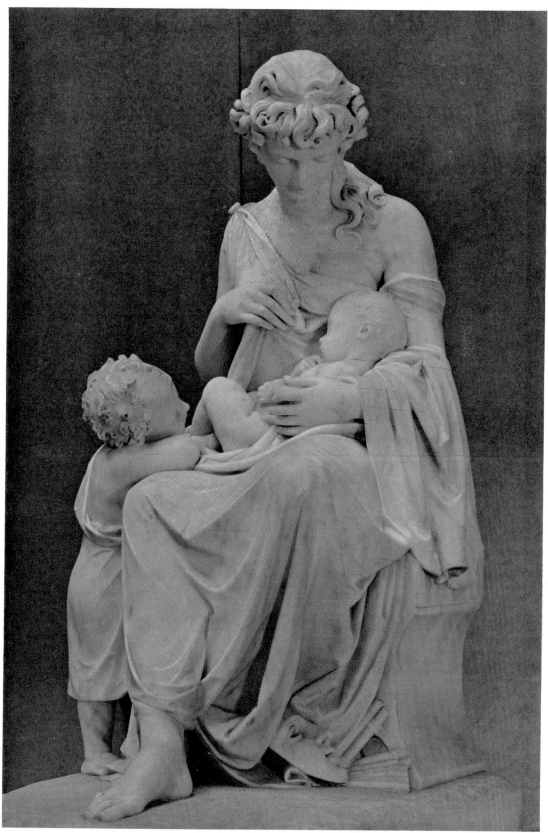

Sir Francis Chantrey: Mrs Jordan, 1834. *Earl of Munster Collection*

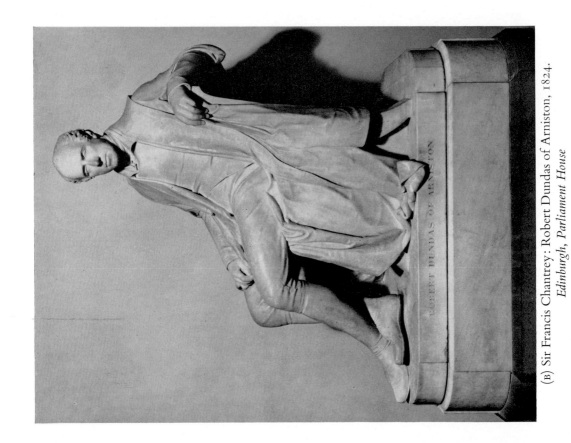

(B) Sir Francis Chantrey: Robert Dundas of Arniston, 1824.
Edinburgh, Parliament House

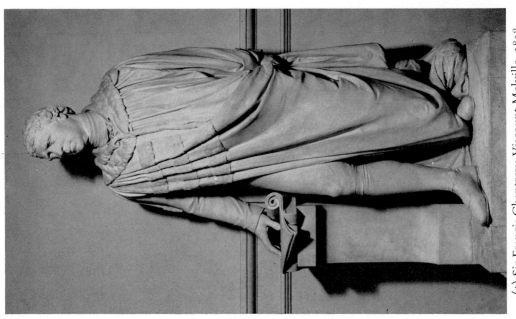

(A) Sir Francis Chantrey: Viscount Melville, 1818.
Edinburgh, Parliament House

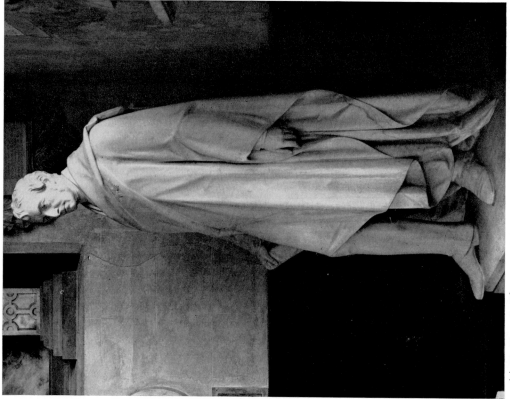

(B) Sir Francis Chantrey: Monument to the 1st Duke of Sutherland, 1838. *Trentham, Staffordshire*

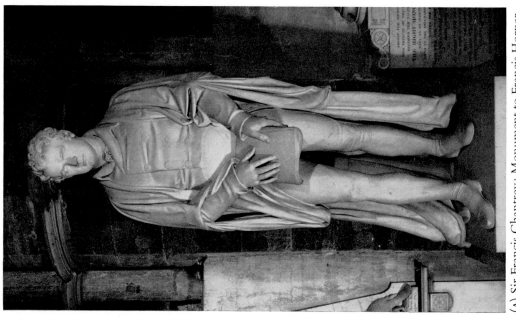

(A) Sir Francis Chantrey: Monument to Francis Horner, 1820. *Westminster Abbey*

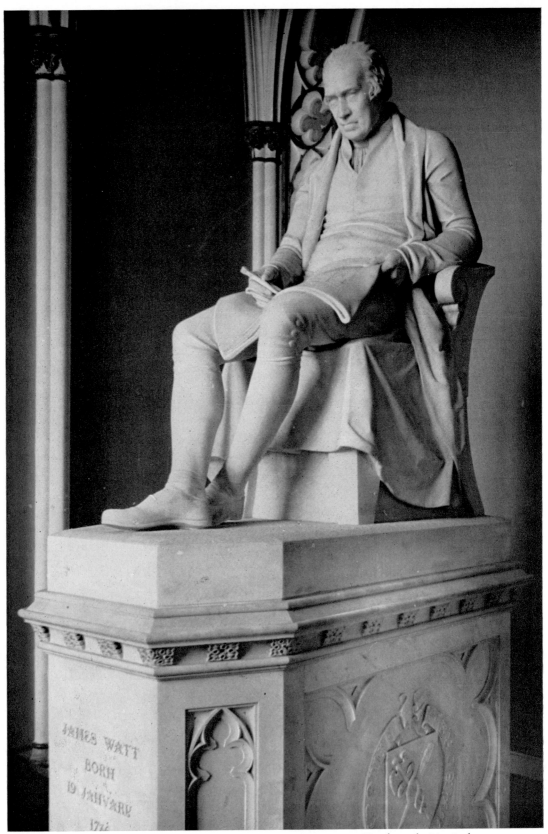

Sir Francis Chantrey: Monument to James Watt, 1824. *Handsworth, Birmingham*

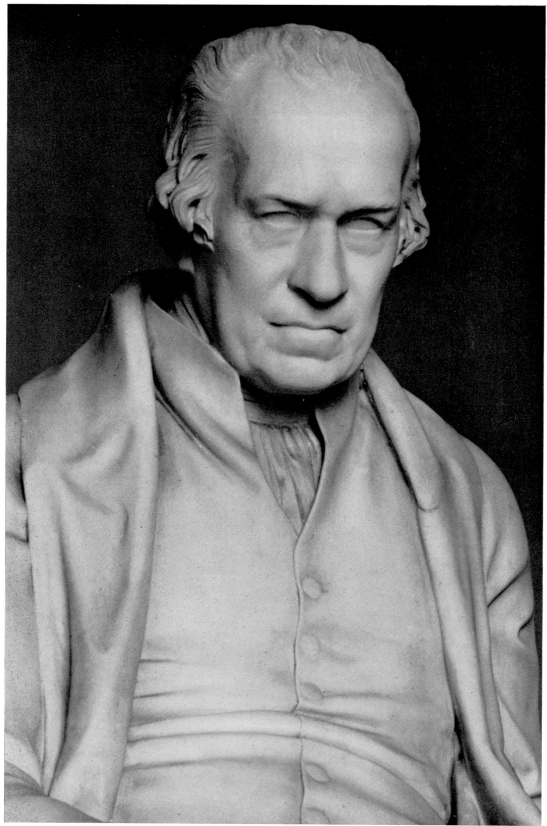

Sir Francis Chantrey: Monument to James Watt, 1824. Detail. *Handsworth, Birmingham*

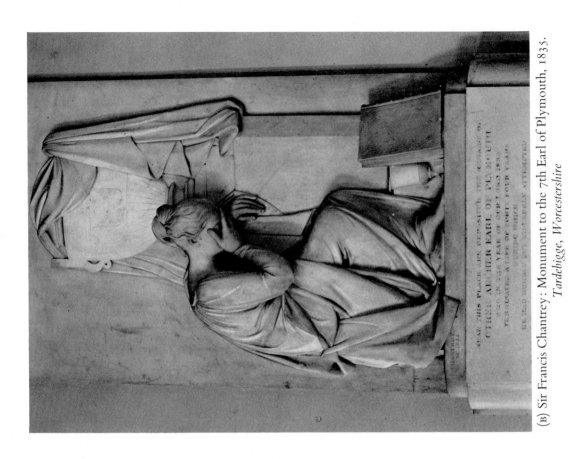

(B) Sir Francis Chantrey: Monument to the 7th Earl of Plymouth, 1835.
Tardebigge, Worcestershire

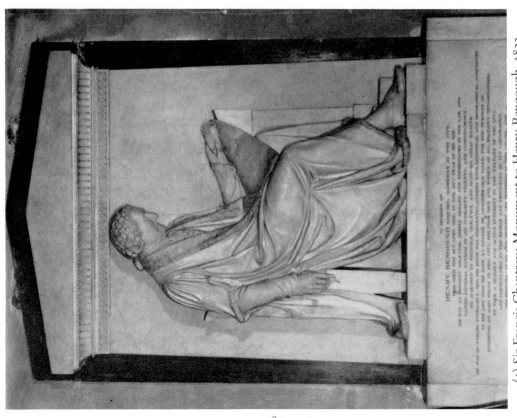

(A) Sir Francis Chantrey: Monument to Henry Bengough, 1823.
Bristol, Lord Mayor's Chapel

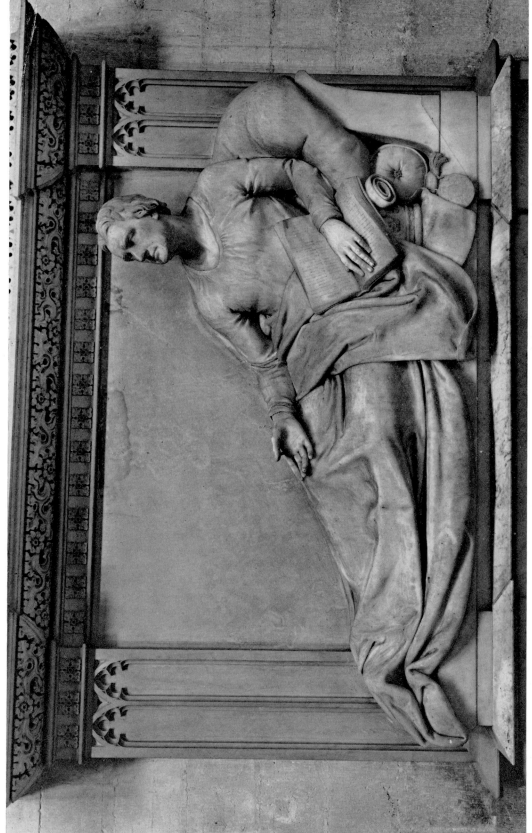

Sir Francis Chantrey: Monument to the 1st Earl of Malmesbury, 1823. *Salisbury Cathedral*

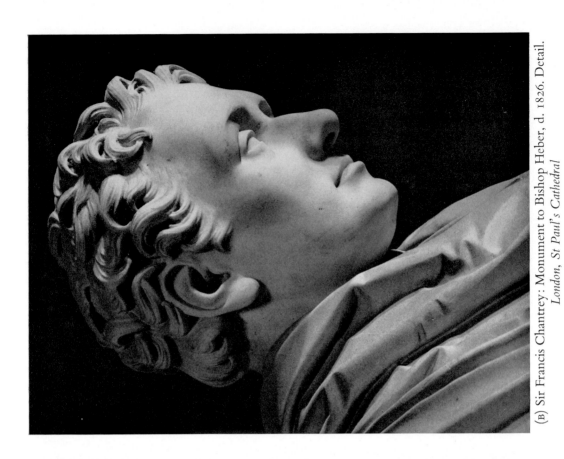

(B) Sir Francis Chantrey: Monument to Bishop Heber, d. 1826. Detail.
London, St Paul's Cathedral

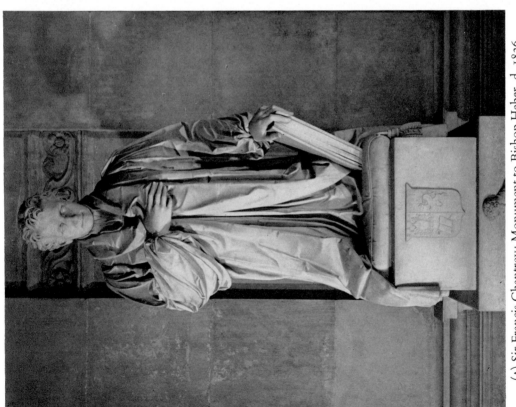

(A) Sir Francis Chantrey: Monument to Bishop Heber, d. 1826.
London, St Paul's Cathedral

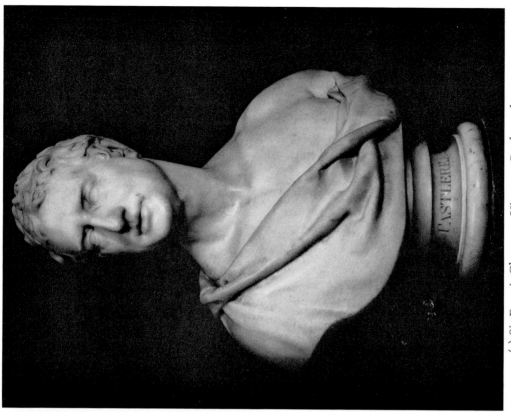

(B) Sir Francis Chantrey: Viscount Castlereagh, 1821. *Howard Ricketts Esq.*

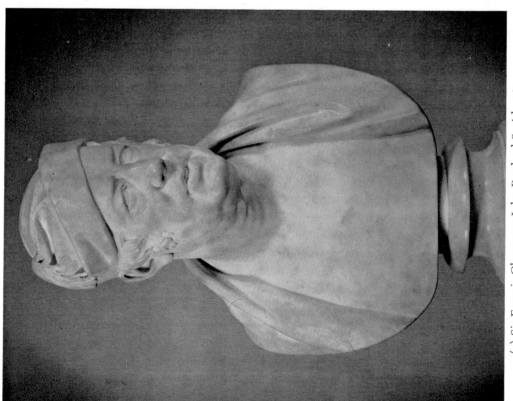

(A) Sir Francis Chantrey: John Raphael Smith, 1825. *London, Victoria and Albert Museum*

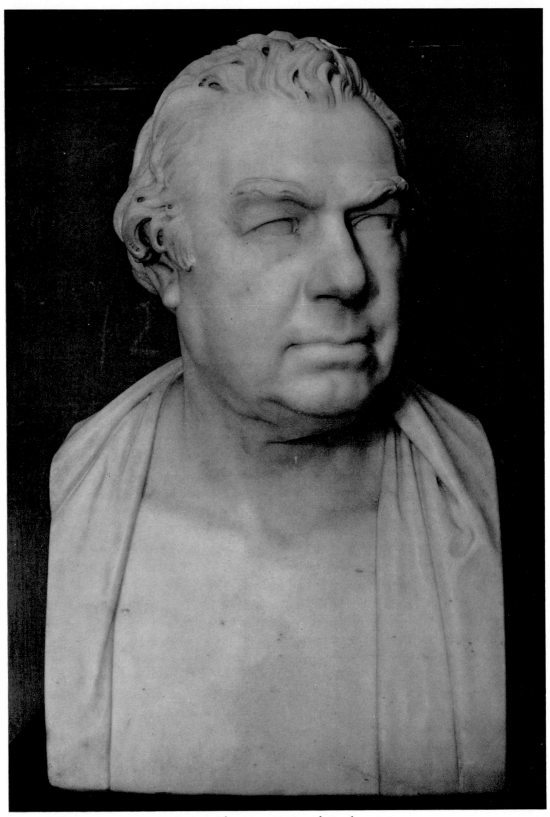

Sir Francis Chantrey: Sir Joseph Banks, 1818.
London, The Royal Society

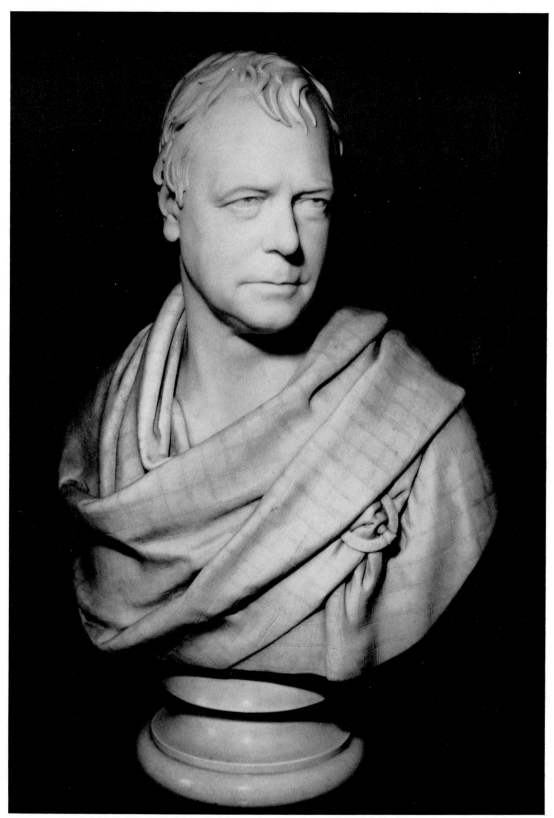

Sir Francis Chantrey: Sir Walter Scott, 1820.
Mrs Maxwell-Scott, Abbotsford House, Melrose

(B) Sir Francis Chantrey: Joseph Nollekens, 1817. *Duke of Bedford, Woburn Abbey, Bedfordshire*

(A) Sir Francis Chantrey: Edward Johnstone, 1819. *Birmingham, City Museum and Art Gallery*

(B) Sir Francis Chantrey: Lord Hume, 1832. *Edinburgh, Parliament House*

(A) Sir Francis Chantrey: William Hunter Baillie, 1823. *London, Royal College of Surgeons of England*

Sir Francis Chantrey: George IV, 1828. *London, Trafalgar Square*

INDEX

Numbers in *italics* refer to plates. Names in *italics* refer to pieces of sculpture and works of art other than monuments or tombs, and are followed in brackets by the name of the artist. The word monument is abbreviated to mon. References to Notes are given to the page on which the note occurs, followed by the number of the note. Thus 242[56] indicates page 242, note 56. Artists' names are indexed under the final element of the surname: thus Sir Anthony van Dyck will be found under Dyck. Noblemen's names are indexed under their title: thus the 3rd Duke of Ancaster will be found under Ancaster. Buildings in London – e.g. British Museum – are under the heading 'London'. Where only a place name is given as a location, the principal church in that place is intended. Private collections are for the most part indexed under the name of the owner: e.g. works of sculpture at Dalmeny House are referred to under the name of the Earl of Rosebery. Where names of places or buildings are followed by the name of an artist in brackets, the entry refers to work by that artist in such places or buildings.

H

Marlborough, 1st Duke of, 68, 79; tomb, 89–90, *70*

Marlborough, 1st Duke of (Rysbrack), 86, 96; (Vervoort?), 84

Marlborough, Henrietta, Duchess of, 78

Marlborough, Sarah, Duchess of, 89

Marney, 1st Lord, 232[11,12]; tomb, 6, 232[12], *4*

Marney, 2nd Lord, 232[11]; tomb, 6, 232[12]

Mars (Bacon), 166, 270[6]

Marshall, Edward, 31–3, 41, 63, 241[44,46,49 ff.], *22–3, 25*

Marshall, Joshua, 31, 32, 63–4, 241[44], 245[16]

Marsworth (Bucks), West tomb, 18

Martin, Richard, mon., 235[29]

Marwood, James, mon., 270[17]

Mary I, Queen, 8

Mary I, Queen (anon.), 3; (Gibbons), 250[57]

Mary II, mon., design by Gibbons, 57, 249[46]

Mary II (Nost), 250[61], 251[68]

Mary, Queen of Scots, tomb, 17, 20, *12*

Mason, Thomas, tomb, 8, 233[26], *6*

Masons' Company, 16, 31, 33, 64, 247[34], 251[5]

Mason-sculptors, 23, 24 ff., 39, 41, 63 ff., 70, 125, 126, 129–30, 143

Mathew, Rev. Henry, 184

Maty, Dr Matthew, 111, 259[13]

Maximilian, Emperor, tomb, 279[23]

Maxwell-Scott, Mrs, Collection (Chantrey), 226, 280[40], *189*

May, Hugh, 53, 54, 59

May, Lady, mon., 44, 246[18]

Maynard, Allen, 233[28]

Maynard, Lord, mon., 130

Maynard, Lord and Lady, mon., 247[33]

Maynard, Thomas, mon., 130

Mazarin, Cardinal, tomb, 253[15]

Mazzoni, Guido, 4

Mead, Dr Richard, 97, 257[21], 261[9]; mon., 119

Meadowbank, Lord, 221

Medley, Vice-Admiral Henry, mon., 122

Melancholy Madness (Cibber), 49–50, 247[8], *36*

Melbourne Hall (Derbysh) (Nost), 61, *43, 46*

Melton Constable (Norfolk) (Bushnell?), 45

Melville, 2nd Viscount (Chantrey), 221, *180*

Mengs, Anton Raphael, 147, 151, 172, 268[27]

Mengs, Anton Raphael (Hewetson), 172

Mercers' Company, 247[6]

Merchant Adventurers, 55

Mercure de France, 107

Mercury (Giambologna), 61; (Nost), 61

Merry, Sir Thomas and Lady, mon., 29

Mersham (Kent), Knatchbull mon., 239[14]

Methley (Yorks), mons.: Mexborough, 140–1, 214; Savile, 120

Methuen, Sir Paul (Scheemakers), 119

Mexborough, Earl of, mon., 140–1

Mexborough, Sarah, Countess of, mon., 214

Michelangelo, 4, 26, 27, 31, 47, 50, 136, 158, 187, 213, 220, 239[15]

Michelangelo (Rysbrack), 87

Middle Claydon (Bucks), Verney tomb, 32, 241[46], 245[12]

Midhurst (Sussex), formerly, Montague tomb, 235[16]

Mid-Lavant (Sussex), May mon., 44, 246[18]

Mignard, Pierre, tomb, 259[15]

Miller, Captain R. Willett, mon., 276[26a]

Milles, Bishop, mon., 259[17]

Milles, Jeremiah (Bacon), 169

Milton (Cambs), Knight mon., 192

Milton Abbey (Dorset), Dorchester mon., 141, 266[36]

Milton, John, 73; mon., 256[20]

Milton, John (Pierce), 46; (Roubiliac), 103, 114; (Rysbrack), 87, 88; (Scheemakers), 261[9]

Minehead (Som), statue of Queen Anne, 76

Minerva (Nollekens), 159

Missirini, Melchior, 204

Mitchell, William, mon., 127

Mitley, Charles, 130

Mitrovitz mon. in Prague, 106

Mitton (Yorks), Shireburn mons., 64, 251[2], *48*

Mocenigo, Alvise, mon., 42, *30*

Mochi, Francesco, 187

Mold (Flint), Davies mon., 99, 255[8]

Molyneux, Sir Thomas (Roubiliac), 114

Monck, General, funeral effigy, 45

Monconys, Duc de, 243[24]

Mone, Jean, 20

Monnot, Pierre, 70, 120, 126, 253[14,15], 254[23], 256[23], 261[11], *53*

Montacute (Som), Nine Worthies, 3

Montagu, 2nd Duke of, mon., 107–8, 260[26,30]

Montagu, 2nd Duchess of, mon., 107–8, 260[26], *80*

Montagu, 3rd Duchess of, mon., 170, *131*

Montagu, Elizabeth, 184

Montague, James, Bishop of Winchester, tomb, 234[7], 235[17]

Montague, Captain James, mon., 273[37], 277[3]

Montague, Viscount, tomb, 15, 25, 235[16]

Montego Bay (Jamaica), Palmer mon., 168

Montfaucon, Abbé, 69, 72, 81, 91, 253[14], 255[9]

Monumenta Anglicana (Le Neve), 65, 254[2,13]

Moore, General Sir John, mon., 201, 218, *162*

Moore, General Sir John (Garrard), 174

Moore, Sir John (Gibbons), 250[57]

Moore, John Francis, 170–1, 270[22–4], *133*

Moore, Colonel Thomas, mon., 129, *103*

Moore, William, mon., 129

Mordaunt, John, Lord, mon. (anon.), 10

Mordaunt, John, Lord, mon. (Bushnell), 43, 52, *29*

Moreton (Dorset), Frampton mon., 170

Morison, Sir Charles, tomb, 29, 239[14], 240[26], *18*

Morison, Sir Charles, Bt, tomb, 29, 240[26], *19*

Morland, George, 173

Morley, Mrs, mon., 186, *143*

Moro, Antonio, 2

Mortlake (Surrey), tapestry factory, 243[18]

Moses, Henry, 204